Kandinsky and Old Russia

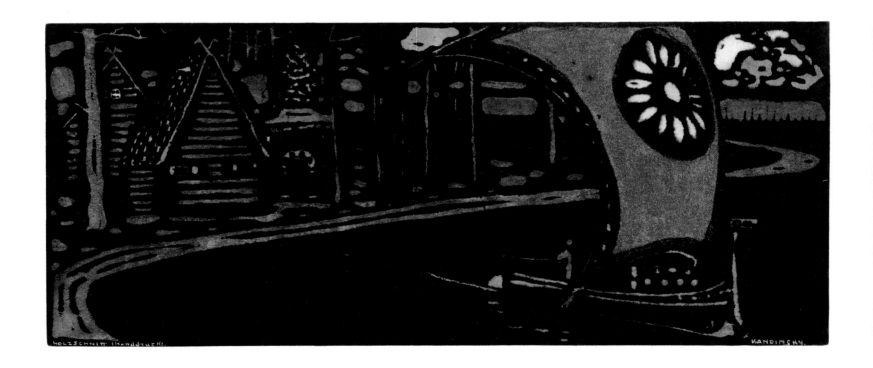

HOLZSCHNITT (HANDDRUCK). KANDINSKY.

Kandinsky and Old Russia

The Artist as Ethnographer and Shaman

Peg Weiss

Yale University Press New Haven and London

**Published with assistance from the
Getty Grant Program**

Kandinksy illustrations © 1995, ARS, N.Y./ADAGP,
Paris

Designed by Sonia L. Scanlon
Set in melior type by Tseng Information
Systems, Inc.
Printed by CS Graphics, Singapore

Weiss, Peg, 1932–
 Kandinsky and Old Russia : the artist as ethnogra-
pher and shaman / Peg Weiss.
 p. cm.

Includes bibliographical references and index.
ISBN 0-300-05647-8
 1. Kandinsky, Wassily, 1866–1944—
Criticism and interpretation. 2. Folklore—Russia
(Federation)—Influence. 3. Shamanism—Russia
(Federation)—Influence. I. Kandinsky, Wassily,
1866–1944. II. Title.
ND699.K3W42 1995
759.7—dc20 94-26210
 CIP

A catalogue record for this book is available from
the British Library.
The paper in this book meets the guidelines for
permanence and durability of the Committee on
Production Guidelines for Book Longevity of the
Council on Library Resources.

10 9 8 7 6 5 4 3 2 1

Frontispiece: Kandinsky. *Golden Sail*, 1903. Color woodcut with gold ink on wove paper, 12.7 x 30.2 cm. Solomon R.
Guggenheim Museum, New York. Photo: David Heald. © The Solomon R. Guggenheim Foundation, New York.

contents

Kandinsky spoke to me with tenderness, richness, vivacity, and humor. In his studio, word, form, and color fused and transformed themselves into fabulous, unheard-of worlds, never seen. Across the roar and tumult of those worlds, by listening attentively, I could hear again the tintinabulation of the brilliant, variegated mushroom-towns of Russia. Kandinsky told me that his great-grandmother had arrived in Russia trotting on a miniature charger studded with little bells, coming from one of those enchanted Asian mountains, all in porcelain. There is no doubt that this great-grandmother bequeathed profound secrets to Kandinsky.

— **Jean Arp**

acknowledgments

At every turn of the page memory conjures the image of a special person without whose kind word or deed this voyage of exploration could not have been accomplished. Since it is impossible to express my gratitude adequately in words, or even to mention every individual by name, I beg indulgence for the following inevitably dry and incomplete recitation, and only hope each will agree that the long, often arduous, yet always exhilarating journey has been worth the effort.

Among the many colleagues who have been generous in their assistance and support, I wish first to express my gratitude to Professor Emeritus Walter Sutton of Syracuse University, who was kind enough to read a dauntingly long draft of this book and to share not only his superb editorial advice but his incisive knowledge of the ethno-mythic dimensions of late nineteenth- and early twentieth-century literature. His critique helped me to focus and sharpen both my writing and my thesis (although he is not to be blamed for either!). Two other Syracuse University colleagues must be mentioned here: the late Prof. William Wasserstrom, whose initial enthusiasm for my "shaman-ist" interpretation of the *Blue Rider* almanac effectively launched the research for this book, and

the late Prof. Catherine Covert, who helped vastly in the formulation of my initial ideas. As always I also owe a great debt of gratitude to Professor Emeritus Kenneth C. Lindsay, of the State University of New York at Binghamton, whose example in Kandinsky studies and continuing enthusiasm for my research have been a great source of intellectual stimulation, moral support, and strength over many years.

Many Russian art historians and curators were unstinting in their hospitality, generosity, and assistance with research, photographs, and so much more. I especially wish to thank Natasha Avtonomova, curator, State Tretyakov Gallery, Moscow; Elena Basner, senior research curator, State Russian Museum, St. Petersburg; and Boris Aswarischtsch, head, Department of West European Paintings, State Hermitage Museum, St. Petersburg. To Lydia Iovleva, deputy director of the Tretyakov Gallery, I am much indebted for her kind assistance and extraordinary generosity in arranging for my lecture in the handsome new Tretyakov Auditorium, in which effort I received the expert assistance of Tatiana Goubanova. Also in Moscow, Natalia Alexandrova, Graphics Department, State Pushkin Museum, offered her very kind attentions. And in St. Petersburg my appreciation goes to Evgenia N. Petrova, deputy director, State Russian Museum, especially for her help in obtaining photographs and transparencies. At the Hermitage Museum, Iurii Rusakov, chief, West European Graphics, and Larissa Doukelskaia, senior curator, also offered not only hospitality but research assistance and moral support.

In Russia I was also most fortunate to have the assistance of ethnograhers in both Moscow and St. Petersburg. Overwhelmingly generous in his enthusiasm for my project and assistance in photography was the late Rudolf Its, at that time director of the Peter the Great Museum for Anthropology and Ethnography (MAE) of the Miklukho-Maklai Institute of Ethnography, St. Petersburg. Also at that institution, Larissa Pavlinskaia, Siberian Section, and Alexander Teriukov, an expert on the Komi (Zyrian) peoples, were generous in sharing their expertise. At the State Museum for the Ethnography of the Peoples of Russia (GME), I was assisted by Natalia Kalashnikova, head, Department of Ethnography, and by Nina Margolina and Karin Solov'eva of the Siberian Section. In Moscow, Valery Tishkov, director of the State Institute of Ethnography, and his colleagues Sergei Serov, Elena Novik, and Sevian Vainshtein were most cordial. At the State Historical Museum, Moscow, Deputy Director Tamara Iguminova offered her assistance, and at the State Historical and Art Museum Preserve of Zagorsk, Valentina M. Zhiguleva, chief of the Folk Art Department, kindly allowed me to photograph Zyrian material in her collecton.

I should also like to thank Ildikó Lehtinen, Archives of the National Museum of Natural History, Helsinki, and curator Paula Jaakkola, who transported me through miles of beautiful Finnish landscape to the museum's storage facilities. In Stockholm I was the grateful beneficiary of assistance at the Nordiska Museet by Åsa Thorbech, Heidi Hendriksson, and Maria Maxén. Inger Zachrisson of the State Historical Museum, Stockholm, was also generous with her time and assistance. My heartfelt thanks go especially to Maria Kecskési, Rose Schubert, Jean-Loup Rousselot, Jörg Helbig, and Wolfgang Stein of the Staatliches Museum für Völkerkunde, Munich; and to Claudius Müller, director, East Asian Section, Museum für Völkerkunde, Berlin, and to Gudrun Müller, formerly of the European Section; as well as to Heinz Israel, director, Museum für Völkerkunde, Dresden.

At the National Museum of Natural History, Washington, D.C., William Fitzhugh, curator of the exhibition *Crossroads of Continents: Cultures of Siberia and Alaska* (1989), kindly included me in his symposium and introduced me to many of our Russian colleagues. At the American Museum of Natural History, New York, I was assisted by Laurel Kendall and Thomas R. Miller in studying the Jochelson Collection.

At the Musée National d'Art Moderne, Centre Georges Pompidou, Paris, I am especially indebted to Jessica Boissel for her tremendous efforts in providing time and space for my study of Kandinsky's Vologda expedition diary and of the artist's personal library, as well as for her indefatigable assistance in all aspects of my research at her institution. I am also grateful to Christian Derouet, formerly of the Musée National d'Art Moderne, for making the diary available for study and quotation for the first time. Also

in Paris, Laurence Delaby and Christine Hemmet, Siberian Section, Musée de l'Homme, Trocadéro, were extremely kind and helpful.

For their generous assistance in studying Kandinsky's correspondence, I am most grateful to Armin Zweite, former director of the Städtische Galerie im Lenbachhaus, Munich, and to Ilse Holzinger, Gabriele Münter- und Johannes Eichner-Stiftung. I would like to thank as well Helmut Friedel, current director of the Städtische Galerie, for his continuing assistance in providing photographs and permissions. For their special efforts in helping to locate rare photographic material, I express my special gratitude to Björn Springfeldt, director, Moderna Museet, Stockholm; Maeght Galerie, Paris; Aivi Gallen-Kallela Sirén, Helsinki; Bo Lönnqvist, Academy of Finland, Helsinki; Bernd Schmelz, Hamburgisches Museum für Völkerkunde, Hamburg; and Galerie Pels-Leusden, Berlin. Prof. Gustav Ränk, of Stockholm, an expert on Finno-Ugric beliefs and customs, now in his nineties, generously shared notes from his early field work with me.

Among the many librarians who provided research assistance and help in obtaining rare books and journals for this effort are: Lois White and her colleagues, Library of the J. Paul Getty Center for the History of Art and the Humanities; Edward Evans, formerly head of the Tozzer Library, Harvard University; Jeff Horrell, head, Fine Arts Library, Fogg Museum, Harvard University; Jean Adelman, University Museum Library, University of Pennsylvania; Sandra Stelts, Special Collections, Pattee Library, The Pennsylvania State University; Dorcas MacDonald and her staff, Interlibrary Loan Department, Syracuse University Library; Randy Bond and Barbara Opar, Fine Arts Department, Bird Library, Syracuse University. Elizabeth McKinsey of the Bunting Institute, Radcliffe College, kindly made possible my use of the Tozzer and Widener libraries. For special assistance in photography I am grateful to Don Williamson, Photo Services, Getty Center, and David Broda, Photographic Services, Syracuse University. Research assistants who provided invaluable aid at crucial times included Alyce Jordan, Elisa Bob, Elena Christova, and Jana Colacino, whose perceptive assistance in the final stages of editing was crucial.

For technical advice on the geography of Vologda Province, the site of Kandinsky's early ethnographic explorations, I am most extremely grateful to Prof. Robert Gohstand, Department of Geography, University of California at Northridge.

For translations from the Russian I am most indebted to Robert De Lossa, who managed to produce a Herculean mountain of translations from difficult late nineteenth-century ethnographic texts while pursuing his doctorate in the Slavic Languages Department, Harvard University. Others who helped include Tamara Alexandrova and Alexei Dmitriev (who, together, worked on Kandinsky's holograph Vologda diary), Lilia Grubisic, Olga Snegireff-Fedoroff Stacy, Anna Gorbatsevich, and Elena Tsypkin.

I would particularly like to express my gratitude to other Kandinsky scholars who provided stimulus without perhaps having been aware of it, among them: Rose-Carol Washton Long, whose precedent-setting dissertation and book on *Kandinsky: The Development of an Abstract Style* taught me the value of the rigorous study of preliminary sketches, drawings, and watercolor studies in reaching conclusions about Kandinsky's painting; Angelica Rudenstine, whose paradigmatic catalogue of the Guggenheim Museum's Kandinsky collection offered convincing evidence of the advantage of paying close attention to context in the analysis of Kandinsky's work; Johannes Langner, whose courage in conceding the need for contextual information about Kandinsky's past was also an inspiration; and Vivian Endicott Barnett, whose recent work on Kandinsky's Paris paintings within the context of his scientific interests provided another encouraging signpost; I am also grateful for her help in obtaining photographs of some of the Kandinsky works illustrated here.

As all explorers know, funding is required for such a voyage. In this case I have been the fortunate beneficiary of financial support from a number of institutions. First and foremost, I should like to thank the J. Paul Getty Trust. As an invited scholar at the Getty Center during the academic year 1989–1990, I was able to complete much of my research and the greater part of the writing of this manuscript. The stimulating exchange of ideas, debate, and suggestions of my fellow scholars contributed substantially

to many aspects of my work, and I also wish to thank all of the staff members at the Getty Center who helped in so many different ways. I was also the beneficiary of a travel grant from the Scholars Program, which helped to defray the costs of my research visit to Helsinki in April 1990. Most especially I am grateful for the award of a generous publication grant from the Getty Grant Program.

At the Getty Center I wish to thank Kurt Forster, Thomas F. Reese, and Herbert H. Hymans, of the Scholars Program, as well as Lynn O'Leary Archer for their constant and generous efforts to provide a stimulating and collegial environment for research. I would also like to thank the Scholars Program staff, especially Suzanna Aguayo and Michelle Nordon.

My research trip to the Soviet Union in April 1990 was funded in part by a generous grant from the Senate Committee for Research of Syracuse University, as well as by a Grant for Independent Short-Term Research from the International Research and Exchanges Board (IREX). That journey yielded significant research and photographic material crucial to the completion of this book, and I am indeed grateful for the support of both institutions. The Smithsonian Institution generously provided a Short-Term Visitor Grant in partial support of research and consultation at the National Museum of Natural History and the Library of Congress, Washington, D.C., in the summer of 1988.

Additionally, I was fortunate to have the moral support, hospitality, and helpful critique and advice of a great many good friends and colleagues, not all of whom can be named here, for which I ask their forgiveness. They include Marjorie Balzer, Artis Bernard, the late Agehnanda Bharati, Yve Alain Bois, Lissa Renaud Bolotnikov and Vladimir Bolotnikov, John Bowlt, Klaus Brisch, Mary Ann Caws, Anthony and Aalo Cutler, Lois Fink, Françoise Forster-Hahn, Elizabeth Gardiner, Reinhold Heller, Alison Hilton, Sharon Hirsh, the late Elizabeth Holt, Anne Kelley, Janet Kennedy, Terryl Kinder, Klaus Kropfinger and Helga von Kügelgen, Diane Lesko, Elizabeth and Thomas Letham, Sarah C. Lewis, Christine Lindsay, Leah Livshits, Svetlana Makurenkova, Scott Manuel, Deborah Marrow, Henry N. Michael, Kenneth Nyirady, Martina Norelli, Felix Oinas, Myra Orth, Anthony Parton, David R. Rosenthal, Rima Salys, Dmitri Sarabianov, Salme Sarajas-Korte, Robin Simpson, Anne Stack, Barbara Stafford, Andrea Swardon, Marianna Teuber, Nancy and Michael Thomas, Peter Vergo, Marit Werenskiold, Oswald Werner, and Otto Wittmann.

To my friends at Yale University Press I am most grateful. They include Senior Editor Judy Metro, who recognized the potential of this project from the beginning; Harry Haskell, whose editorial skills were surpassed only by his enthusiastic response to the musical subtext of the manuscript; and Sonia L. Scanlon, whose sensitive eye produced so harmonious a design. I should like to note that it is a source of personal satisfaction that the preparation of this project has been completed by the fiftieth anniversary of Kandinsky's death in December 1944.

Finally, on a voyage so long and adventurous as this, one's closest companions stand the toughest watches. To my parents, Amy Lemert Hake and Robb A. Hake, I owe the spirit of independence and will to exploration that inspired this journey. But without the steadfast, patient, and loving support of my husband, Volker, and our sons, Erick and Christopher, and their families, the expedition could never have been completed. To them this book is dedicated.

introduction

"Psychology, archeology, ethnography! What has art to do with all this?" With so temperamental an explosion of words did the young Kandinsky castigate a Moscow critic for his temerity in praising a respected artist solely for his "human types full of ethnographic and psychological interest." Then on the brink of what was to become a revolutionary artistic career, Kandinsky brooked no criticism of Art writ large in terms so bald and scientistic. Three decades later, however, in a more chastened mood, the by then world-renowned artist wrote: "My first enthusiasm for ethnography is an old story: as a student at Moscow University I noticed, if somewhat unconsciously, that ethnography is as much art as science." Still later he wrote of the "violent impression" his ethnographic expedition to Vologda province had exercised on him, crediting the "abstraction" of his work to that crucially formative experience.[1]

This book is the first to consider Kandinsky's ethnographic experience as a fundamental key to his life's work. It is, I believe, the first approach to provide a unified view of the artist and his oeuvre, revealing the continuity and coherence of his iconography from beginning to end. In my

essay for the catalogue of the exhibition *Kandinsky in Munich: 1896–1914,* I postulated that the landmark almanac *Der Blaue Reiter* (The Blue Rider), published under Kandinsky's leadership before World War I, had been consciously intended as a therapeutic metaphor for cultural healing and regeneration.[2] Included in the exhibition were a number of the original artifacts from Munich's Ethnographic Museum that Kandinsky had selected to illustrate the book—for example, an *Easter Island Ancestor* figure and the magnificent Ceylonese *Dance Mask of the Demon of Disease* used in healing rituals, both symbols of regeneration that clearly emphasized the intrinsically shamanistic message Kandinsky intended (figs. 98, 108). The quality and authenticity of these artifacts evidenced in no uncertain terms the discriminating eye of the trained ethnologist who had chosen them from the museum's vast collections.[3] Yet, curiously, despite the current widespread interest in the "primitive" and its relation to modernist art, Kandinsky's vital interest in such matters—indeed, his expertise as perhaps the only trained ethnographer among the modernists—has been all but ignored.[4] Thus it was that I came to ask myself exactly what was the background to Kandinsky's informed interest in ethnography? In what context had he developed this interest? To what extent might it have been expressed in his work? The results of my investigations have led to an entirely new perspective from which to view this revolutionary figure.[5]

Kandinsky's oeuvre has been somewhat arbitrarily divided into three disparate stylistic "periods": first, the "Munich period" of 1896–1914, sometimes (however inappropriately) called the "Expressionist" period, when he worked at becoming a craftsman-painter, involved himself in Munich's Jugendstil movement, and succeeded in making what has been called his "breakthrough to abstraction," achieving world renown for his audacious liberation from tradition in such exuberantly charged and apparently "abstract" paintings as *Composition V* and *In the Circle* of 1911 (figs. 106, 90); second, his "Russian and Bauhaus" period (usually, although obscurely, lumped together) marking the date of his departure from Germany in 1914 at the outbreak of World War I, his brief involvement with the Russian avant-garde until 1922, and his return to Germany, where he

joined the faculty of the Bauhaus—a time during which his work seemed to crystallize into what has been called a "geometric" or even "cold" style, as in *In the Black Square* of 1923 or *Yellow-Red-Blue* of 1925 (figs. 128, 158); and last, the "Paris period"—sometimes described as "oriental" or "Byzantine"—marking his removal to Paris upon the Nazi closure of the Bauhaus, where his exotically colored paintings, such as *White Line* of 1936 and *Around the Circle* of 1940, took on a seemingly more biomorphic character (influenced, it has often been said, by surrealism), becoming even more "cryptic" and "difficult" for Western eyes to comprehend (figs. 165, 184).[6]

Such a scenario not only obscured the true complexity of the artist's development, but worse, it obscured its inherent continuity expressed both in formal stylistic terms (in fact, those artificial divisions were never so hard and fast as has been assumed) and, far more significantly, in terms of iconographic *content* and *meaning.* At the same time, this "formalist" approach also conveniently ignored such early paintings as *Song of the Volga* and *Motley Life.* Together with a number of other works often referred to as the "Russian paintings," these works remained somewhat of an embarrassment, given short shrift in an art historical literature concerned more with the Western idea of "abstract painting" than with the visual evidence of Kandinsky's deep roots in Russian culture (figs. 39, 45). Yet it was Kandinsky's lifelong commitment to his Russian heritage that sustained the continuity of his entire life's work. This book explores the myriad ways in which that heritage, with its ethnic and folkloristic ramifications, together with his early experiences and training as an ethnographer, one of the most crucial aspects of which concerns his essential knowledge of Finno-Ugric and Siberian shamanism, provided a well-spring for his iconography.

This ethnographic perspective has uncovered new clues to the "reading" of many paintings by Kandinsky that have hitherto been assumed to demonstrate his presumed theory of "abstraction." It also raises the question of whether Kandinsky's paintings can indeed be "read." One might have thought that the artist had settled this question in his own lifetime. In fact, he often warned against just such an approach: "The content of painting is painting. Nothing has to be deciphered." But the apparent

contradictions in Kandinsky's work and writings must be confronted. On the one hand, he argued that the object was not indispensable to painting and prophesied two directions in art, the "Great Abstraction" and the "Great Realism." On the other, while claiming that "the content of painting is painting," in the same 1937 essay, he went on to say: "I do not become shocked when a form that resembles a 'form in nature' insinuates itself secretively into my other forms. I just let it stay there and I will not erase it. Who knows, perhaps our 'abstract' forms are altogether 'forms of nature.'"[7] And he wrote to his biographer, Will Grohmann, that he wished finally that people would see what lay behind his circles and triangles, later preferring that his paintings be thought of as "concrete" rather than as "abstract." But even Grohmann, who generally refrained from specific readings, scrupulously adhering to the formalist canon ("the left side of the painting is brightly lit, graphic and rectilinear; the right side is dramatic and heavy . . ."), could not resist describing the 1943 work *Circle and Square* as "five actors performing in an exotic theater." Yet his tone in such cases was always cautious, and he was careful never to suggest actual sources.[8]

Kandinsky's somewhat disingenuous cunning in promoting himself as the "first" abstract painter further served to obfuscate matters, while the formalist division of his work into rigid stylistic periods also helped to gloss over the artist's personal temperament and any vestige of the ordinary, vulnerable human being. The image of a "white knight" emerged and the new myth posited Kandinsky as the unblemished and immaculate inventor of "pure painting," as pure as the "colorful whimsies" credited to his last years. He was thought to have distanced himself from the realities of everyday life, charged even with political naïveté. A new critical generation of followers and scholars fanned the "sacred flame" of abstraction until the 1960s, when a few incursions into the temple suggested that, after all, perhaps some "abstractions" were not so "abstract" as others. With that a Pandora's box was opened to a variety of persuasive readings, none of which provided a satisfactory conceptual framework that might be applied to the artist's entire oeuvre.[9]

The advantage of the present study, I believe, is that it demonstrates a unifying iconographic rationale that can be applied to a good number of works in every stylistic transformation throughout the artist's life. Moreover, this new perspective reveals the mythic dimension and multifaceted character of Kandinsky's "abstract" vocabulary. While this book cannot claim to provide the one and only key to understanding so complex a personality, it does open a broad view that extends far beyond the formalist myth. And although some aspects of this study may remain speculative, there is no doubt that much that is illuminating and provocative has emerged.

An effective by-product of the present approach, for example, has been the development of a methodology for deciphering the immediate reactions of the artist to the events of everyday life. The revelation that Kandinsky marked nearly every spring St. George's Day with a painting devoted to the image of his signature saint in one or more of his iconographic guises led inexorably to the recognition that birthdays, anniversaries, births and deaths, even reactions to letters from friends or to the chaotic political events of the times also triggered the production of paintings with quite specific imagery. Thus, as revealed here, the death of his son Volodia apparently inspired the painting *Red Oval* and the Nazi closure of the Bauhaus provoked the painting *Development in Brown*, while *In the Black Square* had its own poignant context.[10]

The fascination that the exotic world of primitive cultures held on the imagination of the nineteenth and early twentieth centuries was demonstrated over and over again in the pseudo-villages of innumerable world's fairs, in post-Darwinian salon paintings of Biblical figures as "Neanderthals," and not least in Gauguin's dramatic escape to the South Seas. That Ensor and Munch sketched in the frigid galleries of ethnographic museums and that Picasso experienced an "epiphany" before the African exotica of the Trocadéro, even collecting examples of African art to use as models—these facts are now accepted as part of a modernist canon first enunciated by Robert Goldwater in his landmark 1938 study *Primitivism and Modern Art*.[11] And one need only consult the catalogue of the monumental *"Primitivism" in Modern Art* exhibition at New York's Museum of Modern Art almost half a century later to see how many artists of the

late nineteenth and early twentieth centuries were stimulated in one way or another by the productions of "primitive" societies, and at the same time how little the modernist canon had changed. Curiously, the only modern artist to have had extensive training in ethnography, and the first to introduce global "primitivism" into the context of modern art, was not represented in that exhibition.[12]

It is, however, little wonder that Kandinsky was excluded from that forum; indeed, one looks in vain for examples of African or Oceanic precedents in his work. But Kandinsky had early on dismissed the idea of *imitating* or "borrowing" the forms of primitive art.[13] Still, he never hesitated to admit his sympathy for the primitives. In an open letter to the publisher Paul Westheim written in 1930, he recalled his efforts in the *Blue Rider* to correct what he called the "destructive detachment" of one art from another—that is, the artificial separation of what in his own eyes appeared to be "identical phenomena"—by reuniting folk art, children's art, and "ethnography" with what was commonly deemed "Art" in the West. He was less interested in any accidental formal resemblances among these phenomena than in their internal coherence, that is to say, their meeting on the ground of what he termed "inner necessity," where the "fractured soul" of a decadent society might be healed. Moreover, the objects of primitive culture that most influenced Kandinsky were not those that appealed to the popular culture of "folk art," although many were indeed "artful," nor were they the artifacts of cultures completely foreign to his own heritage. They were the products of the shamanist societies of the Lappish and Finno-Ugric North and greater Siberia. They were the raw artifacts of life lived in confrontation with nature and the unknowable "gods" that had already to a large extent been confiscated by the West, pathetic but still vital remnants of lost or rapidly changing cultures and customs, lost or threatened rituals. As artist, he was sensitive to the "artfulness" of these artifacts; as ethnographer, he understood their function, context, and metaphysical significance. He knew from first-hand experience their power to endure through change, synthesis, and metamorphosis. He was perhaps uniquely positioned to transform them to his own needs, for he

also understood that a syncretic world view offered a means for faith to endure in the "dark continent" of modern times.

As to Kandinsky's knowledge of specific shamanist artifacts, beyond those he included in the *Blue Rider*, the speculations introduced here stand on firm ground. Certain reasonable assumptions can be made in view of his documented experience as an ethnographer close to preeminent specialists in the field, and in view of his own ethnographic writings, donations to ethnographic collections, acknowledged visits to ethnographic museums, and easy access to collections of artifacts and contemporary publications in the field (including those of his friends and those in his own library). Thus it has not been difficult to confine citations largely to material within the artist's own environment and sphere of interest.[14]

Although Kandinsky never attempted to hide the impact of his ethnographic experience on his own work, neither did he specifically discuss it except to exalt the powerful impression of his expedition to the Zyrians in his 1913 memoir "Retrospects." Apparently no one ever asked, although Will Grohmann, who was personally acquainted with the artist, may have explored the idea with him, since he observed near the conclusion of his 1958 book: "Kandinsky's late works have points of resemblance to Mexican and Peruvian art, but more often they evoke the art of the Altai region, especially the abstract branch of that art, which gave rise to the arabesque; the formalized animal of the Scythians, the bird-fish motive, the landscape forms of the silk weavers of Noin Ula all are repeatedly echoed in Kandinsky." As I believe this book demonstrates, Grohmann came close to the truth.[15]

Indeed, Kandinsky had been "in the field," a shattering experience that colored his entire life. And if in retrospect his field work seems tame as compared, for example, to that of such full-fledged Russian ethnologists as those of the famous Jesup North Pacific Expedition, Waldemar Bogoras and Waldemar Jochelson, nevertheless it was for him personally a fundamentally formative experience. It was *his* epiphany. He had been deeply moved as much by the customs, beliefs, and art of the native peoples he visited as by their socio-economic situation. What is more, his

active participation in professional ethnological circles at the University of Moscow in the 1880s and 1890s had exposed him to the wide range of important discoveries, collections, and ideas related to the contemporary study of primitive cultures, including shamanism. Thus, for Kandinsky, the primitive objects he selected for inclusion in the *Blue Rider* almanac had not been selected because of some vague or mystical "affinity" with modern art, but specifically *because of their original function.* For example, his interest in shamanism was prompted by his training as an ethnographer, and his appreciation of its iconography lay in its significance as social phenomenon and therapeutically effective ritual. His use of primitive motifs throughout his life was in fact based upon his intimate knowledge of their "context, function and meaning." [16]

Like a practiced teller of fairy tales, Kandinsky wove the figures of northern folklore into his work. The crucial leaven of fairy tale, metamorphosis, attached to the imagery he adapted. So the *leshie* (woodland spirits), *rusalki* and *vasy* (spirits of the marshy lakes and waterways), the soul-birds, shadow-souls, and *khubilgans* of ancient pagan belief emerged in the artist's work in syncretic tandem with the pantheon of Christian saints. St. George himself, Kandinsky's alter ego, fused with the shamanic heroes of the Finnic *Kalevala* saga and again with the mythic figure of Finno-Ugric lore, Mir-susne-khum, or World-Watching-Man, and was continually recreated in each new stylistic language. Finally, the figure of the shaman himself, indeed the entire iconography of shamanic lore, from resonant drum to amulet-laden costume, came to represent the artist in his quest after a universal legend for modern times. [17]

Over time Kandinsky's self-identification with the mythic role of the shaman resulted in the creation of a "self-myth" in modernist terms. He learned to bend and, to use his own term,

to "stretch" its components in a variety of stylistic metamorphoses to suit each new formal vocabulary. Each symbol became densely "packed" with accumulated meanings, so that by the end of his life the great verities could be stated in the most succinct terms. Like his contemporary Yeats, the younger Pound and Joyce, and Picasso and his own friends Klee and Miró, Kandinsky forged a personal mythology resonant of the contemporary psyche. "Make it new!" Pound had admonished; and so Kandinsky did. But if others chose Byzantium, the dream garden or the Minotaur, it was the figure of the mythic Shaman in his ecstatic, eternally regenerating flight that Kandinsky conjured against the dark cataclysms of modern times.

The story told here begins with an expedition into the "wilds" of northern Russia, to the edge of Siberia, in the latter decades of the nineteenth century, and ends in the rarefied atmosphere of a Parisian studio just before the end of World War II. Paradoxically, the further removed the artist was in time and place from his roots, the more that heritage came to dominate his imagination. The brash young man who once had written: "Psychology, archeology, ethnography! What has art to do with all this?" was not the same man who in his last months painted such unabashedly "ethnographic" works as *The Arrow* and *The Green Bond.* Yet they were, in fact, one and the same. Ethnography inexorably knit together the young and the old in ways the former could not foresee. The ethnographic experiences of his youth left an indelible imprint on the artist's mind and provided an inexhaustible source of inspiration and imagery.

The writing of this book has been in its own way a voyage of exploration, and Kandinsky himself wrote its coda in concluding a 1939 essay with the following words: "Ask yourselves, if you like, whether the work of art has carried you away to a world unknown to you before. If so, what more do you want?" [18]

abbreviations

Institutions

GME	State Museum for the Ethnography of the Peoples of the USSR, St. Petersburg
GMJES	Gabriele Münter- und Johannes Eichner-Stiftung, Städtische Galerie im Lenbachhaus, Munich
GMS	Gabriele Münter-Stiftung, Städtische Galerie im Lenbachhaus, Munich. (Kandinsky works identified by GMS numbers only are illustrated in Hanfstaengl [1974])
MAE	Museum of Anthropology and Ethnography, N. N. Miklukho-Maklai Institute of Ethnography, St. Petersburg
MNAM	Musée National d'Art Moderne, Paris
SG	Städtische Galerie im Lenbachhaus, Munich
SMV	Staatliches Museum für Völkerkunde, Munich
SRG	Solomon R. Guggenheim Museum, New York

Archives and Publications

D/B (1984) Derouet, Christian, and Jessica Boissel, eds. *Kandinsky: Oeuvres de Vassily Kandinsky (1866–1944)*. Paris: Collections du Musée National d'Art Moderne, 1984.

E.O. *Etnograficheskoe Obozrenie*

IAE *Internationales Archiv für Ethnologie*

KS *Keleti Szemle—Revue orientale*

L/V (1982) Lindsay, Kenneth C., and Peter Vergo, eds. *Kandinsky: Complete Writings on Art*. Boston: G. K. Hall, 1982. For the sake of convenience, the English translation of Kandinsky's memoir "Rückblicke," 1913, in L/V (1982) as "Reminiscences," is cited as Kandinsky (1913 [L/V 1982]), while references to the English translation of the Russian version of the memoir, "Stupeni," annotated in L/V, will be cited as Kandinsky (1918 [L/V 1982]). In this text "Rückblicke" is translated as "Retrospects," with translations by the author unless otherwise indicated.

R/KGW (1979) Roethel, Hans K. *Kandinsky: Das graphische Werk*. Cologne: DuMont, 1979.

R/B (1982) Roethel, Hans K., and Jean Benjamin, eds. *Kandinsky: Catalogue Raisonné of the Oil-Paintings*. Ithaca: Cornell University Press, 1982.

kandinsky as ethnographer 1

Do not go, my little son,
To the villages of far-off Pokhola
Do not go without magic
Without all-powerful wisdom . . .
To the fields of the Lappland children . . .
Even if you be hundred-tongued
You will not throw the sons
Of Pokhola into the water with your singing . . .
You will not sing like the Lapplander

With these admonitions to the *Kalevala* hero Lemminkainen ringing in his ear, Kandinsky stood at the Ethnographic Society meeting to present his paper "The Beliefs of the Permians and Zyrians." He knew that, should his contribution win the Society's competition, he might himself need more

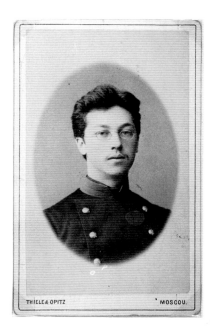

1. Kandinsky, portrait photograph as a student, ca. 1886. Gabriele Münter- und Johannes Eichner-Stiftung, Munich.

with him, like a talisman, his own copy of the *Kalevala*, recording in his diary a deep veneration for this mythic tale with its shamanic heroes.

The presentation was not Kandinsky's only ethnographic endeavor. Soon he was involved with the Society's publications: his first journalistic effort, a brief but signed bibliographic review of an anthology of Cossack folk ballads, appeared in that inaugural issue. The publication of his essay on peasant law in the Society's *Transactions* would also be announced.[2]

His summary of the research and interviews actually conducted during that ambitious field trip into the remote northeastern reaches of Vologda province in the early summer of 1889 thus became Kandinsky's second ethnographic publication. Within months of his return, his nine-page article appeared in the third issue of *Ethnographic Review*, under the title "Materials on the Ethnography of the Sysol- and Vychegda-Zyrians—The National Deities (According to Contemporary Beliefs)."[3]

Should this zealous pursuit of ethnological concerns by the man who would later be recognized as an innovator of abstract painting seem surprising, we have only to turn to Kandinsky's 1913 memoir "Retrospects" for confirmation of an interest that was to play a crucial role in his artistic development. In several paragraphs devoted to an account of his university studies, Kandinsky recalled that he had studied national economy, Roman law, criminal law, the history of Russian law, and most especially "peasant law," which appealed to him particularly, he wrote, for its "opposition" to Roman law. But, further, and "related to this," he had also studied "ethnography (from which I initially promised myself the soul of the people)."[4]

Although he had entered the university with the ostensible intention of devoting himself to the study of law and economics, the catholicity of his mind had soon suggested the integral relationship of these disciplines to the natural sciences. Like many of his colleagues, he recognized that the study of law was necessarily related to the situation of Russia's ethnic minorities. Eventually he would become interested in the working-class minimum wage, proposing a thesis on the so-called Iron Law of wages that clearly declared his interest in social welfare. Mean-

than a little of that magic, for the prize was to be sponsorship of his proposed expedition into that northern wilderness inhabited by the Finno-Ugric Zyrians, in ancient times distant relatives of the *Kalevala* peoples. Just weeks before this event, Kandinsky's friend Nikolai Kharuzin had presented his own paper on shamanism among the Karelian Lapps in which he had quoted this passage from the immensely popular saga of the Finns recently published in Russian translation.[1]

Presiding at this meeting of the Ethnographic Section of the Russian Imperial Society of Friends of Natural History, Anthropology, and Ethnography were the president of the Society, Vsevolod F. Miller, and the section's vice president, Viktor M. Mikhailovskii, an authority on Siberian shamanism. Their appreciation of the aspiring young ethnographer's work was soon evident in a spare announcement of his competitive success in the first volume of the Society's new journal, *Ethnographic Review*: "V. V. Kandinsky—to Vologda" (fig. 1). His proposal had, after all, been accepted. And on the expedition he would carry

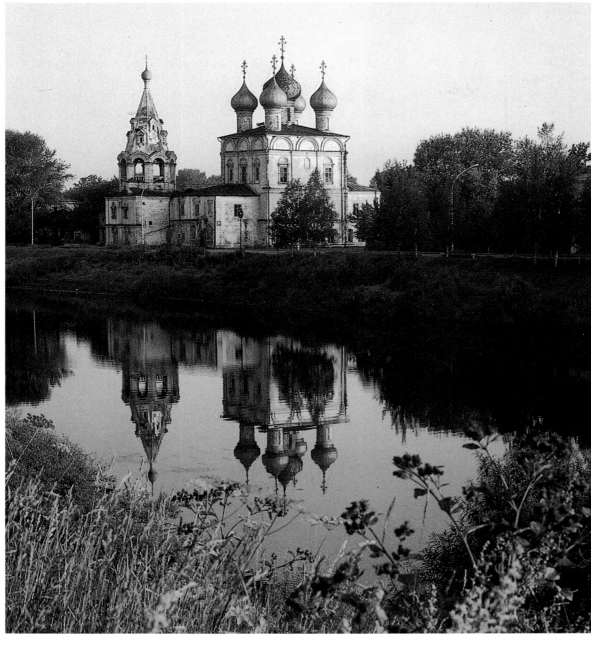

3

2. Church of St. John Zlatousta (the Silver-tongued Orator), embankment of Vologda River, Vologda. Second half of 17th century. With permission from V. I. Belova, *Mastera Russkogo Severa Vologodskaia Zemlia*, no. 128 (Moscow: Planeta, 1987).

while, he was drawn to a group of scholars associated with a department that was for many years Russia's primary center for studies in anthropology and ethnography.[5]

In a passage as moving and poetic as any in his 1913 memoir, Kandinsky recalled that he had set out for Vologda by train with a feeling that he was traveling "on another planet." At the last station he changed to a steamer and spent several days gliding along the Sukhona River, which he described as "deeply submerged in itself." Later he made his way by primitive coach "through unending forests, between brightly hued hills" (see frontispiece). He would have passed by the ancient towns of Vologda and Veliki Ustiug, with their gleaming church towers reflecting in the flowing waters (fig. 2). Traveling alone, he reported, was good for meditation and for "immersing myself in the environment. . . . Days it was often burning hot, nights frosty." But it was the Zyrian people themselves who captivated him with their "contrasting appearance"—now gray or yellow-gray from head to toe, now with "white faces, red-painted cheeks and black hair," clad in colorfully variegated costumes "like brightly-colored living pictures on two legs" (figs. 3–6). The

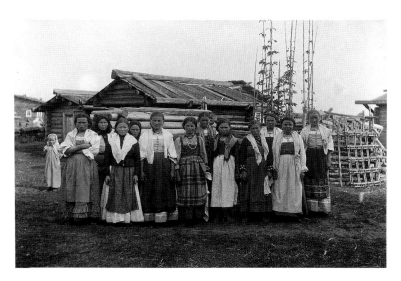

4. Group of young Zyrian women in costume. U. T. Sirelius, 1907. National Museum of Finland, Museovirasto, Helsinki.

great two-storied wooden houses decked with carving likewise captured his attention (fig. 7).

In these "wonder-houses" (Wunderhäusern), in which every surface was brightly painted, the walls hung with folk pictures—perhaps one "like a painted folksong"—the traditional "red" or "beautiful" corner filled with icons shimmered with its eternal light. Here Kandinsky found himself immersed in an environment marvelously rich in color and symbol, moving him to exclaim that it seemed as if he had actually crossed a threshold and entered a painting in which he could move and walk about. In the Russian version of the memoir, Kandinsky likened this moment to "a miracle." It was an experience that would have long-lasting reverberations not only in his art but in his whole attitude toward the arts (figs. 8, 9).[6] Perhaps he had already been prepared for the wonder of such interiors by Surikov's 1883 *Menshikov at Berisov*, in which the czar's former adviser was depicted exiled to a humble peasant's cabin, a candle-lit "red corner" gleaming in the background, with its icon of Mary and the Christ child and another of St. George. A watercolor study for this painting depicts a humbler icon corner in a typical peasant house such as

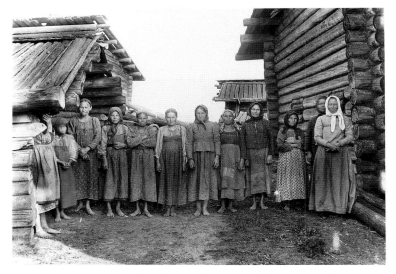

3. Zyrian women in everyday dress as photographed by U. T. Sirelius, 1907. National Museum of Finland, Museovirasto, Helsinki.

5

5. Kandinsky. *Ravens*, 1907.
Linocut, 43.8 x 28 cm. Musée
National d'Art Moderne, Centre
Georges Pompidou, Paris.

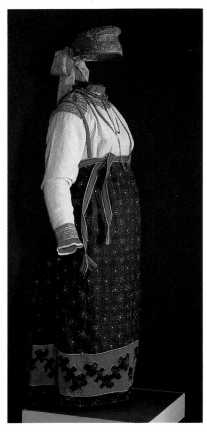

6. Woman's costume, Vologda province, 19th century. Vologda Oblast Regional Museum. With permission from V. I. Belova, *Mastera Russkogo Severa* (Moscow: Planeta, 1987), p. 274.

the "frosty nights" an acknowledgment to this friend who had helped him procure suitably warm Zyrian clothing for the trip, describing him as a botanist, zoologist, and the "author of serious ethnographic studies." He also spoke admiringly of Ivanitskii as a "noble hermit," yet observed that his friend had been active in reorganizing the local cottage industry of handcrafted items made from native horn in an effort to protect the old folk art from exploitation by mercenary traders.[8] In fact, Ivanitskii, who was to exercise an important influence on his protégé, was also a colleague in the Society; his work was published in *Ethnographic Review* as well as in the Society's *Transactions*.

We also learn from "Retrospects" that Kandinsky had personal reasons for his interest in ethnographic studies. Although he had been born in Moscow, his family comprised an eclectic mix of ethnic nationalities. Relatives on his mother's side came from the German Baltic region, but his father had been born in Kyakhta, on the border between Russia and Mongolia, south of Lake Baikal. According to Kandinsky's account, his father's ancestors had moved to eastern Siberia after having been banished from "west Siberia" for "political reasons." This passage suggests that Kandinsky's trip into the eastern fringes of the Vologda area, bordering on the Ural Mountains and the frontiers of western Siberia, may have been prompted by an urge to seek his iden-

those Kandinsky visited (fig. 10). Kandinsky himself attempted to convey the ambience of an icon-cornered peasant interior in a small sketch known as *The Blessing of the Bread*, probably made during his Vologda expedition (fig. 11).[7]

Kandinsky revealed more details of his ethnographic interests in a reference to his friend and colleague Nikolai Alexandrovich Ivanitskii that, in the Russian edition of his memoir, became a lengthy tribute. There he added to his comment on

7. Carved window casing, northern Russia, Gorky region, late 19th century. Wood, 136 x 129 x 23 cm. Zagorsk State Historical Museum-Preserve. Photo by the author.

8. Interior of northern Russian peasant home with *lubki*, icon corner, samovar. With permission from V. I. Belova, *Mastera Russkogo Severa* (Moscow: Planeta, 1987).

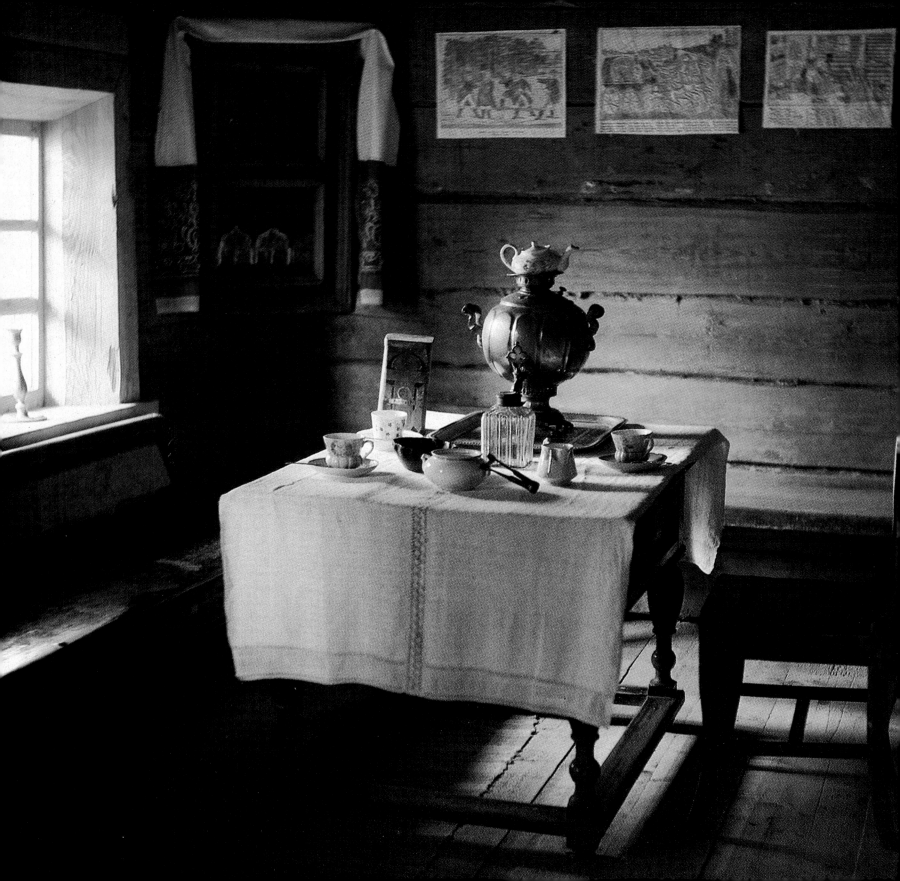

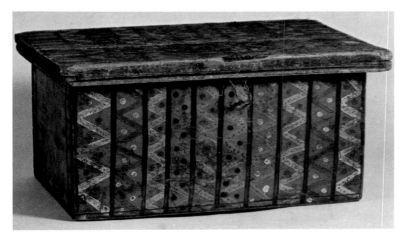

9. Painted chest, Vologda region, Mezhdurechensky district, Igumentsevo village, early 20th century. Painted wood, 58 x 41 x 29 cm. No. 5416d. Zagorsk State Historical Museum-Preserve. From O. Kruglova, *Traditional Russian Carved and Painted Woodwork* (Moscow: Izobrazitelnoye Iskusstvo, 1974), no. 39.

tity in his ethnic heritage, and his own roots in the "soul of the people."[9]

Two interesting geographical facts lend credence to this supposition. For centuries the Zyrian, or Komi, people had traded with their neighbors the Ostiaks, Voguls, and Samoyeds to the north and east across the Ural Mountains. Settlements of Zyrians had existed since ancient times along the Ob River on the eastern side of the Urals.[10] Zyrian traders traveled up and down the great Ob, often exchanging metals or grains for furs, which could then be profitably sold to the Russians. One of the important trading stops along the river was the settlement of Kondinsk (often designated on early maps as Kandinsk), known particularly for its monastery and seminary school. From an etymological point of view, the names are essentially identical. The Finnish linguist and explorer Sjögren insisted on the Finno-Ugric origin of the name. But another feature of the Ob landscape had a similar name—its tributary, the Konda River. According to Sjögren, both Kondinsk and Konda derived originally from the Finnish word for fir tree, *Honka* (or *Honga*).[11]

Moreover, ethnographers have associated the name of an Ostiak idol, identified with the son of the highest god Numi-Tōrem and known in some early accounts as the "kondinskii" or "kondaer" idol, with the name of the Konda River. According to an account published in 1884, the idol was so precious that, with the arrival of the Russians, it had been taken by the Ostiaks from its normal place of honor to a safe haven guarded by the Voguls of the Konda River area south of Kondinsk Monastery.[12]

Thus, the name that loomed so large in Zyrian, Ostiak, and Vogul life and lore may have drawn Kandinsky to explore the possibility of some genealogical connection, legendary or real. His father's ancestors had emigrated to the edge of Mongolia from "*west* Siberia," the land of the Ob, the Konda, the "kondinskii" idol, and the historic Kondinsk Monastery. He knew the works of Sjögren, whose 1861 book he noted in the diary of his Vologda expedition. He knew Sjögren's theories concerning the Zyrian and ultimately the Finno-Ugric origins of his name. It is not difficult to imagine that this was the lure that had drawn him to the Zyrian people.

10. Vasilii Surikov. *Iconed Corner in a Peasant House*, 1883. Study for *Menshikov at Berisov*. Watercolor, 23.8 x 33.8 cm. State Tretyakov Gallery, Moscow. Photo: I. Kozlova, 1991.

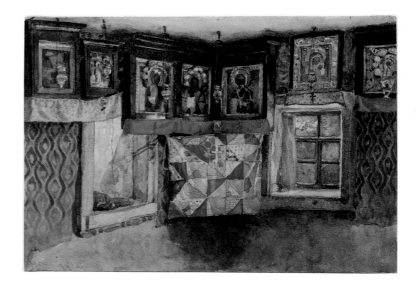

But the fact of his father's birth in Kyakhta, an important center for trade between Russia, Mongolia, and China from ancient times, lends credence to Nina Kandinsky's recollection that her husband also had "Mongolian" blood in his veins and often said with some pride that one of his great-grandmothers was a "Mongolian" princess. Some photographs of the artist tend to emphasize the faintly oriental visage (figs. 1, 203), and Hanna Wolfskehl was not the only one of his acquaintances to remark

11. Kandinsky. *The Blessing of the Bread*, ca. 1889. Watercolor and graphite sketch, 18.3 x 24.6 cm. State Tretyakov Gallery, Moscow.

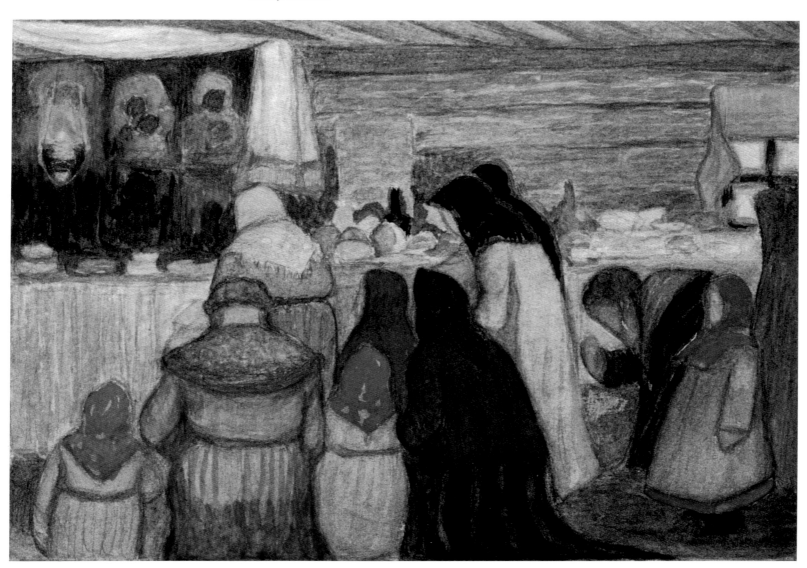

9

on the "Chinese" cast of his features. The native peoples of the Kyakhta region, the Mongolic Buriats and the Manchu Tungus, were of ancient stock, and their traditions and shamanist religion had already attracted the intense interest of several generations of travelers and ethnologists, so that by the end of the nineteenth century a substantial body of literature on them was available to the student of ethnology and doubtless of special interest to the young Kandinsky.[13]

These few extracts from "Retrospects" reveal a great deal about Kandinsky's interest in ethnography and its lasting effect on him. That these memories were recorded with such immediacy and enthusiasm a quarter of a century after the fact lends substance to Wordsworth's insight that "the child is father of the man." As late as 1937, at the age of seventy-one, Kandinsky recalled the "violence" of the impression made on him by his Vologda trip.[14]

In 1913 he wrote that his trip to the Vologda region had provided him with one of the most powerful experiences of his student days. He compared it to his first impression of paintings by Monet and Rembrandt, and his experience of a production of Wagner's *Lohengrin*. "My assignment," he wrote, "was double: to study peasant criminal law among the Russian citizenry (to discover the principles of primitive law), and to collect the remnants of pagan religion among the fishermen and hunters of the slowly disappearing Zyrians."[15]

Heritage and Source

In preparation for his expedition, Kandinsky marked a map of the area he was to visit (fig. 12), indicating that his route lay from Moscow first to the city of Vologda, near the fortieth meridian, and then east and north almost to the Urals. This corresponds roughly to what is today a territory combining parts of the Vologda and Arkhangelsk oblasts with the Komi Autonomous Socialist Republic. This vast and still sparsely populated area, then largely covered by dense taiga forest, stretches west to the crest of the Urals and north to the Arctic tundra. The major rivers—the northern Dvina, the Sukhona, the Pechora, the Vy-

chegda, and the Sysola—had been important transportation routes since long before the area was first explored by the Novgorodian Russians in the eleventh century. The central city of Ust Sysolsk, standing at the confluence of the Sysola and the Vychegda, was a trading center especially noted for its fairs. Due to the density of the forests, rich in game (especially squirrel and arctic fox), and the plentiful rivers, the native Zyrians had traditionally been hunters, reindeer herders, and fishermen.[16]

12. Map of Vologda province, the area Kandinsky was to visit, from the artist's Vologda Diary. Musée National d'Art Moderne, Centre Georges Pompidou, Paris.

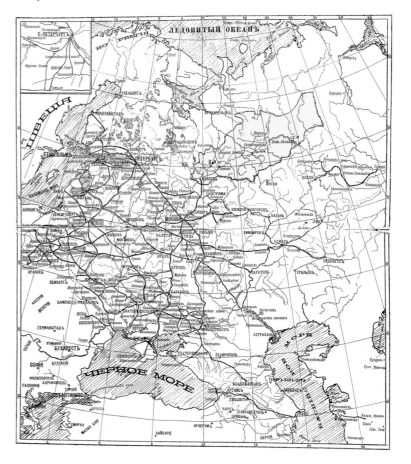

Why did the Society particularly wish to sponsor an expedition to the Zyrians, instead of to the more exotic Ostiaks, Voguls, or Samoyeds, the Yakuts, the Buriats, or even the Chukchees of the far east? And, more particularly, why would this have been of interest to the young Kandinsky? As we have seen, personal reasons appear to have drawn Kandinsky's attention to the Zyrians. But the answers to these questions evoke a larger context and seem to lie at least partially in a growing appreciation of the ethnic populations that had early been absorbed into the Russian sphere of influence and thereafter merely exploited, if not entirely ignored. Indeed, by the early nineteenth century the native cultures of northwest America had been more thoroughly recorded and their artifacts more seriously collected by Russian explorers than those of the natives on the western slopes of the Urals, whose "Russification" had long since been taken for granted.

Thus, too, the nineteenth-century poet Fet's oft-quoted couplet "The Chukchee have no Anakreon/To the Zyrians no Tiutchev goes" was easily understood by his contemporaries as a metaphor for the cultural "primitivism" and geographic isolation of the Zyrian and Chukchee peoples, as opposed to the civilized sophistication of such romantic poets as his friend Tiutchev.[17]

Despite centuries of oppression, however, the "Russified" Zyrians had retained their Finno-Ugric language along with remnants of ancient lore. Their roots were recorded, too, in the many place names of Finno-Ugric origin. It was this that had piqued the interest of many nineteenth-century linguists, notably the Finnish scholar-explorers Sjögren, Castrén, and Ahlquist, who had set out to demonstrate the linguistic and cultural ties between the widely separated Finno-Ugric peoples. All three intrepid scholars had undertaken expeditions into the Zyrian territories and beyond, claiming to have found evidence for their theories that, when published in the second half of the century, stimulated new interest in the all-but-forgotten Zyrians.[18]

By the middle of the nineteenth century, the new awareness had resulted in the formation of public collections of the material culture representing even Russia's less exotic ethnic minorities. Moscow's Dashkov Ethnographic Museum, largely supported by the Society, laid particular emphasis on Russia's diverse ethnic cultures. Thus, it is not surprising that in the 1880s and 1890s the Society was stimulated, even by a sense of urgency, to sponsor expeditions to those areas not yet thoroughly researched.[19]

In the Wilderness

The evident objectivity and scientific cast of the finished report that Kandinsky was to prepare for publication in *Ethnographic Review* utterly masked the excitement of the first-time explorer; only in his later memoir would he reveal a glimpse of the intense psychological and emotional upheaval brought about by the expedition. But his travel diary was not so circumspect, providing an intimate and direct link to the feelings of the young ethnographer experiencing for the first time the unaccustomed rigors of exploration in a perhaps unexpectedly hostile environment. Not surprisingly, Kandinsky carefully preserved this memento, taking it to Munich in 1896 (where he doubtless consulted it while writing "Retrospects"), back to Russia during World War I, to the Bauhaus in 1921, and then to Paris a decade later. The diary is small in format, its notations scanty and often hastily rendered. Inside the front cover is the map of western Russia on which Kandinsky marked the boundaries of his study (fig. 12).[20]

Beginning at the end of May 1889, the trip lasted barely six weeks, yet it covered roughly sixteen hundred miles. We may gauge the physical stamina demanded of the young traveler by noting that he must have averaged some thirty-eight miles per day—by train only on the first and last stages, but for long stretches by boat, by often primitive horse cart, and even on horseback.[21] Kandinsky's notes spark with the intensity, and sometimes the naiveté, of the eager student. Cranky complaints about the severe jolting to which he was subjected in springless carriages, about long hours of discomfort and irregular meals, alternate with sudden insights—as, for example, that the post stations "breathe Gogol" [184]. His comments mirror his unwonted physical exhaustion and anxiety: at one point he worried about "fits" of forgetfulness [197]. But they also reflect the ex-

citement of discovery, with an abrupt intensity suggested by frequent underlinings, exclamation points, and rushes of abbreviated words. Scattered quick sketches suggest the visual impact of the experience. Kandinsky's feelings are projected immediately and without inhibition, so that the mounting excitement as he approached and then actually entered Zyrian territory becomes palpable. A growing self-confidence and sense of accomplishment are transmitted in an increasing sense of humor vis-à-vis the rigors of the journey, as when toward the end he commented wryly on his "musical" bed [202].

Since Kandinsky's trip did not begin in earnest until 28 May, the early pages of the diary were given over to random preparatory notes and to observations apparently made en route. There are, for example, lists of contacts in villages he expected to visit, probably conveyed by colleagues in Moscow. Among them was Ivanitskii at Kadnikov (just north of the city of Vologda).[22] There are also bibliographic notations, perhaps conveyed by Ivanitskii, whose work dealt mainly with the western region of Vologda province. They included references to past issues of the *Vologda Province Gazette* containing information on religious customs of the inhabitants of various towns in Vologda, and to an article by the Estonian ethnographer Wiedemann, whose Zyrian-German dictionary Kandinsky noted down, together with its price. On the same page he also recorded the price of Sjögren's famous book on northern Russia, with its long section on the Zyrians [39]. Because Kandinsky had been fluent in German since childhood—indeed, German phrases occur in the diary—these were obviously accessible sources for his research.[23]

Sjögren's book, while primarily concerned with demonstrating the close linguistic affinities between the Zyrians and the Finns, also included detailed information on the geography, climate, wildlife, agriculture, fishing industry, trade fairs, and history of the territory, as well as on the customs and beliefs of its peoples. It was an essential resource of the day. Sjögren's vivid descriptions of the teeming markets in remote towns where precious furs were traded for grain, the dense forests, the lonely chapels perched on hills above the rivers—Christian signs of victory over the pagan Chuds, whose ancient fortresses once com-

manded those hills—Chudic burial mounds, and St. Stephen's encounter with the sorcerer Pam, provided images that clearly informed Kandinsky's own first-hand observations. Not surprisingly, they were also to fuel Kandinsky's artistic imagination.

Conscientious scholar that he was, Kandinsky noted the varying perceptions of the Zyrians held by his contacts. One found them unsociable, another the opposite, while to another they seemed afraid of officials. Marked with an exclamation point is a note "for the archeological society" concerning the exact locations of two Chudic burial mounds, at least one of which Kandinsky actually visited near the end of his journey [45]. Once he was underway, the daily notations record meetings with informants, places visited, weather conditions (often very cold), distances traveled, and observations on customs as well as on his research and readings.

The diary reveals that Kandinsky had left the Moscow area from Akhtyrka, the country home of his cousin Anna Chemiakina's family, and that she accompanied him as far as the city of Vologda. (Three years later he would marry her.) They stopped at the Golden Anchor Inn ("cheap but clean"), where he sketched his first *vasa*, or "water-spirit"—a figure with bearded face and a fish's tail carved above the inn's door [181] (fig. 13). Pouring rain seemed a gloomy omen for his trip. His status as a traveler associated with the Society was perhaps reflected in his reception in Vologda by the governor and by the local "marshal of the gentry" [183–184].[24]

Among the attractions of the city known for its large number of churches and resonant bell towers that Kandinsky would doubtless have seen was the great sixteenth-century Hagia Sophia cathedral, modeled after the Dormition Cathedral in the Moscow kremlin. Its particularly fine frescoes by the seventeenth-century icon painter Dmitri Grigorevich Plekhanov were noted for their depictions of the Last Judgment, in which the painter emphasized the trumpeting angels by sheer size. Doubtless the young scholar would also have made an effort to see the famous *Zyrianskaia Old Testament Trinity*, a fourteenth-century icon that had been brought to Vologda from a provincial church near Yarensk in the early part of the century. The icon depicts

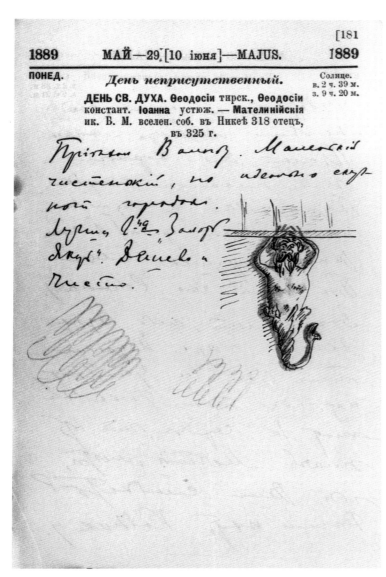

13. Kandinsky. Drawing with annotation, 1889. From the artist's Vologda Diary, detail, [p. 181]. Representation of a carved figure with bearded face and a fish's tail; a water-spirit, or *vasa*, at the Golden Anchor Inn, Vologda. Musée National d'Art Moderne, Centre Georges Pompidou, Paris.

the old testament story of the hospitality of Abraham and Sarah visited by three angels, but its historical importance lies in the fact that it carries rare inscriptions in the Permian alphabet devised for the Zyrian people by St. Stephen of Perm. Of special interest for the future artist must have been the icon *St. George and the Dragon* (fig. 14) and a remarkable painted wood sculpture of St. George of the same period, for the saint was to become a leitmotif in Kandinsky's work. Indeed, an icon painting of St. George and the dragon that is very nearly identical in composition and style to the Vologdan icon eventually found its way into the artist's private collection (fig. 15).[25]

After seeing Anna off, Kandinsky continued on to Kadnikov, where he met with Ivanitskii, later noting in his diary that he was a "seminarian of the best type" [185]. Kandinsky was obviously interested in the fact that his new friend had spent some time on the Pechora River, in the far eastern portion of the province, eight years previously, when the area had been inhabited mainly by "Old Believers."[26] They spent most of a day together, part of it at the municipal library [185]. Perhaps it was then that the older man helped Kandinsky to procure the sheepskin coat, felt boots, and Zyrian hat mentioned in "Retrospects" with which to ward off the severe chill of a typical Arctic summer in an area where the mean high hovered in the fifties Fahrenheit, and the lows were often in the freezing range. He also provided Kandinsky with a fur cap and a map of the district.

On leaving the relative comfort of Kadnikov, a small town that Kandinsky had already described as "completely wooden" (even the pavements were made of wood), he was abruptly introduced to the discomforts of country travel in a jolting springless coach over rough roads, arriving at the next station with aching bones. He found himself plunged into a crude existence involving long, hard hours of travel and often delayed meals. Clearly he was appalled by the poverty he witnessed. Late the night of June 5 he wrote: "Everything is quiet and infinitely poor. Everywhere poverty, poverty" [188]. A group of Zyrian women photographed by an ethnographer almost two decades later provides some notion of their impoverished circumstances (fig. 3).

"I'm reading the *Kalevala*. I worship it," the young ethnog-

13

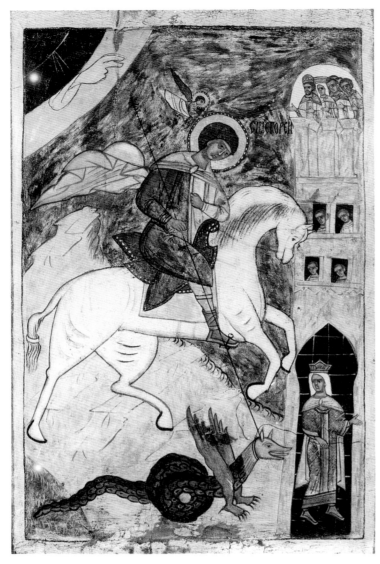

14. *St. George and the Dragon*. Icon from the Church of St. Theodore Tyron at the village of Berezhok, near Kadnikov. Vologda School. First half of the 16th century. Tempera on wood, 94.2 x 59.8 cm. State Russian Museum, St. Petersburg.

15. *St. George and the Dragon*. Icon in Kandinsky's private collection. Musée National d'Art Moderne, Centre Georges Pompidou, Paris.

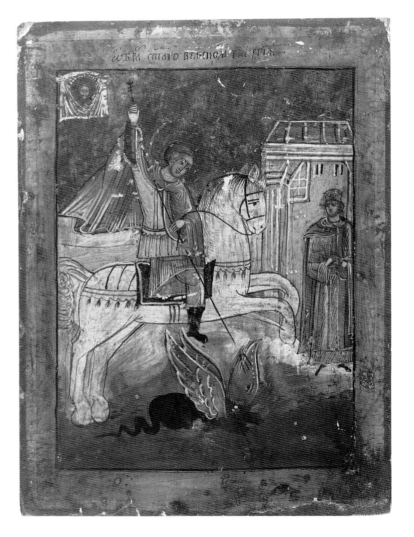

rapher confided to his diary on June 6, as he began the second week of his solitary expedition [189]. Clearly, Kandinsky was steeping himself in the mythology of the Finno-Ugric peoples not only by first-hand experience in the field and by the intellectual pursuit of scholarly materials such as Sjögren's work, but also philosophically and aesthetically by reading the epic legend of the ancient Finns, rich in shamanist imagery and inspiration, first compiled and published by the Finnish folklorist Elias Lönnrot in 1835. Already the stage was set for his later interest in the work of the Finnish artist Axel Gallen-Kallela, whose vivid visual interpretations of the *Kalevala* Kandinsky would later exhibit in Munich (fig. 41). The degree to which the *Kalevala* fired his own imagination would manifest itself throughout his artistic oeuvre.[27]

Midway through his trip, doubts begin to assail him as the realization of the limited time allotted for so ambitious a study pressed in on him and travel conditions worsened, the temperature fluctuating wildly from near freezing at night to oppressive heat at midday. On the tenth day he calculated that he was "700 *versts*" (or 442 miles) from Moscow, and for the first time in his life he learned that hot meat could be a luxury [189]. He then traveled some distance by steamer on the Sukhona River, noticing that the fares for laborers were exorbitant [196]. But the excitement of discovery returned as he set out for Solvychegodsk, crossing the great northern Dvina River on a frigid night. He found time to sketch a crude wooden Russian cross and to note that it was for "public prayers" for the well-being of the cattle [198] (fig. 16). The next day (June 16) he recorded that there had been snow up ahead in Zyrian territory just a few days previously, and that he had been told there were plenty of bears and wolves around [199]. But he remained on the lookout for local superstitions and signs of shamanism to add to his ethnographic collection, and he noted that there was no "casting of spells" even in the Solvychegodsk area [199]. Thus on facing pages of his diary he opposed the Christian cross (albeit used for superstitious purposes) to the possibility that the practices of pagan sorcerers might still be in existence [198–199]. The significance of this juxtaposition became clear in his report, where he specifi-

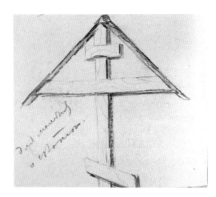

16. Kandinsky. Sketch of wooden cross, 1889. From the artist's Vologda Diary, detail, [p. 198]. Musée National d'Art Moderne, Centre Georges Pompidou, Paris.

cally emphasized the "chaos" of contemporary religious beliefs among the Zyrians, and even later in his work as an artist when religious syncretism became a consistent theme.

Yarensk was described as another wooden village with no inn, so that he was compelled to continue on to Ust Sysolsk the same evening, a distance of some 164 versts (about 108 miles) [200]. Snow had covered the ground a few days ago, and he was grateful for his sheepskin coat. But the wooden houses with their attached barns interested him [200]. With growing excitement he recorded the exclamations of the Zyrian natives he was beginning to meet along the way, who "touch my things and ask how much they are worth" [201]. They insisted, "Me komi!" (We are Komi)—not Zyrian—and refused to listen to Russian [201]. Ivanitskii's prediction that they might be afraid of officials was confirmed. For two rubles Kandinsky purchased a Zyrian cap made of leather [201]. Having arrived in Ust Sysolsk, he found his bed "musical" and mosquitoes bigger than those at home [202].

Now his ethnographer's senses were on the alert. He spent his first evening in Ust Sysolsk, the administrative center of Zyrian territory, at the municipal library [201] (fig. 17). Then he plunged into interviews, sketching, and notations, his observations obviously too copious for the tiny diary pages that were now peppered with red underlinings and slash marks. In a rush he recorded superstitions concerning the harvesting of the rye: when women "lived in" the rye, it was better; bread was not touched before St. Elijah (Elias, Iliia) Day, nor could clothes be

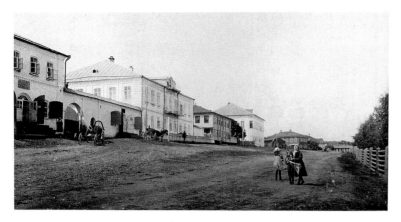

17. Main street of Ust Sysolsk (Syktyvkar), Vologda province, the center of Kandinsky's researches. U. T. Sirelius, 1907. National Museum of Finland, Museovirasto, Helsinki.

18. Sheaf of wheat in icon corner. Finno-Ugric Votes of Estonia. Similar to the same custom described by Kandinsky among the Zyrians. Drawing from photograph made by Gustav Ränk in the home of Ivan Morosov, village of Matti, 1942. Gustav Ränk, *Die Heilige Hinterecke* (Helsinki, 1949), no. 14, with permission.

washed [203]. "Even now," he noted, "straw sticks out behind the icons" [203]. These beliefs and customs centering on the rye, the only staple available in that harsh climate, were of ethnographic interest because they represented remnants of ancient pagan customs intended to propitiate the guardians of the earth and vegetation. Clearly, it was at this point in his expedition that he learned at first hand of the Zyrian midday goddess or "guardian spirit," Poludnitsa, thought to reside in the rye, to whom he devoted special attention in his final report.

Among the Zyrians the custom of carrying the last sheaf home and placing it in the "holy corner" with the icons was reminiscent of the pagan custom of taking grain to the sacrificial sheds in order to assure a safe harvest. Normally this custom was observed on St. Elijah Day (in July), but Kandinsky observed that straw was "already"—that is, by June 20—adorning the icon corners of peasant homes [203] (fig. 18). This conjunction of pagan custom (propitiating the spirit of the grain) within the framework of Christian form (the icon corner) was clearly of particular interest to Kandinsky. Indeed, it was perhaps at this point in his expedition that he recorded the Zyrian "blessing of the bread" custom in a colored drawing (fig. 11).[28]

A note at the beginning of the diary, apparently scribbled hastily in the village of Yarensk, recorded a recent sighting of the forest monster *vörsa* that "lives in water and in the forest.

Ten years ago it kidnapped a boy. Was seen last year. Seized a horse, strangled it. One has to cross oneself. It's as big as a tree and black. Lifts up its right hand" [79].[29] In the same town a *koldun* (sorcerer or shaman) was active [79]. Again the juxtaposition of Christian and pagan beliefs captured Kandinsky's attention as he recorded the use of the sign of the Christian cross to ward off the pagan spirit. If he had consulted the dictionary by Wiedemann that he carried with him, he would have known that in the forest one "may neither whistle nor speak his [vörsa's] name." Whether this admonition affected Kandinsky's decision to omit mention of vörsa from his later article remains a question, but there is little doubt that vörsa remained alive in his fertile artistic imagination.

Scattered throughout the diary is evidence of the artist's eye. Sketches of landscape, costume, architecture, and other objects of material culture, as well as annotated drawings of interior designs abound. The corner of a table top is rendered with detailed notes on the colors and the observation that the "predilection for tables painted in bright colors" is "strongly developed" [50] (fig. 19). Facing this page are sketches of Zyrian clothing, including a hood that was quite typical of contemporary Zyrian dress, as can be seen in a comparison of Kandinsky's drawing with a photograph taken around 1912 (figs. 19 right, 20). He noted the inventive way in which the hood had been adapted by means

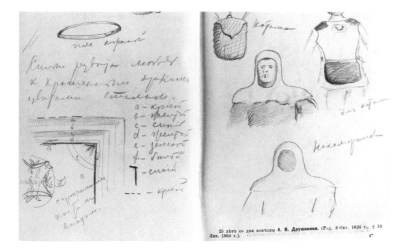

19. Kandinsky. Sketches of Zyrian furniture decoration and clothing, 1889. From the artist's Vologda Diary, [pp. 50–51]. *Left:* "The predilection for tables painted in bright colors [is] strongly developed." The color key reads: "a-red; b-yellow; c-blue; d-yellow; e-green; f-white; -blue; -red." *Right:* Traditional head covering called a *malitsa*, one with mosquito netting, and typical birchbark waist pouches. Musée National d'Art Moderne, Centre Georges Pompidou, Paris.

of netting to make an efficient mosquito barrier. A sketch of a Zyrian birchbark waist pouch is included. On other pages a hitching post for horses attracted his attention, and the pie shape of a Zyrian bread loaf was recorded along with the notation: "Straw or not straw—the devil only knows what it is. They say that it tastes better hot. Maybe!" [173].

Three sketches are devoted to Zyrian bath houses or saunas, including a "hot one," with smoke curling from openings below the roof [172] (fig. 21). The graceful elevated porch entrances to the upper stories of Zyrian houses were also faithfully recorded [175, 192–193] (fig. 22). One apparently hasty sketch represents St. Theodosia, identified as an icon at Podelskaya station [85] (fig. 23).[30] Other sketches recorded in a calmer mood depict details of churches, chapels, farm implements, and landscape [65, 192] (figs. 22, 24). At one point Kandinsky observed that he had encountered "chapels of clearly Mongol type" along the road and wondered about their origin [188]. The depth of his interest in the problem may be judged by the fact that he kept in his library

until his death a publication by his friend Kharuzin on ancient Russian churches with tent-shaped roofs.[31]

Kandinsky's interest in music (he had studied piano and cello) is evident in his comments on the collecting of folksongs. At the town of Votchinskoe he spent some time writing down

20. Group of Zyrians in typical clothing. Zyrian peasant with hooded garment *(malitsa)* similar to that sketched by Kandinsky. Photographed ca. 1912 by S. I. Sergel(?). From L. N. Molotova, ed., *Folk Art of the Russian Federation from the Ethnographical Museum of the Peoples of the U.S.S.R.* (Leningrad, 1981).

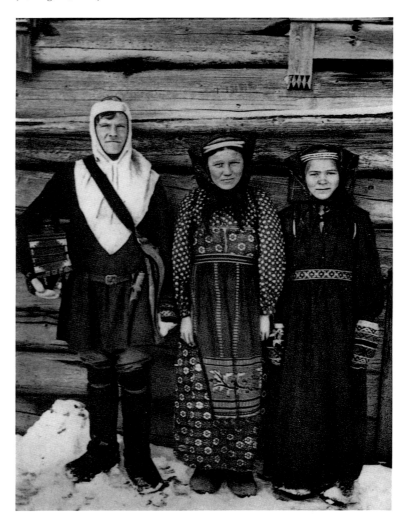

17

21. Kandinsky. Sketch of a Zyrian bath house, 1889. "A hot one," with grazing horse and well with dipper. From the artist's Vologda Diary, [p. 172]. Musée National d'Art Moderne, Centre Georges Pompidou, Paris.

Ukrainian and Russian wedding songs [190]. In Ust Sysolsk, he noted that the songs there were exclusively Russian; one supposed to be Zyrian was apparently only a translation of a Russian folk tune [207]. But near the end of his journey in the village of Kerchëm, far out in the wilds, he found some riddles and a "song about a widow and her daughter" [205].

Other entries in the diary clearly reflect Kandinsky's interest in social and legal questions of the time. At a number of stations along the way he paused to study the town records, doubtless in preparation for his concurrent study of peasant law. In one case, with a double-underlined exclamation, he observed that "'inadvertency' excuses even murder" [190].[32] He had already expressed concern about the high cost of ship fares for workers, and on a visit to the market in Totma noted that the stalls were filled with wares made by convicts [195].

Undeterred by the discomforts he had already encountered, not to mention those anticipated by his readings of Castrén and perhaps Ahlquist, Kandinsky pushed on to Ust Kulom, less than two hundred miles from the Ural Mountains, passing on the way the fallen ruins of Sjögren's Ulianovskii monastery.[33] As is clear from an earlier notation, Ivanitskii had evidently told him that Ust Kulom was the true center of native Zyrian activity [43]. Now exclamation points join the red underlinings; the culmination of his journey has had its rewards. He had evidently made friends

with the locals who had taken him to a *Kerki*, or "church." The immediately following declaration: "The god of the Chuds is found!!" suggests that he had been shown some pagan sacrificial or prayer site, perhaps a sacred grove or burial mound [204]. Or perhaps the observation was intended ironically and he was actually chagrined to find a Christian church so far from civilization. He recorded the purchase of another ethnographic trophy, a Zyrian rifle for sixty kopeks, and consumed game (duck and fish) "like the Komi" with his bare hands [204]. There is humor and amusement here, too, as he was able to document the existence of clans but lamented the lack of a word for "wife" in the Zyrian language—she was merely a "woman" [204].

Not content with reaching this outpost, Kandinsky determined to go still further, on to Kerchëm, southeast of Ust Kulom, although horses were the only means of transportation. Forced to skirt an area of quagmire, another first-time experience, he

22. Kandinsky. *Left*: Sketches of "Mongolian-type" chapel roof and Zyrian farm implements, 1889. *Right*: Porch at Solvychegodsk, Veliki Ustiug district, 1889. From the artist's Vologda Diary, [pp. 192–193]. Musée National d'Art Moderne, Centre Georges Pompidou, Paris.

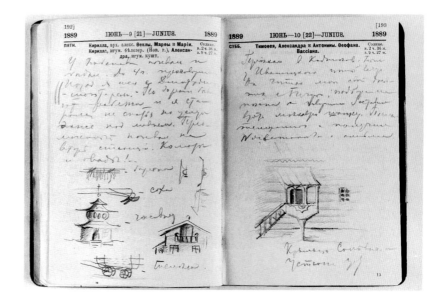

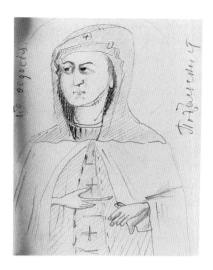

23. Kandinsky. Sketch of St. Theodosia, identified as an icon at Podelskaya station, 1889. From the artist's Vologda Diary, [p. 85]. Musée National d'Art Moderne, Centre Georges Pompidou, Paris.

estimated that he had ridden thirty miles that day, traveling a total distance of some forty-six miles; he wouldn't wish it on his enemy! [205] Nevertheless, the natives had made a great impression on him: the Zyrians, he wrote, were "exceedingly dear people" [205]. In fact, he declared that he had "fallen in love" with them, maintaining staunchly that "everyone slanders them" [205].[34]

At the end of his quest he fulfilled a fervent wish by visiting the sites of an ancient Chudic settlement and the Chud burial mounds he had noted down—with an exclamation mark—at the beginning of the diary [45]. He rode on horseback to Bogorodsk (some twenty-five miles north of the Vychegda River on its tributary, the Vishera River, between Ust Kulom and Ust Sysolsk) and traveled by boat to the outpost Shoi Iag [206].[35] There he found natives who seemed completely "savage," in the sense that they "looked at me as at something miraculous and never before seen" [206]. They pointed at him and a few of the more courageous touched his glasses. Frustrated that his allotted time was at an end, he expressed the wish that he might stay on there. Then, he seemed to be saying, perhaps he could find something truly extraordinary [205].

Returning then directly to Ust Sysolsk, Kandinsky recorded various official business, including dinner with the superintendent of police. But in a clear reference to the date—according to his diary it was St. John's Day—he noted that he had then accompanied the superintendent to a public festival in a nearby village [207]. There he had evidently been on the lookout for authentic Zyrian songs, but was disappointed to find that the songs at the festival were mainly Russian. The social customs, however, occasioned the remark: "[Their] treatment [of each other] is reserved, very few gestures. [But they] walk holding hands" [or "arm in arm," 207]—an extraordinary sight for a student used to the more staid social strictures of city life.[36]

The ceremonies and rituals connected with St. John's Night exemplified the mix of pagan and Christian belief systems characteristic of peasant life. Kandinsky was of course familiar with the St. John's Night customs, at the very least through Gogol's short story "The Eve of Ivan Kupalo," but certainly through his ethnographic studies and his own experience of the countryside.[37] A conglomerate of ancient purification and agricultural ritual and, in Vologda province, intimately connected with the ripening of the grain and its protection for the coming harvest, it was also the celebration of midsummer's night—the longest day of the year, when special restorative powers were thought to be imparted to plants, to water, and to fire. The making of a

19

24. Kandinsky. Sketch at Ust Kulom, 1889. From the artist's Vologda Diary, [p. 65]. Musée National d'Art Moderne, Centre Georges Pompidou, Paris.

straw effigy to represent Ivan Kupalo, the lighting of bonfires and sometimes a wheel of fire, round dances, and processions were all traditional customs whose roots could be traced to pagan observances. The celebration represented not only tribute to the sun before its waning but time-honored hopes for the purification of the fields from evil influences and for the safety of the harvest, as well as a symbolic plea for fertility and the resurrection of the crop the following season. Typically, with the advent of Christianization, all of these had simply been grafted onto the conjunctive saint's day, which happened to be St. John's, with its own purification symbolism. The sight of young couples dancing and leaping over the bonfire, possibly the lighting of a fire wheel, the ultimate destruction of the effigy, and the singing doubtless made a lasting impression on the sensitive observer.[38]

But now that the time for conclusion had come, the young student was eager to be off toward home. He thought of Anna with anticipation; he felt exhausted and dirty, imagining humorously that exotic vegetation must be growing on his feet. He interviewed a last informant, referring to him not as a Zyrian but respectfully as "a Komi," like an old friend: "we discussed old times, war, tobacco" [208]. By June 28 he was back in Veliki Ustiug, and by July 3 he could write "finis" to the saga of a remarkable journey. That he carried back with him vivid pictures of his encounters with the Zyrians is attested in a cryptic but poignant final comment on the day of his departure from Ust Kulom: "The picture of farewell to the Zyrians" [205].

The Russian Paintings

Indeed, we can easily imagine that it was this very scene, firmly embedded in his memory, that inspired the monumental painting *Motley Life* of 1907 (fig. 45), the keystone to a series based on Russian themes. Equally brilliant in coloring and conception are *Song of the Volga*, 1906, and *Riding Couple*, 1907, powerfully evoking the Russian landscape and mise-en-scène of Russia's distant past (figs. 39, 38). *Song of the Volga*, with its cacophony of forms and colors, its carved and painted ships, its folk in medieval Russian costume, renders vividly the exotic

ambience of Russian fairy tale. Much the same can be said of *Riding Couple*, although here the distinctly Jugendstil formal treatment and subdued harmonic colors—Kandinsky himself referred to the painting as "the tranquil couple on horseback"—sing quite another and even more nostalgic tune. Russian motifs in fact haunted his work from the beginning, burgeoning forth in such other early works as *Sunday (Old Russia)* of 1904, with its syncretic overtones (fig. 36), *Arrival of the Merchants* of 1905 (fig. 40), and *Early Hour* of 1907.[39]

Early tempera works on cardboard such as *Russian Beauty in a Landscape* (fig. 33) and *Bridal Procession*, as well as works in other mediums, also display obviously Russian themes. A Russian village with its brightly painted wooden houses mirrored in the river running by, on which ply boats with carved prows reminiscent of Norsk or Scandinavian prototypes in equally brilliant hues, is depicted in an untitled tempera (fig. 25).

The woodcut, too, seems frequently to have stirred Kandinsky's ethnic memories. In that medium (in which, he later confided to his friend Gabriele Münter, "music rings in my whole body"), Russian motifs resound time and again. The graphic work that most nearly evokes the impression of his trip along the "serene and deeply-submerged-in-itself" Sukhona River, bordered by its "wonder-houses," is *Golden Sail* of 1903 (frontispiece). Here wooden structures brightly painted, decorated with carving and characteristic crossed gable beams, are set off against a dark ground that summons up the surrounding primeval forests of the ancient Zyrians.

Kandinsky on the Zyrians

More than a decade was to pass before Kandinsky accomplished these aesthetic transformations of lived experience. Meanwhile, the task of transforming his raw data into a scholarly article for publication must have seemed daunting. Yet the deceptively brief report that finally appeared in print actually demonstrates not only the young scholar's depth and breadth of learning but a distillation of themes that remained essential to the later artist.[40] Close scrutiny reveals not only the care

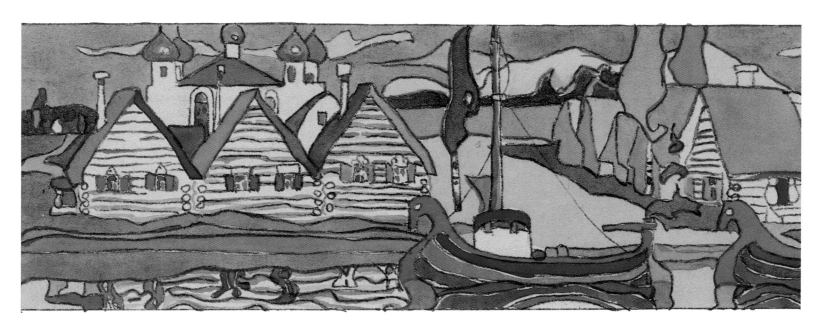

25. Kandinsky. *Untitled*, ca. 1902. View of a Russian village on a river with boats. Tempera and color crayon, 17.3 x 16.7 cm. Städtische Galerie im Lenbachhaus, Munich (GMS 180). Photo: V. G. Bild Kunst, Bonn.

and discipline with which the essay was composed but an uncommon grasp of relevant research and source materials.[41] In the context of the ethnographic literature of his day, Kandinsky manifests himself as a reformist and progressive. For example, his condemnation of the established church for its role in the eradication of pagan beliefs among the Zyrians and what he termed the "desperate energy" with which this goal had been pursued reflects the characteristic liberal perspective of intellectuals of his time. His most important ethnographic contributions concerned the persistence of certain fundamental pagan beliefs within contemporary Zyrian culture, producing results that are cited in the literature to this day.[42] From the perspective of Kandinsky's later artistic oeuvre and writings, the most significant factor is the combination of this ethnographic knowledge, disclosed in his citations of the literature as well as in his chosen subject matter, with his awareness of how ancient pagan belief systems persisted within the structures and strictures of a Rus-

sified and largely Christianized society. Kandinsky specifically alluded in his article to this rich, even chaotic mixture which we will call *dvoeverie*.[43] It is in this multidimensional context that the essay provides an essential key to understanding the later artist.

Themes that later emerged as central to Kandinsky's artistic vision were enunciated here for the first time in the juxtaposition of pagan and Christian belief systems, in his attention to primitive conceptions of an animated nature, and particularly in his discussions of Zyrian customary observances and legend related to childbirth and death. As the diary had recorded with immediacy the visceral and visual impressions of his explorations in Zyrian territory, the essay represents the historical and ethnographic context within which he recollected his experience. Immediacy is forfeited for a semblance of scientific objectivity, yet the young man's sympathies are clearly in evidence.

For example, his caustic critique of the church, especially

St. Stephen of Perm, emphasizes his obvious sympathy for the Zyrians and their ancient Finnic relatives, the Chuds, who were said to have committed mass suicide rather than submit to the persecutions of the good bishop. Fresh from his visit to the Chud burial mounds at Bogorodsk, Kandinsky reported the warnings of his Zyrian contacts on the dangers of disturbing those fabled burial sites, which they called "Chud pits." "The old people," he wrote, "point out these pits, saying that they must not be disturbed, because they are unclean." To "prove" the validity of this superstition, Kandinsky wrote, "they mention the deserted and [now] barren area near Chukayb station along the Viatka Zemstvo road" that had apparently been disturbed, although it was thought to have been "a long time ago" the site of burial places of the Chuds. Here Kandinsky noted that stories of mass suicide circulating among the Zyrians were known "in the literature," a reference that demonstrates again his intimate knowledge of Sjögren's work. Sjögren had described in detail how the heathen Chuds, rather than submit to forced baptism, had constructed mounds supported by posts, which they pulled down upon themselves at the crucial moment. Images of burial and entombment later occurred in several paintings, quite possibly inspired by these tales and by the general interest of Kandinsky's fellow ethnographers in archeological discoveries, especially those related to the ancient burial mounds.[44]

Indeed, it is in Kandinsky's attention to the collision of belief systems that the impact of this collision on his later work is most clearly revealed. Perhaps the most famous of the deeds related about St. Stephen was the bishop's encounter on the shore of the Vychegda River with the powerful Zyrian shaman Pam. According to the fourteenth-century account of the great debate by the saint's biographer Epiphanius the Wise (cited here by Kandinsky), Pam set the many gods of his people against the one God of the Christians, attributing to them the gift of the successful hunt, "with which your princes and boyars are enriched," an acuity in the bear hunt not granted the Christians, and for himself the gift of clairvoyance. But when Stephen challenged Pam to a trial by fire and water that involved walking through a burning hut and then leaping into the icy waters of the Vychegda River, the

sorcerer demurred and St. Stephen won the day. The figure of Pam making his getaway across the frigid waters by boat later appeared in Kandinsky's work.[45]

One result of St. Stephen's success, according to Kandinsky, was that the Zyrians had come to refer to their heathen ancestors by the derogatory (Russian) term *poganyi* (pagan), suggesting something unclean, so that the very word *heathen (iazychnik)* became contemptible. In fact, the secondary meaning "unclean" attached to *poganyi* is emphasized in Russian parlance by its morphological association with the Russian word *poganka*, an "unclean" or poisonous mushroom, with whose uses their ancestors had been familiar, as Kandinsky well knew.[46]

The mysteries of birth and death as reflected in contemporary Zyrian culture particularly drew the young ethnographer's attention. To his chagrin, Kandinsky was forced to report that the ancient childbirth goddess known in the ethnographic literature as Zlata Baba, or "Golden Woman," seemed to have disappeared from the cultural memory of the Vychegda Zyrians. But he cited the graphic account of this figure by the sixteenth-century Austrian diplomat Baron Sigismund von Herberstein, whose famous travel chronicles he had consulted. Herberstein's version of the tale is worth quoting, since it too served to stoke the future artist's imagination: "Slata Baba, that is, the Golden Old Woman, is an idol situated on the mouth of the Oby [Ob River] on its further bank, in the province of Obdora. . . . The story, or I should more correctly call it the fable, runs, that this idol . . . is a statue, representing an old woman holding her son in her lap, and that recently another infant has been seen, which is said to be her grandson; they also say that she has placed certain instruments upon the spot which constantly give forth a sound like that of trumpets. If this be the case, I think that it must arise from the vehement and constant blowing of the wind through those instruments."[47]

Pictorial maps included in most editions of Herberstein's *Commentaries* usually depicted Zlata Baba in a classicizing manner, either standing, with the infant on her arm and another child at her side (sometimes with kneeling figures in prayerful attitude nearby), or seated with the infant on her lap (fig. 26).[48] The fabu-

26. Zlata Baba as depicted in the 1562 London edition of Herberstein's *Chronicles*, detail from pictorial map by Anthony Jenkinson. Photo from A. I. Malein, ed., *Baron Sigismund Gerbershtein Zapiski o Moskovitskikh Dylakh* (St. Petersburg: Izdanie A. S. Suvorina, 1908).

lous "Golden Woman" actually descended from ancient concepts (with which Kandinsky would have been familiar) of Mother Earth and more specifically of the childbirth goddess venerated by the Ostiaks and Voguls native to the Ob and Konda river regions.[49] With Christianization she had often been identified with the Virgin Mary. Like St. Stephen and the shaman Pam, she too persisted in the artist's memory.

The Zyrian Ort

But it was to Zyrian conceptions surrounding the mystery of death that Kandinsky devoted most of his attention, for he had found that a peculiarly Zyrian "soul form" known as the *ort* was still a palpable presence in the daily lives of his subjects. To his credit, the young scholar was concerned with providing an accurate ethnographical description of the phenomenon of the ort and burial customs related to this concept. So convincing was his work that it has been repeatedly cited in the ethnographic literature to the present time.[50] Although modern ethnographic scholarship demonstrates that multiple "soul forms" were common in Finno-Ugric belief systems, Kandinsky was apparently aware only of the ort, which he further believed to be unique among the Zyrians, although he rejected the theory that the ort was a remnant of an ancient ancestor cult.[51]

"Given to every person at birth (although in some areas, the *ort* is present only among those who are close to death)," wrote Kandinsky, "the *ort* appears to the relatives of a person near death and always at night, assuming the guise of the very person who is close to death." However, in some areas, he reported, the *ort* was thought to appear only to the dying person and then it was said sometimes "*to inflict a pinch*" so severe as to "*leave blue spots,*" a pungent expression of ort's physical nature.[52] Such apparitions might occur as much as three years before the actual death. More often the ort would visit the dying person's relatives both before and for forty days after death, walking about in much the same form as the person of whom it is the "double." After that the ort was said to disappear. Although these appearances after death might suggest a form of ancestor worship, Kandinsky was quick to point out that the Zyrians distinguished between visits of the ort and visitations by "the deceased himself." This distinction was apparent in the custom of hanging a towel outside the home where a death had occurred so that both the ort and the deceased might dry themselves in the morning, but only the ort was said to notice the towel (fig. 27)[53]

In the case of a dead "sorcerer" or shaman *(koldun)*, whose ability to transcend earthly bonds was especially suspect, Kandinsky reported that the Zyrians tied up the body so that rela-

23

tives might not be disturbed by his ort's nocturnal visits. It never occurred to anyone, Kandinsky observed, that the soul cannot be bound, once again emphasizing the distinction between pagan and Christian belief. Such customs speak "loud and clear," Kandinsky wrote, against the identification of the ort with Christian concepts of "spirit" or "soul," which in any case were quite absent.

Indeed, Kandinsky took particular care to demonstrate that the notion of the ort was not to be misconstrued as "spirit" in the Christian sense of that term. Sharply criticizing two native Zyrian scholars who had translated the Zyrian term *ort* by the Russian word *dukh* (meaning spirit in the intellectual sense), Kandinsky emphasized that despite what may have been common in contemporary parlance, "this in no way leads us to conclude that the *essence* of the ort is spirit. Even now," he continued, "the Zyrians have a very hazy notion of dukh, and this hazy notion is undoubtedly the result of Russification and Chris-

27. Towel and bowl of water at window for the soul of the dead, funerary custom among the Setukesen of Estonia. Similar to the custom described by Kandinsky among the Zyrians (Komi) of placing a towel and bowl of water at the window for *ort*. Photographed by Ilmari Manninen, date unknown (1920s?). National Museum of Finland, Museovirasto, Helsinki.

tianity." Pointing out that all of the Zyrian forest- and water-spirits were conceived of as corporeal, that they were visible and susceptible to physical pain, Kandinsky emphasized that Zyrian perceptions of the human soul in its Christian interpretation *(dusha)*, on the other hand, were vague if not entirely absent. According to Zyrian tales, Kandinsky wrote, "they used to keep the custom of making a vent in the grave over the mouth of the deceased, through which they would pour beverages." But there were "no stories in which a concern for the [Christian] soul could be glimpsed, this being entirely absent." In this respect, he wrote, "many completely savage peoples surpass the Zyrians." Here the young ethnographer cited a section on worldwide beliefs in death as "a long-suspended animation" from Herbert Spencer's *The Principles of Sociology*.[54] As to where the *ort* came from and whence he disappeared after death, the Zyrians answered that this was simply not to be known. But, Kandinsky concluded, unquestionably the ort was not a spirit in the Christian sense, and certainly not the dukh of ancestors.[55]

Between birth and death Zyrian life was rich with the spirits of an animated nature still vivid in their culture. Kandinsky found that old women still held "conversations with the wind," that the sun was thought to wreak its revenge by sending hail if ice was carried about uncovered before St. Elijah Day, and fire had to be treated with respect lest it, too, seek revenge. Although the Zyrians no longer deified the heavenly bodies, Kandinsky found that they still imagined the North Star as "nailed" to the sky, and the sun and moon as wanderers.[56]

There was still a special place, too, for the *domovoi*, a house-spirit common in Russian lore but, according to Kandinsky, peculiar to the life of the Zyrians in its fondness for the hearth, the traditional site of ancestor worship in ancient times. Here Kandinsky noted that in certain locales the Zyrians were known to have worshipped the hearth and even "the part of the house contiguous to it, which was considered inviolable." According to his informants, the domovoi never moved into a new house before the hearth was completed (fig. 28). Moreover, the quirky domovoi, sometimes mischievous, sometimes benevolent, never inhabited buildings "devoid of a hearth," such as the *kolas*, or

28. Hearth, Skorodumskoye, Vologda district. Photographed by U. T. Sirelius, 1907. National Museum of Finland, Museovirasto, Helsinki.

rustic log shacks, erected by hunters in the forest for the storage of game and temporary shelter. Nor, as Kandinsky pointed out, did the family ever inhabit such a hut; the family resided at home. The domovoi was a protector of the family, tied essentially to hearth and home.[57]

But fear of the domovoi in its more malevolent aspect also led to the belief, persisting to that day, that some kind of propitiatory sacrifice was necessary before a family could move into a new home. So ingrained was this belief that the Zyrians supposed accidental deaths associated with a move were the work of the displeased house-spirit. In fact, Kandinsky had observed that the fear engendered by this belief was so great that many new houses in Ust Sysolsk remained uninhabited. While only a fragment, he postulated that such a belief could be interpreted as the preservation of a form of sacrifice to propitiate the ancestors.[58]

Pursuing his quest for manifestations of the Zyrian ancestor cult, Kandinsky speculated on Zyrian preservation of a special (Russian) name for their ancient progenitors: *elniki*. Because this term is etymologically related to *el*, or fir tree (as in *elnik* for fir grove), Kandinsky conjectured that its application among the Zyrians to their ancestors may have been responsible for a variation in the St. Stephen legend, namely, that the saint had cut down "not a birch tree but a fir tree [or grove] that was the site of many deities." In fact, Stephen was known for the fervor with which he had destroyed the sacred groves of the heathens.[59]

Other spirits Kandinsky tracked among the Zyrians were those of the forests, waterways, and fields. His informants had assured him that the *leshak-mort*, or "forest-man," "used to be" an evil deity, but no one could be more specific. Now, he reported, the name is "identified with a very brave and dauntless man; yet only recently [this term] was a curse word." Explaining the meaning of *mort* as person and the derivation of the word *leshak* from *les* (forest) and *leshie* (wood-spirit), he speculated that the name had been transformed into an "insulting epithet [due to] the change of religions." Interestingly, Kandinsky did not venture to report the Zyrian name for the leshak-mort, vörsa, which he had recorded in his diary along with a vivid description apparently gleaned first-hand from an informant. There he had noted that vörsa was a devil or demon, "big as a tree and black," reputed to kill horses and kidnap children. This coincides with Wiedemann's definition, which elaborated: "Every forest is inhabited by such a spirit and his family, and one may neither whistle there nor speak his name." Possibly Kandinsky, in sympathy with the Zyrians, was simply observing this prohibition, thus acknowledging its vital importance to a race of hunters and fishermen dependent for survival on the forest, its denizens, and waters.[60]

In his diary, Kandinsky had identified vörsa not only with forests but with water, implying his recognition of the ubiquitous northern water-spirit *vasa*, usually imagined as a giant creature with a big round head, either clad in a green robe or naked, who could cause tempests by throwing himself into the water. Vasa had been described by both Wiedemann and Popov, sources cited by Kandinsky himself. This image, too, along with its female counterpart, the *rusalka*, or mermaid, found expression in the artist's later work.[61]

25

Although Kandinsky had hoped to find evidence of other Zyrian spirits, such as *Voipel* (mentioned by Sjögren in conjunction with Zlata Baba), or Iomala (probably a corruption of Jumala, the principal god of the Finns), his informants had seemed perplexed by his questions. Nonetheless, he included detailed descriptions of the few fragments he had been able to piece together from his wide reading.[62]

But it was a deity of the fields, the rye goddess Poludnitsa, who seems to have cast an almost romantic spell on the young ethnographer. Kandinsky reported that "in former times the belief in this goddess was so powerful that not a single Zyrian would touch the rye before St. Elijah Day" for fear of reprisal from her. Yet again he had found that this belief, too, had been diluted if not altogether lost: "[Now] only children fear Poludnitsa, something that the old folks greatly regret because, according to them, when [she] protected the rye, the harvest was incomparably better." But he also reported that "some old men told me that she did not disappear and did not die but went away somewhere, having been angered by the Zyrians' lack of faith." Kandinsky concluded his essay with a poetic allusion to the enchantment of art and to the color he would later profess was his favorite, observing that the Zyrian name for the common blue cornflower (in Russian, *vasillëk*) was *Poludnitsa-Sin*, that is, "Eye of Poludnitsa," the bewitching midday goddess.[63]

An Ethnographic Context

Lest it be thought that the rigors of the Vologda journey in any way deterred Kandinsky from his pursuit of ethnographical interests, a glance through the *Ethnographic Review* demonstrates that his enthusiasm grew ever more vigorous. His participation in the Society's activities and publications increased during the next year and for some time thereafter. In fact, Kandinsky served as a regular and rather prolific book reviewer for the magazine; his name was listed together with those of other contributors, and he published no fewer than seven reviews of ethnographic books and articles between 1889 and the end of 1891. As his colleagues were also lecturing and publishing their

findings in the journal and in other publications supported by the Society, he was clearly in a position to absorb much of the ethnographic literature and thought of his time.[64]

Kandinsky was hardly alone in his interest in pagan beliefs, shamanism, and religious syncretism. Reports on these subjects filled contemporary ethnographic publications, including *Ethnographic Review*. Many of his colleagues and intimate friends devoted themselves to such studies. Among the most influential of these was Victor M. Mikhailovskii, whose encyclopedic study *On Shamanism* was published by the Society in 1892. While Kandinsky was certainly aware of that work, it is also more than likely that he heard Mikhailovskii's oral report "Shamanism Among the North American Indians" on the Society's 1889 fall roster, since Kandinsky himself had reported in the same series on his recent expedition to the Zyrians.[65]

Having returned from his Vologda expedition in early July, Kandinsky might easily have then scheduled his trip to the 1889 Exposition Universelle in Paris, the centerpiece of which, the Eiffel Tower, attracted the attention of the entire world. If so, he might also have taken in the concurrent International Ethnographical Congress at the Trocadéro, where a paper by Mikhailovskii was read. In any case, it can scarcely be doubted that Kandinsky, fresh from his ethnographic expedition, scrutinized perhaps rather critically the wide variety of ethnographic displays from all over the world.[66]

The 1890 archeological congress in Moscow was closer to home, and Mikhailovskii's contribution, a paper entitled "Primitive Art and Pictography as Ethnographic Data," would certainly have attracted the attention of the nascent artist; in any case, it was the year of Kandinsky's most intense engagement with the Society. The talk was illustrated by examples of the pictographic cliff drawings of the Yenissei River area and with pictograms from Siberian shaman drums.[67]

Among Kandinsky's closest ethnographic associates were Nikolai Kharuzin, with whose entire family he enjoyed close ties, and Kandinsky's classmate Petr Bogaevskii, whose wedding he attended. In his later letters to Gabriele Münter, Kandinsky wrote more than once of visits "at Kharuzin's." For example, in

a letter of 1910, he described a visit at Kharuzin's as "riesig nett" (tremendously nice); everyone had been glad to see him and thought he looked younger: "like seven years ago. Therefore, a 'Wunderkind.' " And in his personal library, Kandinsky treasured that offprint of Kharuzin's article on ancient Russian churches, based on a paper originally read at a meeting of the Society on 23 November 1892, while Kandinsky was still at the university.[68]

Certainly Nikolai Nikolaivich Kharuzin was the very epitome of the late nineteenth-century scholar-ethnologist, a "renaissance man," talented in law, philology, archeology, and ethnology, whose interests were wide-ranging and eclectic. Perhaps his most important work—and one which earned him the Society's gold medal—was his study of the Russian Lapps. *Russkie Lopari*, published in 1890, included his research on Lapp shamanism already described in his oral presentation to the Society and his subsequent article in *Ethnographic Review*. His early and tragic death in the spring of 1900 at age thirty-four was doubtless a severe blow to Kandinsky, who, although he had left Russia to study art in Munich four years earlier, remained on intimate terms with the Kharuzin family for years.[69]

But it was Kharuzin's detailed descriptions of Lapp shamanism that resonated most vibrantly in Kandinsky's later career as an artist. Clearly, this early exposure to the then burgeoning research on shamanism of the Finno-Ugric and Siberian peoples was of fundamental significance in the development of Kandinsky's art and thought. The healing role of the shaman in primitive society became a metaphor for the role Kandinsky felt the artist should play in the modern world.

Petr Mikhailovich Bogaevskii was another colleague of the Society with whom Kandinsky maintained close ties. Bogaevskii had lectured on the ancestor cult among the Votiaks during the Society's autumn 1888 series of papers, and his study later developed into a major six-part series of articles in *Ethnographic Review* on religious beliefs of the Votiaks, Finno-Ugric neighbors of the Zyrians. Bogaevskii, too, was interested in shamanism, which was given extensive treatment in his article and in a later study subsequently cited by Mikhailovskii. He also published a short note on folk medicine, recorded from an interview he had conducted with a Votiak shamaness. Like Kandinsky, he contributed to one of the Society's volumes on Russian peasant life edited by Kharuzin.[70] The extent to which Kandinsky valued this friendship, too, is confirmed by the fact that he kept an offprint of Bogaevskii's later article on the Geneva Conventions, signed and dedicated by the author, in his personal library.[71]

Reviewing the Literature

From his debut as a synopsist in the first issue of *Ethnographic Review* to his last full-fledged book review in the fourth number of the journal's seventh volume in 1890, Kandinsky addressed a surprising variety of issues. Ranging widely from the strictly ethnographic to the anthropological, from folklore to socio-political economy, the seven reviews demonstrate not only the scope of the young scholar's interests, readings, and knowledge but also an early emergence of that critical faculty so characteristic of his later writings. They also reveal the depth of his interest in Finno-Ugric and Russian folklore and myth, as well as an ethnographer's sense for the living context of folk beliefs and customs. Brief as they are—and the longest is a mere two and a half pages—they provide a window, too, on the young man's attitudes toward contemporary social, economic, and political questions.[72]

Two of these reviews, among the longest, dealt with Kandinsky's own area of specialization, the Zyrian peoples and the folk beliefs of Vologda province. Kandinsky's critique of Georgi Lytkin's book *The Zyrian Land at the Time of the Bishopric of Perm and the Zyrian Language* appeared in the same issue of *Ethnographic Review* that carried his own article on Zyrian beliefs, in which he had cited Lytkin's work. As might be expected, the young scholar, fresh from his first-hand visit to Zyrian territory, took to the critic's task with some relish. In an excess of youthful zeal, Kandinsky found much to criticize in this work by a native Zyrian who had dedicated his life to advancing the cause of Zyrian nationalism through the promulgation of the Zyrian language and encouragement of its meagre literature.[73]

Kandinsky scarcely appreciated the difficulties of Lytkin's

position and felt the Zyrian ought to have been more stringent in his scholarship. While he commended Lytkin's inclusion of authentic Zyrian (as opposed to Russian) folktales, he lamented that many of them had already appeared in print. He also took Lytkin to task for the subjectivity of his discussion on the derivation of the term *Zyrian*, which had been discussed by numerous scholars with whose writings Kandinsky was familiar. (Once again he cited Sjögren, among others.) Nor did Kandinsky share Lytkin's inflated opinion of St. Stephen of Perm, whose enthusiasm in wiping out an entire heritage he had decried.

On the other hand, Kandinsky wrote a rave review for his friend Ivanitskii's compendious *Materials on the Ethnography of Vologda Province*, edited by Kharuzin. His meetings with Ivanitskii during the Vologda expedition still vividly in mind, Kandinsky praised the work for its "vast scope" and "profound attention" to the verification of factual details. He tactfully observed that Ivanitskii had left "to others" (himself, for example) more detailed work on such specific groups as the Zyrians.[74]

Among a wide variety of areas that drew Kandinsky's particular attention were those sections devoted to traditional customs and ceremonials, such as weddings (with their characteristic bridal laments) and rituals associated with birth, death, and burial, including the burial of shamans. Indeed, Ivanitskii had devoted several pages to reports concerning shamans or sorcerers, and to superstitions related to illness and healing. Often these also demonstrated the imposition of Christianity on ancient pagan custom, as in the ritual washing of the icon along with the corpse. The belief that the dead person's "soul" remains active for forty days, the custom of leaving water and a towel for the use of this "soul," and Zyrian memorial feasts for the dead were also recounted. Rather than tying up the dead shaman, as Kandinsky had reported was the custom among the Zyrians, the Russians of Vologda province might instead sever his hamstrings to prevent his return. In one of the many folktales recounted by Ivanitskii, the metamorphoses of both shaman and shamanic hero (into dove, pike, horse, and golden ring) demonstrated the persistence of such magical beliefs among the people.[75]

Such collections of folktales, Kandinsky observed, consti-

tuted a valuable contribution to the preservation of customs manifesting remnants of their underlying pagan roots, as for example the association of St. Elijah with thunder: in Vologda province St. Elijah's week was "Thunder Week." Ivanitskii's documentation of the veneration of certain holy days such as High Fridays and Sundays, beliefs which also had their roots in pagan lore, later informed Kandinsky's series of paintings on the theme of "Sunday (Old Russia)." Tales concerning the creation and end of the world drew Kandinsky's remark as well.

The common spirit of hearth and home, the domovoi, spirits of the forest (leshie) and waterways (rusalki), and others of the bath house and barn, had occupied Ivanitskii's attention as well as Kandinsky's. But the reviewer found special praise for the author's inclusion of much raw data that included no fewer than sixty-eight folksongs with accompanying musical notation.[76]

Yet Ivanitskii's voluminous research on the peoples of the Vologda area was not exhausted by this special volume. At least two further reports subsequently appeared in *Ethnographic Review*: a note on the worship of fire and trees and on beliefs in metamorphosis, a history of burial customs in Vologda province, and yet another on Vologdan folk medicine.[77] Among other data, Ivanitskii provided a detailed description of the burial ritual for a sorceress and a long list of saints associated with specific cures. Many of these were relics of beliefs in the ancient gods, as for example the association of St. Elijah with prayers for good weather that were once addressed to Perun, god of thunder, and the association of St. George with the protection of cattle. Two favorites of the Vologdians, Cosmas and Damian, were associated with prayers for intellectual enlightenment and literacy. Ivanitskii was also careful to record the persistent roles of the soothsayer and the koldun, or shaman, in villages even as close as eighteen versts (about twelve miles) from Kadnikov, where Kandinsky had visited him.[78]

Although Kandinsky's review of a new Russian translation of Oskar Peschel's anti-Darwinian *Races of Man* was negative, it provided a platform for him to expound on diverse issues, demonstrating his breadth of learning and knowledge of his field.[79] Having briefly outlined the contents of the book, Kandinsky

offered critical judgments on details extracted from the last and longest section, "The Industrial, Social and Religious Stages of Development." Perhaps most significantly, the idealistic young ethnographer took Peschel to task for his suggestion that civilized man had given up his civic liberty to the state but thereby gained spiritual freedom, whereas primitive man, in choosing to retain the freedom of his physical existence, had chosen to remain "enchained" to his superstitions and fears. Kandinsky saw this attitude as a "misunderstanding," since "the difference between a civilized community [the state] and a primitive organization consists precisely in the fact that the former offers without doubt a greater provision for civic freedom" (thus encompassing a broad spectrum of belief systems). In this, he was mirroring the progressive liberal and populist sociological thought of his time, as expressed in the idealism of such authorities as Vinogradov, Kovalevskii, Chuprov, and others with whose writings he was familiar.[80]

Kandinsky took umbrage as well at Peschel's bias in favor of patriarchal primacy and his total rejection of the theories of J. J. Bachofen. Here again the young scholar revealed his knowledge, not only of Bachofen but of Kovalevskii's work, which emphasized the matriarchy as the first form of community in human society. In turning his attention to Peschel's theories on worldwide religion, Kandinsky remarked that Peschel had overlooked the analogies man infers between death and various unconscious states, referring the reader to Herbert Spencer's chapter on ideas of death and resurrection, citing volume and page. Peschel's explanations of the roots of religion as based on fears of natural phenomena, as for example, the deification of the dreaded serpent, appeared suggestive to him, and he also expressed interest in Peschel's explanation of the concept of immortality as rooted in dreams.[81]

Turning from strictly ethnological concerns to the more broadly political, Kandinsky then reviewed Maksim Kovalevskii's *Tableau des origines*, an anthology of fifteen lectures presented by a scholar often considered the founder of modern sociology. The Kovalevskii review is crucial, for it establishes Kandinsky's comprehension of the complex interconnections between the disciplines of ethnography, sociology, political economy, and the law.[82]

Outlining the author's argument, Kandinsky noted that Kovalevskii saw the notion of individual property as having emerged out of a "primitive communism" *(kommunizma)* which had once held the tools of production as "collective property." He particularly recommended Kovalevskii's "greatly detailed" and "most interesting" chapter on "le mir russe," the characteristic Russian system of communal land ownership.[83] Thus clearly encouraging, even enticing, his readers to take up Kovalevskii's book, Kandinsky tactfully avoided an overt discussion of the core of the book that might well have antagonized the authorities. For Kovalevskii, at that point in exile, saw in the traditional rural Russian commune the basis for the development of democratic principles that could be achieved by means of a constitutional monarchy, an idea that, since the time of the Decembrists, had been anathema to czarist censors. The review is, in effect, a good index of Kandinsky's political awareness and acuity. His appreciation of Kovalevskii says volumes about his understanding of liberal sociological, political, and economic thought of the day and provides yet another perspective from which to view his later socially aware artistic activism.

Kovalevskii was in fact one of a group of liberal university professors that included not only the statistician and political economist Alexander Chuprov, who was Kandinsky's thesis adviser, but also Vsevelod Miller, the distinguished ethnologist and linguist who had engaged in ethnological field work with Kovalevskii in the Caucasus during the 1880s and whom Kandinsky knew from meetings of the Ethnographic Society. Also allied with this group was Pavel Vinogradov, a professor of history, whose approach was oriented toward issues of science, sociology, and political economy, which he saw as interrelated. His lectures doubtless appealed to the young Kandinsky; in any case, a copy of his *Textbook of Universal History* (1893) remained in Kandinsky's library. Kandinsky himself may well have studied briefly with Kovalevskii, whom he knew personally; his friend Kharuzin had not only studied with Kovalevskii but considered him his favorite professor. Not surprisingly, Kandinsky

owned several books and pamphlets by Chuprov, with whom he maintained a close personal relationship for years after leaving Russia. In "Retrospects," he described Chuprov as a "highly talented intellectual and one of the most exceptional people" he had ever met.[84]

That Kandinsky himself was involved in liberal student politics during this period is often overlooked by biographers, who have tended to deny his interest in politics. Yet in his 1913 memoir he recalled with gusto his participation in the organization of an all-student union and his awareness of the political movements of the day—as he said, their "subterranean thundering." Those experiences, he wrote, contributed to the development of his sensitivity and receptivity to new ideas. His awareness of the teachings of Kovalevskii, Chuprov, Vinogradov, and Kropotkin can be read between the lines of his memoir observations on the necessity for "cooperative organizations" to be structured in such a way that they serve not for the oppression or limitation of individual independent thought but for a constantly renewed transition toward freedom. His ultimate decision to reject the offer of a teaching position at the University of Dorpat in favor of a move to study art in Munich in 1896 may well have been politically motivated, particularly in view of his experience as a student of ethnography, economics, and law at a time when the dynamic interrelationship of these disciplines was appreciated as never before. It is in this perspective that his turn to the study and practice of art may be interpreted as a choice for activism over academe.[85]

Before leaving this account of Kandinsky's career as a book reviewer, it is worthwhile to examine his last and most vitriolic report. Although presented as a serious ethnographic study, Georg Böhling's *On North-Russian Villages: Experienced and Investigated* was little more than the errant flight of a Western-biased imagination, as Kandinsky was at pains to demonstrate. Dropping the gentlemanly, even kid-gloved, tone of his earlier reviews, Kandinsky let his barbed arrows fly with full force in an all-out attack on what he termed a false and flimsy pamphlet. It appeared to him that Böhling had taken it upon himself to view the life of the Russian village "from the summit of European culture"—possibly a "harmless irony," had it not been presented as a serious ethnographical study. Caustically, he observed that the author had presumed to encompass the entire life of a typical Russian village in only nine pages, for example summing up family life in its entirety by quoting an old Russian proverb on wife beating. Indeed, Böhling's biased generalizations and blatant prejudice dismay the modern reader as well.[86]

Paradoxically, this pamphlet was to provide Kandinsky with imagery that resonated long in his memory. For Böhling had adopted the conceit of a painted scene that he described as *bunt* (colorful, motley) and even *malerisch* (painterly) to conjure the sights of Russian life before the eyes of his readers. The scene, wrote Böhling, was "medieval," full of breathtaking contrasts in subject and mood. He painted a vivid word picture of teeming life on a Russian thoroughfare as peasants and gentry alike traveled to market in sleighs and post coaches, on foot and on horseback. Outlandish as Böhling's pamphlet was, it seems to have made a lasting impression, for the theme of "motley life," with its sharp contrasts, and even some of the very motifs that Böhling described, later appeared in a major painting that Kandinsky entitled *Das bunte Leben*, or *Motley Life*.[87]

Kandinsky's career as a reviewer for *Ethnographic Review* seems to have ended here, as he turned his attentions to serious preparations for a final thesis in the juridical faculty of the university and to crucial questions concerning his future career.[88] The context of friendship and collegueship provided by the Society and his engagement in the production of its journal had been further enriched by the broad scope of the journal itself. Not infrequently, books reviewed in the journal wound up on the shelves of Kandinsky's own library; others provided penetrating images that would surface more than half a century later in his art.[89] Within two years he was to leave the university altogether, having made the decision to devote himself to the study of art. However, his pursuit of the commission for his expedition, the resulting diary, oral reports, and articles, and the seven book reviews suggest that Kandinsky had indeed been deeply and fruitfully engaged in the serious study of ethnography.

Ethnography and Art

Art had held Kandinsky in thrall since childhood. As he would recall in his memoir, art had always provided an immediate outlet for his pent-up emotions and inner dreams, and his insight that ethnography was "as much art as science" had perhaps drawn him to the discipline in the first place.[90] He had always sketched and painted, so that it had been second nature to him to keep a visual as well as a verbal record of his ethnographic expedition. Since such records were in any case a valid and traditional part of the ethnographer's baggage, all the more must his skills have been appreciated by his colleagues. Nor was it surprising that he would have been a regular visitor to the Dashkov section of the Rumiantsev Museum, with its wondrous collections of exotic artifacts from expeditions around the world. Having decided to devote himself entirely to art, he took a step that until this time has not been known: he donated not only artifacts gathered on his Zyrian expedition but also his ethnographic sketches to the Dashkov collections of the Rumiantsev Museum.

It had long been the policy of the Society to encourage contributions to the Dashkov collections by its members, and annual reports were issued listing the donors for the previous year. Among others, Kandinsky's friends the Kharuzin family and Ivanitskii were regular donors. Thus it was that the 1892 report already listed Kandinsky's donation not only of objects from his Zyrian expedition but also of six watercolor sketches of Zyrian clothing and footwear.[91]

The artifacts Kandinsky donated consisted of one Zyrian rifle, a Zyrian *samopal* (smoothbore muzzle loader), and a Zyrian hat made of buckskin. The cap was most likely the result of his first meeting with the Zyrians in the area of Ust Sysolsk. He had recorded in his diary how the people had crowded around him, touching his possessions and insisting that he call them "Komi." Somewhat proudly, he had recorded the purchase of a hat for two rubles. At least one of the guns had been purchased at a far more remote site in the area of Ust Kulom, possibly out of some concern, noted in his diary, for the presence of bears in the area.[92]

But these gifts were not the last of Kandinsky's donations to the Rumiantsev. In 1896, the year he left Moscow for Munich and the life of the artist, he presented a group of five more "illustrations" documenting his Zyrian expedition. Not only were Kandinsky's donations included in the museum's annual report for 1897, but his name was listed together with other benefactors for the year. Quite possibly Kandinsky's gifts were on view at the museum for many years; a 1916 guidebook listed a Zyrian mannequin in hunting costume, complete with rifle.[93]

There is another curious fact concerning Kandinsky's involvement with the Society and museum. In 1887 Vsevelod Miller, then the Dashkov's curator, had published the first "systematic" catalogue of the collections, in which the artifacts were arranged according to ethnic groups, much as they were to be listed in later guidebooks to the museum. By this time the collections were already very substantial, presenting a rather complete panorama of the material culture of Russia's diverse peoples, along with representative collections of other cultures of the world, from the Arctic to the South Seas. Many artifacts connected with religious beliefs and cults were to be found in the collections, including a fine example of a Samoyed shaman's drum and beater.[94]

What is startling at this early date is that Miller described here, among the Tungus artifacts, a full Orochon costume from the environs of Lake Bauntovskii and the Barguzinskii gold fields of the Zabaikalsk (Transbaikal) region, which had been donated by none other than a "Mr. Kandinskii." The costume, which adorned a suitable mannequin, consisted of yellow leather pants, leather boots with light blue needlework, and a fur-and-hide jacket, to which were attached hide mittens. The mannequin also wore a silk "Chinese" hat with black velvet cap-band and a red tassel. Across his shoulders he carried a leather quiver with arrows, and in his hands a wooden bow and lance.[95] Clearly, this gift must have been received before 1887 in order to have been included in Miller's catalogue. If it had in fact been donated by the young Kandinsky, it must have been presented during his first years at the university, suggesting that his association with the Society dated even earlier than has been previously sup-

posed.[96] But how might he have acquired it? Possibly his father, a tea merchant and native of the Lake Baikal region, had brought the outfit back from one of his business trips. It could well be that it was Kandinsky senior who had presented the costume to the museum. He had broad scientific interests himself and was, for example, an honorary member of the Astronomy Society. Whatever the case, the gift of this costume, another potential source of artistic imagery, further testifies to Kandinsky's intimate involvement in the ethnographic context of his time.[97]

Both the museum and the journal continued to thrive up until the Revolution, and there is every reason to suppose that Kandinsky remained interested in them; his continuing friendships with the Kharuzin and Bogaevskii families attest to that. Most significantly, the lessons of ethnography remained indelibly etched upon his memory. Kandinsky had been to the "fields of the Lappland children"; he had learned their "magic songs" and they resonated down the years in his life's oeuvre.

> He went to make the Sampo
> brighten the bright lid:
> He asked for a workshop site
> longed for forging-tools. . . .
> Then the smith Ilmarinen
> the everlasting craftsman
> he hammers away. . . .
> He forged the Sampo with skill. . . .

When Kandinsky left Russia in 1896 to pursue the career of an artist, he carried with him not only an inborn talent and aesthetic sensibility but the rich cultural context of his Russian heritage and an equally resonant trove of folkloristic and ethnographic knowledge. He had already demonstrated a well-developed social conscience, honed on direct observations of the poverty and legal

inequities endured by Russia's native peoples, as well as a deep respect for the principles of peasant law, with its emphasis on humane consideration for the individual within a communal context. Like many artists of his generation, Kandinsky would express his social conscience in his art and in his activism as an artist.[1]

But Kandinsky experienced his aesthetic road to Damascus before a painting of haystacks by Claude Monet at an exhibition of French impressionist art in 1896. In his memoir, he recalled that "for the first time [he] saw a *picture*" that moved him to the depths of his being, even though he could not decipher its subject and only learned from the catalogue that it represented a haystack. He observed "with astonishment . . . that the picture not only worked, but penetrated indelibly into my memory and continued to float in my mind's eye quite unexpectedly to the last detail. . . . But what was completely clear to me—was the unsuspected power of the palette, previously hidden from me, that exceeded all my dreams. Painting acquired a fairy-tale power and splendor . . . the object as an unavoidable element of the picture was discredited. . . . I had the impression that a small part of my fairy-tale Moscow already existed on the canvas."[2]

In fact, a number of events converged in the mid-1890s to precipitate Kandinsky's decision. The immediate catalyst seems to have been the offer of a teaching assistantship at the University of Dorpat, which had been forcibly Russified in 1893. Liberal sentiments were with the Estonians, and Kandinsky's own liberal sensitivities might well have ordained against acceptance of such a post. After leaving the university in 1895, Kandinsky had worked for a year as artistic director for a Moscow printing firm.[3] Despite his success as a student of law, economics, and ethnography, what seemed to him the "infinitely happy life of an artist" had beckoned even then. But that was not all; Röntgen's well-publicized discovery of X rays in 1895 and the discovery of radioactivity by Becquerel the following year had led immediately to speculations about the existence and the nature of subatomic particles.[4] In his memoir, Kandinsky recalled the shattering impact the new experiments in science had exercised upon him: "The disintegration of the atom was equal in my soul to the disintegration of the whole world. Suddenly the thickest walls fell. Everything became uncertain, wobbly and soft. . . . Science seemed to me destroyed: its most important basis was only a madness, a mistake of the scholars, who were not building a divine structure stone for stone but rather were groping about randomly in darkness for truths, and blindly mistaking one object for another."[5]

Social unrest surrounded him; yet the exertions of ethnographers, lawyers, and economists seemed unequal to the task of reform; now even science itself seemed uncertain. He wrote to his former teacher Chuprov that although he had lost his faith in science, his inclination to art, his "first desperate love," was compelling. Thus, in the year of his thirtieth birthday, it seemed to him that he had reached the decisive moment; it was a case of "now or never." Still, the decision was not easy for him. He had married his cousin Ania Chemiakina in 1892; much was expected of him at home and at the university, where his scholarly work was much appreciated. Like Treplev in Chekhov's play *The Seagull*, he found his inner desire to express himself through art threatened by the moral weight of social expectation and family and personal obligation. Fortunately, unlike Treplev, Kandinsky made up his mind for art. The decision taken, he moved the same year with his bride to Munich and registered at the private atelier of Anton Azbé.[6]

In Munich's artist quarter, Schwabing, he found a stimulating atmosphere in which to fulfill his dreams. The radiant metropolis of Thomas Mann's short story "Gladius Dei," where the seductions of art provided a powerful metaphor for the moral decay of society, Munich offered a bracing forum for Kandinsky's personal confrontation with the dragons of materialism and decadence, conservatism and orthodoxy, complacency and despair. Taking the dual image of Egori the Brave and St. George for his leitmotif, Kandinsky transformed himself into a force for "things becoming," an agitator in the cause of social revolution, even salvation, through art. In Munich's Jugendstil movement he found both social justification for his activism and the theoretical principles of a new art that would be called "abstract."[7]

Ethnographic Echoes

First, however, the conscientious scholar determined to submit himself to the discipline of the craft. At Azbé's studio, he reluctantly followed the protocol of studio drawings from the nude and tried his hand at landscape painting in oil. But his preference was for the lyrical expression of romantic imagery stoked by his imagination and a nostalgia for Russian fairy tale and folklore. Many of his most successful early works were inspired by Russian, Nordic, and Germanic folk themes.

Twilight depicts a knight in armor charging across a romantic landscape dark with fir trees, lighted only by the moon, a star, and a single daisy-like flower (fig. 29). The knight's lance seems to emote sparks of flame, suggesting a moral mission; his horse is white, his cape red, the saddle blanket blue. While the setting is indeterminate—it could be the northern Russian taiga or a Teutonic forest—the flower suggests a dual reference to the romantic ideal of the *Blaue Blume* and to the Zyrian spirit of the rye, Poludnitsa, to whom Kandinsky had devoted special attention in his essay on the Zyrians, relating that the Zyrian name for the common cornflower translated literally as "Eye of Poludnitsa." The silvered moon and star clearly indicate that the time is nearer midnight than midday, Poludnitsa's hour, yet the impending collision between knight and flower suggests a symbolic encounter between Christianity and pagan belief, a reference to the phenomenon of "double faith," or dvoeverie. Moreover, the Russian name for cornflower, vasilëk, suggests that here Kandinsky adopted a hidden signature.[8] If this picture is indeed so self-referential, then certainly the charging rider on the white horse already hints at the artist's self-identification with the image of Egori the Brave, uniting within himself both pagan and Christian attributes. While it may doubtless be futile to load a design so clearly decorative with such symbolic weight, it is worthwhile to consider this work in the context of the slightly later oil painting *The Blue Rider*, 1903, with its similarly mysterious rider galloping a white horse across a wooded landscape.[9]

Other early works were more specifically Russian in theme. A depiction of a walled city in an autumn landscape could represent any village on a gentle slope above the Sukhona or Vychegda rivers (fig. 30). A multidomed church rises behind the walls, which are accented by watchtowers reminiscent of medieval Russian walled towns and monasteries. The rooftops of the enclosed town display the crossed-horseheads gable motif characteristic of northern architecture, while birch trees and firs typify the northern landscape. A rustic log structure suggests a chapel

29. Kandinsky. *Twilight*, 1901. Tempera with color crayon, silver, and bronze on cardboard, 15.7 x 47.7 cm. Städtische Galerie im Lenbachhaus, Munich (GMS 99).

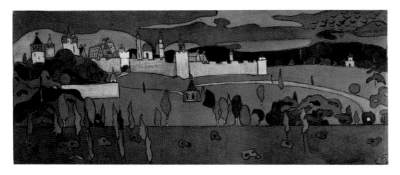

30. Kandinsky. *Untitled* (walled city in an autumn landscape), ca. 1902. Color crayon and tempera on cardboard, 15.8 x 36.6 cm. Städtische Galerie im Lenbachhaus, Munich (GMS 101).

or, more precisely, the sheds used for storing grain or the booty of the hunt in northern Russia (figs. 46, 47).[10]

Russian Village on the River with Ships, left untitled by the artist, is nevertheless even more demonstrably Russian in inspiration, with its distinctly Russian domed church towers (fig. 25). The log houses with brightly painted shutters recall the Vologdan villages Kandinsky had visited and later described with such poetic force in his memoir. While the ships with their carved-horsehead prows may have been unlike any he might have seen along the Sukhona or Vychegda rivers in 1889, they recall medieval northern and Scandinavian prototypes, adding an exotic, otherworldly note.[11] Yet another very early work, *Russian Knight*, of 1902, leads directly back to Kandinsky's knowledge of Russian history (fig. 31). In this case the title is the artist's own invention, providing firm ground on which to claim its Russian inspiration. But the motif can be verified through a specific source known to the artist. This rider, a Russian soldier of the sixteenth century, strikes the pose of an armed archer illustrated in the sixteenth-century book by Herberstein that Kandinsky had cited in his article on the Zyrians (fig. 32).

Clearly, the "Russian paintings" take on new meaning when viewed with the artist's ethnographic background in mind. *Russian Beauty in a Landscape* indicates that even four years "out of school," and at a time when his artistic activism had already led

to the foundation of his first artists' group bearing the militant name Phalanx, Kandinsky had not abandoned his lyrical Russian mode (fig. 33). A woman in medieval Russian dress sits in a flowery meadow next to a birch tree. Behind her on the hill is a typical Russian church, very similar to any number of churches that Kandinsky would have known in his youth and from his travels (fig. 2). One might perhaps surmise that she, with her flowery wreath, represents "Mother Russia," that the tree stump at her side represents the sacred tree of the pagan tribes chopped down by zealous missionaries of the church, which stands triumphant on the hilltop. But the birch in Russian folklore was also an ancient symbol of love and marriage.[12] Thus the tree·stump refers to the characteristic prenuptial laments of northern Russia in which the bride sings that she will hang her maiden's cap upon a birch, "but the birch will be cut down; she will put it in a field among the flowers, but the flowers will be mown." The picture also recalls the rituals of "Rusalka Week" or "Semik" associated with Trinity Sunday or Ascension Day, in which the sacred birch tree was cut and its branches plaited. Kandinsky may have had in mind the words of a folksong associated with this festival published in a book that had been reviewed in the *Ethnographic Review:* "Let us go, girls,/To the meadows, the meadows,/To plait the wreaths"[13]

In many of these Russian paintings Kandinsky's meticulous attention to costume—generalized though it may be in the final

31. Kandinsky. *Russian Knight*, 1902. Tempera over pencil on cardboard, 17.6 x 36.6 cm. Städtische Galerie im Lenbachhaus, Munich (GMS 622).

32. Group of Russian soldiers armed with arrows, 16th century. Woodcut. From Sigismund von Herberstein, *Rerum Moscoviticarum Commentarij*, Basel, 1556. Photo courtesy Division of Rare Books and Manuscripts Collections, Cornell University Library.

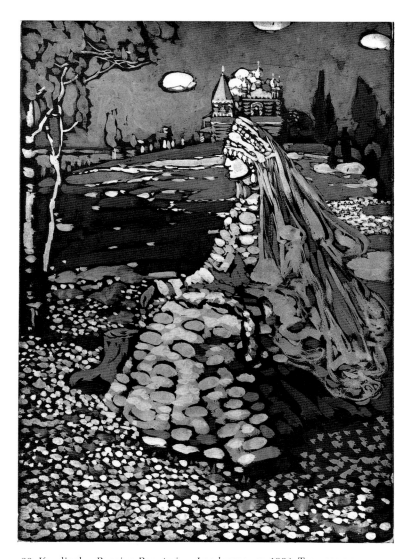

33. Kandinsky. *Russian Beauty in a Landscape*, ca. 1904. Tempera on cardboard, 41.5 x 28.8 cm. Städtische Galerie im Lenbachhaus, Munich (GMS 92).

version—reveals his ethnographic background. Not only did his travel diary include costume sketches, but his early Munich sketchbooks are full of costume studies and even lists of books on costume of various times and places, weaponry, livery, and so on.[14] But perhaps even more interesting is the fact that Kandinsky kept a costume copy book in his own library. Its publication date of 1884 suggests that Kandinsky may well have acquired Freidrich Hottenroths's two-volume tome even before leaving Russia, while he was immersed in ethnographic studies. Clearly, it was important to him; motifs that appear in sketches and paintings can be traced directly to Hottenroth models. For example, the group of Biedermeier ladies and gentlemen portrayed in *Group in Crinolines*, 1909, may be traced to the prototypes in Hottenroth's second volume.[15] But that he turned to Hottenroth even for Russian models is also clear. For example, an early study previously identified only as *Young Woman in Oriental(?) Costume*, is in fact a rather faithful rendering of a Russian prototype published by Hottenroth (figs. 34, 35). Kandinsky has given his young woman a decidedly more appealing aspect, toning down the color contrasts of the original considerably, but the costume details have been quite precisely copied from the Hottenroth model.[16] Scattered throughout the volumes are groups of Russian costume models from various periods. But one that undoubtedly held special significance for Kandinsky was a reproduction of the group of armed archers from Herberstein's account of his travels in sixteenth-century Russia. When Kandinsky adapted the pose

and costume of one of those "archers" in his early tempera painting *Russian Knight* (fig. 31), had the Hottenroth volume perhaps served as a reminder?[17]

Among the other early works on Russian themes is a series on the theme of "Sunday (Old Russia)," which occurs in at least

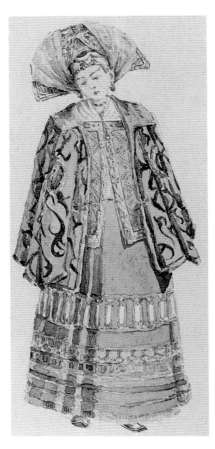

34. Kandinsky. *Young Woman in Oriental(?) Costume*, n.d. (ca. 1900?). Watercolor over pencil, 19.3 x 10.8 cm. Städtische Galerie im Lenbachhaus, Munich (GMS 465).

and the "Eighth Millennium" that was to last forever. Voskresenyi was specifically connected with Easter and especially with Palm Sunday, which, in the church calendar, heralded the coming of the Resurrection and was closely allied with Christ's miraculous resurrection of Lazarus.

In Russia, indeed commonly throughout northern Europe, Palm Sunday had been celebrated not with palms but with pussy willow branches, the first of northern plants to bloom in the spring.[20] The willow had in fact also been revered by the pagans as a herald of the spring season of renewal. Furthermore, among the peasants since ancient times the willow had been associated with the revival of good health because of its medicinal qualities. Willows were as well an integral part of the ceremonies associated with driving the cows out to pasture on the spring St. George's Day, a day also connected with seasonal resurrec-

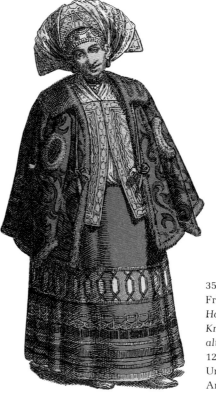

35. "Woman from Kaluga." From Friedrich Hottenroth, *Trachten, Haus-, Feld-, und Kriegsgeräthschaften der Völker alter und neuer Zeit*, vol. 2, pl. 120, detail (Stuttgart, 1891). University of California at Los Angeles Library.

five variations, depicting a crowd of people in medieval dress promenading before a characteristically walled and bedomed Russian town (fig. 36). In their bright costumes they stroll outside the walls, folk in their "Sunday best" enjoying their day of rest. But, as is characteristic of Kandinsky, the full dimensions of the content are hidden from direct view.[18]

Sunday in old Russia actually had two names; one, *nedelia*, of distinctly pagan origin connected with rituals surrounding an idol by that name, and the other, *voskresenyi*, of Christian etymology relating specifically to the Resurrection. Despite official church condemnation of such "pagan rituals, idol worship, and sacrifices," *nedelia* continued to be used by the church itself to signify Sunday.[19] The name voskresenyi resulted from the fifteenth-century association between Sunday, the "Eighth Day,"

36. Kandinsky. *Sunday (Old Russia)*, ca. 1904. Tempera on cardboard, 23 x 54.7 cm. Musée National d'Art Moderne, Centre Georges Pompidou, Paris.

tion. Thus the term for Palm Sunday in old Russia came to be *Verbnoe voskresenie*," or Willow Resurrection, Willow Sunday (literally, "Pussy-Willow Sunday"). It represented, thus, a congruence of pagan custom and Christian belief that was a deeply ingrained characteristic of Russian experience, another instance of dvoeverie.[21]

That Kandinsky was aware of the pagan associations of the day is demonstrated in a notebook sketch related to the "Sunday (Old Russia)" theme in which a similar crowd of costumed people stroll before a walled city (fig. 37).[22] One of the strollers carries a pronged branch, perhaps the pussy willow branch of Willow Sunday. Without doubt Kandinsky was well aware of the medicinal qualities of the willow, for he had reviewed Ivanitskii's book on peasant customs of Vologda province in which his friend had provided a long list of plants and herbs used by Vologda peasants for medicinal purposes. According to Ivanit-

37. Kandinsky. Sketch for the series of paintings on the theme of "Sunday (Old Russia)," ca. 1904–1907. Pencil in sketchbook, 19.8 × 12.5 cm. Städtische Galerie im Lenbachhaus, Munich (GMS 336, p. 73).

skii, the willow was prized for an infusion of tea from its bark that was used to cure intermittent fever.[23] Although no willow branches can be discerned in the finished versions of this painting, or in the woodcut, we can take our clue from the sketch that Kandinsky was also well aware of the pagan associations of *Verbnoe voskresenie*. That the artist should have omitted so vital a clue to discursive meaning as the willow branch in the final versions of *Sunday (Old Russia)* is hardly surprising. This kind of omission was a characteristic Symbolist strategy that became a working method Kandinsky employed until the end of his life. Indeed, at just about this time he was writing to Münter about a tempera painting based on "an *invented old-Russian*" theme: "Perhaps it is . . . much much better never to say the last holiest word."[24]

But there is yet another hidden reference to pagan custom in this painting. In the tempera version (fig. 36), the masses of people and town on the left side are balanced on the right, not by more crowds (as in the two oil versions) but by a single birch tree. Its compositional importance suggests that it symbolizes pagan reverence for the birch tree celebrated in bridal laments of the northern peoples and held sacred by many of the Finno-Ugric and Siberian tribes of northern Russia. The relationship between the birch and bridal customs is underscored in the painting by the depiction of a woman being pursued by a suitor just to the right of the birch tree. Moreover, the birch was actually tied to a particular Sunday, Trinity Sunday, following the pagan spring festival of Semik during Rusalka Week, with its customs surrounding the celebration of the birch as vegetative symbol of renewal. Thus, in compositional terms, Kandinsky has created in this version a clear confrontation between pagan and Christian belief systems.[25]

Kandinsky's several references in letters to Münter to paintings with Russian themes, occurred within the context of a continuing discussion concerning public reaction to his work and his ambivalence toward revealing his innermost thoughts to the outside world. People noticed the "decorative" element of his work, he lamented, but not its content. On the other hand, he didn't really want to emphasize the content: "The content, the inner, must only be felt . . . the thing must resonate [klingen], and through this resonance [Klang] one comes gradually to the content." He felt that one "old Russian" piece had failed despite its "passionately deep, festive colors that must resonate like an *ff* in the orchestra." He mused about trying again but ended by reaffirming his reticence about his inner dreams. In a letter written some months later, he explained that he particularly liked "the Russian city with many figures" and went on to say that he had done a similar drawing as well as a "decorative" oil version. Presumably he was speaking of *Sunday (Old Russia)* and referring to the drawing with the willow branch. In any case, these references indicate the singular importance Kandinsky attached to his Russian paintings. What is most striking is that these paintings reveal at so early a stage in his career the artist's concern with two themes that would become leitmotifs in his life's work: dvoeverie and themes of healing and resurrection as metaphors for cultural renewal. The remarks in these letters also help to explain why the real content of these works is not openly revealed but must be sought in the deeper dimensions of his past.[26]

During this period, from about 1903–1904 until about 1908, Kandinsky produced a major series of paintings on old Russian themes, all in his "lyrical mode." Whether in oil or in tempera, they are all couched in stylistic terms that breathe the romantic otherworldliness of fairy tale.[27] The technique employed is a mosaic of rich, lapidary color brushstrokes emulating tesserae and ranging in color from the depths of black to the heights of brilliant yellow and white, yet with subtle tonal modulations that never glare. The resultant "choral" effect is exactly as Kandinsky described it in his 1904 letter to Münter: the paintings "resonate" as if "orchestrated." The subject matter is a blend of "old" or medieval Russian and "ethnic" Russian.

Riding Couple (fig. 38) is perhaps the paradigm evocative of fairy-tale romance, at once recognizable as "Russian dream" yet at the same time mysteriously moving in a universal way. In contrast to the riotous mood of *Song of the Volga* (fig. 39), this

38. Kandinsky. *Riding Couple*, 1907. Oil on canvas, 55 x 50.5 cm. Städtische Galerie im Lenbachhaus, Munich (GMS 26).

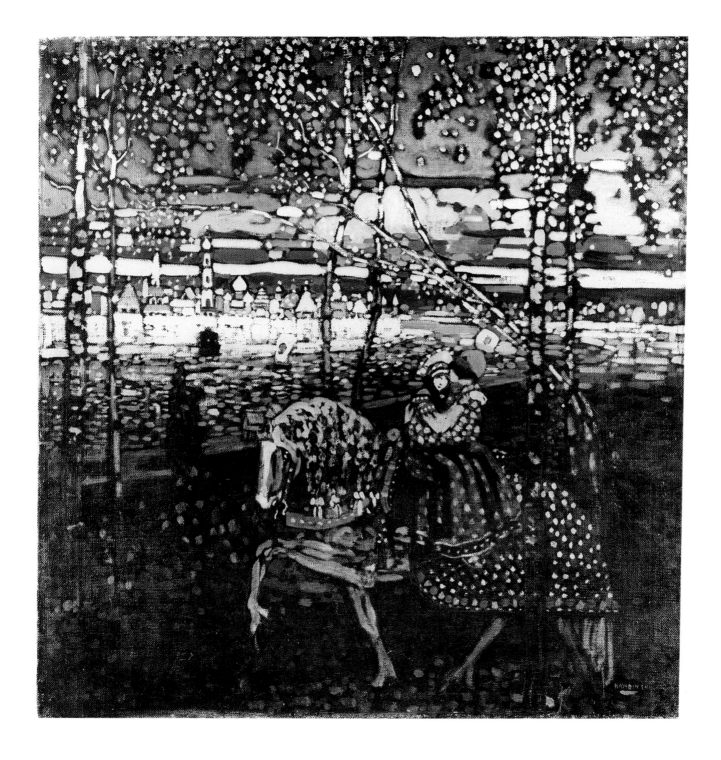

twilight reverie evokes harmonic calm, Kandinsky himself referring to this image as the "tranquil pair on the horse." In the same letter he further underscored its musical quality by comparing it to an organ: "I have embodied much of my dreams: it is really similar to an organ, there's music in it." In the next sentence he revealed something of the tensions within him: "This awakens again courage in me for other things and twice already I have experienced that peculiar throbbing of the heart that I so often had when I was much more the painter-poet."[28] These lines, written in December 1906, while he was living at Sèvres, near Paris, seem to hark back three years to the period of *Sunday (Old Russia)*.

The geographic setting of *Riding Couple*, with its bending birches, is evocative of the old towns along the banks of the Vologda, Sukhona, and Vychegda rivers. The bride's cap and costume are variations on forms typical of old Russian costume still known at that time among the Zyrians (figs. 4, 6). As in *Russian Beauty* and later in *Motley Life* (fig. 45), as well as in such graphic works as *The Ravens* (fig. 5), *Schalmei*, and *Women in the Wood*, costume details refer to the general forms of old Russian dress, but often even more specifically to northern Russian and Zyrian forms.[29] The Viking ships on the river of *Riding Couple* and the horse's medieval livery suggest a time long gone. But more, the pair reveals once again the ethnographer's special knowledge, for "stealing the bride" was one of the ritual traditions common among some northern Russian and Finno-Ugric tribes in ancient times. Among the Zyrians, remnants of such customs remained in the elaborate etiquette of the wedding festivities, which as late as the nineteenth century still involved bartering for the bride.[30]

Song of the Volga is another such orchestration of fairy-tale ambience, but in another mood (fig. 39), its musical origin underscored by its title. That it was originally exhibited simply as *Song* emphasizes this aspect even more strongly. Here are the banks of the Vychegda River, the tall bell tower of the distant town suggesting the bell towers of many a northern Russian church, set apart from the main building, just as Kandinsky painted it.[31] The horsehead prows of the Viking ships suggest Scandinavian precedents and emphasize Kandinsky's knowledge of Norse commerce on the Volga and other northern rivers in ancient times. But the icon affixed to the mast of the central ship suggests that the setting is in fact "old Russia."

Other paintings of this period with an "old Russian" air belong to a series of market, fair, or crowd scenes. The earliest of these, possibly painted around 1903–1904, depicts a crowd in Russian peasant costume at a market before the Church of the Nativity of the Virgin in Moscow. The setting evidently held a special fascination for Kandinsky, since he kept in his possession until his death a drawing he had made of the same church during his days at university.[32] Several of the figures in peasant dress are closely related to figures similarly costumed and posed in the later *Motley Life*. In fact, a number of motifs in these related works, also from *Sunday (Old Russia)*—for example, that of the boy chasing a girl—eventually found their way into *Motley Life*.

Arrival of the Merchants also belongs to this series, depicting a throng of people gathered about a merchant sailing ship that has arrived at a river port below a Russian city (fig. 40).[33] As in the case of the previous crowd picture, despite the antiquity of the setting, the composition has been incongruously influenced by a convention of modern photography. The figures in the foreground are cut off and casually framed as in a snapshot.[34] The original title of his woodcut on the same theme was *Gomon*, the Russian word for "hubbub," suggesting not so much the physical qualities of the crowd as its *sound*, echoing the musical import of *Song of the Volga* and forecasting the lyrical Russian motifs of such later works as the woodcut album *Xylographies*, with its direct allusion to the "sounds" of the wood itself.[35] In a letter written years later to his biographer Will Grohmann, Kandinsky recalled: "I painted this picture . . . in Paris—to ventilate my nostalgia for Russia. I tried then, through the linear directions and disposition of bright dots, to express the musical element of Russia. In other pictures of that time the oppositions and later the eccentric element of Russia mirrored themselves."[36] The motifs shared by these works, inspired by Kandinsky's ethnographic studies and expedition, were to culminate in the monumental *Motley Life* of 1907. The fact that they form a continuum of

39. Kandinsky. *Song of the Volga*, 1906. Tempera on cardboard, 49 x 66 cm. Musée National d'Art Moderne, Centre Georges Pompidou, Paris.

theme, compositional style, and lyric mode speaks for the consistency of the artist's development, but also for the powerful effect of that ethnographic experience upon his work.

During the period spanned by these works, Kandinsky had been preoccupied by the closing exhibitions of the Phalanx artists' group he had led since 1901; with the exhibition of his own work in Germany, France, and Russia; and ever more by his growing relationship with Gabriele Münter, with whom he would undertake several trips abroad. But the degree to which his ethnographic training had become an integral part of his life continued to be reflected not only in his work but in his exhibition activity.

40. Kandinsky. *Arrival of the Merchants (Hub-bub)*, ca. 1903. Tempera on canvas, 90 x 135 cm. Private collection, Berlin. Photo courtesy Galerie Pels-Leusden, Berlin.

Ethnic Associations

In 1902 Kandinsky had invited the Finnish painter Axel Gallen-Kallela to exhibit in Munich in the fourth exhibition of his Phalanx society. Like Kandinsky, the Finn—by that time world-renowned for his murals on the theme of the *Kalevala* at the Finnish pavilion of the 1900 World Exposition in Paris— had long been interested in Finnish folklore, an interest he shared with his friends and countrymen Jean Sibelius and Eliel Saarinen. Like Kandinsky, Gallen-Kallela had also undertaken an excursion into the "wilds" of his country in order to immerse himself in its folklore and craft, in the ambience of the *Kalevala* that was his heritage. Indeed, the nationalist subtext of Gallen-Kallela's murals, which had drawn the ire of Russian censors at the exposition, would scarcely have been lost on Kandinsky. In fact, many of the works shown at Phalanx were also based on themes of the *Kalevala*, the mythic epic of the Finns that had so enthralled Kandinsky during his expedition to the Zyrians.[37]

Gallen-Kallela's *Kullervo's Departure*, of 1898, was one of the episodes from the *Kalevala* exhibited at the Phalanx (fig. 41).

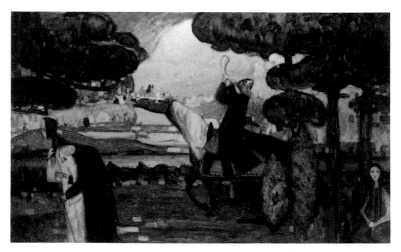

42. Kandinsky. *With the Red Horseman*, ca. 1904(?). Oil on canvas, 79 x 123 cm. Archival photo from R/B (1982), with permission Gabriele Münter- und Johannes Eichner-Stiftung.

The hero on horseback, blowing his trumpet as if to summon the forces of good in the world, made a lasting impression on Kandinsky. The prevalence and importance of the horse-and-rider motif in Kandinsky's work is well documented, but now the trumpet-blowing horseman appeared as well. *With the Red Horseman* represents the clearest instance of Kandinsky's adaptation of the motif (fig. 42). There Kandinsky depicted Kullervo as he rode off into the forest blowing on his horn, leaving behind the forlorn figures of his sister and their grieving parents. With its forested enclosure, it is compositionally closer to Gallen-Kallela's watercolor study for the scene than to the better-known tempera. Kandinsky's horseman also rode from right to left, flinging his horn upward to the heavens while his horse likewise tossed its head upward as if in alarm. But the composition lacked the tension and high drama of its predecessor, a failure apparently appreciated by the artist, who painted over it. There followed a block print depicting a trumpeter on a rearing horse against a ground of dark fir trees and twilit clouds. An ink drawing of about 1908–1909 is particularly reminiscent of the Gallen-Kallela painting, depicting the rider turned backward in the saddle to blow the trumpet in a gesture suggesting a summon-

41. Axel Gallen-Kallela. *Kullervo's Departure*, ca. 1901. Watercolor, 16 x 25 cm. Courtesy of the Jorma-Gallen-Kallela Family Collection and Aivi Gallen-Kallela, Helsinki.

ing of the troops (fig. 43). Significantly, it was this image, slightly modified, that Kandinsky later chose for the back cover of the *Blue Rider* almanac. Clearly, Gallen-Kallela's Kullervo imagery stimulated a long-lasting resonance in Kandinsky's eidetic memory; a similar constellation of motifs evoking both its folkloric and its shamanist elements reappeared years later, transmuted into the visual vocabulary of the Bauhaus era.[38]

Other works of Kandinsky's Munich period have an ethnic flavor—those inspired by his trips with Gabriele Münter to Holland in May and June 1904 and to Tunis from December 1904 to April 1905. Once again the sketchbooks, especially those made in Tunisia, reveal the ethnographer's attention to ethnic detail. There are acute recordings of ornamental and architectural detail as well as of costume, and even a rendering of Arabic calligraphy.[39] The "color drawings" *Arabic City* and *Tunesian Sheep Festival* also captured the ethnic ambience of the country with an ethnographer's specificity. The latter work was actually inspired by a Muslim holy day that took place during Kandinsky's visit to Tunis and to which he naturally responded with interest. The event was an important festival of the Muslim year known as "the Feast of Sacrifice" or *al-ʿīd al-aḍḥaʾ* ("the great feast" *[al-ʿīd al-Kabir]*). In the days preceding the festival, the sheep driven into the city for sacrifice were also recorded in Kandinsky's sketchbook. Although the sheep do not appear in the final painting, Kandinsky signified the ritual's bond with heaven by introducing a brilliant rainbow at the upper left.[40] Eventually the memory of this trip, with its rich and exotic ethnic reverberations, would surface again in such lyrical paintings as *Improvisation 3* and *Arabs I (Cemetery)*, both of 1909.[41]

Pagan and Christian

The phenomenon of dvoeverie, sometimes translated as ditheism or "double faith," had already entered into the thematic content of Kandinsky's early work. Several prominent Russian artists of the nineteenth century had previously dealt with this theme, but in a historicizing, realistic style. For example, Vasilii Surikov's famous *Yermak's Conquest of Siberia* of 1895, a painting undoubtedly known to Kandinsky, dramatically opposed the

43. Kandinsky. *Landscape with Trumpet-Blowing Rider*, 1908–09. Ink on paper, 16.5 x 20.9 cm. Städtische Galerie im Lenbachhaus, Munich (GMS 386).

armies of Rus' under the banners of Christianity to the pagan hordes facing them, urged on by a shaman in full dress holding his drum aloft (fig. 44). And Vasilii Maximov's *Arrival of a Sorcerer at a Peasant Wedding*, of 1875, opposed the power of the shaman to that of the priest in a more intimate confrontation.[42]

Kandinsky's treatment of the subject was to be equally dramatic, despite his rather different approach. In the artist's memory, the moment of his "immersion" within the brightly painted walls of a peasant house with its naive folk prints, or lubki, and its "holy corner" was the apotheosis of his Vologda experience. Now, from the perspective of the ethnographic essay, one can imagine the overwhelming sense of presence in that room of the domovoi, perhaps even an ort. If perchance he had noticed an icon upside-down, he would have been told that the saint was being "punished" for visiting an illness upon the family. With his own eyes, he had observed the custom of placing a sheaf of rye or oats before the holy corner to assure a successful harvest the following season, as early as June, well before the prescribed St. Elijah Day observance in July (fig. 18). Although the sheaf of wheat is not in evidence in Kandinsky's own rendering of an icon corner, still the subject of blessing of the bread was one clearly associated with rituals of the harvest (fig. 11). On St. Elijah Day itself, he might have followed the peasants out to the fields, where they appealed for a good harvest to their ancestors,

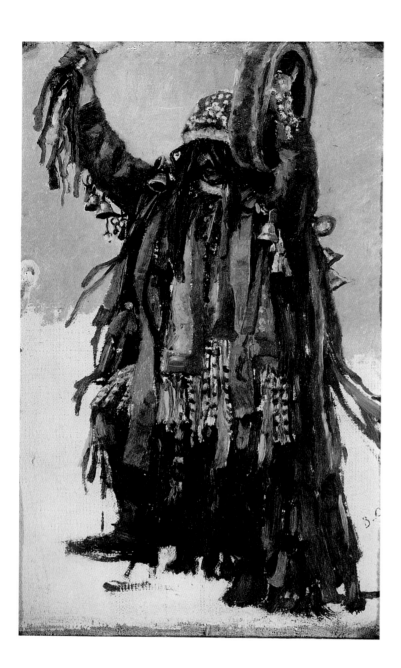

44. Vasilii Surikov. *Study for Shaman*, 1893, for the painting *Yermak's Conquest of Siberia*. Oil on canvas, 33.5 x 23.5 cm. Krasnoyarsk Museum, Krasnoyarsk.

whose spirits they imagined as residing with Poludnitsa among the grain.[43]

Motley Life, with its multitude of figures and action, may be seen as the culmination of the series of paintings on Russian themes that had begun with *Sunday (Old Russia)*: it may also be seen as the climax of Kandinsky's early concern with the theme of "double faith" (fig. 45). Like *Arrival of the Merchants*, this painting presents a throng of people in old Russian costume converging on a town bordering a river. While there are doubtless many prototypes for "crowd scenes," a theme refined by the impressionists, Kandinsky particularly prized the lyric qualities, motley colors, and cacophonous sounds inevitably evoked. The artist revealed in his memoir how vividly his eidetic memory retained images for years, often driving him to desperation. Yet, despite what seemed to him a troublesome affliction, his ability to transform imagery beyond the materialistic present, in which so many precedents remained mired, into a universal lyrical mode, raised his oeuvre to another level. At the same time, it often disguised the origins of his inspiration.[44]

But there was a literary source for *Motley Life* as well, for its title recalled the book on Russian folklife by Georg Böhling that Kandinsky had reviewed for *Ethnographic Review*. The word *bunt* (motley) had appeared repeatedly in Böhling's text, in which he had used it to describe a crowd of people at a Russian country fair. Böhling had actually insisted on the artistic appeal of his scene; it was, he had written, a "subject for a painter, with its contrast of the savage and the idyllic, of movement and half-rest, of pleasure and work, of high spirits on the one hand and unconscious elegy on the other." Just such contrasts are central to the theme of *Motley Life*.

In fact, a number of Böhling's specific motifs found their way into *Motley Life*. For example, a beggar with an enormous "beggar's sack" on his back had particularly captured Böhling's attention and must have captured Kandinsky's, too, for a bearded

47

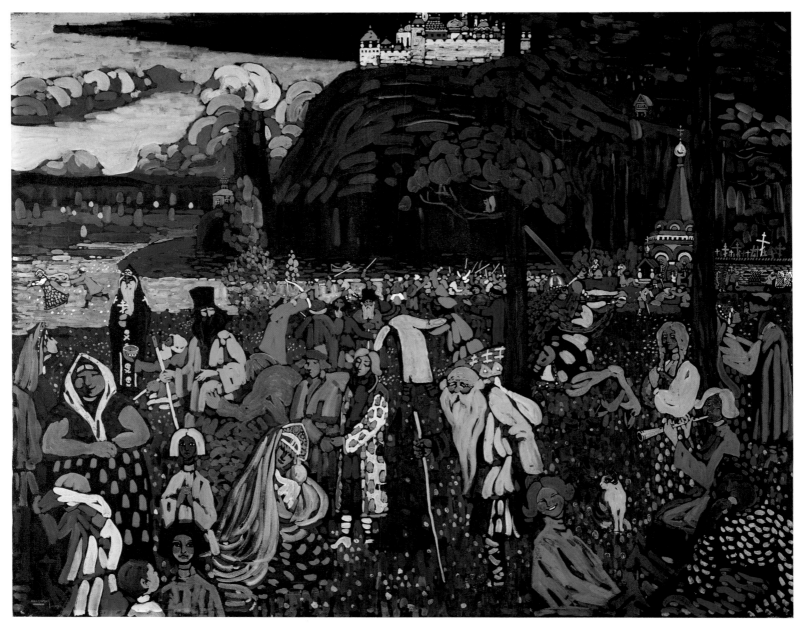

45. Kandinsky. *Motley Life*, 1907. Tempera on canvas, 130 x 162.5 cm. Permanent loan from the Bavarian Landesbank. Städtische Galerie im Lenbachhaus, Munich (FH 225).

old man carrying a rucksack is the central figure in *Motley Life*. Much to Kandinsky's dismay, Böhling had characterized Russian peasantry in general as dissolute: in one passage he described an encounter with an apparently drunken peasant who imagined that a "squirrel in the fir tree" was in fact a hunter after the twittering sparrow on the branch beside him. Although Kandinsky dispensed with the sparrow, he retained the squirrel as a central image of *Motley Life*. Moreover, Böhling had also digressed on the mixture of Christian and pagan beliefs among the Russian peasants, who, he observed, still identified St. Elijah with the ancient pagan god of thunder, Perun or Thor. But, as Kandinsky had complained in his scathing review, Böhling's descriptions were so general that it was impossible to relate them to an exact locale.[45]

In contrast, Kandinsky was quite precise in locating the scene of *Motley Life*. We recognize at once the general locale at the confluence of two rivers as the market town of Ust Sysolsk, the center of Kandinsky's activity as ethnographer. Even had he not traveled there himself, Sjögren had described the region in considerable detail, down to its topological features.[46]

Sjögren had, for example, observed that the *gorodki*, little more than wooden encampments, built upon the hills in that region by the early Finnic Chuds, had eventually been overrun by conquering Russians who had often replaced them with churches and monasteries as a reminder of the power of Christianity over the heathen religion of the Chuds. Many place names, however, still betrayed their pagan Finnic origins and had originally been the sites of famous trade fairs, in many cases remaining so into the nineteenth century. Sjögren named Solvychegodsk, Veliki Ustiug, and Ust Sysolsk, all stops on Kandinsky's itinerary. He particularly noted the dramatic effect of such geographic features in an otherwise flat, low landscape distinguished by its vast network of rivers, streams, marshes, and lakes.[47] Another nineteenth-century traveler and linguist, August Ahlquist, had described the monastery town of Kondinsk on the Ob as standing "on a steep height on the right bank of the river." Ahlquist's account must have interested Kandinsky, for whom, as we know, the place name held genealogical sig-

nificance. The engraving of Kondinsk monastery published by Ahlquist may even have suggested the form of the tower for the cemetery chapel in *Motley Life*.[48]

What is most striking in respect to the setting of *Motley Life*, however, is Sjögren's description of the site of a monastery built by St. Stephen in 1390. It was erected on a hilltop south of Ust Sysolsk on the banks of the Sysola River, which flows into the Vychegda. Here St. Stephen had conducted church services in the Zyrian language. And here Sjögren found "an impressive hill" that was still called "Gorodok." From a distance this hill, described as "an *irregular rectangle*," had a "high, isolated prospect." According to Sjögren, the precipice formed a steep cliff dropping down to the Sysola. A highlight of his visit to that area had been his discovery of Chudic burial mounds just outside Ust Sysolsk, an event that he described with some excitement—as did Kandinsky some three decades later.[49]

With Sjögren's descriptions in mind, *Motley Life* comes alive as the landscape of Sjögren's—and Kandinsky's—travels. The squarish hill, dropping steeply to a river and surmounted by a monastery, seems a fairly exact realization of Sjögren's description, heightened of course by artistic imagination and poetic license. Sjögren's description of archeological finds, including a "rusty sword," may have inspired the artist's insertion of the charging warrior wearing a helmet and chain mail and brandishing his sword. Further confirming the Zyrian locale of the site is the small log structure just below the summit of the hill, at upper right. In Kandinsky's day such buildings, set up on stilts, were used by the Zyrians as storage sheds for grain or for the hunter's booty (fig. 46). Kandinsky had described them in his essay and recorded them in his diary (fig. 47). But in earlier times, before Christianization, similar huts had been used by the natives as sacred idol sheds.[50] Thus the hill of *Motley Life* may be taken not only as the symbolic site of St. Stephen's monastery and a "new Jerusalem" but as a representation based on the facts of ancient Zyrian history juxtaposing the mythology of the pagan Chuds with that of Russian orthodoxy and suggesting the many dimensions of religious belief.

Clearly, both Christian and pagan imagery are present

throughout this composition, with its teeming multiplicity of life. The whole painting is built upon a series of contrapuntal contrasts: life and death, old and young, love and hate, peace and war, and so on. Central to the composition is the figure of the long-bearded old man, a rucksack on his back, a staff in his hand. Is this the "old man" among Kandinsky's Zyrian informants who carried within himself the recollections of the Zyrian people? For assuredly the viewer is transported to the area of Ust Sysolsk, in the midst of a fair by the Vechegda, Sysola, or Sukhona rivers. The squirrel in the tree, target of the archer below, provides a crucial clue, for the harvesting of squirrel pelts was then as central to the region's economy as the fir tree was central to its spiritual life. Squirrel pelts are mentioned as a mainstay of the Zyrian economy in travel accounts as ancient as Herberstein's chronicle.[51] But the squirrel had another function in the lore of the northern peoples, for among the Zyrians his pelt was considered an appropriate sacrifice to the forest-spirit, the leshak-mort or "master" of the forest, and among the Voguls he was considered a mediator between the hunter and the highest god.[52]

But the old man may have other connotations. While he might be identified casually as a typical old Russian pilgrim going his rounds of holy sites, in fact his unrealistic green beard suggests an alliance with the supernatural and hence his possible identification as "old sorcerer."[53] He carries a stave that points to the central vertical axis of the painting, leading the eye upward to the pair engaged in a life-and-death struggle, and then on to the walled town (or monastery) with its church domes at

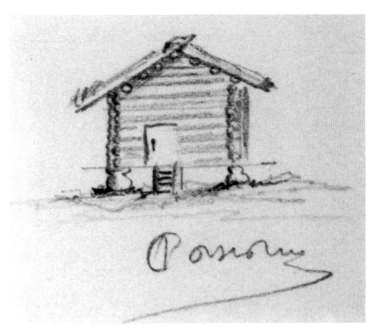

47. Kandinsky. Sketch of Zyrian grain-storage hut, 1889. From the artist's Vologda Diary, [p. 168], detail. Musée National d'Art Moderne, Centre Georges Pompidou, Paris.

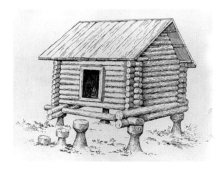

46. Zyrian *ambar*, or storage shed. Kerchëm, Ust Kulom. Kandinsky visited Kerchëm during his Vologda expedition in the summer of 1889. From V. N. Belitser, *Ocherki po Etnografii Narodov Komi* (Moscow, 1958), p. 195, no. 72b.

upper center. Thus another counterpoint is set between upper and lower spheres, between pagan and Christian, an axis that turns about life and death.

An identification of the old man as old sorcerer is reinforced by the fact that among the Votiaks, another Finno-Ugric tribe with whose traditions Kandinsky was familiar through the writings of his friend Bogaevskii, the "being" who instructed the shaman on supernatural matters was imagined in the form of an old man. In Zyrian dialect of the Vychegda region, the word *tödys* was used to signify both the "all-knowing person" and the sorcerer or shaman. The simple belted tunic worn by this all-knowing elder was typical of peasant dress among the Finno-Ugric tribes. Furthermore, the stave carried by the old man may also suggest a reference to shamanic lore, for among several

Siberian tribes the stave functioned as the shaman's symbolic "horse," on which he rode to "other worlds" in the course of his duties. Although the staff carried by this old man does not resemble the Buriat shaman's "horse-stick," it may be taken as a poetic allusion.[54]

Motley Life was painted in 1907, when Kandinsky was living in Sèvres, where his father lived with him for some time. Since the elder Kandinsky would have been a source of Buriat lore, having lived near the Lake Baikal Buriat peoples much of his life, another interpretation of the old man is possible. The Balagansk Buriats imagined the "master of the whole earth," a personage called Daban-Sagan-Noyen, as a benevolent old man. Then, too, it was primarily among the Buriats that the shamanic use of horse-staves, or horse-sticks, was common.[55]

Immediately behind the central figure of the old fellow, almost growing out of his back, is a tall tree—pine, cedar, or fir— symbolizing the home of the ancient pagan spirits with whom he is linked. Dramatically opposing him, across that vertical axis, is the figure of an elaborately costumed mother and child, flanked by a child in prayerful attitude, an obvious reference to orthodox veneration of the Virgin and Child. Thus, horizontally across the central axis, is found yet another contrapuntal expression of dvoeverie.

A double meaning may in fact also accrue to the mother-and-child image for the cult of the Virgin (as Mother of God) in Slavic "old Russia" had also been allied with pagan veneration of the Rozhanitsy, the goddesses of childbirth and destiny. It was another case of church exploitation of a pagan custom for its own purposes. This ancient association invested the Russian "Mother of God" concept with the deeper pagan dimension of "Mother of All Creation" or "Mother Earth."[56] In turn, the ancient myth of the Zolotaia Baba, or Zlata Baba, the "Golden Woman"—for whose existence Kandinsky had sought confirmation among the Zyrians—was also associated with a childbirth goddess, particularly among the Finno-Ugric tribes of the Urals. In Herberstein's account which Kandinsky had cited, and in other old chronicles as well, the Golden Woman had most often been depicted with a babe in her arms and a small boy standing by her side (fig. 26).[57]

Later accounts and depictions with which Kandinsky was familiar, such as those by Sjögren, Castrén, and Gondatti, came closer to the truth of her origins as a childbirth goddess of the northern tribes embodied in a wooden idol that was wrapped in layers of precious metals. Her position in Ostiak and Vogul lore as childbirth goddess and mother of the son of their highest god, Numi-Tōrem, had provided the missionaries with the opportunity of linking her with their own cult of Mary, Mother of God. The son of the Golden Woman, known among the northern tribes as World-Watching-Man and Golden Prince—whose image was also to take its place in Kandinsky's iconography— was then eventually allied with the Christian figures of Christ and St. George.[58]

Kandinsky alluded to the double meaning of his mother and child by including in the composition, directly next to her, a youth with hands clasped together in prayerful attitude, just as the Zolotaia Baba had been described by Herberstein, and as she had so often been depicted. The fact that Kandinsky had specifically cited Herberstein's passage on the Zolotaia Baba, and his obvious knowledge of other relevant ethnographic sources, demonstrates conclusively that his mother and child in *Motley Life* lead a double life. On the opposite side of the picture is the figure of a youth playing on a typical Finno-Ugric wind instrument, perhaps intending a subtle allusion to the fabled wind instruments of the Zolotaia Baba.[59] Kandinsky's multidimensional reference to the Christian and pagan "mothers of all creation" clearly suggests that in fact this painting has to do with the ramifications of dvoeverie.

The love-hate juxtapositions in the painting have references to Kandinsky's ethnographic experiences as well. The pairs of lovers (in the right middleground and left background) recall Kandinsky's observations that young Zyrians were permitted, even encouraged, to engage in open displays of affection.[60] On the other hand, the pair just to the right of center behind the mother and child, with arms slung about one another in brotherly amity, was most likely intended by the artist as an idealized and symbolic reference to the populist "going to the people" movement of the nineteenth century that had attempted to ally

the intelligentsia, particularly the student population, with the peasantry. The student is here represented by the young man in the long mottled coat, and the peasant by the youth to his right dressed in the typical belted tunic and peaked cap of the people. This pair was destined to turn up later in Kandinsky's *All Saints' Day* depictions.

The criminal element represented in *Motley Life* by the central pair engaged in a struggle, one figure attacking another with a knife, was undoubtedly related to Kandinsky's own interest in law and criminal justice among the peasants. In particular, it will be recalled, he was impressed with the people's courts, where justice was meted out according not so much to the act but to the intentions and circumstances of both perpetrator and victim.[61]

Further examples of the pagan-Christian opposition can be found throughout the picture. Just above right center, smoke from a fire opposes the church tower of a Christian cemetery, recalling Kandinsky's observations on the veneration of fire by the Zyrians, a subject also investigated by his friend Ivanitskii. An early notebook sketch also meditated on this theme, juxtaposing a Russian scene with an open fire and rising smoke to a background hilltop, a former gorodok, from which rise the opposing spires of a Russian church.[62]

Other figures were drawn from folklore as from life. For example, the wreath in the hand of the young girl standing at the right suggests her status as a bride, as do the two braids that were traditionally plaited on the wedding day from the maiden's one.[63] And the cat at the lower right clearly resembles Kandinsky's own cat, Vaske, but at the same time refers to the magical powers associated with cats in folklore.[64]

Thus *Motley Life* is truly "motley." It was clearly a vehicle by which Kandinsky sought to come to terms with his heritage—as he said, a means of venting his nostalgia for Russia. In it we find bits and pieces of his life orchestrated in a bright medley, like tunes snatched from memory. Archeological, ethnographic, and folkloristic fragments mix in a never-never-land of dream and memory. But in fact a significant theme emerges from this mélange representing dvoeverie in broadest terms and expressing the universal duality of life, a theme to which Kandinsky would return again and again.

Syncretic Themes in Transition

Within two years of *Motley Life* Kandinsky was ready to launch a heroic transition in style that would catapult him to the world stage of art while at the same time drawing strength from the past as never before.[65] After a hiatus of two years, during which he had resided in Paris and Berlin, he returned to Munich and in January 1909 founded a new exhibition group, the New Artists' Society, which was to become his vehicle for change. With its second exhibition in the autumn of 1910, it was to establish the international scope of the avant-garde movement, with Kandinsky at the fore.[66] Melding the linear freedom of drawing with the rich, lapidary tones of his earlier style and laying both open with broad swathes of color washed upon his canvas, he now moved boldly beyond traditional naturalistic painting. He began to differentiate his works by title as "Impressions" (after nature), "Improvisations" (both more considered and more lyrical) and, of most serious import, "Compositions." What remained constant, however, was the recurrent thematic content that formed a continuum with his earlier "Russian" paintings, for in his work he continued to explore the ramifications of dvoeverie, the vocabulary of Russian and Bavarian folk art, and the double lives of saints whose roots in ancient beliefs made them doppelgänger in the land of Rus'.

At the new society's second exhibition, Kandinsky exhibited his most monumental painting since *Motley Life*, entitled *Composition II*. Although it was immediately castigated by Munich critics as no more than a sketch for tapestry, it actually expressed in no uncertain terms the continuity of his development.[67] "Once, in the throes of typhoid fever, I saw with great clarity an entire picture, which, however, somehow dissipated itself within me when I recovered. Over a number of years, at various intervals, I painted *Arrival of the Merchants*, then *Motley Life*; finally, after many years, I succeeded in expressing in *Composition II* the very essence of that delirious vision." By this revelation in the Russian edition of his memoir Kandinsky clearly indicated the iconographic relationship of these three pictures. Like *Arrival of the Merchants* and *Motley Life*, *Composition II* of 1910 is crowded with figures and goings on (fig. 48). Although previously described as a representation of the apocalyptic deluge,

48. Kandinsky. Sketch for *Composition II*, 1909–1910. Oil on canvas, 97.5 x 131.2 cm. Solomon R. Guggenheim Museum, New York. Photo: David Heald. © The Solomon R. Guggenheim Foundation, New York.

53

the storm and rising waters are only details of a vaster, far more complex tapestry densely woven together with elements of the artist's ethnographic background.[68]

The giant wave-washed figure lying prone in the foreground can only be Vasa, the Zyrian water-spirit, often imagined as clad in a green robe, who was thought to cause great tempests by throwing himself into the water.[69] He was also responsible for victims of drowning, drawing unwary bathers into the depths, just as Kandinsky has indicated by the wave-threatened figures— one flinging up his arm in a cry for help—at lower left. A secondary figure to the right may be another vasa, characterized by his large eyes, also an attribute of this demon. The water-spirit was also sometimes accused of stealing horses when they strayed too near the water's edge. Here two figures flying on horseback above Vasa's head appear to escape his grasp.

The horsemen may actually represent Florus and Laurus, the patron saints of horses, particularly beloved in Vologda province. They are usually depicted in Russian icons with dark and light horses, as here in *Composition II*. Kandinsky's friend Ivanitskii had listed them among the saints to whom Vologdan peasants customarily prayed for miraculous cures. Here they suggest an alliance with shamanic powers, as they appear to "ascend" the "cosmic tree" or pillar rising in the center of the picture. Indeed, the conjunction of a recumbent figure with horsemen flying upward above his head also suggests a shamanic dimension: the shaman in trance whose spirit-helpers fly heavenward.[70]

On the other hand, we find the "old man" of *Motley Life* now stretched out before a willow-like tree in the upper right, perhaps a reference to the pagan custom of shaman burial in the sacred grove. A mourning figure beneath the drooping willow bends over him. It was said, too, that the death of a shaman might provoke a great storm.[71] Between this group and the "pillar" looms a figure in brown raising its arm in a threatening gesture. Kandinsky himself had described the Zyrian forest-spirit vörsa with unconcealed excitement in the diary of his Vologda expedition: "A devil and demon It live[s] in water and forest. Ten years ago it kidnapped a boy. Was seen last year. Seized a horse, strangled [it]. One has to cross oneself. It's as big as a tree

and brown-black. Lifts up its right hand." In *Composition II* the brown-colored forest-spirit towers above a seemingly oblivious and child-like kneeling figure. His raised arm threatens to snatch his victim away.[72]

To the left of the "cosmic tree" or pillar a yellow figure with arms outstretched stands in a boat. If we are dealing with a tempest brought on by Vasa, then perhaps here we encounter Yanukh-Tōrem, the son of Numi-Tōrem, the principal god of the Voguls and Ostiaks, who controlled all natural phenomena.[73] Yanukh-Tōrem was said to take the form of a man, and "from the splendor of his raiment he shines like *gold*," hence his secondary name, Golden Prince. He was also known, among the Voguls, as Mir-susne-khum, the World-Watching-Man. It was he who descended to earth in response to mortal appeals concerning atmospheric conditions. As mediator for the distant and indifferent highest god, he was thought to intervene actively in the affairs of men, in this respect taking on a Christ-like aspect. This heroic god in his guise as divine rider was invariably depicted with outstretched arms, an image that was highly stylized and traditionally used on sacrificial blankets (figs. 49, 50). Although conventionally depicted on horseback, he was also said by some accounts to come to earth by boat with his two rowers, a motif that would also appear repeatedly in Kandinsky's work.[74] While in some accounts the god rode a white, or white-and-golden, horse, he might also ride on the back of a soaring goose, a bird sacred among the northern peoples. As World-Watching-Man,

49. Traditional depiction of Mir-susne-khum, the World-Watching-Man, also called Yanukh-Tōrem and Golden Prince, on sacrificial blankets (Mansi/Vogul). Collection MAE, St. Petersburg. From S. V. Ivanov, *Materialy po Izobrazitelnomu Iskusstvu Narodov Sibiri XIX-Nachala XX v.* (Moscow and Leningrad, 1954), p. 53, no. 32.

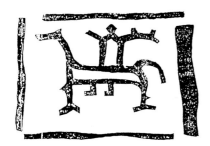

50. Mir-susne-khum. Watercolor pattern on paper. Collected by Artturi Kannisto among the Voguls, ca. 1901–1906. National Museum of Finland, Kannisto Collection, Museovirasto, Helsinki.

World-Surveying-Man, or World-Traveling-Man, he was thought to ride or soar about the world at night, watching over the affairs of humankind.[75]

This Golden Prince, as mediator and hero on the white horse, often identified with the sun, gradually assumed the identity of Egori the Brave and eventually of St. George as well. Candles were even lighted for the World-Watching-Man in church. In one account, Mir-susne-khum was subjected to many of the same tortures braved by St. George. Over time a relationship was established between World-Watching-Man and the Golden Woman of the Ob River basin as her son, and their further ramifications after Christianization as "Christ" and "Mary, Mother of God."[76]

In *Composition II*, the Golden Prince, clad in his golden yellow suit, arrives in the midst of the storm with at least one rower, arms outstretched in the Christ-like gesture of calming the waters. Behind him the storm fills the sky and lightning strikes in the tops of trees.[77] The contrasting moods of the painting, opposing apparent tranquility—the reclining couple and kneeling figures on the right, the figure in black leading the small child-like figure—to the demons and dangers of Nature controlled by an indifferent god on the left, together with the subtle vibrations between Christian and pagan belief systems as they collide, set up a disconcerting tension that Kandinsky fully intended: "Painting," he wrote in his memoir, "is a thundering collision of different worlds." Like *Motley Life*, then, it would appear that *Composition II* is a highly complex statement on the phenomenon of dvoeverie.[78]

Kandinsky had already begun experimenting with the motif of World-Watching-Man in *Composition I* of 1910. There the central of three riders posed facing the viewer with outstretched arms, an unlikely position considering that the riders appear to be galloping at full tilt. The pose is unnatural enough to suggest an intentional reference to the mythic figure, a reading reinforced by two related drawings that clearly imply the artist's further meditation on this theme. In both drawings, the figure is seated on a spotted, or piebald, horse that is generally considered sacred among the shamanistic peoples of Siberia, a fact well known to Kandinsky (fig. 51). In these drawings, then, Kandinsky has conjoined the magical World-Watching-Man with shamanist tradition. A watercolor that mediates between these two *Compositions* depicts the hero with outstretched arms on a white horse, as described by Gondatti, a motif that recurred frequently in Kandinsky's work (fig. 52).[79]

Around this time, a band of "apostles" had coalesced around Kandinsky, whose exhibition of *Composition II* with the New

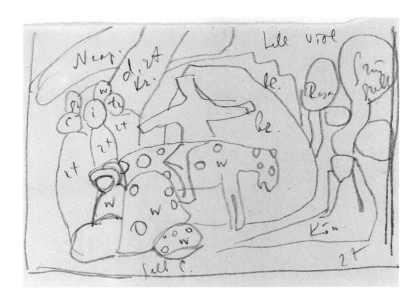

51. Kandinsky. Untitled sketch, motif central to *Composition I*, ca. 1910. Pencil on paper, 11.3 x 18 cm. Musée National d'Art Moderne, Centre Georges Pompidou, Paris.

Artists' Society in the autumn of 1910 had drawn Franz Marc and with him August Macke to his side. They saw themselves, with some justification, as an embattled band of prophets against a world enmeshed in chauvinistic strife and decadent materialism. During this period visions of All Saints' Day and St. George began to fill Kandinsky's canvases with reminiscences of his Russian heritage and references to double faith. In a very real sense the *All Saints' Day* paintings, with their pagan and Christian heroes, celebrated a triumph over the death sentence imposed by such traditionalists as Carl Vinnen, whose vituperative and chauvinistic attack on modern art had been published in the spring of that year. At this point in his career, with "apostles" gathered in a "phalanx" at his side, Kandinsky naturally turned to themes that expressed his revolutionary aesthetic aims.

The first versions of his *All Saints' Day* paintings were created in May and June 1911, when the "clan" had begun to gather and as preparations were being made for publication of a response to Vinnen that included emphatic counterstatements by Kandinsky, Marc, Hausenstein, and many other prominent supporters of modern art. Kandinsky's contribution emphasized the duality of existence: "Like the world and the cosmos equally, man consists of two elements: the inner and the outer." In this brief but brilliant series of works, Kandinsky included references not previously understood that reflected his knowledge of pagan beliefs and concepts while expressing that sense of duality in a growing iconographic vocabulary based on the concept of dvoeverie. In such works as the *All Saints' Day* and *Sound of Trumpets* series, we find not only references to those themes that first surfaced in *Sunday (Old Russia)* and *Motley Life*, and encountered again in *Composition II*, but a greatly expanded range of folkloristic imagery.[80]

For example, in the reverse painting on glass now called *All Saints II* we now recognize the figure of the Zyrian shaman Pam, whose confrontation with St. Stephen, the bishop of Perm, on the banks of the Vychegda River was part of the legend Kandinsky knew from his own visit to the Vychegda River area (fig. 53).[81] But here Pam, distinguished by his pointed "sorcerer's" cap, rows off in a boat (at lower left). According to the account of St.

Stephen's life by Epiphanius that Kandinsky had cited in his essay on the Zyrians, the shaman Pam was a powerful adversary of the good missionary, whom he had finally agreed to debate in public. Pam, it was said, raised three major arguments in defense of the heathen faith. Whereas the Christians had only one god, he said, "we have many. . . . They give us game, all that is in the waters, and in the air, in the swamps and forests—squirrels or sables, martens or lynxes and other game." This game, he emphasized, even reached as far as to the table of the czar. Further, he claimed that his faith was more powerful than Christianity because of the superior success of his people in hunting the bear, whereas the Christians' record in the bear hunt was "shameful." But probably his most important claim was that "we quickly learn all news; whatever happens in a far-off country, in a foreign town . . . the complete news of it reaches us at the same hour. . . . For we have many gods aiding us." According to Epiphanius, it was a hard debate, continuing all day and all night. Eventually Stephen invited Pam to a "divine trial by fire and water," demanding that they walk through a burning hut and throw themselves into the Vychegda River. At this point, Pam was forced to acknowledge his defeat, for he assumed that Stephen possessed some special knowledge concerning the conjuration and conquest of fire and water that he lacked.[82]

In Kandinsky's version of the Pam legend, Pam escapes drowning by prudently resorting to a row boat, of a type common to the Vychegda River area. While one rusalka tries to climb into his boat, her head and upraised arms clearly visible just above the stern of the boat, another sits naked on a rock at the water's edge (directly at the center of the painting). A preparatory watercolor sketch (thus reversed), shows this rusalka clearly, with her fabled tresses flying (fig. 54).

Standing on the promontory above her are two figures with arms slung about each other in an amicable embrace. They have

52. Kandinsky. *Untitled*. Study for *Composition II*, ca. 1910. Watercolor and pencil on cardboard, 32.9 x 32.9 cm. Städtische Galerie im Lenbachhaus, Munich (GMS 353). Photo: V. G. Bild Kunst, Bonn.

53. Kandinsky. *All Saints II* or *Composition with Saints*, 1911. Reverse painting on glass with painted frame, 31.3 x 48 cm. Städtische Galerie im Lenbachhaus, Munich (GMS 122).

stepped out of the romantic market setting of *Motley Life* into the more overtly symbolic *All Saints' Day* milieu, demonstrating once more the hitherto unremarked continuity of Kandinsky's work. One, wearing a light-colored tunic, carries a cross, the other wears a dark tunic. The same pair (more developed in terms of dress) appears in another reverse painting on glass entitled *All Saints I*, but there the left-hand figure clearly represents the Zyrian people in his peasant tunic, loose trousers, and brightly colored knit stockings (fig. 55).[83] The figure in the long plain coat may have several identities. In *All Saints II*, the cross

he carries identifies him as St. Stephen in the act of befriending the Zyrian people, an identification reinforced by the presence of the sorcerer Pam in this work. In *All Saints I*, on the other hand, as in *Motley Life*, he may also represent the intellectual of the "going to the people" movement. In this sense Kandinsky may have intended a hidden reference to his own visit to the Zyrians. The pair might also refer to the twin physician saints Cosmas and Damian, especially beloved among the peasants of Vologda, who, according to Ivanitskii, prayed to them for "enlightenment of the mind" and "instruction in literacy." In a broader sense, the two may represent as well the reconciliation between pagan and Christian belief systems expected by many turn-of-the-century Russian intellectuals. Quite possibly the artist intended multiple identifications, even extending so far as to a symbolic representation of his own relationship with Franz Marc in their "sainted" fight against the "devilish" troops of Vinnen for the salvation of civilization through art.[84]

Amusingly, Kandinsky has given all the figures, including the sorcerer Pam, the halos of sainthood. By the same token, most of them sport pointed "sorcerer's" caps like the one worn by Pam (although his is dark), suggesting their alliance in a shamanistic *Bund* of saints. It should not be thought for a moment that Kandinsky was without a sense of humor. In a note to his *Composition VI*, which also combined pagan with Christian

54. Kandinsky. Study for the reverse painting on glass *All Saints II (Composition with Saints)*, 1911. Watercolor, ink, and pencil, 31.5 x 48 cm. Städtische Galerie im Lenbachhaus, Munich (GMS 616).

imagery, he commented upon the reverse painting on glass that had served as its inspiration, remarking that it had been "fun" for him to "mix serious forms with comical external expressions."[85]

Galloping into the darkening heavens above Pam and his rusalka is St. Elijah in his troika-drawn chariot. Behind him upon a hill, trees appear to be swept by a whirlwind. In Finno-Ugric mythology, this saint had come to stand for the pagan thunder god who controlled the weather and was thus also associated with the fecundity of the earth and the waters. With Christianization, the missionaries had found it expedient to associate the ancient "Thunderer" with the saint of the heavenly chariot whose wheels sounded the thunder and the hooves of whose horses struck the lightning. According to Ivanitskii's list, Vologda natives prayed to St. Elijah for both fine and bad weather. Here again there can be no doubt of Kandinsky's intentions in associating St. Elijah, steering his chariot across the darkening and stormy skies, with the "Thunderer" god of Finno-Ugric myth.

To the lower right (left in the watercolor), we find a depiction of St. Simon Stylite, a double reference to Simon or Semyon of the Russian folktale "The Seven Semyons." St. Simon was the Stylite, noted for his conversions of the pagans, who spent his life in meditation upon a pillar. In the story of the seven Semyons, it was the eldest Semyon, the smithy, who forged the iron pillar, a shamanic device, from which to survey the world and foretell the future. Standing upon it, his brother became the shamanic "all-seer." With the coming of Christianization, it was hardly surprising that the healing saints Cosmas and Damian became the patron saints of smiths. Nor is it surprising that the smith, an artist and craftsman, should be associated with shamanic powers, a connection Kandinsky would not have missed; after all, it had been the "eternal smith," Ilmarinen, who had forged the magical "Sampo" of the *Kalevala*. Thus here, too, the artist has included a figure with a dual function pointing to both Christian and pagan sources. The cosmic pillar would also become a persistent motif in Kandinsky's later work.[86]

The saint mounted on horseback and posed with outstretched arms suggests here a dual reference to the World-Watching-Man and St. George, Kandinsky's signature saint, although bereft of shield and spear. In fact, the lack of the usual accoutrements suggests that in this instance the more primitive double is dominant. The Golden Prince, often imagined as riding upon a white horse on his magical journeys around the world, was also associated with the golden sun, in whose rays Kandinsky's horseman basks. In depictions of St. George, too, his shield or saddle blanket is often marked with the image of the sun. That this figure had multiple meanings for the artist is reinforced by a small oil painting depicting the crucified Christ, also of 1911. There, directly before the Christ figure, is the motif of horse and rider with arms outstretched as in the reverse painting on glass, implying once again the conjunction of St. George/World-Watching-Man with Christ.[87]

The reverse painting on glass *All Saints I* is perhaps the most overtly "apocalyptic" of this series (fig. 55). Yet even here hints of a syncretic theme are revealed. Significantly, Münter identified

55. Kandinsky. *All Saints I*, 1911. Reverse painting on glass with painted frame, 34.5 x 40.5 cm. Städtische Galerie im Lenbachhaus, Munich (GMS 107).

this work as the "Russian All Saints," suggesting that its protagonists belong specifically to the Russian pantheon of saints and gods rather than to the European. In that case the identification of the horseman as St. George is all the more likely, ubiquitous as the saint was in Russian lore. Here St. George is in possession of his lance and characteristic sun-marked shield, referring to his association with the pagan World-Watching-Man and perhaps also with the Finno-Ugric figure of Iarilo, a pagan fertility and sun god. Here, too, the saint is decked out in his warrior's helmet, a reference to his militant political role. He is depicted against a setting of flame recalling his terrible trial by fire. This appropriation of sun mythology by St. George was to become a characteristic of Kandinsky's St. George imagery.[88]

Once again St. Stephen appears with his arm about the Zyrian convert, a motif with multiple allusions. In the background St. Vladimir, founder of the Russian church—and another Vasilii—turns his face to the heavens. His namesake, the artist who thought of himself as a "founder" of modern art and who intended to introduce a new aesthetic era to the world, has clearly conferred a dual meaning upon the saint. Instead of his church (held high in the glass version devoted to St. Vladimir alone (fig. 56), the saint here grasps a vaguely wreath-like shape, perhaps the laurel Kandinsky hoped to achieve for himself. Again, the ambiguity of this motif—one that replaces the church-motif of the other All Saints versions—suggests the ambivalence of the entire composition. The cloistered monk of Motley Life turns up recumbent as if in death, sprouting a magnificent flower symbolic of the resurrection and a possible dual allusion to the "world-tree," often resembling an enormous flower, found on shamans' drums.

On the obvious level, this scene is doubtless a fusion of the syncretic All Saints' Day theme with that of the apocryphal Last Judgment. Although often discussed as a Last Judgment painting, it deviates greatly from typical Last Judgment scenes in many respects, most particularly in lacking the judging Christ.[89] Instead, here the crucified Christ stands on a distant Golgotha, like a Bavarian Marterl. Still, it does include a trumpeting angel and a vision of the New Jerusalem. At the same time, it is yet another reverie on syncretic phenomena. As further proof, Kandinsky has added a butterfly fluttering above the head of the sleeping monk, representing the soul leaving the body at death, a belief ubiquitous among the Finno-Ugric peoples.[90] The butterfly's significance is reinforced by the nearby figure of the fabled Phoenix bird, taken over from Arabic tradition as a symbol of resurrection by the early Christians. In this "motley" crew, the vasa seated in the foreground waves also wears a halo. He might double for St. John, with closed eyes dreaming his vision. The crowned female saint behind him is wearing a brightly decorated Russian peasant costume. It seems reasonable to suppose that this figure is a variation on the Virgin Mary/Golden Woman motif of Motley Life. Or, standing as she does in a rather dangerous relationship to the mounted St. George, she may represent the "queen" of the artist's own household, Gabriele Münter, whom he depicted as St. Gabriel in another reverse painting on glass.[91]

All Saints II, an oil version of the picture, depicting a motley assortment of saints, returns St. Elijah the "Thunderer" to the scene along with other double allusions. The central "saint" on the white horse is once again a clear reference to World-Watching-Man, this time atop the "world mountain" where, in Vogul legend, he was said to have been born. He is easily distinguished in his characteristic arms-outstretched pose in the watercolor Sound of Trumpets.[92]

The giant-fish-and-boat motifs common to these pictures are again motifs as important in Finno-Ugric lore as they are to shaman drum imagery. Among Zyrians and Votiaks the powerful water-spirit might often take the form of a giant pike, a particularly toothy fish, just as represented here by Kandinsky, who also knew that it was on the back of a giant pike that the heroic craft of the Kalevala foundered.[93]

That a resurrection theme was intended is emphasized by the figure restoring its severed head in all four versions. But Kandinsky was also aware of the shamanic tradition that associated the severance of the head from the body and its restoration with the receipt of the shaman's gift of healing and clairvoyance.[94] Thus motifs common to both the apocryphal tales of the Last Judgment and to pagan Finno-Ugric and shamanic mythology

61

56. Kandinsky. *St. Vladimir*, June 1911. Reverse painting on glass, 29 x 25.6 cm. Inscribed in Cyrillic on reverse: "Holy Prince Vladimir." Städtische Galerie im Lenbachhaus, Munich (GMS 127). Photo: V. G. Bild Kunst, Bonn.

have been mingled in this picture as well. Again St. George/ World-Watching-Man, the pike, a boat, and a Phoenix fuse with more traditional Last Judgment and All Saints' Day imagery. The repeated flower motif might also refer to the cornflower goddess Poludnitsa, earlier encountered by Kandinsky among the Zyrians. That Kandinsky decorated the frame of this painting in its *Hinterglas* (reverse painting on glass) version with bright dabs of color announces his intention to identify it with the Russian and Bavarian folk art that he so admired.

Indeed, Kandinsky's 1911 reverse painting on glass *St. Vladimir* is an overt imitation of *Hinterglasmalerei,* and in this sense takes the form of an ethnic artifact itself (fig. 56). The Cyrillic inscription translates as "Holy Prince Vladimir," recalling Vladimir's secular life before his baptism in A.D. 989, when he received the name Basil (Vasilii), also Kandinsky's Christian name. The saint's position as "founder" of the Russian church is symbolized by the cupolaed church held aloft in his left hand, while ranks of the baptized, white-faced and red-cheeked (like Kandinsky's recollection of the Zyrians), stand below. But below the saint's right arm, a forest of fir or pine trees recalls the sacred groves of the heathens and the homes of their former deities. Vladimir's identification with the ancient cult of the sun can be recognized in the halo behind his head, with sun streaks emanating from it. St. Vladimir, in fact, was also known in Russian epic poetry as Krasnoe Solntse', literally, "beautiful sun."[95] Kandinsky's knowledge of the ancient cult of the sun and his awareness of the loss of cultural heritage brought by Christianization led him to create in this modern "icon" a veritable symbol of dvoeverie.

That Zyrian and Russian folklore continued to resound in Kandinsky's paintings of the Munich period and for decades after, is further demonstrated in his painting *Nude* of 1911 (fig. 57). Perhaps because the nude figure is unusual in Kandinsky's oeuvre, this work has been considered insignificant and is little discussed in the literature. Yet it represents another link with Kandinsky's reminiscence of Zyrian beliefs in the animating spirits of Nature. In the context of his ethnographic experience, we now recognize a vision of Rusalka, the "wife" of the Zyrian water-spirit Vasa. By all accounts, she is imagined as a woman with pendulous breasts and long hair, who sits on a stone by the water combing her hair. Waves lap at the knees of Kandinsky's nude, also seated upon a rock by the water, and although she seems to lack a comb, her pose and décolletage are true to the legend. Perhaps most vivid in Kandinsky's memory was the account by his friend Kharuzin of the Lapp rusalka or satsien. According to Kharuzin: "In every body of water, whether it be a lake or a river, lives Satsien and her daughters. She manifests herself before people in the shape of a naked woman, she combs her hair with a 'good' comb. Her face is white and pure, her hair is dark. If someone frightens Satsien, she throws herself in the water in a fright, leaving her comb and part of her hair on the bank, on the stone, on which she was sitting."[96]

The figure of this female nixen is not confined to Zyrian folklore; it is also ubiquitous in old Russian and Finno-Ugric lore. Of all the pagan sprites of the natural habitat, she is one of the most ancient and alluring. A happy and carefree figure endowed with incredible sexual attributes and sensuality, she is said to lure men into her sphere and often to tickle them to death—obviously one of the more dangerous denizens of stream and forest.[97]

Given the autobiographical nature of so much of Kandinsky's work, that there are subtextual references in this painting cannot surprise. In this year his marriage to Ania Chemiakina was dissolved and at long last he seemed on the verge of marrying Gabriele Münter. Meanwhile, however, at just about the time he painted his *Nude,* a visit from a Moscow friend, Bena Bogaevskaia, wife of his friend from days at the Ethnographic Society, Petr Bogaevskii, brought new tensions, doubtless reminding him again of his ties to Russia.[98]

Rusalki were in fact regular visitors to Kandinsky's visual world at that time, appearing in several of the *All Saints' Day* paintings. Rusalka with her endowments intact also appeared in *Deluge,* an early reverse painting on glass study for *Composition VI,* again betraying his penchant for humor. Not surprisingly, Kandinsky himself owned a folk woodcarving of Rusalka, doubtless a memento of his Vologda journey, which he displayed on the wall of his apartment in Munich (fig. 58).[99]

But *Nude* reveals yet another reminiscence of "old Russia." Details of architectonic structures in the background recall the characteristic roof finials of peasant homes prevalent across northwestern Russia and familiar to Kandinsky not only from his travels and the Slavophile movement in architecture but from the ethnographic literature. An ancient and widely distributed form, they represent crossed horseheads and originally had a protective function.[100] Perhaps still closer to home, they were depicted in the lubki described as "Russische Volksblätter" in his personal collection, later reproduced in the *Blue Rider* almanac. Similar finials are depicted in Kandinsky's woodcut *Golden Sail* (frontispiece).[101] For Kandinsky, the crossed-horseheads motif, widespread across northern Europe, occurring as well in Bavaria and Austria, may have represented a cultural link between Russia and the German-speaking countries. In his work, however, it is always associated with other motifs that are specifically Nordic and Russian. This architectonic detail was to reappear a quarter of a century later in the artist's drawing for *Hut of Baba Yaga*, a set design for the 1928 performance at the Bauhaus of Mussorgsky's *Pictures at an Exhibition* (fig. 59).[102]

Folk Art and Ethnographer

Not surprisingly, Kandinsky was an avid collector of folk art whose own collection included not only the fine example of a woodcarved rusalka that dominated one wall of his home but many other examples of Russian and Bavarian folk art. Reverse paintings on glass covered the walls of his apartment in Munich and the house he shared with Münter in Murnau.[103] Among his Russian artifacts, a wooden horse on rockers, painted with spots to represent a piebald and bearing the figure of a sorcerer or shaman, was to provide an increasingly significant image in his iconography (fig. 60). A carved wooden bird, possibly representing the woodcock (sacred to several Finno-Ugric and Uralic tribes) and a wooden salt cellar in the form of a hen (perhaps originally intended to represent the greyhen that was associated by the Ostiaks with magical protective powers) were also reminders of Kandinsky's ethnographic travels (figs. 61, 62). An

57. Kandinsky. *Nude*, 1911. Oil on canvas, 147.3 x 99 cm. Private collection, Switzerland. Photo courtesy Solomon R. Guggenheim Museum.

elaborately carved ceremonial spoon, similar to those used in the bear ceremony by many of the Siberian peoples, and a Lapp hunting knife in an engraved ivory sheath typical of Lapp workmanship are perhaps of greater interest from an ethnographic point of view (figs. 63, 64). Two highly polished carvings, one of a horse-drawn sleigh with driver and riders and another depicting a horse-drawn farmer's sledge, are typical of the work of the nineteenth-century Slavophile artisan Chushkin (fig. 65).[104]

Besides his collection of lubki, Kandinsky also owned at least four icons, including one of St. George slaying the dragon and another of the prophet Elijah, both images of great iconographic significance to the artist (fig. 15). A large wooden figure of St. Martin on horseback sharing his cloak with the beggar, probably of Austrian or Bavarian origin, represented a socially significant motif that was to reappear in the frontispiece to the *Blue Rider* (fig. 66). While Kandinsky's collecting activity was clearly important in the creation of the aesthetic environment with which he sought to surround himself, it also demonstrated his continuing ethnographer's response to the world at large.[105]

59. Kandinsky. Set design for Picture XV, *Hut of Baba Yaga*, 1928 performance at the Bauhaus of Mussorgsky's *Pictures at an Exhibition*. India ink and watercolor, 30 x 40 cm. Musée National d'Art Moderne, Centre Georges Pompidou, Paris.

58. Rusalka. Russian folk woodcarving from Kandinsky's personal collection. Painted wood, 22.9 x 47.4 x 6.1 cm. Musée National d'Art Moderne, Centre Georges Pompidou, Paris.

60. Toy horse on rockers (with the figure of a sorcerer or shaman). From Kandinsky's personal collection. Russian folk carving. Wood, carved and painted. Location unknown.

precedents, their scenic imagery is rather more sophisticated. A night stand is decorated with a motif of two leaping horses with their riders, the male waving the following female on. Münter would later comment rather tartly that, in fact, he never waved her on.[107] Below that image on the stand is a stylized hill topped by a house—the Russenhaus itself—flanked by two imaginary turreted towers distinctly more Russian than Bavarian. Accents on the edges of the furniture, consisting mostly of colorful dots and dashes, curves and flowers, emphatically recall the painted furniture of the Vologda region that Kandinsky had sketched on his expedition (figs. 9, 19).[108]

Perhaps driven by earlier dreams, Kandinsky had sought something nearer to the bone, as it were. In 1909, finally eschewing the overly sophisticated and hyperintellectualized atmosphere of Jugendstil decor that many of his contemporaries preferred and that had lured him for a time, he had escaped to the countryside. There he and Münter took up residency in a rather simple house—without running water or electricity—that they decorated with Bavarian and Russian folk art. The artist strove to recreate that effect he recalled with such vividness in "Retrospects," inspired by his entry into a Vologdan peasant house, with its brightly painted furniture, icons, and folk prints. The appeal of the environmental work of art was what had attracted him to Jugendstil in the first place and would later lead to his association with the Bauhaus.[106] Now in Murnau he turned a hand to the decoration of what soon came to be known locally as "the Russian House" (Russenhaus), painting a stenciled frieze of leaping horses and flowers on the staircase and decorating several pieces of furniture crafted by a local carpenter in uninhibited "peasant" style (figs. 67, 68). While these pieces owe their bright colors and simple designs to Russian and Bavarian

61. Carved wooden bird, from Kandinsky's personal collection. Russian folk carving. Wood, painted, 7.8 x 3.3 x 8.7 cm. Musée National d'Art Moderne, Centre Georges Pompidou, Paris.

62. Salt cellar in the form of a bird (greyhen?), from Kandinsky's personal collection. Russian, 19th century. Wood, carved and painted. Location unknown.

63. Ceremonial spoon, from Kandinsky's personal collection. Russian, 19th or early 20th century(?). Wood, carved. Location unknown.

64. Lapp hunting knife in an engraved ivory sheath, from Kandinsky's personal collection. Late 19th to early 20th century, souvenir trade. Location unknown.

Munich's Ethnographic Collection

If his own collection was modest, Kandinsky had at his doorstep an ethnographic resource that was to prove invaluable in the creation of his next artistic triumph celebrated in the *Blue Rider* exhibitions and almanac. As it happened, the intimate relationship between art and ethnography was a primary concern of the then director of Munich's Ethnographic Museum, Lucian Scherman, a man ahead of his times in this respect.

Already a well-established institution by the time of Kandinsky's arrival in the Isar "Athens" in 1896, the Ethnographic Museum at the picturesque Hofgartenarkaden was a product of four hundred years of Wittelsbach family collecting. Chief among the museum's holdings by the middle of the nineteenth century were objects from two major Russian collections: one formed by donations from the Krusenstern and Langsdorff circumnavigation of the world that had been undertaken at the direction of the Russian czar Alexander I, the other consisting of a significant number of artifacts from the Arctic and subarctic peoples of the Bering Strait and Northwest Coast of America, bequeathed by the duke of Leuchtenberg, consort of Grand Duchess Maria of Russia. As might be expected, these Russian connections were not lost on Kandinsky.[109]

During Kandinsky's years in Munich, the museum developed as a major institution of exhibition, learning, and research. Scherman's wide-ranging research included efforts to enhance the Siberian collections. In 1908, for example, he took special

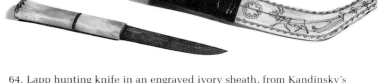

65. Horse-drawn sleigh with driver and riders, from Kandinsky's personal collection. Russian, 19th century. Wood, carved. Location unknown. Photo courtesy Centre Georges Pompidou.

pains with the Eugen Wolf collection of Chukchee objects (including a Chukchee shaman drum), which he compared favorably with that of the famous Russian authority and collector Gondatti. Scherman had in fact consulted the lavishly illustrated 1901 study of the Gondatti collection by Waldemar Bogoras, and in 1909 he reported an exchange with the museum in St. Peters-

66. St. Martin, wood carving, from Kandinsky's personal collection. Bavarian or Austrian, early 19th century. Wood, painted, 75 x 54.5 x 37 cm. Musée National d'Art Moderne, Centre Georges Pompidou, Paris.

67. Stairway in the "Russian House," Murnau, ca. 1910. Stenciled decoration of leaping horsemen by Kandinsky. Photo courtesy Gabriele Münter- und Johannes Eichner-Stiftung, Munich.

burg which included, among other items, a Tungus shaman's costume that would certainly have drawn Kandinsky's interest.[110]

Not surprisingly, of the nine objects from the Munich museum selected for reproduction in the *Blue Rider* almanac, at least two were from its Russian collections. The Tlingit (Chilkat) ceremonial cape from the Northwest Coast of America was from the Leuchtenberg collection (fig. 97). Such capes, of mountain-goat wool and cedar bark attached to fringed leather, were to be found as well in Russian museums, which to this day have extraordinary representations of Northwest Coast American Indian art, particularly rich in Tlingit materials.[111] There is no doubt that Kandinsky knew the Dashkov collection of Tlingit (Koloshi)

materials, which included a dancing cape similar to that in the Munich collection and a Tlingit shaman's drum and apron, as well as other items of clothing, masks, and decorated storage boxes. These collections, too, had benefited from the voyages of Krusenstern and others, and could boast of impressive holdings of other Northwest Coast materials. The cape in the collection of the Munich museum, a particularly fine example in excellent condition, was a natural choice for one whose taste had been honed on the Dashkov collections. The second "Russian" item Kandinsky selected from the collection was the Marquesas Island *Stelzentritt*, or stilt-figure, which had come via Langsdorff from the Krusenstern expedition. Such objects represented ancestor

68. Furniture painted by Kandinsky for the "Russian House" in Murnau, ca. 1908–1910. Gabriele Münter- und Johannes Eichner-Stiftung, Munich.

69

figures (Tiki) and, fastened to light wooden staffs, were used in ceremonial competitions. Like most of the ethnic artifacts in the almanac, it bespoke the regenerative symbolism manifested throughout.[112]

In a sense, then, Kandinsky had found in the Russian-related collections of the Hofgartenarkaden gallery a second home. No wonder that his earliest letters and notes to Gabriele Münter indicate that the Hofgartenarkaden was a favorite trysting place for the clandestine lovers.[113] Indeed, it was to be Kandinsky who later introduced his young friends Franz Marc and August Macke to the wonders of the Ethnographic Museum. In a letter to Macke shortly after his first meeting with Kandinsky, Marc spoke of a "richly rewarding" visit to the "Völkermuseum," where he had stood "gawking and shattered" before carvings from the Cam-eroons, going on to say that over the past winter—when he had first seen Kandinsky's paintings and met the artist—he had "become another man."[114]

With the exhibition of his works by the New Artists' Society, Kandinsky had achieved recognition far beyond Munich. Now, in command of his resources as never before, he was poised to move his discourse to a still wider audience with the enterprise of the *Blue Rider* exhibitions and almanac during the late winter and early spring of 1911–1912. Like the heroes of the *Kalevala*, he had forged his tools and moved beyond the workshop; like them in their fight for the Sampo, he had set his sights on a battle to be waged in defense of a cultural legacy, convinced that here modern civilization would find its salvation.

the artist as shaman

It is too early to cheer
 still too soon to sing:
Pohjola's gates are in sight
the evil gateways glitter
the bright covers are glowing
of the man-eating village
the village that drowns heroes. . . .

Just then Väinämöinen sang
and the hero's voice thundered
over the waves as it sang
on the water as it shrilled:
it jarred mountains, jolted hills
it set all the cliffs trembling

Kandinsky's use of Munich's ethnographic collections was neither strictly ethnographic nor paradigmatically artistic. Rather, they served as a great well which primed an imagination already richly stocked with ethnographic lore. As undisputed leader of the radical group of artists now engaged in the production of the *Blue Rider* almanac and exhibitions, Kandinsky himself assumed more and more the mantle of shamanic reference. Indeed, as the shamanistic theme of the almanac began to take shape in his mind, the vocabulary of shamanism began to assert itself in his iconography. St. George in particular provided Kandinsky with a concrete identity replete with adumbrations of shamanic powers of rescue and regeneration. By virtue of his association with the therapeutic metaphor of the *Blue Rider*, Kandinsky's St. George had clearly been endowed by his creator with shamanic aspects; he appeared triumphant on the very cover of the book.

By June 1911 Kandinsky had already revealed his sure knowledge of Siberian shamanism by depicting St. George astride a dappled or piebald horse, the preferred shamanic steed. It is a blue horse spotted with golden flecks (fig. 69). A model stood close at hand in Kandinsky's collection of folk art; that wooden image of a sorcerer likewise riding a piebald horse (fig. 60). But here St. George's golden helmet and armor also suggest an association with the Golden Prince, World-Watching-Man.[1]

St. George as Shaman: Initiation and Resurrection

For Kandinsky, the step from identification with the role of St. George to the role of shaman was easy enough: the Siberian shaman was also a "rider," whose calling was to heal. The many analogies between the roles of artist and shaman have often been remarked. The shaman has been described as an innately creative individual and the artistic expression of the Siberian peoples is demonstrably bound up with their shamanism.[2] As St. George/World-Watching-Man served not only as a symbol of the triumph of good over evil but also as a symbol of intercession between mankind and divine power, so too the shaman was a mediator

between man and the gods, with a particular mission to heal, a mission Kandinsky now took upon himself.

As a student of ethnography at a time when the discipline was growing by leaps and bounds, particularly in Russia, where the lure of the mysterious Siberian tribes had been felt for centuries, Kandinsky had long since become familiar with the basic literature on shamanism.[3] In fact, the role of the shaman in Russia's primitive tribes both east and west of the Urals was already well documented and understood by both European and Russian ethnologists by the 1880s. The shaman was the all-knower who assumed the role of intercessor between humankind and the supernatural powers. Through his or her offices, physical and psychological ills could be healed, social problems of the clan resolved, the future foretold, good hunting assured, the lost found, and the dead safely conveyed to their own realm. The shaman thus played a distinctly social role within the community.[4]

Ubiquitous in ethnographic accounts of shamanism is the experience of "shamanic illness" or ecstatic hallucinations, often of a catastrophic order, in which the candidate shaman was said to be torn to pieces and then "reconstructed" or, in effect, resurrected. Often the initiatory candidate was assailed by personal "demons" and subjected to tortures in dreams.[5] Kharuzin had described in some detail the ordeal of the apprentice Lapp shaman reportedly afflicted by a series of illnesses characterized by visions and culminating in a life-threatening illness with diabolic visions. Often the initiatory ceremony required that the shaman envision his own dismemberment and resurrection. The frequent result of the initiate's decision to become a shaman, to take up the drum and to shamanize, was his own self-curing. That is, by becoming a healer, he overcame his own illness.[6]

In thus curing himself, the shaman demonstrated a remarkable self-control that extended to the onset and length of his trance and even its degree. He was also apt to be particularly

69. Kandinsky. *St. George I*, June 1911. Reverse painting on glass with painted frame, 19 x 19.7 cm. Städtische Galerie im Lenbachhaus, Munich (GMS 105).

adept at both ventriloquism and sleight-of-hand tricks, while the artistry of his performance was frequently recorded as nothing less than astonishing.[7] None of which detracted from the positive good he was often able to achieve in terms of restoring the physical, psychological, and social well-being of both individuals and groups. It is hardly surprising then to find among accounts of shamanism the following list of qualifications from an 1833 report: a keen intelligence, strong character, self-confidence, great powers of imagination, acute vision, and flexible limbs.[8]

By all accounts, including his own, Kandinsky exhibited many of the characteristics attributed to shamans. Most striking is his report of the evolution of *Composition II*, according to which a painting had come to him while he was in an hallucinatory state, brought on by an illness many years before. Over time, he recalled, *Arrival of the Merchants*, then *Motley Life*, and finally *Composition II* had resulted from that initial vision. Since the first two paintings are representative of his early style and of a time when he was still wrestling with his own demons of self-doubt and insecurity, while the last represents his "breakthrough" to a new, far more "abstract" style, his "coming of age," as it were, this entire development might well be situated within the construct of shamanic initiation. From a tortured, fragmented style of mosaic color dots, the artist emerged to a new plane of expression characterized by broad color fields and linear rhythms set into a complex but unified compositional whole. The development paralleled his personal psychological development as well. While the earlier paintings were completed during years of instability and restless wandering with Gabriele Münter, *Composition II* was a product of a stable period during which, settled in Munich and Murnau and openly declaring his commitment to Münter, the artist had taken up his role as the leader of a radical new movement in art. In shamanic terms, he had passed through a period of torment that had only been relieved by a radical break with the past. This break was accompanied by a new self-confidence achieved by a transference of his lyrical woodcut style to the medium of oil painting on canvas.[9]

That Kandinsky was afflicted by many of the characteristic symptoms of shamanic illness is attested to over and over

again in his travel diary and later in his letters to Münter. Complaints of headaches, depressions, self-doubt, dizziness, and fits of absentmindedness and forgetfulness are rife. He was assailed by bad dreams and sometimes driven to near hysteria and despair. Eichner makes much of his neurasthenic temperament: "Behind his self-control and good upbringing grew a heavy nervosity. Outsiders knew nothing of the fact that, alone in his room he could cry out from inner excitement." As Eichner records, during the stressful year they spent in Paris, Kandinsky's "soul suffering" became so severe that isolation seemed the only solution, and he begged Münter to leave him alone by moving out of their Sèvres apartment. When she complied, letters followed that were filled with complaints of loneliness and expressions of self-doubt. He later confessed to her that after putting her on the

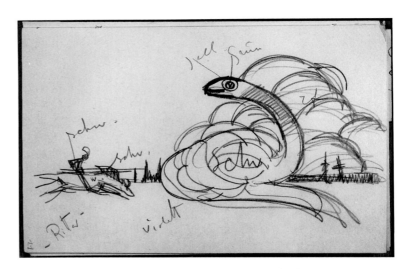

70. Kandinsky. Untitled sketch of St. George battling the dragon, ca. 1903–1904. Pencil in sketchbook, 15.8 x 10.3 cm. Städtische Galerie im Lenbachhaus, Munich (GMS 327, p. 11).

71. Kandinsky. *St. George III*, 31 March 1911. Oil on canvas, 97.5 x 107.5 cm. Städtische Galerie im Lenbachhaus, Munich (GMS 81).

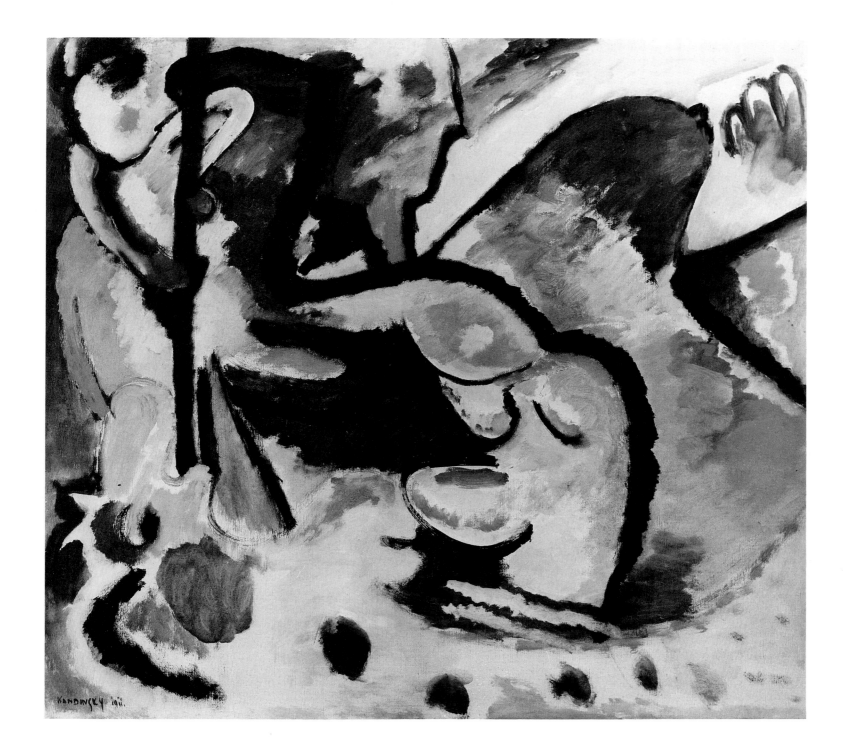

train and returning to the isolation of his room in Sèvres, he had broken down in tears of anguish.[10]

Eichner refers to Kandinsky's experiences of artistic "ecstasy," which parallel the shamanic experience, as "psychopathisch." In "Retrospects," Kandinsky recalled that from childhood on periods of intense anxiety characterized by "inner shuddering" (inneres Beben), depression and nightmare could only be resolved through drawing, which lifted him "out of time and space . . . so that I also no longer felt myself." He confessed that the sight of Moscow's Kremlin towers in the light of the afternoon sun was so shattering that it brought him to "ecstasy." In a 1904 letter to Münter, the artist explained that only his artistic activity—specifically, the creation of a woodcut—was capable of freeing him from the plague of thought or sadness; only in that state did he find that "music rings in my whole body and God is in my heart." Eichner likened this state to "ecstasy."[11]

At the end of the desperate Paris year, Kandinsky had sought recovery at an actual *Kurort*, or spa, in Bad Reichenhall, Switzerland, where he spent five weeks in the early summer of 1907. According to Eichner, he suffered at this time from dizziness so severe "that he scarcely dared to move his head." Other symptoms included "nervous heart, headaches, bad sleeping and dreams, distractedness, forgetfulness." It was only months later, during 1908, as he began to transfer the lyrical mode of his woodcuts—the art that made "music ring in [his] whole body"—to painting, that his splendid new style began to emerge along with his role as leader. The artist/shaman had begun to "shamanize."[12]

Kandinsky's "coming of age" may also be traced in the artist's use of the St. George motif as it evolved from a pint-sized and hopelessly outweighted opponent of a monstrous dragon into the shamanic giant of mythical proportions depicted in the post-1908 works (figs. 69, 70). The earlier composition, rendered in a drawing and a zinc plate for an etching, expressed Kandinsky's mental state of those years, his self-doubt with respect to his artistic capabilities together with anxiety over his illicit relationship with Münter.[13]

By the triumphant years of 1911–1912, however, St. George the artist-shaman had assumed his due stature in a series of St.

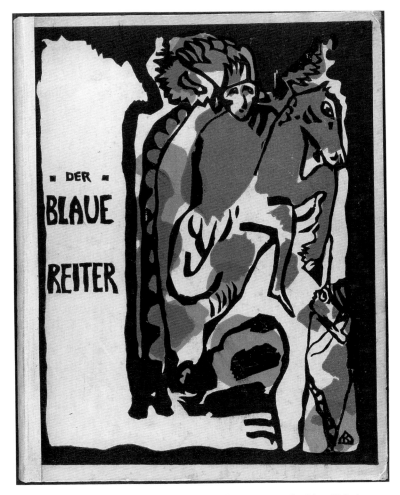

72. Kandinsky. Cover of the almanac *Der Blaue Reiter* (The Blue Rider), 1914 edition. Color woodcut, 27.9 x 21.1 cm. Getty Center for the History of Art and the Humanities Library, Santa Monica.

George paintings, and on the cover of the *Blue Rider*, where the saint towers both proportionately and compositionally above his opponent (figs. 71, 72). As we have already observed, in the reverse painting on glass *St. George I*, the saint even rides the shaman's piebald horse, and in *Improvisation 13* Kandinsky also

monumentalized the figure, conflating the images of St. George and World-Watching-Man, in his characteristic arms-outflung attitude, astride a piebald horse.[14]

Yet at the very peak of his success, Kandinsky was assailed by pangs of doubt. As he journeyed to Russia in October 1912, he wrote to Münter that his feelings were even "more mixed now when new paintings by me are purchased. For a long while I sat on a high, lonely tower. Now I am no longer alone. Is the tower still so high?" It was St. George on horseback who had occupied the high tower in the square in Rothenburg so many years before, in that medieval town Kandinsky and Münter had visited together in 1903.[15] Yet, immediately upon his return from that 1912 trip which had begun with so much doubt, he began work on another St. George painting, *Picture with the White Edge*, in which the saint would once again recover himself—in the process of the shamanistic performance, as it were—and be clearly positioned to vanquish the dragon.[16]

The Rider-Shaman

The shaman achieved his communication with the heavenly powers by leaving his body and journeying to other worlds, of which most tribes imagined there were several. He made this journey either by means of his drum, which during his trance became his magical horse on which he could fly above the tree tops and mountains or descend to the underworld, or by means of his horse-stick or "hobbyhorse," used notably by the Buriats of the Lake Baikal area. Depictions of Siberian and Lapp shamans and their drums had been ubiquitous in the literature for centuries. For example, Scheffer had depicted both the drumming and the entranced Lapp shaman in his classic seventeenth-century work (fig. 73).[17] The Buriat stick-horse was an actual hobbyhorse cut from the sacred birch tree. The upper end was sometimes crudely carved to suggest the horse's head, sometimes the middle was shaped to suggest the knee joint, and the lower end might be carved to suggest the hoof. Kandinsky would have seen many examples of such staffs in the Dashkov Museum (figs. 74a and b, 75).[18] Both the drum and the horse-stick would have held special

meaning for Kandinsky. For the drum provided a kind of "canvas" upon which the shaman drew pictograms of the "upper" and "lower" worlds and the creatures in those spheres who operated as his helpers (fig. 76), while the shamanic hobbyhorse evoked memories of his own youth.

In the opening sentences of "Retrospects," Kandinsky revealed how near was this shamanic hobbyhorse to him. Recalling that, like all children, he had loved "to ride," he described in particular how his family's coachman used to carve for him just such a "horse" from the branch of a tree.

73. Lapp shaman drum with drumming and entranced shaman. As depicted by Christoph Gottlieb von Murr in *Beschreibung der vornehmsten Merkwürdigkeiten in der Reichstadt Nürnberg, in deren Bezirke, und auf der Universität Altdorf* (Nürnberg, 1801), as adapted from Johannes Scheffer, *Lapponia*, 1673. From E. Manker, *Die lappische Zaubertrommel*, vol. 1 (Stockholm, 1938), illus. 31, p. 54.

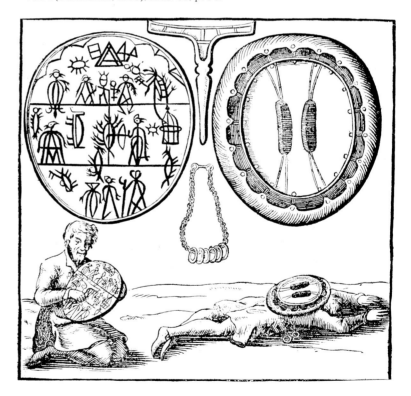

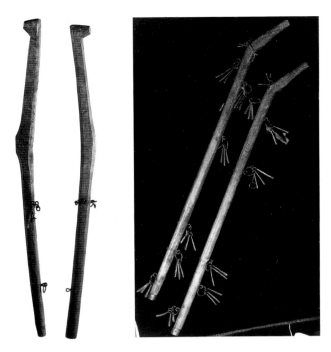

74a and b. *a)* Pair of Buriat horse-sticks, 19th century. Wood, carved at ends with stylized horseheads, iron fittings. Height: ca. 89 cm. Probably from the Joseph Martin Siberian Expedition, early 1880s. Photothèque du Musée de l'Homme, Trocadéro, Paris.

b) Pair of Buriat horse-sticks, 19th century. Wood, angled heads incised to suggest bridled horseheads, iron eyes, iron fittings. Height: 104 cm. Museum of Anthropology and Ethnography, St. Petersburg (MAE 1109–3/2). Photo: Dana Levy. Horse-sticks were also catalogued in the Dashkov Ethnographic Collections of the Rumiantsev Museum, Moscow. Photo courtesy MAE.

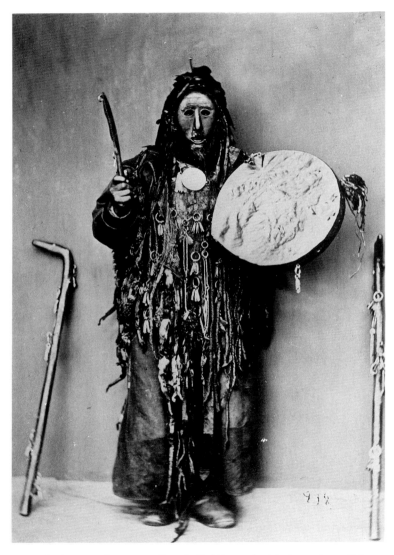

75. Masked Buriat shaman (or Transbaikal Tungus) with drum, drumstick, and horse-sticks. Photo: Toumanoff, n.d. Photothèque du Musée de l'Homme, Trocadéro, Paris.

Like all children I liked to "ride" with a passion. To this end our coachman [used to] cut thin spiral-like stripes on skinny sticks and pulled the two layers of bark away from the first stripe on the branch and only the upper [layer] from the second stripe, so that my horses usually consisted of three colors: one the brown-yellow of the exterior bark (that I didn't like and that I would like to have seen replaced by

another), a juicy green of the second layer of bark (that I especially loved and that had something bewitching about it, even in a wilted condition), and finally the color of the ivory white wood of the stick (that was damp-smelling and tempting to lick, but that soon became sadly wilted and dry, which spoiled the joy of this white for me from the very beginning).[19]

Although the wooden hobbyhorse in Kandinsky's personal collection of folk art was, as we have seen, not of the "stick" variety, but rather of the representational, rocking type, its shamanic rider, clothed in a sorcerer's cap and gown, sat astride a piebald horse (fig. 60).[20] Moreover, the image of the piebald horse occurred three times in "Retrospects," first in Kandinsky's recollection that the sight of a piebald horse in Munich had called up memories of his Russian past, in particular a horse-racing game involving another piebald horse that he declared his favorite, and again in his childhood memory of attempting to paint a "white piebald" but having accidentally blotted his picture with black ink while attempting to fill in the horse's hoofs. We are left to wonder if the piebald of the favorite game was the same as the wooden toy in his collection.[21]

But there is more that recalls shamanism in "Retrospects." In speaking of the creative experience Kandinsky echoed the sense of "transport," the image of "riding" and "reining in" or "bridling" his inner resources in much the same language ethnographers have used to describe the shamanic experience. Expanding on the image of riding, Kandinsky wrote: "The horse carries the rider with power and speed. The rider, however, guides the horse. Talent carries the artist to great heights with power and speed. The artist, however, guides his talent." He continued in the Russian edition: "The artist is perhaps in a position, albeit only partially and by chance—to summon up within himself these states of inspiration by artificial means. Moreover, he can qualify the nature of those states which arise within him of their own volition. All the experience and knowledge that relate to this area are but one of the elements of 'consciousness.'"[22] These "confessions" parallel to a surprising degree the reports of ethnographers on the special psychological traits of Siberian shamans that we have observed. Shamans, too, were required to keep themselves in check, to "rein in" their talent, as it were, and to control their capacity to achieve various states of trance. As Bogoras had observed, it might be "an inner voice" that would bid a likely candidate into communion with the supernatural.[23]

In a similar vein, Mikhailovskii had described a shamanic ritual in which the shaman *places the drum close to his host's ear*, blowing on his "sacred instrument" in order to drive into him the "spirit and power of his forefathers, thus preparing him to receive and understand the succeeding prophecies of the shaman." Reminiscent of this passage is Kandinsky's often quoted introduction to the catalogue of the second New Artists' Society exhibition. In a passage that reverberates with shamanic analogy, the artist wrote of: "The calling. The speaking of secrets through secrets," admonishing him who would turn "*the ear of his soul from the mouth of art.*" He concluded by speaking of art as the means by which "man speaks to mankind about the supernatural." It is the artist who holds the key to communication with supernatural powers; the artist in the role of shaman.[24]

For the shaman, too, the creative act was a "transport"—in trance he imagined that he left his body and was transported to other realms, where he "saw" figures and images of all kinds; upon his return, he reported what he had seen. As he drummed and chanted the tale of his incredible journey—for it had not been without struggle and hair-raising adventure—the drum became his vehicle, as the canvas or woodblock becomes the artist's vehicle, a concept Kandinsky tried to convey in naming his book of poems and woodcuts *Klänge*, "sounds" or "resonances." Repeatedly, the shamanic experience is compared to a kind of "rebirth" or to a creation of "worlds," an analogy Kandinsky would apply to art: "Painting is a thundering collision of different worlds, which in and by means of the battle with one another are destined to create the new world, which is called the work. Every work is created technically as the cosmos was created— through catastrophes that finally form, out of the chaotic medley of the instruments, a symphony that is called the music of the spheres. Work creation is world creation."[25]

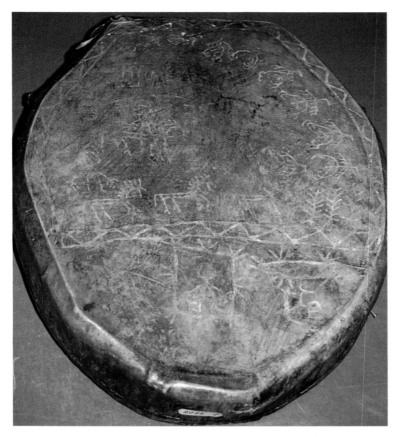

76. Teleut shaman's drum, late 19th to early 20th century. Leather stretched on wood frame, 67 x 51 x 16 cm. Museum of Anthropology and Ethnography, St. Petersburg (MAE 2014–1). Photo: V. Weiss.

Kandinsky's metaphor of the artist riding his talent as a horse recalls the role of the drum-horse in the shamanist ceremony. Without his drum the shaman could not make his journey either to retrieve the soul of a fatally ill person or to ask the gods for direction to the best hunting grounds. Drumming upon it, he imitated the hoofbeats of his magic steed and upon its back he soared to those other worlds.

The Shaman's Drum as Pictorial Source

The pictograms of the shaman's drum symbolized the "map" of his universe, and the drum itself was almost universally inter-

preted as the shaman's steed, while the drumstick served as his "whip" or as the "tongue" of the drum. Among the many sacred images that might be depicted on the drum's surface were the cosmic tree, the ladder or ladder tree, the sacred path, boats, and signs of the heavenly bodies, as well as a host of animal and bird-spirits and figures with special attributes representing various gods. Even details of landscape, such as mountains or encampments, might be delineated. The figure of the shaman himself, sometimes mounted on his steed, often appeared, together with his spirit-helpers. Although the specific imagery, the size and shape of the drum, and its embellishments and proportions varied from group to group, the sacred and magical nature of its use as a means of communication between the shaman and the gods was universal.[26]

Among the more elaborate of the Siberian drums that were exhibited in museum collections and frequently illustrated in the literature during Kandinsky's years at the university were those of the Minusinsk Tatars and the Teleuts (figs. 76–78). The surface of the Teleut drum was traditionally divided into upper and lower spheres, corresponding to the celestial and netherworlds, which were separated by a zigzag line (the sacred path) continuing around the border of the upper half. Within were depictions of the sun and moon, the North Star and Venus, grid-like signs that may refer to the "Book of Divination," horses, riders, and birdmen. In the typical examples illustrated here, the celestial tree bends like a giant flower above the figure of the shaman upon his horse.[27]

Besides the Siberian shaman drums in museum collections, such as the Dashkov, and the vivid verbal descriptions in the writings of such colleagues as Kharuzin and Mikhailovskii, Kandinsky would also have had access to numerous contemporary illustrated volumes on the subject. For example, both Grigorii Potanin and Dmitri Klements had illustrated Siberian shaman drums and costumes in their well-known and oft-cited ethnographic publications, and Lankenau, to name just one of many, had published dramatic illustrations of a Minusinsk shaman and his drum by 1872 in the widely circulated journal *Globus* (fig. 79a and b). In a Siberian example published by Potanin, the horse was reduced to a curved line with a crooked end repre-

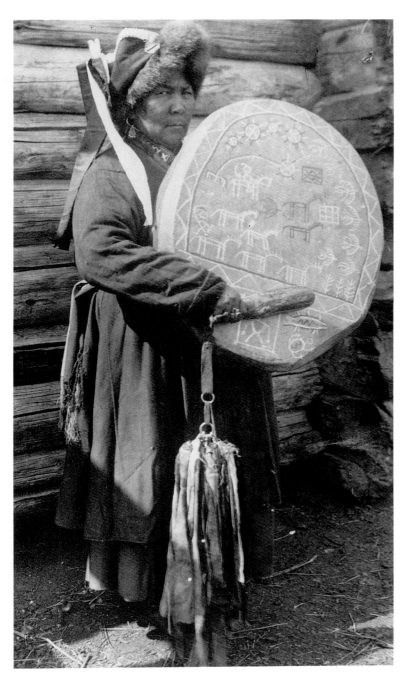

77. Teleut shamaness with drum, 1930s. Photo (by N. P. Dyrenkova?) courtesy Museum of Anthropology and Ethnography, St. Petersburg.

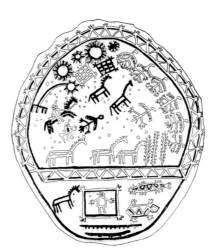

78. Teleut shaman drum schema. Museum of Anthropology and Ethnography, St. Petersburg, Archive A. V. Anokhin (no. 275). With permission from Vilmos Diószegi, *Popular Beliefs and Folklore Tradition in Siberia* (Budapest: Akadémiai Kiadó, 1968), p. 493.

senting the head; the legs are sticks; trees and a bird are similarly reduced to outline and skeletal elements (fig. 80a and b).[28]

Lapp Shamans and Their Drums

While Teleut drums may have been among the most developed in Siberia in terms of pictograms, Lapp drums were even more elaborate, representing in vivid and various detail the complex cosmology of those ancient northern peoples (figs. 81, 82a and b, 83). Because of their rich pictography and obvious power within the Lapp social context, the drums had long been objects of curiosity to explorers and ethnographers. Like the drums of Siberian shamans, they had been described and depicted in the travel literature from earliest to most recent times. Kandinsky would even have found his own remarks on Zyrian beliefs cited in an 1894 report by Julius Krohn on pagan rituals of the Finnic tribes, in which several Lapp drums and a selection of Siberian drums were illustrated, along with the same dramatic illustrations of a Minusinsk shaman that had appeared in Lankenau's article and a graphic depiction of a shamanic ritual in progress (fig. 79a and b).[29]

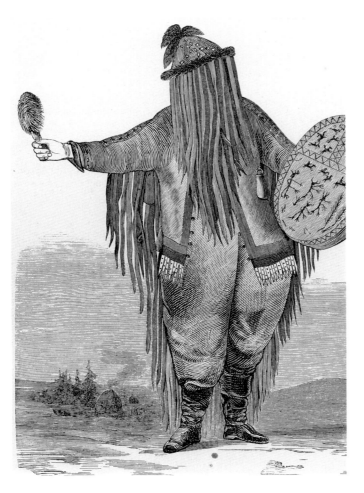

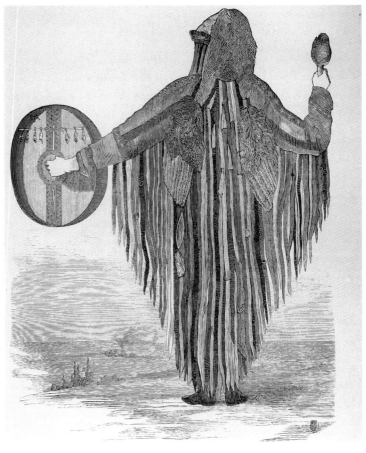

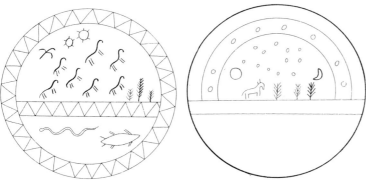

79a and b. Minusinsk Tatar shaman, front and back views. From H. v. Lankenau, "Die Schamanen und das Schamanenwesen," *Globus* 1872. The same illustrations were published by Julius Krohn in 1894 in the book in which he cited Kandinsky's article on the Zyrians.

80a and b. Schemata from Altaic shamans' drums. From G. N. Potanin, *Ocherki Severo-Zapadnoi Mongolii* (St. Petersburg, 1881–1883), vol. 4, pls. VIII, IX (details).

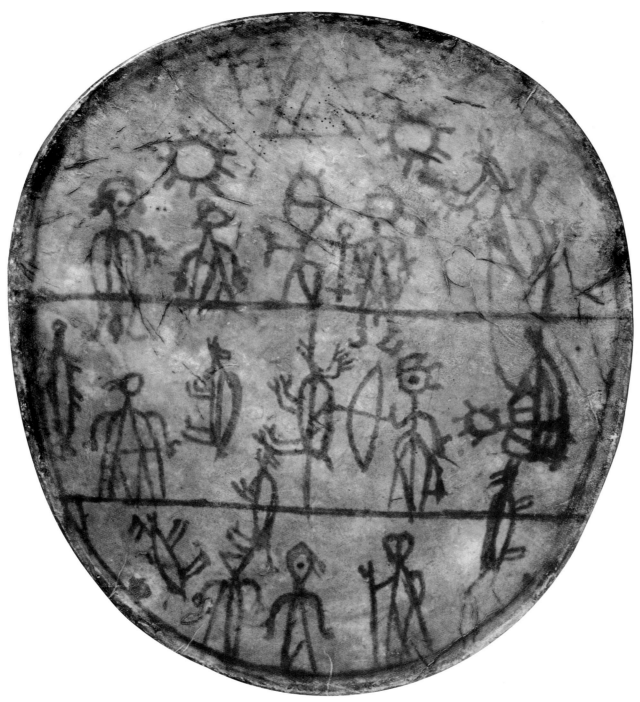

81. Lapp shaman drum, 17th century(?). Reindeer hide over hollowed-out pine, figures painted with alder-bark pigment, 37.5 x 32.9 x 9.4 cm. Accessioned by the Ethnographic Collections in Munich before 1862, this drum previously had been in the collection of the University Library at Altdorf, a gift of Christopher Wagenseil before 1801. Photo: Swantje Autrum-Mulzer. Staatliches Museum für Völkerkunde, Munich.

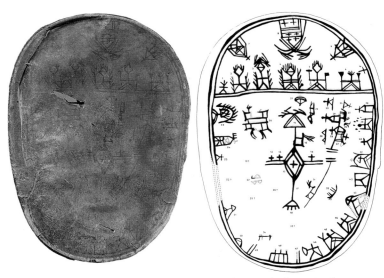

According to Kharuzin, so highly were they esteemed that Ivan the Terrible had called Lapp shamans to Moscow in 1584 "in order to explain to him the comets observed at that time." Kharuzin also recounted the tale of the first False Dmitri, after whose death it was rumored that he had learned the sorcerer's art from Lapp shamans and possessed the power to resurrect himself.[30]

Calling upon the shamanistic hero of the *Kalevala*, Lemminkainen, as representative of the heroic stature of those reputed to possess magic, Kharuzin pointed out that "since time immemorial" Lappland had been considered a land of "enchanters."[31] Among the earliest authorities on Lapp shamanism cited by Kharuzin was Scheffer, who had related several tales told of the shamans describing their alleged powers, including their notorious ability to inflict harm on enemies by sending magic "gan flies" or arrows of destruction, and their capacity to relate information concerning events in distant places. Kharuzin, interested in the transmutation of beliefs with the passage of time, related similar stories that had been told to him as "true," noting that the belief in the ability of the noid to send disease-inflicting "arrows" or, on the contrary, to reverse their effect on an afflicted person, persisted in contemporary belief. In one such tale, the arrows

82a and b. *a)* Lapp shaman drum. Reindeer hide stretched on pine frame, with alder-bark pigment for pictography, 52.5 x 36.5 x 6.7 cm. Accessioned by 1830. Staatliche Museen zu Berlin–Preussischer Kulturbesitz, Museum für Völkerkunde (Inv. II C 954). *b)* Schema for this Lapp shaman drum. From E. Manker, *Die lappische Zaubertrommel*, vol. 2 (Stockholm, 1950), drum 5, illus. 86, p. 234.

What is remarkable in the case of Lapp shaman drums, as in the case of many Siberian drums, as we have seen, is the degree of "abstraction" with which the figures were represented— usually no more than stick-figures reduced to the simplest geometry. Signs for boats were little more than semicircles with masts and triangular sails, or stick-figure boatsmen; trees, signified by sticks with angled branches; mountains, by triangles and semicircles; the "evil-eye," by crossed lines with blunted ends; Thor, by crossed hammers; and, Radien, the highest god, might be shown only by his triangular "tent."

But Kandinsky's most immediate source for information on Lapp shamans and their drums was his good friend Kharuzin. As we know, the lore of the Lapp shamans and their drum pictograms had been the subject of Kharuzin's article on the noids, or shamans of the Lapps, in the first issue of *Ethnographic Review*.

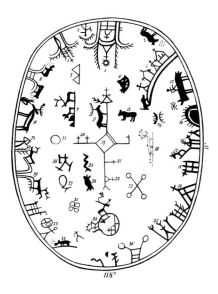

83. Lapp shaman drum schema. As reproduced by J. A. Friis, *Lappisk Mythologi*, no. 4 (Christiana, 1871), with an explanation of the figures. National Museum, Copenhagen. Photo courtesy Photothèque du Musée de l'Homme, Paris. The same schema was published by Kaarle Krohn in 1906.

could only be warded off by means of a magic shawl or kerchief and an offering of silver coins.

Emphasizing the sacred nature of the drum, Kharuzin described its characteristic pictographs in detail. He identified the figure of Thor, the god of thunder, with his family, other powerful gods, and even "Christ with his apostles," along with depictions of animals, birds, the moon, and so forth. Some of these figures stood on horizontal dividing lines drawn across the drum. In the center of the drum was an upended square (or diamond form), representing the sun (peive), with lines radiating from its four corners, "which must have represented the paths to the four corners of the earth" (as in figs. 82b, 83). The drum was used both in the healing of sickness and in the inflicting of disease on enemies, as well as in prophesying, fortune telling, the selection of sacrifices, and divination. In the curing of illness, according to Kharuzin, the shaman, beating on his drum, fell into a trance-like "state of ecstasy" during which he was able, with the help of the spirits at his beck and call, to travel to the netherworld in order to retrieve the soul of the patient. It was said that the Lapp shaman rode to the kingdom of the dead on the spiny back of a magic fish. There he discovered what sacrifices would be required in order to restore the health of the victim.[32]

As Kandinsky would do in his essay on the Zyrians, Kharuzin also noted the destructive effects of Christianization on ancient beliefs and customs: "The rich mythology of the Lapp was replaced by a new pantheon, [but] Christianity was assimilated only in a purely superficial way." Thus, he wrote, although most of the actual drums had been destroyed, many vestiges of the old beliefs remained, even in the fact that modern-day sorcerers were still called by the ancient appellation noid, and that they were still considered far and wide to be the "most powerful" shamans of all. In the custom of asking a priest for "a spell" instead of a prayer, for example, he noted the side-by-side existence of ancient pagan and modern Christian beliefs. Yet, as Kharuzin wrote, "no matter how pale the reflection of the glory of the ancient shamans might be [today] . . . Lappland is [still] a 'dark land of enchanters,' " as depicted in the Kalevala, from which he quoted. Indeed, other scholars had sought to prove that the fabled cultural treasure known in the Kalevala as the Sampo had in fact been the magic drum of the Lapps.[33]

The Shaman's Motley Costume

The drum was only one attribute of the shaman's office. His power was also often associated, especially in Siberia, with his ritual costume. Varied as their forms and degree of elaboration might be, Siberian shaman coats, caftans, and capes were nearly always distinguished by prescribed symbolic markings, embroideries, or pendants intended to emphasize the shaman's immortality or to protect and even convey him on his dangerous journey. Iron "ribs," often attached to a separate breastplate or apron, and other skeletal bones represented his resurrectional power, while the plethora of other protective objects might include brass and copper disks representing the sun and moon, arrows and arrowheads, ribbons of fur twisted to represent snakes, miniature idols often in the form of horses, birds, and fish, and conical bells to announce his coming or the arrival of his spirit-helpers. There might also be protective amulets such as a six-fingered glove that singled out its wearer as unique, or skins of brown and white ermines, dozens of long ribbons, or the wings of a great grey owl sewn to the shoulders, which flapped as the shaman danced, suggesting his flight to other worlds. Clearly, Kandinsky would have known at first hand the shaman costumes of a number of Siberian tribes represented in the Dashkov Museum and on view there from 1885 through the mid-1920s. The Dashkov prided itself on its collection of costumed mannequins, so that, for example, the visitor was treated to the sight of fully clothed Yakut, Tungus, and Goldi shamans with characteristic costumes and drums (fig. 84).[34]

Equally distinctive was the shaman's headdress, whether feathered or antlered. The Minusinsk shaman, for example, wore a cap decorated by three feathers, while from its headband dangled a profusion of ribbons hiding the shaman's face so that he might see with his "inner eye." The feathered headdress was widespread across Siberia, where, among many tribes, it represented the bird that was to convey its wearer to other

worlds during his ecstatic trance. When the bird represented was supposed to be an owl, the headdress often appeared to be "horned." Among other peoples, such as the Tungus, the cap was surmounted by iron "horns" representing the reindeer or the stag (fig. 168).[35]

As it happened, excellent photographs of a Karagas (Tofa) shamaness were published in *Ethnographic Review* in 1910 (fig. 85a and b). The elaboration of the costume, especially the characteristic breastplate representing the shaman's skeleton, is striking in these unusually clear photographs. Other attributes of the costume also mimicked the shaman's skeleton, as for ex-

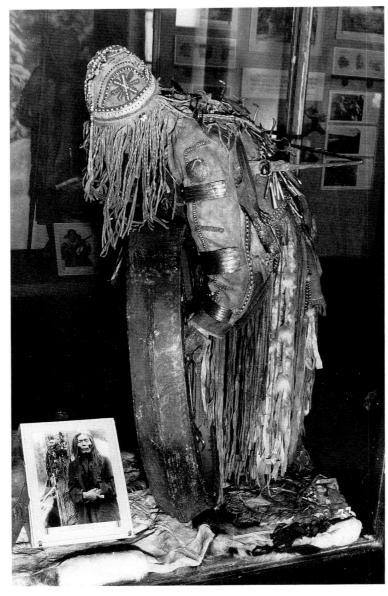

84. Tungus shaman mannequin displayed at the State Museum for the Ethnography of the Peoples of the Russian Federation (GME), St. Petersburg. Photo: Bo Lönnqvist, Helsinki. By the end of the 19th century such mannequins were common in Russia's ethnographic museums, including the Dashkov Museum in Moscow.

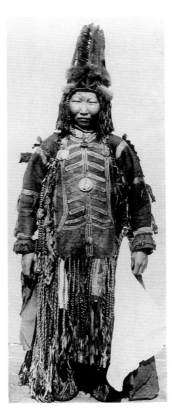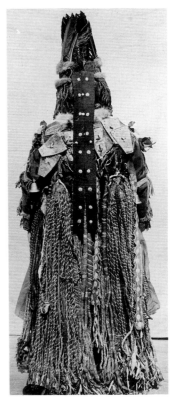

85a and b. Karagas (Tofa) shamaness. Front and back views as illustrated in *Ethnographic Review* 1910. Photos: V. N. Vasiliev. Collection Alexander. © Hamburgisches Museum für Völkerkunde, Hamburg.

ample, the shoulder blades, arm bones, and elbow joints sewn to the sleeves. But the prominently feathered headdress is particularly impressive. The long ropes of plaited leather and ribbons represented the "tails" and "wings" of the bird that would carry the shamaness on her journey to the other worlds. There is every reason to suppose that Kandinsky knew these photographs, since the artist spent several months in Russia during 1910, when he renewed contact with his ethnographic colleagues.[36]

Pictographic Transformations

Not surprisingly, it was during 1911, the year that saw the feverish activity surrounding the creation of the *Blue Rider* almanac and the peak of Kandinsky's contacts with the collections of Munich's anthropology museum, that his borrowings from the iconography of Lapp and Siberian shamanism began in earnest. During this period his paintings were becoming increasingly "pictographic," more "abstract." It is also the time when his self-identification as St. George/leader/shaman resulted in the dominance of St. George and a new leadership role for the artist. Already in such works as the sketch for *Composition IV* and *Lyrical* of 1911 (fig. 86), the horse and rider had been daringly reduced to expressive lines of force. The period would climax in the *Picture with the White Edge*, of 1913, begun immediately after his return from a visit to Russia. In the sketches for this major painting, Kandinsky further developed his pictographic language for the horse-and-rider motif that had become so significant in his oeuvre. On a single sheet the artist tried out a series of hieroglyphs for the motif that would represent St. George in the painting, as well as for the horses that would signify the troika of St. Elijah/Perun (figs. 87, 88). Meanwhile, in other paintings of this time still more motifs—trees, boats, figures—took on the aspect of pictographic representation.

This period during which Kandinsky successfully transferred the lyric manner of his tempera and graphic works to the medium of oil marked a major stylistic transition closely related to his personal self-realization. It is therefore not surprising that he turned to the shamanic references hidden—not so deeply,

after all—in his consciousness. The drawings on the face of the shaman's drum symbolized the universe; Kandinsky, too, sought a universal symbolism.[37]

The Painting as Cosmogonic Map

The drum as cosmogonic map and as shaman's horse served as a direct analogy to the artist's canvas, providing the justification to look to the vocabulary of drum pictography for sources of Kandinsky's abstract schemata. Perhaps as he sifted through the wonders of the ethnographic museum in Munich, Kandinsky had been reminded of Mikhailovskii's lecture "Primitive Art and Pictography as Ethnographic Data" at the Eighth Archeological Congress in Moscow in 1890. Mikhailovskii had traced the evolution of picture writing, discussing among other things the petroglyphs of the Yenessei River cliffs, picture writing of the American Indians, and the pictograms of Altaic and Ostiak shaman drums.[38]

Kandinsky had begun to invent schematic hieroglyphs for many of his most essential figures: horses to hooked curves, suns to circles radiating streaks, boats to pods with angling oars, mountains to triangles, and so on. In the development of his hieroglyphs for horses and riders, Kandinsky seems in fact to have recalled especially Potanin's plate VIII (fig. 80a). Here we find the hooked curved lines that, together with stick-legs, stand for the horse—depicted not once but seven times, together with stick-trees and a schematized bird, sun, and moon. They suggest in particular the source for the hieroglyphic horses the artist developed in preparation for *Picture with the White Edge*, where, as we have observed, an entire sheet is covered with "practice" horse hieroglyphs, as if his eidetic memory recalled Potanin's plate quite precisely (fig. 87). In another preparatory sketch for this picture (fig. 88), Kandinsky set the rider hieroglyph within a circle, which would become a circular color wash in the painting. Eventually St. George himself would be represented by little more than a circle (for horse and rider), a straight line (for lance), and a whiplash line (for serpent). But the final reduction, as it were, was to occur only years later, in the artist's design for the

86. Kandinsky. *Lyrical*, 1911. Oil on canvas, 94 x 130 cm. Illustrated in the *Blue Rider*, 1912. Museum Boymans-van Beuningen, Rotterdam.

87. Kandinsky. Sketches for the horse-and-rider motif, ca. 1912–1913. Lower left, the St. Elijah/troika motif. Pencil on paper, 27.5 x 37.8 cm. Städtische Galerie im Lenbachhaus, Munich (GMS 396).

cover of *transition* magazine (fig. 164). By that time Kandinsky had already described his substitution of the circle for the horse schemata to the psychologist Paul Plaut, explaining his preference for the "inner power of the circle" and stating that, by then, the circle had in fact "taken the place of the horse."[39]

Any number of other examples from this period that reveal the artist's growing reliance on schematic hieroglyphs might be cited, as for example a watercolor in which once again the figure of St. Eliajah/Perun, the thunder god, rides his horse-drawn troika toward a sun-streaked sky, leaving behind a schematic haloed green "moon," while the Zyrian water-spirit Vasa waves from his watery home, and stick-trees mind the horizon (fig. 89). But perhaps the paradigm case of Kandinsky's borrowings from shamanist precedent is the large watercolor entitled *In the Circle*, with "pictographic" inclusions that are particularly reminiscent of elements on shaman drums (fig. 90). Suggestions of horses, ladders, and zigzag "paths" float within a clearly circular "drum" form. The shaman's drum is his horse, and for Kandinsky the representational horse was to become the circle, a form closely

analogous, with its "inner possibilities," to that of the drum with which the shaman "shamanizes." Again, a comparison of *In the Circle* to Potanin's drums is illuminating (figs. 80a and b, 90). Particularly conspicuous is the similarity between the horse schemata of the drum and the hooked curving lines just above and left of center in Kandinsky's watercolor. Round suns and moons proliferate. Linked angles suggest mountains. Moreover, the segmented sections along the edge of Kandinsky's circle are reminiscent of similar motifs found on Lapp shaman drums.

Even more startling is a comparison between this picture and a Chukchee drawing of "the three worlds" published earlier

88. Kandinsky. Drawing for the horse and rider surrounded by a circle, *Picture with the White Edge*, 1912. India ink on paper, 25.5 x 24.7 cm. Musée National d'Art Moderne, Centre Georges Pompidou, Paris.

89

89. Kandinsky. *Watercolor No. 2 (St. Elijah)*, ca. 1911–1912. Watercolor, 31 x 47.5 cm. Stedelijk Museum, Amsterdam.

90. Kandinsky. *In the Circle*, ca. 1911–1913. Watercolor, 48.9 x 48.5 cm. Musée National d'Art Moderne, Centre Georges Pompidou, Paris.

by Bogoras (fig. 91). According to Bogoras, the three concentric rings signify the "three worlds" of the Chukchee universe, the innermost being "our world." Within it are signs for the North Star, sun, and moon, while semicircular segments represent such underworld destinations as the Mountain of Shadows. In these and other Chukchee drawings, as well as in many Lapp and Siberian drum drawings, the figures appear to "float" in an indeterminate space without regard for any "up" or "down" orientation except with respect to the "rim" defined by the concentric universe. Even in drum drawings that are segmented by lines into the "upper" and "lower spheres," the figures may depart from these "ground" lines altogether. In Kandinsky's painting we find not only the semicircular segments along the rim echoing those of the Chukchee drawing but also whiplash "snakes" and

numerous circular elements similar to those representing stars and planets in the Chukchee drawing.

Another drawing published by Bogoras may also have contributed elements to *In the Circle* (fig. 92). Representing the sky and lower worlds, this drawing includes semicircular segments that represent Dawn and Evening as well as Darkness, or the world of shadows. The segments are "inhabited," much as the segment in the upper left of Kandinsky's circle seems to be. The indefinite lines that may represent the edges of the Milky Way in the Chukchee drawing find their counterpart in various wavy streaks in Kandinsky's spinning universe.[40]

This compositional departure from the strictly horizontal-vertical norm of traditional painting toward a spiraling, more or less concentric orientation in which the lines of force may

91

Many sketches for *Composition VII*, as well as fragments of the final painting, not only demonstrate the new orientation but also contain suggestions of shamanist and tribal motifs, including brand marks like those published by Potanin. Among the more persistent motifs in Kandinsky's sketches for this *Composition* is a zigzag figure that resembles a similar motif on Teleut drums said to mark the path of the shaman on his journey to other worlds.[43]

This metaphorical projection of the universe as a kind of primitive cosmological map filled with circling or spiraling structures and more or less hieroglyphic symbols carried over into much later Kandinsky works, as for example in *Little Worlds (Kleine Welten)*, of 1922. With their concentric compositions featuring pictograms of horses and riders, boats, mountains, waves, stars, and planets, these graphic designs represent a development that is entirely consistent with Kandinsky's view of art as a creation of worlds.

The Blue Rider as Shamanic Metaphor

By far the most revealing demonstration of Kandinsky's profound ethnographic literacy, however, was his inclusion of ethnic

91. Chukchee drawing of the universe (the "three worlds"). From V. Bogoras, *The Chukchee* (New York and Leiden, 1909), p. 312, fig. 219.

gravitate from any edge of the work toward the center, or from the center outward, seeming to burst from the frame in any direction, became characteristic of much of Kandinsky's work from this point on.[41] Two schematic preparatory sketches are particularly revealing: a sketch for *Painting with the White Edge* clearly indicates the concentric orientation of the composition (fig. 93), while a sketch for *Composition VI* suggests almost eerily yet another possible Chukchee precedent from Bogoras (figs. 94, 95). Kandinsky even discussed the new and ambiguous orientation of this particular painting, likening it to the disorientation experienced in a "Russian steam bath." The sketch for *Picture with Three Spots*, 1914, is especially suggestive again of the Chukchee drawing of the universe, even to the three concentric rings (figs. 91, 96).[42]

92. Chukchee drawing representing the sky and the lower worlds. From V. Bogoras, *The Chukchee* (New York and Leiden, 1909), p. 311, fig. 218.

93. Kandinsky. Sketch for *Painting with the White Edge*, 1912–1913. Black crayon, 21.1 x 24.7 cm. Städtische Galerie im Lenbachhaus, Munich (GMS 451).

and Marc threw themselves into the almanac project with enthusiasm, and by September, Marc was ready to reveal their plans to his friend August Macke, writing excitedly that the almanac had become "our whole dream." Describing their concept of present-

94. Kandinsky. Sketch for *Composition VI*, 1913 (detail). Pencil on paper, 10.3 x 17 cm. Städtische Galerie im Lenbachhaus, Munich (GMS 539/5).

artifacts in the groundbreaking and influential *Blue Rider* almanac. In fact, the idea of introducing primitive artifacts into the context of contemporary art had been percolating in Kandinsky's mind for some time. He had adumbrated this approach in a 1910 letter to Münter written from Moscow during one of his periodic returns to Russia. He had been invited to present a lecture to a group of musicians and wrote that during his two-hour presentation he had "demonstrated the Primitives and the Persians."[44]

By June of 1911, six months before the exhibition that would catapult him to international fame, Kandinsky was writing to his colleague Franz Marc concerning his notion of founding a new art journal, a yearly almanac with a dual function as both "mirror" and synthesis: "A Chinese [work of art] next to a Rousseau, a folk print next to a Picasso . . . [contributors will include] writers and musicians."[45] Throughout the summer of 1911, Kandinsky

95. Chukchee sketch of the aurora borealis. From V. Bogoras, *The Chukchee* (New York and Leiden, 1909), p. 335, fig. 235.

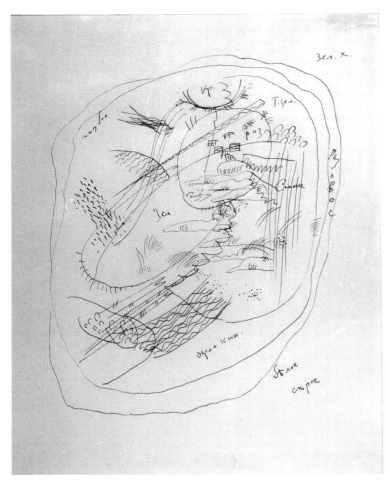

96. Kandinsky. Sketch for *Picture with Three Spots*, 1914. Pen and ink, 26.7 x 31.3 cm. Städtische Galerie im Lenbachhaus, Munich (GMS 494).

ment of the illustrations as well (fig. 72). A wide variety of ethnic objects, most having to do with themes of healing and salvation, was to be illustrated in the almanac: Bavarian "miracle" paintings, the Ceylonese dance mask, the Easter Island ancestor figure, and so on. The editors had consciously provided the almanac with a "shamanistic" theme, symbolizing their belief in the new art as a therapeutic metaphor for cultural healing and salvation.[47]

Soon Kandinsky and Marc, whose wonderment at the treasures of Munich's ethnographic collections had already been expressed in a letter to Macke, dispatched their younger collaborator to the museum to make arrangements for photographs of those objects that had particularly drawn their attention. Kandinsky already knew precedents for the Ceylonese dance mask from the Dashkov collections and had seen the Munich example illustrated in the journal *International Archive for Ethnography*; now he knew exactly where he would place its photograph in his almanac. He also demanded photographs of the Tlingit dancing cape and Easter Island ancestor figure like those he had already admired at the Dashkov (figs. 97, 98). Marc had particularly exclaimed over the carvings of the Cameroons brilliantly exemplified in two Cameroons house posts he had found at the museum (fig. 99). Macke threw himself into his task enthusiastically, and the masks that excited his imagination provided the topic for the essay he was to contribute. Indeed, six of the photographs he obtained from the museum, including two of masks, were concentrated within the pages devoted to his essay "The Masks," in which he equated the primitive power of these objects with that of all truly great art. The museum's director, Lucian Scherman, whose sensitivity to the artistry of the objects under his care was public knowledge, was pleased to cooperate in so worthy an effort, perhaps somewhat nonplussed at the high quality of the objects selected. Meanwhile, through the offices of their new friend Paul Klee, an enthusiastic collaborator in their ethnographic exertions, photographs of still more artifacts were obtained from the ethnographic collections of the Historical Museum in Bern.[48]

In Murnau, where plans for the *Blue Rider* were forged, the artist was surrounded by reminders of his signature saint.

ing illustrations of folk and ethnic art together with examples of contemporary art, he added: "We have hopes for so much [that is] *healing* and inspirational from it."[46] In fact, the concept of the book as a symbolic agent of healing, even of exorcism and salvation, was to be reflected not only in its title reference to the "blue rider"—blue already identified by Kandinsky as the heavenly color and the rider of the cover image clearly depicting the heroic and sainted rescuer St. George—but in the selection and arrange-

97. Tlingit (Chilkat) Northwest Coast dancer's cape, before 1858. Wool and leather, width: 92 cm. Leuchtenberg Collection. Illustrated in the *Blue Rider*, 1912. Photo: Swantje Autrum-Mulzer. Staatliches Museum für Völkerkunde, Munich.

The patron saint of the town itself, St. George was depicted in paintings and sculptures everywhere, from the centrally located Mariahilf church "am Markt," in the middle of the main street, to the exquisite St. Georg im Ramsach church set between the meadows and the lake. Founded in the eighth century, although its altar painting of St. George slaying the dragon and a small sculpture of the saint are of later date, the church was remarkable for the stone below its altar that was originally used for pagan sacrifices, a curious bit of local history that would not have escaped the notice of the ethnographer-artist recently moved to town.[49]

The final choice of St. George slaying the dragon as the almanac's cover emblem was in a sense preordained, even though the artist had tried out and discarded several other images. In Kandinsky's mind, the saint had become the therapeutic metaphor for cultural salvation that he required as his leitmotif. Representing at once the amalgamation of Christian and pagan belief systems and an active force for social good, the saint's shamanistic dimension had been apparent to the artist since his encounter with Egori the Brave on the frontispiece of Herberstein's chronicles. Depicting the "pagan" saint as the heraldic emblem of Czar Vasilii III, this image set the precedent for the

98. Ancestor figure, Easter Island, before 1776. Wood with mother of pearl, 46 cm. Illustrated in the *Blue Rider*, 1912. Photo: Swantje Autrum-Mulzer. Cook Collection, Staatliches Museum für Völkerkunde, Munich.

99. House post, Cameroons, before 1893. Carved (on both sides) and painted wood, 182 x 32 x 15 cm. Collected by von Stetten. Illustrated in the *Blue Rider*, 1912. Photo: Swantje Autrum-Mulzer. Staatliches Museum für Völkerkunde, Munich.

modern Vasilii's cover woodcut, and the chronicler's account of the resurrectional powers associated in old Russia with the spring St. George's Day pointed directly to Kandinsky's inclusion of a St. George's Day lubok among the first illustrations in the almanac (figs. 100, 101).[50]

The social dimension of the editors' intention was emphatically proclaimed in the book's first illustration, a hand-colored reproduction of a Bavarian mirror painting depicting St. Martin, another saint on horseback, sharing his coat with the beggar. Indeed, in his opening essay Marc declared their obligation to share what he called "the spiritual treasures" of art with a maimed and benighted public. It was perhaps at this time that Kandinsky had acquired his own St. Martin folk carving (fig. 66). Marc himself chose a striking metaphor for the magical healing the editors hoped to effect through art, closing his third essay with a full-page reproduction of a mosaic from St. Mark's Cathedral in Venice, depicting the miraculous apparition of St. Mark's body. Not only does this selection evoke the author's name, but it references the gospel that is the primary source for the tales of Christ's miraculous exorcisms, healings, and raisings from the dead, a fact well known to the former theological student.[51]

That the selection of these illustrations and their placement in the almanac was entirely deliberate is documented in the correspondence between Kandinsky and Marc and between them and their publisher Reinhard Piper. The task had been undertaken with such zeal that Piper had even felt it necessary to reprimand them and to point out that their "independent" actions, particularly in respect to number and size of the plates, had greatly increased the costs of the book. He was particularly incensed since his authors had insisted on a low price for the publication so that it might reach as wide an audience as possible, a "quite correct presumption," he responded archly, for a "propaganda sheet."[52]

The conservative Piper's suspicion of propagandistic motives on the part of his two rebellious editors was not far off the mark. Indeed, two other factors, hitherto overlooked, underscored the social, even political, consciousness with which Kandinsky and Marc had chosen the almanac's therapeutic theme. One was Kan-

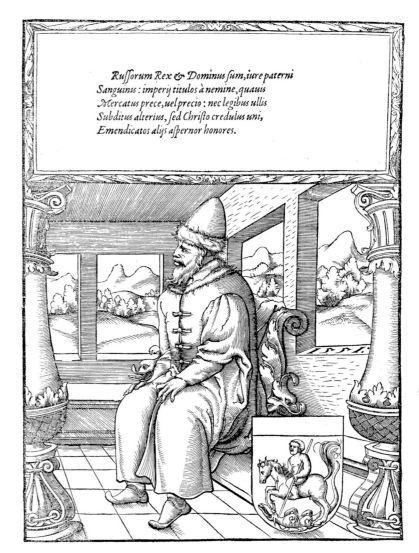

100. Czar Vasilii III, 1556. Frontispiece to Sigismund von Herberstein, *Rerum Moscoviticarum Commentarij* (Basel, 1556). Photo courtesy Division of Rare Books and Manuscripts Collections, Cornell University Library.

dinsky's decision to emphasize the curative message of the almanac by including an essay on music by his friend the Russian physician Dr. Nikolai Kulbin, an advocate of the arts associated with Russia's growing avant-garde, who has himself been called a "propagandist."[53]

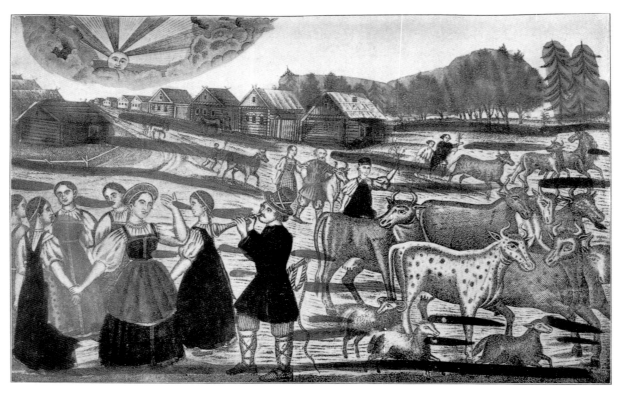

101. St. George's Day *lubok*, from Kandinsky's personal collection, 19th century. Lithograph, hand-colored, 35.3 x 44 cm. Illustrated in the *Blue Rider*, 1912. Photo from the 1914 edition. Getty Center for the History of Art and the Humanities Library, Santa Monica.

Another hitherto unremarked documentation of Kandinsky's interest in providing a socio-political program for the almanac is the fact that he had intended to include an essay by Sergei Nikolaevich Bulgakov, a political economist and former Marxist who had served in the Second Duma in 1907. At first glance such a person might seem out of place in the context of the *Blue Rider*. But Bulgakov was a recognized member of Russia's intelligentsia who later confessed that it was his "love of art and literature" that had saved him from the "gloomy revolutionary nihilism" to which he had fallen victim. His 1906 essay "Karl Marx as a Religious Type" had already distanced him from Marxist atheism and revealed his revulsion to its perverse anti-Semitism. Always

an activist, he was also a contributor to *Vekhi* (Signposts), the notorious 1909 volume to which many of the intelligentsia contributed; his essay "Heroism and Asceticism" called for a renunciation of contemporary atheism and a "healing" regeneration of spiritual life.[54]

In a letter to Marc at the beginning of September 1911, in which he discussed potential contributors to the almanac, Kandinsky wrote: "We [shall] bring something of the Russian religious movement, in which *all* classes are involved. To that end I have [invited] my former colleague Prof. Bulgakoff (Moscow, national economist and one of the most knowledgeable scholars of religious life.)"[55] In fact, Bulgakov had also been enrolled in

the faculty of law at the University of Moscow and had studied with Kandinsky's professor Chuprov at the same time as Kandinsky; they were indeed colleagues. Not only that; Bulgakov had married a favorite cousin of Kandinsky, Elena Ivanovna Tokmakova. During his lengthy 1910 stay in Moscow Kandinsky had called upon the Bulgakovs, having reported the invitation enthusiastically in a letter to Münter. In the end Bulgakov's contribution did not appear in the almanac, but Kandinsky kept a signed abstract of the scholar's 1908 essay "The Intelligentsia and Religion" in his library until his death. The inclusion of Bulgakov would doubtless have made the socio-political program of the almanac more overt; in the event, the program was expressed not only in its essays but most especially in its illustrations.[56]

Indeed, the plethora of ethnic and folk-art objects illustrated in the almanac communicate the healing message of the book quite literally. Particularly remarkable are the illustrations selected to accompany Kandinsky's major essay "On the Question of Form," which include five Bavarian votive pictures, representing scenes of exorcism, healing, or salvation, each given a full page to itself, along with two other naive "miracle" paintings.[57]

Syncretism and Therapeutic Metaphor in Composition V

But the most startling juxtaposition of healing motifs in the almanac occurs in Kandinsky's essay "On Stage Composition," that inherently syncretic form on which he placed so much emphasis as the art of "inner necessity" that was to heal the "rift" in the soul of the modern world.[58] Situated at the core of the book, in a context that left no doubt as to its meaning, Kandinsky ordained the placement of his recently completed Composition V back to back with Van Gogh's 1890 Portrait of Dr. Gachet (figs. 106, 107). It was Composition V that had precipitated his break with the New Artists' Society and the decision to mount the competing landmark exhibition of the editorial board of the almanac that would focus international attention on the Blue Rider.

By early November 1911, after weeks of frenetic administrative activity, Kandinsky felt the inexorable necessity to create

again. He wrote to Marc that "finally after so many months" he was impatient to begin his fifth Composition. Clearly, the idea for the painting had been percolating in his mind during the preceding hectic period, which had seen the creation of an entire series of syncretic paintings on the theme of dvoeverie, the planning of the almanac with its own syncretic program, and the selection of the ethnic artifacts. Aware of the approach of the New Artists' Society exhibition deadline, but also in the grip of professional and personal distractions, the artist threw himself into the creation of his composition. Between November 11 and 21 he completed a picture that Marc would call a "fabulous giant-picture," the "most remarkable ever painted."[59]

Now the long series of works on syncretic themes related to both pagan heroes and Christian saints culminated in a final statement of his commitment to the concept of regeneration through art. He had already defined the serious import the term Composition held for him and now, in an obvious effort to make his program manifest, he conferred upon this painting the subtitle "Last Judgment," a clue to its metaphorical significance which nevertheless withheld its underlying syncretism.[60] Driven to this creative catharsis as much by personal demons as by altruistic motives, he may in fact have felt himself the subject of a "last judgment" and, through his creative fury, through "shamanizing," may have hoped to find a personal "resurrection" of the spirit.[61]

The great sweeping black line that unifies Composition V like a resounding Klang strikes the eye as the first obvious syncretic motif, suggesting at once the "last trump" of the apocalyptic final judgment and the trumpet of the death angel Israfil calling Iskandar back to life. Like its Persian prototype, this trumpet stretches out across the full width of the picture encompassing a "seething abundance" of details yet revealing, as Kandinsky wrote, an "inner realm."[62]

Inspired by the example of primitive pictography, the artist adroitly compressed bits and pieces from his own syncretic iconography together with borrowings from the Persian miniature, a shaman's drum, and motifs of the Kalevala, reducing his pictorial universe to an iconography of skeletal remnants floating freely

in an explosive constellation of events shrouded in a nebulous haze. Shunning the large, flat, overlapping planes of brilliant primary colors that had characterized much of his recent work and placing greater emphasis than ever on the expressive value of line, Kandinsky created a work unlike any before, but possessed of a power, as Marc said, to "excite and move."[63]

Sweeping into the apparently stormy heavens above the trumpet (upper left), two horse hieroglyphs recall the dual St. Elijah/Perun the Thunderer motif that had already enlivened his many *All Saints' Day* paintings. The pictographic boat motif, in

102. Kandinsky. Sketch for *Composition VI*, 1912–1913 (detail). Pencil on paper, 33.6 x 43.8 cm. Städtische Galerie im Lenbachhaus, Munich (GMS 979).

the lower left-hand quadrant, that might have been better suited to a "deluge" context, carries a figure in yellow and two others; a motif reminiscent of the figure in yellow standing in a boat previously identified in *Composition II* as the dyadic Christ/World-Watching-Man (or Golden Prince) and son of the Ostiak and Vogul highest god Numi-Tōrem, who was sometimes envisioned as voyaging from heaven to earth in a boat accompanied by his two rowers, a motif later repeated in *Composition VI* (figs. 48, 102).[64] At the same time it invokes the intrepid craft of the *Kalevala* with its three celestial sailors.[65]

Below the rowers motif, at lower left, is a ghostly figure with upraised arms (more clearly defined in the study for the painting). A comparison with *Composition II* (fig. 48) and the Elijah watercolor (fig. 89) demonstrates that this is again a reference to the Finno-Ugric water-spirit Vasa, traditionally associated with the dangers of traversing seas, lakes, and rivers.

A turreted structure topping a hill at upper center represents at once the conglomerate architecture of the apocalyptic "New Jerusalem" and the multicolored home of Numi-Tōrem or a Russian kremlin atop the site of a Chudic gorodok. Flying above its towers, as if to emphasize his celestial role, World-Watching-Man, outlined in red, arms outflung, rides a white horse, partially obscured by his "sun-disk" shield, into the heavens. World-Watching-Man as rider with outstretched arms had already appeared in the painting *All Saints II* (fig. 53) and in the watercolor and woodcut versions of *Sound of Trumpets*, and again in *Glass Painting with Sun* (fig. 103) as the rider on the blue horse with the "Indian" headdress, where his identification with Kandinsky was suggested both in the color of the horse and the headdress, presaging the feathered "Indian" headdress of St. George on the cover of the almanac (fig. 72).[66]

Below the "kremlin" to the right, floating sidewise in a primal haze, appears a group of slender forms suggesting a bundle of candles. It recalls not only the candles of Christian ceremony (often associated with healing) but the candles employed in the seasonal and religious ceremonies of the Zyrians' neighbors, the Cheremis, for whom candles had great symbolic power, being used in ceremonies for the dead and other rituals.[67]

103. Kandinsky. *Glass Painting with Sun*. Reverse painting on glass with painted frame. 30.6 x 40.3 cm. Städtische
Galerie im Lenbachhaus, Munich (GMS 120). Photo: V. G. Bild Kunst, Bonn.

Central to the composition, at the end of the trumpeting horn, is the suggestion of a figure restoring its head, the ultimate resurrectional feat, as presaged in *Sound of Trumpets*, an act also commensurate with Siberian shamanism, where the candidate for the shaman's mantle was required to envision his own dis-memberment and restoration. Prominently displayed next to this figure is a double-sided triangle, whose origins are rooted in the artist's desire to create of this work a form so significant that it might be, as it were, effective through and through, very like a shaman's drum.

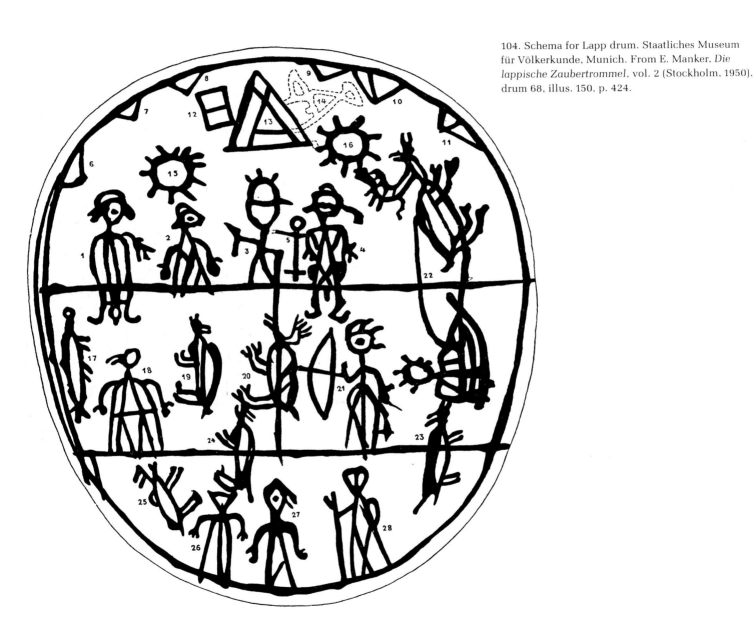

104. Schema for Lapp drum. Staatliches Museum für Völkerkunde, Munich. From E. Manker, *Die lappische Zaubertrommel*, vol. 2 (Stockholm, 1950), drum 68, illus. 150, p. 424.

As Kandinsky shaped this painting that was to be the keystone of his metaphorical therapeutic program, the Lapp shaman drum he had found and recognized in Munich's ethnographic collections seems to have fired his imagination (figs. 81, 104). Indeed, the double-sided triangle of *Composition V* finds its counterpart in the strikingly similar double-sided triangle at the top of the drum, a motif that had been identified as the home of Radien himself, the highest Lapp god, the world god who creates, structures, and orders all of life. Its centrality in the painting, just below the "bell" of the "trumpet" and next to the figure restoring his head, confers a special significance. In fact, this was the same drum that had been depicted in Scheffer's volume on Lappland, so often cited and reproduced; a drum that Kandinsky—with his eidetic memory—had every reason to recognize at once (fig. 73).[68]

The Munich drum happens to be a particularly fine example of the genre, distinguished by its clear red-ochre pictograms on a skin bearing the rich earthy patina of antiquity (fig. 81). Remarkably preserved, and accurately described in the museum catalogue by 1904 as a Lapp shaman drum, it bears on its surface—just as Kharuzin had described—an array of figures relating to the Lapp pantheon of gods and to their world of reindeer, hunters, fishermen, and shamans.[69] Marking the upper or heavenly sphere are figures for the sun (Peive) and moon. Unlike most Lapp drum schemata, the sun motif here is not a rhomboid but a circle with halo, nor is it the central figure. However, standing at the center of the top dividing line in his usual position is the thunder god, Hora-galles, or Tiermes-Thor-Perun, who, as we know, was to merge in Finno-Ugric myth with St. Elijah. Along the upper border, thus allied with the gods of the heavenly sphere, are a series of triangular forms relating to Radien, representing the god's encampment or a heavenly horizon with mountains.[70]

The middle zone is populated by figures relating to the activities and magic powers of the shaman: fish, wolf, bear, and reindeer. The figure with his bow and arrow pointed at the central reindeer doubtless represents the god of hunting. To the right, running upward along the edge of the world, is a haloed figure, probably the shaman himself, in a reindeer-drawn sled,

105. Bavarian reverse painting on glass depicting St. Luke. Illustrated in the *Blue Rider*, 1912. Arents Rare Books Collection, Bird Library, Syracuse University.

the wolf barking at his heels suggesting at least demonic powers. To the lower left, in her accustomed realm, stands a female figure representing the chief goddess of childbirth, Madderakka, accompanied below by her daughters, the traditional three Akkas, also goddesses of childbirth.[71]

106. Kandinsky. *Composition V*, 1911. Oil on canvas, 190 x 275 cm. Illustrated in the *Blue Rider*, 1912. Private collection, Switzerland. Photo: Colorphoto Hans Hinz.

Here were ready-made hieroglyphs the meaning and power of whose expression would not have been lost on Kandinsky. Indeed, *Composition V* includes other borrowings from the Munich shaman's drum. There is, for example, a striking similarity between the schematized head of the "angel" with its one eye and its streaks for flying hair in the upper left corner of the painting and that of the one-eyed figures with streaks for flying hair that inhabit the drum, most notably the central figure on the bottom rim, where the childbirth goddesses are normally represented. Perhaps intentionally, the figure "going out" of Kandinsky's composition at lower right bears no such attributes. Zigzag lines that commonly represent the shaman's path on Siberian drums, but may signify mountains and encampments on Lapp drums, also appear in Kandinsky's painting.

Iconographic remnants are not the only borrowings from the Munich drum, however. What is perhaps most remarkable about *Composition V* in life—as opposed to its representation in reproductions—is its coloring. Unlike most of the paintings Kandinsky produced at this period, with their brilliant color scales, this painting is distinguished by its somber brownish earthen hues, displaying much the same umber-and-russet patina of antiquity that characterizes the Munich shaman drum.

Despite all these clues as to the significance of Kandinsky's "giant-painting," it remained a puzzlement to his colleagues, whose decision to ban it from their exhibition precipitated the competing *Blue Rider* exhibition. Now, with that revolutionary exhibition successfully launched, but the almanac still only in mock-up form, Kandinsky undertook a forceful explication of his work. He ordered a photograph of his new *Composition* and ordained its crucial placement in a sequence of illustrations manifestly intended to explain its metaphorical content. He introduced the sequence with a Bavarian reverse painting on glass depicting St. Luke (fig. 105), a physician and painter who became the patron saint of both physicians and painters, together with his attributes, the palette and paint brushes, the sacrificial ox, and the book of his gospel. He in turn is followed by a reproduction of an Egyptian shadow play puppet, one of many in the almanac symbolizing the concept that art may be brought to life by the "divine fire" of the creator.[72]

107. Vincent van Gogh. *Portrait of Dr. Gachet.* 1890. From the *Blue Rider.* 1912. Reverse side of the reproduction of Kandinsky's *Composition V.* Arents Rare Books Collection, Bird Library, Syracuse University.

Composition V follows immediately in a full-page reproduction directly backed by another full-page illustration: Van Gogh's portrait of Dr. Paul Gachet, the eccentric physician who attended the artist during his last weeks at Auvers, with its foreground symbol of the doctor's craft, the foxglove flower, wilting but still the source of the medicinal digitalis, stimulant to the heart

(figs. 106, 107). In his essay on masks Macke had commented on the portrait of Dr. Gachet, comparing it to the Japanese wood-cut which appears directly opposite it: "Does not the portrait of Dr. Gachet by Van Gogh derive from a similar spiritual life as that of the astonished caricature of the Japanese magician cut into the wood block?" The comparison of the act of healing with an act of artistic conjuration (for a *Gaukler*, as Macke called the Japanese figure, is a conjurer) is further demonstration of the message implied by this sequence. The physician, like the painter and sleight-of-hand artist, not to mention the sorcerer or shaman, employs large doses of illusion in effecting his cure or trick. And all of them offer a tonic for the heart or soul of humankind.[73]

In the same paragraph Macke commented: "What the wilting flowers are for the portrait of the European physician, the wilting corpses are to the Mask of the Conjurer of Disease," clearly referring to the Ceylonese dance mask reproduced full-page between the first and second scenes of Kandinsky's color composition *The Yellow Sound*, a mask specifically employed for exorcizing the demons of disease (fig. 108).[74] Macke, indeed, railed against the "connoisseurs and artists [who], with a contemptuous wave of the hand, to this day have relegated all art forms of primitive peoples to the area of ethnology or applied art." In the pages devoted to Macke's essay, a small ceramic figure of the Aztec god Zipe Totec, associated with the miracle of spring, of regeneration and rebirth, known as *The Flayed God*, appeared just under the author's assertion of the relationship between van Gogh's portrait of Dr. Gachet and the Ceylonese dance mask.

Thus consciously—in locating his syncretic painting so precisely—did Kandinsky draw upon the analogy between the efficacy of the medicinal flower to stimulate the heart and the mask of art as mediator between life and death, pointing the way to resurrection and regeneration. The implication is clear, indeed inescapable, that he considered his *Composition V* appropriately placed between St. Luke, the physician-painter, and Dr. Gachet, the physician to painters, revealing thus the painting's therapeutic mission. In the context of the almanac as "medicine book," then, the resurrection theme of *Composition V* becomes an expression of faith in the restorative and transforming powers of art

as spiritual "medicine" prescribed by the physician- or shaman-artist. Both by virtue of its position in the *Blue Rider* context as a powerful symbol of cultural healing and by virtue of its hieroglyphic borrowings from shamanist as well as Christian iconography, *Composition V* is seen to be rooted in Kandinsky's concept of the therapeutic power of art and in his sense of mission as cultural "shaman." In fact, *Composition V* may be seen in retrospect as the first in the artist's series of shaman "drum" paintings.[75]

Sounds of the Shaman

Kandinsky's essay on stage composition served as introduction to the closing section of the almanac devoted to the performing arts, which included the scenario for his own "color composition" *The Yellow Sound*.[76] Again, as in his book of prose-poems and prints, *Klänge*, or "Resonances," published near the close of his Munich sojourn, Kandinsky drew from shamanist tradition in the creation of this synthetic rift-healing Gesamtkunstwerk, for the shaman's drum offered not only a visual paradigm to inspire Kandinsky's imagination, but an aural one as well. For an artist whose works were so often entitled "Improvisation" or "Composition," "Sonority" or "Resonance," the shamanic ritual in its entirety was a mixed-media "performance piece" par excellence. The drum was at once the shaman's "map of the universe," the canvas upon which he drew the hieroglyphic tale of his magic journey, and his vehicle of transport, a musical instrument empowered to induce his ecstatic trance.

By "tuning" the drum over the fire and by the adroit manipulation of his drumstick, the shaman was able to coax from his instrument a wide variety of eerie and hypnotic tones. The drum was often hung besides with numerous metallic ornaments, sometimes miniature bells, that clanged together as the drum was beaten.[77] Further enhancing the drama of the performance, the shaman often engaged in ventriloquism. Thus the voices of animals—beaver, bear, wolf, fox, even walrus—and of birds—the owl, eagle, loon—growled and whistled through the darkened, fire-flickering yurt. The skillful shaman could make his

108. *Dance Mask of the Demon of Disease* (Maha-cola-sanni-yaksaya). Ceylon. Painted wood, 120 x 79.8 cm. Illustrated in the *Blue Rider*, 1912. Photo: Swantje Autrum-Mulzer. Staatliches Museum für Völkerkunde, Munich.

animal- and bird-spirits "speak" from different corners of the room or seem to cry out in flying through the air. "Bears growl, snakes hiss and squirrels jump around in the room," Castrén had reported.[78]

For Kandinsky, too, the work of art produced a Klang, a sound or resonant chord. As he once said, he did not wish to "paint music"; rather, he felt that the true work of art "resonated" like a musical instrument, that its "vibrations" were felt by the perceptive viewer who not only "saw" but "heard."[79]

The Resonant Ritual

Kandinsky's essay dealt at length with the synthesis of the arts and the ways in which they might be made to complement one another on the stage. But his idea of "synthesis" was quite different from the nineteenth-century concept of synthesis expressed in the Wagnerian term *Gesamtkunstwerk*. What he had in mind was much closer to the cacophonous and often improvisatory character of the shaman's rite, in which each element was free to reach its "internal" potential unfettered by preconceptions and "external" expectations. Thus, for example, he explained, the human voice should be used "purely," freed from the sense of the word.

In the Chukchee rites described by Bogoras, the shaman's ritual vocabulary consisted of a vast medley of sounds, only occasionally broken by understandable words, cleverly improvised to suit the situation. In some areas the shaman was mysteriously endowed with the ability to speak words in strange tongues that sounded like nonsense words. Bogoras reported that the conversation of the "spirits" as relayed by the shaman often consisted of unintelligible words such as " 'papire kuri muri' or 'kotero, tero, muro, poro!' " Eventually, Bogoras wrote, the shaman would call "for an interpreter, and at last . . . the 'spirits' send for one who can speak Russian and who translates the orders of the 'spirits.' "[80] Thus the shaman became the "translator" for the spirits, confirming Castrén's observation that the shaman was in fact the *Dolmetscher* of the gods, an idea echoed in Kandinsky's notion that the role of the artist was to serve as the voice or "translator" of that which transcends human experience.[81]

Here then is another precedent for Kandinsky's libretto. His instructions in the third scene, or "Picture," call for a voice crying out *undeutliche* words that emphasize the vowel *a*, such as *"Kalasimunafacola!"* The gibberish word suggested by Kandinsky is clearly reminiscent of the "spirit talk" of Bogoras's Chukchee shamans. At other times, as in "Picture 2," members of the chorus are asked to cry out "in ecstasy" or as if "possessed." The observers at a shamanic ritual were often reported to act as a chorus to the shaman's song.[82]

That Kandinsky was well aware of the capacity of music to induce states of ecstasy and of its alliance in this respect with shamanic ritual is attested by a passage in his "Program for the Institute of Artistic Culture," written in Moscow in 1920:

> Continued use of parallelism, if applied exclusively, can produce at first sight extraordinary and very instructive results. I once happened to see how Arabs used the continuous parallelism of sound (a monotone drum) and primitive movement (a pronounced, rhythmic kind of dancing) to achieve a state of ecstasy. Even a simple, schematic divergence of similar lines could never produce such a result. I also happened to observe the audience during one of Schoenberg's quartets, in which the manipulation of the line of the instruments and, in particular, the incorporation of the voice, produced the impression of the lashing of a whip. It is interesting to note that Arnold Schoenberg introduced the movement [flow] of parallel lines into some of his compositions with (at least for musicians) virtually the same revolutionary effect.[83]

Kandinsky's linkage of an Arabian ecstatic ritual dance with a performance of Schoenberg's music may at first glance appear startling. The juncture between the lives of Kandinsky and Schoenberg, at a point when both were about to take their places on the world stage as leaders of the avant-garde, was crucial for both. Kandinsky included a dissonant self-portrait by Schoenberg—a view of himself from the back, seen walking away— and one of his series of "Visions," as well as an essay by the musician, in the *Blue Rider*.[84]

Franz Marc, who had accompanied Kandinsky to the Schoenberg concert that brought composer and painter together,

soon drew an analogy between Schoenberg's music and "primitive" music, linking both to the concept "Orient" and to Kandinsky. In his letter to Macke in which Marc raved about the primitive art that had so astonished him at the anthropological museum, he wrote, almost in the same breath, that the Schoenberg concert had given him a similar "shock." Schoenberg's dissonances reminded him of Kandinsky's paintings and Schoenberg, too, seemed convinced of the dissolution of European laws of art and harmony, and thus "grasps after the musical artistic means [Kunstmitteln] of the Orient that (until today) have remained primitive." Clearly, Kandinsky's juxtaposition of Schoenberg's music and Arabian ecstatic dance is to be understood now within the context of his ethnographer's knowledge of primitive music, and in particular of his awareness and direct observation of the uses of music in shamanic ritual.[85]

The famous bear festival of the Voguls may also have stimulated Kandinsky's imagination as he conceived *The Yellow Sound*. Vivid descriptions of the Vogul ceremonies associated with the bear hunt, an event that was in effect a dramatic performance lasting several days, were easily available. Both Ahlquist in 1885 and Kannisto in 1906 had emphasized the improvisatory nature of these performances and noted their combination of song, dance, and satire. Both provided illustrations of the bizarre improvised costumes and birchbark masks worn by the players and emphasized their stylized, puppet-like gestures (fig. 109). Kandinsky would have known such masks from the Dashkov Museum. Ahlquist particularly pointed out the religious origins of the tradition and the Voguls' uninhibited combination of Christian with pagan symbols and legends.[86]

Kandinsky also knew the shamanic ritual as intensely dramatic experience from a book in his own library—Frederick Devel's *Tales of Eastern Siberia*. Vividly describing the shaman's entrance in a costume laden with iron and copper amulets that rang and clattered as he moved, and the warming of the drum over the fire to bring out its resonance, Devel wrote:

> The small fire goes out, everyone grows quiet, and in the dark yurt, the drone of the drum is heard. Then a seagull cries out, then a raven and a falcon. These birds are also the

109. Vogul (Mansi) dance for the bear hunt ritual, 1877. Sosva, Sartynya, northern Russia. Photo: E. Boem. National Museum of Finland, Museovirasto (© Finnish Literature Society), Helsinki.

109

> helpers of the shaman. Against the drone of the drum the shaman draws out a song, at first quietly, but as it progresses, the louder the drum drones, the louder the song grows with it: it is as if the spirits are growing closer, and the shaman practices sorcery on them by means of the song. . . . The song finally culminates in a sort of wild roar. The shaman jumps up and begins to twirl and dance as if possessed. By the faint light of the dying embers his rattles flash, his bared teeth are visible, as are his half-closed eyes and disheveled braids. And suddenly the song and the racket of the drum cease, and the shaman stops. There is foam on his lips and sweat streams from his tortured face.

The light-and-sound spectacle with its intrinsic significance as healing ritual seems to have persisted in the artist's memory. Indeed, a sense of ritualistic performance pervades the instructions for *The Yellow Sound*.[87]

Like the shamanic ritual, Kandinsky's chamber opera, too, has been compared to the medieval "mystery play." But within its pages in the almanac, the editors deliberately placed illustrations of Russian lubki and Egyptian shadow-play puppets side by side with reproductions of Christian symbols and artifacts. Moreover, the only full-page reproduction in the *Yellow Sound* text is devoted to the Ceylonese dance mask of the demon of disease that appears as a climax to the accumulating therapeutic messages of the book (fig. 108). The World-Watching-Man of northern mythology also makes a climactic appearance in Kandinsky's stage composition, as in the final "Picture," a "yellow giant" *with outstretched arms*, recalling the dualistic yellow figure in *Composition II*, "grows" to the full height of the stage. Is this once more a double allusion to Christ and the son of Numi-Tōrem, Mir-susne-khum, the "Golden Prince" and World-Watching-Man? Can we doubt then that Kandinsky's ethnographic knowledge informed the creation of his "color composition" *The Yellow Sound*, as it informed and shaped the entire almanac?[88]

The Resonant Woodcut

For Kandinsky, who once wrote that cutting the wooden blocks made "music ring" in his whole being, graphic art had always been his most synaesthetic form of expression, the woodblock becoming in effect a virtual musical instrument from which the artist had coaxed tones of enchantment as might the shaman from his drum. Now, at the culmination of his Munich career, Kandinsky created yet another work demonstrating his commitment to the concept of art as a "resonant" and syncretic experience, as full of magic as the shaman's drum: his magnificent book of prose-poems and woodcuts appropriately entitled *Klänge*. He later described his "musical album" as a "synthetic" work and emphasized its crucial importance in his development toward a more abstract idiom: "In the woodcuts and in the rest—woodcuts and poems—one discovers the traces of my development from the 'figurative' to the 'abstract.'" Although its shamanist ramifications were never overtly stated, in this work Kandinsky came closer to revealing the shamanistic sources of his inspiration than in any other work of the Munich period.[89]

Indeed, the drum-beating shaman himself appears in the opening poem and falls into an ecstatic trance, inviting the reader to come along: "His face is pale, but on the cheeks are two / red spots. Likewise red are the lips. He has a great / drum hung 'round and drums"

Although he carries two drumsticks, contrary to usual shamanic practice, his identity is unmistakable. At the end of this poem, the reader is adjured to "see all this from above," that is, in flight like the artist-shaman himself. Viewed within the present ethnographic context, it becomes apparent that Kandinsky intended this work to serve both as a metaphorical vehicle of "healing" and as the symbolic musical instrument of the artist/reader/shaman, even as his vehicle of trance induction.

That the album was to have a therapeutic function is further revealed in several poetic references to wounds that are magically healed, a clear reference to the shamanic practice of both inflicting self-wounds and ritually healing them.[90] Among the visual references to shamanist sources of inspiration are piebald horses and sorcerers, not to mention woodcut versions of *Composition II* and the glass painting *Judgment Day*, as well as fragments of other syncretic works (such as *All Saints* and *St. Vladimir*).

The vignette to the poem "Leaves" is perhaps the most overtly shamanist image of *Klänge*, for its rider on horseback with outstretched arms is dually reminiscent of the familiar World-Watching-Man and of the horse-riding shaman often found among the images on shaman drums (fig. 110). It seems a twin of the rider motif characteristic of Teleut shaman drums (figs. 76–78). Here the artist has even suggested the shape of the drum, down to the resonators around its rim. Once again, Kandinsky's rider with his outflung arms takes on the aspect of World-Watching-Man. Underscoring its synaesthetic impact is the fact that the artist originally intended this vignette to accompany a poem entitled "Sounds" in the planned Russian version of the book.[91]

The shamanic ritual itself is recalled in a poem entitled "Seeing" as: "From every corner came a humming," and the initiate-reader is admonished to "cover your face with a red cloth." The "humming" from every corner manifestly refers to

110. Kandinsky. Vignette to the poem "Leaves" ("Blätter"). Woodcut, 5.1 x 5.3 cm. In *Klänge* (Munich: Piper, 1913). Städtische Galerie im Lenbachhaus, Munich.

the ventriloquism often practiced by shamans and reported, for example, by Bogoras, who described the sounds of the spirits coming from every direction in the shaman's tent. Devel had also described the shaman's ventriloquistic summoning of his spirit-helpers, who responded in the voices of birds. The reference to the red eye covering is an allusion to Castrén's observation that the Samoyed shaman shamanized with a cloth stitched with red thread over his eyes to indicate that he would see into the world of the spirits only with his "inner eye."[92]

Pagan sacrifice of a piebald cow in a sacred grove is the apparent subject of the poem "Bell"; piebald animals were favored shamanic sacrificial objects.[93] The action of this poem takes place in a flat, "very flat," landscape evidently reminiscent of the northern taiga of the Zyrians. Moreover, "to the left stands a

birch grove," while not far off in the village a church bell rings. Once again, the theme of dvoeverie has been sounded. The sacred tree, the birch, and the "world-tree" of iron also appear in several of the poems. The thunderbolt of Thor appears as a motif in two poems: "Look and Lightning" and "Unchanged."

But perhaps most striking are Kandinsky's repeated references to the shaman's hallucinatory agent, the red or "fly agaric" mushroom. Both mushrooms and healing wounds appear in conjunction in the poem "In the Forest." This wood magically fills itself with mushrooms, and the intruder, stepping on them, speaks repeatedly of "healing scars/corresponding colors." In "Unchanged," references to the lightning of the thunder god (Perun/Thor/St. Elijah), the piebald horse, sorcery and divination, ancestors and ancestor worship, and the fly agaric mushroom appear all at once, creating a concatenation of shamanic reference.[94] Not surprisingly, Christian motifs and symbols are also woven into the fabric of poems and woodcuts, once again demonstrating Kandinsky's syncretic program. But most tellingly, in this work Kandinsky has created a true analogue to the shaman's instrument of enchantment and healing. In the publisher's prospectus to *Klänge*, the artist wrote that he had wanted to create with these woodcuts and poems "nothing but sounds." In fact he created the medley of sounds that Lankenau had called "shaman-music."

If we return now to the opening poem of *Klänge*, we realize at once that the artist was overtly invoking the imagery of his ethnographic experience. The man with the white face and red cheeks in the long black coat who drummed his way along the road was a shaman, albeit in masquerade. Sometimes he drummed "feverishly," sometimes "mechanically," sometimes he drummed—so Kandinsky wrote—"like the white-furred toy rabbit, that we all so love." The white rabbit pelt was of particular significance to the Buriat shaman, for it represented the spirit of the hunt and was widely considered a messenger or helper of the powerful forest-spirit. The fur of the white rabbit was said to have fallen from heaven into a shaman's drum to aid the original hunter, and among the Altais it was also associated with the protection of horses. Again the man in the black coat beat his drum with "feverish, irregular beats." Next he is discovered lying there

on the path "as if totally exhausted," an allusion to the shaman's trance. Kandinsky ended the poem, as we know, by observing that he himself had seen all this "from above": the shaman-artist, on his resounding drum, had taken wing and would indeed fly to other worlds.[95]

From about 1910 to the end of his Munich sojourn and the beginning of World War I, Kandinsky had transcended the doubts and difficulties that had assailed him in the early years to become an undisputed leader on the world stage of modern art. Neither the seductions of the "man-eating village" and the barbed arrows of its critics nor the profound torments endured in his personal life had deterred his inner commitment. He had survived the tortures of apprenticeship and initiation. In the great *Compositions* of this period, especially *Composition V*, and in the *Blue Rider* almanac and *Klänge* he had exorcised his demons, slain his dragons. Now his voice—like that of the *Kalevala* hero Väinämöinen—had "set all the cliffs trembling." In shamanizing, the shaman was said to overcome his initiatory illness, thereby coming into his own. As Bogoras observed: "The performance itself is considered as a recovery from illness." Kandinsky had taken up the tools of his calling and by "shamanizing"— exploiting his talents to the hilt—had assumed the mantle of a modern shaman.

painting as shamanizing 4

Väinämöinen, old and steadfast,
Lifted up his head and answered
In the very words that follow:
"True it is, and well I know it,
I am in a foreign country,
Absolutely unfamiliar.
I was better in my country,
Greater in the home I came from."

When the "Great War" ended the Munich idyll in August of 1914, the *Blue Rider* circle was sundered forever. After a hastily arranged interlude with Gabriele Münter and the Klee family at Goldach on Lake Constance, Kandinsky departed for Russia with considerable misgiving, for he left behind not only his phalanx of friends and a country he had come to think of as "home," but

most significantly the milieu of his revolutionary artistic success. His brush was stilled, his affair with Münter in crisis, and the world situation could not have seemed bleaker. The day after war was declared he confided in a letter to Herwarth Walden at the Sturm Gallery in Berlin that he felt as if he had been "torn out of a dream." "My delusion has been taken from me," he wrote. Stunned by the turn of events, Kandinsky soon wrote to Marc in the field that he had not believed his friend's prediction of war. Marc had written of the potential "purifying" effect of conflict, but Kandinsky replied: "I thought that for the Monument of the Future the plaza might be cleansed in another way. The price for this method of purification is horrific." Indeed, it was to take his colleague's life in March of 1916.[1]

Nor was this return to his native land to be an easy one. Despite his constant efforts to maintain contact with his Russian colleagues, despite their initially enthusiastic acceptance of his revolutionary ideas, it was almost as a stranger that he reentered a country much changed since his university days. Although he returned as an internationally recognized cultural leader and prophet, nevertheless a new generation was now ascendant in Moscow; a brash new breed with its own agenda would view his program with the skepticism and arrogance of youth.[2]

Norseland Bagatelles

Throughout 1915 his creative output, at a peak just prior to the political chaos of 1914, came to a near standstill. Among the more painful psychological burdens that hampered him was the unresolved situation with Gabriele Münter, whose demands to marry he could not bring himself to fulfill, yet to whom he still turned for strength. Perhaps in an effort to release himself from conflict and at the same time from his creative paralysis, he agreed to meet her in Stockholm in conjunction with his exhibition at Gummeson's Gallery during the early months of 1916.[3]

The year was to be a fateful one for Kandinsky. He would turn fifty years old in December of 1916, divorced, estranged from his fiancée, unsettled in his personal and professional life, and uncertain of his future. It was a period of deep and painful

introspection during which he was forced to confront his own human weaknesses and the distress he was causing both Münter and his family and friends. He was poised to reenter, possibly for good, a milieu he had left behind two decades earlier; a perhaps dreaded return to what once had seemed the stifling atmosphere so often the subject of Chekhov's dramas and short stories. Yet Russia exercised a powerful hold on his imagination and his nostalgic vision of "Mother Moscow" drew him relentlessly eastward.

Kandinsky had always been at his most autobiographical in his "Russian paintings" and in his reverse paintings on glass that reflected, with often startling clarity, the continuity of his Russian past and the impact of his ethnographic training. Now the artist embarked upon another intensely autobiographical series of small-format works on glass and on paper, comparing this method to the art of the jeweler. As before, he turned to the folkloric mode for regeneration of energy; to prime the pump, as it were. He referred to these as his "bagatelles," again emphasizing the musical quality that had become so integral a part of his expressive language, and exhibited some of them at Gummeson's Gallery as the Great War in Europe took its horrifying toll.[4]

But the "bagatelles" reveal only by default the overwhelming dread and anxiety the artist suffered. Overtly they often reflect an inner wish to escape into the past, at the same time suggesting great personal ambivalence about his relationship with Münter and about his impending return to the life of his native land. For example, *Picnic* clearly recollects happier days in Murnau, depicting Marianne von Werefkin, with her distinctive jutting chin and characteristic oversized hat, ensconced upon the picnic blanket with Jawlensky, while Münter, somewhat incongruously equipped with pince-nez, surveys the countryside. A swan and fishes inhabit the nearby lake, flowers blossom; a dragon lurks, but lazily, like a sleeping cloud on the horizon beyond the castellated towers to the left, hardly a threat at all. Here is little hint of anxiety; this "bagatelle" emits a benevolent "Klang."[5]

But many of these apparently innocent "bagatelles" alluded both to the approaching rift between Kandinsky and Münter and to the trauma of his separation from Munich. *Harbor*, a glass

111. Kandinsky. *Harbor*, 1916. Reverse painting on glass, 21.5 x 26.5 cm. State Tretyakov Gallery, Moscow.

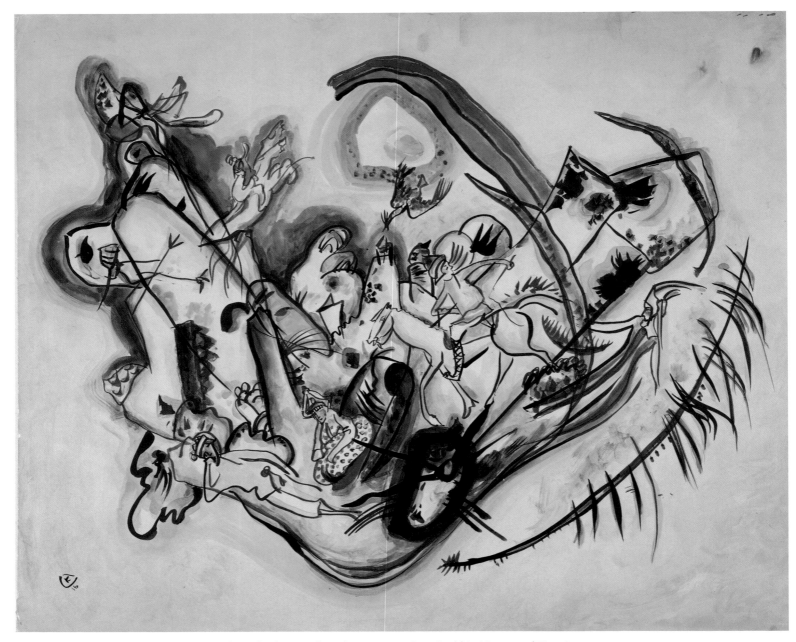

112. Kandinsky. *The Firebird*, 1916. Watercolor and ink on cardboard, 51 x 61 cm. State Pushkin Museum of Fine Arts, Moscow.

painting of the same year, graphically depicts a rift that forms a "safe harbor"—Stockholm?—set between two promontories (fig. 111). Below a porticoed dacha on the left, a pair of crinolined ladies are greeted by a man in Russian peasant costume. On the right rears a prancing horse with top-hatted rider, while a crinolined woman sits blue-faced below a bending tree. The piebald horse and the zigzag "dragon's tail" design on the tree, together with the relationship between the two figures, hint but faintly of the St. George and dragon theme. The hill behind the rider recalls those of such works as *Small Pleasures*, but its summit sports only barren trees. Between the two sides poses a dog, reminiscent of Kandinsky's own Daisy. However, in conjunction with the harbor theme, the animal recalls the *Mops* of another autobiographical glass painting, the terrier of the 1912 *Lady in Moscow*. Inspired by Chekhov's short story "The Lady with the Dog," the work had in fact summed up the artist's entanglements of the heart through allusions to various love triangles. Here these themes of division and deceit, though muffled, are once again held together by the symbol of faithfulness.[6]

The artist's ambivalence of the heart and his longing for resolution, even redemption, was most poignantly revealed in the clearly folkloric *Firebird*, by title a reminiscence of the famous Russian folktale (fig. 112). But here the horseman-hero seems torn between visions of past and future: in an ambivalent gesture, he whips his horse forward toward a woman in Russian costume kneeling by a pond, while at the same time looking backward over his shoulder toward a rusalka-like figure at right who appears to summon him from a reedy pool. A green-faced male figure in peasant garb—dreamer, guardian, or forest-spirit—leans to the left. Far above, a pair of riders hurl themselves toward the sun and a bird swoops into the center of the picture: the "firebird" itself, or a phoenix promising a new life? One searches in vain for the golden apples, the golden cage, and the magical wolf of the legend. Clearly, this is a tale with more personal dimensions.

In another watercolor of this period the artist revealed both his nostalgia for Russia and his anxiety (fig. 113). Here the horseman stands at a crossroads, bereft of lance, nor flinging out his arms, apparently perplexed. Only the plume in his cap and the shield on his saddle blanket suggest his identification with the St. George of old. A woman in Russian costume beckons away from a setting sun and drooping tree. An ornamental "border" hangs in the sky above the rider—a direct reference to that far distant trek into the backwoods of Vologda province nearly three decades before. There among the Zyrians, Kandinsky had wondered at the native love of decoration that had turned a peasant hut into a miraculous adventure for the young ethnographer. In his diary he had quickly sketched a table top, jotting down the bright colors and making note of the scrollwork in the design. Now memory elaborated the decoration so long remembered (fig. 19).

But it was in a watercolor manifestly inspired by the *Kalevala* that Kandinsky revealed his equivocation most directly (fig. 114). The central figure is a bearded old man standing high in the prow of a fantastical Viking ship, none other than the old sorcerer Väinämöinen, who built his boat with magic songs to sail forth and woo the "peerless Bride of Pohja":

> And the boat with red he painted,
> And adorned the prow with gilding,
> And with silver overlaid it;
> Then upon the morning after,
> Very early in the morning,
> Pushed his boat into the water
> Then he raised a mast upon it,
> On the masts the sails he hoisted,
> Raised a red sail on the vessel,
> And another blue in colour,
> Then the boat himself he boarded
> And he walked upon the planking,
> And upon the sea he steered it,
> O'er the blue and plashing billows.[7]

The colorful imagery of the ancient hero's adventure takes center stage between two damsels, one doubtfully pointing a daintily extended finger, the other seeming to descend a stair toward the outdoor setting of the boat. A plumed "phoenix" and

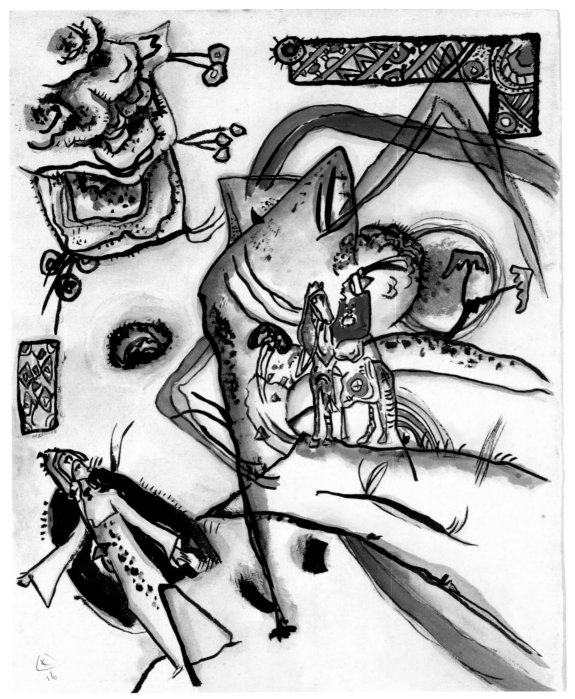

113. Kandinsky. *The Horseman* (also known as *Rider*), January 1916. Watercolor and India ink, and pencil on paper, 32.3 x 24.9 cm. Museum of Modern Art, New York, Joan and Lester Avnet Collection. Photo © 1994 The Museum of Modern Art.

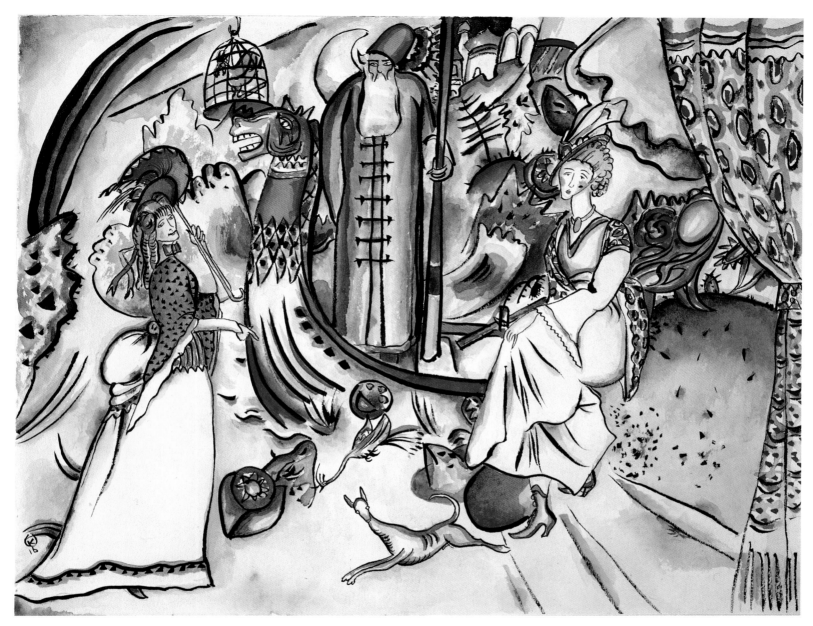

114. Kandinsky. *Boatsman*. Watercolor and tusch on paper, 22.8 x 29 cm. Nationalmuseum, Stockholm. Photo courtesy
Solomon R. Guggenheim Museum.

a male dog escape between the two. Incongruously, the caged "firebird" of the Russian folktale seems magically suspended from the heavens. Again the theme of ambivalent affection dominates. In the *Kalevala*, the "Maid of Pohja" (whose name was Annikki, a match for Kandinsky's Ania) delighted in setting her suitors impossible tasks. But apparently to Kandinsky it seemed that all of his women set him impossible goals.[8]

Return to Russia

Desperate to recover peace of mind in the face of personal and social chaos, Kandinsky returned to Russia for good, so he thought, in mid-March 1916. But that his break with Münter was even then not finalized was demonstrated in their continuing correspondence. A month later Kandinsky wrote that he was planning a triptych for the Akhtyrka dacha of the Abrikosovs. It was to be another bagatelle-like work: a river with boats and fishes, flowers, birds, a crinolined lady, mountains, suns, and the Moscow Kremlin. Scattered slogans doubtless intended to suggest the hopeful and carefree tone of a summer house were included in the design, such as *ad astra* (to the stars) and *panta rhei* (all is in flux), the Heraclitean conceit.[9] At the house he had shared with Münter in Murnau he had decorated the stairwell with a frieze of leaping horseman and painted the furniture in folkish style. Here once again he evidently hoped to relive the interior decoration of those Zyrian peasant houses, wishing to realize his old dream of being surrounded by such an environment, a dream that would eventually lead to his association with the Bauhaus.

That indeed the Vologda experience was immediate in his mind at the time was demonstrated in a variety of ways. For example, a bagatelle-style ink drawing depicted St. Elijah in his chariot rising into the sun-drenched sky above a hilltop church, the sort that in Vologda province typically marked the site of an ancient Chud fortification. On the road below dances a man in a high hat, his arms flung up in surprise, while a maiden in Russian costume leans against a nearby tree.[10] Several other watercolors revealed a similar nostalgia for old Russian themes.

One depicts a game hunt in full cry, with comical bears backed up against a tree, a happy boar, horsemen galloping about with bow and arrow, unconcerned picnickers, and another hilltop kremlin. An untitled winter scene depicts a strolling couple, a horse-drawn sled, and a skier, doubtless inspired by woodcuts included in Herberstein's account of his Russian travels.[11] Yet another watercolor returns the Viking ship motif of *Song of the Volga* and *Golden Sail*, along with placid piebald horses, mountains, a shipboard crinolined lady, a piano-playing sailor decked out in a feathered Indian headdress, and a declaiming Heldentenor, all combined in a concentric composition with scattered suns and planets like those on a shaman's drum (fig. 115).

Two horseman images of this period provide further intimations of Kandinsky's bewilderment vis-à-vis the women in his life. *St. George IV* is a pale reminiscence—amusing, perhaps even intentionally ironic—of the artist's Munich heroism (fig. 116). The saint is center-front on his piebald horse, outfitted with shield, lance, and plume, as of old, the background encampment recalling the artist's *Phalanx* poster and the skirmishes of the early Munich period. The somewhat befuddled dragon is no match for the saint; the damsel primly awaits her liberation. But the work has a curious static quality and little of the verve of the grand old days; it seems a dream on the brink of dissolution. A glass painting entitled *With Green Rider* demoted the horseman to a costumed Russian peasant. His girlfriend has dismounted from her horse, which prances off in the background while she points an accusatory finger at her suitor. The knight has abandoned his saintly subterfuge and accepts her reproaches.[12]

On 11 February 1917 Kandinsky suddenly married the decades-younger Nina Andreevskaia, whom he had first met the previous autumn. Two years earlier he had written to Münter that he was helpless to resolve conflicts in his personal life; he wished only that no one should suffer because of him. Only in art, he declared, did he know precisely what he wanted. What he required most of all, he wrote, was freedom.[13] Certainly the time was ill chosen, for the couple departed on a wedding trip to Finland, doubtless passing through St. Petersburg in the chaotic days just prior to the February uprising. They returned to a czar-

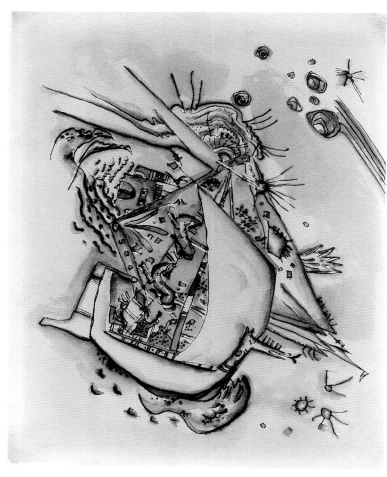

115. Kandinsky. *Untitled* (with Viking ship). Watercolor and ink, 29.1 x 22.9 cm. Musée National d'Art Moderne, Centre Georges Pompidou, Paris.

war, revolution, and personal crisis.[15] In fact, in the autumn of 1917 he regained momentum in oil paintings as well, some of them clearly reflecting the joys and crises of personal and public events. A month after Volodia's birth, a bagatelle-style oil painting replayed the old theme of boats, mountains, and dragons. But now an enormous dragon curls around a mountain in *Gray Oval*, threatening the seafarers in the foreground. With this work, the artist also returned to the concentric orientation within a circling, here oval, format that he had adopted in his late Munich works.[16]

Yet reentry into the marital state, far from providing the freedom Kandinsky sought, again seems to have presented its obstacles. Indeed, fiercely amazonion equestriennes provided the subject for a series of glass paintings executed in 1917 and lingering on into the following year. No fewer than four glass paintings entitled *Amazon* survive. All four women are mounted, three carrying whips and sporting top hats; three, one of whom salutes, commanding magnificently rearing steeds. Curiously, one equestrienne appears to caper upon a stage, framed by stagelights and curtains, while another is planted incongruously in thin air. Perversely, the Amazons call to mind Böhling's book on Russian folklife critiqued by Kandinsky so long ago in the *Ethnographic Review*. In his vividly picturesque verbal portrait of Russian village life, Böhling had described a young country lass on a gypsy horse as a genuine "Amazon." The mountainous backgrounds of three of the images suggest that the Amazon in question was the artist's "muse" of the Bavarian mountains, Gabriele Münter. Perhaps the barren tree on the mountaintop in one of these was a comment on that relationship.[17]

Although so long submerged, Böhling's imagery once again rose to Kandinsky's consciousness in *Ladies in Crinolines*. The glass painting returned Böhling's city-born young lady walking her "Gordon setter," or at any rate a reasonable facsimile thereof, to the scene. Once again the setting is split by a rift in the landscape with buildings to each side—perhaps the apartment house at Ainmillerstrasse in Munich, where Kandinsky and Münter had resided when not at Murnau, on the left, and another reminiscence of the park at Akhtyrka on the right. Again the opposing

less Russia, to the breadlines and riots that accompanied general chaos. Their son Volodia was born in Moscow the following September, as Kerensky in Petersburg proclaimed a Russian republic and the Bolsheviks, urged on by Lenin, mustered their forces for the impending Revolution.[14]

Slight and ambivalent as they were, the bagatelles signaled that the shaman had once again taken up his drum and sought, by "shamanizing," to overcome the catastrophic disruption of

116. Kandinsky. *St. George IV*, 1917. Oil on cardboard, 64.4 x 91 cm. State Tretyakov Gallery, Moscow.

forces are held together by a faithful dog, clearly here "pointing" to the left. As usual in Kandinsky's view of women, the men are in the background and "all at sea," top-hatted in the boat.[18]

Glass-Painting with Boat of 1918 integrated ethnographic reminiscence with autobiographical past and present. Here the artist recalled once again the piebald horses of his youth (fig. 117). At first glance the picture seems little more than a trifle perhaps intended for his son. But a second glance at both title and content belies so simplistic a reading. In the background, the boat of the title rears its prow in a last stormy farewell as it sinks into the sea. Minuscule figures call for help from its decks and one sailor gestures in distress from the water. In the foreground the overwhelming society of crinolined ladies have eyes only for each other and the child seated before them. Like many new fathers—indeed, like the hapless sailors of the painting—the artist seems to have felt abandoned by the women in his life. A powerful rival had taken center stage. But the painting has another dimension. For undoubtedly Kandinsky must have appeared to himself the victim as he confronted his return to a stifling past. He, too, had been raised by a bevy of doting women. Here he depicted them as overwhelming his small alter ego. There at front and center stands his toy piebald horse, so fondly recalled in "Retrospects"; next to it, the small "shaman." Above them the society of smothering crinolined women, ges-

123

117. Kandinsky. *Glass-Painting with Boat* (also known as *With Toy Horse*), 1918. Reverse painting on glass, 24.7 x 37 cm.
State Tretyakov Gallery, Moscow. Photo: I. Zubareva, 1991.

turing this way and that, threatens to back over them. Only one, doubtless his beloved aunt Lydia Tikheeva, whom he credited with his early education, casts her gaze on him in concern. The picture seems to ask: if the ship sinks, will it rise again? Will the drowning sailor be reborn as the little shaman?[19]

Integrating Past and Present

The paintings with which Kandinsky proclaimed the return of his vigor represented both a coming to terms and a continuity with the Munich experience. How vividly had he described in "Retrospects" the visual and aural impact made on him by his beloved Moscow at dusk, a synaesthetic experience that lifted him to ecstasy. He likened that hour to "the final chord of a symphony that allows, even forces, all of Moscow to resound like the *fff* of a giant orchestra. Pink, lilac, yellow, white, blue, pistachio-green, flaming red houses, churches—each an independent song The Kremlin wall and over it, towering over everything, like a shout of triumph, like an uninhibited halleluja, the white, long, elegant, serious stroke of the Ivan Veliki bell tower. . . . To paint this hour I thought to myself [must be] the most impossible and highest good fortune of an artist. . . . These impressions . . . were a joy that shattered me to the depths of my soul, that raised me to ecstasy."[20]

In a letter to Münter written in June of 1916, a little more than two months after their parting, he had written that "all the power of my old studies had been lost." But in Moscow he hoped to recover it: "I would like to make a great landscape of Moscow—to take the elements apart and reunite them in a picture—of weak and strong fragments, all mixed together as the world is mixed of different elements. It must be like an orchestra. I sense the general idea, but the general form is not yet precise.

"8 p.m. I have gone to the Kremlin to see the churches from that point of view that I need for the picture. And new treasures were revealed before my eyes. . . . I've painted up to now a sketch that isn't bad [but has] . . . too few variations—of richness, too little of tragedy."

He was still working on his ecstatic vision in September of that year, admitting in another letter to Münter that what had

foiled him was "the profundity, the profound sound, very serious, complicated and simple at the same time."[21] Toward the end of November he was able to write: "I feel . . . that my old dream nears realization. You know that this dream was to paint a large picture whose sense must be the happiness, the joy of life or of the universe. Suddenly I feel harmonies of colors and forms, that are the joy of this world."[22] Perhaps the most serious complication was his insistence on grafting motifs and memories of Munich onto his Moscow hour. In the center of the picture that would be called *Moscow I*, he mounted a pair of figures clearly reminiscent of the couple in the painting *Improvisation (Ravine)*, which had been one of the last works of the Munich period (figs. 118, 119).

In July 1914 Kandinsky and Münter had journeyed to Garmisch Partenkirchen in the Bavarian Alps above Murnau for the last time. There they had visited the Höllentalklamm, or Hell's Valley Ravine, well known to Kandinsky from prior visits. This spectacular natural gorge, down which crescendoed the glacial runoff of the Zugspitz, had been transformed into a tourist attraction during the early years of the century by means of an almost equally spectacular engineering feat that involved tunneling and hewing steps into the stone walls. It had been opened to the public with much fanfare on 15 August 1905, and Kandinsky had been among its first visitors, arriving during the first week of September.

The dramatic oppositions of brilliant light and deepest darkness shot through by the roaring sound of water cascading, crashing, and gliding down the precipitous rocky faces of the gorge provided powerful stimulation to all the senses. Although clever engineering had made the tunnels resemble nature's own work, man's intrusion into the cleft mountain was still evident in the rusting remains of iron ladders originally fastened to the cliff walls during the construction and when the gorge was briefly used as a sluice for ore. The artist, who loved the mountains and mountain climbing, visited the ravine at least two, perhaps three more times during the Munich years.[23]

A sketchbook drawing dated 22 June 1914 conveys the main compositional elements of *Improvisation (Ravine)*. The artist set down the Russian title *Zakat*, meaning sunset or decline. As

118. Kandinsky. *Improvisation (Ravine)*, 1914. Oil on canvas, 110 x 110 cm. Städtische Galerie im Lenbachhaus, Munich (GMS 74).

is sometimes the case in Kandinsky's sketches, the motifs are more "readable" than in the final painting. Besides the couple dressed in Bavarian attire, the falling water, and the ladders that are prominent in the painting, less obvious fragments are apparent in the sketch: a figure on horseback holding aloft a scale and a row of forms reminiscent of gravestones. The rider apparently represents the Apocalyptic rider with his scales of justice. But Kandinsky's title and the entire ambience of the painting, bathed in yellows and reds, as if backlighted by the setting sun, suggests that what he had in mind even then was his twilight Moscow hour when both colors and sounds united in a resounding chord, when dusk held the balance of day and night.[24]

Between the date of Kandinsky's sketch and the execution of the final work, the assassination of Archduke Franz Ferdinand of

Austria and his wife at Sarajevo had horrified the world, and for many the inevitability of war had become apparent. Although the mood of this painting seems a premonition of impending catastrophe, Kandinsky's word is on record that the actual outbreak of war was a total surprise to him.

The magnificent orchestration of this "improvisation"—the couple attired in ethnic costume, the rider with the scales, the careening ladders, the falling waters, the tombstones (which in the painting take on the aspect of a row of Ostiak idols), the boats, and the dramatic sunset coloring—assumes a symbolic majesty. The work seems to speak of final things, of guilt and innocence, death and resurrection, aspiration and despair, the contradictions between day and night, indeed, of that "thundering collision of worlds."

Back again in Moscow and perhaps hoping to recover something of that magnificence, Kandinsky took up the motif of the couple and the tombstones, placing the pair in an even more central position than before. In *Moscow I* (also known as *Red Square*), the couple appears to stand on a promontory above the sluice of the earlier work (fig. 119). The tombstones have been converted to more easily readable crosses set in a black cemetery plot. In the second version of this painting, known as *Moscow II*, he went further, adding his old St. George to the composition at upper left to replace the rider with scales of *Ravine*. The return of that syncretic saint, raising his lance above the defeated dragon, signaled the return of the shaman/artist's strength. In the second painting, as in a preliminary sketch, St. George is placed high in the sky, juxtaposed to the coming night with its moon (fig. 120).[25]

Whereas in *Moscow I* the artist retained the horizontal-vertical orientation of *Ravine*, in the second version he adopted the radial orientation of many of the late Munich works; the motifs are further fragmented and strewn hither and yon. Here, in part, mountains and some figures at lower right are turned upside-down so that the orientation is thrown from the expected to the unexpected, and the whole composition appears to swirl. From the center of the composition explode fragments of the Moscow Kandinsky knew: the Kremlin, the church towers, the radiating sun, birds, apartment buildings. The central motif in

119. Kandinsky. *Moscow I (Red Square)*, 1916. Oil on canvas, 51.5 x 49.5 cm. State Tretyakov Gallery, Moscow.
Photo: I. Kozlova, 1991.

holm had had its impact in more ways than one, for Kandinsky had doubtless taken the opportunity to view numerous examples of Lapp shaman drums. The famous Nordic Museum that had opened to international acclaim in 1907 was already a repository for some of these rarities; but they were also on view at the city's State Historical Museum and still often to be found in the hands of private collectors. There is little doubt that certain of them had engraved their cosmogonic icons into Kandinsky's eidetic memory.

In drawings for the first version of the Moscow picture and in the painting itself, a yurt or teepee-like form is evident at the lower left, partially obscured. It may be a fragment from his *Phalanx* poster with its militant encampment, or it may simply refer to the common homes of tribal Siberia. The tombstones clearly visible in both versions may commemorate the deaths of his comrades Marc and Macke. Macke had fallen in the first weeks of the war in September 1914, but Marc's death, a tragic blow to Kandinsky, had come only weeks before he commenced work on this painting. In the crayon sketch and in a related watercolor, a cannon motif in conjunction with the tombstones makes this deduction even more likely. In this watercolor, with its clearly drawn fragments, St. George appears with outflung arms in the familiar pose of World-Watching-Man. Before the Kremlin a robed figure appears to stride, while the female partner of the couple appears to dance away from her mate, who turns away.[26]

In place of the cannons of the first version, an enigmatic robed figure stands just below the cemetery in *Moscow II*, calling to mind the similarly robed figure at lower right in *Composition V*. If *Moscow II* is to be taken as a conglomeration of Munich and Moscow motifs—and indeed it is just that—then perhaps it is appropriate to recall once more Münter's comment that Kandinsky had painted her in *Composition V* "going out of the picture, below right." As in *Composition V*, the figure in *Moscow II* seems to "walk out of" the picture. Was the painting then also an attempt to exorcise the ghosts of his recent past?[27]

That the Munich muse remained powerful in his memory is evidenced in the fact that the following year, in September 1917, the same month in which his son was born, the artist once

120. Kandinsky. Sketch for *Moscow II*, 1916. Pencil and colored crayon on paper in a notebook, 18 x 26.3 cm. Musée National d'Art Moderne, Centre Georges Pompidou, Paris.

both the *Moscow* paintings and in *The Blue Arc*, of the following year, is a sunburst. Taken together with the concentric orientation, this sun motif recalls again the central motif of Lapp shaman drums, Peive, the all-powerful sun god. Clearly, Stock-

again drew upon his Munich experience. *The Blue Arc* bears a close formal relationship in compositional terms to both *Ravine* and the *Moscow* paintings (fig. 121). But it is in fact derivative of the Munich painting *Small Pleasures*. The world mountain with its kremlin rears up in the center, and boats traverse high seas below. Hieroglyphs associated with horses, riders, and troikas leap into the sky. Not surprisingly, one of the boats is accompanied by rusalki and vasas (against the hull of the boat at lower right). But the horsemen springing joyfully up the mountainside in *Small Pleasures* seem at first glance to have vanished. Instead, on the left mountainside, plies a boat bearing two horseman hieroglyphs. In this characteristically incongruous way has Kandinsky grafted the World-Watching-Man on horseback to his alter ego in the rowboat, recalling at the same time the boatmen of the *Kalevala*. Other rider hieroglyphs leap from right to left above the blue arc of the sky. If they are the horses of Elijah, they have broken from their troika's shaft bow, visible below them, next to the kremlin towers. Another horse hieroglyph, somewhat modified but nonetheless consistent with Kandinsky's usage, leaps across the mountain-peak-waves that rise above the boat at lower right. Once again the watery-blue promontory of *Ravine* and the *Moscow* paintings rises to an occluded sun or moon at the center of the composition. Another element from those latter paintings, the blue arc, which had been only a blue streak in those works, now defines the sky's arc, taking much the same form as it had in *Small Pleasures*. Beneath this heavenly arch the explosive oppositions of universal experience collide. Already the surface of the painting as cosmogonic "map" of the universe analogous to that of the shaman's drum, with its oppositions of the heavenly and nether worlds and their hieroglyphic inhabitants, asserts itself in the artist's compositional scheme and intention.

"Primitivism in Modern Art"

But Kandinsky soon found it was not enough simply to recapture the creative impulse of the Munich days; now he was forced to confront the demands for change that overwhelmed every segment of Russian society, including the artistic. With the cultural revolution that accompanied the political and social revolution, Kandinsky was plunged once more into the politics of art. Much as he later protested any interest in politics, in fact from the beginning his unquenchable optimism and idealism had allied him with political concepts of progress. Appalled though he was by the excesses to which politics could be driven, he hoped always for utopian change. The contacts with the younger generation of Russian artists that he had forged in the days of the *Blue Rider* almanac and exhibitions now bore fruit. He had become, after all, a kind of elder statesman for the young radicals of the Russian avant-garde. Despite the obvious generation gap and the inevitable tensions it caused between them, he had made his mark in the years before the war.[28]

Although many of his most intimate friends of the pre–world-war Russian avant-garde movement—Goncharova, Larionov, Vladimir Burliuk, Kulbin—were now gone, Kandinsky's stature was sufficient that in January 1918 he was approached by Vladimir Tatlin, as emissary for Anatolii Lunacharsky, newly installed "Commissar of Enlightenment," to participate in the Department of Visual Arts (IZO) of Narkompros, the People's Commissariat for Enlightenment. With characteristic energy Kandinsky threw himself into the task and soon became an acknowledged leader in the development of new concepts of art education in the service of what it was hoped would become a utopian society. But the relentless activity and demands on his time—not to mention the privations of everyday life—soon led to a second stilling of his brush: he produced no paintings at all for well over a year between the October Revolution of 1917 and early to mid-1919.[29] Nevertheless, he wrote, edited, published; he involved himself in the distribution of art to provincial museums; he conceived and put into action a program for the Moscow Institute of Artistic Culture (known as Inkhuk) which opened in May of 1920 under his leadership. Little wonder that he found his artistic drive frustrated.[30]

Not surprisingly, throughout this period of frenetic activity Kandinsky's interest in the ethnographic dimensions of art continually bubbled to the surface both in his editorial activities and again in his art, as he began once more to "animate" his canvas.

121. Kandinsky. *The Blue Arc*, September 1917. Oil on canvas, 133 x 104 cm. State Russian Museum, St. Petersburg.

129

It has been little noted that when his memoir was readied for publication in Russia in 1918, the passages on his ethnographic expedition to Vologda province and his association with his colleague Ivanitskii were considerably elaborated.[31]

Similarly, in preparing the Russian translation of his essay on stage composition for publication in the journal *Izobrazitelnoe Iskusstvo* the following year, Kandinsky added a note that clearly displayed his knowledge of Lapp folklore by comparing Wagner's use of the leitmotif to the Lapps' distinctive "musical motif" *(vuolle)*, which each family was said to possess and by which it was identified.[32] Moreover, in various proposals that he prepared for Inkhuk and for RAKhN, Kandinsky time and again urged the study of the primitive experience in art, music, and ritual. His allusion to an Arabic shaman's ecstatic dance has already been noted, but in another proposal in 1921 he pointed out the pressing need for "research into primitive art and into all the aesthetic concepts that give primitive art its style," including in his list the art of "primitive peoples," as well as *primitivism in modern art*"—thus clearly acknowledging a distinction between the two.[33]

Thus, as he took up his brush in 1919 and began once more to "shamanize," it is hardly surprising that he returned to the iconography of the shaman's drum and to the shamanic folklore with which he was familiar. During this chaotic period the idea of a cosmic view of the universe set free from traditional gravitational orientation must have appealed, for it began to assert itself—as it had toward the end of his Munich experience—in paintings in which the composition was pulled away from the edges of the canvas and set to swirling action within a more or less oval "rim."

Shamanist Inspirations

A transitional painting which retains the old orientation but in which the action pulls away from the edge of the picture, hurling its objects into a primal sea of indeterminate space is *In the Gray* of 1919 (fig. 122). Kandinsky himself later identified it with the conclusion of his "dramatic" period.[34] It has been described as an "abstract landscape" and a "variety of allusions" have been ascribed to it, but only a boat and "oarsmen" have been identified. Although designated a "minor" work, this painting was in fact of such major importance to the artist that it remained with him in his subsequent migrations and was seldom allowed out of his possession for exhibition. He even used an anticipatory drawing on the cover of the 1918 Russian translation of "Retrospects."[35] It would seem that, on the contrary, *In the Gray* held special meaning for him, for Kandinsky actually created here an allegory of the Revolution based on an ancient Buriat myth concerning the "First Shaman."

The most obvious image, and one that has been consistently although unaccountably ignored, is the overturned bottle in the center of the picture spewing out its contents in clearly drawn black strokes. This bottle appears in both the preparatory drawing and watercolor.[36] In the final painting, the bottle is shown at once upright, tipping slightly to the right, and fallen. Once this central motif has been identified and accepted as a literal representation of a bottle, the key to the painting has been revealed.

According to the Buriat myth as related by Kandinsky's colleague Mikhailovskii and countless others, the First Shaman, Khara-Gyrgen, was all-powerful and could cure all the ills known to humanity. But the Highest God, wishing to put him to the test, one day stole away the soul of a beautiful maiden, leaving her fatally ill. So Khara-Gyrgen, on his shamanic drum, rode into the highest heaven to confront the Highest God and retrieve the maiden's soul, thus to effect his cure. In Kandinsky's painting, adopting the custom of the ancient Lapp noids, the shaman rides in triplicate on the back of a fish, here a dolphin-like creature (just to the left of center in front of the bottle in its "standing" state).

Once there, Khara-Gyrgen found that the Highest God had placed the soul of the maiden in a bottle and stoppered it with his finger—hence the centrality of the bottle motif. Seeing this, the First Shaman quickly changed himself into a wasp—clearly visible in the upper right quadrant, represented in characteristic yellow and black—and stung the Highest God on the cheek! In great pain and surprise, the Highest God lifted his finger from the

122. Kandinsky. *In the Gray*, 1919. Oil on canvas, 129 x 179 cm. Musée National d'Art Moderne, Centre Georges Pompidou, Paris.

bottle, knocking it over and spilling its contents hither and yon—the spill marks, as we have observed, are clearly delineated—thus allowing the soul of maiden to escape, in the form of a bird- or butterfly-soul, and return to her body. Again, the disembodied finger of the stunned god appears in nearly naturalistic form at upper right, while the winged soul of the maiden is represented both as a multicolored "bird" (immediately below the finger) and as a black hieroglyph. Thus did Khara-Gyrgen save her life. But the Highest God in his anger diminished the power of the Shamans forever.

In a preparatory drawing Kandinsky betrayed his knowledge of another version of the story, by which the First Shaman turned himself into a *spider* rather than a wasp. There the spider's web is delineated at upper left (fig. 123).[37] In the final painting, the upper left-hand corner signals the land of Finno-Ugric myth, for the troika shaft bow of Elijah/Thor partially obscures a setting sun. Further compounding the complexity of the imagery, are the rower-horsemen identified with the combined motif of St. George/World-Watching-Man and his rowers in the lower left quadrant (below the fallen bottle). The boat and one oar are clearly defined in the drawing; in the watercolor the oar has already been lifted into the sky and the keel of the boat decorated in the manner of Kandinsky's serpents. A small "troika" of hieroglyphic horsemen leaps to the right of the boat.

In allegorical terms, the painting suggests that as the First Shaman stung the face of the Highest God in order to liberate the soul of the dying maiden, so the Revolution was to sting the face of the old regime in order to liberate the "soul" of the Russian people. But the painting's somber coloring and its title, *In the Gray*, suggest the disappointment of Kandinsky and many of his fellow idealists in the outcome of the actual Revolution, an idea that was hardly popular at the time and perhaps another reason that Kandinsky kept this painting close.

Ethnographic Contacts

Kandinsky's interest in ethnography had been shared by other artists of the early Russian avant-garde movement. For example, both Goncharova and Larionov had collected and imi-

123. Kandinsky. Untitled study for *In the Gray*, 1919. Drawing, 20 x 26.9 cm. Musée National d'Art Moderne, Centre Georges Pompidou, Paris.

tated Russian icons, folk art and lubki. Moreover, Larionov too had been interested in shamanism and owned a copy of Khangalov's famous 1890 book on shamanism among the Buriats.[38] Two years after his meeting with Kandinsky, perhaps stimulated meanwhile by the juxtapositions of contemporary art, primitive art, and folk art that had appeared in the *Blue Rider* almanac, Larionov also acquired an original sacred drawing by a Buriat tribesman.[39] And in 1912 he had illustrated a pamphlet of poems by Kruchenykh with drawings that apparently illustrated the same Buriat tale about the "first shaman" and his loss of god-like powers. On another occasion, Larionov had illustrated a poem by the avant-garde poet Khlebnikov entitled "Shaman and Venus." In any case, it was natural that some of these artists, interested as they were in recapturing the power and naive freshness of the artifacts of primitive societies, would first have looked to those sources of inspiration closest to home, namely, to the example of Siberian shamanism.[40]

The Estonian-born artist Vladimir Ivanovich Markov had also been interested in primitive art and had been in contact

with Kandinsky from 1912, when he had approached the older artist with plans to visit Murnau and with questions about African art. Because Markov was on his way to Paris, Kandinsky had suggested that he would find plenty of information on African art in the Paris libraries. Markov was by then already the author of an article entitled "Principles of the New Art," in which he had extolled the values of oriental and primitive art, equating the latter with the naiveté of children's art, and using language that suggested the powerful influence on him of Kandinsky's work.[41]

Although Kandinsky's good friend Nikolai Kharuzin had died in 1900, he had continued to visit the Kharuzin family during his frequent visits to Moscow; he kept up with the Bogaevskii family as well, and there is every reason to suppose that he continued all of these friendships. Nikolai's sister, Vera, was still actively involved in writing articles and book reviews for *Ethnographic Review*, which was published through 1916, and the journal continued to cover a wide range of subjects, including shamanism.[42]

Meanwhile, he would have found the Dashkov ethnographic collections much expanded and handsomely installed in the north wing of the Rumiantsev Museum. One can well imagine the pleasure he may have taken in seeing the materials he had donated to the museum displayed in vitrines. The Zyrian material was displayed on the first floor and the 1916 catalogue provided information on geography, demographics, and material culture, along with the laconic remark: "All of them have been Christianized, but many of them are Christians in name only."

The display included a mannequin dressed as a Zyrian hunter with his flintlock weapons and other accessories; perhaps he wore the cap and carried the old-fashioned blunderbuss donated by Kandinsky after his expedition. The Orochon mannequin that had been described in such detail in the 1887 catalogue as a gift of "Mr. Kandinskii" was now shown in cabinet 3 in the Tungus section in the same large exhibition hall. Besides his weapons and other items, a shaman's staff, or horse-stick, was shown with him. In the same case were Tungus shaman costumes and another mannequin representing a Goldi shaman of the Amur region with drum and amulets. Nearby was a display of other Goldi shamanist objects, such as a shaman's magic drawing

with its dragons, horsemen, and idols. In the same room another cabinet displayed Samoyed objects, including a shaman mannequin along with a shaman's drum and idols. Strolling into the main hall, the visitor was greeted by the Yakut collections, including a mannequin representing a shaman with his drum and drumstick side by side with "crosses of baptized Yakuts" (fig. 84). As the catalogue explained: "The Yakuts are considered Christians, but in essence they are shamanists." Next to the crosses was an idol "for the conjuring of spirits." The display included two more shaman costumes, along with metal costume embellishments and, suspended to float in the air above these, a display of sacred wooden birds of the shamans.

A stunningly colorful display of Aleutian, Eskimo, and Northwest American Indian artifacts, including amulets and brilliantly decorated Aleut ceremonial fishing hats, surprised the visitor in a small room off the main hall. A Tlingit mannequin was draped with the same type of ceremonial Chilkat blanket that Kandinsky had illustrated in the *Blue Rider* (fig. 97), and objects displayed with him included a shaman's drum. A neighboring case included a collection of shaman's rattles and a shaman's apron. In another smaller room were collections of more shamanist objects of the Giliak, Goldi, and Orochi tribes, as well as birch-bark masks of the Voguls and Chukchee religious artifacts. Although many Muscovites may have taken the collections for granted, it must be supposed that the artists were not among them.[43]

Return to a Cosmogonic Mythology

By 1919, then, Kandinsky's resurgent creative energies drove him to experiment ever more drastically with concentrically organized compositions. In actuality the series of paintings, in which the dual motif of edge and the oval "drum shape" itself was emphasized both in title and composition, had begun as early as 1916 with such works as *Painting on Light Ground* and *Picture with Orange Edge*, continuing with *Gray Oval* of 1917 and later works with "Edge" and "Oval" designations in their titles.[44] In most, fragments of "mountains," "planets," suns, moons and stars, crosses, horsemen, boats, and other objects represented on

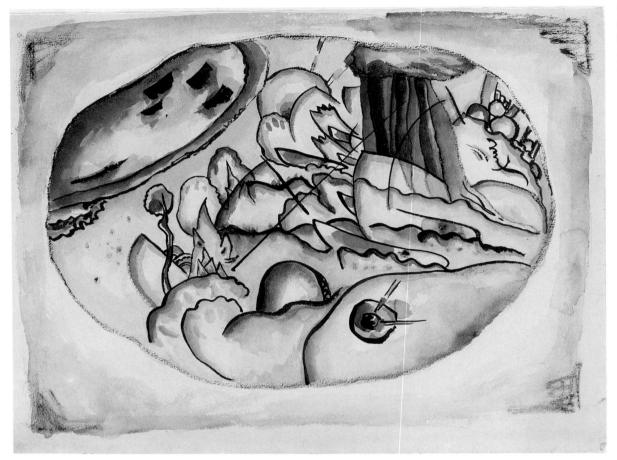

124. Kandinsky. *Untitled*, ca. 1917. Watercolor, 27.5 x 38 cm. Musée National d'Art Moderne, Centre Georges Pompidou, Paris.

the surfaces of shaman drums range themselves along the rims or float freely in their internal space. In *The Green Edge*, 1920, suns, moons, and stars float around the "rim" created by the green border, with mountains apparently hanging upside-down from the upper left edge (particularly clear in the watercolor). There are even the Hexenschuss signs common to Lapp shaman drums, which Kandinsky had already employed in the Munich period. Some of the motifs of the earlier *Gray Oval* and *White Oval* are repeated here, such as the spotted, spiky tail of the dragon.[45]

An untitled watercolor also suggests the inspiration of Lapp drums, with its segmented half-circles around the rim and signs for suns, mountains, and buildings set free from normal orienta-tion (fig. 124).[46] It shares with *Green Edge* the motif of a circular element radiating two streaks (lower right in the former, upper right in the latter) that suggests a "drum" emitting sounds. Instead of the troika motif for the thunder god Thor/Elijah, the storm itself deluges from a heavy cloud. In general terms, all of them suggest a metaphor for the "universe" filled with hiero-glyphs in the manner of shaman drums.

Picture with Points of 1919 differs from these paintings in that, while the action swirls around a center, a painted "rim" is absent (fig. 125). Instead, the disorienting loss of the traditional order is indicated by upside-down mountains and trees hung from the upper left corner, poking out crazily from the left-hand

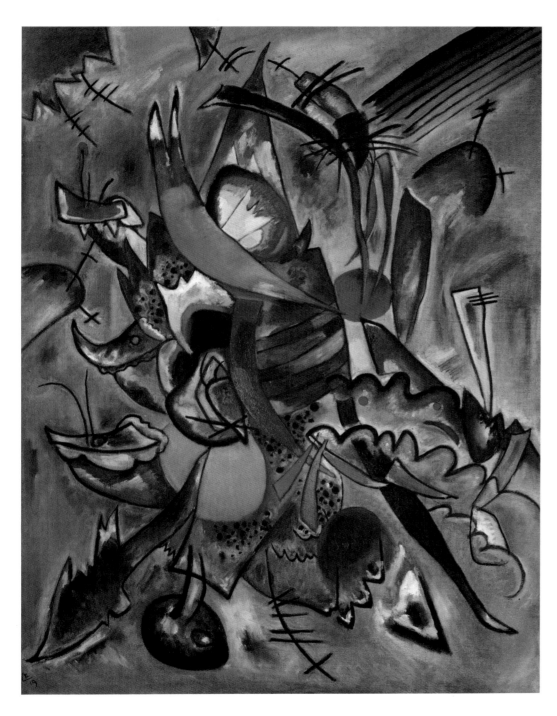

125. Kandinsky. *Picture with Points*, 1919. Oil on canvas, 126 x 95 cm. State Russian Museum, St. Petersburg.

side, or dangling from the bottom of the swirling mass. Startling similarities to Lapp drum pictograms are the hillocks with their abstracted trees, as, for example, on a drum that Kandinsky may well have known from a visit to the State Historical Museum in Stockholm or from a variety of publications (fig. 155).[47] In the upper center a yellow figure with upraised arms, seeming to ride on the back of a fish, recalls yet again World-Watching-Man, the Golden Prince.

Red Oval, 1920, perhaps the most symbolically and emotionally charged of this series, differs formally in that the "edge" is created by another means (fig. 126). In formal terms it carries to fruition the introduction of a geometric plane into the composition that was first suggested in *In the Gray*. While this has been seen as a result of the artist's encounter with the geometricizing vocabulary of his younger Russian colleagues, it may also be seen as a logical step in freeing the "picture" from the fixed plane of the canvas.[48] The pivoting plane of the yellow trapezium creates the illusion of an ambiguous space that is virtual rather than "real," one upon which the painter's "story" unfolds as life unfolds in the existential space of the universe. The effect might also be described in Kandinskyan terms as a "Klang" that has been liberated from the surface of the drum by the stroke of a mallet. Once again a symbolism that held autobiographical significance for the artist confronts the visitor to his realm.

In June 1920, at the age of only two years and nine months, Kandinsky's son Volodia died. A photograph of the artist and his wife that must have been taken at about this time in their Moscow apartment attests to the tragic dimensions of this agonizing loss. Nina's face is drawn and aged, the artist's expression is grim. *Red Oval* would seem to have been painted to commemorate this death.[49] Several recognizable motifs suggest this interpretation. The boat motif here hovers above ranges of mountains and waves on its upward journey. It carries this time only one rower, a figure clad in yellow to signify the gold associated both in Christian iconography and in Finno-Ugric legend with divinity. The familiar association of rowboat and rower with the golden figure of World-Watching-Man echoes again; here the little rower seems to represent the soul of the infant. In fact,

among the Ob-Ugrian peoples it was commonly believed that after death the soul would ride to the other world in a boat; boats were traditionally set atop burial mounds. Kandinsky would also have known of the custom of burial in a boat common among several Finno-Ugric tribes of the far north, as well as among the Yakuts of the Lena river. Other, more shadowy boats follow at lower right.[50]

To the right of center is a jagged form reminiscent of a "broken eggshell," a form that had already occurred in paintings of the Munich period such as the *Untitled Improvisation II* of 1914. In the latter, where it was paired with a leaping trio of horsemen, the "broken eggshell" suggested an association with the creation myth enunciated in the *Kalevala*, in which the universe was said to have originated from the broken egg of a seabird or eagle laid on Väinämöinen's knee in the ocean. For example, Castrén, whose work Kandinsky had cited, related how a shaman in a Karelian village had provided him with a variant on the *Kalevala* creation myth quoting the very lines: "From the egg's upper half was the high heaven's arc [created]."[51]

The central red oval of the title, also resembling an egg, suggests the commemorative intention of the painting. For it was customary in Russia to take eggs, an ancient symbol of rebirth, to the cemetery during the week following Easter as an offering to the deceased. That food must be provided for the dead was a custom rooted in ancient pagan belief, discussed by Kandinsky in his essay on the Zyrians. Most especially, it was the custom to take *red* eggs for this purpose.[52] But in an even more specifically related rite, it was the custom in some parts of Russia from ancient times for bereaved women to throw red eggs into streams at Eastertime to commemorate infants who had died before baptism.[53]

In Russian, the word for red, *krasnyi*, has the dual signification of "beautiful"; hence the icon corner in peasant homes was

126. Kandinsky. *Red Oval*, 1920. Oil on canvas, 71.5 x 71.2 cm. Solomon R. Guggenheim Museum, New York. Photo: David Heald © The Solomon R. Guggenheim Foundation, New York.

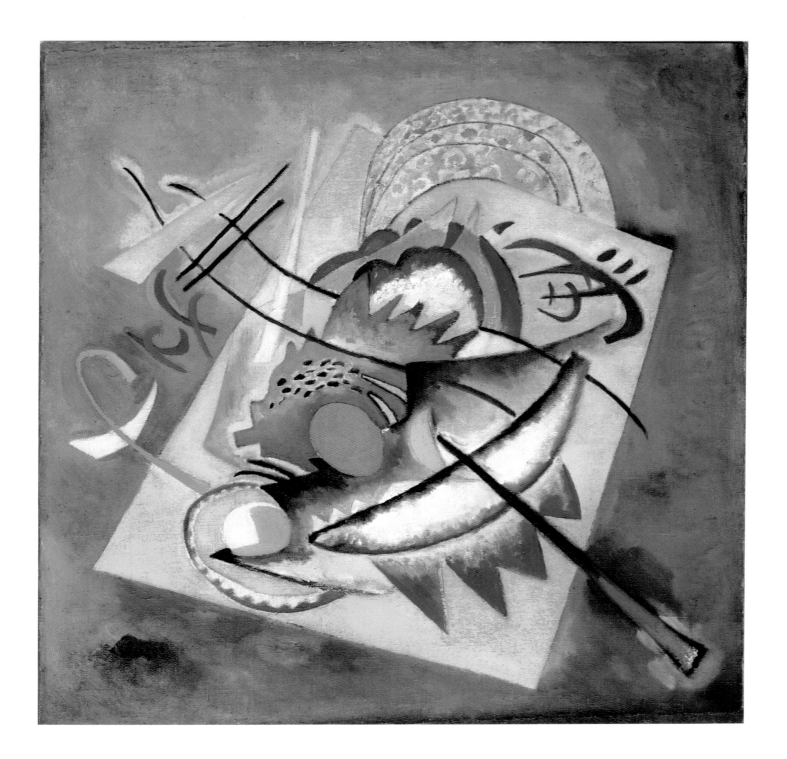

called the "red corner," so that the subtext of the word carries with it a sense of matters sacred. Near the upper left corner of the golden plane rises a red arc with a white diamond pattern suggesting again an Easter egg motif. In Kandinsky's hieroglyphic vocabulary, this pattern is also associated with the serpent motif which, in coiling back upon itself represents the ancient symbol of regeneration.

In the upper right portion of the painting, leaping or flying forms, simplified versions of horseman or bird hieroglyphs, veer off into indeterminate green space. Among the Ob-Ugrians the souls of the dead were often believed to take the form of birds. The form created by the two black lines bending across the composition and linked by two perpendicular lines is reminiscent of the hieroglyph Kandinsky had already developed for an embracing couple. Here the motif suggests the bereft parents. The horn-shaped form, in conjunction with the couple motif, suggests abstracted versions of the "resurrection" motif of old, as for example in *Sound of Trumpets*, and thus the hope of eternal reunion with the lost child. In a season of tragedies, this had been the ultimate tragedy.[54]

Indeed, Kandinsky's enforced sojourn in his native land had been of brief duration and tragic dimension—less than eight years, during two of which the artist produced no oil paintings at all. During this period he had been subjected to powerful forces of personal, social, political, cultural, and aesthetic nature that altered both the outward circumstances of his life and his inner being. In analogy to the shamanic experience, his soul had been torn apart and forged anew on the anvil of fate. He emerged strengthened in will and resolve, having refined and drastically disciplined his aesthetic vocabulary. Despite the cruelties he had endured and the emergence of a new social and political world order, the major works of this period revealed not only his immediate response to those events, but the persistence of his allegiance to ethnographic and shamanic imagery inspired by his roots in the "old Russia" of his creative imagination.

Now, hampered in his efforts to achieve his program for educational reform, Kandinsky recognized a potential forum for his ideas in the newly created German Bauhaus; the time had come for yet another emigration. He had been a foreigner in his native country; he would return to the land of his earlier triumph.[55]

drum and canvas

> Day by day he sang unwearied,
> Night by night discoursed unceasing,
> Sang the songs of by-gone ages,
> Hidden words of ancient wisdom,
> Songs which all the children sing not,
> All beyond men's comprehension,
> In these ages of misfortune,
> When the race is near its ending.
> Far away the news was carried,
> Far abroad was spread the tidings
> Of the songs of Väinämöinen,
> Of the wisdom of the hero

In December 1921, with an official invitation to visit the Bauhaus in hand, Kandinsky left Russia for Germany. Less than four months later he was invited by the school's director, Walter Gropius,

to join the faculty in Weimar. Once again Kandinsky entered a crucial transition period. By now acknowledged as one of the "deans" of modern art and the "founder" of abstract painting, Kandinsky moved from the frenetic revolutionary milieu of Moscow to the more measured and practical environment of the Bauhaus, where he was designated a "master." We may only speculate as to the inner tensions caused by reentry into the German-speaking environment that he had previously shared with his colleagues of the tumultuous *Blue Rider* days and with his German-speaking muse, Gabriele Münter, from whom he was now permanently estranged. Another metamorphosis was in process; he was engaged in a struggle to transform his formal vocabulary. Geometric shapes had already entered his compositions like visitors from another planet. Now, in an effort to overcome all remnants of the past, an entirely new vocabulary had to be forged; yet at the same time continuity had to be assured, the inner self maintained.[1]

As during previous demanding transitional periods, St. George returned to the scene. In a watercolor of this first year in Germany, St. George resumed his role in the conquest of adversity, indicated in *Watercolor No. 23* by the old rider hieroglyph, now clarified by virtue of his airy light background (fig. 127). Armored in blue and his helmet plumed, he carries a long, straight red lance in his clearly defined arm. His horse is a sorrel form

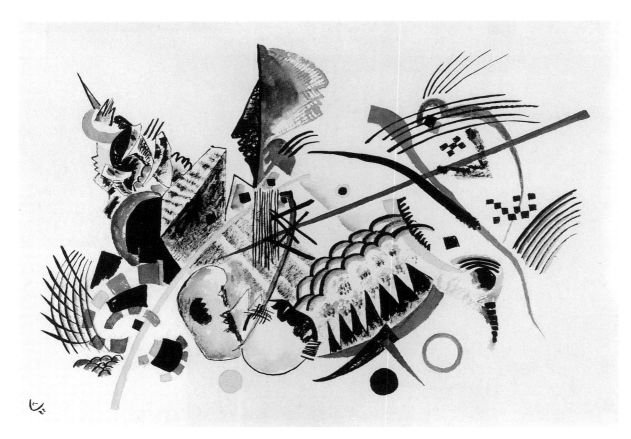

127. Kandinsky. *Watercolor No. 23* (with St. George), 1922. Crayon, watercolor, and India ink, 33 x 47.8 cm. Musée National d'Art Moderne, Centre Georges Pompidou, Paris.

128. Kandinsky. *In the Black Square*, June 1923. Oil on canvas, 97.5 x 93 cm. Solomon R. Guggenheim Museum, New York. Gift, Solomon R. Guggenheim, 1937. Photo: David Heald. © The Solomon R. Guggenheim Foundation, New York.

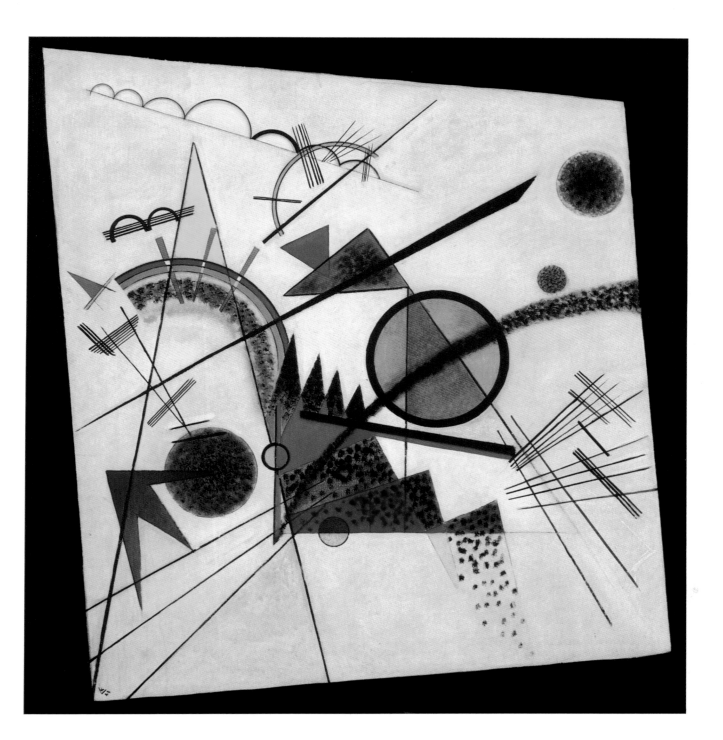

141

with extended black foreleg, and the direction of their common leap is suggested by parallel lines of force. This snub-nosed, seahorse-like figure introduces a new variation on the horse hieroglyph that would often be repeated, even standing in at times for the horseman himself. The saint's feathered headdress flows out in the wind and his coat bears the checkerboard pattern of destiny. As if more than ever aware of a high sense of mission, the artist called frequently during this period upon the checkerboard motif. That the saint here assumes the form of the shaman in magic flight is indicated by the diminutive mountains and clouds ranged below; the scene has been set for *In the Black Square* (fig. 128) a year later. To the lower left tumbles his foe in a swirl of color checks grasping a yielding yellow lance. In the "sky" above the battle loom back-to-back profiles, one dark and one lifting from dark shadow into light. They suggest the contrast of opposites as between id and ego, ego and alter ego, or between the good and evil forces of the universe. The motif as presented here in such overt form might seem unusual in Kandinsky's work, yet it would return in other works of the Bauhaus period. Here, coupled as Janus heads, the profiles suggest not only the new beginning before him but also the psychological stress of confrontation with the past, paralleling and enforcing the conflict represented by St. George's charge. The profiles anticipate by more than a decade the biomorphic forms of the artist's Paris period.[2]

Along with St. George, another driving force with roots in the artist's past accompanied his return to Germany—the vision of the Vologdan peasant house with its magic walls, where he had been overcome by the feeling that he had stepped inside a painting. By his own testimony, that memory was one of the motivating factors in his decision to join the Bauhaus, offering an opportunity to join "synthetic work in space" to "my old dream."[3] His first major project at the Bauhaus was the design of murals for a museum reception room. To a degree the murals enunciated the new geometric vocabulary, but in texture one mural particularly reiterated the elaborate accumulation of incident typical of earlier works, where once again two entities clash in a "battle" of sorts. There the right-hand conglomerate,

set upon a "boat and wave" motif, has grafted onto it a double-horse motif and a "rider" with white arms thrown out. Opposing him is an even more "byzantine" conglomerate, rocking back in a yielding gesture, assailed by "lances." Over the doorways leap the old horsemen hieroglyphs joined by circles, grids, and checkerboards. Again, as if in contemplation of the past, the murals are all on dark grounds, like the early tempera paintings on cardboard of the Munich period. The subject of one of those had been a clash between two jousting knights in full caparison, to which the two mural personages bear an eerie resemblance. The darkly glowing, rich, almost mosaic color texture is reminiscent, too, of *Motley Life*.[4]

Poet and Artist: Sorcerer and Shaman

During this transitional period, echoes not only of Kandinsky's nostalgia for the Munich years but, even more potently, of his nostalgia for "old Russia" came to the fore. Once again his early immersion in Russian folklore and ethnology impelled the direction of his work, as demonstrated in a set of pen-and-ink drawings intended to accompany a selection of short stories by his countryman and contemporary Aleksei Mikhailovich Remizov. At the same time, the drawings provided a means for working out the artist's new geometric vocabulary (figs. 129, 130, 131).[5]

That Kandinsky would have been particularly interested in illustrating the works of Remizov is hardly surprising, for artist and writer drew from the same well. Remizov was intimately familiar with Vologdan folklore, having lived in Ust Sysolsk for an entire year, although for quite other reasons.[6]

In fact, Remizov's first published work, "Maiden's Lament before Marriage," was based on a traditional Zyrian lament published by Lytkin, whose 1889 book about the Zyrians had been cited by Kandinsky in his own essay and reviewed so critically by him in *Ethnographic Review*. Kandinsky had particularly complained that the "lament of the maiden at the time of marriage" published by Lytkin had been "in part reprinted from Mr. Savvaitov. It is also indubitable that this lament is of a much

later origin and with a significant stamp of Russian influence." It seems quite probable that Remizov knew not only Kandinsky's essay but also the reservations expressed in his book review, because in his own recreation of the lament, the poet "improved" upon Lytkin's version by substituting more "authentic" pagan for Christian references.[7]

Adopting an essentially primitivist point of view, Remizov achieved an enchanting naiveté in his tales by employing childish expressions and rhythms of speech. His earliest works, of which *Sunward* is an excellent example, were steeped in the lore of "old Russia." The superstitions, folk characters (like Ivan Kupalo and Iarilo), and rites associated with the spring St. George's Day and the early summer St. John's Night pop up in unexpected ways; the world is apprehended as personified and animated. Similarly Kandinsky had exploited the naive point of view in such fairy-tale works as *Motley Life* (fig. 45), *Song of the Volga* (fig. 39), *The Night, Golden Sail* (frontispiece), and many other early graphics. He had also experimented freely with naive perspective in his Russified adaptations of Bavarian folk paintings on glass, as in *St. Vladimir* (fig. 56), *St. George I* (fig. 69), and the *All Saints' Day* series (figs. 53, 55). Likewise, many of the "bagatelles" of the Swedish interlude affected a child-like and naive attitude, some, like *The Firebird*, transforming Russian folktales into personal fantasies (fig. 112). Moreover, as we know, he had included reproductions of children's art and Russian lubki along with artifacts of primitive cultures in the *Blue Rider* almanac.

Although it has been suggested that the title *Sunward*, in Russian *Posolon* (literally, "toward the sun"), might have been chosen by the author to emphasize the loose association between the tales and ancient myths related to the seasonal cycle, in fact it appears that the title was actually inspired by the phrase used by Kandinsky's friend Kharuzin in his book on the Russian Lapps, where he explained that the wood for the Lapp shaman's drum had to be cut from an alder that was growing "po-solon," sunward. Significantly, this suggests that the actual source for Remizov's title had been in shamanic lore rather than in agricultural ritual. Remizov, who had taken to footnoting his sources

after having been accused of "plagiarism," cited not only Kharuzin's book in *Sunward* but also other authors published in *Ethnographic Review* during the period when Kandinsky had been involved with the journal. He then came as close as he would to actually citing Kandinsky's own article, by including a reference to the Zyrian ort, the "shadow soul," which Kandinsky had discussed at length in a note to his story "Vedogon." There Remizov claimed that his title referred to an ancient Slavic belief in a guardian spirit corresponding to the Zyrian ort. Clearly, he had read that issue of *Ethnographic Review* from cover to cover. In fact, the *Sunward* tales are full of references to specifically Zyrian superstitions and ancient beliefs, to spirits of the house and barn, field and forests, to sorcerers and enchanters. Among the Zyrian spirits whose names became the titles of Remizov tales were Poludnitsa, the female spirit of the rye described by Kandinsky, and the prankish nightmare figure Kikimora. Like Kandinsky, Remizov combined folk legend and primitivist perceptions with Christian beliefs and abstractions, in effect exploiting the concept of dvoeverie that was of continuing relevance to Kandinsky.[8]

Kandinsky's drawing for the tale "Monkeys" (fig. 129), which reads today like a prophetic allegory of racial war, with its motifs of violence and torture in a nightmarish setting, appears at first glance unmotivated. But just as many Remizov stories are dream tales, often juxtaposing incongruous images out of the subconscious, Kandinsky's drawings for them exhibit a similarly loose and apparently illogical juxtaposition of imagery. Two images from "Monkeys" captured Kandinsky's attention: the "rider on a brass horse clad in green copper [who] came galloping like the wind" and the "dreadful rider . . . majestic rider, odious death." Here Kandinsky combined not two but three variants of the horse-and-rider motif along with a coiled and lashing line that clearly resembles a monkey's tail. The horses are represented in one instance by the "snub-nosed" or "blunt-nosed" hieroglyph; another by a "stick-horse" (one short line set at an angle to a long line); and the third by a more naturalistic flowing curved line with flying "mane" and "tail" accompanied by the hooked-curve rider with triangular head, carrying a lance.[9]

129. Kandinsky. Drawing for the tale "Monkeys" by Alexei Remizov. Pencil and India ink, 23 x 17.6 cm. Musée National d'Art Moderne, Centre Georges Pompidou, Paris.

"Monkeys," suggesting the dual function of the drum as both instrument and steed.[11]

Clearly, Kandinsky had more than a passing interest in Remizov, and shamanism was another shared source of inspiration. Remizov, who often compared the role of the writer to that of the sorcerer or magician, and referred to the "magic" of his art, also spoke of his ability to see with the "eyes [that] were given to my soul": "My eye turned to the mysterious in the life of nature, opened up for me the mysterious and magical in human life."[12] A collection of tales and poems Remizov published in Paris in 1924, entitled *Echoes of Zvenigorod: St. Nicholas's Parables*, bore on its cover figures from a Minusinsk shaman's drum that had been published by Klements in 1890 (fig. 132).[13] It is hardly surprising then that Kandinsky, who also thought of himself as a "shaman," would have chosen Remizov's "The Sorceress" as one of the tales he wished to illustrate. Unfortunately,

Another tale to which Kandinsky responded with more or less "readable" imagery was "The Flower" (fig. 130). The tale itself, actually no more than a one-and-a-half-page erotic dream fantasy, contains the images of a flower that the teller transplants and a vengeful snake that transforms itself into a fish. But Kandinsky portrayed the teller himself in the guise of a "Pierrot" in pointed cap and checkered costume. The clownish checkerboard-chested figure with an apparent fountain spraying from between his "legs" suggests in fact Iarilo, the pagan fertilizing sun god of ancient Russian folklore whose resurrectional rites were celebrated in the spring.[10]

Most pungent of Kandinsky's Remizov drawings is that for the tale "The Sorceress," or "The Witch" (fig. 131). Here the shaman's horse-drum and her drumstick, along with a runic hieroglyph or "ownership mark," stand for the sorceress. The double-rimmed circle bears on its face a single "sun," "planet," or "evil eye," and the drumstick is signaled by a bar intersecting the form of the drum. A train of streaming lines dangles from the drum—like the tail of the horse in the drawing for the story

130. Kandinsky. Drawing for the tale "The Flower" by Alexei Remizov. Pencil and India ink, 20.1 x 14.5 cm. Musée National d'Art Moderne, Centre Georges Pompidou, Paris.

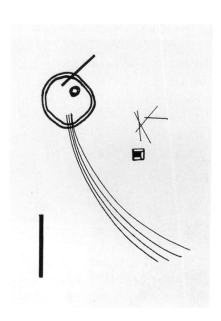

131. Kandinsky. Drawing for the tale "The Sorceress" by Alexei Remizov. Pencil and India ink, 19 x 13.55 cm. Musée National d'Art Moderne, Centre Georges Pompidou, Paris.

eye and feathered hat, clinging tenuously to his back. On either side of the rider his coat of checkerboard pattern flies out, much like the saint's checkerboard coat of the earlier *Watercolor No. 23* (fig. 127). Henceforth, the checkerboard saddle blanket/coat was to accompany St. George in many transformations. His lance counters the direction of the horse and is pointed not downward but upwards, and along its lower edge hangs a clouded or hilly horizon. A circle rides its upper edge, bouncing off triangular

132. Artist unknown. Cover illustration for Alexei Remizov's *Zvenigorod Oklikannyi Nikoliny Pritchi* (Echoes of Zvenigorod: St. Nicholas's Parables), Paris, 1924. Bird Library, Syracuse University.

the project never came to fruition and whether Kandinsky ever showed his drawings to Remizov remains unknown; certainly it is significant, however, that he kept them in his possession until his death.[14]

St. George in Geometric Transformations

With *On White II* of 1923, Kandinsky initiated a new series of major St. George paintings that would culminate, though hardly cease, two years later in *Black Accompaniment* (figs. 133, 135). Thereafter, the St. George motif occurred with superlative freedom in innumerable guises, and often in conjunction with the spring and autumn St. George's Day celebrations. In *On White II*, the black, blunt-nosed horse motif, like nothing so much as a Buriat horse-stick (fig. 74a), streaks across the painting from lower right toward upper left, his blunt-nosed violet rider, with

133. Kandinsky. *On White II*, 1923. Oil on canvas, 105 x 98 cm. Musée National d'Art Moderne, Centre Georges Pompidou, Paris.

elements like sounds off the surface of a drum. To the upper left surge red and yellow mountain peaks, between which a rising or setting sun radiates light. Before the yellow peak races a troika of horse hieroglyphs recalling the troika of Elijah/Thor. Toward the upper right flies a red-and-black "bird." The action is set free from the white plane of the canvas by an underlying brownish trapezoid. This device of separating the elements of a motif and then reassembling them in variant arrangements was now to be frequently employed by the artist.[15]

Although a strictly literal "reading" was not Kandinsky's intention, he hoped to express the transcendental significance of the work in the sum of the tensions and energies released in his effective orchestration of colors, lines, and forms activating,

or animating, the plane of the canvas. By means of the device of figural fragmentation, already introduced in the works of the late Munich period, further explored in Russia, and now applied to his geometric works, Kandinsky became adept at structuring the elements of his "picture" upon the ground plane in such a way as to emphasize the compositional tensions of his works while submerging the narrative content. As in a Symbolist poem, the primary elements of the work served merely to suggest, not to "narrate."[16]

Kandinsky took up the St. George motif again in *Through-going Line* in March 1923 and in *Open Green* (fig. 134) the following November, marking the spring and autumn St. George's days. In both cases a horse-stick rises from lower left to upper right, its head defined in the one case by a short striped bar and circle, and in the other by three black strokes crossing the stick of his back at upper right. Whereas the rider of *Through-going Line* combines the blunt-nosed figure with an interior triangle for head and transparent body within a dark outline, the autumnal rider is composed of a circle for body and a triangle suggesting the arm, a circle in yellow and orange defining the head, capped by a plumed helmet. His dual shamanic function is suggested in the first case not only by his magic flight but by his compositional function as a link between the upper and lower worlds, leaving behind a "picture within a picture" that may be interpreted as the tale of his magical journey. Again a checkerboard rides with horse and horseman. Before him lies his destiny in the affective world marked by its mountainous landscape in the round sphere of the planet that is "home." The location of the serpent further identifies this area as that of "earthly" concerns. The shaman-rider of *Open Green* also rises above the mountaintops, his steed, its forelegs raised for the leap, adorned as well by a multicolored saddle blanket. In keeping with a shamanic reading of the St. George figure, the tall white form at the left may be read as the "world pillar" supporting the ghostly alter ego of the shaman.[17]

Now Kandinsky committed to canvas his idealist message of the ultimate triumph of good over evil, and the salvation of the

134. Kandinsky. *Open Green*, 1923. Oil on canvas, 97 x 97 cm. Blue Four–Galka Scheyer Collection, Norton Simon Museum, Pasadena.

world through the healing powers of a spiritually directed art, in two of his grandest St. George paintings. *In the Black Square* painted in the summer of 1923 and *Black Accompaniment*, painted about a year later, display the artist's skillful experimentation with figural fragmentation and structural assemblage at its most daring (figs. 128, 135).[18] But in the first instance, his annual recognition of the spring St. George's Day was disrupted by the tragic circumstances of his renewed correspondence with Arnold Schoenberg, his colleague of *Blue Rider* days. As it happened, it was in April 1923 that Kandinsky wrote to Schoenberg, inviting him to join the Bauhaus. But in an atmosphere poisoned by rumor and deceit, Schoenberg replied that as a Jew he would feel out of place at the Bauhaus, directly accusing Kandinsky of anti-Semitism. Kandinsky received this letter on 23 April, St. George's Day, and the following day penned his stricken and poignant reply. Finally, on 4 May, Schoenberg responded with a long and tortured analysis of his condition as a Jew and human being, condemned by a society determined to recognize either the Jew or the human being but not both at once. The artist was now forced to recognize that the halcyon Munich days were lost forever; the world was blacker than he had ever wanted to know. Restrained by grief from replying to Schoenberg's outpouring, Kandinsky immediately transformed his emotion into a recreation of that beloved image so powerful in its promise of regeneration and hope, another St. George painting that he called *In the Black Square* in June 1923 (fig. 128).[19]

For Kandinsky, black was that "*nothing without possibility*," that "*nothing after the quenching of the sun . . . an eternal silence without future and hope.*" It was the silence "represented in music by that final, closing pause—after which the continuation follows like the beginning of another world—because *this* closing pause is finished for all time." But—and here Kandinsky left open the crack for hope—black is the color against which all others resonate the strongest. His resonant, regenerational St. George, in his watchful and healing roles as World-Watching-Man and shaman, soars on a white trapezoidal plane that is bound to rise beyond the black silence. And indeed, as we know, a reconciliation of sorts with Schoenberg finally did take place in the summer of 1927.

Kandinsky had often stated that the work of art must "resound" (*klingen*). According to his theoretical scheme, the ground plane of the canvas is a "living being." Here the canvas resounds like the shaman's drum telling the tale of a magical flight. In the *Blue Rider* almanac, he had written: "The world sounds. It is a cosmos of spiritually affective beings. Thus dead matter is living spirit." Now he was soon to write: "I would like, in fact, that one finally sees, what lies *behind* my paintings . . . and not be content with the determination that I use triangles or circles." With *In the Black Square* Kandinsky had taken an audacious risk and won. He had animated the canvas to speak of transcendent things without recourse to traditional means of narration. His drum resounded with the tones of hope, faith, and triumph to a degree seldom matched in the annals of modern art.[20]

Within the year his sense of self-irony and humor brought about a wry comment on this work. *Black Accompaniment* of 1924 recalled to service the good-humored St. George of the Munich paintings, now in his guise as World-Watching-Man with arms outflung and his white horse plunging from the blackened sky, attacking the hapless, goggle-eyed dragon at lower left, as in *St. George III* of 1911 (figs. 135, 71). Here St. George's body is a russet brown circle inscribed by a white border. This "drum" is the color of the shaman's drum, and the saint-shaman seems to raise a mallet (in his foreshortened right hand) to beat it. His right arm is shown extended, in a pinkish sleeve, while the extended left arm is indicated by a series of parallel white lines. The saint's head is one-eyed and chinstrapped, his feathered headdress suggested by three flying yellow triangles that give him a somewhat astonished expression. Beyond him a boat-like motif with furled sails offers another means of transport. The horse's one-eyed head is a lavender triangle, his arched neck and flying mane again beribboned, his forelegs raised in leaping form. His piebald back is signaled by a lance-like thrusting form. His tail flies out behind his rider's and his own multicolored coat.

In a related drawing of 1924, the arms-outflung attitude of World-Watching-Man is dominant, straight lines flying out from an enormous round body, but the serpent assumes a more classical lashing form and pose, superimposed upon the horse and

135. Kandinsky. *Black Accompaniment*, March–June 1924. Oil on canvas, 166 x 135 cm. Private collection, Switzerland. Photo Martery: Jean Testard, Lausanne.

149

136. Kandinsky. Untitled drawing, 1924. Ink on paper, 23.5 x 32 cm. Dedicated to M. Maeght. Collection M. and Mme Adrien Maeght, Paris. Photo: Claude Gaspari.

rider (fig. 136). The horse has been reduced to a single hooked line, "abstracted" from the very similar form in *Black Accompaniment* (for which, in fact, this may have been a sketch), and the rider's identity as World-Watching-Man is emphatically declared by the all-seeing eye emblazoned upon his chest.[21]

These works triggered an avalanche of variations on the theme of horse and rider, St. George and dragon, riding shaman and drum that are marvels of disassociation and reconstruction, of dissemblance and significance, often sounding the syncretic theme of dvoeverie with poignant resonance. Like a magician, the artist practiced his transformational wizardry, leaving clues in the telltale checkered saddle blankets, thrusting lines of force, levitating plumed helmets, triangular or snub-nosed horse-heads (now raised for the leap, now lowered to graze), brilliantly confounding horse, rider, lance, and drum. Sinuous elements, part bird, part fish, like wings in the wind or tendrils in water, anticipate the Paris inventory of biomorphic imagery already in transition (fig. 137).[22]

Kandinsky had already imposed a "Remizovian" metamorphosis on his St. George motif in a 1924 work known as *Drawing No. 4*, in which he had transformed the horse and rider into a pike—the fish sacred to many Siberian tribes and nemesis of the *Kalevala* boat. Here the sacred pike wears St. George's checkerboard saddle blanket. That he is indeed a fish breaking the surface of the water is suggested by a row of boats. His identification with St. George is also clearly indicated by the lashing serpent pierced by the saint's lance that he attacks. The saint himself appears only as a circle with elongated triangular "head-dress." Kandinsky's transformational play with this motif was demonstrated yet again that year in an untitled etching where St. George, wearing his checkered coat and helmet and riding his hooked-curve horse with its checkered saddle blanket, attacks the sharp-toothed pike, here standing in for the serpent. That the boat of the *Kalevala* heroes foundered on the back of a giant pike adds yet another layer of significance. Two years later, brilliantly transformed, the toothy pike, ridden by a hooked-curve St. George, would appear with renewed vigor in the painting *Tension in Red* (fig. 138).[23]

Multiple meanings and transformational devices are the familiar ploys of Russian folklore and fairy tale, in which frogs turn into princesses and princesses into arrows and "an apple rolling over the silver saucer conjures up visions of distant lands." Through this accumulation of disparate but related meanings the artist achieves narrative tensions, just as, through the assemblage of disparate figural segments, he has achieved compositional tension. That Kandinsky was able to make such subtle, self-mocking jokes in the face of vitriolic public attack on his work tells a great deal about his courage. He was at the height of his powers and he was undaunted.[24]

In this series of St. George paintings, the circle had become an integral part of the St. George/World-Watching-Man/drum conglomerate. Already the artist had moved to disassociate the circle from all other elements, using it alone for the first time in paintings like *Circles in the Circle*, 1923, and *Several Circles*, 1926. But once again in 1924 he returned to a theme of the Munich period, translating *Small Pleasures*, which he had already

137. Kandinsky. *Hard but Soft*, October 1927. Watercolor, opaque white, and India ink on paper, 48.3 x 32.2 cm. Solomon R. Guggenheim Museum, New York. Gift, Solomon R. Guggenheim. Photo: Robert E. Mates. © The Solomon R. Guggenheim Foundation, New York.

revived once before in *Blue Arc*, into the formal language of his new style. In *Retrospect*, a title reminiscent of his 1913 memoir, circles entirely replace the riders leaping up the sides of the mountain. Once again the shamanic heroes of the past were to animate the plane of the world mountain, providing the continuity he required (figs. 121, 139, 140).

Indeed, in retrospect, the entire composition has been clarified. The lowermost rider, he of the arms-outflung, World-Watching-Man pose in the earlier painting, is now a transparent circle floated before an upside-down "mountain range" motif that in turn helps to emphasize the concentric movement of the composition, reinforced by the blue arc sweeping above the mountain. Below this mountain-rider circle rocks the *Kalevala* rowboat (displaced from its earlier position on the right of the mountain), whose passenger is outfitted in "golden" orange. His brethren rider-circles (one blue, another blue with a yellow center) continue their upward flight, bypassing a pinkish seahorse-like creature that anticipates future developments. Topping the mountain, once inhabited by vaguely architectural forms, stands a figure with a golden head and robe, his blue arms outflung, a small color circle hovering at heart level—surely yet another representation of the Golden Prince. Another horseman in the form of the old hooked curve has been added at upper right. Below him, also to the right of the mountain, a sailboat plies cosmic waters. Meanwhile at upper left, where they might least be expected, two serpent motifs hover on either side of a "through-going" line, its direction contained by a radiant planetary motif. This serpent/rod image suggests, without imitating, the healing symbol of the caduceus, while echoing the usual Elijah/Thor motif. The central sunburst around which the entire composition swirls, together with the disorientation caused by mountains peaked in opposing directions and the turning motion of the sky's "blue arc," once again suggest the painting's inspiration in the shaman drum as cosmogonic "map" of the universe.[25]

Clearly, Kandinsky had by now thoroughly subsumed the signifiers horse-and-rider, St. George, World-Watching-Man, and drum-horse into one multisignificant motif: the circle. In statements Kandinsky intended to be made public, he more than

138. Kandinsky. *Tension in Red*, 1926. Oil on cardboard, 66 x 53.7 cm. Solomon R. Guggenheim Museum, New York. Photo: David Heald. © The Solomon R. Guggenheim Foundation, New York.

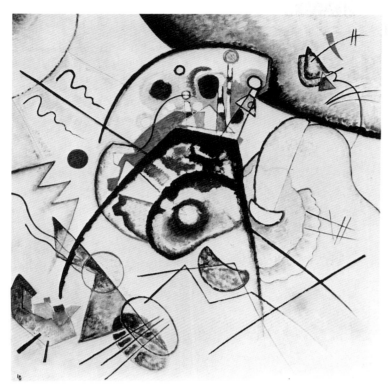

139. Kandinsky. *Rückblick (Retrospect)*, 1924. Oil on canvas, 98 x 95 cm. Kunstmuseum Bern. Gift of Nina Kandinsky. Photo courtesy Solomon R. Guggenheim Museum, New York.

once offered detailed explanations for his use of the circle. Not only did he tell Grohmann that he wanted people to see what lay behind his circles and triangles, but he characterized them unabashedly as "romantic" and "symbolic." [26] Perhaps most revealing was his statement to the psychologist Paul Plaut in 1929: "If, for example, in recent years, I use the circle so often and passionately, the reason (or original reason) for this is not the 'geometric' form of the circle . . . but rather . . . the inner power of the circle in its countless variations; I love the circle today as I previously loved, for example, the horse—perhaps more, because I find in the circle more inner possibilities, which is why it has taken the place of the horse." [27]

For Kandinsky the circle could, and did, hold multiple meanings that he himself considered both "symbolic" and "romantic." Significantly, the form had "taken the place" of that magical horse, just as, in the artist's mind, the shaman's horse-drum and the sound of the drum had become associated with the image of the circle. From the early twenties on, circles proliferated in his work as devices of metamorphosis. [28]

Circle, Drum, and Horse

In the spring of 1925 Kandinsky began a series of paintings that can only be described as "drum paintings." The Lapp

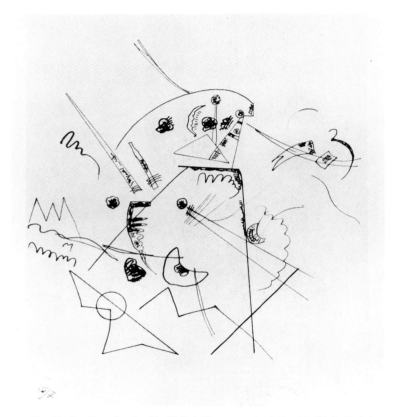

153

140. Kandinsky. Drawing for *Rückblick (Retrospect)*, 1913–1924(?). India ink, 35.5 x 30.6 cm. Musée National d'Art Moderne, Centre Georges Pompidou, Paris. Photo courtesy Solomon R. Guggenheim Museum, New York.

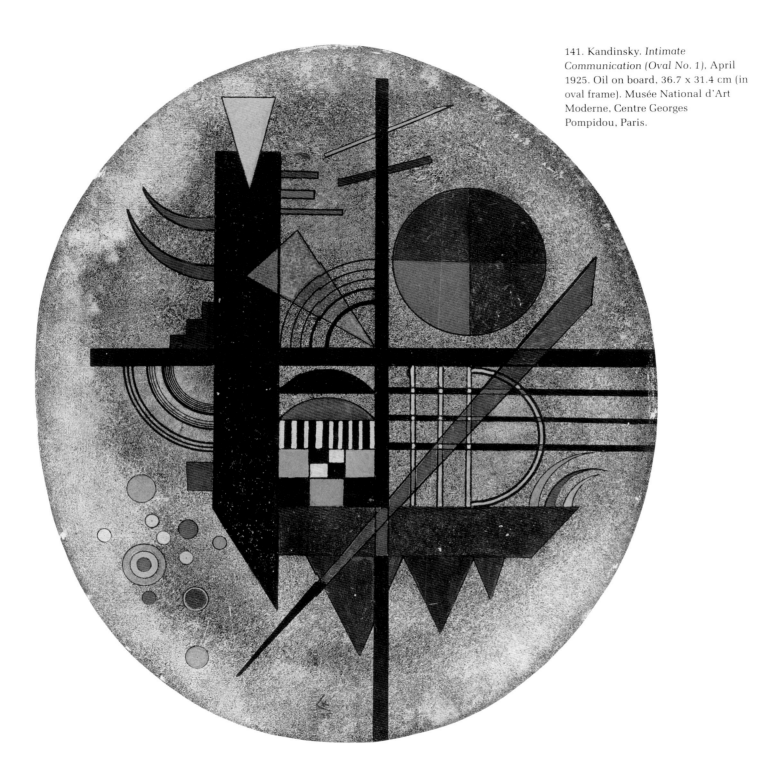

141. Kandinsky. *Intimate Communication (Oval No. 1)*, April 1925. Oil on board, 36.7 x 31.4 cm (in oval frame). Musée National d'Art Moderne, Centre Georges Pompidou, Paris.

shaman drum in the collection of the ethnographic museum in Munich had inspired his approach to *Composition V*, and the concept of the drum as the shaman's magic horse and cosmogonic map had already begun to inform his work. He had clearly expressed this concept and anticipated much of his later work as early as 1911 in the painting *In the Circle* (fig. 90). At the Bauhaus he had already created a major painting in which the "picture" was entirely contained within a circle—*In the Black Circle*, of 1923. With its black form set spinning on a pale, airy ground, its lashing world-serpent and "lunar landscape," it had suggested with particular force the concept of the painting as cosmogonic map.[29] A visit to Dresden in February 1925 may well have provided the immediate impulse for this series, for it would also have afforded the opportunity for a visit to the city's ethnographic museum, where the famous Lapp "Klemm drum," described at length by his colleague Mikhailovskii, was on display, along with costumed mannequins representing Siberian shamans with their drums. Perhaps the displays called to mind similar ones in Stockholm, where he had enjoyed access to the largest collections of Lapp shaman drums in the world.[30]

The first of the drum paintings, all fitted with oval frames, was *Intimate Communication (Oval No. 1)*, painted in April 1925 (fig. 141). Not only in shape but in color, and in its figures, it recalls its inspiration in the genre of the shaman drum. In size it also approximates the Lapp drum and some of the smaller

Siberian drums, measuring 36 by 32 centimeters, almost exactly the same size as the Lapp drum in Munich that measured 37.5 by 32.9 centimeters. The ground of the painting is brown umber, evocative of the antique skins of ancient shaman drums. It is divided, as were many Siberian drums, into quadrants (fig. 142); a "drum" within a drum at upper right mimics this partition (although its segments are equal). In most Siberian drums, this division is evident in the frame. In Kandinsky's thumbnail sketch for his house catalogue, his notation of this "drum" might be taken for an ethnographer's schematic drawing of a Siberian shaman drum. Even the drum within a drum is a convention often found on shaman drums, as illustrated by Potanin (fig. 143). The Dresden Lapp drum also has circles representing stars, perhaps

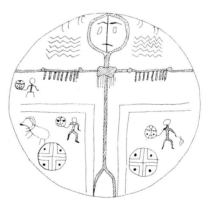

143. Altaic shaman drum schema: interior and exterior designs. From G. N. Potanin, *Ocherki Severo-Zapadnoi Mongolii* (St. Petersburg, 1881–1883), vol. 4, pl. VI (nos. 55, 56).

155

142. Altaic shaman drum schema. From G. N. Potanin, *Ocherki Severo-Zapadnoi Mongolii* (St. Petersburg, 1881–1883), vol. 4, pl. X (no. 65).

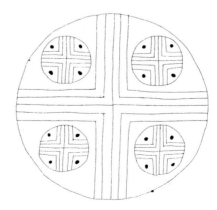

a constellation, as Klemm had suggested, on its surface. The smaller circles in the lower left quadrant of *Intimate Communication* are clearly reminiscent of the signs for planets, stars, sun, and moon on such drums.

It is not surprising to find the combined motif of circle and triangle—here expressed as semicircle and triangle in the upper left quadrant—already identified as a symbol of sound; for this is a sounding drum. The title of the work, *Intime Mitteilung* (Intimate Message, or Intimate Communication), also suggested the notion of sound—the voice of the drum or the secret language of the shaman. Jochelson, as noted, had remarked that among the Koryaks "the power of the drum lies in the sounds emitted by it," and that "the sound of the drum, just like the human voice, or song, is in itself considered as something living, capable of influencing the invisible spirits." For Kandinsky the "ground plane," that is, the surface of the painting itself, was also a living being that could be coaxed into emitting "Klänge," even an entire "orchestra" of sounds; it could be "animated" by the artist as the shaman animates his drum.[31]

The through-going lance form recalls at once St. George/World-Watching-Man, especially in combination with the circle in upper right and the semicircle it crosses at lower right. Both grid and checkerboard accompany this configuration as well. The figure formed by the vertical bar at left with a triangular "head" may allude to the shaman himself or to his guardian spirit or "master." Among the Altaic peoples, the figure of the deity was often the central motif of the shaman's drum (figs. 142, 143).[32]

In the upper sphere, the "heavenly" area of the shaman drum's surface, the central vertical bar is crossed near its top by two narrower bars aslant, suggesting the configuration of the Eastern, or Russian, cross and again enunciating a syncretic theme. Christian crosses had been common motifs on Lapp shaman drums from the earliest days of Christianization, quite often marking the home of Radien, the highest pagan god, or indicating settlements with Christian churches (figs. 82b, 83, 144), and several crosses are depicted on the Lapp drum at Dresden.[33]

Across the lower two quadrants of the painting a linked series of blue triangles suggests the upside-down mountain-

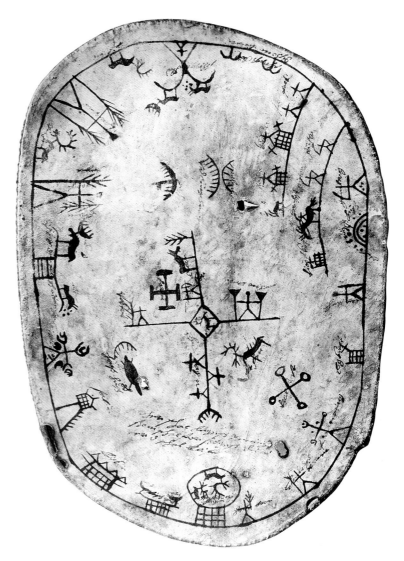

144. Lapp shaman drum. Reindeer hide stretched on pine, 47.5 x 31.8 x 8.7 cm. Nordisk Museum, Stockholm (no. 228.847).

range device observed before. On Lapp drums just such a row of linked or separated triangles, identified as tents, encampments, and sometimes, when standing alone at the "top" of the drum, as the home of Radien, as in the case of the Munich drum, is often to be found along the rim or sometimes even floating free

(fig. 81).[34] Among the curious devices of the Lapp drum was the abstracted horizon line, echoed by this mountain-range figure, usually indicated on the drum by a curving line (sometimes doubled) upon which houses, animals, figures, tents, and trees might be stationed. Such "floating" horizon segments may be found anywhere on the drum, either attached to the rim or quite separate. In some cases they were intended to suggest "paradise" or the world beyond, in others, this world or the netherworld (fig. 144).[35]

The following year Kandinsky published a drawing based on this painting in his book *Point and Line to Plane* (fig. 145). Here the "figure" has been transformed into a pattern of bars crisscrossing each other to create grid and checkerboard patterns, its new proportions suggesting a figure with outstretched arms. St. George is still adumbrated in the juxtaposition of lance and circle, while a "sound motif" (a circle radiating lines) is substituted for the "mountain range" motif at lower right. A little off-center, one of the grid squares is divided into eight segments, creating a sunburst effect reminiscent of the sun motif on Lapp drums, where it is also, often as not, off-center. But here Kandinsky has brought the vertical line of the "cross" that creates the major division of the picture into the exact center, whereas in the painting this line was off-center, initiating an effect of energy and motion, an instability that was countered by the heavy vertical bar of the "deity."

Almost immediately, in May 1925, Kandinsky followed with another drum painting. Untitled, it is catalogued simply as *Oval No. 2* (fig. 146). In this work the ground is white but, perhaps because of the umber tones stippled over several of the figures, also evokes a primitive design on deerskin. Again the surface is divided by a convergence of straight lines into right and left, upper and lower areas. In this case the central divider has the general appearance of a tree trunk with branches, its crown consisting of two small triangles at the very top, which may also be read as a boat. A branch like a tree shoots off toward the upper left, sprouting its own smaller branches. This configuration approximates the tree branching off the sun's central ray on the Stockholm drum published by Friis (fig. 144), but it recalls even

more precisely another Lapp drum reproduced by Friis, with its branching tree likewise sprouting toward the upper left from beneath a triangle perched at the top of the central "sun" motif's radiating line (fig. 83). In Kandinsky's painting, another "branch" stretches out toward the right rim. But this branching structure clearly symbolizes the world-tree, so often depicted on Siberian shaman drums, upon whose branches were to be found the nests

145. Kandinsky. Drawing on the theme of *Intimate Communication*, ca. 1926. Pencil, red crayon, and India ink on notebook paper, 38.6 x 30.8 cm. Musée National d'Art Moderne, Centre Georges Pompidou, Paris.

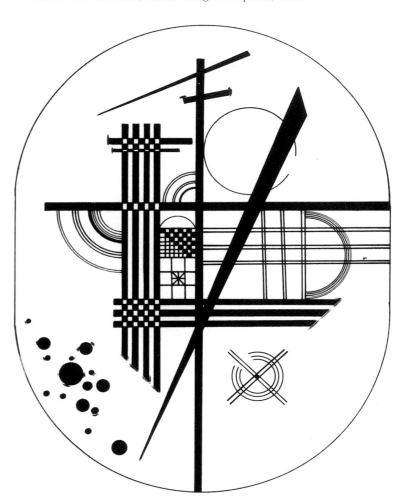

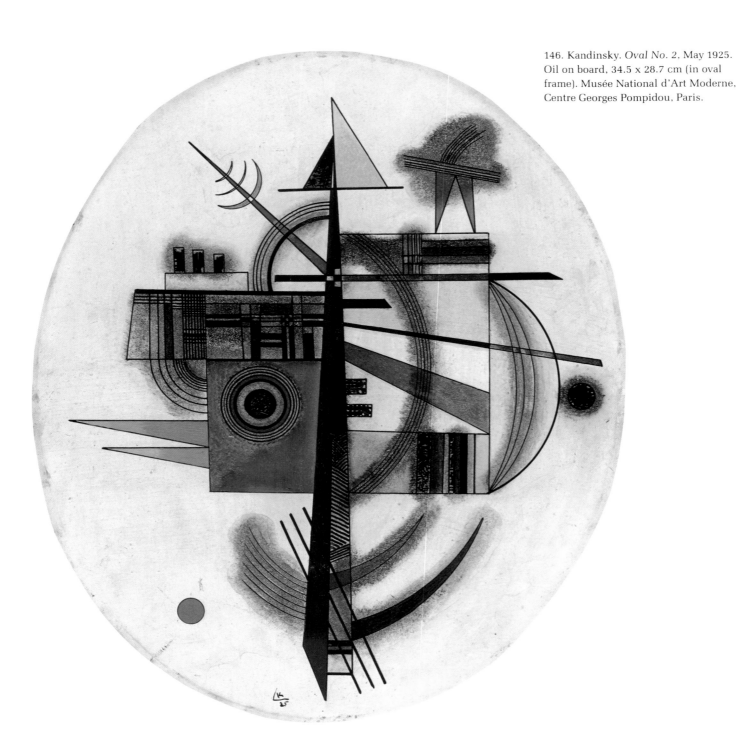

146. Kandinsky. *Oval No. 2*, May 1925. Oil on board, 34.5 x 28.7 cm (in oval frame). Musée National d'Art Moderne, Centre Georges Pompidou, Paris.

or mythical "cradles" where the first shamans were raised and where, according to the legends of peoples as widely separated as the Ob-Ugrians and the Nanai, the souls of children were said to reside before birth. On the right "branch" of Kandinsky's world-tree sits a rectangular "nest" with a figure that may well represent the "bird-soul" of Finno-Ugric, Ob-Ugrian, and Altaic belief balancing upon it.[36]

Yet this figure has a double aspect, for it clearly echoes the stick-figure gods that balance on the directional cosmic map configurations of Lapp drums, the most powerful of which was Hora Galles, the Lapp equivalent of Thor/Perun.[37] Singularly striking is the uncanny resemblance between Kandinsky's nesting "Thor bird" in *Oval No. 2* and the Thor with triangular legs and flying hair represented on the Lapp drum schema reproduced by Friis (figs. 82, 147). Kandinsky's "god" standing on points with outstretched arms has rain where his head should be—a real "thunder god," with a cluster of curving parallel lines denoting the deluge.

In fact, the artist would use the Thor/Perun figure based on the Lapp drum precedent as the subject of an entire painting, *Black Triangle*, and of a lithograph published in *Point and Line to Plane* (fig. 148). In that painting the figure is elaborated to the

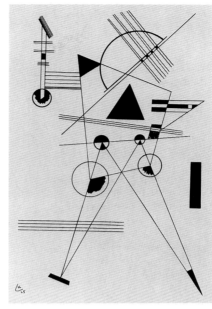

148. Kandinsky. *Lithograph No. 1*, 1925. 33.1 x 20.7 cm. Published in *Point and Line to Plane*, 1925, no. 23. Musée National d'Art Moderne, Centre Georges Pompidou, Paris.

point of being clearly recognizable as Thor holding his distinctive hammer. He, too, is very similar to the Hora Galles figure on the Berlin drum, second from right (figs. 82, 147). The pinwheel motif of the painting, which Kandinsky omitted from his print, is an elaboration of the traditional *Hammerkreuz* that symbolizes Thor on many shaman drums (as in fig. 144). In both painting and print Thor's chest is branded with the triangle that normally marks the home of the highest god. Although the legs of Kandinsky's figure are more pointed, the lines that form them also cross at the pelvis as in the Lapp drum drawing. Indeed, Kandinsky seems to have known the Lapp drums reproduced in Friis; there he would have found not only the Thor's hammer motif but also figures in which the legs were represented by very similar pointed triangular configurations.[38]

At the foot of the tree in *Oval No. 2*, three diagonal lines suggest a ladder-like structure affirming the "heavenly ascent" theme. At the juncture of the tree's "branches" is a cluster of three yellow spots suggesting the sun motif. A circle with concentric rings in the middle left quadrant is reminiscent of the motif associated earlier with sound. The themes of drum and world-tree are indissolubly united since the magic drum, by

159

147. Thor figure, schematic detail, from Lapp shaman drum. Museum für Völkerkunde, Berlin. From E. Manker, *Die lappische Zaubertrommel*, vol. 2 (Stockholm, 1950), drum 5, illus. 42, p. 70.

means of which the shaman attains his flight, is made of the wood of the world-tree. As Eliade has so eloquently expressed it: *"By the fact that the shell of his drum is derived from the actual wood of the Cosmic Tree, the shaman, through his drumming, is magically projected into the vicinity of the Tree."* [39]

In *Über das Geistige in der Kunst* Kandinsky had written with admiration of the "primitive's" bold use of red and blue. In *Oval No. 2* the brilliant sea blue of the rectangular box at the lower left side of the tree, with its pendant bright red triangles, suggests the red and blue combinations of Northwest Coast American Indian artifacts, as frequently seen, for example, in Tlingit masks, boxes, and shaman rattles, such as Kandinsky would have known from displays at the Rumiantsev Museum, the ethnographic museum in Berlin, and elsewhere. In combination with the immediately adjoining geometric pattern in black, brown, and red, which also evokes similarly painted and carved Tlingit and Haida masks and storage boxes, artifacts of the Northwest Coast American Indians are inevitably brought to mind.[40]

Kandinsky must have been fascinated by the Tlingit designs in which abstracted figures representing beaver, whales, and ravens were disassociated from their familiar structure and reassembled on the two-dimensional surfaces of such artifacts, as for example, on the dancing blanket he had illustrated in the *Blue Rider* almanac (fig. 97). Kandinsky had clearly learned to employ this method in constructing his own works. Perhaps he had this combination of colors and the primitive expression of such abstract shapes in mind when he painted this configuration, although it looks less like a beaver or whale than like a bird. Indeed, a Tlingit shaman's dancing mask in the form of a raven's head, now in St. Petersburg, suggests a direct source for Kandinsky's motif (fig. 149). When perceived in this context, the central motif of *Oval No. 2* is seen at once as just such a magical bird, and the small figure in the nest above becomes a peeping Thor-bird.[41]

Still closer to home, as it were, Kandinsky's own collection of folk art included a carving of a small bird with an unusually long beak and large round eye (denoted by a black dot surrounded by a black circle set within a larger light-colored circle), apparently representing a woodcock or similar bird of the sandpiper family (fig. 150). It may well have been a memento of his Vologda excursion, the sandpiper being one of the "magic birds" of Finno-Ugric legend. The long-billed bird also evokes the woodpecker, associated in Russian and Finno-Ugric lore with the sacred oak as well as with thunder and rain. Indeed, as we have already noticed, the beaked bird depicted here harbors a small "thunderbird" in its nest.[42]

When viewed without the veil of "abstraction" to cloud the eyes, but rather with the straightforward, open-eyed gaze of the child, this painting is clearly about a bird in a tree with its young in a nest. The Ob-Ugrian and Siberian myths Kandinsky knew about the bird-souls of children that the shaman fetched from the heavenly tree are the foundation of this painting, grafted onto structures suggested by Lapp drum precedents. The association of world-tree, shore bird, woodpecker, thunder god, boat, and ladder strongly suggests a multidimensional reference to shamanist themes of the world-tree with its bird-souls, to myths of the thunderbird, and to the imagery of Lapp and Siberian drums. But the picture may have had an even more personal meaning for Kandinsky.

The legend of the bird-soul in the world-tree was the basis of widely reported rituals for fulfilling the wish of a barren woman for a child. Among the Goldis, for example, it was believed that in shamanizing with his drum, the shaman could fly to the celestial tree in order to retrieve the soul of an infant for a bereft or barren woman. Priklonskii had also reported that in another ritual to relieve barrenness, the Yakut woman was guided by the shaman into the forest, where a tree with boughs only at the top was selected, under which a *white* horsehide was spread. The woman then sat upon the hide around which the shaman "conjured the spirits." Perhaps this shaman's drum with its bird-soul symbolism had a special significance for a couple who had lost one child and may have longed for another. Nina Kandinsky's passionate comment in her autobiography about the first painting in this series, *Intimate Message*, might be interpreted as supporting this speculation: "In this picture, that he painted for me,

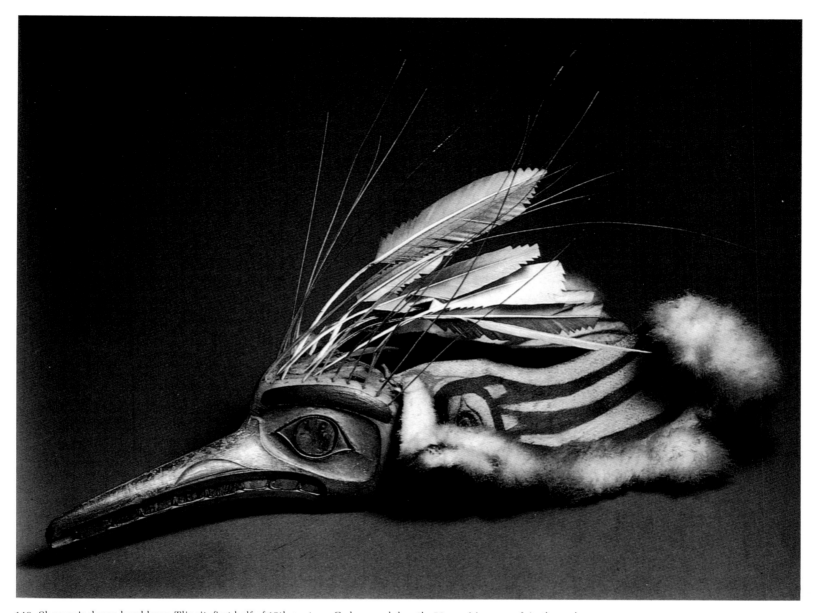

149. Shaman's dance headdress. Tlingit, first half of 19th century. Cedar wood, length: 50 cm. Museum of Anthropology and Ethnography, St. Petersburg. With permission from Rudolph Its, ed., *Peter the Great Museum of Anthropology and Ethnography* (St. Petersburg: Aurora, 1989), no. 13.

150. Carved wooden bird from Kandinsky's personal collection. Russian folk carving. Wood, painted, 7.8 x 3.3 x 8.7 cm. Musée National d'Art Moderne, Centre Georges Pompidou, Paris.

Kandinsky speaks with me and I with him. It is a conversation that is meaningful only to us and that we will take with us in all eternity."[43]

Whispered, the next in Kandinsky's series of drum paintings, was also painted in May 1925 (fig. 151). Paradoxically, it is at once the most "abstract" and the most telling of these magic pictures. Here the cosmogonic map theme is most apparent. The orbs of planets, suns, and moons are drawn on a surface that is again antiqued by tones of umber and sienna. From the upper left fall parallel curving lines suggesting the fertilizing rain of the thunder god. Their curving configuration also suggests the rainbow, and among the Finno-Ugric peoples the rainbow was often said to be Thor's bow. The rainbow, too, was often represented on Altaic shaman drums. On a high mountaintop at upper left stands a vertical figure crossed by three perpendicular lines, clearly symbolizing the world-tree at the top of the world mountain.[44] Nearby hover two other figures, their "heads" separated from their "bodies." One figure in a vertical position seems to be robed; before him hovers a smaller figure in a horizontal position. Below them two curving lines suggest the motion of rocking. Is this then the shaman in the act of fetching the infant bird-soul from the branches of the world-tree? Near the center floats a large planet or "sun" in the general area occupied by Peive on Lapp drums; its stippled bluish-gray suggests a distant planet. Toward it streak lines from the rim, intersecting other lines that point beyond. At lower left, attached to a slanting horizon line backed by a setting or rising sun, are two of the "mountain" or "tent" motifs characteristic of Lapp drums; here they suggest "steps" to the world-mountain. To their left is attached a "planet." Along the right rim semicircular elements rise up. At upper right five soft-edged bars standing on the rim suggest mysterious beings. From the middle of the top rim a triangular form, in the position traditionally assigned to the home of Radien, the highest god, thrusts its point toward the center.

The drastic abstraction of the design is reminiscent of many Siberian drums (figs. 142, 143). The vertical division into left and right sides, representing the "night" and "day" sides, respectively, is also characteristic. At the same time it follows Kandinsky's own scheme which designated "earthly" concerns at lower right and "heavenly" at upper left. Moreover, it was to the oval that Kandinsky assigned the greatest ability of all "ground planes" to "transcend geometric forms." But again the figures, especially the placement of the triangular home of Radien, suggest the precedent of Lapp drums. In color, this painting closely approximates the Munich Lapp drum with its somber antique brown umber and red sienna intonations, suggesting the solemnity of the "whispered" message. The title, *Whispered*, further suggests the private significance of the painting.[45]

A year passed between this painting and the next in the series. *Easter Egg* of April 1926 was specifically dedicated on the reverse side "for Nina" (fig. 152). As in the case of the previous drum paintings, this too owes much to its Lapp precedents. At the center is found again a red "sun" or Peive symbol. Recognizable, too, are the angular line of mountains at lower left and figures standing on the side of a triangular mountain at upper left. But the most striking motif is directly readable as a ship with checkerboard smokestacks moving across the lower center from right to left, and beyond the ship, a breakwater with lighthouse, attached to the upper right rim. Waving flags appear to float forward, while a circle at lower left seems to sport a "sail." Again Lapp drum precedents with their ubiquitous boat motifs are recalled. Despite the gaiety of the red sun, blue and yellow

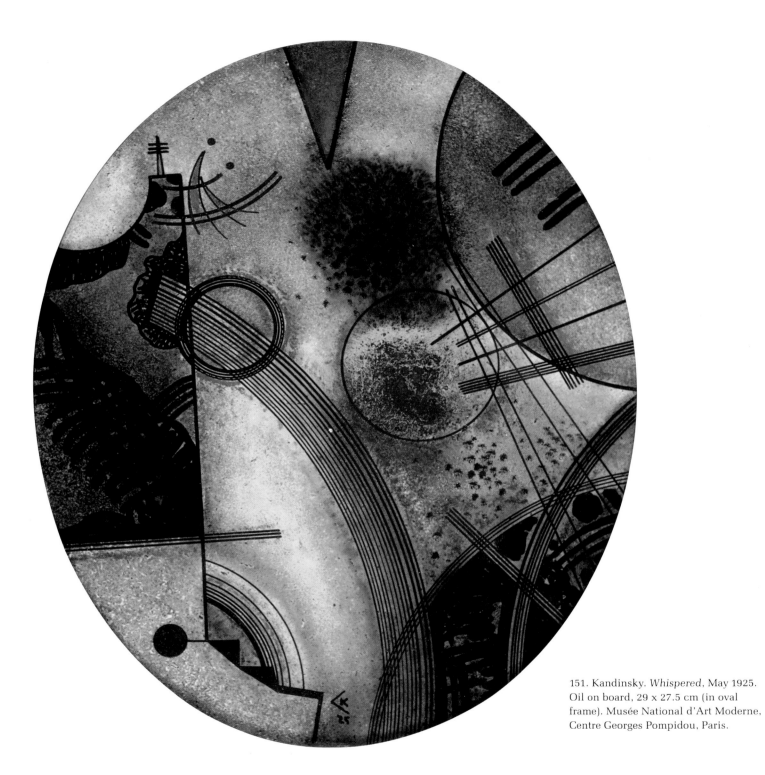

163

151. Kandinsky. *Whispered*, May 1925.
Oil on board, 29 x 27.5 cm (in oval
frame). Musée National d'Art Moderne,
Centre Georges Pompidou, Paris.

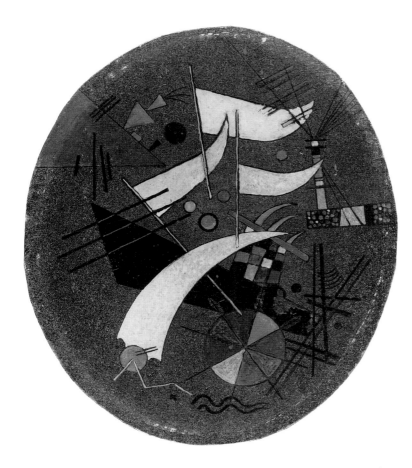

152. Kandinsky. *Easter Egg*, April 1926. Oil on board, 26.5 x 22 cm (in oval frame). Musée National d'Art Moderne, Centre Georges Pompidou, Paris.

"planets," and waving flags, the muted greenish background and the black ship maintain a more somber balance. Perhaps this funereal note was a result of the death that year of Kandinsky's father in Odessa, at the age of ninety-four. The shaman's drum, it may be recalled, might also serve as his boat for traversing mythical rivers en route to other worlds.[46]

But the last in the series of drum-shaped paintings recovered the child-like joy of *Oval No. 2*, repeating some of its themes. In *Lyrical Oval* of 1928 once again the surface is divided into quad-

rants in the manner of the Lapp drums with an accent at center in the position of the sun god (fig. 153). Again the central vertical represents the world-tree with its high, sail-like crown. There are also the usual "floating" horizon lines with "mountains" or "tents" and clouds or hills. The checkerboard book of fates nests on a branch close against the trunk at upper right, just above center. Suns, moons, and planets mark the cosmogonic "sky map." Enormous radiating half-moons cannot eclipse the sun that is suggested by the yellow drum itself. The golden yellow background, together with the many other tints of yellow, suggests the iconic use of gold and recalls Kandinsky's words on the "fanfare tone" of yellow and its stimulating warmth.

In many mythic tales of the world-tree, it is described as growing from a "lake of milk" or as flowing with a divine and restorative liquid. For example, an epic of the Minusinsk Tatars published in the middle of the nineteenth century described the world-tree as as a golden-leaved birch flowing with the "water of life" which is caught in a golden bowl. In Kandinsky's version, the bowl, a pale blue pod-shaped form at upper right, hangs miraculously from a detached "branch." Into it flows the multi-colored rainbow "water of life" from the trunk of the heavenly birch with its "golden leaves."[47]

The title of this painting, *Lyrical Oval*, is also an allusion to its dual existence as shaman's drum and work of art, for *Lyrical* was the name of the artist's quintessential painting of the leaping horseman of 1911, flying above the tree tops on the sha-man's magical journey (fig. 86). The conjunction of world-tree, drum shape, and the musical title leaves little doubt about the shamanistic function intended.

In this series of paintings—so small, so exquisite, yet so monumental and so pregnant with meaning—Kandinsky clearly enunciated his shamanistic intentions and delineated a parallel between the creative act of the artist and the shamanizing of the shaman. These drum paintings with their "intimate messages" speak, as Kandinsky said art should, of the "suprahuman," of things that transcend the bounds of human understanding (that is, the "bounds of geometric forms"). With their images of the world-tree and the bird-souls therein, the gods of the sky, the star

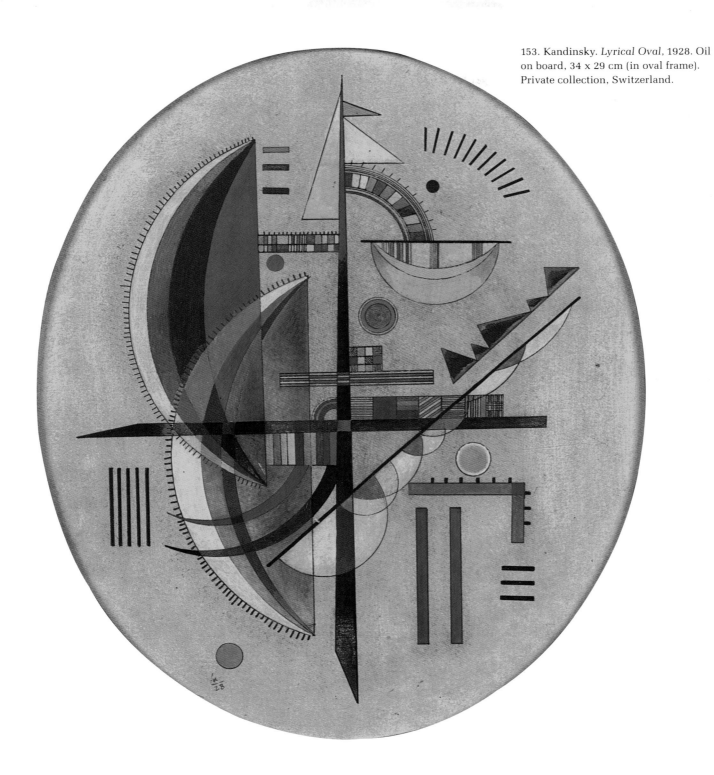

153. Kandinsky. *Lyrical Oval*, 1928. Oil on board, 34 x 29 cm (in oval frame). Private collection, Switzerland.

map of the universe, these paintings invoke that magical communication that can only be achieved by means of the shaman's drum and his ecstatic flight. Once eyes have been opened to this context, the viewer is able to participate in that flight of artistic imagination, as everywhere in the artist's work reverberations of these "shamanistic" conversations are found.

From this perspective major works both prior to and following this series yield new dimensions of meaning. The 1922 *Small Worlds* series of graphics, for example, can be better understood both from the purely constructive standpoint and within the context of these mythologies. Their free-floating compositional structures that sometimes approach the oval or round-drum shape and their many drum-inspired motifs find a suitable context. Such major works as *Several Circles* of 1926 also yield to this perspective. Certainly this work, in which the sole motifs are circles—with their inevitable references to the horse and thence to the shamanic horse-drum in Kandinsky's symbolic vocabulary—functions as a synthesis of accrued meanings and reflections.[48]

Levels of 1929, with its branching structure suggesting the world-tree, although rectangular in shape, is nonetheless reminiscent of two Lapp drums that Kandinsky might have seen in Stockholm and Leipzig and that had been repeatedly reproduced in the literature over the centuries (figs. 154, 155, 156). The projecting structural elements of the Leipzig drum, which look like prehistoric drawings of boats on the Stockholm drum, are more stylized, with sharply rectangular geometric ends that point down, whereas in *Levels* these end projections, reversed in direction and clearly alluding to the world-tree, point upward.[49]

The "branches" of Kandinsky's world-tree are populated like the "levels" of the Lapp drums with numerous and varied "individuals." The overall impression of similitude is striking, but there are also close correspondences in particulars. For example, the "capped" figures on the lowest right branch and on the second lowest left branch of *Levels* are strikingly similar to the "capped" figures on the uppermost level of the Stockholm drum. The repeated groupings of vertical bars parallel those on the Leipzig drum. Rounded "hummocks" are found in both *Levels* and the Stockholm drum. Two figures seeming to meet on

154. Kandinsky. *Levels*, March 1929. Oil on board, 56.6 x 40.6 cm. Solomon R. Guggenheim Museum, New York. Photo: Robert Mates. © The Solomon R. Guggenheim Foundation, New York.

the second lowest right-hand branch of *Levels* suggest the reindeer figures of the Leipzig drum. But what is most startling are the analogous images of the shaman with his drum. He is to be found near the left rim, just below the uppermost left level, of the Leipzig drum, and his twin on the central right-hand branch

155. Lapp shaman drum. Reindeer hide stretched on pine, 85 x 53 x 11.5 cm. Nordiska Museet, Stockholm (no. 228.845). From E. Manker, *Die lappische Zaubertrommel*, vol. 1 (Stockholm, 1938), frontispiece (drum 43).

for the "Hut of Baba Yaga," the magical witch or sorcerer of Russian fairy tale, has already been noted (fig. 59). The round form that graces this "magic house" is distinguished by the crossed-horseheads gable characteristic of rustic architecture of the Russian north, a motif that had identified the locale of such early works as *Golden Sail* and *Nude*. But here its pointed arrow-like minute-hand refers to the original "clock-cum-Baba-Yaga-hut" design by a Russian architect that had inspired Mussorgsky in the first place. At the same time its shape is drum-like, so that its arrow motif might also be taken for a reminiscence of the arrow-like "gan fly" of ancient Lapp shamans. Kandinsky's old friend Kharuzin had discussed at some length the belief in the noid's ability to inflict harm in this way. While Baba Yaga was generally imagined in the form of an old woman who lived in a revolving rustic cabin raised on chicken legs, Kandinsky has provided her a more "refined" home elevated upon shamanic ladders, while bestowing upon her the power of the Lapp shamans of antiquity.[50]

of Kandinsky's *Levels*. Both have round heads and triangular bodies; both are accompanied by their drums. What is interesting about Kandinsky's shaman figure is the way in which it extends below its "level." This small detail is reminiscent of a figure of a god on the upper level, far left, of the Munich drum, that also extends below its "level" (figs. 81, 104). A figure in a boat on the second highest right-hand level of the Kandinsky painting corresponds to the many boat-with-figure motifs of Lapp drums.

In 1928 Kandinsky undertook a more obvious synaesthetic experiment at the Bauhaus, designing the sets and costumes for a dramatization of Mussorgsky's *Pictures at an Exhibition*, which he also helped to stage. This obvious conjunction in music and art of folklore and nostalgia for "old Russia" offered a superb opportunity for Kandinsky to display his ability to transform memory into a modernist aesthetic vocabulary. The distinctive architectural detail with which Kandinsky endowed the scene

156. Lapp drum schema. "Drum F" illustrated by Scheffer, *Lapponia*, 1673. From E. Manker, *Die lappische Zaubertrommel*, vol. 2 (Stockholm, 1950), drum 44, illus. 125, p. 357. Manker located the original drum in the Städtisches Museum für Völkerkunde, Leipzig.

Shaman at Sea

In 1930 an even older memory resurfaced concerning an incident recounted by the Finn Castrén in his *Travel Memoirs*, which Kandinsky had read in preparation for his expedition among the Zyrians four decades before. What provoked the re-turn of Castrén's account to the artist's memory may never be known, but *Peevish* illustrates in remarkable detail a series of scenes in which the Finn vividly described the surprising events that had overtaken his entourage in the early stages of his jour-ney across Zyrian territory in the late 1830s (fig. 157). Castrén's

157. Kandinsky. *Launisch (Peevish)*, 1930. Oil on cardboard, 40.5 x 56 cm. Museum Boymans-van Beuningen, Rotterdam.

observations, while often "peevish" and certainly tainted by prejudice, were not without humor, despite the primitive conditions enforced upon him. One of his more amusing and at the same time revealing recollections concerned a chance meeting aboard a primitive river craft as he made his way, with the help of Zyrian traders, toward Obdorsk, hoping to locate Samoyed settlements. In characteristically pungent fashion, Castrén described the boat his Zyrian friends had obtained for the trip as follows: "I began my Asiatic voyage in a craft that is called by the Russians a *Kajuk* and that consists of a rather large covered barge which is wide at the front and narrow at the back and is fitted out with only a single mast. . . . In order to shield themselves somewhat from the autumnal rain showers, some—the more affluent passengers—had equipped themselves with small tents or so-called *Balagans*. . . . One naturally belonged to me, another to the owner of the barge, a third to his nephew and wife; but to whom belonged this *Balagan*, that is sewn together out of rose-colored shawls? Presumably to a beauty with rosy cheeks."

Promising to introduce this personage to his reader later on, Castrén continued with a description of the port town of Kolwa with its church dedicated to the "Miracle-Worker Nikolai," and the adventures of the first several days' journey into a wild, seemingly endless, and utterly deserted tundra-like landscape inhabited mainly by waterfowl. While anchored one evening for supper, the party was overtaken by a sudden and ferocious thunderstorm: "The rain streamed heavily down, the storm howled in the tackle and threatened to wreck the *Kajuk* on the rocky shore." After moving anchor in the teeth of the howling gale, they tried to settle down for the night. Unable to sleep, Castrén lay in soggy discomfort until he heard the crackling of a fire from the bow of the boat. Thinking to warm himself, he lifted the corner of his tent and "a strange sight met my eyes":

Around the fire there moves something that would have given even the most objective mind, even one steeled against all [sorts of] ghosts, an involuntary case of the jitters. This object had wrapped itself in a shaggy reindeerhide coat, from which hung in fantastic confusion ribbons of all the colors of the rainbow. The head, the shoulders and a part of the face are covered with an armor hanging together of wolver-

ine hides which is decorated with shiny, free-hanging brass disks, that clatter on the back. . . . This spooky object appears to move softly around the grate on which the fire has been lighted; on all four sides it stands still a while and bows toward the corners of the earth. By each of these movements of the specter, we notice that one leg is noticeably shorter than the other. As the spook stands so, with its face turned toward the east, and probably has the intention of bowing in this direction, during the bow the body makes such a significant turn to the north, that the whole complement falls in that direction. If it wants, on the other hand, to turn its head toward the west, the bow in fact takes place toward the south. No matter which way the head wants to send its greeting, the leg protests against it and forces the aforementioned part of the body to greet another quarter of the heavens. . . . [At last] the wonderful form sits down before the fire with crossed legs and breaks out in a "Huh! huh! huh!" beating upon the grate with soft blows. Now we comprehend that here a Samoyed exorcism of the wind is taking place; whether the exorcist had come out of the air or out of the water was a puzzle for me until my eyes happened to fall upon the rosy red *Balagan* illuminated by the fire.

Castrén's specter was, of course, none other than a Samoyed shamaness—not at all the rosy-cheeked beauty he had imagined might inhabit the pink-shawl tent!

Kandinsky captured the mixture of irony, spookiness, and humor in Castrén's story. The barge—for now it is clear that the subject of *Peevish* is indeed a barge—fits Castrén's description to a fault. Wide at the bow and narrow at the stern, it boasts a single mast. No matter how one looks at it, its direction cannot be reversed: the wide end *is* the bow. And despite its fin-like keel and whale-like "tail," its function as a boat is recognizable. From the heavens a torrential rain pours down. On the deck three figures and three "tents," of which one is certainly rosy red, can be discerned. Near the bow, a red triangle splits the hull; it is, of course, the fire defying the storm. "Red is the color of flame," Kandinsky had written in *Über das Geistige in der Kunst*. Directly beneath the downpour, amidships betwixt fire and tents, stands a spooky figure. It wears a feathered headdress and a red

coat with spiky decorations. It leans forward toward the fire, holding a drumstick aloft in one hand, a round drum in the other as it calls the spirits. At the stern stands another manifestation of Castrén's shamaness, clearly recognizable because one leg is shorter than the other, and the obeisance she pays the moon that hangs on the stern is a comical balancing act. At the bow, *en pointe*, another figure balances, ballet-like, more successfully: the rosy-cheeked beauty of Castrén's imagination. Hovering in the background appears the ghostly outline of the church of the "Miracle-Worker Nikolai" left behind at Kolwa. In the sky float other moons or planets, and a gull skims the reddish sky; a flounder plies the reddish water below the boat. All that remains to remind the viewer of Castrén's peevish contempt for his primitive craft and exotic companion is the title: *Peevish*.[51]

Toward a Shamanistic Aesthetic

During the same period in which the drum paintings were conceived, Kandinsky also created *Yellow-Red-Blue*, a masterpiece of his Bauhaus period (fig. 158). Once again reminiscences of the past and a store of Finno-Ugric folklore were crucial; both compositional and thematic ties exist between this painting and a work by Gallen-Kallela that had been selected by Kandinsky for exhibition in Munich more than two decades earlier (fig. 41). The fundamental color scheme of the painting recalls a passage in Kandinsky's Bauhaus teaching notes in which, like a poet, the artist associated the color blue with the moon, yellow with the sun, and the "mysterious birth" of red with their meeting at dawn and dusk.[52]

In Gallen-Kallela's watercolor study for *Kullervo's Departure*, the downfall of the hero through no fault of his own, condemned by fate to self-destruction, had been told in the characteristic vocabulary of fin-de-siècle pathos. There the hero rode off-stage to his destiny in the forest accompanied only by his dog. The poignancy of his defiant gesture as he announced his departure with a blast of his trumpet was emphasized by its opposition to the coiling world serpent symbolizing the sins of the world that he left behind, a scene framed by empathetically

encircling trees. Kandinsky had addressed the same scene shortly thereafter (figs. 41, 42).[53]

The basic compositional structure of *Yellow-Red-Blue* and of the Gallen-Kallela watercolor is also remarkably similar. In simplest terms, each painting has a coiling serpent on the right-hand side; on the left, a "heroic" figure with a long horn; a background studded with celestial phenomena (stars here, planets there); an inexorable "movement" on the diagonal from lower right to upper left; and a strong color opposition between deep blue and golden yellow.

In *Yellow-Red-Blue*, the forces of "heaven" and "hell" are as symmetrically opposed to one another as in the Gallen-Kallela watercolor. Recalling Kandinsky's scheme in which the right-hand side of the "ground plane," as symbol of earthly concerns, is opposed to the left-hand side symbolizing "heavenly" concerns, it is understood that this painting has to do with the oppositions of good and evil, the divine and the earthly, the sacred and the profane. Movement to the left, according to Kandinsky, is liberating; it leads toward "adventure" and, when combined with an upward movement, "heaven." On the right—the direction of earthly tensions in Kandinsky's rationale—the serpent, St. George's dragon of old, coils in the same seductive fashion and in the same compositional location as that in the Gallen-Kallela picture. It is associated with the multicolored forms of earthly life's seductions. Receding, as blue must, in the background is the heavenly blue circle that is St. George himself on his horse—placed on the *upper* right-hand side of the painting in his role as God's messenger on earth, sent to heal the world of its decadence and materialism. The circle is Kandinsky's symbol for the horse and at the same time a link to the "cosmic." Nor need we hesitate to call the circle, or for that matter, a given color, in Kandinsky's work "symbolic."[54]

The St. George/blue circle reels off the rainbow colors of the palette that collide with a reddish cruciform, St. George's cross, emphasizing the artist's redemptive mission. This notched red form is overshadowed by a translucent moon-like profile consistent with the artist's earlier introduction of profiles into his work, as in the 1922 St. George watercolor (fig. 127). In the context of

158. Kandinsky. *Yellow-Red-Blue*, 1925. Oil on canvas, 128 x 201.5 cm. Musée National d'Art Moderne, Centre Georges Pompidou, Paris (Gift of Nina Kandinsky).

the *Kalevala* myth, the rainbow kaleidoscope of color planes may be read as an overt reference to the coveted mythical "motley lid," or multicolored cover, of the magical Sampo.[55] Scattered through the rainbow's debris—the Sampo was broken to bits and dropped in the sea—are checkerboards of destiny, recalling, too, the presence of St. George with his multicolored checkered coat

and saddle blanket. A floating horizon line with its triangular mountains again recalls those on Lapp drums. A flag waves over the aesthetic "battle."

To the left, set in radiant opposition to the blue circle, a divine personage in gold, radiating a halo, takes on the compositional function of Kullervo, albeit pointing his horn in the

opposite direction—toward heaven, in Kandinsky's scheme. It is, in fact, the direction of the horn in the artist's much earlier rendition. Clad in the golden raiment of divinity, the hero here represents once more a composite of all the heroes previously encountered: World-Watching-Man, St. George, and Christ, together with the heroes of the *Kalevala*. But this radiant figure suggests at the same time the pagan god of the sun, Iarilo. In a drawing apparently preparatory to *Yellow-Red-Blue*, Kandinsky reprised his Iarilo of the Remizov series (fig. 159). Instead of the pillar-like personage of the final painting, here is the dunce-capped figure of the illustration to "The Flower" (fig. 130). And instead of the spray of fertilizing black lines between his legs, the artist has introduced an enormous phallic symbol in direct recollection of the Iarilo dolls of springtime folk celebrations. His transformation in the final version to a far more powerful figure with multiple personae is typical of Kandinsky's working method. Hovering between Kullervo-Iarilo's golden heat and the cool blue of St. George's circle floats the eerily moon-like profile, a motif

160. Lapp shaman drum, schema. "Drum L" as illustrated in J. A. Friis, *Lappisk Mythologi* (Christiana, 1871), pl. 11. From E. Manker, *Die lappische Zaubertrommel*, vol. 1 (Stockholm, 1938), illus. 16, p. 37.

159. Kandinsky. Drawing related to *Yellow-Red-Blue*, 1925. India ink on paper, dimensions unknown. From Will Grohmann, *Wassily Kandinsky: Life and Work* (New York, 1958), p. 198.

that would become a frequent autobiographical signifier in the artist's later work. Low in the left-hand corner of the final painting, a configuration of lines suggests, without describing, the ghost of Kullervo's dog.[56]

All the heroes of the saga exhibited shamanist capacities, from the ancient shaman Vipunen, who possessed the magic knowledge, to the legendary singer of magical songs, Väinämöinen, who could create, from the jawbone of a pike, a harp to enchant the world; from the craftsman-smith Ilmarinen, who forged the multicolored Sampo, to Lemminkainen, who could metamorphose himself and who was himself restored to life by his mother. Kandinsky's friend Kharuzin had emphasized the shamanistic power of Lemminkainen, quoting the very passage in which the hero's mother, bidding him farewell, admonished him not to go "to the villages of far-off Pokhola . . . without magic."[57]

Even the doomed Kullervo had magical powers. Moreover, Väinämöinen was able to traverse the seas on a "peastalk" horse, or shamanic horse-stick. In *Yellow-Red-Blue* the horse-stick bears a dual function. Its function as floating horizon line bearing its row of mountains, as on the face of Lapp drums, may

161. Kandinsky. *Development in Brown*, 1933. Oil on canvas, 105 x 120 cm. Musée National d'Art Moderne, Centre Georges Pompidou, Paris. Photo courtesy Solomon R. Guggenheim Museum, New York.

also be taken as the signifier of St. George's horse, in conjunction with his multicolored saddle blanket, which floats just below, with the battle flag lofted above.[58]

It is hardly surprising that yet another reminiscence of Lapp shaman drum imagery appears in this work, which was created in conjunction with two of the artist's "drum" paintings. The juncture of lashing serpent and standing pillar-like figure recalls again a drum image reproduced by Friis (fig. 160). There

the pillar motif stands on the drum's lower rim, surmounted by a radiant sun that is joined by a lashing serpent to the image of a moon with profile at the upper rim. In formal terms, the rectangular pillar below the sun on the drum suggests the heroic figure surmounted by a radiant head (represented by a white disk) in the Kandinsky painting. The dominant motifs of sun, moon, and serpent are common to the ancient precedent and to the modern reverie.[59]

Kandinsky's interest in primitive art continued unabated, and in December 1931 he wrote to Grohmann: "In Berlin we saw the 'Altamerikanische Ausstellung.' How ever have these 'Primitives' achieved this monumentality in clay with a few of the simplest colors? I mean the color-chord *[Farbenklang]* that is so 'economical' and simultaneously pure-full-resonating *[rein-vollklingend]*."[60]

Two years later, as the Nazi menace to modern art climaxed in the closure of the Bauhaus, Kandinsky employed just such a restricted but eloquent palette to suggest the situation of the artist forced once more by catastrophic circumstance into a new environment. The symbolic significance of *Development in Brown*, painted in August 1933, is inescapable (fig. 161). The motley figure of the artist/shaman/Pierrot in the central "door-way" appears in the process of being squeezed out by inexorably moving, ponderous brown "gates." Did Kandinsky perhaps recall the Chukchee myth related by Bogoras about the moving "rocks of the sky" that meet the "rocks of the earth" in autumn at the four corners of the horizon, where their bellows-like movement produces the winds and crushes those migrating birds unfortunate enough to delay their departure? In *Development in Brown* arc-like forms attached to the triangulated figure suggest both wind blowing out a caftan and birds slipping fortuitously between moving rock gates. *Development in Brown* was the last painting Kandinsky was to create in Germany. The Nazis closed the last vestige of the Bauhaus—it had moved finally to Berlin—in July 1933. In late December of that year Kandinsky moved to Paris and to a new chapter in his aesthetic development.[61]

Then the aged Väinämöinen
Went upon his journey singing,
Sailing in his boat of copper,
In his vessel made of copper,
Sailed away to loftier regions,
To the sky beneath the heavens.
There he rested with his vessel,
Rested weary, with his vessel,
But his kantele he left us . . .
left the harp behind,
the great songs for his children.

The figure of St. George in his multiple transformations—as shaman, World-Watching-Man, *Kalevala* hero—had often come to the rescue during those transitional periods of Kandinsky's life when crisis threatened to disrupt the wellsprings of creative inspiration. Now, in the late winter of

162. Kandinsky. *Untitled*, 1934(?). Mixed media on cardboard, 32 x 42 cm. Musée National d'Art Moderne, Centre Georges Pompidou, Paris.

1933 and early spring of 1934, after the difficult move to Paris where he found himself, the world-renowned artist, nonetheless an outsider—no longer the center of any particular group, or even a member of any cohesive school or movement—the artist turned yet again to the comforting image of his patron saint and alter ego.[1]

In a small, untitled painting on cardboard Kandinsky once again represented the hobbyhorse of old, metamorphosed into a toy-like fantasy creature on a "rocker" that seems a cross between a seahorse and a bird, while at the same time clearly recalling the folk-carved rocking horse that had in fact accompanied him to Paris (figs. 162, 60).[2] Its large eye, ribbed appearance, and posture of neck suggest the seahorse. The bill-like protuberance, too, suggests the elongated snout of the seahorse, yet at the same time the diver bird or loon associated in Finno-Ugric lore with the creation myth. While the "crest" and tail argue for its designation as bird, the crest may also be read as a mane, and beneath the tail grow two primordial "legs" that hint again at the designation "horse." The creature's back is pied and it wears a distinctive "saddle blanket" that may also be read as the wing

feathers of a bird. But this is a strange "duck" indeed, for it bears a "crowned" rider astride its back and is inscribed upon a clearly drum-like round form. Below this "drum" lies another biomorphic figure, arranged horizontally; as it were, the shaman in his trance. Here is the ambiguity characteristic of Kandinsky's self-imagery: St. George upon his horse merges with the image of World-Watching-Man as gander or the shaman flying to other worlds on the back of a goose. Within the context of Kandinsky's ethnographic knowledge and his recent emigration, the fact that World-Watching-Man was also known as World-Traveling-Man is no less significant. This large-eyed, biomorphic, multidimensional creature heralds a metamorphosed shaman as well. Kandinsky's friend Ivanitskii had recorded a folktale of the Vologda region in which a shaman possessed the magical power to transform himself from a dove to a swan, to a horse, to a fish, and finally to a golden ring. Metamorphosis, a universal trait of the fairy tale, would become the key to the artist's new vocabulary.[3]

The old St. George hieroglyph, accompanied by his circle-horse and triplicate lance, returned as well in one of the first watercolors of the Parisian era (fig. 163). But now the hooked line is extended to suggest the neck and shoulder of the rider and the possibility of further development. The triangulated form that had escaped from the crushing gates of *Development in Brown* is about to take on a more humanoid appearance. Evidently recalling the Janus heads of the early Bauhaus days, the artist also tried out new "profiles" for himself in another watercolor early in 1934. Again it was a question of a new vocabulary for a new environment and a new chapter in his life.[4] Yet the continuity of the artist's imagination is underscored by the fact that it was in the "biomorphic" Paris period that the geometric circle, lance, and whiplash motif representing St. George and the dragon was to reach its apotheosis in the cover design for *transition* magazine in 1938 (fig. 164).[5]

Kandinsky's cover design for the April issue marked the tenth anniversary number of the journal and, in a sense, another kind of apotheosis for the artist, for it recalled the environment of his ethnographic origins and synaesthetic sensibilities. In his anniversary editorial Eugene Jolas noted that the magazine had

"encouraged a new style by postulating the metamorphosis of reality." Clearly, with its juxtapositions of eclectic materials from contemporary literature and poetry, the visual arts and music, myth and language, archeology and ethnography, ethnic poetry and songs, even reproductions of ethnic artifacts, *transition* echoed Kandinsky's own *Blue Rider* almanac. But the journal

163. Kandinsky. *Untitled*, 1934. Watercolor and India ink, 31.6 x 24.6 cm. Musée National d'Art Moderne, Centre Georges Pompidou, Paris.

must also have reminded him of his days on the editorial staff of *Ethnographic Review*, with its collage of ethnography, folklore, folk poetry, and music.[6]

In Paris, too, the artist would be required to continue that constant battle against those who would take the definition of "abstract" too literally, as he put it in his 1931 essay "Reflections on Abstract Art." It still bothered him that people failed to see what lay behind his triangles and circles: "The label 'abstract' is misleading and detrimental as long as it is taken literally," he wrote, enunciating the theme of many of his writings of the thirties. Eventually he would embrace the term *concrete* (as opposed to *abstract*) as a valid description of his kind of art. Again and again he attempted to explain that his painting was not "without objects"; that what he called "geometric" entities and "free forms" functioned "like objects" in his painting, bringing their own "inner sounds" just as objects of everyday life do in more traditional painting. The line, for example, may function, he wrote in 1935, "as an object itself." In fact, he would not even discount the possibility of everyday objects appearing in his paintings, since "perhaps all our 'abstract' forms are 'forms in nature'" and his painting, he always claimed, was inspired by all of nature—both inner and outer.[7]

In the metamorphoses of the thirties, the sacred hieroglyphic horse and rider endured: the shaman's feathered cap and the multicolored saddle blanket or checkered coat remained more or less constants, while hero and horse often took on new aspects. All of the "abstracting" devices employed by the artist persisted while undergoing subtle transformations.

It was in his 1935 essay for *Cahiers d'art* that Kandinsky released a clue indicating that he had found his way to a new metamorphosis of his favorite equine motif. He had just explained that in "abstract" painting the "abstract" entities themselves—such as geometrically bounded forms as well as "free" forms—are capable of exuding their own inner sounds and arousing emotions: "This abstract form does not have a belly like a horse, or a bill like a goose. If you want to subordinate an object to your plastic idea, you must usually change or modify the natural limits that it presents to you. *To stretch a horse, you must pull*

177

him by the head or by the tail. That is what I *used to do* before I found within myself the possibility of liberating myself from the object."[8]

The latter comment was somewhat disingenuous, because in fact Kandinsky continued to "stretch" his horses, lines, and forms. *The White Line*, of 1936, demonstrates the lengths to which he could stretch both horse and imagination (fig. 165). The motif of shamanic horse and rider is recognizable in its new transformation, first of all by the three feathers that usually distinguish the helmets of Kandinsky's shamanic riders. They are attached to the whiplash line that suggests both coiling serpent and extended rider hieroglyph, similar to the extended hieroglyphs in the watercolors *Hard But Soft* (fig. 137) and *No. 225* of the twenties. Again the artist has disassociated the elements of his "objects" only to recombine them in a new assemblage. Hovering behind the helmet-feathers is the profile of the rider with which the artist had already experimented in the untitled "double profile" watercolor of 1934, in which the two profiles— one set above the other, with a light-colored profile facing left and a dark-colored profile facing right—formed a configuration

164. Kandinsky. Cover design for *transition* magazine, no. 27, April–May 1938. Photo courtesy Brooklyn Museum.

clearly reminiscent of the similar double dark/light profiles (also facing in opposite directions) associated with the St. George motif of the 1922 Bauhaus *Watercolor No. 23* (fig. 127).

The profile of *The White Line* is attached to a biomorphic body that is "seated" upon a fantastical piebald steed, once again partially covered by a shawl-like saddle blanket. The horse's neck is "stretched" beyond recognition, indeed, to goose-like proportions, and from it dangles another decorated shawl-like form waving like a banner in the breeze. The rider's helmet tumbles below the horse's feet; but it is "stringed" and suggests as well the shaman's "instrument." It is no accident that Kandinsky mentioned the horse and the goose in one breath, a seemingly incongruous juxtaposition. For, as we have seen, among many Siberian and Finno-Ugric peoples, the shaman could fly to "other worlds" on the back of a goose, and among the Voguls World-Watching-Man was thought to transform himself into a gander. Here the elongated neck of the "horse" suggests the neck of a goose outstretched in flight. At the same time, this protuberance may be seen as a "horn" on the elongated head of a horse that raises two stubby legs for the leap. In the drawing for this picture, the feathers of the rider's helmet are arranged in closer relation to his head, and the hind legs of the horse, even to the naturalistic detail of the nearer hoof, are easily recognizable (fig. 166). Once again the black ground is reminiscent of the artist's early "color drawings" on black, many of which were based upon folk and fairy-tale themes; as in those early works and the 1923 murals for a reception room, this dark ground lends the colors a startling "fairy-tale" brilliance. The stage has been set for metamorphosis.[9]

It is doubtless significant that Kandinsky chose *The White Line* for publication in *transition* in 1938, the issue which bore his geometric St. George-and-dragon design on the cover, as if to claim the validity of both geometric and biomorphic forms of expression. Significant, too, is the fact that this was the April– May issue, since Kandinsky's St. George motifs often appeared in close conjunction with the April celebration of St. George's Day. Indeed, one of his great April St. George paintings, the important *Dominant Curve* of April 1936, had been reproduced in the magazine's preceding issue.[10]

165. Kandinsky. *The White Line*, June 1936.
Gouache and tempera on black paper, 49.9 x
38.7 cm. Musée National d'Art Moderne,
Centre Georges Pompidou, Paris.

179

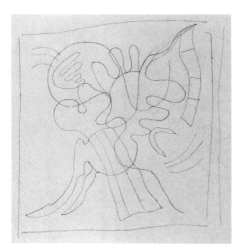

166. Kandinsky. Drawing for *The White Line*, 1936, detail. Pencil, 21 x 17.6 cm. Musée National d'Art Moderne, Centre Georges Pompidou, Paris.

Portrait of the Artist: The Shaman in his Studio

Paradoxically, it would appear that the further the artist was removed in time and space from his early ethnographic training and experience, the more frequently the accoutrements of the shaman's costume, headdress, and drum would reappear in his work. Possibly the Tungus costume in the collection of the Musée d'Ethnographie in Paris served as a reminder, for Kandinsky could well have known it from previous visits to the city (figs. 167, 168).[11] But now the rider dismounts and frequently finds himself in the artist's studio, distinguished by his autobiographical, bulbous, slightly aquiline profile, with his feathered headdress or helmet and sometimes accompanied still by his disconcerting serpent.

Ambiguity of 1939 belongs to a series of works that may be designated as "artist-in-his-studio" paintings, clearly representing a self-portrait of the artist-as-shaman before his easel (fig. 169). His bulbous profile floats within the green outline of his skull, upon the forehead of which perches his feathered cap, two more feathers adorning the back of his head for good measure. The head rests upon a trapezoidal chest, below which two dancing legs transport the artist-shaman in his creative trance. Before him stands his easel holding a painting that may or may not be another self-portrait. Bits of himself—another bulbous profile in a circular form and a horned two-legged creature—attempt to make their way into the picture from which geometric figures project. Below the easel painting, and rising toward it, is a shape like a hot-air balloon that raises as cargo a dangling biomorphic form vaguely reminiscent of a sperm or fetus; as if the artist were willing the insemination into his work of the creative soul. This "soul form" attached to a rising balloon-like shape would become an important element of the artist's vocabulary. Its fetal shape is even more pronounced in the drawing of the picture recorded in the artist's house catalogue. The dappling of the surrounding light paint against a dark ground suggests that the whole lies in that ambiguous realm where fantasy or imagination and reality meet, as in the classic folktale. A glance at the preparatory drawings for this painting provides further evidence of the identification of the bulbous profile as the artist's self-portrait. At an early stage the profile is very similar to the feathered piebald creature previously associated with Kandinsky's St. George images.[12]

The progressive development of the autobiographical shamanic profile is manifest in a number of paintings and drawings that led up to *Ambiguity*. In *Between Two* of 1934, Kandinsky had placed two profiles in immediate confrontation, dark against light, both "helmeted" and "feathered," like gods above the image of a "world-tree" (lower center). A colored-crayon drawing of about 1936 presents the bulbous profile, now with three feathers, and a superimposed checkerboard pattern (fig. 170). Still later, on a page of drawings obviously related to the St. George theme, possibly as studies for the *transition* cover, with their conjunctions of circles, whiplash serpents, lances, and ladders, one image presents not the usual circle but a profile with three feathers that might also be read as a piebald "creature" with a feathered headdress (fig. 171).

But the most elaborate headdress of all appeared in *Dominant Violet* of 1934, the earliest in the series, fitting within it by virtue of its organization, treatment, and confrontation of profiles. A blue profile on the right, shadowed by a lighter, more bulbous profile and distinguished by a triplicate all-seeing eye,

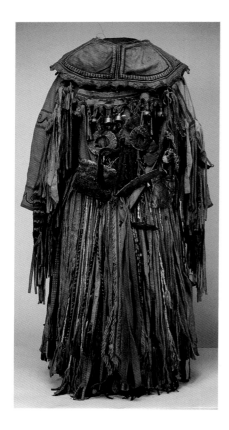

167. Shaman costume, Tungus (back view). 19th century. Acquired from the Joseph Martin Siberian Expedition, 1887, by the Musée d'Ethnographie, Trocadéro, Paris. Musée de l'Homme, Paris (MH 87.42.1). Photothèque du Musée de l'Homme (J. Oster).

Diverse Parts of 1940 again presents the shaman in his studio, while at the same time describing the complex milieu of the artist who must deal both with the events of the real world and with those equally vital events of his imagination (fig. 172). Here the artist's profile is less bulbous and more fluid, but it rests within the usual St. George circle, although here the circle is no longer the blue of the heavens but the green of the earth—a pungent, possibly self-ironic comment by the artist that should not be ignored. Once again feathers both fore and aft deck his head. The artist's body takes the form of some creature, perhaps his

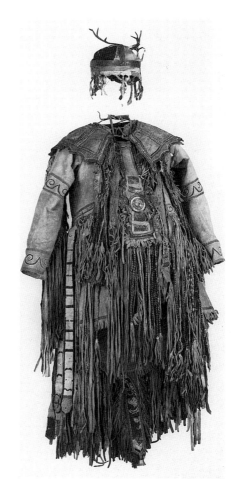

168. Shaman costume, Tungus (front view), with iron "antler" headdress. 19th century. Acquired from the Joseph Martin Siberian Expedition, 1887, by the Musée d'Ethnographie, Trocadéro, Paris. Musée de l'Homme, Paris (MH 87.42.1). Photothèque du Musée de l'Homme (J. Oster).

sports a prominent reddish feathered headdress nearly as elaborate as a Native North American headdress. It is settled within a construction of horizontal rectangles that is imprinted with a checkerboard and attached by a skeletal red "neck" (a small red rectangle) to a "body" of vertical rectangles, its blue "wing" attached to its coat like some shamanic amulet. The serpent identified with St. George undulates before it. A winged violet form has penetrated the artist's canvas, animated by the somewhat muted "fanfare" of the yellowish ground. It appears in flight toward the upper left (or celestial sphere), suggesting new hope overcoming the "slag heap" of the recent past; an overwhelming affirmation of the bond between intellect and spirit in the artist's endeavor.[13]

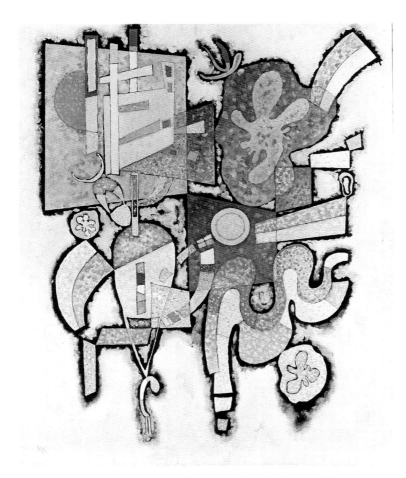

169. Kandinsky. *Ambiguity (Complexity Simple)*, March 1939. Oil on canvas, 100 x 81 cm. Musée National d'Art Moderne, Centre Georges Pompidou, Paris.

in" to a zigzag, or "lightning," source of electricity below, illuminates the scene. Outside the studio, to the left, a skeletal figure outlined in black, apparently uniformed and monocled—surely a threatening figure of death—knocks at the door and even manages to thrust his spiky arms into the room. Although it has sometimes been said that Kandinsky remained aloof from the political catastrophes around him, this painting belies any such presumed isolation.[14] To the right, in a rosy panel, dances a figure with "bird-souls" on its knee and head, suggestive of the artist's muse or perhaps of the spirit of youth. Below, glimpses of the animated world inhabited by the artist's imagination are caught. At lower right two impinging triangles poignantly recall Kandinsky's exuberant claim that the meeting of a triangle and a circle could hold "no less effect" than the touch of God's finger upon Adam's in Michaelangelo's Sistine ceiling. This implied creation theme is, of course, entirely appropriate in a painting that represents the artist in his studio.[15]

170. Kandinsky. *Untitled*, ca. 1936. Colored crayon on paper, 23.8 x 31.4 cm. Musée National d'Art Moderne, Centre Georges Pompidou, Paris.

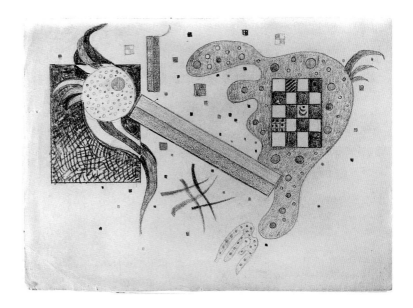

horse, but his skeletal self—indicated by three curving lines—clearly assumes a human sitting position. Before him stands his easel, where the color blue can exist with impunity, radiating lines issuing from its surface, while behind it a biomorphic form with a serpent motif seeks entry. At the artist's feet and moving toward the left—that is, toward "heaven"—is his "rocking horse," his shamanic steed. A lamp that is apparently "plugged

with an eye to anchor its beribboned head. But the "rider" in this instance is the curving lavender-and-blue form, like a shawl, that floats across the black ground. Such a shawl can perform any magic if it is the shaman's costume. Like the real shaman's caftan, this robe displays the amulets of his trade: snakes, "ribs," animals, disks, amulets, and arrowheads, among other things. The arrows signify not only the shaman's magic flight but also the magic arrows or "gan flies" of the Lapp shamans described by Kharuzin. Here an arrow at upper left appears to threaten the flying shaman, but he is protected by his own arrow and by the snakes that symbolize his power and magic art. In *The White Line*, the rider or his steed had also worn a long decorated "robe" or caftan, and the "banner" hung from the steed's neck was also decorated with shamanic signs: snake, disks, and a paw-like amulet. The shaman's costume with its snakes and amulets now became a persistent motif in Kandinsky's work, cor-

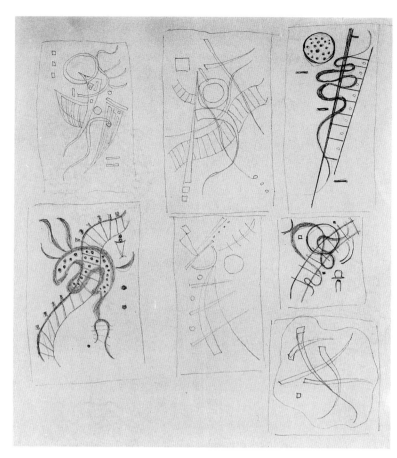

171. Kandinsky. *Untitled*, ca. 1936. Pencil and ink, 26.9 x 21 cm. Musée National d'Art Moderne, Centre Georges Pompidou, Paris.

172. Kandinsky. *Diverse Parts*, 1940. Oil on canvas, 89 x 116 cm. Städtische Galerie im Lenbachhaus, Munich (Gabriele Münter- und Johannes Eichner-Stiftung).

183

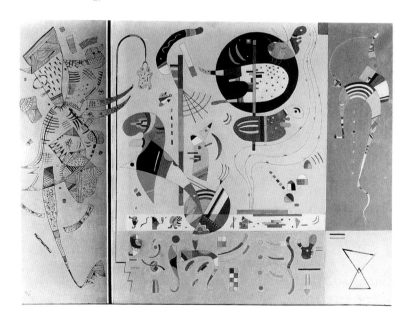

But Kandinsky's shamanist aesthetic vocabulary extended beyond the feathered headdress to the elaborate caftan of the Siberian shaman costume, providing yet another metamorphic device. In *Floating*, a companion piece to *The White Line*, the black ground and nearly iridescent colors again recall the folkloric mode of the early Russian paintings, but here the free, metamorphosing line clearly derived from the St. George hieroglyph of the past assumes new vigor (figs. 165, 173). As the shaman's horse, this hieroglyph prances leftward, toward the heavens,

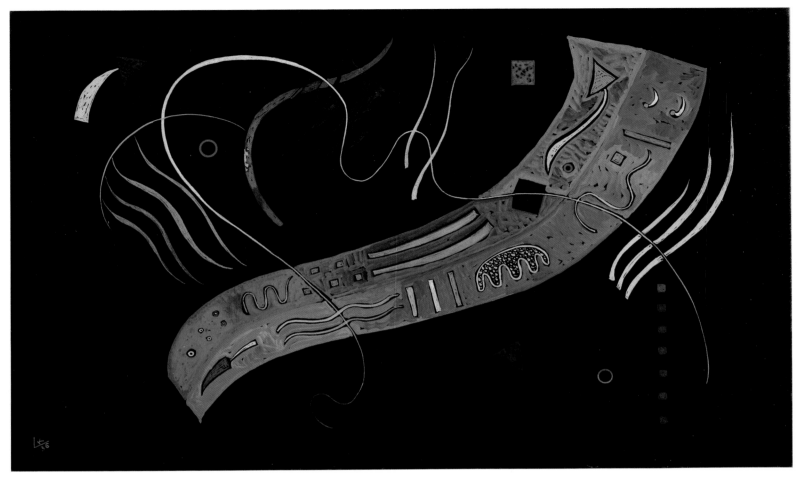

173. Kandinsky. *Floating*, June 1936. Gouache and pencil on black paper, 31 x 50.2 cm. Solomon R. Guggenheim Museum, New York. Photo: David Heald. © The Solomon R. Guggenheim Foundation, New York.

responding to the checkerboard saddle blankets and robes of the Bauhaus period. Its next major appearance, in a conjunction that leaves little doubt as to its significance, was in *Dominant Curve* of 1936.[16]

In *Dominant Curve* the shamanic robe is in fact the dominating motif (fig. 174). Again the costume is hung with a variety of amulets: snakes, ribs, a jagged claw-like ornament similar to the bear claws commonly found on Siberian shaman robes, forms that resemble birds and "guardian spirits," and a prominent "sun disk," the whole ensemble resembling a conglomerate of remembered shaman costumes, including the Trocadéro's Tungus example (figs. 167, 168). It is "sewn together" of numerous color patches and assumes a sitting position, leaning forward toward the left. Below, to the right, rises a flight of steps suggesting a

clear ascensional intention. A cluster of feathery shapes and triangles ride ahead of the costume, to the left, set off by a striking yellow circle. Again, recalling the many disassociated St. George images of the Bauhaus period, a phalanx of horseheads is at once discerned. There are four of them, each assuming a slightly different position. Each is given an eye, ears, and a flying mane. The forward thrust of these horseheads is strongly emphasized by their arching black necks. To the lower left stretch the forelegs of one horse. But the hind legs have been disassociated from the main motif. Their shadow alone is visible in the foreground; their actual thrust is indicated by two parallel lines sweeping lightly over the steps behind the shaman robe.

Are there then four horses or one? Is this painting to be taken as an "apocalyptic" painting on the theme of the Four Horsemen? But, no, the telltale scales, sword, trident, and the bow and arrow are lacking. Nor are there four horsemen. There is only one set of legs and one rider. The date of the painting offers the decisive clue. *Dominant Curve* was entered into Kandinsky's house catalogue in April 1936, clearly another in his lifelong series of St. George's Day paintings. The brilliant yellow circle recalls the circular sun-body of St. George in the painting *In the Black Square* (fig. 128). As in the latter work, in which the legs of the horse were shown in several positions to indicate his motion, here the repeated series of triangular horseheads provides that sense of movement and tremendous energy, representing but one horse in motion. Here the syncretic identification of the saint with the pagan shaman is made explicit by substituting the shaman's costume for the figure of a helmeted warrior. The artist has apparently put himself into the picture as a dancing, skeletized shaman with the ubiquitous feathered headdress at upper left, the heavenly quarter, suggesting his position as "creator" of this universe, his "bared ribs" attesting to his resurrectional capacity.[17]

The Artist-Shaman

Clearly, Kandinsky's identification with the role of the shaman had grown ever deeper with the passage of time. Not only did the signs and symbols of shamanic imagery appear in his works, but his writings, always visionary in tone, took on more shamanistic imagery as well. A striking example of this phenomenon occurred in the artist's 1935 essay "Empty Canvas, etc." in which he chose as metaphor the drum animation ritual of the Siberian shaman.

Kandinsky began his essay with an address to his "empty" canvas. It is only apparently empty and silent, he wrote; in actuality it is "full of tensions with a thousand soft voices, expectant." As each of the artist's elemental forms appears on the canvas, it announces, "Me voilà. . . . Each line says 'Here I am.' . . . Black circle—distant thunder, a world for itself that seems to concern itself about nothing. . . . 'Here I am.'" All these voices come together in the total painting as a chorus: "HERE I AM." What "happens" in the painting shouldn't happen on the surface of the canvas, but "somewhere" in "illusory" space. In this way, the artist concluded, truth speaks out of untruth. This truth, said Kandinsky, is called "HERE I AM."[18]

These words echo almost verbatim the shamanic incantation that accompanied an Altaic drum animation rite recorded by the German-Russian ethnologist Radloff in 1884. Before undertaking his precarious journey to other worlds in a sacrificial ceremony honoring the deity Bai-Ülgön, the shaman animated his drum by solemnly summoning his spirit-helpers; drumming and chanting, taking on the roles of the spirits as they appeared, he gathered them into his drum:

You who rides amongst the thunder
Who playfully with lightning comes
Autumn cloud great with thunder
Vernal cloud rich with lightning . . .
Come

After each new appeal, the spirit-helper arrived with the clarion call: "Here am I."[19]

In Kandinsky's essay, the reference to a distant "thunder" that seems not to concern itself with external affairs recalls the Vogul and Ostiak conception of the principal deity, Numi-Tōrem, who was thought to be all-powerful over natural phenomena

but remained reserved and "distant." In speaking of a truth that is born "out of untruth," Kandinsky makes reference to the frequently reported phenomenon that the shaman often performs a miraculous deed through an apparent ruse. The parallelism between the Radloff report and Kandinsky's 1935 essay suggests in no uncertain terms the extent to which the artist had been moved by words he had read nearly half a century before and something of the degree to which he had been steeped in the literature on shamanism.

Three years later, in *Ruled Accumulation*, Kandinsky inscribed a drum in its state of animation (fig. 175). The title of this, another springtime painting, implies a "steady accumulation" of ideas and memories, while its secondary title, *Buntes Ensemble*, a "motley" or "multicolored" ensemble, emphasizes its reference to past memories, recalling that seminal work *Motley Life*. But the French title *Entassement réglé*, entered by the artist into his house catalogue, bears the Klang or subtext of musical association, suggesting an accumulation of notes on a sheet of ruled music paper. Indeed, the painting's musical connotations ultimately provide the key to its content.[20]

The overall shape of the dominating form suggests both the physiological shape of a human heart and a Yakut shaman drum. Near its center we find a dislocated form similar to the helmeted-head motif of earlier works. In a preparatory drawing, the helmeted head has a distinct body with arms and legs. To its right is the piebald biomorphic form previously identified with St. George's or the shaman's steed. To the left is a lyre-like form with a bird as its sounding board or neck. Below this group is a distorted ladder-like form implying the ascensional meaning of the whole. Just below the shaman's "steed" at lower right is a mushroom-like form, among the first appearances of this motif in the artist's work. Floating in a dark sky or sea are innumerable dots of many colors. Just below the yellow rectangle near the lower center is a somewhat sperm-like form, while above swim forms vaguely resembling fish and other creatures of the sea.[21]

The idea of "accumulation" in the title permits a retrospective search for the significance of this painting. The *Kalevala* hero Väinämöinen employed his shamanic powers to create a magic lyre with which to enchant the world, and in the passage recounting the creation of this magic instrument it is associated with the cuckoo, a bird widely known as a harbinger of spring and often associated with magical portent:

> Then old Väinämöinen
> uttered these words: "There is the body of the harp,
> the frame of the eternal source of joy . . .
> the frame of curly birch
> . . . When the cuckoo calls out,
> uttering its five notes, calling out a sixth, too,
> gold wells from its mouth . . .
> Thence are the harp's pegs, the curly birch's screws.
> Steadfast old Väinämöinen then uttered these words:
> "Now the pegs in the harp, the screws in the curly birch
> are from the call of cuckoo's gold, from the sad cry of
> silver"[22]

Here Kandinsky's lyre clearly manifests the cuckoo from whose golden call Väinämöinen fashioned the pegs of his stringed *kantele*. The bird, frequently associated with concepts of the soul and of rebirth among the Finno-Ugric peoples, had often appeared as a motif in the artist's shamanic paintings. Perhaps most compelling of all is the fact that Kandinsky was undoubtedly aware that the favored and traditional stringed instrument of the Finno-Ugric peoples of northern Russia, the *Crane*, was so named because its neck took the shape of a bird (fig. 176). Doubtless, there is yet another "sounding" echo of the past in this "accumulation," for the lyre motif itself recalls one of Kandinsky's earliest efforts to invoke musical reverberations by means of visual analogy, the print *Lyre* of 1907, in which a bird perched high on the bough of a tree sang descant to a strolling musician with his harp and his enchanted listener.[23]

The Sampo, the magic treasure that is the central motif of the *Kalevala*, while never described in actual detail in the epic, was known throughout the songs as the "multicolored (or motley) lid." The subject of much academic speculation, the Sampo was thought among some circles in Kandinsky's day to have been a shaman's drum crafted by the smithy Ilmarinen, another of the

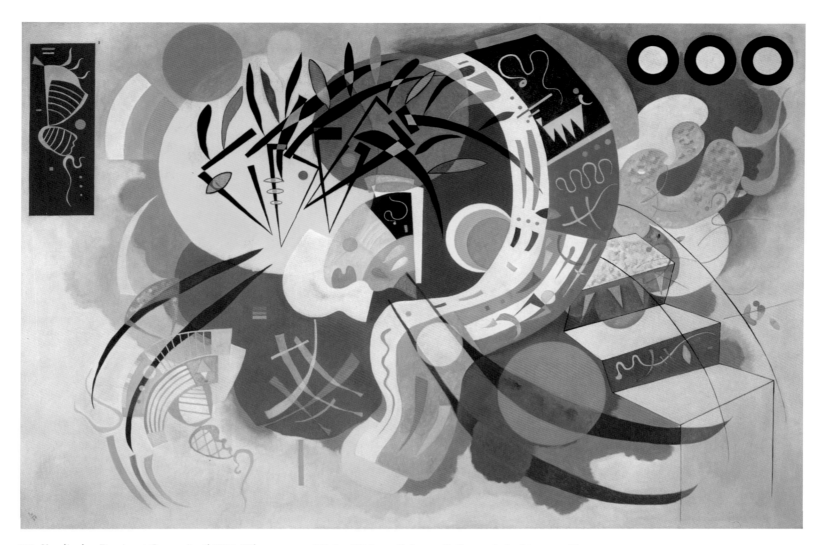

174. Kandinsky. *Dominant Curve*, April 1936. Oil on canvas, 129.4 x 194.2 cm. Solomon R. Guggenheim Museum, New York. Photo: David Heald. © The Solomon R. Guggenheim Foundation, New York.

175. Kandinsky. *Entassement réglé (Ruled Accumulation*; also known as *Ensemble multicolore* or *Motley Ensemble)*, February–April, 1938. Oil and mixed media on canvas, 116 x 89 cm. Musée National d'Art Moderne, Centre Georges Pompidou, Paris.

Sky Blue, painted in March of 1940, is another "accumulation" painting. A clue to its meaning resides in the figure at upper left, which clearly recalls Kandinsky's beloved toy rocking horse and rider. The figure floating almost directly at the center of the painting wears a "ribbed" breastplate on its back, a motif that marks its shamanic status, while its head is covered by a checkerboard motif and feathered headdress. The shaman's "steed" blinks humorously, if somewhat disconcertingly, from his tail. We are reminded once again of the artist's essay "Empty Canvas, etc.," where he also commented that what he sought was "a liaison between 'fairy tales' and 'reality,'" not so much the fairy tales of old, but "purely pictorial fairy tales and someone who knows how to 'tell the story' of a painting uniquely and exclusively through its 'reality.'" While the overall tone of the picture appears whimsical, it carries, after all, the usual freight of serious significances.[25]

176. "Cranes," Finno-Ugric harps. Collected by August Ahlqvist, 1877. National Museum of Finland, Museovirasto, Helsinki. Photo courtesy Museovirasto, Helsinki.

Kalevala's heroes. According to the legend, the Sampo, retrieved after great adventures and difficulties, was eventually lost and broken to bits in the sea. Here the multicolored bits of the broken Sampo seem to float in a sea of accumulated memories, fully sounded by the lyre at its core.[24]

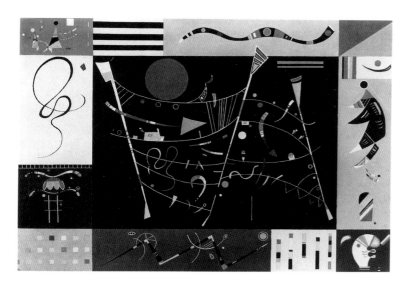

177. Kandinsky. *The Ensemble*, 1940. Oil on canvas, 81 x 116 cm. National Museum of Modern Art, Tokyo.

Pictographic Correspondence from Siberia

Filled with accumulated messages, these works were tangential to a series of "communication" paintings in which the artist explored another ethnographically inspired concern: pictographic writing. Throughout the thirties and until the last year of his life, Kandinsky created works with manifestly hieroglyphic intentions, some even filled with cascading "letters" inscribed with "messages," others laid out in rows like ancient tomb inscriptions.[26] In still other compositions, often bipartite in organization, entities were set into communication with one another, "connected," by means of "books," "letters," or "telegraphic lines."[27]

Clearly, Kandinsky intended *Composition X* as a major statement combining the theme of communication with a bipartite composition. Once again the "shaman-artist" in his checkered caftan presides, his arms-outflung attitude recalling World-Watching-Man, although in this instance his pointed cap and

phallic projections also recall the artist's Iarillo persona.[28] To the left floats his partner, an apparently feminine figure with a bird's tail, reminiscent of the Russian fairy-tale "swan princess," although her fish-like "skirt" also recalls the water sprite Rusalka of northern Russian folklore. The feathers attached to her costume suggest the traditional feathered costume of Siberian shamans, both male and female. She, too, adopts the arms-outflung attitude and is clearly a composite symbolic muse. Her head is filled with pictographic "messages" and she is linked to her "significant other" by a prominent book-like image imprinted with signs.

In other "connection" paintings the artist tied vertical elements together by means of complexes of web-like or curving lines, like ropes strung between poles and hung with hieroglyphs or shamanic amulets, as, for example, in *The Ensemble*, of 1940, reminiscent of the lines strung between trees or posts by Siberian shamans as part of the sacrificial ritual, and later hung with *ongons*, or sacred amulets, and the skins of sacrificed animals (fig. 177). But perhaps most poignant of them all is one of the artist's last watercolors in which the standing elements wear the shawl-like costumes marked with significant amulets, such as

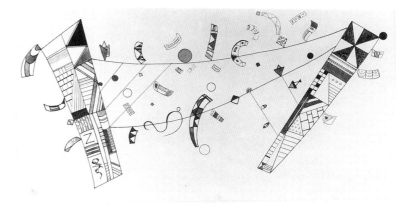

178. Kandinsky. *Untitled* ("next-to-last watercolor"), 1944. Watercolor and India ink, 25.9 x 49.1 cm. Musée National d'Art Moderne, Centre Georges Pompidou, Paris.

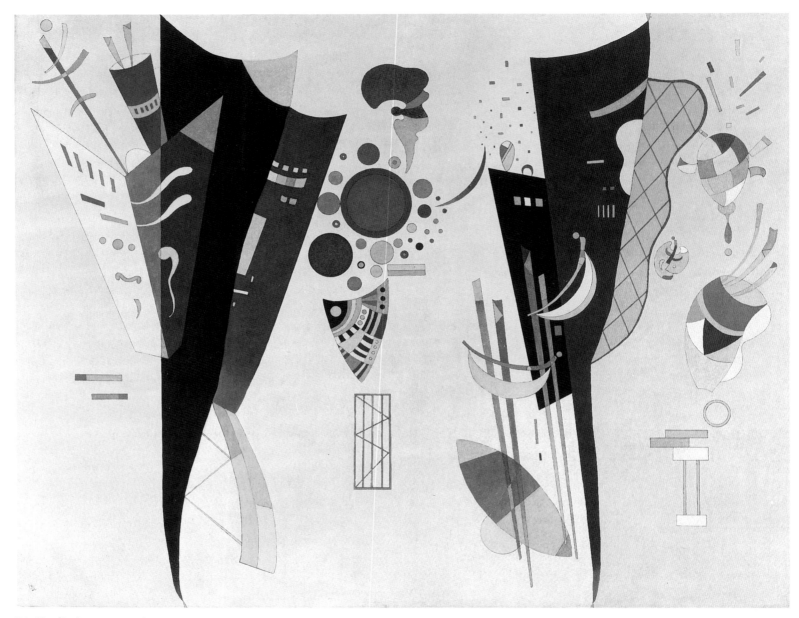

179. Kandinsky. *Reciprocal Accord*, 1942. Oil and mixed media on canvas,
114 x 146 cm. Musée National d'Art Moderne, Centre Georges
Pompidou, Paris.

the "Z" at lower left, as if to mark "finis," and one of the "sac-rifices" hung upon the line is Kandinsky's own horse-and-rider hieroglyph (fig. 178).[29]

Letters, like connections, represent a form of communica-tion, a theme close to Kandinsky, who was an inveterate, even irrepressible correspondent. These closely related series of paint-ings suggest a deep-seated desire for reciprocity in human rela-tions. Indeed, they would culminate in a masterwork of the late period entitled *Reciprocal Accord*, of 1942, to which the tempera painting *Le Filet*, of the same year, is closely related (figs. 179, 180).

These latter works represent yet another reminiscence of the artist's early ethnographic experience. Their "umbrella"-like forms echo rather precisely the imagery found in birchbark "love letters" of the Yukaghir, a people of far northeastern Siberia which had come to public attention in the 1890s (figs. 181, 182). It is easy to see that they combined the "connection" and "communication" themes that Kandinsky was exploring dur-

180. Kandinsky. *Le Filet*, 1942. Tempera on cardboard, 42 x 58 cm. Musée National d'Art Moderne, Centre Georges Pompidou, Paris.

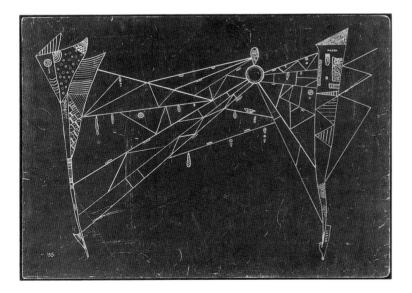

ing the Paris years and that must have arisen quite naturally in his mind.[30] Inscribed by means of a deftly wielded knife on birch bark, these messages communicated the hopes, fears, and desires of young Yukaghir maidens expressed in an "abstract" vocabulary of signs derived from natural forms. The umbrella-like images represented people dressed in traditional Yukaghir parkas that imparted this shape to their bodies, their skeletons articulated by dots at the joints, their sex by distinctions in girth or dots that signify braids. Even the most subtle and complex relationships could be indicated by means of connecting lines, crisscross configurations, and curlicues.[31]

Although Kandinsky inverted his umbrella-like forms in *Reciprocal Accord*, it is clear that communication is the theme, the left-hand personage appearing to "read" a book or letter, its feathered "head" peeking out above the epistle. The figure wields a baton resembling an Eastern cross. As in the Yukaghir figures, a variety of crisscross patterns unite parts of the figures (lower left and upper right), while at the center of the picture, below a one-eyed "shamanic mask," a rectangle of vertical lines crossed by a zigzag line recalls the "love embrace" motif of the Yukaghir precedents. Circles, rectangular dots, and a slender sickle form unite the two figures like thoughts. To each figure is attached a "shaman's coat" and, in the case of the right-hand figure, a "rib-bed" breastplate. Off-center to the lower right are two sets of sub-sidiary paired figures also united by sickle forms. To the far right hover disassociated parts of a body distinguished, from the top down, by the feathers of its headdress, a masked face, feathered coat, and vertical "legs." Is this perhaps another commentary on religious syncretism? A stand-off between two "shamans," one Christian and the other pagan?[32]

In *Le Filet* of the same year, the "umbrella" figures reappear, united by a complex web of connections that again recalls the connecting configurations of the Yukaghir letters (fig. 180). Here, too, the "ribbed" effect of the Yukaghir figures is suggested in the details of both figures.[33] These clearly ribbed forms had already appeared in 1940 in the painting entitled—with trans-parent irony—*Light Construction*, in which two skeletons, one surmounted by a grisly skull, are connected by a zigzag line

181. Birchbark "love letter."
Yukaghir, 19th century. Knife
drawing incised on birchbark.
Jochelson Collection, American
Museum of Natural History, New
York (No. 70/8488). Photo: Lee
Boltin. Courtesy Department of
Library Services, American Museum
of Natural History.

182. Yukaghir "love letter," no. 3. Late 19th century. Schema from S. M. Shargorodskii, "Ob iukagirskikh pismenakh," *Zemlevedenie*, vols. 2 and 3, 1895. The letters refer to Shargorodskii's key to interpreting the figures.

manism (figs. 184, 185). At first glance the picture seems awash with a plethora of disconnected forms, but now we recognize at once the feathered and helmeted head, in the large red circle just off-center in the upper left quadrant, with its golden all-seeing eye, peering back over his shoulder, poised in ecstatic flight, his caftan, adorned with the usual amulets of his office, flying out behind. Feathers, a bird, and an upward thrusting arrow emphasize his levitation.

Immediately below, and absolutely central to the composition, stands his alter ego, enabling his flight through his drumming. He wears the distinctive horned headdress of Tungus and Evenki shamans, and his drum is seen in double perspective, both "in the round" and from the side, its ribbons dangling (fig. 168).[35]

The asymmetrical placement of his dreaming self throws the entire composition into motion, whirling it in counterclockwise rotation "around the circle" and dislocating expected spatial relationships. Following the implicit directional command of the

193

(fig. 183). The right-hand figure again suggests the inverted form of the Yukaghir figures, distinguished particularly by the dots along its length, which in the Yukaghir precedents indicated joints of the skeleton. Other small ribbed beings float by and bird-souls appear; a "lightning" strike and rainbow in juxtaposition below the skeletons suggest the celestial arena of events. The painting clearly represents the artist's meditation on death: not only was Europe at war but his friends Aleksei Jawlensky and Paul Klee were fatally ill.[34]

The Figure of the Shaman

Kandinsky's ever-increasing immersion in the ethnographic experiences of his youth and his reliance on motifs associated with shamanic lore persisted during the last four years of his life and, in the end, came to constitute the major part of his imagery, the figure of the shaman often dominating.

Around the Circle, conceived in April 1940, another in the St. George's Day series, is a rich compendium of Siberian sha-

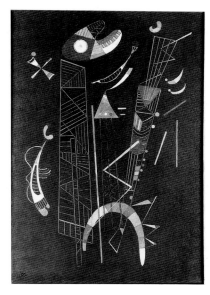

183. Kandinsky. *Light Construction*, April 1940. Oil on canvas, 73 x 50 cm. Kunstmuseum, Bern. Hermann and Margrit Rupf-Stiftung.

title and rotating the picture "around the circle," we see that the motley conglomerate of forms now to the left of the antlered shaman, viewed "upside-down," reveals a third shaman. His mask-like head is surmounted by a serpent, his body clothed in a decorated caftan, his midsection revealing his "skeleton"— a reference to the resurrectional capacity of the shaman and commensurate with the symbolism of the traditional shaman's breastplate. Studded with "stars," his caftan also displays a claw-like amulet, while from his right hand dangles a broad, flat, curving knife-like object and his left terminates in a pincers-like form exactly like that depicted on the traditional Udegei shaman's apron (fig. 186). His mask-like face, with its pinkish

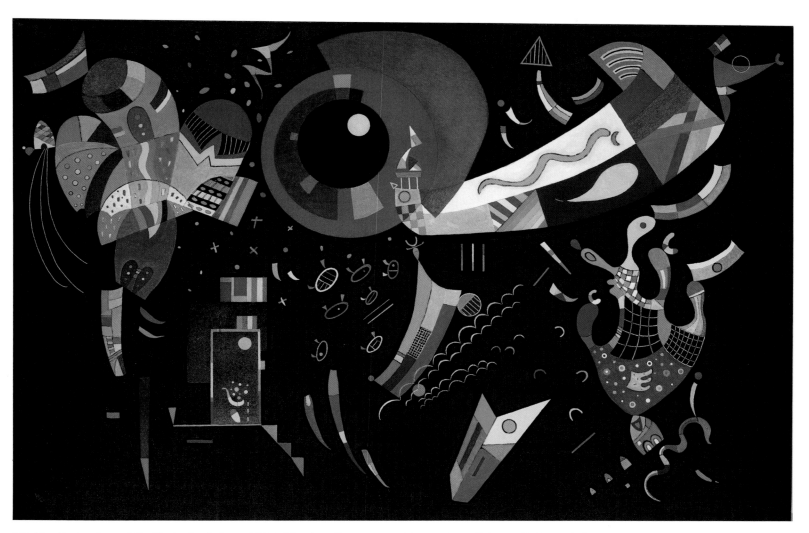

184. Kandinsky. *Around the Circle*, April–August 1940. Mixed media on canvas, 96.8 x 146 cm. Solomon R. Guggenheim Museum, New York. Photo: David Heald. © The Solomon R. Guggenheim Foundation, New York.

cast and large eyes, is eerily similar to the stylized faces of the Udegei precedent; Kandinsky's shaman likewise dances below an undulating "world-serpent."[36]

Turning the painting back to its normal orientation, the conglomeration of forms at upper left appears as a group of brightly colored Siberian "yurts" with paths leading to their doors. Below this group, to the right, a flight of stairs leads to a doorway through which are glimpsed a pale "moon" and a disembodied mask with a long-necked bird as its headdress. The "rainbow" of colors that frames the door, and the symbolic stairway, suggest a "doorway to heaven" or the "magic gate" that symbolized purification and regeneration. Above the doorway, the green sky is dotted with stars and planets, while to the right floats a fleet of amulets and at lower right an open "book" form hovers. The autobiographical nature of the entire painting is reinforced by the inverted *W* (for Wassily) at upper left that appears in many other Kandinsky works. *Around the Circle* is a major work of the artist's maturity, one that offers a summation of his knowledge of shamanic lore and its deep personal significance for him.[37]

The subject of the shaman in trance and in flight was now joined with that of the dancing shaman in *The Arrow* of 1943, with its "skeletonized" figures, the emphatic magic arrow challenging the serpent, and the floating "drum" and "drumstick" (fig. 187). Like the Udegei shaman in *Around the Circle*, the left-hand shaman is surmounted by an undulating snake. Here Kandinsky revealed his knowledge of Native North American

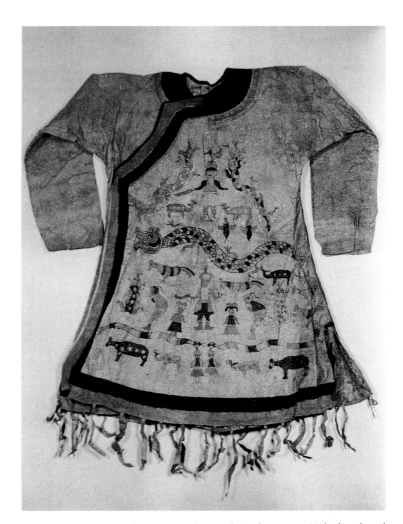

195

186. Udegei shaman caftan. Late 19th to early 20th century. Fish skin, length: 90 cm. State Museum for the Ethnography of the Peoples of the USSR. St. Petersburg (no. 5656–151). With permission from A. Okladnikov, *Ancient Art of the Amur Region* (St. Petersburg: Aurora, 1981), no. 70.

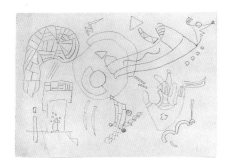

185. Kandinsky. Drawing for *Around the Circle*, 1940. Pencil on detached sketchbook paper, 16.1 x 22 cm. Musée National d'Art Moderne, Centre Georges Pompidou, Paris.

187. Kandinsky. *The Arrow*, 1943. Oil on cardboard, 42 x 57 cm. Öffentliche Kunstmuseum, Basel. Gift of Richard Doetsch-Benziger, 1946. Photo: Öffentliche Kunstmuseum, Basel, Martin Bühler.

shamanism, for this figure bears a startling resemblance to a figure on an Apache amulet illustrated in John Bourke's 1892 report on the medicine men of the Apache (fig. 188). Besides the snake, Kandinsky has depicted both a "Great Water Serpent" and the rain, slanting down at upper left, unmistakably evoking the Hopi snake dance performed in supplication for rain. The zigzag posture of the figure, its horned and crested headdress, and the snake above its head are all reminiscent of Native American sandpainting precedents as well.[38]

On the right side of the picture, a Siberian shaman appears with ribbed breastplate, drum, and drumstick balanced at his left shoulder. He is masked and wears a horned headdress. Above him a flying red form represents his enchanted flight, now in the form of fire, a legendary phenomenon reported among the Norsk Lapps as well as among the Buriats. The magic arrow of the painting's title attacks the serpent, forcing it back toward the other exhorting shaman, recalling yet again the Lapp noid's purported use of the "magic arrow."[39]

188. Apache amulet, front and back (Tzi-daltai). Wood, with painted protective figure, eagle-down feathers, and buttons. According to Bourke, to bring rain, find lost objects, and discover direction when lost. As illustrated in John G. Bourke, "The Medicine-Men of the Apache," Ninth Annual Report of the Bureau of Ethnology (Washington, D.C., 1892). J. Paul Getty Center for the History of Art and the Humanities Library, Santa Monica.

There is no doubt that Kandinsky was now wrestling with the encroachments of age and the inevitability of death, with both the pain and the succor of past memories. In Brown Elan, painted in April 1943, it is clear that St. George has undergone yet another metamorphosis: from the invincible rider of In the Black Square to the image of a more vulnerable, although still undefeated, hero (fig. 189). Skeletized and wearing his regenerational ribbed breastplate, his pied, visored helmet feathered as before, recalling the similarly pied and helmeted figure in Fixed eight years earlier, he straddles his horse, with its "checked" and tasseled saddle blanket, arching his neck and rearing gamely above the upended serpent. The birds' heads at his tail signal the possibility of his transformation into the gander of World-Watching-Man, yet his rider leans back, grimacing and recoiling from the fatal confrontation before him; his lance is broken and snagged upon a wayward triangle. To the upper left, in the celestial quadrant, rises a figure that may represent the soul of the saint or his flying alter ego. Between the horse's arched neck and the saint looms a shamanic mask, while, to the right, as if tossed aside, the magic drum with its attached pendants or ribbons strikes a hopeful resonance of healing and salvation.[40]

April 1943 also prompted another return to past memories and a meditation on aging and death in which the artist/saint/shaman paired himself with his two companions of the heart. Circle and Square presents two couples both separated and linked by the figure of destiny and death, characterized by his checkerboard mask, skeletal body, and scythe-like arms.[41]

In Red Accent, painted two months later, the artist contemplated the failure of his creative powers and the inevitability of death in no uncertain terms (fig. 190). Most of the action takes place against a ground of black that Kandinsky had equated to that "eternal silence without future and hope . . . [the] symbol of death." At upper right rocks the sainted horse bereft of rider. Only the lance and the empty halo remain; the saddle blanket is empty. The tumbled rider lies a step below, his piebald coat slipped off and the downward direction of his fall emphasized by a cascading arc. On the step below him, a small checkerboard is tipped askance by an "evil eye" topped by a down-arrow or

189. Kandinsky. *L'Elan brun (Brown Elan)*, April 1943. Mixed media on cardboard, 42 x 58 cm. Collection M. and Mme Adrien Maeght, Paris. Photo courtesy Galerie Maeght, Paris.

doubled triangle. But the Eastern cross that had appeared next to the checkerboard and "evil eye" in the preparatory drawing is missing, an alteration that perhaps suggests a loss of faith—or might it merely recall the habit of Yukaghir shamans of turning their orthodox icons to the wall before beginning the shamanist ritual? At the lowest level, the shaman's ascensional ladder has been wrecked and thrown into instability.[42]

Across the white abyss—in Kandinsky's scheme, the color of silence before birth—against another black void out of which only rebirth might ensue, the last painting on its easel stands in the empty studio, accompanied only by a final drum beat and a bird-soul winging its way toward heaven. The shaman's magic instrument has struck its final Klang, etched white in the void by a red-tipped brush or drumstick, decorated by a small serpent. This interpretation is encouraged by Kandinsky's discussion of the color vermilion that dominates the painting above: "Vermilion sounds like the tuba and *can be drawn in parallel with strong drum beats*." The vermilion painting is apparently an incomplete

self-portrait, its upper portion missing, with serpent and barred "window." Below, a mottled structure, pale shadow of the "Zukunftsbau" of the artist's dreams, slides downward. In the middle of the off-center white void there remains a lonely seed-shaped form suspended by four triangles: perhaps the *Kalevala*'s "multicolored Sampo" or its "Klang," with which this white silence is still pregnant.[43]

As Kandinsky felt his life coming to its close, his paintings took an ever more somber turn. *Ribbon with Squares*, painted in January of his final year, sets its figures out upon some cosmic plane like nothing so much as a shamanic "icon," combining imagery from Siberian shamanism with that of Finno-Ugric lore. Here the head of the "iron eagle" who begat the first shaman, his ascensional ladder, and his checkered caftan join St. George's serpent, the fire wheel of St. John's Night, and an ascending balloon with its regenerational cargo on the iconic plane of an infinite space, invoking for what was to be the last time with such clarity his syncretic program of dvoeverie (fig. 191).[44]

190. Kandinsky. *Accent rouge (Red Accent)*, June 1943. Oil on cardboard mounted on wood, 41.8 x 57.9 cm. Solomon R. Guggenheim Museum, New York, Hilla Rebay Collection. Photo: Robert E. Mates. © The Solomon R. Guggenheim Foundation, New York.

199

191. Kandinsky. *Ribbon with Squares*, January 1944. Gouache and oil on board, 41.8 x 57.8 cm. Solomon R. Guggenheim Museum, New York. Photo: Robert E. Mates. © The Solomon R. Guggenheim Foundation.

192. Kandinsky. *Le Lien vert (The Green Bond)*, February 1944. Oil on cardboard, 46 x 54 cm. Collection M. and Mme Adrien Maeght, Paris. Photo courtesy Galerie Maeght, Paris.

The Shaman's Self-Portrait and Journey Home

Now, perhaps faced with a premonition of his death, in February 1944 Kandinsky turned once more to his ethnographic past for an appropriate symbolic context. In *The Green Bond*, he painted an almost representational image of himself assuming the shaman's role for his last journey (figs. 192, 193, 194). In what was perhaps the most self-revelatory work of his career and a final revelation of his shamanist program, Kandinsky joined the aquiline profile of his auto-portrait to the body of his alter ego clothed in shaman's garb and grasping his "heaven tree" in an almost literal transcription of the Altaic ritual he had paraphrased in his 1935 essay "Empty Canvas, etc."[45]

Ascending the triplicate trunk of the world-tree at right, which rises from the summit of the world mountain toward a "heaven-cloud," this shaman wears his distinctive ribbed breastplate, motley caftan, feathered headdress, and leggings with articulated joints, his drum floating near his head and its mallet just below.[46] Turning his head back over his shoulder, he gazes upon the central image of a triangulated figure clothed in a shroud, tied with green thread in the traditional "knot of the dead" to prevent its "ort" from wandering, and recalling Kandinsky's report on Zyrian burial custom: "They bind their deceased sorcerers so that they do not disturb their relatives with visits." It is the "green bond" of the painting's title that binds this skele-

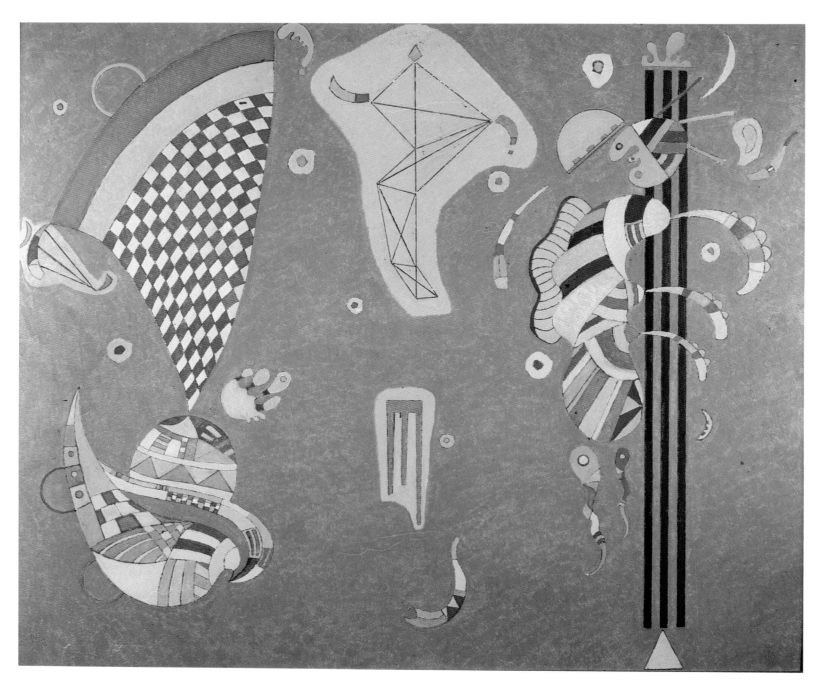

193. Kandinsky. *Untitled.* Drawing for detail of *The Green Bond*, 1944. India ink, 27.3 x 17.2 cm. Musée National d'Art Moderne, Centre Georges Pompidou, Paris.

formed of mud from the bottom of the primordial sea scooped up by the diver bird, hidden in his cheek, and spewed out upon the water's surface at god's command. And among many Finno-Ugric tribes it was believed that the breath-soul of the deceased had to be released by opening the smoke-hole of the dwelling. Hovering near this volcanic act is a hand-like form with seven "fingers," like the shaman's many-fingered glove that distinguished him from mere mortals, perhaps here suggesting the hand of god in the act of creation.[49]

The shaman climbing his triplicate tree into the heavens is an almost literal transcription of the Altaic rite Kandinsky knew by heart. At the climax of the ritual, as the shaman on his horse-drum reached the zenith of his ride, he sang a paean to the

194. Kandinsky. *Untitled.* Drawing for *The Green Bond*, 1944. India ink and pencil, 19.6 x 21.1 cm. Musée National d'Art Moderne, Centre Georges Pompidou, Paris.

ton, whose pointed head evokes those point-headed magical "spirit-figures" of the Voguls and Ostiaks reported by Castrén (fig. 195).[47] Below, at lower center, encased in its own shroud, floats a sacred instrument, a set of panpipes, of which the central pipe is appropriately broken in preparation for its burial.[48]

On the far left, where a celestial theme is naturally expected, a conglomerate of forms announces its presence with a flourish of checkered squares rising incongruously like smoke from the top of a yurt that is sustained on an island of mud spewed out of the beak of the diver bird in the ultimate act of creation. Its upper edge arcing like a rainbow, it seems to balance a divine amulet at one end, an unmistakable fetal symbol of regeneration at the other, partially occluding a rounded form like a halo, sun, or planet. The bird-like shape of the fetal form, emphasized in the preparatory drawing, reveals its intention as soul winging heavenward (fig. 194). Like a shaman's amulet string, its forms dangle asymmetrically, appearing to swing the sacred bird at its end to and fro (fig. 196). According to Finno-Ugric and Buriat creation myth, the earth, here symbolized by a colorful yurt, was

But one detail is poignantly missing from the final painting. It is the mushroom, perhaps too close and too "secret" to expose to public view, floating near the shaman's legs in the preparatory drawing (fig. 194). In the poems of *Klänge*, the artist had several times invoked the mushroom, clearly revealing his sure knowledge of its hallucinatory use in shamanic ritual.[51] It will be recalled, too, that both *Motley Life* and *Composition II* had come to Kandinsky while he was in a state of hallucination, from typhoid fever, according to the Russian edition of "Retrospects," where he had also remarked: "The artist is perhaps in a position—albeit only partially and by chance—to summon up within himself these states of inspiration by artificial means."[52] Only

195. Spirit-figures (Ostiak and Siberian). These figures, in some cases "effigies" of the dead, in others representing the shaman's "master," or even gods and goddesses, often embodying special powers of intercession with the gods, were usually carved of wood, often wrapped in several layers of cloth, and bound. *Left*: Spirit-figure wrapped in red felt and tied, with wooden "wolf" amulet, "master of the wolf"; wood, Archangel Samoyed (no. 979–11ab). Peter the Great Museum of Anthropology and Ethnography, St. Petersburg. *Center*: Siberian spirit-figure, Goldi (D1823). Peabody Museum, Harvard University. Photo: Hillel Burger. © 1994, President and Fellows of Harvard College. *Right*: Spirit-figure, Ostiak (Khant), collected by U. T. Sirelius 1898–1900; wood with white bead eye, wrapped in several layers of cloth, with three ties (no. SUL 3904:812). National Museum of Finland, Helsinki.

196. Amulet string of a Chukchee shaman. 19th century. From V. Bogoras, "Aperçu sur l'ethnographie des Tchouktches d'après les collections de N. L. Gondatti," *Sbornik Muzeia po Antropologii i Etnografii* 1, no. 2 (1901), pl. XVIII, no. 4. Photo courtesy Tozzer Library, Harvard University.

highest god Bai-Ülgön, master and creator of blue mountains, blue clouds, blue skies, to whom three ladders lead, pleading: "Thou who the starry sky thousands and thousands of times hast turned, condemn not my sins!"[50] Here the blue of the shaman's celestial environment is blended with the green of the primordial sea to produce an aquamarine plane of apparent infinity on which float the sacred objects, anchored on the right by the sacred tree and on the left by the scene of universal creation.

197. Kandinsky. *"Last Watercolor,"* 1944. Watercolor, India ink, pencil, 25.5 x 34.6 cm. Musée National d'Art Moderne, Centre Georges Pompidou, Paris.

years of experience train the artist to control these moments, to bring them up at will, he had written then. While it cannot be known exactly what he meant by "artificial means," in *The Green Bond* he has left a suggestion that he envied the shaman's intoxication and ready trance. Indeed, in his last watercolor Kandinsky filled the sheet with a veritable rain of mushrooms, together with some butterfly "souls" (fig. 197). Perhaps, in his seventy-eighth year, he felt his own creative powers slipping away and gave expression to a dream of the past, of a time when he was in his youth and nothing was impossible. In any event, this is a painting that clearly expresses the artist's shamanic intention and aspiration, his hope for triumph and rebirth, and at the same time his submission to a destiny that had brought him, at the end of a long and fruitful career, to a death in a far country with only memories of a lost homeland and its ancient lore to sustain him. Yet it was not to be the last work of his career.

St. George and Khubilgan

Tempered Elan was the last painting entered into the artist's house catalogue in March 1944 (fig. 198). In anticipation of what was to be his last St. George's Day, the artist presented himself in three of his metamorphoses: as St. George, as biomorphic St. George/shaman, and as shamanic caftan. The figure of St. George on horseback appears as if inlaid within an emblematic "palette" or "shield" form, much in the same way that he had appeared in that sixteenth-century edition of Herberstein's chronicles that Kandinsky had consulted for his essay on the Zyrians so long ago (fig. 100). The saint-shaman is shown with halo and shield or drum. His horse, whose head is assimilated to his forequarters, wears the checkered saddle blanket, while his saint's vermilion lance, or shaman's horse-stick, crosses behind the palette form. The palette-shield itself is distinguished by hanging ribbons suggesting its alternative role as drum.

Attached to this form by three arcing lines floats the biomorphic portrait of the artist as St. George and shaman. He is char-

198. Kandinsky. *Tempered Elan*, March 1944. Oil on cardboard, 42 x 58 cm. Musée National d'Art Moderne, Centre Georges Pompidou, Paris.

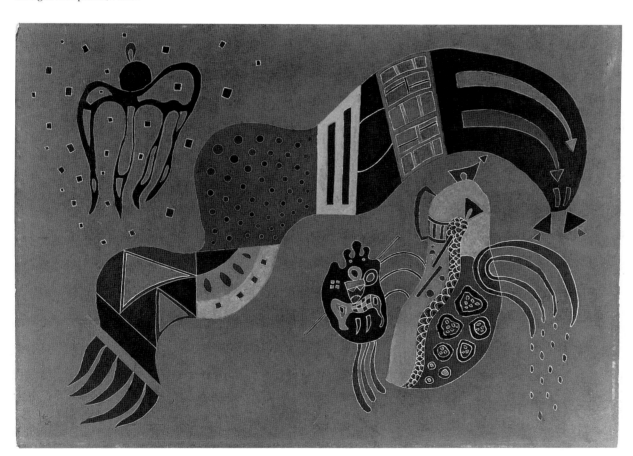

acterized by his visored and crested helmet, his scaled and pied costume with its feathers, and the drumstick-brush he appears to wield in an upraised scaly hand.[53] The fin-like attachment at the left of his helmeted head is a remnant of the ribbed breastplate in *The Green Bond* and the uppermost fin recalls the ubiquitous plumed cap.[54]

The flying tapestry-like form is reminiscent here of a "magic carpet," but, as usual, it is hung with shamanic ornaments: "ribs," disks (which lend a distinctly "pied" look), feathers, and especially arrows. While two arrows at the upper right curve to point downward toward earth and the place of burial, they are repelled by two upward-thrusting arrows, like "gan flies," at the corners, and an arrow consisting of two triangles affixed to the robe at the lower left points decisively upward toward the upper left and celestial area of the painting's "ground plane."[55]

In this "celestial" corner floats a form that has been described as an "angel" and even as an "angel of death."[56] But there are yet deeper dimensions to be plumbed, and this image may best be interpreted within the context of the metamorphosed shaman-artist. For there is good reason to relate it to ancient and widespread shamanist conceptions of the shaman's guardian bird or animal and to concepts of the bird-soul. Here the image commands the area of the canvas formerly reserved for the figure of St. Elijah/Thor, the thunder god, whose stormy presence was also personified by many Siberian peoples, as among many North American tribes, in the image of the "Thunderbird." In fact, the Transbaikal Buriat-Orochons specifically associated the figure of St. Elijah with their ancient belief in the Thunderbird.[57] The artist would also have known that among the Tungus, wooden images of birds were raised above the grave of the shaman to aid him on his flight into the heavens.[58]

Among the Buriats images of birds and animals represented a guardian spirit, often considered an "ancestor." Such a figure was called *khubilgan*, meaning "metamorphosis," and was related to the concept of the migration of souls. The Buriat shaman, who was thought to possess a metamorphic animal soul as his escort and helper, might call upon his "guardian helpers" in the following words: "Grey hare our runner, grey wolf our ambassador, bird Khon our *khubilgan*, eagle Khoto our messenger."[59]

199. Kandinsky. Notebook sketch, ca. April 1938. Pencil and colored crayon, 27.1 x 33.1 cm. Musée National d'Art Moderne, Centre Georges Pompidou, Paris.

Migrating birds such as the loon, swan, and goose were also often associated with this concept. Among some tribes the reindeer was often the guardian spirit of the shaman, signified, for example, by the antlered Tungus headdress (fig. 168).[60]

The shaman's guardian spirit in animal form had already taken up residence in Kandinsky's work, as, for example, in the tempera painting *Three*, 1938, in which triplicate biomorphic animal forms appeared in checkerboard frames, one above the other. These many-legged, piebald creatures bear an uncanny resemblance to elk or reindeer, even growing delicately drawn "horns" or "antlers" on their "heads" in the preparatory drawing (fig. 199). In *Five Parts*, January 1944, four "animal guardians" ranged across the top, sustained as in some pagan "iconostasis" by images of the dancing shaman as World-Watching-Man with arms outflung (middle right), an upended dragon (lower left), and a feathered "Indianesque" profile (lower right).[61]

But in *Tempered Elan*, it is the bird aspect of the khubilgan, with its wing-like appendages, that dominates and led to interpretations of this form as an angel. If we recall the excitement with which Kandinsky had reported the discovery of Chud burial mounds in Zyrian territory during his 1889 expedition and his visit to such a mound at Bogorodsk, it will hardly surprise us to

200a and b. Bird/shaman artifacts, cast bronze, Ural region. *a)* Ural region, Pechora (also illustrated in Anuchin [1899]). *b)* Ural region, Siberia (also illustrated in Anuchin [1899]). From I. Tolstoi and N. Kondakov, *Russkiia Drevnosti*, vol. 3 (1890).

learn that among the archeological fragments of Chudic culture commonly unearthed in that area then as now were cast-bronze representations of sacred birds with long drooping wings, often supplied with loops for use as pendants, which have also been interpreted as depictions of shamans in the guise or costume of the sacred bird (figs. 200a and b). Among the ancient Ob-Ugrians, the fourth soul, known as the "reincarnation-" or "breath-soul," was said to take the form of a bird, and phrases such as "little bird of the soul" or "falcon of the soul" were coupled with the notion that this soul was attached to the head or skull. This bird-soul was thought to enter into infants thus experiencing rebirth. Hence bird images were customarily used as pendants on women's braids, explaining the loops on the ubiquitous bird artifacts.[62] Moreover, the bird was often seen as a portent of death, and Ivanitskii had reported on the Vologda peasant custom of placing a bowl of water near the bed of a dying person so that his soul might "wash its wings" before flying away.[63]

So acute was Kandinsky's eidetic memory that he even included a reference to the loop at the upper edge of these bird pendants from which they were originally suspended. The magical and tutelary relationship between the bird and the shaman had been emphasized by Dmitri Anuchin in his profusely illus-trated 1899 study on the art of the ancient Chuds, and the same year by the archeologist Spitsyn in a study of shamanist artifacts.[64] Moreover, at hand in Kandinsky's own library lay Kondakov's *Russian Antiquities and Monuments of Art*, in which two of the same Uralian bird artifacts illustrated by Anuchin, one in fact from the Pechora area of Vologda province, were illustrated (figs. 200a and b). These two shamanist birds were published in volume 3, where, interestingly enough—in view of the title of Kandinsky's last painting—Kondakov wrote of the "élan" with which a Scythian bird he was describing lifted its prey.[65]

Indeed, Kondakov had gone so far as to associate the Chudic bird form with an image of a "bird-man" he had located in the Palatine Chapel at Palermo and which he interpreted as an image of Alexander the Great being carried into heaven on the back of a divine bird (fig. 201). Anuchin, however, arguing against Kondakov, countered that in his opinion the Palatine image had originally been intended as a representation of the mythical bird of the Hindus, Garuda, in confrontation with its arch enemy, the serpent Naga, whose snake-like tendrils surrounded the griffin-like bird. In conclusion, Anuchin emphasized the shamanistic nature of the Uralian artifacts, noting that depictions of soaring birds having religious significance extended far beyond the

201. Mosaic panel. Palatine Chapel in Palermo, interpreted by Kondakov as the image of Alexander the Great being carried into heaven on the back of a divine bird (also illustrated in Anuchin [1899]). From I. Tolstoi and N. Kondakov, *Russkiia Drevnosti*, vol. 5 (1897).

Urals and that later images of "soaring angels" discovered in the mounds of central and western Russia represented at least "echoes of that belief in the divinity of winged creatures."[66]

It appears that, indeed, deeper layers of meaning than hitherto suspected inform the powerful image of the bird-like khubilgan of *Tempered Elan*. In a final metamorphosis, the artist created a new multidimensional mythic creature to serve as psychopomp and protector on his last journey. Like its companion piece, *Brown Elan*, this painting has a tragicomic edge with traces of a gentle self-irony. If the figure in the heavenly quadrant may be read not only as "angel of death" but as the shaman's khubilgan and his psychopomp, as heavenly dove and as shamanic bird-soul—in sum, as the artist himself, like Kondakov's Alexander the Great, in winged ascent into heaven—then an appropriately syncretic interpretation has been achieved that is consistent with Kandinsky's life-long interest in dvoeverie and that is, as well, a reflection of the rich ethnological and folkloristic context of his own past.

Epilogue

In the months that followed completion of *Tempered Elan*, Kandinsky's health declined, although he continued to work until the end of July.[67] Among those final aesthetic statements were the last two watercolors that referred obliquely to the shaman's sacrifices and to his trance (figs. 178, 197). An unfinished watercolor that seems indeed a meditation upon death remained taped to the artist's working panel (fig. 202). Here circle and serpent signal the presence of St. George'and, together with a symbolic checkerboard, they hover in approximately the same configuration they had taken in *Yellow-Red-Blue*, with faint yellow, rose and blue washes also recalling the earlier masterpiece (fig. 158). But the St. George/shaman's helmet is laid to rest for the last time upon a tilting coffin-like form, the entire bier slanting downward and covered by the shaman's costume embellished with the amulets appropriate to his office; all as if laid out in death. An overall brownish patina—"an indescribable inner beauty"—hints at earthen interment. To the lower right—in Kandinsky's scheme, "toward home"—a hieroglyphic message is carefully inscribed, directed to those who are left behind. To the upper left—toward "heaven"—floated in a wash of intense blue, a well-defined rectangle, containing within its boundaries a series of linked forms, appears to paraphrase the artist's own work; it is filled with motifs selected from the paintings of the thirties and forties that had emphasized the theme of "reciprocal accord."[68]

With his citations of shamanic ritual and lore in *The Green Bond* and a direct quotation of Herberstein's St. George in *Tempered Elan*, Kandinsky had come full circle. Harking back more than half a century to an expedition into Vologda province and Zyrian territory that had so excited his imagination, he lived once again with the ancient myths. It is perhaps not too much to say that in the entire Byzantine-Scythian cast of his last paintings, Kandinsky was thinking in mythological terms of time out of mind. Vividly alive and persisting in his memory were the stories of the ancient Chuds who had preferred to bury themselves rather than surrender their pagan beliefs, discoveries of Chudic burial mounds with their archeological treasures, tales

of the leshie and the rusalki, the goddess of the rye, Poludnitsa, and the domovoi still vivid in Zyrian belief; of the dual divinities Elijah/Thor and St. George/World-Watching-Man. The tale of the sorcerer Pam's encounter with Stephen, the bishop of Perm, on the banks of the Vychegda River stood before his eyes. Herberstein's tale of the Golden Woman and the magic of the *Kalevala* inspired his thoughts. He recalled as if it were only yesterday, the old man who had described for him the Zyrian custom of tying up the dead sorcerer or shaman. He remembered the fabled ort and his readings of Radloff, Castrén, Sjögren, Mikhailovskii, and Kharuzin, with their descriptions of the shamanic ritual. The words of the shaman invoking his spirit-helpers returned to him,

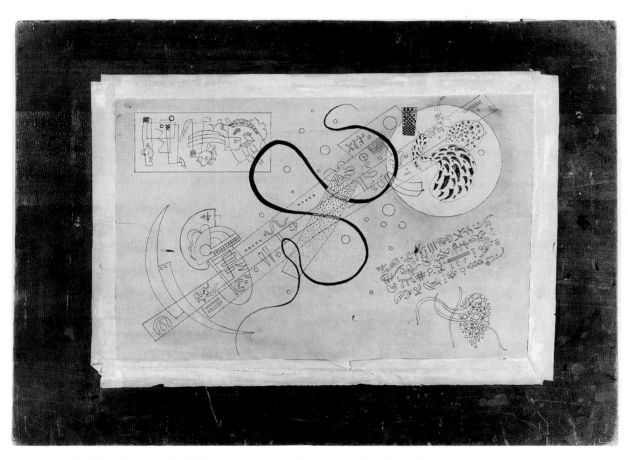

202. Kandinsky. Untitled and unfinished watercolor, 1944. Watercolor, India ink, and pencil, 30.2 x 46 cm. Musée National d'Art Moderne, Centre Georges Pompidou, Paris.

203. Hannes Beckmann. *Portrait of Kandinsky*, ca. 1935, at about the time his essay "Empty Canvas, etc." appeared in *Cahiers d'art*. Musée National d'Art Moderne, Centre Georges Pompidou, Paris.

and as the image formed itself for the last time upon his canvas, it seemed to murmur: "Here I am."

In celebration of his seventy-eighth birthday on 4 December 1944, just nine days before his death, the artist joined in a Russian song. Having opened a new way in the art of the twentieth century, he had remained until the end true to his own cultural inheritance. In ways he could not have foreseen, the shaman-artist transcended death.

This voyage of exploration has traced the remarkable development and dimensions of a creative spirit hitherto unsuspected of such complexity. In conclusion, the words of another explorer of Russia's Arctic north come to mind: "Who knows only our side of existence cannot comprehend the other. But he who has witnessed life in its more original form, never forgets what he has seen, and once he has left the infinite plains, the memory becomes for him a radiant revelation from which he can never again tear himself away. He has become a man with a double life, something of him has remained in the wilderness. So did it happen to me."[69]

And thus did it happen to Kandinsky, whose double-life remained for so many years so much a mystery.

His magic drum they hung on him
His magic drum pulled itself tight
Again he shamanized
The old one doesn't cease

notes

Epigraph: Memoir of a visit to Kandinsky's studio in Munich, 1912. From Max Bill, ed., *Wassily Kandinsky* (Paris: Maeght, 1951), 89. Translation by the author, with gratitude to Mary Ann Caws for her generous consultation.

Introduction

1. Kandinsky (1901), in L/V (1982), 42 (the unnamed critic had thus described a work by the realist painter and war correspondent V. V. Vereshchagin); Kandinsky (1930), as in Bill (1963), 134–135; on the "violent impression" of the Vologda expedition, Kandinsky to André Dézarrois, 31 July 1937, quoted in D/B (1984), 13; and on the origins of his abstraction in his early experience of northern Russian folk art, see Kandinsky (1937) in Bill (1963), 212.

2. See Weiss (1982a), 28–82.

3. I was greatly assisted in my search for these objects by Dr. Rose Schubert and Dr. Maria Kecskési of the Staatliches Museum für Völkerkunde, Munich. On Kandinsky's relations with Munich's Ethnographic Museum, now the Staatliches Museum für Völkerkunde, see Weiss (1990b), 285–329.

4. See, e.g., Rubin (1984).

5. What I found has been the subject of several articles, numerous public lectures, and, at last, the present book (completed in 1990). See Weiss (1986), 43–62. An expanded and corrected version of the latter article appeared under the same title in Weisberg and Dixon (1987), 187–222. See also Weiss (1990b), (1992), and (1994). The basic material was first presented in public lectures at the State University of New York, Binghamton, 17 Oct. 1985, and at Syracuse University, 5 Dec. 1985.

6. Most biographies of Kandinsky have followed this scenario. Cf. Grohmann (1958), N. Kandinsky (1976), and Roethel (1979). Roethel, e.g., continued to refer to "the expressionistic abstractions" of the pre–World War I era, "the geometric constructions of the Bauhaus period," and "the cool, cryptic conjurations of Paris."

7. Kandinsky (July 1937), as translated in L/V (1982), 802. Cf. Bill (1963), 208–209.

8. Grohmann (1958), 196 and 240. For a new interpretation of this painting, see Weiss (1985), 137, and chap. 6 below.

9. As early as 1959 Kenneth Lindsay pleaded for guilt-free "readings" of Kandinsky's imagery (Lindsay [1959], 349) and soon provided "readings" to what he called Kandinsky's "Themes of the Unconscious," finding narrative content in a number of the later "abstract" paintings, sometimes offering a contextual rationale, such as the artist's general knowledge of Russian folklore on the one hand or the "existential malaise" of wartime Europe on the other (Lindsay [1966], 46–52). License to "read," however, led some to stray dangerously from the historical to the Gestalt-psychological (e.g., Paul Overy, *Kandinsky: The Language of the Eye* [New York: Praeger, 1969]). Meanwhile, others seized upon the artist's obvious allusions to religious themes in works of the Munich period to apply the gloss of a narrow Theosophical bias (e.g., Ringbom [1966 and 1970]). Also in this vein, although widening the net and demonstrating the artist's attention to specific apocalyptic and Biblical motifs through meticulous study of his sketches, Washton Long's work proved the value of this methodology, without however taking it beyond the Munich period (Washton [Long] [1968], [1980]). For critiques of the Theosophical approach, see L/V (1982), 23, 117, Weiss (Spring 1984), 91–95, and Weiss (1990a), 313–26. *Kandinsky in Munich: The Formative Jugendstil Years* was the first effort to situate the artist's early evolution within a cultural and historical context, demonstrating the origins of specific theories, motifs, and themes within the Jugendstil-Symbolist milieu of Munich at the turn of the century (see Weiss [1979]). Also reacting to the limitations of previous approaches have been those efforts to apply a broader historical brush to specific paintings, e.g., Langner (1971, 1979, and 1982). Quoting Adorno's questioning of the very possibility of "absolute non-representational" painting, Langner admitted that further biographical and contextual information might have rendered

the content of a given work more readily available ([1979], 139, and [1982], 108, citing Adorno, *Aesthetische Theorie* [1972]). An experimental application of Kandinsky's theories (in *Point and Line to Plane*) to *In the Black Square* (1923) yielded the undeniable figure of St. George battling the dragon as the subject of a work hitherto judged "purely" abstract (Kimball and Weiss, [1983]). More recently Kandinsky's interest in the biological sciences provided an innovative reading of specific "biomorphic" works of the thirties (see Barnett [1985], 61–87). For a semiotic experiment in Kandinsky "reading," see Thürlemann (1986).

10. Many more instances are demonstrated in the following text. On the context of *Red Oval*, see chap. 4 below; on *Development in Brown*, see chap. 5. I discussed the context of *In the Black Square* in my lecture "Evolving Perceptions of Kandinsky and Schoenberg in the Twentieth Century: Toward the Ethnic Roots of the 'Outsider,'" at the conference *Constructive Dissonance: Arnold Schoenberg and Transformations of Twentieth Century Culture: Vienna, Berlin, Los Angeles*, Arnold Schoenberg Institute, University of Southern California, November 1991 (publication in progress); see also chap. 5 below. Nevertheless, no biographical monograph has been attempted here; there are still far too many gaps in our knowledge (unexplored archives in Russia, reams of unpublished correspondence, etc.) to justify a complete biography. Inevitably, this research has shed some new light on his personal life—e.g., concerning his relationships with friends and colleagues of the Ethnographic Society. However, this study can only hope to provide details to a future overall reassessment of Kandinsky as artist and person.

11. Robert Goldwater (1986 [1936]). On Cormon's depiction of Cain as "Urmensch," see Lois Fink, *American Art at the Nineteenth-Century Paris Salons* (Cambridge: Cambridge University Press, 1990), 187.

12. See Rubin (1984). In his essay for this catalogue, Donald Gordon wrote: "there is no

compelling evidence that tribal art ever directly influenced Kandinsky's style—then or later" (p. 375).

13. In the opening pages of his manifesto *Über das Geistige in der Kunst*, Kandinsky prophesied a short duration for that kind of modern art which, in its affinity for primitive art, depended upon what he called "borrowed form." (Kandinsky [1912a], 4.) Indeed, Kandinsky's uses of ethnography were far ahead of his time, as may be seen in comparing James Clifford's review of the 1984 "*Primitivism*" exhibition. Clifford's insistence that "primitive" societies must be viewed in a context as vital and changing as our own is a corrective to what he has described as a tendency, especially among historians of art, to view other cultures as trapped in some sort of "mythic time." (Clifford [April 1985], 164–215, and [1981], 539–564.)

14. Thus have I hoped to steer clear of the dangers of "pseudomorphosis." I am grateful to Kenneth Lindsay for passing on Spengler's implied warning, couched in mineralogical terms, against pseudomorphosis, as in misidentifying "stones of one kind [that present] the appearance of stones of another" (Spengler [1926], II, 189). Robert Rosenblum touched upon the question in his leap from Caspar David Friedrich to Mark Rothko, citing Erwin Panofsky's earlier warning against pseudomorphosis, construed as attributing similar meanings to works of art that display apparently similar formal structures "at different moments of history." (Rosenblum [1975], 10, citing Panofsky [1964], 25–26.) As we have seen, Kandinsky himself warned against the tendency in modern art to "borrow" the external forms of the "Primitives" without comprehending their inner essence (Kandinsky [1912a], 4–5). Precisely for these reasons have I emphasized Kandinsky's intentional metamorphic transformations, disassociations, and dislocations in his adaptations of significant motifs selected less for their external appearance than for their inner resonance (which he thoroughly understood) with his own

aesthetic program. Thus I have largely confined myself to sources that were demonstrably known to the artist (such as Sjögren, Castrén, Kharuzin, Bogaevskii, and many others, whose work will be discussed in the following text) or that we can reasonably assume he knew (such as Jochelson, Bogoras, etc.).

15. Grohmann (1958), 246. Grohmann also called for a study of the possible relationships between Kandinsky's work and Chinese art.

16. If, as both William Rubin and his critic James Clifford have said, the artists represented in the 1984 MOMA exhibition "knew little or nothing of these objects' ethnographic meaning" (Clifford), and "Picasso and his early twentieth-century colleagues knew nothing of their real context, function, or meaning" (Rubin), there is yet another reason why Kandinsky would not have been comfortable as a guest at that exhibition: he was the modernist who knew too much. Clifford (1984), 171 and Rubin (1984), 258.

17. The syncretic nature of Kandinsky's quest is evoked in the term "Old Russia" in the title of this book. In Russian historiography the term generally signifies the medieval and pre-Petrine period of Russia's past (about the tenth to the end of the seventeenth century), "dark" times characterized not only by great political and social upheavals but by an extraordinary collision between pagan and Christian belief systems throughout what later came to be a vast empire. That "motley" Old Russia was often contrasted to the post-Petrine period of "enlightenment," but by the end of the nineteenth century even that distinction was viewed with growing cynicism. The Slavophile movement that characterized much of the cultural environment of Kandinsky's youth expressed a nostalgic yearning for those "dark" times of Old Russia and for its syncretic mythologies and heroic epics, of which shamanism had been an element: "Old Russia" had become a metaphor for a mythic past. The term "Shaman" in the title of this book is, of course, likewise metaphorical in intention. See Florovsky (1964), 125–139; Andreyev (1964), 140–147; Billington (1964), 148–172.

18. This translation is my own, from the original French version, "La Valeur d'une oeuvre concrète," *XXe Siècle* 5/6 (1939). Cf. the German version in Bill (1963), 247. Both French and English editions of the magazine were published for a time; in the English edition of *XXe Siècle*, the translation of this passage was somewhat garbled. There the article appears as a continuation on unnumbered pages (Kandinsky, "The Value of a Concrete Work," *XXe Siècle*, second year, no. 1 [1939]). Interestingly enough, this issue of *XXe Siècle* included commentaries by two representatives of the Musée de l'Homme (C. van den Broek d'Obrenan and Henri Lehmann) on sculpture of Africa, Oceania, Central America, and Mexico, along with twelve photographs of works from those areas.

Chapter 1

1. From the *Kalevala*, Rune 12, as quoted by Kharuzin (in the translation by L. Belskii) in Kharuzin (1889), 40–41. English translation by Robert De Lossa, Harvard University. Lemminkainen, a "shaman-chieftain," is one of the heroes of the *Kalevala* saga. Pokhola, usually rendered Pohjola in English, refers to a mythic "land in the North, destination of dangerous journeys." See Kuusi, Bosley, and Branch (1977), 583–585. "Ethnographic Society" refers to the Ethnographic Section of the Imperial Society of Friends of the Natural Sciences, Anthropology, and Ethnography; hereafter referred to simply as the Society.

2. This sequence of events, recorded in *E.O.*, indicates that he was already an active member of the Society by the autumn of 1888, a year earlier than previously thought. For announcements of Kandinsky's presentation and expedition, see *E.O.* 1 (1889): 177; announcement of Kandinsky's essay on law, 150. For Kandinsky's review of Novitskii's Cossack ballads, *E.O.* 1 (1889): 154. See Weiss (1986), 43–62; Weiss (1987), 187, 214; Weiss (1994). Cf. chronology in D/B (1984), 12; N. Kandinsky (1976), 29. See Shumikin (1983),

337–344, on the actual dates of Kandinsky's enrollment in the university from 1885. On the prestige of the Society, in particular the Department of Anthropology, University of Moscow, see Levin (1963), 12–13. For more on the Society and its members, see Weiss (1994).

3. Kandinsky (1889b), 102–110, considered in detail below. His third ethnographic essay, on Russian peasant law within the district courts of Moscow province, was included in a series of ethnographic studies published separately by the Society (Kandinsky [1889c], 13–19). The latter essay, primarily concerned with customary law and its relationship to economic hardship, is not considered in detail here.

4. Kandinsky (1913), VIII.

5. On Kandinsky's thesis and preliminary report, see Shumikin (1983), 338–339.

6. Kandinsky (1918 [L/V 1982]), 891, nn. 47, 48. Cf. Weiss (1979), esp. 63, 111; and Haxthausen (1847), VIII–IX, 223–282, whose observations strikingly anticipated Kandinsky's.

7. According to curator Natasha Avtonomova, its provenance is unquestionable; she believes that the work is Kandinsky's. The slightly stylized figures are consistent with figures in such later works as *Composition II*, which is closely related to Kandinsky's Vologda experience, as will be demonstrated.

8. Kandinsky (1918 [L/V 1982]), 891, n. 45.

9. Kandinsky (1913), IV, VII (where he referred to himself as "Slav"), XXVIII. Kandinsky (1918 [L/V 1982]), 897, n. 105, reporting that his father hailed from Nerchinsk.

10. Komi was the original ethnic name for these Finno-Ugric people and the name by which they called themselves (in use again today). The name Zyrians (German *Syrjänen*) was imposed by the Russians in the seventeenth century to differentiate them from their southern cousins, to whom the Russians gave the name Permians (now Komi-Permyak). See Belitser (1973), 598. For the sake of historical context and consistency, the Russian names used in the literature of Kandinsky's day will be retained in this text.

The other major ethnic groups in the northern Ural region (with their Russian-imposed names given first, followed by their actual ethnic names in parenthesis): the Ugric Voguls (Mansi) and Ostiaks (Khanty); on the Uralic side, the Samoyeds (Nenets). Others mentioned in the following text include the Finnic Votiaks (Udmurts), the Cheremis (Mari), and the Mordvins (Mordva).

11. See, e.g., maps in Sommier (1887), n.p., and Sommier (1885), n.p. Nineteenth-century Russian maps placed Kondinskoe, and the Kondinsk or Kandinsk Monastery, on the Ob between Sharkalanskoe and Malo Atlymskoe (at approximately 62 degrees latitude, 66 degrees longitude). While some Soviet maps locate a Kondinskoe on the Konda River itself, the former site of the monastery is apparently the present-day Oktyabrskoye (as of 1989). Karjalainen also published a map (from Itkonen) that placed Kondinsk on the Ob between "Sherkala" and "M. Atlym." In his history of Ugric religion, he observed: "Already in the year 1591 the sovereign [Fürst] of Obdorsk, who received the name Vasilj, was baptised, [and in] 1599 Anna, the wife of Altsheis, the sovereign of Kondinsk, as well as her son Igishei" (emphasis mine). See Karjalainen (1921), I, 10–11, 200–201, and Karjalainen (1922), 181, 194, where Kondinsk Monastery is discussed. I am grateful to Felix Oinas, Indiana University, for advice on the etymological identity of Kondinsk and Kandinsk. See Unbegaun (1972), 19–20, 126–127. On the origin of "Konda," from the Finnish for fir tree, see Sjögren (1861), 240 (n. 8), 290, 307, 410 (cited by Kandinsky; see below). Kandinsky's fondness for the fir tree and its abstracted form, the triangle, clearly observable in his later work (e.g., Three Sounds, 1926), suggests that the triangle with which he habitually surrounded his signature may have been a coded reference to the origins of the family name.

12. Novitskii (1884), quoted in Karjalainen (1922), II, esp. 180–181, 186–187, 194. Today a large part of this region is known as the "Kondinskii Rayon" and is still inhabited by ethnic Ostiaks and Voguls. See Levin and Potapov (1964), 511ff.

13. See Jean Arp's memoir of his visit to Kandinsky's studio in Munich, 1912, in Bill (1951), 89–90. N. Kandinsky (1976), 22. Hanna Wolfskehl, wife of the Munich Symbolist poet Karl Wolfskehl, remarked on Kandinsky's oriental features in a letter to Albert Verwey: "Kandinsky dessen Gesicht immer so wie so von chinesischer interessanter Schärfe und Feinheit vorkommt." Quoted in Weiss (1979), 82, 191, n. 17. On Kandinsky's "orientalism," see Weiss (1991). Ethnographers and anthropologists have often remarked on the "Mongoloid" features of the Konda River Ostiaks and Voguls from whom Kandinsky may also have descended. On the prevalence of such ethnic mixing in the Russian empire, see, e.g., Levin and Potapov (1964), esp. 57, 203–210, 620–625; and Cheboksarov (1962), 207–219. Many 19th-century ethnographers and linguists believed ancient links existed between the Finno-Ugric peoples and the peoples of the Far East, a theory that fueled many of their expeditions, the reports of which were well known to Kandinsky (e.g., Sjögren, Castrén). See also Baraev (1991), which reached the author's desk only after this manuscript had been completed. It for the first time provides a genealogy of Kandinsky's family which helps confirm my speculation that the Kandinsky family name derives from the geographic name of the Konda River, tracing the first Kandinsky (Aleksei; no patronymic, no dates) to the Konda River area of Tobolsk province at the beginning of the 18th century. According to Baraev, it is "possible" that this "first" Kandinsky was banished to eastern Siberia "for political reasons," as the painter suggested in his memoir. The genealogy then skips to a Kandinsky (Pyotr Alekseivich, 1735–1792), said to have been a "Yakutsk tradesman" who was exiled to Nerchinsk in 1752 for having stolen from a church. One of his sons, Khrisanf Petrovich (1774–185?), became a rich "robber baron" and merchant, eventually achieving first guild and then "honorary citizen" status. He in turn fathered Sylvestr Khrisanfovich, the artist's grandfather, who sired Vasili Sylvestrovich, his father. Baraev traces many connections by friendship and marriage

between the Decembrist Bestushevs and the Kandinskys, and their common links to other Decembrist exiles, revealing that Kandinsky's father traveled to London for meetings with the writer and Decembrist revolutionary Alexander Herzen in 1862. The Bestushev genealogy demonstrates that it was via the Tokmakov family (and perhaps also via the Sabashnikovs) that they and the Kandinskys were related. (On Kandinsky's "favorite cousin" Elena Ivanovna Tokmakova and S. Bulgakov, see chap. 3 below.) The Bestushev genealogy indicates that there was indeed Buriat heritage on that side of the family. Moreover, a Bestushev had resided in Vologda province in the early 18th century. On the Kandinsky side, however, it appears to be according to family legend that there was a direct blood relationship to the 17th-century Tungus chieftain Gantimur (an ally of the Russians at the siege and Treaty of Nerchinsk in 1689, later ennobled to prince), whose people had settled east of Nerchinsk and along the Amur River (Baraev [1991], 237–269). According to Grohmann, Kandinsky had also once accompanied his father on a trip into Russia's Kazan province, where "he was struck by the diversity of the nationalities in that part of Russia" (see Grohmann [1958], 29, and chap. 3 below).

14. Kandinsky to André Dézarrois, 31 July 1937 (D/B [1984], 13). The same year he recalled the Vologda journey and the deep impression made on him by the brightly painted folk interiors in an interview with the dealer Karl Nierendorf (Bill [1963], 212). Neither of his 1889 articles has been published in English, nor were they included in L/V (1982), although a summary by John Bowlt concludes: "But there is very little indeed that relates to Kandinsky the artist or thinker of later years" (863).

15. Kandinsky (1913), xi.

16. Ust Sysolsk was renamed by the Soviets Syktyvkar. Shabad (1951), 154–169; Levin and Potapov (1964), esp. 91, 100, 106–108; Strmecki (1955), esp. 27, 38b; and Kolarz (1952), 55–58.

17. Even today this couplet from Afanasii A. Fet's epigram to the poet Tiutchev appears frequently in modern publications about the

Zyrians, where it is used to emphasize their remoteness (e.g., Uvachan [1975]). Fet (1982), 204. In the same poem, Fet further contrasted the Grecian Helicon with the flat expanses of the northern Asian plateaus, and the blossoming laurel of southern climes with the frigid ice floes of the Arctic.

18. Castrén was even convinced of a relationship between the ancient Finns and the Altaic speaking peoples of central Asia and Mongolia, an idea that would have appealed to the multiracial Kandinsky, who was also familiar with Castrén's work. See Sjögren (1861), Ahlquist (1885), and Castrén (1853). On Kandinsky's citation of Castrén, see his review of Peschel, discussed below. Weiss first explored the relationships between the writings of Castrén and Sjögren and Kandinsky's work as early as 1985 (see, e.g., Weiss [1985, 1988] and, for a bibliographic review, [1994]). For modern sources on the history of the Finno-Ugric peoples, see Hajdu (1976), Vuorela (1964), and Shabad (1951). See also Belitser (1958); Sivkova, Zimina, and Surinoi (1955); Oplesnin (1959); and Plesovskii, Sidorov, and Gribova (1972). In contrast, see Istomin (1892) and Efron (1894). See Vzdornov (1978), for a history of the artistic culture of the city of Vologda. I am grateful to Kenneth Nyirady for sharing bibliographic information on the Komi (see Nyirady [1989/90]).

19. For more on the Dashkov ethnographic collections that were a part of the Rumiantsev Museum, see below and Weiss (1994).

20. In 1981, at the death of his widow, Nina, the diary passed into the collection of the Musée National d'Art Moderne, Paris. As of this writing, this is the first time that the diary has been considered in the literature on Kandinsky. Cited hereafter as Kandinsky (1889a), the diary is a more or less daily record of Kandinsky's journey. Although it contains some notes that were obviously the basis for remarks in his later article on the Zyrians (as mentioned below), it does not contain verbatim interviews or extended notes; if the latter exist, they have not yet come to light. The diary is a standard pocket calendar with the names of appropriate saints at the top of each page, together with the dates according to both the old and new (or Gregorian) calendars. In the following text, quotations from the diary will be referenced by page numbers (as printed in the upper outside corner of each page) set in brackets. When the diary is eventually published and thoroughly analyzed, it will doubtless provide much more information. I am grateful to Jessica Boissel and Olga Makhroff for their help in making the diary available. My translators in this effort were Tamara Alexandrova and Alexei Dmitriev, who had to deal with Kandinsky's difficult orthography. Because of our limited access to the originals, the translations used here should be considered preliminary.

21. For help with these calculations, I am grateful to Robert Gohstand, Department of Geography, California State University at Northridge. Without an exact itinerary, since we do not know what deviations Kandinsky may have made from his intended route, it is difficult to measure the distance he traveled with any accuracy. The diary includes lists of destinations, but it cannot be deduced from them that he actually traveled to every town mentioned. Even in the 1920s, the 314-mile train trip from Moscow to Vologda took over 18 hours. Following mainly the winding river routes from Vologda to Kerchëm (the end station of Kandinsky's trip), and including the side trip to Bogorodsk, we calculated that the distance traveled one-way from the city of Vologda was approximately 800 miles, or 1,600 miles round trip. Taking into account the Moscow-Vologda portion and return, the entire trip covered approximately 2,228 miles. Although it was also difficult to locate accurate maps of this region, we compared U.S. Army Corps of Engineers maps (1954) with a map of Vologda province published in 1892 (*Entsiklop. Slovar*, vol. 13), another undated (ca. 1890s?) in the map collection of the Library of Congress, and a British map of 1896 at Bird Library, Syracuse University.

22. Ivanitskii was then engaged in collecting legends, beliefs, customs, riddles, and folksongs of the immediate Vologda region. (For more on his publications, see below.) His botanical research had already been published (Ivanitzky [Ivanitskii] [1882]).

23. Wiedemann (1880 [1964]) and Sjögren (1861).

24. On the "marshal of the gentry" (*predvoditel*), see Katz (1984), 123, n. 1. Cf. Pushkarev (1970), 102.

25. Vzdornov (1978), 22, 44, 65, 93 (figs. 26, 49, 75).

26. The "Old Believers" of the Pechora region were direct descendants of the *Raskolniki* of the 17th century, whose leader, the Archpriest Avvakum, had been exiled to Pustozersk on the lower Pechora. By the 19th century they had become romanticized heroic legends, often the subject of paintings and tales such as Vasily Surikov's *The Boyarynia Morozova*, 1887, and Nikolai Leskov's "The Sealed Angel," a story about a wandering band of schismatic icon painters which Kandinsky doubtless knew. Two volumes of Leskov's works were in Kandinsky's personal library, Kandinsky Archive, MNAM. See Armstrong (1965), 91–93; Kemenov (1979), 73–116.

27. Most likely the edition Kandinsky read was the 1889 Russian translation from Lönnrot by Petrovich Belskii, first published in *Panteon Literatury*. See also Setälä (1910), 1–39. Elias Lönnrot (1802–1884) published versions of the *Kalevala* from 1835 to 1849, having devoted years to collecting the ancient runes, or ballads. See Kirby/Branch (1985), the classic English translation by W. F. Kirby (1907) with introduction by Branch. On Kandinsky and Gallen-Kallela, see Weiss (1979), esp. 66–67, and Weiss, (1982a), 47–49. That the *Kalevala* exists within the shamanist traditions of the ancient Finns and Lapps is manifestly underscored by Castrén's report (known to Kandinsky) that when he set out in 1839 hoping to interview shamans in Karelia he found that Lönnrot had preceded him and had already interviewed all the shamans for miles around (Castrén [1853], 79). On shamanist elements of the *Kalevala*, see Oinas (1987), 39–52.

28. Among the ancient Finns, the last sheaf of grain was preserved as a harbinger of the following year's good harvest. The syncretism evidenced in the conjunction of grain preservation with a Christian holiday was also of interest to many ethnographers of Kandinsky's and later generations. Taboos concerning behavior during the sensitive harvest season and those concerning the use of bread were of similar origin. See Ränk (1949), 59–61, citing Nalimov, among others; and Holmberg (1927), 246–248, citing Kandinsky on Poludnitsa.

29. This translation suggests the emphatic excitement implicit in the hasty notation by omitting the pronoun "it" in some instances. Kandinsky, (1889a), 79.

30. The awkwardness of this sketch might be attributed to the rigors of the journey, for it was apparently recorded during the arduous horseback expedition to the Chud burial mounds near Bogorodsk, which Kandinsky describes near the end of his diary. On the other hand, the exaggerated distortions also suggest that Kandinsky may simply have wished to emphasize the naive nature of the original. An 1892 map of Vologda province indicates that Podelskoe was situated on the Vishera River on the route Kandinsky would have traversed to Bogorodsk. See Vzdornov (1978), 47, on disproportions as characteristic of early Vologdan icons and describing an early Vologdan icon (now at the Vologda Museum) representing the lives of Saints Cosmas and Damian with specific depictions of their mother, St. Theodosia, as "betraying a certain lack of technical skill on the part of its painter."

31. Kharousine [Kharuzin], (1893), Kandinsky Archive, MNAM, Paris.

32. Kandinsky, (1889a), 190 (" 'Nechaiannost' izviniaet i ubiistvo." An alternate translation might be: "even 'inadvertent' murder is excused."

33. See Castrén (1853), 61–66, 236, 280, and passim; Ahlquist (1885), esp. 180, 182–184 (hair-raising tales of catastrophic misadventures). Kandinsky, who knew of the fame of Ulianovskii

monastery from his readings of Sjögren ([1861], esp. 375), had noted directions to the monastery in his diary ([1889a], 43).

34. Kandinsky finally calculated that the entire trip was 70 versts (a bit over 46 miles). He may only have ridden 45 versts (30 miles) on horseback, but that was apparently enough. The incidents of horseback riding here at last confirm the hitherto uncertain fact that, indeed, Kandinsky could and did ride. Because horse and rider were to become so important a motif to the mature artist, it has been assumed that he was a "riding enthusiast" (Lindsay [1953], 48). The wry diary comment may cast the enthusiasm in some doubt but indicates at least some experience. Other explorers (e.g., Castrén [1853], 225, 304) had accused the Zyrians generally of drunkenness, moral laxity, unethical business dealings, and exploitation of other tribes, especially the Samoyeds. But cf. Sjögren [1861], 436–437, who had generally high praise for Zyrians as morally upright, hard-working, and honest.

35. A third Chud site visited (by two-wheeled carriage) is illegible. For a discussion of Chud burial mounds and a photograph of an ancient Chud site at Bogorodsk, see Lashuk (1959), 54.

36. Anthropologists of Kandinsky's day were fascinated by what they assumed to be an immorally lax attitude among the Zyrians toward adolescent sex (e.g., flirting and even trial marriage). In fact, their lives were ruled by strict codes of behavior between the sexes that were based on ancient purification rituals and beliefs. See Nalimov ([1908], 1–31).

37. Sjögren, e.g., had commented specifically on St. John's Night customs among the Zyrians (Sjögren [1861], 440). Kandinsky's diary recorded St. John's Day as 24 June, although the date of celebration is variously given as 23 or 24 June.

38. See Zelenin (1927), 370–374; Warner (1977), 29–31; Propp (1974), 384–391; Propp (1975), 84–86. Propp considered the making and destruction of the Kupala (Kupalo) effigy a res-

urrection ritual. At the same time, the fertility effigy Iarillo, celebrating the fertilizing power of the sun, was also associated in some areas with the Ivan Kupalo festivities (Vernadsky [1959], 113). See also Ivanits (1989).

39. Motifs for *Riding Couple* and *Motley Life* appeared in his sketchbooks as early as 1906. On *Motley Life* and *Sunday (Old Russia)*, see chap. 3 below. See also *Troikas*, another work in this series. Unless otherwise noted, illustrations of Kandinsky works cited here may be found in R/B (1982), D/B (1984), R/KGW (1970), and Hanfstaengl (1974). Unfortunately, *Kandinsky Watercolours: Catalogue Raisonné*, 2 vols., by Vivian Endicott Barnett (Ithaca: Cornell University Press, 1992–1994) became available too late to be cited here.

40. Kandinsky (1889b), 102–110. Translation into English by Olga Snegireff-Fedoroff Stacy, edited by Robert De Lossa. A copy of this translation is on deposit in Special Collections, Bird Library, Syracuse University. Cf. Weiss (1986), 48–50, and Weiss (1987), 191–195, for the first detailed analyses of Kandinsky's ethnographic essay.

41. E.g., he defined the geographical boundaries of his study with great care. Noting that the literature on the Zyrians was full of "inaccuracies and even irreconcilable contradictions," he suggested that the source "of these shortcomings" might be attributed to the fact that previous scholars had written about "the Zyrians" in general, without recognizing the fundamental differences between distinct geographical branches of the Zyrian people: "Current names such as 'Sysola,' 'Vychegda,' 'Pechora,' and 'Udora' Zyrians define not only the locale but also differences in the way of life, beliefs, and customs." He emphasized that his own study was confined "exclusively" to "the *Sysola* and *Vychegda* Zyrians living along the entire Sysola and Vychegda rivers, i.e., those who occupy the entire southwest portion of the Ust'-Sysol'sk district [*uezd*] of Vologda province." Kandinsky (1889b), 102–103. While Kandinsky's diary

obviously provided source material for the essay, if further notes or transcriptions of interviews exist, they have not yet come to light.

42. E.g., Teriukov (1977 and 1979), Teriukov (1983). Further citations noted below; cf. Weiss (1987), 215, n. 12, and Weiss (1994).

43. "I have intended," he wrote, "to trace the vestiges of the pagan period insofar as they manifest themselves in the chaos of *contemporary* religious concepts shaped under the powerful influence of Christianity." Kandinsky (1889b), 102 (emphasis in original). On the term *dvoeverie* (dual faith), see chap. 2 below, n. 42.

44. Sjögren (1861), 288. The diary annotation has been mentioned above; see Kandinsky (1889a), 45. Two sites were named with exact directions, and it is clear that he noted the information for the benefit of the archeological section of the Society. For "burial theme" paintings by Kandinsky, see, e.g., *Improvisation 18, with Tombstones* and *Improvisation 21*, both of 1911; for later improvisations on similar themes, see chap. 6. Kandinsky reported that the Zyrians remembered only that they themselves had "not followed the example of the Chuds, having been baptized and having lived from that time hence 'in accordance with the Christian rite.'" "I met only one literate old man who claimed that the Zyrians and the Chuds were one and the same. They have been living here . . . since time immemorial, always being called *Komi* (i.e., Zyrians), but the Russians, not understanding their language, called them Chuds, from the word *chudnoi*, meaning 'unintelligible.'" On the other hand, Kandinsky noted that he had also been told that "the Chuds were not at all a savage people but rather a settled agricultural people." More fanciful was the tale told in order "to prove the high level of culture and wealth" of the Chuds, namely, that they had "cultivated their fields with silver implements."

45. As his source for the information on St. Stephen, Kandinsky referred to the fourteenth-century *Life of St. Stephen, Bishop of Perm* by Epiphanius the Wise. Noted for his literary style

of "word-weaving," Epiphanius was a contemporary of St. Stephen (and of the icon painter Andrei Rublev). St. Stephen of Perm (1349–1396), born in Veliki Ustiug, a settlement on the banks of the Sukhona River (also a stop on Kandinsky's route), had a natural sympathy for the Zyrian people and, although he destroyed the arbors of the spirits and the idol sheds of the heathens, also created the first Zyrian alphabet, translating some of the liturgy into their language, wishing not to "Russianize" them but to bring them the gospel in their own tongue. From Fedotov (1966), 230–245; cf. Zenkovsky (1974), 259–262. See also Nalimov (1903a), 76–86 (citing Kandinsky's article), and Nalimov (1903b), 120–124. For Kandinsky's Pam imagery, see chap. 2 below.

46. As Robert De Lossa has pointed out, although the words *poganyi* and *poganka* are not etymologically related, they are "morphologically similar words that have acted upon each other." According to De Lossa, there is no doubt that the words would have been connected in the minds of 19th-century Russian ethnographers, as well as in the minds of Finno-Ugric peasants of the time. (Unpublished note to the author by Robert De Lossa, 8 April 1989.) Among other sources on the uses of mushrooms for medicinal purposes and shamanizing, Kandinsky would have known Castrén (1853), e.g., 197 (see chap. 6 below).

47. Here *Zlata* (for *zolotaia*, or "golden") is rendered as "Slata." See Herberstein (1556), 82. Herberstein's account, first published in Vienna in 1549, remains a classic source for the history of modern Russia. Sent on diplomatic missions to Moscow in 1517 and 1526 by Emperor Maximilian, Herberstein recorded not only his personal experiences at the court of Czar Vasily III, and his travel impressions, but also Russian customs, religious beliefs and myths, observations on social and economic conditions, etc. Many editions of his book, varying in format and illustrative material, were published in various languages from 1550 onwards. This excerpt is from the British Hakluyt Society translation (1851–1852).

48. Zlata Baba is sometimes depicted standing alone, with a staff. Pictorial maps with images of Zlata Baba both with and without the infant were republished in a 1908 Russian edition of the *Commentaries* (Herberstein [1908]). See Karjalainen (1914), tracing the imagery of Finno-Ugric mythology, including Zlata Baba, in several illustrated chronicles which may also have been known to Kandinsky.

49. See Sjögren (1861), 396; Holmberg (1927), 260–261; and Sokolova (1978), 498. Kandinsky's disappointment manifests itself here in his observation that "only Mr. Lytkin rebels" against this secondary evidence of Zlata Baba (i.e., such sources as Herberstein, among others), citing Lytkin (1889) on Zyrian history and language. In fact, Lytkin was one of the first native Komi scholars to concern himself seriously with Zyrian history and culture. Quite likely Lytkin's observations simply coincided with Kandinsky's: the memory of Zlata Baba had been lost to the Zyrians. In any case, Kandinsky soon had further occasion to be critical of Lytkin's work (see below).

50. E.g., as recently as 1983 by Teriukov (1983); see also Teriukov (1977 and 1979). Further references are cited below. Cf. Weiss (1986), 50, nn. 22, 23; Weiss (1987), 194–195, nn. 23, 24, 25; Weiss (1990b), 302–303, nn. 33–35; Weiss (1994).

51. Citing Popov (1874), 20, 57–60. Popov had stated that the Zyrians' belief in the ort was a remnant of ancestor worship practiced by their ancient forefathers. Kandinsky referred not only to Popov's opening words on the subject but also to his more detailed observations. In this instance Kandinsky's reliance on an outdated source led him astray, for he agreed with Popov on the uniqueness of this belief to the Zyrians, encountered only on the Sysola and Vychegda rivers but not elsewhere, reporting that it was not found among the Russians nor even among such closely related neighboring peoples as the Permiaks and Votiaks. In this they erred, as subsequent research demonstrated. Kandinsky

(1889b), 106–108. Cf. Holmberg (1927) 6, 10–14, 167–168, and passim, relating the *ort* to the Cheremiss *ört* and the Votiak and Vogul *urt*. See also Rédei (1970), 95, n. 19, also relating it to *urt* and *vurt*, and Roheim (1954), 49, 59, 85. For a contemporary discussion of the *ort*, see Wiedemann (1880), 211. For more recent research on the number and types of spirit/souls recognized by the Zyrians and their neighbors, see Paulson (1964b) and Chernetsov (1963), 3–45, positing multiple spirit/souls.

52. Kandinsky (1889b), 107 (emphasis in original). Kandinsky's description was later cited by the Hungarian ethnologist, Fuchs (Fokos-Fuchs) (1923–1924), 264.

53. Kandinsky (1889b), 107–108. Rédei cited Kandinsky's testimony on the bruise or "blue spot" almost verbatim (though without reference); although confusing the *ort* with "spirit" (*Geist*). Rédei (1970), 95, n. 19. See Holmberg (1927), 169–172, with respect to the Votiak spirit *ubyr*. On the towel custom, see Ränk (1949), 48ff. The custom is also mentioned by Nalimov (1907), 2. Among other proofs of the *ort*'s physical nature Kandinsky reported, were certain common expressions, such as "he is thin as an *ort*" and "a real *ort*."

54. As an extreme example of ambiguity in conceptions of the human soul, Kandinsky pointed to the Indian *Bils (Bhils)*, who "divide the rice cooked for the deceased into two parts—one part they leave by the grave, while the other part is placed at the threshold of his last dwelling as food for the spirit *[dukh]*." Kandinsky (1889b), 107, citing Spencer, I, 172. That Kandinsky had consulted Spencer's seminal work is further testimony to his knowledge of the ethnographic literature of his time. Cf. Weiss (1987), n. 25 and Weiss (1990b), n. 35. Kandinsky cited Kuratov (1865) and Lytkin (1889) on their translations of the term *ort* as *dukh*.

55. These musings on the *ort*, the discussion of the precise meanings of *dukh* (the root of the adjectival noun *dukhovnom*, the term Kandinsky later used in the title of his treatise *O dukhovnom*

v iskusstve [Über das Geistige in der Kunst]), and the references to practices concerning the burial of the *koldun*, the sorcerer or shaman, were to have important repercussions in Kandinsky's later art and thought. Kandinsky's careful scrutiny of the usage of the word *dukh* (German *Geist*) and his *rejection* of its use in defining the concept of a palpable "double" or shadow (which he described as "relief-like") lend further weight to my discussion of his later use of the term to emphasize its meaning as spirit/mind. See Weiss (1979), 139–141 and Weiss (1990b), 303, n. 36. For a photograph of a Zyrian corpse tied up in the traditional manner, see Honko (1971), 179 (also 181–182). For more on Finno-Ugric customs of tying the corpse of the deceased, see Balzer (1980), 80, and chap. 6 below.

56. "When I suggested that they carry the ice without covering it, some said: 'perhaps nothing will happen . . . but what if the sun *becomes angry?*'" Thus, natural phenomena were "often perceived even now as animated beings." Kandinsky (1889b), 105–106 (italics in original), citing Lytkin (1889) as having stated that such behavior (i.e., conversation with the wind) was now considered a joke. Kandinsky pointed out that it would nevertheless indicate an underlying serious belief. (Lytkin was, of course, attempting to demonstrate that his people should not be considered backward.) Among the neighboring Samoyeds, the North Star was called the "nail of the sky." See Holmberg (1927), 221. Kandinsky noted that veneration of fire among the Zyrians was reflected in numerous taboos still observed and in the use of fire for purification. Ivanitskii was also to write on the veneration of fire among peasants of the Vologda area. See Ivanitskii (1891), 226–228.

57. Kandinsky (1889), 108–109. Kharuzin also associated the hearth and household protectors of the ancient Lapps with ancestor worship in his article on Lapp shamans that had appeared in the first issue of *E.O.* Kharuzin (1889), 48, 59–60.

58. A family would be happy, he wrote,

if the *domovoi* chanced to "fall upon" an animal, since this was taken as an indication that family members would be spared. So persuasive were Kandinsky's arguments on the relationship between the *domovoi* and moving house that Holmberg later cited this passage in his chapter on house-spirits. Holmberg (1927), 164, 168, 536, n. 10, citing Kandinsky.

59. Kandinsky (1889b), 108. Most authorities agree that among the Finno-Ugric peoples (and indeed most other Siberian tribes), the birch, pine, fir, and cedar trees were most often designated as "sacred." Nevertheless, the tree varies from tale to tale; according to Vernadsky ([1959], 34), St. Cyril cut down the "sacred oak."

60. On the other hand, Wiedemann included *leshak* in his dictionary as a Zyrian word, defined as *Waldgeist*, or "forest-spirit," perhaps acknowledging the fact of the centuries-long mingling of the Russian and Zyrian peoples. Perhaps for this reason, too, Kandinsky used the term *leshak* rather than the Zyrian name. Kandinsky (1889a), 79; Kandinsky (1889b), 109. Cf. Wiedemann (1880), 150; Holmberg (1927), 177. The forest-spirit is also rendered by Wiedemann as *vörys*, the form used by Holmberg in his discussion. Holmberg's *vörys-mort*, a forest-spirit taller than the highest tree who rushes about like a whirlwind, was identified by him as one of the many forms of the leshak-mort. Holmberg (1927), 181–182. See also Popov (1874), 57–58. Kandinsky's *vörsa* was also described by Fokos-Fuchs as the forest-spirit *versa*, a giant as tall as a tree and having magic powers (Fuchs [Fokos-Fuchs] [1911], 236, and [1959], 103). Cf. Paulson (1961), 124–125.

61. Kandinsky (1889a), 79. On vasa, see Wiedemann (1880), 399, and Popov (1874), 58 (where the female water-spirit was also described). Cf. Holmberg (1927), 195–198.

62. On the elusive Voipel, Kandinsky cited Mikhailov (1850), who had written a number of articles on the Zyrians that had appeared in various provincial historical journals in the 1850s; and Arseniev (1873), who had also published

on the Zyrians. Kandinsky (1889b), 104. Sjögren equated Voipel in importance with Zlata Baba. See Sjögren (1861), 408, n. 819, and Wiedemann (1880), 229, 419. Cf. Nalimov (1903a), 83. Likewise, another deity mentioned by Arseniev as a "purely Zyrian name," Iomala, had been lost, although Kandinsky recalled that Arseniev had cited a proverb, "Ioma baba kod l'ok" (Angry as Ioma) as proof of the Zyrian provenance of the word *Iomala*. But, according to Kandinsky, the Zyrians he met could only translate it with difficulty, some rendering Ioma as angry or malicious, i.e., "angry as an *angry baba* (woman)," while others could give no meaning at all. On Joma as "angry," Kandinsky cited Savvaitov (1850). In Wiedemann the meaning for Joma was in fact given as "sehr böse" (very angry). Although they claimed never to have heard of Iomala, "one old man" had assured Kandinsky that he had learned about the Chuds as a child from "the elders," and about a god named Churila, whom he identified as the ancient principal god of the Chuds (whom he had surely confused with Iomala or Jumala). This elderly informant further attributed to the Chuds an animistic religion, reporting that they "worshipped cows, cats and other domestic animals." According to Kandinsky's contact, the name Churila was the source for the word *churka*, as in a proverb spoken among women, "Churki budi en vomzias" (Do not go bad). Relying on his copy of Wiedemann, Kandinsky explained that the word *churka* had by then an altered meaning signifying an illegitimate child (see also Nalimov [1907], 22).

63. Here he cited Savvaitov's dictionary (1850), 177. But since he owned Wiedemann's dictionary, he also knew Wiedemann's definition of *pölödnitsa*: "pölödznitsa ein Wesen das im Roggen wohnen soll, *p.-sin Kornblume (Centaurea Cyanus)*," with its reference to cyan or blue (Wiedemann [1880], 249). Wiedemann gives *sin* as the Zyrian word for "eye;" interestingly enough, he also gives *sin vezhny* as the Zyrian term for "to enchant, to make works of art, to fool the eye" (289). According to Unbegaun, the

name Vasilëk (cornflower) was used as a literary pseudonym. Might Vassily Kandinsky also have associated his own name with the blue *vasilëk*? (See Unbegaun [1972], 321.) See Holmberg (1927), 181 and 247, where he again cited Kandinsky in his discussion of Poludnitsa. See also Zelenin (1927), 391; and Oinas (1985), 103–110. Although this essay, which provides so rich a source for Kandinsky's later iconographic and aesthetic development, has been overlooked in the art historical literature, ethnographers have not been so remiss. Perhaps the most influential references to Kandinsky's work were made by the Finnish sociologist and ethnologist Uno Holmberg in his early work on water-spirits of the Finno-Ugric peoples (Holmberg [1913], 107, 286), and later in his monumental *Finno-Ugric, Siberian*, vol. 4 of *The Mythology of All Races*, where Kandinsky's essay was not only footnoted but also referenced in the bibliography (Holmberg [1927], 10, 164, 527, 536, 542, and 576). Thereafter the essay was regularly cited as authoritative. Most recently Kandinsky's work has been cited by the Russian ethnographer and native Komi (Zyrian), Teriukov (1983), 79–80; see also Teriukov (1977), 80–86. On the dissemination of Kandinsky's Zyrian research in the ethnographic literature from its first reference in *Internationales Archiv für Ethnographie* in 1890 to the present time, see Weiss (1986) 45, nn. 12, 13; (1987), 189, 215, nn. 12, 13; (1990), 295–297, n. 23, and Weiss (1994).

64. Kandinsky's involvement in *E.O.* as a reviewer, first reported by Weiss in public lectures 1985–1986; see also Weiss (1987), 215, n. 2. See *E.O.* 4 (1890), no. 1, where Kandinsky's name is listed on the back page (in the manner similar to a "masthead") as a "collaborator" together with his friends Kharuzin and Bogaevskii, along with Mikhailovskii, Anuchin, Gondatti, and V. Miller, among others; heady company indeed for the young scholar. In an endeavor to keep Russian ethnographers abreast of contemporary ethnographic thought, *E.O.* offered its readers not only extensive bibliographies but also reviews of the

international professional literature of the day. International congresses on archeology, prehistoric anthropology, and ethnography were also reported. For further details and a brief survey of the contents of *E.O.* during this period, see Weiss (1994).

65. Mikhailovskii's oral paper on shamanism among the North American Indians and Kandinsky's, "The National Gods of the Sysol and Vychegda Zyrians," were reported in *E.O.* 3 (1889), 212. Quite possibly they made their presentations at the same meeting. It was not possible at the time research on this manuscript was underway to locate the minutes of these meetings, which might shed light on this matter. Mikhailovskii's two-part study (with its special section on Siberian shamanism) was long considered the best world-wide survey of the subject, frequently cited in the literature; the second section was almost immediately translated into English, appearing as early as 1895. See Mikhailovskii (1892) and Mikhailovskii (1895 [Wardrop]). See also Weiss (1994).

66. Most chronologies of Kandinsky's life place his first trip to Paris in 1889 and a second in 1892. See N. Kandinsky (1976), 29. Mikhailovskii's paper "The Religion of the Ancient Slavs" was read in his absence (to the session on comparative religion). See announcement in *E.O.* 2 (1889), 238. The meeting took place from 30 Sept. to 7 Oct. 1889, and the program included a visit to the exposition. See Paris (1890), esp. 40–41, with summary of Mikhailovskii's paper. On the exposition, see Monod (1890) and *Catalogue générale officiel de l'Exposition Universelle de 1889* (Lille: L. Danel, 1889). For a critical overview, see Silverman (1977), 71–91.

67. A contemporary reviewer reported that Mikhailovskii demonstrated the transition from picture writing to "ideological" script, and from hieroglyphic to phonetic writing, by means of several examples drawn from primitive peoples around the world, including the Yenissei River cliff drawings and figures on Altaic and Ostiak shaman drums, as well as examples of American

Indian picture writing, Egyptian hieroglyphs, Aztec and Mayan glyphs, and numerous other forms. See Heger (1890), 162. The meetings took place from 8–20 Jan. and 24 Jan.–5 Feb. at the Historical Museum, Moscow.

68. Kandinsky to Gabriele Münter, 14 Oct. and 5/18 Oct. 1910 (GMJES, Munich). It is clear from the context that Kandinsky expected Münter to know who the Kharuzins were, having obviously told her about them. His reference to "seven years ago" clearly suggests that he had visited with them on his 1903 visit to Moscow. See Kharuzin (1893).

69. Born in 1865, Kharuzin, like Kandinsky, had attended high school in Moscow. Well-traveled and educated in history, law, and anthropology, he was active as a secretary in the Ethnographic Section of the Society and already a published scholar by age 21. He also served as editor of the Society's volume on Russian peasant life in which Kandinsky's article on customary peasant law was published, and by 1898 he had begun to teach the first formal course devoted entirely to ethnography at a Russian university. See Kharuzin (1890a) and (1890b). Cf. Miller (1900), 1–14. Both of his brothers had been engaged in ethnography and his sister, Vera, an exact contemporary of Kandinsky, also carved out a successful career as an ethnographer, becoming Russia's first female professor of ethnography. On Vera Kharuzina, see Eleonskaia (1931), 153–155. For Kharuzin's collected works, see Vera Kharuzina and Aleksei Kharuzin (1901, 1903).

70. See Bogaevskii (1890); (1889a), 101–105; and (1889b), 1–12.

71. See Bogaevskii (1904), 34–49, Kandinsky Archive, MNAM. Further evidence of this friendship is recorded in the letters Kandinsky later wrote to Münter from Russia and in a personal correspondence he maintained with Petr's wife, Bena Bogaevskaia, suggesting that Kandinsky's ties to the Bogaevskii family were far more than casual. Letters from Bogaevskaia to Kandinsky more than once refer to her husband's

defense of his dissertation on the Geneva Conventions (GMJES). For more on this relationship, see chap. 3 below.

72. See Weiss (1994) for a more detailed analysis of Kandinsky's seven known E.O. book reviews. Kandinsky's fluency in German and French is evidenced by reviews of works written in both languages. It was the journal's convention to use only the author's initials as signature to book reviews (e.g., "V. K—ii."). On the journal's eccentric numbering system, see Weiss (1994).

73. V. K—ii. (1889 [2]), 166–168. Cf. Nalimov, a native Zyrian and student of Lytkin (1907b), 77–81.

74. V. K—ii. (1889 [5]), 183–185. Kandinsky's review dealt with part 2 of Ivanitskii's *Materialy po Etnografii Vologodskoii Gub[erni]*, before it was actually published in Kharuzin's series on Russian folk life (see Ivanitskii [1890] and Kharuzin [1890b]). Kandinsky's own article on Russian peasant law had already appeared in a previous volume of the same series (Kandinsky [1889c]).

75. Most of Ivanitskii's research had centered on customs and beliefs of the Russian population of southwestern Vologda province, rather than on those of its native Finno-Ugric peoples. His seminarian background emerged in biased remarks about the natives, including the Zyrians; e.g., he decried Zyrian homes for "their well-known filth." Moreover, the tales about shamans or sorcerers included in the collection emphasized their destructive powers, a selectivity that might be expected of a seminary scholar. Interestingly, an eight-page list of plants used medicinally in Vologda province—Ivanitskii was best known as a botanist—ended with *Agaricus muscarius*, the poisonous mushroom notorious for its ability to induce hallucinations and the frequent recourse of shamans. But Ivanitskii reported only its use as a salve for rheumatism, which was doubtless precisely what the natives hoped he might think. Although well acquainted with reports on the use of hallucinogenic mushrooms by shamans, Kandinsky

refrained from pointing out his friend's naiveté.

76. Part 2 of the study also included 33 "spells" (normally, spells for healing or luck recited by a shaman), 29 children's games, 55 fairy tales. See Weiss (1994).

77. Not reviewed by Kandinsky, who did, however, provide two other, much briefer, reviews of folk data collections, including his summary of IA. P. Novitskii's "Songs of the Cossack Age," which had been appearing serially in a provincial newspaper (cf. V. K—ii. 1889 [1], 154), his "debut" article for *E.O.*; and a review of another ethnographer, Magnitskii (cf. V. K—ii. (1890 [7], 208–209). See Weiss (1994). In his review of the latter, Kandinsky, as before, commended his author's inclusion of "raw data." In a poetic turn of phrase rather characteristic of the later artist, Kandinsky here described currents of folk life as "new tributaries . . . which fill the old river bed of experience," resounding with "echoes of the lore of antiquity," as, for example, how new words to an ancient folk song about life on the river now extol boats "with two smokestacks."

78. Moreover, Ivanitskii reported that in one village a dead sorceress was said to have reappeared regularly for 40 days after her death, sometimes in the form of a cat. In another, the sister of a sorceress was said to have turned into a wolf. In the tale about the sacred and anthropomorphic nature of fire, the master who abused his home fire by spitting into it and otherwise mistreating it had his house burned to the ground. And in a song supporting ancient belief in the sacredness of trees, a young woman was turned into a birch tree. Horses had also to be treated with respect, especially those used for riding (rather than hauling). Ivanitskii related that he had discovered in the environs of Kadnikov itself a sacred burial site marked with an overturned sledge and a wooden fence that, on investigation, turned out to have been the burial place of a favorite riding horse. He took care to note that the brand-new sledge on which the carcass had been brought to the burial site would

be left to rot upon the grave. Ironically, both church and later Soviet authorities considered this among wasteful practices that had to be banished, hence the secrecy with which such rituals were often carried out. See Ivanitskii (1891), 226–228, and (1892), 182–185.

79. V. K—ii (1890 [3]), 229–231. Originally published in 1874, the Russian translation was from its sixth edition (1885), supervised by Alfred Kirchhoff. In fact, Kandinsky was in the awkward position of reviewing a book already in circulation for nearly two decades and at the outset criticized for its unselective presentation of masses of deficiently organized information. Moreover, Peschel had considered the Darwinian theory flawed, a position that imposed what had seemed even to most contemporary reviewers a generally outmoded bias on much of his text. See, e.g., Wallace (1877), 174–176.

80. Characteristically, Kandinsky also disagreed with several of Peschel's attempts to define a people as primitive on the basis of certain preconceived standards, finding numerous inconsistencies, e.g., in Peschel's categorization of the Brazilian Botocudos as the most primitive peoples in the world due to their "nudity," facial ornamentation (e.g., the insertion of wooden plugs), and use of vines to construct suspension bridges. Kandinsky pointed out that Peschel himself, in describing the African Bushmen, had rejected their nudity as an index of primitivism. As to the latter two reservations, Kandinsky noted that both were, contrary to Peschel's view, "data which of course elevate the tribe high above the level of a primitive state." Kandinsky also pointed out errors in Peschel's remarks about the Finno-Ugric peoples, especially the Lapps and Votiaks, objecting specifically, e.g., to the author's reliance on Castrén's outdated data in regard to their marriage and courting customs.

81. While Kandinsky took note of Peschel's sections on shamanstvo (shamanism) and other religions, including the monotheism of the Jews, Christianity, and Islam, it is hardly surprising that he did not choose to discuss in detail Peschel's particularly outmoded and pietistic ideas on shamanism. The negative tenor of this review was vindicated a few months later, when a second, even more virulent attack on the Peschel book was published in the journal on the occasion of the completion of the entire Russian edition. See Smirnov (1890), 169–176.

82. V. K—ii. (1890 [4]), 167–177. A scholar who saw himself as a student of Comte, and a political activist (elected to the First State Duma from Kharkov in 1906), Kovalevskii was among the first to attempt a system of sociology that was, as Vucinich writes, "not derived from a grand philosophical assumption but from factual material supplied by ethnography, history, and so-called sociocultural paleontology." Kovalevskii had been forced to leave the university in 1887, during the second year of Kandinsky's residency there, because his teachings suggested an alliance with political movements advocating constitutional government that the czarist regime viewed with some suspicion. Nor did his expressed interest in the relief of Russia's contemporary social and economic conditions meet with the approval of the authorities. See Vucinich (1976), esp. 153–172.

83. For a definition of the mir as "the whole community of shareholders," see Kovalevskii (1891), 88. For a historical definition of the mir, see Pushkarev (1970), 62.

84. For more on this group and others associated with it, see Vucinich (1976), 169. Letters from Kandinsky to Chuprov indicate that he knew Kovalevskii personally, suggesting that he may well have studied with him (see Shumikhin [1983], 337–344). On Kharuzin's appreciation of Kovalevskii, see Miller (1900), 2. For Kandinsky's remarks on Chuprov, see Kandinsky (1913), VII. Kandinsky also owned copies of Kropotkin's later works Anarchy, Its Philosophy, Its Ideal (1900) and Modern Science and Anarchism (1901) (Kandinsky Archive, MNAM). Those by Chuprov include one with a personal dedication to the artist (some have uncut pages). Chuprov (1842–1908), considered a founder of Russian statistics, taught political economy and statistics at the university. He participated in the zemstvo (provincial self-government) movement and was the primary advocate of the liberal populist school of economics. Chuprov called for reforms that would have left the peasant commune intact with land ownership retained by the gentry, a position later criticized by Lenin. For a bibliography of Chuprov's writings, with portrait photograph, see Pashkova and Tsagolova (1959), 501–502. See also Sorokin (1963), 86, and Weiss (1994).

85. See Kandinsky (1913), VII; also VIII and XXVI for revealing comments on Russian peasant law, where he observes that punishment was relative to intention and where he makes the connection between the study of ethnography and the study of common law. Politics was in fact the reason he gave to Münter for his withdrawal from the Dorpat offer, as reported by Eichner (1957), 69–70. See Weiss (1979), 160, n. 1. See also Simirenko (1966), 1–37. Within the context of Kandinsky's socio-political awareness, the socialist inclinations of the Union Internationale des Beaux-Arts et des Lettres, the sponsoring organization of the exhibition Le Musée du Peuple, in which Kandinsky participated during his year in Paris, 1906–1907, should be noted (see Fineberg [1975], 82).

86. V. K—ii, (1890 [6]); Böhling, 200–201. Cf. Weiss (1994).

87. On Kandinsky's adaptations of Böhling's imagery, see chaps. 2 and 4 below. The reviews in the fourth number of the journal for 1890 (vol. 7) appear to be the last of Kandinsky's critical efforts as an ethnographer; on this point, see Weiss (1994).

88. Kandinsky's move to the juridical faculty did not necessarily mean estrangement from his commitment to ethnography. As noted above, his final thesis was to have dealt with problems relating to the "Iron Law" of wages, perhaps directly inspired by his experience of poverty among the peasants of Vologda province. See Shumikhin (1983) for documentation of Kandinsky's 1893 report Le Minimum de salaire et

l'encyclique Rerum Novarum (an analysis of the 1891 *Rerum Novarum* encyclical of Pope Leo XIII, based on a question raised at the first Catholic Congress on Social Science in 1892). This report was accepted by Chuprov as proof of competence to work on the doctoral thesis that Kandinsky then proposed, entitled "An Exposition on the Theory of the Work Fund and the So-Called Iron Law" ("Izlozhenie Teorii Rabochego Fonda i tak Nazyvaemogo Zheleznogo Zakona"), which, however, was apparently neither finished nor defended. See Shumikhin (1983), 338–339.

89. A more detailed survey of the contents of *E.O.* during this period is found in Weiss (1994).

90. Kandinsky to Paul Westheim (1930) in Bill (1963), 134–136.

91. The author made this discovery in the course of research for this book. See Weiss (1990d, 1994). Kandinsky's donations are listed in *Otchet Moskovskago Publichnago i Rumiantsovskago Muzeev za 1889–1891* (Moscow, 1892), 142 (for the academic year 1889–1891). In a letter to the author (26 June 1990), Tamara Iguminova, scientific secretary, State Historical Museum of Moscow, reported that curators had been unable to locate any of Kandinsky's donations to the Dashkov collections.

92. See Kandinsky (1889a), 201, 204.

93. Mannequins used to display ethnic clothing were a distinguishing feature of the museum. It is not entirely clear from the catalogue whether these "illustrations" were photographs, drawings, or watercolors. See Weiss (1994); also Moscow (1897), 31, item no. 17; and 42, list of donors. See also Golitsyn (1916), 49.

94. See Miller (1887). In succeeding years more shaman costumes, drums, and other shamanist artifacts were to be added (see Ianchuk [1910], Golitsyn [1916]).

95. Miller (1887), 152, item no. 67.

96. See Shumikhin (1983), 337, documenting Kandinsky's inscription in the university by 1885.

97. The senior Kandinsky's connection to the Astronomy Society, documented in Kandinsky to Gabriele Münter, 13 Oct. 1905 (GMJES). From Baraev's account, we now know of possible, although perhaps legendary, Tungus connections with the Kandinsky family. Moreover, Baraev documents other Kandinskys who resided in Moscow as well as a cousin, Vera Alekseevna (1866–1926), married to the anthropologist Ivan I. Popov, editor of the *Eastern Review* and *Siberian Anthology*. Interestingly, the son of the first Kandinsky recorded by Baraev, Petr Alekseevich Kandinsky (1735–1796), had married an apparent descendant (Daria Dmitrievna Atlosova) of the renowned first explorer of Kamchatka, Vladimir, who had arrived in Yakutsk in 1700. See Baraev (1991), 243, 248. On the costume's iconographic resonance in Kandinsky's later work, see chap. 6 below, Weiss (1994), and Weiss, "Kandinsky's Self-Portraits as 'Other'" (in progress).

Chapter 2

Epigraph: From Lönnrot (1989), Runo 10, pp. 113, 116. Translated by Keith Bosley. From *The Kalevala: An Epic Poem after Oral Tradition by Elias Lönnrot* (Oxford: Oxford University Press, 1989). By permission of Oxford University Press. The "Sampo" of the *Kalevala* has been variously described as the Finns' cultural treasure, sometimes more specifically as shaman's drum, cosmic pillar, magical mill, etc. For more on this crucial image, see chaps. 3, 5, and 6 below.

1. I use the term "artistic activism" to suggest the hitherto neglected social and political ramifications of Kandinsky's work.

2. Kandinsky (1913), IX. Cf. Wildenstein (1979), no. 1288 (*Haystack in the Sun*, 1891), recording an "exposition d'art français," St. Petersburg and Moscow, 1896–1897. Cf. also Weiss (1982a), 34–36.

3. See chap. 1 above and Shumikhin (1983), 338. According to a letter he wrote to Chuprov (7 Nov. 1895), Kandinsky had made his decision to leave the university during the "late winter" of 1894–1895. According to Roethel, relying on Eichner (1957), Kandinsky spent 1895 working at the Kushverev printing plant in Moscow. See R/B (1984), 47.

4. Although it was not until 1897 that this radical new concept was to be announced in print; cf. Garte (October 1987), 137–144.

5. Kandinsky (1913), X.

6. Kandinsky to Chuprov, 7 Nov. 1895, explaining that he no longer had "a strong, keen, essential love for science." Shumikhin (1983), 341. For Kandinsky's "now or never" remark, see untitled introduction to the Goltz catalogue (Kandinsky [1912c], 1–2). See also Kandinsky (1913), VIII: "I was too weak to feel myself justified in abandoning other obligations."

7. On Kandinsky's evolution with respect to Munich's Jugendstil aesthetic and theoretical context, see Weiss (1979) and Weiss (1982a and b). "For the mythological hero is the champion not of things become but of things becoming; the dragon to be slain by him is precisely the monster of the status quo: Holdfast, the keeper of the past." Joseph Campbell, *The Hero with a Thousand Faces* (New York: Meridian, 1960), 337.

8. See chap. 1 above. On the conjunction of midday and midnight as special times for fundamental changes in life in Russian and Finno-Ugric mythology, see Oinas (1985), 107. On usage of the term *dvoeverie*, see below. On the stylistic treatment as a Jugendstil design for appliqué, see Weiss (1979), esp. 107 and 129–130.

9. A work Kandinsky deemed important enough to exhibit in Wiesbaden, Prague, St. Petersburg, and Paris in 1903–1904.

10. Other early depictions of walled towns also show distinctly Russian churches and bell towers, surrounded by dark silhouetted ranks of fir trees (e.g., GMS 173, 532/2 and GMS 172).

11. Two related pencil sketches depict a Viking ship in full sail (GMS 489, 532/2). These works may have inspired the 1905 appliqué designed by Kandinsky (GMJES); see Weiss (1979), 119, fig. 92.

12. Afanasiev (1865–1869), 707, cited in Propp (1975), 82.

13. Shein (1887), quoted by Propp (1974), 381 (see also 7, 22, 81–84). Shein's book was reviewed in *E.O.* 6 (1890): 178.

14. Sketchbook GMS 341, and independent sketches in Hanfstaengl (1974), nos. 39–50.

15. See Hottenroth (1891), II, pl. 119 (Biedermeier group); Kandinsky Archive, MNAM. For a discussion of the direct inspiration for this painting in an earlier "salon" work by Adolf Münzer, see Weiss (1979), 144–145.

16. Hottenroth further identified this woman as "from Kaluga." Possibly there was a sentimental reason behind Kandinsky's choice of this model: in letters from Moscow to Gabriele Münter, 1910, Kandinsky mentioned that a Frau Unkowski in Kaluga had been urging him to visit, although it appears from the correspondence that the visit never actually took place. Kandinsky to Münter, 16/29 Oct. 1910 and 22 Oct. 1910 (postmark), GMJES. It remains unknown whether this Frau Unkowski was the same Frau Sacharjin-Unkowsky (sic) mentioned by Kandinsky ([1911], 41) in the context of a school in St. Petersburg at which children were taught to associate colors with music.

17. Hottenroth (1891), II, pl. 99. The Herberstein print appears reversed in Hottenroth, a fate that had befallen it in various editions of the original. Details from other plates in the Herberstein work were also copied by Hottenroth (see below). Kandinsky's pencil-and-pen sketch of two men in Russian costume may also be related to a plate in Hottenroth illustrating the costume of eastern Slavs. See Hottenroth (1891), I, no. 118, and Kandinsky, GMS 481.

18. *Sunday (Old Russia)*, 1904, recorded in the artist's house catalogue as *Sonntag (Alt Russisch)*, which should be rendered in English as *Sunday (Old Russian)*. The artist also explored the theme in an oil sketch (GMS 613), two tempera paintings (MNAM; second tempera not located), and a woodcut. The general subject and compositional scheme of this painting and the tempera version may have been suggested to Kandinsky by one of Munich's best-known turn-of-the-century artists, Richard Riemerschmid, whose painting *Sonntag* had been exhibited at the Secession in Munich, 1896, and was illustrated in *Dekorative Kunst*, 1901, vol. 4, 337. (See Nerdinger [1982], 87, no. 18.)

19. Flier (1964), 143; but see entire article, 105–149. Flier has shown that several popular 14th- to 15th-century sermons concerned with the "End of the World" condemned this particular cult, decrying "pagan rituals, idol worship, and sacrifices performed on Sunday in lieu of church attendance." I am indebted to Flier's explanations of the meaning of Sunday in medieval Russia, on which I have drawn for this discussion. (Cf. Fedotov [1960], I, 358.) As observed in chap. 1 above, the church had taken advantage of extant pagan customs (e.g., those connected with the cyclic celebrations of the seasons) by adapting its calendar and rituals to them.

20. See Flier (1964), 137, 143–146.

21. See Flier (1964), 132, 136 and 138, on peasant custom that "sprinkled the fields with broken willow branches to guarantee a good harvest," also used to ward off an ill wind. See Weiss (1985), 143–144, on the St. George's Day celebration.

22. Although Hanfstaengl dated the notebook (GMS 336) 1906/07, several of the sketches are demonstrably earlier (e.g., sketch for *Crusader*, 1903).

23. Ivanitskii (1890), 153, "Salix pentandra" (with its Zyrian translation). The analgesic qualities of willow bark, produced by the component salicin from which aspirin was eventually derived, had been known since ancient times.

24. This reservation of discursive meaning was a typical Symbolist ploy by artists committed to the empowerment of means and to the "significance" of form. Kandinsky to Münter, 10 Feb. 1904, GMJES (emphasis added). See Weiss (1985), 137–145.

25. On the birch and bridal customs, see on *Russian Beauty in a Landscape*, above and, e.g., Holmberg (1927), 231, 266–267, 340, 349, 350, and 404. On the birch and Semik, see Propp (1975), 81–84, and (1974), esp. 378ff.

26. Kandinsky to Münter, 31 Jan. and 10 Feb. 1904 (GMJES); *ff*, of course, referring to the musical notation for fortissimo. See Gollek (1982), 323, unaccountably omitting the word "decorative" from Kandinsky's description of a work he had begun that he called his "decorative sun-color-composition." See also Kandinsky to Münter, 1 July 1904 (GMJES). (Gollek takes the position that these two letters definitely refer to *Sunday [Old Russia]*.)

27. See Weiss (1982a), esp. 50–57 and 59–61, terming this characteristic style his "lyrical mode." For its crucial significance in his aesthetic development, see Weiss (1982a), 57–63.

28. Kandinsky to Münter, 4 Dec. 1906 (GMJES).

29. The Zyrian bride's cap is a modification of the traditional Russian headdress. See Belitser (1958), 275–278, figs. 121, 124, and Gribova (1980), 103 (fig. 44 and pl. III, no. 4). For aristocratic variations of this form, see Obolensky (1979), figs. 40, 42, 44. But Kandinsky's maiden is dressed in peasant garb.

30. The custom of "stealing the bride" among the Finno-Ugric tribes had been discussed by Peschel in *Races of Man*, reviewed by Kandinsky for *E.O.* (see chap. 1 above and Peschel [1876], 225–227). See also Sjögren (1861), 442–444, and Nalimov [1908], 23–24, on bartering for the bride and elaborate prenuptial ceremonies among the Zyrians. See also Propp (1975), 23, 93–94. As noted, the birch, here bending in a gesture of compliance or lament, is a signifier of love in Russian folklore.

31. The church is somewhat reminiscent of St. Stephen's Cathedral in Ust Sysolsk and the church photographed there by Sirelius in 1907; see Izhuroff (1913), 280.

32. Archival photograph of painting (unidentified source and location) in R/B (1984), 131. Preliminary drawing and ink drawing of church (1886), MNAM. Although Roethel places

the date at ca. 1903–1904, clearly the figures are related directly to *Motley Life*, three to four years later. If the earlier date is correct, it merely demonstrates still more forcefully the continuity of Kandinsky's preoccupation with Russian themes.

33. Although the painting has been dated 1905, a woodcut of the same theme and similar composition was published in the portfolio *Poems Without Words* the previous year, suggesting that Kandinsky had been working on this composition for at least a year. On dating of the woodcut, see Weiss (1979), 193, n. 38.

34. Also true of *Motley Life* and the woodcut *Spectators*, 1903, depicting a crowd, however, in modern dress.

35. On the musical inspiration of *Xylographies*, see Weiss (1979), 213, n. 2. Cf. Roethel (1970), 38, where *Gomon* is translated as "Bewegtes Leben," which does not convey the sense of sound intended by the artist.

36. Kandinsky to Will Grohmann, referring to *Arrival of the Merchants*, 12 Oct. 1924 in Gutbrod (1968), 46–47.

37. See chap. 1 above. Finnish nationalist aspirations gathered momentum throughout the latter years of the nineteenth century, inspired to a great extent by the *Kalevala*; Gallen-Kallela himself participated in the patriotic movement. On the incident at the World Exposition, see Bosley (1989), 672. For more on later Finnish nationalist uses of the *Kalevala*, see Wilson (1978), 51–75. On the author's rediscovery of Kandinsky's personal invitation to Gallen-Kallela (along with six other letters relating to the Phalanx exhibition, in which Gallen-Kallela was the featured artist with 36 works, and its long-lost catalogue) in the archives of the Akseli Gallen-Kallela Museum, Espoo, Finland, see Weiss (1982a), 47–48. (The discovery allowed a hypothetical partial reconstruction of the exhibition; see below.) See also Sarajas-Korte (1966).

38. In the last version of the Kullervo saga, the hero who had been born in the camp of his enemies, thus doomed to a life of revenge, unknowingly seduced his sister, an act that

ultimately drove him to suicide. See Branch (1985), xxxi, 476, 480. It is uncertain which of Gallen-Kallela's studies for scenes from the life of Kullervo were actually shown at Phalanx, although three were listed in the catalogue: *Kullervo, Episode from His Youth (Kalevala)*, no medium given; *Kullervo's Return from War*, watercolor; *Kullervo* (gouache). Moreover, unspecified sketches for the 1900 World Exposition were also shown. The "Departure" scene's title is often coupled with the words "to War" or "from War," but his final departure is also implied. The literature is unclear on these distinctions, but it is reasonable to assume that one of those shown by Kandinsky was either the tempera (Weiss [1982a], 49) or the watercolor reproduced here. Kandinsky's earliest versions of this motif seem to have been a pencil sketch and a related ink drawing in an early notebook (GMS 330 [4, 31], dated ca. 1903–1904). Roethel postulated the dates 1907–1908 for *With the Red Horseman*, but the work may have been done much earlier, perhaps shortly after the Gallen-Kallela exhibition at Phalanx, ca. 1903–1904; cf. R/B (1984), 191, on the house catalogue notation that this work had been "übermalt." On Kandinsky's later use of this imagery, see chap. 5 below.

39. The trips were recorded in Kandinsky's Netherlands sketchbook (studies of costumes, ships, and architecture), and in several tempera works, e.g., *The Windmill* and *The Ships (Holland)*, and sketchbooks GMS 324 (1–36) and GMS 325 (1–57).

40. See Rudenstine [1976], 210–211, documenting for the first time the facts concerning the Tunisian holiday in relation to this painting. The feast was celebrated on the tenth day of Dhū al-Ḥijja, which in 1905 fell on 15 Feb. Other ethnic works related to this trip include *Arabische Reiterei* (GMS 95, 38, no. 80), *Arbeitende Neger* (GMS 91, 36, no. 79) and *Landstrasse* (GMS 98, 36, no. 78). Others were reproduced in the *Sturm* catalogue *Kandinsky, 1901–1913* (1913), 25 (depicting: Arab horsemen racing; a street or market scene; a crowded carnival scene). Kandinsky

called these tempera-on-dark-cardboard works "color drawings." In his list of 121 color drawings are several others from the trips to Holland and Tunis, but it is not always possible to associate the titles given with actual works, many of which have been lost or destroyed.

41. But there were other works of this later period, e.g., *The Elephant*, 1908, *Oriental*, 1909, *Picture with Archer*, 1909, and *Blue Mountain*, (1908–1909), each striking a strong ethnic note. The image of the archer in *Picture with Archer* may have been suggested by a similarly backward-turning archer illustrated in the costume book by Hottenroth (1891), I, pl. 62 (Sarmatian prototypes).

42. Used by such authorities as Vernadsky and Fedotov to describe the side-by-side existence of pagan and Christian belief systems, the term *dvoeverie* (or "double faith") has been attacked as too simplistic. As James Billington has pointed out, the notion of a distinct duality is not exactly accurate. In his words, the actual situation was more "a continuing influx of primitive animism into an ever-expanding Christian culture." See Fedotov (1960), I, 346 ("double faith") and passim, and (1966), II, 138; Vernadsky (1959), 315, and Billington (1966), 18. For a recent discussion of the term, see Hilton (1991), 69, n. 1. It is used here for lack of a better term with which to describe the often ambiguous intermingling of Christian concepts and imagery with ancient pagan concepts and imagery over many centuries. But the reader must be aware that the "influences" were often reciprocal; that Christian missionaries had often found it expedient to suggest an alliance between pagan "gods" and Christian saints; and that just as often a long-Christianized native (i.e., non-Russian) might adapt a Christian idea to ancient pagan superstition, as, for example, in supposing that sacrifices to the icons might bring improved luck in hunting or in health, or even in punishing an icon for ill luck (see, e.g., Ränk [1949], 32–33). While religious syncretism is an ancient and universal phenomenon, its peculiar interest for Russian

ethnographers of the nineteenth century was doubtless stimulated generally by the Slavophile movement that celebrated growing nationalist interests characteristic of the period (as in Germany nationalist sentiments fostered similar developments—the Grimm brothers reconstructed ancient folktales and Wagner revived the myths of Nordic antiquity; in Finland, Lönnrot reconstructed the myths of the *Kalevala*, and so on). On the specifically Russian phenomenon, see Florovsky (1964), 125–139, and Andreyev (1964), 140–147. For Maximov's *Arrival of a Sorcerer at a Peasant Wedding*, see Iovleva (1986), no. 93 (here titled *The Magician Comes to a Peasant Wedding*); for Surikov's *Yermak's Conquest of Siberia*, see Kemenov (1979), 139–140.

43. Ränk (1949), 23–29, 32–33, 59–62, and *passim*, describing how the "holy corner" came to symbolize the coexistence of pagan and Christian beliefs, particularly among the Finno-Ugric peoples.

44. Among Russian painters who had dealt with the subject of crowd scenes were Andrei Petrovich Riabushkin and Apollinary M. Vasnetsov, who produced historical scenes of Russian crowds in church or in the streets on holiday, and Sergei V. Ivanov, who specialized in scenes of village life. B. Kustodiev painted a more explicit *Fair* in 1906 (Tretiakov Gallery, Moscow); but whether Kandinsky could have seen it before painting his *Motley Life* remains undetermined. On the striking parallels between *Motley Life* and a painting by the Munich artist Ludwig von Zumbusch, see Weiss (1979), 143. On his eidetic memory and its oppressive effects, see Kandinsky (1913), XVI–XVII.

45. Kandinsky had read Böhling's text in the original German for his review. See chap. 1 above and K—ii. (1890 [6]); Böhling (1890), 1–58. Böhling had compared his picturesque view to the kind of "medieval scene" found in Gustav Freytag's German tales, citing Freytag's *Die Ahnen*. Gustav Freytag, the writer's son, became a supporting member of Kandinsky's Phalanx society (Weiss [1979], 59 and 180, n. 28); pos-

sibly this happenstance reminded Kandinsky of Böhling's comparison. On Kandinsky's even later recollection of Böhling's pamphlet, see chap. 4 below.

46. See chap. 1 above; Sjögren (1861); Kandinsky (1889a), 39; and Branch (1973).

47. See Sjögren (1861), 315ff., 338ff., 396–404. Sjögren also demonstrated that the river system, which provided both north-south and east-west transportation, allowed the flourishing of such markets all the way to the Urals and south to the Kama.

48. Ahlquist (1885), 186, 263. The original purpose of Kondinsk monastery had been for the conversion of the shamanist natives, but by the time of Ahlquist's visit in 1877, the monastery was long past its heyday and could boast only of a small school for Ostiak and Samoyed boys, and a fishery. Alhquist had also described the importance of trading centers for the Zyrians and their neighbors, the Voguls and Ostiaks. Still another traveler may have fueled Kandinsky's iconographic imagination. Stephen Sommier, tracing his travels among the Zyrians, Ostiaks, and Voguls, had also described the village of Kondinsk and its monastery, rendering the name as Kandinsk both in his text and on the map that he included. According to Sommier, the natives were Christians "in name only," still attached to their pagan beliefs. Besides the same view of Kandinsk published in Ahlquist, Sommier also published a plate from a watercolor by Znamensky depicting the winter market at Obdorsk, which includes images (such as an embracing couple) that also appear in Kandinsky's market scene. But like the von Zumbusch precedent (see above), the Znamensky is also a prosaic naturalistic work. Cf. Sommier (1885), map n.p., and 163–167. Sommier's writings, cited in *E.O.* 3 (1889): 176–177, 184; *Un' Estate in Siberia* also cited in *E.O.* 5, no. 2 (1890): 242 (bibliography).

49. Sjögren (1861), 423–424 (emphasis added). See also Weiss (1985), (1988), (1992). This hill seems to have been just north of Kaigorodok. Although the monastery had fallen to

ruins by the seventeenth century, it remained the site of successive churches, in the last of which Sjögren had come across papers indicating the importance of the place in previous centuries. He also described two smaller hills in the immediate neighborhood of Ust Sysolsk, one that was still called "Tschudskoje Gorodishtsche" (Chud Gorodok) and another at Ib, just south of Ust Sysolsk. He noted particularly that the 60 or so Chudic graves appeared to have been laid out in the form of an enormous triangle (Sjögren [1861], 426–427).

50. An inscription below the sketch of a log shed in Kandinsky's Vologda Diary (fig. 47) indicates that he had attempted to assign the correct Zyrian usage and name to the structure. He wrote one word: *Ronysch* (Kandinsky [1889a], 168). Although this word is meaningless today as it stands, it reveals the earnest scholar's attempt to capture the sounds of a language with which he was unfamiliar. In today's Zyrian dialects, such a shed (known as an *ambar* in Russian) is called *zhitnicha, kum,* or *turysh.* See Belitser (1958), 194. But Kandinsky's German-Zyrian dictionary by Wiedemann recognized the word *önbar,* probably a corruption of the Russian *ambar,* as well as *zhitnik* and *kum,* but also the even more specific term *rynysh,* defined as a grain-drying shed. Kandinsky, to his credit, upon hearing the term as *ronysh,* clearly intended to make an accurate record of the dialect spoken in that specific area of Zyrian territory. (In his essay he described the type of shed built specifically for the use of hunters [called *kola*], which was distinguished by the fact that it had no hearth.) Even in Kandinsky's time, sheds similar to these were still in use by neighboring tribes (e.g., Cheremis, Votiaks, Ostiaks) for the preservation of idols and had been described in the literature (e.g., Finsch [1879], Novitskii [1884], Patkonov [1897–1900], Gondatti [1888]). Cf. Karjalainen (1922), II, 98–113, 111–113; Kodolányi (1968), 103–106; and Holmberg (1927), 113–138, pls. XI, XV (Votiak and Cheremis).

51. And as recent as 1926 (see Radó [ca.

1926], 353 [two million squirrel pelts harvested in 1924]). According to Ahlquist ([1885], 173), the squirrel was the common measure of value for all barter at the fairs of Beresov and Obdorsk, which the Zyrians still visited regularly in the 1880s. Bow and arrow (so as not to spoil the hide) were the chief means of hunting the squirrel. See Levin and Potapov (1964), 518. On the significance of the fir, pine, or cedar tree, see chap. 1 above.

52. Sources that would have been known to Kandinsky included Popov (cited by Kandinsky), Smirnov, Zhakov, and Nalimov (1903a and b). Cf. Munkácsi (1908), 243, several references to the mediating role of the squirrel. Cf. Paulson (1964a), 162, and Karjalainen (1922), II, 271.

53. In the same sense the hair of rusalka, whose magical powers were notorious, was often described as green (see Moyle [1987], 222).

54. See Wiedemann (1880), 345 (Kandinsky's dictionary), and Fuchs [Fokos-Fuchs] (1959), 1028a. Many words in the Zyrian language were used to designate those who assumed the various roles of the shaman. Kandinsky defined the perimeters of his study as Vychegda and Sysola Zyrians, and commented expressly on the elderly as the source of much of his information (Kandinsky [1889b], 103, 105, 106). Interestingly, among the neighboring Cheremis the specific name for the shaman or sorcerer was *kart*, or "old man," information published by Kandinsky's friend Bogaevskii in *E.O.* (1890), subsequently quoted by Mikhailovskii, also citing the Cheremis term for sorcerer (Mikhailovskii [1895], 153–155). Cf. Nosilov (1904), 169, photograph of a Vogul shaman dressed similarly to Kandinsky's "old sorcerer." On "horse-staves," see chap. 3 below and Mikhailovskii (1895), 81–83; Holmberg (1927), 522; and Eliade (1970), 467.

55. On Daban-Sagan-Noyen, see Khangalov, an authority on Buriat shamanism, in a report well known to ethnographers of Kandinsky's generation (Khangalov [1890], 44). Cf. Weiss (1987), 196, inadvertently misread as "Daban-Sagan-

Khatun," conflating the name of the master's wife, Delente-Sagan-Khatun, with his.

56. See Fedotov (1960), I, 349, 359–361.

57. Kandinsky (1889b), 104. Cf. chap. 1 above. For a summary of historical accounts of the Zolotaia Baba, see Munkácsi (1902), 3, 273ff. Munkácsi's work is interesting because he was a contemporary of Kandinsky, citing many of the original sources Kandinsky would also have known. Given the riches available in the Rumiantsev Library, Kandinsky could easily have known numerous other elaborate depictions of the "Golden Woman." See, e.g., the 1562 pictorial map by Anthony Jenkinson in Herberstein, illustrated here. Many cartographic depictions, including Jenkinson's, were republished in 1908 in a variorum reprint of Herberstein's chronicles which included all other illustrations from previous editions, as well as the maps (Malein [1908], 327 [following] and 382, n. 2). Cf. Karjalainen (1914), 4–16, and (1922), II, 168–174, for another account of the "Golden Woman."

58. See, e.g., Castrén (1853), 288–289, and Sjögren (1861), 402–403, describing the use of precious metals, such as gold and silver, to ornament the wooden idols of the ancient peoples. Cf. Tolstoi and Kondakov (1891), pt. III, 363, citing Semen Ulianov Remizov's 17th-century pictorial history of Yermak's conquest of Siberia (repr. 1880), in which the worship of the Golden Woman was associated with the Ostiaks and Voguls who had hidden the idol before the approach of the Russians. As the Tolstoi and Kondakov volume was in Kandinsky's own personal library, it may be deduced that he knew the Remizov as well (for more on Kondakov's influence on Kandinsky, see chap. 6 below and Weiss [1994]). Cf. Gondatti (1888), 59–60, demonstrating that the Kältas-Anki (the native name for the Golden Woman) was venerated as a childbirth goddess (active as well in determining destiny). Cf. also Karjalainen (1922), II, 172–180. Modern research tends to support the early reports, lending credence to the story of the metal-sheathed

idol of the Ob that came to be known as the Golden Woman. See Sokolova (1978), 491–501. Cf. Schellbach and Lehtinen (1983), photographs of Ostiak idols (wrapped in cloth, some sheathed in metal), collection of the National Museum, Helsinki.

59. This flute (in a form common among the Finno-Ugric peoples) resembles Cheremis linden bark *sürem*-horns used in ritual ceremonies intended to drive out evil spirits. See Holmberg (1926), 181–182.

60. See chap. 1 above and Kandinsky (1889a), 207, on Zyrian morés. Cf. also Sjögren (1861), 444, and Nalimov (1908), 1–31.

61. See chap. 1 above and Kandinsky (1889a), 190 ("even 'inadvertent' murder is excused") and 195.

62. Notebook GMS 336, SG. Cf. Ivanitskii (1891), 226–228, on worship of fire and trees in Vologda province.

63. Propp (1975), 23.

64. E.g., Ivanitskii (1892), 183, relating in *E.O.* a folktale about a sorceress who returned from the dead as a cat.

65. For details of this crucial stylistic transition in which elements of his lyrical mode, adapted both from tempera paintings and woodcuts, were amalgamated to the more impressionistic mode of his landscape paintings, see Weiss (1982a), 57–65.

66. As Peter Selz has stated, the second exhibition of the New Artists' Society of Munich (Neue Künstlervereinigung München) was the first exhibition anywhere "in which the international scope of the modern movement could be estimated" (Selz [1957], 193). See also Weiss (1982a), 62.

67. On Kandinsky's stylistic transition and his reception by Munich critics, see Weiss (1982a), 62–63, and (1979), 187, n. 143.

68. Kandinsky (1918 [L/V, 1982]), 890. The painting was destroyed during World War II, but its oil sketch, reproduced here, remains in the SRG. For complete provenance and review of

the literature, see Rudenstine (1976), 228–236. Cf. Brisch (1955), 232–238; Long (1980), esp. 112–113 and 132; Weiss (1984), 93; Weiss (1986), 56–57; and Weiss (1987), 205–206. According to Eichner, Kandinsky stated that *Composition II* was painted "without theme"; on the other hand, Kandinsky also referred to the "tragic quality" of its composition and drawing (Eichner [1957], 111–114). For interpretations of this and other Kandinsky works as "apocalyptic," see, e.g., Long (1968 and 1980) and Ringbom (1966, 1970, and 1986). For critiques of these positions, see Introduction above.

69. On Vasa (Russian, *vodianoi*), see chap. 1 above and Holmberg (1927), 197–199; Holmberg (1913), 96–107, citing not only Kandinsky but other sources such as Popov that Kandinsky himself knew and had cited.

70. See Iovleva (1986), no. 16, *The Miracle of St. Florus and St. Laurus.* Cf. Ivanitskii (1892), 182–185. The fusion of the motif of the prone figure "in trance" with a rider on horseback is also found in Kandinsky's *Improvisation 9*, 1910. A drawing for the latter makes the shamanic reference more explicit, as the hand of the prone figure appears to rest on a vaguely drum-shaped form, and the rider on the "cosmic mountain" is enveloped by a surround that suggests his existence as "dream-" or "trance-" related (D/B [1984], no. 86).

71. See Paulson (1964a), 223. As noted, the medicinal willow was traditionally associated with Palm Sunday and other resurrectional rituals such as the spring St. George's Day. Cf. Lankenau (1872), 280, a source Kandinsky could have known.

72. Kandinsky (1889a), 79. That the vörsa in Kandinsky's picture raises his left rather than his right arm hardly detracts from his identity. As noted in chap. 1 above, this description of the prankster forest-spirit tallies with descriptions by other ethnographers such as Popov and attests to the contemporaneity of such beliefs among the Zyrian people of Kandinsky's time, as well as to

the existence of dvoeverie, for Kandinsky noted that the sign of the cross was thought to ward off the pagan spirit. Cf. Holmberg (1927), 181–182. Tales and accounts of vörsa and other *leshie*, or forest-spirits, could be quite local; see, e.g., Ivanitskii (1890), 122–126; and Popov (1874), cited by Kandinsky (1889b), 57–58. Popov had specifically referred to the child-snatching reputation of vörsa.

73. Numi-Tōrem was the appellation of the highest god most often invoked among several northern tribes (including Votiaks and Samoyeds). On the various names and roles of the gods of the Voguls, see Gondatti (1888a), esp. 51 and 55–68. Whatever his name, Numi-Tōrem never revealed himself to humans.

74. Kannisto's often cited 1906 account of the dramatic arts of the Voguls, which Kandinsky seems to have known, described a typically humorous scene in which Mir-susne-khum appeared in the company of his rowers (Kannisto [1906], 228–229). Cf. Karjalainen (1922), II, esp. 186–194.

75. The name of this god is usually translated as "World-Watching-Man," but also as "World-Surveying-Man" or "World-Traveling-Man." In the following text Mir-susne-khum and World-Watching-Man are used interchangeably. Cf. Gondatti (1888a), 55–65, who described Mir-susne-khum as a horseback rider. Kandinsky may well also have known the work by Sirelius (1904), in which many of these images were reproduced. Several watercolor renderings of traditional "Mir-susne-khum" designs for sacrificial blankets collected by Kannisto are in the collection of the Museovirasto, National Museum of Finland, Helsinki (e.g., no. 489a). The figure with the same sacred connotation was also used on birchbark objects and clothing. See Ivanov (1954), 50–55, nos. 27, 32, 33, and 34, and passim; also Ivanov (1959), 116; and Rudenko (1927), 32. The image of the figure standing in a boat with outstretched arms is also similar to many such images on Lapp shaman drums. See Manker

(1938–1950), e.g., I, nos. 32 and 56, and II, no. 39 and passim.

76. On the candles for World-Watching-Man, see Karjalainen (1927), II, 186, citing Poliakov (1877). On the St. George aspect of World-Watching-Man, see Kannisto (1906), 229, n. 1. Cf. Patkanov (1897), 101–102, 131; Munkácsi (1907, vol. 8), 111–113; and Munkácsi (1903, vol. 4), 63, 189–191, and 97 (often citing Novitskii). Brisch, writing on *Composition II* ([1955], 234), referred obliquely to the syncretic ramifications of this figure in describing his gesture as one of "blessing or exorcism."

77. "Great flood" tales occur in both Finno-Ugric and Buriat legends. An Ostiak folktale concerning the rescue by boat from a great flood of a son of the highest god was reported by Gondatti. Its syncretic apocalyptic connotations and currency among the Konda River Ostiaks suggest a possible motive for Kandinsky's interest in the theme. See Gondatti (1888a), 68–70. See also Nioradze (1925), 91; Holmberg (1927), 361–370; Karjalainen (1922), II, 296–297.

78. Kandinsky (1913), XIX. At lower right a couple stretch out as if communicating with one another; one gestures toward the action, the other apparently listening. These two may be the tellers of folktales, or they might represent the couple in a Tatar tale, recorded by Castrén, who were condemned to an eternity of argument over the one scant blanket they were forced to share in the underworld (Holmberg [1927], 489–494, citing Castrén).

79. Here the combination of the prone figure, leaping horsemen (of which one bears a clear relation to World-Watching-Man), and the detached tower in the background clarifies the interpretation of the tower as "cosmic pillar."

80. See Weiss (1982a), 62–70; Vinnen (1911). Extracts had already appeared in *Münchner neuesten Nachrichten*, no. 171, 11 April 1911. Vinnen's attack, signed by a large proportion of Germany's Secessionist artists, protested the importation of French—indeed, any foreign—

art into Germany. The diatribe prompted the response initiated by Kandinsky and Marc, subsequently published by Reinhard Piper (Heymel [1911]). See Lankheit (1983), 28. See also the correspondence among Marc, Kandinsky, Alfred Walter Heymel (editor of the brochure), and Piper (in Buergel-Goodwin and Göbel [1979], 122–137). See Piper (1947), 431–433. Dating of the *All Saints' Day* paintings remains uncertain and has been confused by the arbitrary numbers assigned by R/B (1984). In letters to Münter dated mid-July 1911, Kandinsky indicated that at least one version of *All Saints' Day* (a reverse painting on glass, numbered either I or II) had *preceded* the one he was then working on, now numbered I by R/B (1984), 393.

81. Also known as *Composition with Saints*.

82. Fedotov (1966), II, 230–245, citing Druzhinin (1897). See Kandinsky (1889b), 103. Sjögren ([1861], I, 422) had also referred to "the famous sorcerer Pan [sic] Sotnik" mentioned in the biography of St. Stephen of Perm. According to Nalimov, the Pam legends were still current among the Zyrians in his day; according to his Zyrian informant, a Pam was a person who "possesses enormous will power," "commands the elements and the forest people," has "good spiritual qualities," and struggles against the enemies of the Zyrian people. Pam Shipicha, who lived at the confluence of the Sysola and Vychegda rivers (i.e., Ust Sysolsk), fought off the Russians by drowning them in the rivers, thus satisfying the vasas. Despite his powers, Pam bemoaned the fate that prevented him from attaining the power of En (Jen), the highest god. Ultimately he was betrayed by cowardly servants and his mistress, in whose loving embraces he lost his powers. According to Nalimov, the last "Pam" lived about "a hundred years ago," his descendants having died out around 1845. See Nalimov (1903b), 120–124.

83. For examples of Zyrian knit stockings with their characteristic patterns and bright colors, see Belitser (1958), esp. 245 and 255, and Klimova (1972), 77–85.

84. See Weiss (1982a), 75, and (1984), 91.

See also Ivanitskii (1892), 182–185. Significantly, in this context, Marc had been a student of theology. Another pair of "twins" common to Russian iconography are Boris and Gleb, the secular warrior saints who were murdered by their brother, but they are generally represented holding swords and similarly dressed.

85. Kandinsky (1913), XXXV. Kandinsky's colleague Mikhailovskii had remarked: "The shaman . . . gives rein to his fancy, and tries by an original mise-en-scène to make an impression on the visual faculty; he brings up spirits, [and] *mingles the comic with the tragic element*" (emphasis added). See Mikhailovskii (1895), 97.

86. Because of their power over fire and metals, smiths were perceived in ancient societies as possessing magical powers, especially with respect to healing, second only to that of the shamans. Kannisto reported that among the Konda River Voguls, St. Simeon was accepted as a healer (see Virtanen and Liimola [1958], 320 [collected 1901–1906]). He also found that the Voguls associated the ancient thunder god with Iliia (St. Elijah). On the smith as healer, see also Klements (1910), III, 4. See Vernadsky (1959), 136, and Eliade (1972), esp. 470–474.

87. See *Christ on the Cross*, 1911. A conjunction common among the Voguls and Ostiaks of the Konda/Kondinsk region, as noted above. See Karjalainen (1922), II, 192–194; Munkácsi (1907), vol. 8, esp. 112. See also Iovleva (1986), pl. no. 11, where the sun imagery of St. George is associated with Iarilo, the pagan god of the sun and fertility, who is also associated with St. John's Night festivities.

88. For Münter's comment, see R/B (1984), 401. On St. George's trial by fire, see, e.g., an old Russian folksong on George the Brave: "O Georgi Khrabrom," Voskresenskii (1881), 213, quoted in Kannisto (1906), 229, n. 1.

89. See Long (1980), 89–93, providing a Last Judgment reading for this series of paintings. Lindsay also read the imagery of the reverse painting on glass *All Saints I* within the context of the biblical Apocalypse, noting the lack of the

"Judging Christ" (Lindsay, [1985]). Yet a strictly biblical reading is inconsistent with Kandinsky's use of multiple allusions. E.g., Lindsay's identification of the horseman as St. Michael, although appropriate for the Apocalypse, is consistent neither with Kandinsky's repeated use of the St. George motif nor with the specifically Russian context of this work in which St. George/World-Watching-Man faces a trial by fire. Moreover, on Russian icons St. Michael is almost invariably depicted with wings and a sword, not on horseback. An interesting exception to this is the depiction of a horseman saint encircled by a geometric "nimbus" in an icon called *The Church Militant*, pointed out by Lee ([1982], 208–212) as a possible precedent for Kandinsky's association of the horseman and the circle. Yet Lee's analysis ignores the fact that Kandinsky did not represent his horsemen with wings, crowns, or daggers, but instead *without* wings and *with* feathered helmets, lances, and often capes or "caftans."

90. Holmberg (1927), 8–9 (citing Gavrilov [1880]); also 13, 240–241 (among the Votiaks). See Sebeok and Ingemann (1956), 233.

91. Münter in turn depicted St. George in relation to a naive wood carving of the Virgin and Child in her *Still Life with St. George*, 1911; the same painting included the carved wooden bird salt cellar from Kandinsky's collection of Russian folk art. See Lindsay [1985], on this figure as Sophia, the image of Divine Wisdom favored in medieval representations of the Last Judgment, and the foreground figure as St. John. Within the context of the cult of Sophia that had been promulgated among late 19th-century Russian literary groups by Vladimir Soloviev, Lindsay's interpretation is persuasive, yet it is perhaps doubtful that the Westernizing and Roman Catholic–centered Soloviev would have envisioned his Sophia in the garb of a Russian peasant. On Soloviev, see, e.g., Mirsky (1958), 362–368; Maslenikov (1968), 56–60; and Billington (1966), esp. 464ff.

92. By virtue of the repeated motifs, this painting is closely related to a reverse paint-

ing on glass (*Large Resurrection*, also known as *Resurrection on Silver*), a watercolor (*Sound of Trumpets [Great Resurrection]*), 1911, and a woodcut also known as *Sound of Trumpets*. Another woodcut, *Jüngster Tag*, and drawing are related to this series. For a discussion of some of the motifs read strictly in the Christian biblical sense in this work, see Long (1980), esp. 89–95. See Munkácsi (1907), vol. 8, 97–104. According to some legends related by Munkácsi, the "Tundrahügel," or world mountain, was also the original home of Numi-Tōrem. Some legends also describe the golden, silver, or many-colored house of Numi-Tōrem. The hieroglyph invented by the artist to stand for this motif in the woodcut based on the same composition (and in its preparatory drawing, GMS 378), is remarkably "abstract," differing from Kandinsky's usual "hooked curve," the head of the rider and the outstretched arms appearing to float above a doubled half-circle.

93. On the *Kalevala*'s boat-pike collision, see, e.g., Kirby/Branch (1985), 516. According to Krohn, whales and boats with rowers were among the earliest motifs on Lapp and Siberian shaman drums (K. Krohn [1906], 155). See Holmberg (1927), 195, 198, citing Nalimov. A legend among the Chukchees also warned of a man-eating pike (Bogoras [1904–1909], 328).

94. A well-known source for this element of shamanic belief (i.e., decapitation and resurrection of the shaman), that was contemporary with Kandinsky was Priklonskii, originally published in 1886, and again in 1890–91 in the popular journal *Zhivaia Starina* (see Priklonskii [1953, Wise], 33:11). Priklonskii's studies had been cited in the bibliography of the same issue of *E.O.* in which four of Kandinsky's book reviews appeared. See Eliade (1972), 36ff. and 108–109; Basilov (1976), 151; and Lehtisalo (1936–1937), 3–34.

95. Also translated as "Ardent Sun" or "Radiant Sun" by Vernadsky (1959), 109–110, 314–315, passim.

96. Kharuzin had described the Lapp

rusalka or *satsien* in his article on Lapp shamans in *E.O.* (see Kharuzin [1889], 61). According to Klaudius Popov, Rusalka is the wife of the water sprite Kul (another Zyrian name for Vasa), and she and her like are "often seen when they come ashore to comb their long, wet hair with a large comb." Popov (1874), 58; a work cited by Kandinsky (1889b). Nalimov also discussed the Zyrian water-spirits (see Nalimov [1903a], 78–79). See Paulson (1961), 124–127, 278–279.

97. Although the rusalki are sometimes described as dancing wildly or climbing about in trees, they are often depicted in the visual arts with fish tails, like mermaids. Nearly always associated with water (although also with field and forest), especially with places where death has occurred, they are particularly associated with suicide by drowning, often the fate of young girls who had become pregnant out of wedlock. Indeed, in another example of dvoeverie, the so-called Rusalka Week of the ancients had been taken over by the church and associated with Trinity Sunday and with special observances concerning "impure" deaths. For a thorough discussion of rusalki, see Moyle (1987), 221–238. See also Reeder (1975), 83; and Zelenin (1927), 391–393.

98. See chap. 3 below, on Bogaevskaia's relationship with Kandinsky. According to the artist's house catalogue, *Nude* was painted on 11 March 1911.

99. *Deluge*, dated ca. October 1911 by the artist. A painting of the apartment interior by Gabriele Münter depicts the mermaid below the clock, between two reverse paintings on glass, surrounded by friends of the *Blue Rider* editorial board, including Kandinsky. See photograph of the artist's Munich apartment in D/B (1984), 452. Cf. Heller (1992), 64, n. 1. Rusalki appeared in such later works as *Improvisations 33* and *34* (*Orient I* and *II*).

100. See, e.g., Heikel (1888), IV, 173; figs. 166, 169, 292, 294. Although the single horsehead or bird motif is more often characteristic of Zyrian ridge-pole decoration, see Gribova

(1980) 205, 227, on the use of the crossed-horseheads motif in a variety of Zyrian handcrafts including architectural details. See also Belitser (1958), no. 142, and Wolfram (1968), 62–65, fig. 23.

101. See, e.g., Kandinsky's woodcut *Schalmei* and Kandinsky and Marc (1912), *lubki* opp. 16 and 127. The horsehead-gable motif also appears in a lost painting illustrated but not otherwise identified in R/B (1984), 192, again reminiscent of the river banks of the Vychegda area (although much exaggerated), in which apparently mourning female figures may be associated with the rusalki suicide legends. See undated sketch, *Abendfahrt*, GMS 769, possibly a study for *Golden Sail*.

102. For more on this design and its derivation, see chap. 5 below.

103. See, e.g., Gollek (1977), 39, and D/B (1984), 452.

104. The salt cellar appears in Münter's *Still Life with St. George* (see Hoberg and Friedel [1992], 271, no. 107, incorrectly described as "Huhn aus Steingut"). On sacred birds of the Ob-Ugrian peoples, see Chernetsov (1963), 3–45. On the significance of the greyhen, see also Sokolov (1978), 500. I am grateful to Jean-Loup Rousselot, SMV, for identifying the knife positively as Lapp (letters to the author, 12 May and 9 Aug. 1989). In the auction catalogue of the Nina Kandinsky estate, the knife was erroneously identified as "Eskimo" (see *Succession de Madame Nina Kandinsky* [1983], 39, no. 133). See also D/B (1984), nos. 800–810. For an example of Chushkin's work, see Ovsiannikov (n.d.), 35. A photograph of the farmer's sledge carving is in the Kandinsky Archive, MNAM.

105. Some of the reverse paintings on glass that remained in Münter's collection may have been collected by Kandinsky and Münter together, possibly carvings from Oberammergau as well (see Gollek [1977], 35–39). Icons of St. Elijah (condition precludes reproduction), St. Barbe, St. Mitrophane de Voronège, Kandinsky Estate, MNAM. Many important objects from

Kandinsky's personal collection of ethnographic memorabilia were offered for sale at the 1983 estate auction after Nina Kandinsky's death, including the sorcerer on horseback, the bird salt cellar, the Lapp knife, the ceremonial spoon, the two wood carvings of horse-drawn sleighs, two wooden crucifixes, and a number of other similar items. It has been impossible to ascertain the present locations of any of these auctioned objects at the time of writing. Neither the MNAM, Paris, nor the auctioneer, M. Raymond Caron was able to shed light on the matter. It must also be kept in mind that it is impossible at this time to know the true extent of Kandinsky's collection of folk and ethnic artifacts. Besides his donations to the Dashkov Museum (chap. 1 above), which have since been dispersed to other museums, he may well have left other objects behind in Russia at the time of his move to Munich or later at the time of his emigration from Moscow to Berlin.

106. As Kandinsky himself explained in a letter to Grohmann of July 1924 (Gutbrod [1968], 45). See Weiss (1979), 124.

107. See Gollek (1977), 14.

108. Amusingly, one Murnau bookcase carries the image of a crinolined Biedermeier lady with a spotted dog, possibly referring to Kandinsky's own dog, Daisy. For his Vologda furniture sketches, see Kandinsky (1889a), 50, and chap. 1 above. See Kruglova (1974), figs. 34, 39, and 40, for examples of Vologdan furniture.

109. By the first half of the 17th century the collections had already exceeded the limits of a mere "curiosity cabinet." More than 3,000 objects were housed in extensions to the royal palace which came to be known in Munich as the Hofgartenarkaden. In 1868 the consolidated collections were officially designated as an "ethnographic museum." See Müller ([1981], esp. 21 and 24–26), for an exemplary history of the Munich collections and details of the Krusenstern and Leuchtenberg collections. Another link between the Ethnographic Museum and Kandinsky was Princess Therese of Bavaria, the daughter of Prince Regent Luitpold. It is said

that Kandinsky personally escorted the prince through the Monet exhibition sponsored by the artist's Phalanx society (Weiss [1979], 68, 158, n. 109). The princess was a self-trained naturalist and ethnographer whose travels in northern Russia and the Arctic had resulted in publications appearing in 1885 and 1889 that may well have been known to Kandinsky. The princess was especially noted as an Americanist, having collected many fine American Indian artifacts on exhibit at the museum (Müller [1981], 27–28). For a more detailed account of Kandinsky's relations with Munich's Ethnographic Museum and its director, see Weiss (1990b).

110. During Scherman's term, attendance soared from ca. 8,000 in 1907–1908 to over 12,000 in 1910–1911; his annual reports were published in the popular *Münchner Jahrbuch der Bildenden Kunst*. See Scherman (1910), 119. For the information on the Eugen Wolf Chukchee collection, see Scherman's 1908 report (Scherman [1909], 85). The Bogoras report on the Gondatti collection was published in the journal of the Museum for Anthropology and Ethnography in St. Petersburg, which was available in the Munich museum's library, as were other early publications by the noted exile ethnographer, a contemporary of Kandinsky (see Bogoraz [sic] [1900/01], I, no. 2, 1–66, 25 pls.).

111. Collected not only from the Krusenstern and Cook expeditions but from many others. For more on the history of Russian collections, particularly of Northwest Coast artifacts, see Kinzhalov, (1983). For color plates of selected objects, see Siebert and Forman (1967). See Fitzhugh and Crowell (1988), esp. 60. See also Staniukovich (1978), 62–63.

112. See Golitsyn (1916), 19, illus. 5, and 22–23, 25. This catalogue is more complete than the 1910 French edition by Ianchuk (1910), 15–18. I am grateful to John Bowlt for kindly providing a xerox copy of the latter. This Tlingit ceremonial cape and the Marquesas stilt figure were included, along with other objects reproduced in the *Blue Rider* almanac in the *Kandinsky in*

Munich exhibition organized by the author (see Weiss [1982], nos. 304–310). On the *Stelzentritt* figures, see Müller (1981), 39, nos. 34–36.

113. See, e.g., Kandinsky to Münter, 19 and 27 Oct. 1902 (GMJES). Münter had come as a student to Kandinsky's Phalanx painting school in 1902 and they had fallen in love. But it was not until 1911 that Kandinsky succeeded in obtaining a divorce from Ania Chemiakina. During much of that time, especially in the early years, his turbulent affair with Münter remained behind the scenes.

114. Franz Marc to August Macke, 14 Jan. 1911 (in Brücher and Gutbrod [1964] 39–40). It is apparent that they then introduced Macke to the Munich museum for, in a 1930 letter to the publisher Paul Westheim, Kandinsky recalled how Marc had brought Macke into the *Blue Rider* enterprise: "We gave him the assignment, mainly to take care of the ethnographic material, [an activity] in which we participated as well. He carried out his assignment splendidly and got another, to write an essay on masks, which he did equally well." As we know, it was in fact the elder artist who had the final say concerning the content of the almanac. See Kandinsky (1930) in Bill (1955), 134–136.

Chapter 3

Epigraph: Kuusi, Bosley, and Branch (1977), 123, "Sampo III," song 14, collected in North Karelia in 1845 (related to runes 42 and 43 of the 1849 edition of Lönnrot's *Kalevala*). Translated by Keith Bosley. By permission of the Finnish Literature Society.

1. See Potapov (1978), 172–176; Potapov (1976), 338–341, on the piebald horse as sacred among the Teleuts, the Yakuts, and other tribes, the Teleut word for piebald eventually coming to signify the shaman's drum itself. See Diószegi (1978), 117. See, e.g., Priklonskii ([1886] Wise, 1953), 33:10, reporting the preference for the piebald as the sacred sacrificial horse.

2. See Nordland (1967), 167–185. See also Ivanov (1954), largely devoted to the iconography of shamanism; Ivanov (1970) and (1979). See also Sieroshevski (1901), 105; Mikhailovskii (1895), esp. 97; Casanowicz (1924), 431; Boyer (1964), 254; Vasilevich (1968), 343; Voigt (1978), 61; Lommel (1967); and Weiss (1987). The assumption of the shaman's artistry has carried over into our own day; as recently as 1988 Martha Graham, commenting on the death of the Japanese artist Isamu Noguchi, stated: "I feel the world has lost an artist who, like a shaman, has translated myths of all our lives into living memory" (quoted in Brenson [1988], 9).

3. For an indication of the enormous bibliography on shamanism available in Kandinsky's day, see Popov (1932). Articles on shamanism and review articles appeared in *E.O.* and other journals. See chaps. 1 and 2 above, on oral reports and publications on shamanism by Mikhailovskii and Kharuzin.

4. The term *shaman* is derived from an Evenk or Tungus word, *šaman*, which has been shown to have the etymological root of the Tunguso-Manchurian verb *ša*, "to know." See Siikala (1978), 14; Diószegi (1947), 211–212; Eliade (1972), 495ff. See Hultkranz (1978), 33–37, 43–48, defining the shaman's role as threefold: physician, diviner, and psychopomp, thus emphasizing the social role of the shaman, an important distinction separating historical shamanism from what is commonly described as "spiritism" or the "occult." Paulson, e.g., remarked, the shaman "is the master and not the slave or a passive tool of the spirits . . . [a] great and substantial difference" (Paulson [1959], 225). Eliade emphatically rejected the occultist approach to shamanism, by which the shaman is seen as himself "possessed," as too facile and incapable of accounting for the characteristically dramatic and dangerous nature of the genuine shamanic experience (Eliade [1972], esp. 5, 93, and 507). See Krader (1978), 188–190 and Voigt (1978), 62–63. Shirokogoroff (1935) also attacked the "theosophic writers" as unscientific, empha-

sizing the social role of the shaman (see 6, 271, 275, 334–335, 358, 363). See Siikala (1979), 13–14, 18, 29, 138, 339–340, also emphasizing this social role. See Weiss (1987), nn. 41, 42.

5. Experiences that parallel the traditional initiatory process of "suffering, death, resurrection," Eliade (1972), 33–66. Accounts of the characteristic "illness" suffered by the shaman initiate vary, but the most common traits included: a nervous disposition and restlessness, a desire for solitude, a meditative cast, absentmindedness, headaches, dizziness, ecstatic seizures, hallucinations, and sometimes a tendency to hysteria. Many of these characteristics were identified by ethnographers with whose work Kandinsky would have been familiar, such as Scheffer, Radloff, Potanin, Gondatti, Mikhailovskii, Kharuzin, and Bogoras. Bogoras's important article on the psychology of shamanism, e.g., appeared in *E.O.* in 1910, the year Kandinsky spent several weeks in Russia renewing contacts with his ethnographic colleagues (Bogoras [1910], no. 1–2, vol. 84–85, 1–36). See also Bogoras (1904–1909), 415ff. Priklonskii, e.g., had particularly emphasized the nervous predisposition of the shaman. Mikhailovskii had also dealt with the shamanic illness (e.g., Mikhailovskii [1895], 85, 87, 90, 147). According to Scheffer, the shaman may have been subjected to disease from childhood (see Schefferus [Scheffer] [1673]). See Potanin (1881–1883), II, 81–101; IV, 40–77 (also on shamanic illness, with numerous illustrations of shaman drums and costumes). See also Gondatti (1888a), 52–54. See Munkácsi (1902), vol. 3, 273–302; (1903), vol. 4, 85–110, 172–194; (1904), vol. 5, 56–88, 204–227. See also Byhan (1909), 126–127. See A. Erman, *Archiv für wissenschaftliche Kunde von Russland* (Berlin: Georg Reimer, 1850), VIII, 219 (on desire for solitude and depression as signs of a predisposition to shamanism); and Erman (1867), XXV, 186.

6. Kharuzin (1889), 49, quoting Scheffer. See Hultkranz (1978), 39, n. 62. On dismemberment, see Ksenofontov (1955/1928), 136 ff. See Eliade (1972), 27; Holmberg (1927), 496–

498; also Czaplicka (1914), 172, and Bogoras (1904–1909), 421.

7. Control of his motor skills and physical abilities while inducing his trance was another mark of the shaman. See Sieroshevski (1901), 105, and Mikhailovskii (1895), esp. 97. On the ventriloquism practiced by Chukchee shamans, see Bogoras (1904–1909), 435ff.

8. See Munkácsi, vol. 5 (1904), V, 204, citing Beliavskii (1833).

9. Weiss (1982a), 59; also Weiss (1985), 139.

10. Eichner (1957), 42 (citing letters from Kandinsky to Münter of 13.2.1907 and 19.3.1907), and 168 (citing letter of 8 Dec. 1910). According to Münter, Kandinsky was so psychically sensitive that even sitting at a crowded table could be a torture.

11. Eichner (1957), 57, 60–61, 63. Kandinsky (1913), VI, X; Kandinsky to Gabriele Münter, 10 Aug. 1904 (GMJES).

12. See Eichner (1957), 168.

13. See Weiss (1982), 77–79, for illustrations and a full discussion, and the relation of the composition to Crane's *St. George's Battle with the Dragon* (thus mirroring Kandinsky's own utopian socialist inclinations). Both works date from the pre-1908 era; the drawing has been dated 1903–1904 and the engraving, tellingly enough, ca. 1907.

14. *Improvisation 13*, 31 Aug. 1910, is a tandem painting to the oil version of *St. George II*, autumn 1910 (unaccountably dated 1911 in R/B [1984], 365), the similarity of the two works indicating that they were painted close together. A St. George painting in conjunction with either the spring or the autumn St. George's Day on the Russian Orthodox calendar would be consistent with Kandinsky's practice. On *Improvisation 13*, see Langner (1977), 115–146, who, while recognizing the subject matter as related to the St. George theme, was unable to account for the attitude of the rider with his outstretched arm (in fact, both arms are stretched out) and the lack of lance, etc. Interestingly, he questioned whether his inability to identify the subject firmly was due to a lack

of special information about possible literary sources or about the artist's intention. As we now understand, the attitude of this rider is a direct result of Kandinsky's ethnographic knowledge. Moreover, the picture's intentional syncretism is indicated by the inclusion of the dragon's victim at left and her parental hilltop castle at right. The saint's position as shamanic folk hero is suggested not only by his attitude but by his closed eyes and "veiled" face.

15. Kandinsky to Münter, 14 Oct. 1912, quoted in Eichner (1957), 105. This might also have been a veiled, perhaps even subconscious, reference to other personal involvements (see below). See Weiss (1982a), 77, and (1990a), 313–325.

16. Kandinsky reported that this picture was "the result of the last as usual very strong experiences in Moscow, more precisely stated— of Moscow itself" (Kandinsky [1913], XXXIX). See Werenskiold (1989), 96–111, emphasizing the social and political ramifications of the association between the artist's St. George image and his vision of "Mother Moscow." While her thesis that the popular Russophile concept of Moscow as the "Third Rome" may have been shared by Kandinsky, is persuasive, it does not account for the artist's fundamental skepticism with regard to the role of the church both historically and in his own time. See Weiss [1982a], 78–79, on this painting and Kandinsky's interest in the work of the social reformer Walter Crane.

17. In some groups the drum might serve as a magical reindeer, a bird, or even a boat. See Mikhailovskii (1895), 78–80 (citing Agapitov and Khangalov [1883], cited and commented upon in many issues of E.O.). See Hultkranz (1978), 35–36; Potapov (1978), 174–175; Vajn-stejn (Vainshtein) (1968), 331–338; and Eliade (1972), 173–174, 467. Scheffer's illustration was subsequently elaborated upon by Murr (1801), describing the Lapp drum that would later be transferred to Munich, and that will concern us later in this text. See Manker (1938–1950), I, 803.

18. See, e.g., Golitsyn (1916), 43–44, and

Ianchuk (1910), 30, listing horse-sticks on view at the Rumiantsev's Dashkov Museum. See Diószegi [1968c], 42, reporting hundreds of horse-sticks in the museum at Leningrad (St. Petersburg). The author also located horse-sticks in the collections of both the MAE and GME, St. Petersburg, in 1990.

19. Kandinsky (1913), III.

20. See chap. 2 above. The author photographed this toy horse and rider during a visit to Mme Kandinsky in 1980. It was of painted wood and stood approximately 18 inches high; the rider was detachable from the rocking horse. According to Jessica Boissel, the piece is not part of the Kandinsky estate at the MNAM, Paris (letter to the author, 17 Oct. 1985). See chap. 2 above, on the 1983 Kandinsky estate auction. See N. Kandinsky (1976), following 128, photograph of the artist's studio with hobbyhorse. A similar shaman image in a tall, pointed cap figured in Kandinsky's painting *Storm Bell* (ca. 1907; Grohmann [1958], 350, no. 14), and in a vignette to the poem "Vorfrühling" in *Klänge* (see below). As noted, the shaman Pam appeared in similar guise in *Composition with Saints (All Saints II).*

21. Kandinsky (1913), IV and X (on the incident of the "scheckiger Schimmel"). On the shamanic significance of the piebald horse, see, e.g., Potapov (1978), 174–175, and n. 1 above.

22. Kandinsky (1913), XVI, and (1913 and 1918 [L/V 1982]), 370 and 892, nos. 54, 55, 57.

23. See Bogoras (1904–1909), 418; Siikala (1978), 31ff.; Eliade (1972), esp. 29–30.

24. Mikhailovskii (1895), 76; Kandinsky (1910), n.p., emphasis added. Kandinsky's phrase "the calling" is an echo of Gondatti's description of "the calling" of the shaman (Gondatti [1888a], 52). See Vasilevich (1968), 345.

25. Kandinsky (1913), XIX.

26. On the drum's "ascensional symbols," Eliade (1972), 171. The cosmic tree might even be represented in the shamanic ritual by an actual tree, freshly cut and set up inside the tent, or yurt; sometimes steps were cut into it to form the ascensional ladder. Depending upon local condi-

tions, the vehicular function of the drum might be conferred upon the horse, the reindeer, the elk, a giant fish, a boat, or a sacred bird, usually the goose or the eagle (see, e.g., Eliade [1972], esp. 173f. and 192). On the shaman drum as a symbol of the universe and cosmogonic map, see Prokofieva (1963), 150; also Lot-Falck (1961), 36–37; and Jankovics (1984), I, 149–163. It has even been proposed that Lapp shaman drums may actually have been intended as "star charts" (Sommarström [1985], 139–156). On the drumstick as the "tongue" of the Yukaghir drum, see Jochelson (1908), I, 54.

27. The author located several Teleut drums at the MAE, St. Petersburg, and at least one at the GME during a research visit in April 1990. Drum imagery is widespread and is found among the Lapps, Ostiaks, Yenesei Ostiaks (Kets), Dolgans, Pechora Nentsy, Selkups, Tungus and Orochens (Evenki), Kachins, Altais, Shors, Teleuts and Minusinsk Tatars, among others. Snakes, birds, frogs, fish, reindeer, bear, and other animals may also appear, as well as "fantastic" forms resembling strange microscopic amoebae (see Diószegi [1978], 83–167). On the "book of fates" image (book of divination), see Ivanov (1978), 22. See also Potapov (1968), 210. On Siberian drums, see Levin and Potapov (1961), including Prokofieva (435–497). On Lapp shaman drums, see Manker (1938–1950), I and II. For source material close to Kandinsky, see Miller (1887); Golitsyn (1916) and Ianchuk (1910). See also Baedaeker (1970/1914), 302–303. The identification and location of Dashkov collection objects dispersed by the Revolution remains a problem yet to be resolved.

28. See Potanin (1881–1883), IV, pl. XI (Teleut drum); pl. VIII (Altaian drum); and three schemata of Lapp drums from Scheffer. See also Klements (1890), II, no. 2, 25–35, pls. 1–9 and Lankenau (1872), 280–281. See Scheffer (1673); Pallas (1771–1776), e.g., III, pl. V; Radloff (1884); and Byhan (1909), for descriptions and illustrations of shaman drums.

29. So powerful were they thought to be that Christian missionaries had made it their

mission to confiscate and burn Lapp drums by the hundreds, yet nonetheless many found their way into private and later public collections, their imagery and meaning often copied down by those who destroyed them. Manker catalogued 71 surviving Lapp drums located in Western European museums as of 1938 (Manker [1938–1950]). By the end of the 19th century, they had become the subject of innumerable studies. J. Krohn (1894), references to Kandinsky: 11, 189, also citing many of Kandinsky's colleagues, e.g., Mikhailovskii, Kharuzin ("Haruzin"), and Bogaevskii. See also Friis (1871), 11 Lapp drums and a Siberian drum with detailed explanations. See Weinitz (1910), 1–14 (reported in *E.O.* 84–85 [1910]: 208). See K. Krohn, (1906), 155–180 (both Lapp and Siberian drums). See Qvigstad and Sandberg (1888), 104–109, Lapp drums. For more recent discussions of the symbolism of the Lapp drum, see Pentikäinen (1987), 17–36; Paproth (1988), 269–318; and Sommarström (1985).

30. Kharuzin (1889), 36–76 (also presented as a lecture to the Society and included in the text of his *Russkie Lopari* [1890a]). See Itkonen (1946), 150, n. 2.

31. On the *Kalevala* as a shamanistic saga, see Oinas (1978), 293–94; (1985), 41–42; and (1987).

32. Although Kharuzin's information on the meaning of the pictographs was limited and not always reliable, he provided a vivid description that was basically correct, also describing the shaman's ecstatic trance in detail.

33. See e.g., Friis (1869), 263–265.

34. The Dashkov displayed, among others, Samoyed, Yakut, Ket, Tungus, Orochon, Nanai (Goldi), Buriat, and Tlingit shaman costumes, drums, and other paraphernalia. See, e.g., Miller (1887), Golitsyn (1916), and Ianchuk (1910). According to Radó ([1926?]), 57, the Dashkov collection remained on view in Moscow (as the "Ethno-gallery" of the Lenin Library) at least through 1926. See Mikhailovskii (1895), 81–85, and Radloff (1884/1893), esp. 17–18. As noted, Kandinsky also knew Castrén's descriptions of

shaman costumes (Castrén [1853], 192–193). See Lankenau (1872), 279, and J. Krohn (1894). Potanin, too, had described the snakes, arrows, pelts, feathers, and disks sewn to the Altaic shaman's costume (illustrated, including a back view showing "snakes," bells, disks, and two breastplates or aprons). Potanin (1881–1883), IV, 49–54, and pls. XXV and XXVI. See Ivanov (1954); Prokofieva (1971), (1949), and (1963); and Eliade (1972), esp. 145–165.

35. See, e.g., Mikhailovskii (1895), 81–85; also Holmberg ([Harva] 1938), 499–526.

36. See Vasiliev (1910), 46–76. This issue of *E.O.* included Bogoras on the psychology of the Chukchee shaman and his review of Byhan, q.v. See Diószegi (1968), 239–294. See Kandinsky to Münter, 14 and 5/18 Oct. 1910 (GMJES), documenting 1910 visit (chap. 1 above). See also Pekarskii and Vasiliev (1910), 93–116.

37. See Weiss (1982a), 30–31 (fig. 5), 58–61, and 81. See Gutbrod (1968), 60, quoting Kandinsky to Grohmann (23 Nov. 1932), in which the artist singled out three paintings that exemplified his successful transfer of drawing to painting: *Improvisation 8, Nude* and *Winter II*, two based on Russian reminiscences, all exhibiting motifs reminiscent of shaman drums. The "guardian" figure of *Improvisation 8* recalls a similar figure on a Lapp shaman drum illustrated by both Friis ([1871], pl. 1) and Krohn ([1894], 114), while the "stick-trees" in the other two might well have been suggested by similar "abstractions" from nature on either Lapp or Siberian drums, such as those illustrated in Potanin (1881–1883).

38. See Heger (1890), 162. There was at the time a general fascination among ethnographers with runic and pictographic writing. Even the work of American anthropologists on American Indian pictography was well known in Russia: for example, Mikhailovskii cited Washington Matthews on Navajo healing ceremonies and sand paintings, and W. J. Hoffman on American Indian pictography and on Ojibwa pictography and shamanism. Tribal ownership marks or brands (which may have provided precedents

for "abstract" figures) were also investigated and illustrated by Potanin, Bogaevskii, Kharuzin, and others. Of course, stick-figures were not the sole province of primitive art but belonged to the universal vocabulary of children's art, much admired by Kandinsky and included among the illustrations of the *Blue Rider* almanac.

39. In Plaut (1929), 308; see also chap. 5 below. See Weiss (1979), 128–132, and (1982a), 78–79, analyzing the transition in Kandinsky's work from horse motif to circle.

40. Bogoraz (sic) (1904), 353 (translated and presented at a Société d'Anthropologie congress, Paris, May 1904). Bogoras later published these and other drawings in *The Chukchee—Religion*, papers of the Jesup North Pacific Expedition (see Bogoras [1907]), 277–337, 311–312; also published in Bogoras [1909], and reviewed by Maximov in *E.O.* 81–82 (1909, nos. 2–3): 186–189. See also Bogoraz (1913), 397–420, other Chukchee drawings, in a festschrift for Prof. Dmitri Anuchin, whom Kandinsky would have recalled from his years with the Ethnographic Society.

41. See, e.g., such works as *Small Pleasures, Composition VI, Composition VII,* and *Black Lines* all of 1913. Many of the sketches for these works, as well as many of the preparatory sketches for engravings of the late Munich period, reveal this new orientation.

42. Kandinsky (1913), XXXVII: "The person standing in the steam is neither near, nor far; he is *somewhere*. This 'somewhere' determines the inner sound of the entire picture" (emphasis in original). See Kandinsky (1889a), 170, 171, 172; sketches of Zyrian bathhouses, one steaming. See also *Improvisation with Cold Forms*, 1914, which, interestingly, Kandinsky chose to exhibit in Malmö, Sweden, in 1914, and in Stockholm, where fine collections of Lapp shaman drums were to be found, in 1916. Many late Munich works include motifs from shamanist iconography: horse hieroglyphs, ladders, boats, suns, and mysterious triangles, e.g., *Fugue*, 1914, and *Dreamy Improvisation*, 1913. See also *Un-*

titled, 1916 (with distinct sun motif at center; see Ebert-Schifferer [1989], no. 85). See also, sketch for *Composition VII*, GMS 375; and drawing for *Black Lines*, GMS 428; *Sketch for Engraving V*, GMS 471, and *Sketch for an Unknown Engraving II*, GMS 525.

43. Drums with such "shaman roads" had been published not only by Potanin, Lankenau, and Klements, but by such earlier observers as Strahlenberg. See Diószegi (1978), 118. See, e.g., GMS 137, GMS 374. The zigzag motif is also prominent in the related *Fragment to Composition VII (Center)*. The brands for horses *(tamgi)* in Potanin (1881–1883), II, pl. XXVI, figs. 28 and 29, and IV, pl. I, may have provided precedents for several of the motifs in *Composition VII*. The brands in vol. II are particularly suggestive of the lines with blunted ends that intersect the central circular motif of the painting with its concentric rings. The geometric "cross" with radiating extensions to its "arms" in sketch GMS 363, *Composition VII*, recalls some of the tamgi of Potanin's pl. I, vol. IV.

44. Kandinsky to Münter, 10 Oct. 1910: "Ich habe Primitive demonstriert und Perser (alle Reproduktionen haben mir Hartmanns verschaffen)" (GMJES).

45. Kandinsky to Marc, 19 June 1911, quoted in Lankheit (1974), 15–16. Lankheit's documentary edition ignored the order and placement of the illustrations of the almanac's original layout. References in the present text to the original edition of the almanac will be to the more recent (and more easily accessible) facsimile reprint edition by Kandinsky's original Munich publisher, Piper. The almanac was actually an anthology clearly inspired by Kandinsky's contact with the ethnographic publications with which he had been familiar as a student. Not only the *Transactions (Trudy)* of the Society but also *Ethnographic Review* itself frequently included musical transcriptions, poetry, riddles, charms, runes, charts, maps, photographs, etc., as well as contributions by a broad spectrum of scholars. (Cf. Vergo [L/V 1982], 880, n. 7, suggesting that

the Society's "yearbooks" might have served as a precedent by virtue of their occasional inclusion of folk music.)

46. Marc to Macke, 8 Sept. 1911, quoted in Brücher and Gutbrod (1964), 72–74 (emphasis added). Playfully heralding the symbolist dimension of their intentions, Marc wrote his return address as *Symbolsdingen* (sic) rather than the more prosaic Sindelsdorf.

47. See Weiss (1982a), 67–76, cat. 304–310; Weiss (1985), 137–145, and (1990b), 285–329.

48. See Brücher and Gutbrod [1964], 39–40, Marc to Macke, 14 Jan. 1911; Bill (1955), Kandinsky letter to Paul Westheim, 1930. Scherman apparently provided the photographs free of charge in exchange for a copy of the finished book but when, in gratitude for his cooperation, Kandinsky later arranged that a copy be hand-delivered to the director, his efforts met with somewhat disastrous consequences. Apparently, Scherman leafed quickly through the book, found no credits to his institution directly next to the reproductions, and failed to notice the conscientious list of captions and credits at the back of the book. He quickly drafted a note sharply critical of the editors from whom he had expected so much. The author located the draft letter from Scherman to Kandinsky at the SMV with the help of Wolfgang Stein. For the text of Scherman's letter and discussion, see Weiss (1990b), 285–329. In all, photographs of nine artifacts from the Munich collections and five from Bern were to be reproduced in the almanac. A letter from Louis Moillet (who introduced Kandinsky and Klee) to Münter mentions the enclosure of ethnographic photographs and could also indicate that it was Moillet, not Klee, who actually obtained the photographs from the Bern museum for Kandinsky (n.d., GMJES). However, Klee's interest in primitive art and its relevance for contemporary art was clearly expressed in his review of the *Blue Rider* exhibition, December 1911, where he drew a telling parallel between the kind of art shown at the revolutionary exhibition and "the primitive beginnings *[Uranfänge]*

of art, as one more often finds [them] in the ethnographic museum." See Geelhaar (1976), 13, 97. Illustrations of ethnic artifacts and folk art in the almanac were not confined to those obtained from the Munich and Bern ethnographic museums, but included many from private and other public collections as well (see below, and Lankheit [1974], 268–281, for a complete list). Many of the original artifacts illustrated in the almanac were located by the author and included in the 1982 Guggenheim exhibition *Kandinsky in Munich, 1896–1914* (see Weiss [1982a]); others were added to the Städtische Galerie venue (Weiss [1982b]).

49. Previous unintentionally misleading reports notwithstanding, a sculpture of St. George and the dragon designed by the architect Emanuel Seidl was set into an archway connecting the facade of the Mariahilf church to its neighboring building on the town's main street in 1906–1907, about a year before Kandinsky and Münter settled in Murnau.

50. See Weiss (1986), 53, (1987), 197–198, and (1990b), 306–307. Although unidentified in the almanac, the subject of this *lubok* from Kandinsky's personal collection was identified by the author via a nearly identical ethnographic photograph made in the 1930s by Oskar Loorits documenting the St. George's Day procession in an Estonian village (see Weiss [1985], 143–144). The image of St. George appeared more than once in the almanac and was echoed in the reproduction of Münter's *Still Life with St. George* depicting an icon or reverse painting on glass of St. George prominently displayed, together with other objects from Kandinsky's personal collection of Russian folk artifacts, including his painted wood salt cellar in the form of a bird (chap. 2 above) and examples of Bavarian folk art.

51. The *Blue Rider* almanac as therapeutic metaphor was first suggested in Weiss (1982a), 71–76, and (1982b), 72–77.

52. See Buergel-Goodwin and Göbel (1979), 128–129. See Lankheit (1965), 38, and (1983),

where the two artists' concerns with the illustrations are documented in several letters (e.g., no. 56, 76–77). Their intentional placement of illustrations with respect to text has also been traced by Stein (1980). Kenneth C. Lindsay was the first to suggest that the editors' arrangement of text and illustrations in the almanac was deliberate.

53. It was Kulbin who, at Kandinsky's request, was to introduce the latter's ideas to his Russian colleagues by reading the artist's influential treatise *Über das Geistige in der Kunst* before the All-Russian Congress of Artists in St. Petersburg at the end of December 1911. See Kovtun (1981), 399–410. Kandinsky began writing to Kulbin in June 1910 and his own active participation in the eccentric physician's exhibition-planning activity is revealed in their correspondence. For more on Kulbin, see Bowlt (1976), esp. 11–17; and Bowlt and Long (1980), esp. 17–19.

54. For details of Bulgakov's biography and the essays, see his "Autobiographical Notes," Pain and Zernov (1976), 3–9, 51–53, 57–60; on his attack on Marxist anti-Semitism, see Treadgold (1979), 22. See also Bulgakov (1906 [1979]) and Shatz and Zimmerman (1986), viii–ix, 17–49. Bulgakov returned to the church on the eve of the Revolution, becoming a priest in 1923. His writings were suppressed after the Revolution. Exiled, he settled in Paris, where he died a few months before Kandinsky in 1944.

55. Kandinsky to Marc, 1 Sept. 1911, Lankheit (1983), 55. The verb *invited*, although implied, is omitted in the original.

56. Tokmakova was a third cousin to Kandinsky, "to whom good childhood memories unite me" (Kandinsky to Münter, 25 Oct. 1910, GMJES). The abstract is now in the Kandinsky Archive, MNAM, Paris. See Baraev (1991), 240, 247, 250, for other details of the Tokmakov relationships to the Kandinsky (and Bestushev) families. As Baraev clarifies, Elena Ivanovna Tokmakova was the daughter of Ivan Fedorovich Tokmakov, whose son Sergei married the granddaughter of Nikolai Bestushev's union with

a Buriat woman. Apparently, family reunions were held at the Tokmakov estate in the Crimea which was also visited, according to Baraev, by Gorky, Chaliapin, Rachmaninoff, Kuprin, Ermolova, and others of the cultural elite (Baraev [1991], esp. 238–240, 245, 247, and 249). It cannot be discounted that during documented trips with his father to Crimea as a child, Kandinsky may have been taken to the Tokmakov estate (see Grohmann [1958], 29, recording trips to the Caucausus, Crimean peninsula, and Kazan).

57. All five pictures, from the parish church of St. Nikolaus in Murnau. See Lankheit (1965), e.g., 148, which includes the inscriptions under the votive pictures omitted in the original edition of the almanac, documenting the specific cures effected by the prayers of the faithful. The other miracle pictures depict Mary and the Descent of the Holy Ghost (as tongues of fire) and the Dormition of the Virgin.

58. A theme enunciated in the opening pages of *Über das Geistige in der Kunst*, published in time for the opening of the *Blue Rider* exhibition. See Weiss (1982a), 70–71, 74.

59. Kandinsky to Marc, n.d. (probably after 10 Nov. 1911), in Lankheit (1983), 77. Marc to Macke, 21 Nov. and 3 Dec. 1911 (Brücher and Gutbrod [1964], 81, 86). It was the size of the picture that ordained its rejection by the New Artists' Society jury under a rule set originally into its statutes by Kandinsky himself. The conclusion is inescapable that his submission of an oversize painting was an intentional stimulus to his secession from the group, together with Marc and Münter on 2 Dec. 1911. Cf. Marc's detailed description of the jury deliberations in Marc to Macke, 3 Dec. 1911 (Brücher and Gutbrod [1964], 83–86, and Weiss [1982a], 70, n. 49).

60. On the painting's subtitle, see Marc to Macke, 3 Dec. 1911 (Brücher and Gutbrod [1964], 84). For Kandinsky's definition of "Composition" as almost "pedantic" in origin, based on "reason, the conscious, the intentional, the purposeful", see Kandinsky (1912a), 104 (the manuscript of which had already been completed).

61. That the artist was driven in part by personal demons to this creative catharsis is suggested by a congruence of events related to the distaff side of his life in the preceding weeks and months. During his lengthy visit to Moscow the previous autumn, Bena Bogaevskaia, wife of his good friend and colleague in the Society, Petr Bogaevskii, had been the muse most often at his side, serving as his faithful amanuensis and visiting him in Munich in the spring of 1911. That reunion may have inspired the creation of his Rusalka painting *Nude* (11 March 1911) and given rise to a correspondence suggesting that all was no longer well between the two old friends. Just weeks before beginning work on *Composition V*, Kandinsky received a letter from Bogaevskaia revealing her pregnancy and insisting that he become the godfather. She wrote that when her condition became known, "everyone lamented" over her and moaned *strashnyia*, a word that connotes "death, doom," but also "Doomsday" or "Last Judgment." Indeed, the painting with its congruent subtitle was completed within days of the child's birth on 19 Nov. Ksenija Petrovna Bogaevskaia later recalled Kandinsky as a doting godfather who frequently visited her home during her childhood, having attended her parents' wedding on 15 March 1894 and later presented her mother with a copy of "his book." (I am grateful to Natasha Avtonomova for this information.) For correspondence relating to this relationship, see Kandinsky to Gabriele Münter (in which Bogaevskaia's help in typing his lectures is gratefully acknowledged): 5, 7, 10, 13, and 23 Oct. 1910 (GMJES). The correspondence between Bogaevskaia and Kandinsky (GMJES) cannot be dated with certainty (years lacking except in the case of one postcard, but added in another hand); however, the following order appears logical with respect to content: Bena Bogaevskaia to Kandinsky: postmark 16 Sept. 1906 (postcard); 28 April [1911? (following her visit to him in Munich)]; 15 June [1911?] (postcard, postmark blurred); 22 Aug. [1911]; 7 Dec. 1911, from Ksenija [Bogaevskaia] to "Onkel Vasja" (written by Bena;

listed in index of correspondence, GMJES); and 8 April [1914? (apparently referring to a lecture on Kandinsky by Dmitri Mitrinovich, February 1914)]. (I am grateful to Dr. Armin Zweite, former director, SG, Munich, for permission to quote; and to Rob De Lossa for translation and analysis of the subtext of strashnyia.) That this period coincided with tensions in the relationship between Münter and Kandinsky is suggested by her later recollection that "In *Komposition 5* hat Kandinsky mich gemalt—ich gehe aus dem Bild, unten rechts, hinaus," in Münter to Kenneth C. Lindsay, 16 July 1956; I am grateful to Lindsay for permission to quote, and to S. Gregg for calling the passage to my attention.) The figure, head bowed, is to be found, as she said, at lower right. The difficulties of the relationship between Kandinsky and Münter are outlined in Barnett (1989) and Eichner (1957). On Kandinsky's entanglements of the heart, see Weiss (1990a), 313–325. See Münter's *Dark Still-life (Secret)*, 1911, possibly an oblique allusion to the tensions of this period. Exceptionally, and despite Kandinsky's insistence that his "Compositions" were based on slowly developed sketches, with the exception of one oil sketch, no pencil or watercolor sketches for the work are listed either in R/B (1984), or in Hanfstaengl (1974).

62. A scene in the life of Alexander the Great as depicted in a Persian miniature displayed at Munich's 1910 Mohammedan exhibition that Kandinsky had reviewed for *Apollon*, particularly marveling at the genius of the Persians (see Weiss [1982a], 63–64, 75–77 [fig. 39]). Several motifs that may seem obscure in the final work began as readable motifs in other "Last Judgment" works, such as *Sound of Trumpets* and *All Saints II* (see Long [1980], esp. 113–116).

63. Marc to Macke, 3 Dec. 1911 (Brücher and Gutbrod [1964], 86).

64. The rowboat and spirits of the water would also later appear in *Composition VI*, 1913, presaged in the reverse painting on glass *Deluge*, 1911. However, the rowboat, absent in the reverse painting on glass, appears as a prominent motif in the *Composition*. A sketch for the 1913 painting includes the rowboat with its two rowers, here carrying a standing figure with outstretched arms—a clear reference once again to World-Watching-Man (fig. 102). The lost reverse painting on glass reproduced from an old photograph in R/B (1984), no. 425; related drawing, GMS 978; its relationship to the "deluge" series put in question by the presence of the beaming sun.

65. The three main heroes of the *Kalevala* saga so beloved by the artist set out in a row boat to capture the "Sampo," and boats are ubiquitous motifs throughout the epic. Not only were the rowers associated in Finno-Ugric myth with World-Watching-Man, but boats were often left at burial sites as conveyances for the dead. Moreover, among some Siberian peoples the shaman's drum was regarded as "a boat in which the shaman 'sailed' on an imaginary shamanistic river," the drumstick then visualized as an oar. On drum/boat imagery among the Narym Selkups, the Altais and the Evenki, see Prokofieva (1961 [typescript trans.]), 863, 876, 897. The significance of the rowers motif for Kandinsky is underscored by the fact that he made the rowers the main subject of several other works, e.g., *Improvisation 26 (Rowers)* and the reverse painting on glass *Rowers*, both 1912. Characteristic of his syncretic program is the fact that the rowers often appear in conjunction with the Elijah/Thor motif. In *Glass Painting with Sun*, the rowers appear on the right-hand side of the picture closely shadowed by the troika of Elijah/Perun represented only by the triple-horse hieroglyph. In *Improvisation 24 (Troika II)* and its study, the rowers are central while the Elijah/Perun troika rises to the upper left. Similarly, see *Black Spot*, 1912. The rowers are included in many other works, such as *Small Pleasures* and its ancillary paintings, as well as in *Improvisation 23 (Troika I)*, again paired with Elijah/Perun; see also *Composition VII*, among others.

66. In *Composition V*, this celestial rider has been moved from his spot before the hilltop kremlin in *Sound of Trumpets* into the sky above it. The World-Watching-Man motif also storms up the mountain side with outflung arms in *Improvisation 21A*. In the related painting, *Small Pleasures*, two years later, the figure, much abstracted, is again shown with outflung arms.

67. Certainly Kandinsky would have known of the fanatic, fundamentally pagan Cheremis sect known as the "Big Candle" *(kugu sorta)* cult, essentially a nationalist rebellion against the czarist regime, that attracted considerable attention at the turn of the century. See, e.g., Kuznetsov (1893–1897), the first installment appearing in the same issue of *IAE* (VI, no. 3) which featured the full-page color reproduction of the Ceylonese dance mask of the demon of disease; and in *E.O.*, Kuznetsov (1904); 1–59, and Kuznetsov (1908), 67–90, 56–109, 73ff. See also Holmberg (1926), 30–33, 117–118, 179–182; and Holmberg (1927), 150, 246; Hämäläinen (1937), and Sebeok and Ingemann (1956), 320–337. Candles were also used in religious ceremonies by the Votiaks.

68. The identification of this hieroglyph as the home of Radien, or Jumala, had already been published in the early 19th century by Sjöborg (1804 and 1824), quoted in Manker (1938–1950), II, 426, 884. It was a characteristic of Kandinsky's working method that the final rendering of a given motif was often more likely to approach the detail of the original prototype than any preliminary rendering. Thus it is not surprising that the triangle motif of *Composition V* is closer in detail to the Lapp precedent than the same motif in the preliminary oil *Sketch for Composition V*. On the other hand, sketches sometimes revealed more than the finished work (e.g., *Improvisation [Ravine]*, chap. 4, below).

69. Kharuzin (1889), 36–76. The provenance of the Munich Lapp drum was confirmed in letters to the author from Michaela Appel, SMV, Munich, 26 Feb. and 17 March 1986. See Manker (1938–1950), I, 802–806; II, 423–26, in which the Munich drum is catalogued as no. 68. See also the related drum, no. 69. As previously mentioned, drum no. 68 had also been depicted by Byhan.

70. To Thor's right stands a figure with shovel-like hands probably intended to represent

the wind god. Two other gods, possibly fertility figures, accompany them.

71. Manker provides the basis for this description (Manker [1938–1950], I, 54–55, 803; II, 76–86, 423–26. See also Lommel (1985), 802–807. See Ivanov (1954), 72–73, figs. 58 and 59, Selkup-Samoyed drum depicting a similar sled-riding shaman in the same position, easily identifiable by the drum and drumstick he flourishes. See also Weiss (1986), (1987), and (1990b).

72. On the inclusion in the almanac of eight Egyptian shadow play puppets from the collection of the Islamic scholar Paul Kahle, see Weiss (1982a), 76, n. 67.

73. See Weiss (1982a), 73–76, noting the derivation of the name digitalis from the German name for foxglove, *Fingerhut* or "finger-hat," i.e., "digit-hat," the reference being particularly apt here in the context of the Japanese conjurer, the finger-artist or prestidigitator. That this detail from a Kuniyoshi print of "warriors" was mistaken by the editors for a circus performer is of no consequence, since it is what they thought at the time that concerns us here.

74. See Grünwedel (1893), *IAE*, VI, no. 3, 82–88, pl. VII (as noted above, same issue as Kuznetzov [1893–1897]); same journal had previously reviewed Kandinsky's Zyrian article; see Macke (1912 [Lankheit 1965]), 88).

75. On Kandinsky's "drum" paintings, see chap. 5 below. The essay was introduced with an illustration of a Pongwe mask from the Ogawe River area in Gabon, a mask traditionally worn by stilt dancers of the Mashango to personify the individual who returns from the dead; but whether the editors were aware of its meaning is unclear since the mask, from the Bern museum, was mistakenly identified in its caption as "Chinese? found in West Africa." Bringing this syncretic sequence full circle, Kandinsky's essay closed with a Bavarian reverse painting on glass depicting the sacred heart surrounded by signs of the Crucifixion.

76. Including also transcriptions of three songs by Arnold Schoenberg and his students Alban Berg and Anton von Webern, settings of symbolist poems by Maurice Maeterlinck, Stefan George, and Alfred Mombert. See Weiss (1979), esp. 81–91, and (1991).

77. Among the Ostiak Samoyeds small stones were sometimes placed in the drum resonators and even in the mallet. As the shaman moved about, chanting and singing, often accompanied by his helpers and sometimes answered by the chorus of onlookers, the metallic ornaments fastened to his coat added to the din. Lankenau (1872), 279, 281, described how the Minusinsk Tatar shaman brought forth from his drum "shaman music" that was "harmonic, passionate, thunder-like, sorrowful, lamenting and suffering," accompanied by the "clinking and clattering" of his costume's metal ornaments, altogether creating a deafening roar. Jochelson reported: "The sound of the drum, just like the human voice or song, is in itself considered as something living, capable of influencing the invisible spirits" (see Jochelson [1908], 54). See Prokofiev (1940), 370, and Eliade (1972), on the "musical magic" of the shaman's drum, 174–175.

78. See Castrén (1853), II, 173, 313; Lankenau (1872), 281; Bogoras (1904–1909), 436. Priklonskii found the ritual's din wholly unnerving (Priklonskii [1888], 175). See also Siikala (1978). Some idea of the sounds of the shamanic performance (albeit only that of far northeastern Siberia), may be gleaned today from wax recordings made by Bogoras and Jochelson during the Jesup expeditions (collection, American Museum of Natural History, New York, preserved at the Archives of Traditional Music, Indiana University, Bloomington). See also Weiss (1990c).

79. Kandinsky recalled in "Retrospects" that Wagner's music had evoked in his imagination visions of colors and forms (see Kandinsky, [1913], IX), and time and again invoked musical analogy in the titles of his paintings. As noted, such early "Russian" works as *Song of the Volga* and *Riding Couple* were fraught with musical analogy. In his 1929 interview with Paul Plaut, Kandinsky elaborated on the concept, stating that both "organized and unorganized sounds," or "noises," stimulated his visual imagination

(see Plaut [1929], 306–308). In notes for a lecture at Cologne (never presented), Kandinsky denied that his goal was to "paint music" (see Eichner [1957], 116). On synaesthesia, see Kandinsky (1912 [Lankheit, 1965]), 190–193. Among others who have commented on Kandinsky and synaesthesia, see Ettlinger (1964), 10–17, 50; Ashmore (1977), 329–336; and Long (1980), esp. 53–54, 65.

80. See, e.g., Castrén (1853), I, 193; Bogoras (1904–1909), esp. 434, 483, on the improvisatory nature of the shamanic ritual. See Diószegi (1968c), 169, and Siikala (1978), esp. 127, 134, 137, 141. See also Bogoras (1900–1901) and (1904). See also S. Freed, R. Freed, and Williamson (1988), 97–103.

81. Kandinsky (1910). See Castrén (1853), 295. See Mikhailovskii (1895), 65, reporting Gmelin's observation that the "language of the [Tungus] shaman's utterances was unknown." See Lehtisalo (1936–1937), 26. See also Hajdu (1978), 370–371.

82. See, e.g., Gáldi (1968), 132–33; and Lankenau (1872), 282.

83. Kandinsky (1920 [L/V 1982]), 136–137; alternative translation "flow" (for *techenie*) as substitute for "movement," suggested by L. Grubisic.

84. This collaboration followed their meeting, which itself had been precipitated by Kandinsky's attendance at a concert of Schoenberg's music in Munich in early January 1911. Almost immediately thereafter Kandinsky had captured his impression of the concert in a drawing that evolved less than two days later into the painting that he called *Impression III, Concert*. See Weiss (1991) and (1992). See Hahl-Koch (1980a), 42, 177–178, and Brücher and Gutbrod (1964), 39–42.

85. Where Kandinsky may have witnessed such an Arab ceremony remains a question; possibly at a public performance at one of the world's fairs he attended, or during his visits to Kazan as a child or to Tunis in 1904–1905. (See Weiss [1990c] and [1991].) For the letter from Marc to Macke, 14 Jan. 1911, see Brücher and Gutbrod (1964), 39–42, and chap. 4 below. Marc used the word *primitif*.

86. See Ahlquist (1885), 255–259, and Kannisto (1906), 213–237. Kannisto had described the effectiveness of the performances despite the extreme simplicity of costumes and "sets," comparing them to operettas. Among the many details recorded by Kannisto, his description of a scene in which World-Watching-Man appeared with his two rowers, and his identification with St. George, have already been mentioned. As noted, Kandinsky was doubtless familiar with Gondatti's report on the Vogul bear cult (Gondatti [1888b], 74–87). Moreover, Ahlquist published transcriptions of Vogul melodies and Kannisto collected some 30 Vogul folksongs. For Vogul birchbark masks in the Dashkov collections, see Golitsyn (1916), 86, case 45.

87. See Devel (1901; orig. 1896), 37–38 (trans. Rob De Lossa), describing also the shaman's recovery from his trance and his role as intermediary between his people and the netherworld, revealing instructions as to where good hunting is to be found or on how best to heal those suffering from illness. Although the book is hardly a scholarly work, intended as a general educational text on the material culture and religious practices of far eastern Siberia, the tales included are basically factual. Its publication date of 1901 suggests that Kandinsky acquired the book during one of his frequent returns to Russia from Munich, and that he considered it of enough value to keep with him subsequently (Kandinsky Estate, MNAM, Paris).

88. On *The Yellow Sound* as mystery play, see Weiss (1979), 98, 201–202, nos. 65–66, and Grohmann (1958), 56. See Casanowicz (1925), 427. For its Symbolist ramifications, see Weiss (1979), esp. 92–106. For its Christian iconography and its synaesthetic and other aspects, see Stein (1980); Stein (1983), 61–66; Hahl-Koch (1985), 354–359; Boissel (1986–1987), 240–251; and Sheppard (1990), 41–67.

89. See Kandinsky, *Klänge* (1913) and (1938), 31. See Weiss (1979), 127–128, 213, n. 2, on the synaesthetic dimension of the earlier *Xylographies*. The synaesthetic dimension of

Klänge is revealed beyond the title in obvious ways. Several of the poems have titles that allude to music, such as "Oboe," "Bassoon," "Sounds," "Bell," "Song," and "Hymn." Other poems reveal their synaesthetic content in allusions and puns. For example, the subject of "Song" is the critic who has neither eyes nor ears and who therefore misses the "sound" as well as the sight of the sunset; while in "Unchanged," among other synaesthetic motifs, a bell rings colorful inks. Unfortunately, many of the puns and underlying references have been misunderstood or ignored in the Napier translation; e.g., Napier (1981), 45, 110. Among the accompanying graphics are visual motifs evoking sounds as well, as in the woodcut version of *The Sound of Trumpets*. See also the following dissertations: Brinkmann (1980), Bamberg (1981), Fuhr (1983), and McGrady (1989). See also Sheppard (1990) and Hahl-Koch (1985). See also L/V (1982), 291–340, for English translations.

90. The poems "Spring" and "In the Forest," e.g., refer specifically to "healing stabs and cuts" and "healing scars." See, e.g., Bogoras (1904–1909), 444–447, and Gondatti (1888a), 54.

91. This conjunction of horse-circle-drum motifs became crucial in the artist's work. In a more "abstracted" version of horse-and-rider motif, the figure bursts forth from the drum form in the vignette to the poem "The Soft." Several rider motifs, including at least one with outstretched arms, had been illustrated in Dmitri Klements's article on shaman drums of the Minusinsk region (Klements [1890], pls. 2, 5, and 8). A man with outstretched arms is also the subject of the poem "Why?" On plans for the Russian version, see Roethel (1970), 278.

92. Devel (1901), 37–38. On ventriloquism, see Bogoras (1904–1909), esp. 435–438; Findeisen (1956), 142–143; and Siikala (1978), 136ff. Lankenau, Bogoras, and others also reported the shaman's use of eye coverings for this purpose. See Castrén (1853), I, 192. It may also be noted that a red cloth was often used to cover the eyes of the dead so that they might find

the "right way" into the other world (see Verbov [1968], 124).

93. See, e.g., Bogoras's account of a Chukchee rite to quell a storm, as quoted by Findeisen (1956), 19 (also numbered 155), where the shaman relays the information that the "Spirit of the Wind" has requested a "scheckige" or "piebald" dog as sacrifice.

94. The literature on the use of the *Agaricus muscarius*, or "fly agaric," mushroom in the shamanic ritual was considerable even in Kandinsky's day (see chap. 6 below). See Napier (1981), 45, where the word *Ahne* (literally, "foresee") is inexplicably mistranslated as "Anna," to rhyme with the second half of the word "Banana," and *Bann* as "Ban," to rhyme with the first half, when in fact the allusions here are multiple. The verb *bannen* may indeed be translated as "ban" or "banish," but it may also refer to the "spell" or "charm" cast by the sorcerer or enchanter. The imperative "*Ahne!*" refers to the sorcerer's uncanny ability to foresee, to "divine," although in this context the word may have as its subtext a reference to *Ahnen*, the ancient ancestors of the Zyrians, the Chuds. Kandinsky had discussed Zyrian folklore about the Chuds, as well as Zyrian customs involving ancestor worship, in his 1889 essay. Thus the imperative to banish ancestors (as the Chuds were banished by the church) or ancestor worship might be read into this line along with a seemingly contrary exhortation to "Cast a spell! Foresee!" Cf. L/V (1982), 308. McGrady has suggested "ancestress" as a possible translation of "Ahne," but without the ethnographic context and the complex of associations suggested here (see McGrady [1989], 79). Numerous references to the enchanting power of the mushroom occur, sometimes only in subtextual hints, as for example in "Water," where the "kleiner dünner roter Mann" in yellow sand calls up the well-known children's riddle song: "Ein Männlein steht im Walde ganz still und stumm/ Es hat vor lauter Purpur ein Mäntlein um," originally a cautionary tale of the red-caped fly agaric mushroom.

95. See Weiss (1986) and (1987). See Ränk (1949), 156–158, citing Radloff (1893/1968); see also Potanin (1881–1883), IV, 62, 77, 93–96, 327ff.

Chapter 4

Epigraph: Branch (1985), 73, Runo VII. Translated by W.F. Kirby (1907).

1. Kandinsky to Herwarth Walden, 2 Aug. 1914 (Poling [1984], 9). Kandinsky to Marc, 8 Nov. 1914 (Lankheit [1983], 265–266 ["Bau der Zukunft"]). That Kandinsky and Marc had hoped for a political resolution to human conflict, and that they considered their common effort in the *Blue Rider* almanac and exhibitions a contribution to that resolution, is clear in their correspondence. See Eichner (1957), 162–172, and Lankheit (1983).

2. In Kandinsky's absence, Kulbin had read a Russian version of *Über das Geistige in der Kunst* to the Second All-Russian Congress of Artists, St. Petersburg, 29 and 31 Dec. 1911. Throughout his Munich sojourn, Kandinsky had remained close to the Russian art scene: participating in exhibitions (Odessa, Moscow, St. Petersburg) and meetings; lecturing publicly himself; and meeting privately with artists of various persuasions. See Bowlt and Long (1980) and Bowlt (1976) for detailed accounts.

3. Late December 1915 until mid-March 1916. See Eichner (1957), 172–178, 210. See Barnett (1989), quoting from the Kandinsky-Münter correspondence, with details of their activities; and Springfeldt (1990), with essays on the Stockholm interlude.

4. Kandinsky to Münter, 16 Nov. (1915), quoted in Barnett (1989), 30–31. See also Kandinsky to Münter, 12 June 1917 (R/B [1984], 584).

5. *Picnic*, watercolor, January 1916, SRG.

6. The hilltop neoclassical building (left) recalls a similar one near the dacha of Kandinsky's relatives, the Abrikosovs, at Akhtyrka. See D/B (1984), 150 (photograph of church with neoclassical facade, Akhtyrka). On *Lady in Mos-*

cow, see Weiss (1990a), 313–325. Gregg noted the significance of the faithful dog motif with respect to the Kandinsky-Münter relationship (lecture, "Women Artists in Early Twentieth-Century Germany" Symposium, Busch-Reisinger Museum, Cambridge, Mass., October 1980) and Gregg (1981), 116–119.

7. Lönnrot (1849 [1985, Kirby/Branch]), 213–214, Runo XVIII.

8. Kandinsky's first wife was Anna (Ania) Chemiakina, with whom he maintained cordial relations.

9. Kandinsky to Münter, April 1916, quoted in R/B (1984), 579. Sketch in D/B (1984), 183. A third slogan (far left) underscored the artist's inner wish to free himself of the past: "The river doesn't flow backward."

10. See ink drawing, GMS 433.

11. Hunt scene, D/B (1984), 200, no. 224. Cf. Ivanov (1954), 273, fig. 133, for uncannily similar scene. Winter scene, D/B (1984), 200, no. 223. Kandinsky's scenic renderings of this period are strikingly similar to those bordering maps in various editions of Herberstein, e.g., demonstrating means of winter transport by depicting horse-drawn sleds and skiers. Cf., e.g., Herberstein (Basel 1556) and Malein (1908).

12. *With Green Rider*, dated 1918 in R/B (1984), 606.

13. Kandinsky to Münter, 11 March 1915, quoted in Eichner (1957), 167, 179. Many of the "bagatelles" and reverse paintings on glass of this period depicted women set off against each other on opposite sides of the scene; of the watercolor *Imatra* (1917), e.g., Lindsay has suggested that "Germania" pulled one way and "Mother Russia" the other (conversation with the author, 18 July 1989). If so, then the "tug-of-war" continued after Kandinsky's marriage to Nina Andreevskaia, for their honeymoon destination had been Imatra, Finland, a resort famous for its rapids (Gallen-Kallela's painting of Imatra in winter had been shown in his Phalanx exhibition). For Kandinsky's unrevealing letter to Münter just days before his marriage, see Barnett (1989), 87–88.

14. A detailed chronology of Kandinsky's movements and activities during this period has yet to be established. Although he was later to deny an interest in politics, there is no doubt that he followed the events of the revolutionary months with the same acuity demonstrated in his correspondence with Münter during the 1905 uprisings. During that period he had been in Odessa and reported passionately, with "tears rising in the eyes," the success of the revolt and "endlich, endlich die Freiheit" (finally, finally freedom). With an equal display of passion he had also reported the anti-Semitic pogroms that had accompanied the fighting in Odessa, which had "completely spoiled the most beautiful moment in Russian life." He confided to Münter: "Now you will better understand why it is that I don't like it to be taken for an Odessan." See Kandinsky to Münter, 29 and 30 Oct. and 3 Nov. 1905, and two letters dated 6 Nov. 1905 (GMJES).

15. Ambivalence and doubt still echoed in a note to Münter of 12 June 1917 [?]: "I am well and work principally on glass and in watercolor—in the manner [genre] of those 'bagatelles' that I exhibited in Stockholm. I hope always that I will return to large pictures in oil. [But] strength has continually failed me for that." Quoted in R/B (1984), 584, and in Eichner (1957), 177. See Barnett (1989), 88–89.

16. R/B (1984), 592 (Art Gallery of Sverdlovsk). The political ramifications of this October 1917 painting, and certain others, such as *Twilight*, September [?] 1917, need further study. The general melodramatic turbulence of the imagery and the malevolent gaze of the lurking dragon, not to mention the somber coloration and title, suggest that the subtext of this work relates directly to the Revolution.

17. For Kandinsky's "Amazons," see R/B (1984), 602–610 (including a fifth amazon painting that seems to have been lost). Münter painted an "amazon" on glass at around the same time (see *Circus Rider*, Gollek [1977], no. 107). See Lindsay (1981), 56–62. On Kandinsky's review of

Böhling's book and previous use of his imagery, see chaps. 1 and 2 above.

18. The picture also returned the round side table and bouquet of flowers from *Lady in Moscow*. The left-hand lady seems to be associated with Munich; "pointedly" she aims a sharpened walking stick at the "Moscow Lady" ensconced at her table. Although the picture is dated 1918 (R/B [1984], 611), such overt altercation suggests that it might more accurately be dated as early as 1916.

19. Although Kandinsky wrote the title *Glass-Painting with Boat* in Cyrillic letters on the back of this work, it has been retitled *With Toy Horse* in R/B (1984), 607.

20. Kandinsky (1913), V–VI.

21. Kandinsky to Münter, 4 June and 4 Oct. 1916, quoted in R/B (1984), 580.

22. Kandinsky to Münter, 26 Nov. 1916, quoted in Eichner (1957), 176.

23. See Eichner (1957), 206–209. According to Eichner, Kandinsky visited the Höllental-klamm alone 1–6 Sept. 1905; he was in Garmisch Partenkirchen with Münter in May 1908 and again on 20 Feb. 1909 (a visit to the ravine itself was not likely at that time of year); his last visit was on 3 July 1914.

24. That the sketch preceded the July visit is not surprising. Given the powerful impression his previous visits had made, the plan for the picture must have been long in his mind. Once the idea was captured in a sketch, the visit was mandatory and was made within the next ten days, the painting soon following. Thus Münter's recollection that the painting was done immediately after their return from Garmisch is entirely reasonable. Cf. Roethel (1976), 49–52; and Long (1980), 128–129. Sketch, GMS 323, SG.

25. In the preparatory colored-crayon study for *Moscow II*, St. George stands lower in the composition (D/B [1984], 185, no. 201 f 5 [inaccurately described as sketch for *Moscow I*]). Here the apparent moon motif is more obvious. The juxtaposition of St. George and moon recurred a decade later in *Yellow-Red-Blue*. (To avoid

confusion, it should be noted that a drawing for *Moscow I* was inadvertently reproduced in reverse in D/B (1984), 184, no. 203.)

26. In Grohmann (1958), 154, no. 32; the "arms outflung" doubling for lance.

27. Gabriele Münter to Kenneth C. Lindsay, 16 July 1956 (chap. 3 above). Common to all the sketches and the two oil versions of the Moscow paintings is a curious sign or "brand" mark just below center-right, reminiscent of the marks of ownership and calendar markings recorded, e.g., in Bogaevskii (1890), IV, no. 1, chart of ownership marks, after 122, and in Priklonskii (1886 [Wise, 1953]), 32:40 (reproducing signs for calendar holy days). None, however, is exactly like the hieroglyph in Kandinsky's depictions of his Moscow vision. The fact that this form remains very nearly the same in every rendition, however, suggests that a special significance must attach to it and that it, too, may very well refer to his ethnographic training. Only further research may unravel the meaning of this mark.

28. Kandinsky had first met Goncharova on 13 Oct. 1910, during his visit to Moscow, and he met Larionov three days later. In December of that year he participated with them in the first *Jack of Diamonds* exhibition. They were then later invited to participate in the second *Blue Rider* exhibition, and Larionov offered to contribute an article to a projected second issue of the almanac, a project that was never realized; however, Goncharova contributed a lubok-inspired drawing to the actual almanac. See Kandinsky to Münter, 13 and 16 Oct. 1910 (GMJES). Kandinsky described Goncharova as "cool" but "very talented." His meeting with Larionov apparently took place at the home of Lentulov. Kandinsky corresponded with both Goncharova and Larionov, and wrote an unpublished essay on them. See Anderson (1966), 99, n. 22, and Bowlt and Long (1980), 41, n. 125. Both David and Vladimir Burliuk, highly visible members of the Russian avant-garde circle, had also been included in the *Blue Rider* almanac.

29. Goncharova and Larionov had emigrated

in 1915; Vladimir Burliuk was killed in Greece in 1917; Kulbin also died in 1917, and David Burliuk would soon emigrate, leaving in 1918 and eventually settling in the U.S. Except for a handful of reverse paintings on glass, no oil paintings that can be dated to the month have been catalogued from October 1917 until January 1919, when it is reported that *White Oval* was entered into the artist's house catalogue (R/B [1984], 614). This information is at variance with Grohmann's report that Kandinsky "resumed work" in July of 1919 (Grohmann [1958], 166); following Grohmann, Poling stated that the dearth of paintings lasted to the "middle of 1919" (Poling [1984], 18). Kandinsky later complained that the demands on his time made by the new bureaucracy had kept him from his painting. See interview with French journalist Charles-André Julien, 1921 (first published in 1969), in L/V (1982), 475–477.

30. Kandinsky's activities within Narkompros; his work as a teacher at Svomas (the Free State Art Studios); his tenures as director of the theater and film sections of IZO (the visual arts department of Narkompros) and as editor of its short-lived journal; his work with Rodchenko in the acquisition and distribution of the new art to museums; his initial leadership role in Inkhuk; and his continuing exhibition and publication activities have been outlined elsewhere and lie outside the scope of the present study. See, e.g., Bowlt (1976); Bowlt and Long (1980); and Barron and Tuchman (1980); also Hahl-Koch (1980b), 84–90. See also Anderson (1966), 90–110. See Umanskii (1920a) and (1920b), 28–30. See also Poling (1983) and Rudenstine (1981), 12–51, and for a general account of Russian constructivism, see Lodder (1983). However, much remaining in Russian archives has not yet been published, and much remains to be done to fill out the true dimensions of Kandinsky's biography during these years.

31. See chap. 1 above. See L/V (1982), esp. the notes to the 1918 Russian edition of "Reminiscences," 886–898, esp. nn. 44–48.

32. The Russian version of "Über Bühnen-

komposition," which had originally appeared in the *Blue Rider* almanac, was published as "O Stsenicheskoi Kompozitsii" (Kandinsky [1919]); the comment on the Lapp musical motif, or *vuolle*, appeared on p. 44. See also Weiss (1991) and chap. 3 above. I am grateful to Prof. Viacheslav Vsevolodovich Ivanov, Stanford University, for finding Kandinsky's vuolle reference in a notation by Eisenstein, who had been inspired by its ethnographic ramifications (conversation with the author, June 1991). See V.V. Ivanov (1985), 205.

33. Italics added. Seventeen years before Goldwater's use of the phrase for the title of his book *Primitivism in Modern Art* (1938); historically, perhaps the first use of this conceit. See also Weiss (1991). Kandinsky's proposal for the "Physico-psychological Department of the Russian Academy of Artistic Sciences" (RAKhN), June 1921, was published in 1923 (translated in Bowlt [1976], 196–198). See also Kandinsky, "Program for the Institute of Artistic Culture," his more elaborate proposal for Inkhuk, 1920 (trans. in L/V [1982], 455–472 [where a correction should be noted: Kandinsky did not speak of "Greek rituals" (p. 467) but rather alluded to pagan rituals generally]).

34. Kandinsky to Hilla von Rebay, 4 July 1936, The Hilla von Rebay Foundation Archive, SRG, quoted in Poling (1983), 20, n. 14.

35. See Poling (1983), 20–22, and D/B (1984), 210–212. While Derouet and Boissel note a relationship between the *Tekst Khudozhnika* (subtitled *Stupeni*) cover design and the painting, they describe the latter as reactionary and interpret Kandinsky's reluctance to exhibit it as a negative evaluation. Grohmann passed off this painting in one sentence, calling it "complicated and confusing" and "exploratory" (Grohmann [1958], 166).

36. In D/B (1984), 208–209, nos. 236, 237.

37. Mikhailovskii (1895), 63–64, citing Shashkov (1864), in which the malevolent insect is a spider. See Holmberg (1927), 477–478, recounting the same tale with slight variations,

citing Banzarov (1891, first published in 1846; material also doubtless known to Kandinsky). Absent from the drawing but present in the watercolor and painting are two oval shapes, one black, the other reddish, which suggest oval shaman drums such as those of the Yakut (e.g., in Levin and Potapov (1961), 457, nos. 2 and 3).

38. As noted, Khangalov's work was known to Kandinsky (chap. 2 above). See, e.g., Khangalov (1891–1896) in *E.O.*; Khangalov (1890); Khangalov and Satoplaeff (1889); and Agapitov and Khangalov (1883). Khangalov, a native-born Buriat, was educated in Irkutsk.

39. Anthony Parton has speculated that Larionov may have acquired the book around 1912 in conjunction with the purchase of the Buriat drawing. I am grateful to Parton for sharing the typescript of his lecture "Larionov and the Buriat Shaman," University of Essex, 20 Nov. 1986.

40. For the cover of the Kruchenykh book, Larionov had drawn a vase of flowers, inside of which the figure of a nude female was visible; on the back cover the vase is overturned and the "girl's spirit escaped" (Parton, "Larionov and the Buriat Shaman"). The Kruchenykh pamphlet was *Old Time Love*. "Shaman and Venus" was included in a 1913 futurist book called *Sadok Sudei* or *A Hatchery of Judges II* (also known as *A Trap for Judges*). That Khlebnikov, too, was interested in shamanism is suggested by the title of a 1915 book he published with illustrations by Filonov, *The Wooden Idols*. Parton speculates that the shaman's nonsense language may have provided an inspiration for Kruchenykh's *zaum* (transrational) poetry. According to Parton, when the first zaum poem, "Duir Bul Shchuil," was read aloud, members of the audience protested that the poet was "nothing more than a shaman." Not surprisingly, copies of both *Old Time Love* and *Sadok Sudei*, together with other publications of the Russian avant-garde, found their way into Kandinsky's personal library (Kandinsky Archive, MNAM, Paris; see D/B [1984], 454–455).

41. Eventually, Markov wrote a slim volume entitled *The Art of Easter Island (Iskusstvo Ostrova Paschi)* before his untimely death in 1914. Evidently, Kandinsky thought well enough of the young man because he kept not one, but two copies of this book in his library (Kandinsky Archive, MNAM, Paris). The reproduction of an Easter Island ancestor figure in the *Blue Rider* almanac had perhaps inspired the younger man's interest in the subject. For Kandinsky's correspondence with Markov (Matveis, 1877–1914), see Andersen (1966), 94–96. They did not meet on that first occasion because of Kandinsky's hernia operation (10 July 1912), which occurred just as Markov was passing through Germany. Markov, e.g., adapted Kandinsky's notion of "inner necessity" as the source of what he called "free creation" (see Markov [1912], in Bowlt [1976], 23–38). Markov's *Negro Art (Iskusstvo negrov)* was published in 1919 by Narkompros in Petrograd. Given Kandinsky's activity in Narkompros at the time, the possibility exists that it was he who promoted this posthumous publication. See Paudrat (1984), 149–150, who seems to have been unaware of the relationship between Markov and Kandinsky.

42. On Vera Kharuzina, see chap. 1 above. Already the first female professor of ethnology in Russia, she would doubtless have kept Kandinsky informed on the latest developments in the field.

43. Many of the artifacts on display were from the collections of Gondatti and from Count Rumiantsev himself, but also off the main hall were artifacts from Kamchatka and Alaska collected by the Ryabushinski-Jochelson expedition. Both the Goldi shaman mannequin and the two Tlingit mannequins, one clad in a Tlingit dancing cape, were illustrated in the guidebook. See Golitsyn (1916). (The back pages of the catalogue carried an advertisement for *E.O.*) See also Ianchuk (1910). For this description I have also made use of the 1914 Baedeker for Russia (see Baedeker [1970 (orig. 1914)], 302–303). See also Radó (1925?), indicating that, although the Ru-

miantsev Museum was reorganized in 1924, the ethnographic section was still "temporarily" on view in its old setting, by then, however, known as the Lenin Library. Eventually, as noted, the Dashkov collections were removed from the Rumiantsev collection and dispersed to other museums. The Russian Imperial Historical Museum likewise held archeological treasures of interest to the young artists of the avant-garde, including examples of the stone "Babi" or steles of the southern Siberian steppes, as well as Scythian artifacts (see, e.g., Sherbatov [1914], guide to the historical museum).

44. The series includes *Red Edge*, 1919, *White Oval*, 1919 (also known as *Black Edge*), *The Green Edge*, 1920, and numerous other formally similar watercolors and drawings. As noted, several of the "bagatelles," such as *The Firebird*, already displayed the new orientation. To them must be added the paintings that approached the oval/edge composition by virtue of corners that were either softened or cut off altogether, such as *Red Oval*, 1920, *White Line*, 1921, and *Red Spot II*, 1921. See Poling (1983), 19–20, noting the formal relationship between oval and edge designs of this period but suggesting its possible derivation from cubist painting, an analysis the artist himself vehemently rejected when it was first proposed by Alfred Barr in 1936 (Kandinsky to Galka Scheyer, 29 May 1926 [Blue Four–Galka Scheyer Archive, Norton Simon Museum of Art]).

45. These "x-shaped" signs on Lapp shaman drums were interpreted as representations of the magic "gan fly" with which the shaman could inflict illness on his enemies (Manker [1938–1950], II, 131–135; e.g., figs. II 63, II 64). See Hanfstaengl (1974), 68, cat. 166 (GMS 146), where this drawing with its dominant "Hexenschuss" sign is linked with the series of works for a planned Russian edition of *Klänge*. In this context, the Hexenschuss motif is well suited to the shamanist themes of the poems (see chap. 3 above). See Friis (1871), in which the Lapp drum designs reproduced for pls. 7, 8, and 9 all include

the Hexenschuss sign and in which mountains, trees, other figures, boats, etc., are arranged around the periphery or float in indeterminate space. The drum represented by Friis' pl. 9 was in a Stockholm collection, catalogued by Manker as no. 1 (fig. 144, below). See also fig. 83, chap. 3, above.

46. Dated 1917 in D/B (1984), 189.

47. Published in Scheffer (among others). See drum no. 43 in Manker (1938–1950). Other drums illustrated in Manker with similar trees and mountain (or encampment) signs around the rims include nos. 32, 35, 36, 38, and 39.

48. See Rudenstine (1976), I, 294, who wisely leaves tentative the suggestion of influence by Malevich. In fact, Kandinsky had begun contemplating the geometric possibilities of painting by the summer of 1914, when he had begun work on his book *Point and Line to Plane*, later published at the Bauhaus.

49. Photograph in D/B (1984), 151, no. 10 (undated). R/B (1984) does not indicate a specific month for this painting, but of only ten paintings listed for 1920 this is the fourth, according to the house catalogue numbering system. The first for the year is listed as February, the second is entitled "Easter" (hence March or April), and the third is not designated by month. The fourth might thus have been done after Volodia's death in June or at least before autumn, since the fifth painting was shown in an exhibition in October of that year. Details of Volodia's tragic death have never been disclosed. His existence was never acknowledged by the Kandinskys, nor have the reasons for their secrecy about the loss been adequately explained. Only with the chronology published in Poling (1983) did the fact become widely known. A letter of condolence from Kandinsky to Pierre Bruguière, 1 May 1941, may be the artist's only written hint at the dimensions of his personal grief: "We understand quite well that this loss causes you profound anguish. To lose an infant is one of life's greatest misfortunes" (my translation). See D/B (1984), 150, and Derouet (1990), 134.

50. See Gondatti (1888a), on boat burial among the Voguls, 66. See Czaplicka (1914), 164, and Chernetsov (1963), esp. 19. According to Priklonskii, on the Lena River corpses were placed in hollowed-out boats and supplied for the afterlife with oars and a wooden scoop to use as a bailer (Priklonskii [1886 (Wise, 1953)], 35–36). But well-publicized archeological digs during the 19th and early 20th centuries had also demonstrated that boat burial had been customary among the ancient Scandinavians; for example, the famous Oseberg burial ship of ca. 800 that was found in Norway in 1904 (I am grateful to Marit Werenskiold, University of Oslo, for calling this to my attention).

51. Castrén (1853), 87–88. See Oinas (1985), 16, and Lönnrot (1969), 7.

52. See Kandinsky (1889b), 107. The Russian custom associating red eggs with Easter appears in chronicles of Russian life as early as the 16th century. See Newall (1971), 207–231, citing, e.g., a report by Anthony Jenkinson of 1557–1558. According to one Russian tradition, an egg held by St. Mary Magdalene turned red with the blood of Christ as a sign of the Resurrection (Newall [1971], 216; see also 227–230). Red eggs were also offered to the rusalki in the case of drowning (Newall [1971], 165); they were associated with fertility and offered on St. George's Day in some areas (Newall [1971], 121, 167). According to another ancient pagan Slav custom, red eggs were offered to propitiate the housespirit or domovoi (Newall [1971], 56–57). See Vernadsky (1959), 146, and Propp (1974), 403.

53. Newall (1971), 57–58, 230.

54. On bird-souls, see Chernetsov (1963), esp. 16–45. On the "couple" motif, see, for example, such works as *Somber* of 1917, and the painting known only as *Sketch*, 1920, for which there is a watercolor study in the Kandinsky Archive, Paris. *White Line*, 1920, and *White Center*, 1921, may also refer to this tragic event. Kandinsky had described white as a great silence full of possibilities, as the silence before birth, and in *White Center* he included hieroglyphs suggesting

the butterfly-souls of Finno-Ugric legend.

55. While the initial idea for the journey was to assess contemporary advances in art education in Germany (as in the example of the Bauhaus) for the benefit of reforms in Russia, the couple planned eventually to return to Russia (see N. Kandinsky [1976], 88–92). But the oppressive demands of colleagues wishing to promulgate their own point of view, lack of time for his own work, and the frustration of his efforts at reform were undoubtedly more pressing factors, as well as a natural desire to break away from associations with great personal grief and tragedy. Meanwhile, the Soviet political move away from freedom of expression was already under way and doubtless Kandinsky sensed the approaching demagoguery. For differing accounts of the reasons for Kandinsky's decision to leave Russia at this time, see N. Kandinsky (1976), 88–92; Poling (1983), 28–30; Derouet (1990), 136; and Bowlt (1980), 32–34.

Chapter 5

Epigraph: Branch (1985), Runo III, 22. Translated by W.F. Kirby (1907).

1. On Kandinsky's Bauhaus experience, see Grohmann (1958), 171–220; Poling (1983), 36–83; and Peter Hahn (1984), with essays by Poling, Hahn, Droste, and Haxthausen. On his teaching at the school, see Poling (1982).

2. The snub-nosed seahorse motif recurred, e.g., in *On White II*, 1920, and *Black Grid*, 1922; the checkerboard and grid motifs, in *On White I*, *On a White Ground* and *Pointed Hovering*, 1920, and in *Chessboard*, ca. 1921, *White Cross*, 1922, and *Black Grid*, among others. The chessboard's ancient association with the dead soul's journey to the beyond, as well as its function on Altaic shaman drums as symbol of the Book of Fates, or "book of divination," was certainly known to Kandinsky. Cf. Potapov (1968), 210, and Ivanov (1978), 22.

3. Kandinsky to Grohmann, July 1924 (Gutbrod [1968], 45).

4. Exhibited in the autumn 1922 Juryfreie Kunstschau, Berlin. For maquettes, sketches, and installation photographs, D/B (1984), 250–255, 257 (no. 290, not a sketch for *Ohne Stütze* as indicated there, but a sketch for a mural). For *Duel*, 1902, see Grohmann (1958), 403, no. 648; see *Zweikampf*, 1903, Hanfstaengl (1974), 24, no. 28. See Kandinsky to Münter, 3 April 1904 (GMJES), describing such a battle scene.

5. Alexei Mikhailovich Remizov (1877–1957) had also taken refuge in Berlin in August 1921, moving on to Paris in November 1923. Two of his books—*Posolon* (Sunward), in the *Golden Fleece* edition of 1907, and *Razskazi* (Tales), of 1910—remain in Kandinsky's library (MNAM, Paris). See D/B (1984), 259–261, where the drawings are dated "vers 1923."

6. Arrested for his participation in a student demonstration while at the University of Moscow in 1896, Remizov was exiled first to Penza and thence, arrested for further transgressions, to Ust Sysolsk in 1900. Later he moved to the capital, Vologda, where he remained in exile until 1903. During this period he gathered much of the material that he would later use in the folkloristic tales for which he became known. This Vologda connection between Kandinsky and Remizov has not been previously observed. On the details of Remizov's exile, see Lampl (1986), 11, 53 (n. 1), 54 (n. 14). See also Schilling (1982), 2. Remizov's arrest is dated 1897 by some scholars. Cf. Kodrianskaia (1959), 79; Shane (1972), 303–318; and Shane (1973), 10–22. The date may be important in the present context since it was in 1896 that Kandinsky left Russia for Munich; it is not known whether he knew Remizov at that time. See Weiss (1990d).

7. Also including references to the Zyrian deity "En" (Jen) and to other exotic phenomena such as charms and dreams. After the lament was published, there followed a lyric cycle based on Zyrian legend and lore, beginning with a Zyrian creation myth entitled "Devil and God." Remizov's version of the lament was later published again in *Posolon* as "Plach" (Lament).

Without noting the source provided by Kandinsky's review, Rosenthal has observed that Remizov " 'paganizes' the model by changing the Christian addressees to celestial phenomena." See Rosenthal (1987), 195–205, and (1986), 95–111. My discussion of Remizov's primitivism is much indebted to these studies and to Burke (1987), 167–174. See also Rosenthal (1980) and Schilling (1982).

8. The possibility that Kharuzin's research on the Lapps may have inspired the title of Remizov's book has not hitherto been suggested (see Kharuzin [1889], 50, and Kharuzin [1890], 218). In the 1910 edition of *Sunward* Remizov cited over a dozen sources, from Afanasiev to Gogol to Lytkin, as well as numerous articles from issues of *E.O.* that had included contributions by Kandinsky (e.g., Sumtsov's notes on "sleep grass," which appeared in the same issue with Kandinsky's article on the Zyrians; and another article that appeared in an 1890 volume with four of Kandinsky's reviews). See Remizov (1971 [1910–1912]), e.g., citing Lytkin (255, n. 68); on the Zyrian ort (204, n. 190); Sumtsov (263, n. 179; 265, n. 208); Kharuzin (267, n. 234). See Kandinsky (1889b), 110. Remizov's footnoting was his response to a charge of "plagiarism" when in 1909 a critic had pointed out that one of his stories was based on an already published folktale. The author's reply in a letter to *Zolotoe Runo* (The Golden Fleece), that his aim was to recreate folk myth on his own terms, as a participant in the continuum of accumulated folklore, might well have been echoed by Kandinsky, whose own "distant past" remained with him and revealed itself continuously in his work. Remizov wrote: "I come across a legend, I read it and suddenly remember: I participated in the legendary event. And I begin to tell it in my own way. My 'retelling' is never a reprint." See Burke (1987), quoting Remizov, 169 [letter to *Zolotoe Runo*, nos. 7–9 (1909), 145–149], and 171. Kandinsky, too, learned to disassemble the elements of mythic tradition and reassemble them in the terms of a modernist vocabulary and structure. In

this context, see Markov's comments on "plagiarism" in respect to the avant-garde's exploitation of folk arts (quoted in Bowlt [1976], 34). See also Burke (1987), 172. On Remizov's combination of a "primitivist" perspective with a "modernist" form, see Rosenthal (1987), 200–203. In this context, a comparison of Remizov's work with Kandinsky's *Klänge* might be instructive. See also Baran (1987), 175–193. Besides their common friendships with members of the Russian avant-garde (including Lunacharskii), Remizov also knew Kandinsky's relative Bulgakov (see chap. 3 above).

9. Similar "stick-horses" with bounding lines of force are found in several Kandinsky paintings (e.g., *Multicolored Circle*, 1921). Kandinsky's own edition of Remizov's *Razskazy* (St. Petersburg: Progress, 1910) bears the *ex libris* of Alexander and Zinaida Eliasberg, Munich friends of Kandinsky, the Klees, and their publisher Piper, who published Eliasberg's book on Russian art in 1915. Cf. Geelhaar (1976), 12, 13, and 141, n. 21. In 1917 Eliasberg published a German edition of Remizov's short stories entitled *Princess Mymra*. Remarkably, each of the nine Remizov drawings created by Kandinsky illustrates a story included in this Eliasberg edition, suggesting that Eliasberg himself may have approached Kandinsky with the project prior to the publication of *Princess Mymra*, lending the artist his own copy of the Russian tales. If so, the drawings might date the artist's geometricizing style much earlier than has hitherto been thought. Indeed, since the drawings are inscribed with the *German* titles of the stories rather than the Russian, a link to the 1917 edition seems possible. On the other hand, it is perhaps more likely that the political situation had interrupted the project and that Kandinsky simply took it up again on his return to Berlin, perhaps as early as late 1921 or 1922. See Eliasberg (1915) and Remisow [sic] (1917); in the event, the edition appeared with "2 Originallithographien von Robert L. Leonard." On various editions of Remizov, see Sinany (1978), to which I am much indebted.

10. In traditional enactments of the rite, the person chosen to play Iarilo, or the doll made to mimic him, was dressed in Pierrot-like multicolored clothing, wore a dunce-like hat, and was provided with an exaggerated phallus, suggested in Kandinsky's drawing by the appropriately placed lines spraying both upward and downward. Like other folkloric figures in the old Russian spring rituals (e.g., Ivan Kupala and Kostroma), Iarilo was the center of high hilarity and games until his preordained symbolic burial, a prelude to rebirth. Historically associated with the agricultural calendar, such rites were intended to assure a successful harvest. See Remizov's condensation of this tale, as "My Dream" (1954), 67. On the symbolism of Iarilo, etc., see Fedotov (1960), I, 14ff.; Warner (1977), 22–31; Vernadsky (1959), 112–114; and Propp (1974), 384–394.

11. The Russian edition of Remizov's tales evidently lent or given to Kandinsky by Eliasberg included a tale entitled "Koldun" (Sorcerer). Kandinsky, too, had used the term *koldun* to refer to the sorcerer or shaman in his discussion of the Zyrian concept of the *ort*. The tale is a typically folkloric recitation of the terrible abilities of one Ivan Tarakan, a *koldun* who could wreak havoc with his hexes. This drawing is inscribed with the German title "Die Hexe." Besides the three drawings discussed here, there are illustrations to the following stories: "Sulky," "Makaroni," "Without Hat," "Devil and Tears," "Red Cabbage," and "The Tower" (see D/B [1984], 259–261).

12. See Rosenthal (1987), 204, n. 2 (he also spoke of the "incantatory quality of words"), and Burke (1987), 171.

13. In apparent reminiscence of his 1910 novella *The Indefatigable Drum*. See Klements (1890), 25–35, pl. 3. Remizov's references in these instances to the shaman's drum recall the shamanic origin of the title for his earlier book *Sunward* (see above). See Remizov (1924); the punning title is worthy of Kandinsky, with its play on aural phenomena; the root *zven* (a sound

such as ringing or clanking) suggests the meaning "echoing ring-town." The cover design in turn puns on the sounding drum both as steed of the shaman/creator and as home of souls; perhaps it was also intended to emphasize the role of the artist as intermediary.

14. In the 1930s their correspondence reveals that Kandinsky attempted to introduce Remizov to the Paris art dealer Jeanne Bucher, who had begun to exhibit Kandinsky's work in her gallery (see D/B [1984], 362). Remizov had actually trained professionally as a calligrapher, and throughout his life he delighted in making calligraphic drawings that he referred to as "dreams." His letters were often masterpieces of the calligrapher's art, and his calligraphic drawings exhibited a child-like naiveté and directness that doubtless appealed to Kandinsky. Their admiration was mutual: in 1936 Remizov wrote to Kandinsky, having just seen the artist's first exhibition at Bucher's gallery, how vividly the paintings had remained etched upon his inner vision (Remizov to Kandinsky, 23 Dec. 1936, quoted in D/B [1984], 259). For reproductions of Remizov's drawings, see Kodrianskaia (1959) and Rannit (1979), 47–61. That Kandinsky and Remizov shared a belief in the intuitive, irrational source of creativity is a point also made by Burke (1987), 167.

15. For example, in the thumbnail sketch Kandinsky made to record the preparatory watercolor for *On White*, the circle appears to be the head of the rider, suggesting its eventual amalgamation into the rider's body and its ultimate assumption of the entire horse-and-rider meaning in later related works. In another preparatory sketch, the dragon in serpent form associated with St. George, omitted entirely from the final composition, lashes below the horse at lower right. See D/B (1984), 263, no. 310, and 262, no. 309 (a sketch related directly to *On White II*, and only far more distantly to the lithograph *Violet*). In the painting, another russet trapezoid thrusts out its offering of spotted sacrificial cows toward the lower right. Although not immedi-

ately readable, these "amulet-shaped" glyphs originated in the mural for the summer house at Akhtyrka, where the same capsule with circle for head and two curved lines for horns served to denote a cow at pasture. These creatures were also "set out to pasture" in the cosmic spacescape of *Circles on Black*, 1921, where instead of curving "horns" they sport more pointed, bull-like horns, their heads separated from their bodies. See also an untitled ink drawing, 1918 (D/B [1984], no. 232), and a design for cup and saucer (Leningrad Porcelain Factory, ca. 1921). See D/B (1984), 264, and Poling (1983), 50.

16. Although *Punkt und Linie zu Fläche* was first published at the Bauhaus in 1926, Kandinsky, according to his own testimony, had begun work on systematizing his theoretical ideas during the months spent at Goldach in Switzerland at the outbreak of the World War I. To the foreword to that first edition he appended two dates, 1923 and 1926, suggesting that he had been actively writing the manuscript since 1923, the year of the paintings here under consideration. Thus it can safely be assumed that in the works of this and succeeding years Kandinsky was consciously experimenting with his own theories. See Kandinsky (Bill, 1964 [1926], 129–168). Here, the term *Grundfläche* used by Kandinsky is translated as "ground plane," since the artist was specifically referring to the *plane of the ground*, i.e., the *canvas*, not to the "picture" per se. Cf. L/V (1982), where the translation "picture plane" is employed.

17. According to Kandinsky's compositional scheme as enunciated in *Point and Line to Plane*, the left side of the ground plane is the side associated with lightness, distance, and the "heavenly," while the right side is associated with heaviness, closeness, and the "earthly." The sphere motif of *Through-going Line* is a refrain of the planetary symbol he had already employed in *In the Black Circle* in January of the same year. The "picture within a picture" reprises and amalgamates the motival themes of *On White* and *Violet*.

18. For detailed formal analyses of these two pictures see Weiss (1982a), 82; Weiss and Kimball (1983), 36–40; and Weiss (1985), 140–141. Cf. Poling's rejection of the author's interpretation (Poling [1983], 50–51, n. 91).

19. For the correspondence between Kandinsky and Schoenberg: 15, 19, and 24 April and 4 May 1923, see Hahl-Koch (1980a), 90–97. See also Stuckenschmidt (1985), 409. For a more detailed discussion of this exchange in the context of their shared experience as "outsiders," and Kandinsky's aesthetic responses, including the painting *Black and Violet*, April 1923, see Weiss, 1991 (in progress).

20. On black, Kandinsky (Bill, 1965 [1912], 98). Kandinsky, "Über die Formfrage," (1912), as in L/V (1982), 250. Kandinsky to Grohmann, 21 November 1925 (Gutbrod [1968], 49 [emphasis Kandinsky's]). The "question of form" had always played a subordinate role for him, he explained in this letter, and he wished that the public "not content itself" with the mere determination that he used triangles or circles.

21. First analyzed in Weiss (1990d).

22. Cf., e.g., *Without Support*, 1923, *Yellow Point*, 1924, and the watercolors *Hard But Soft* and *No. 225*, both 1927.

23. *Drawing No. 4*, 1925 (Volboudt [1974], no. 48). Related etching, 1924, (Roethel [1970], no. 183).

24. Warner (1985), 130. For a review of German critical attacks on Kandinsky's work during the Bauhaus period, see Haxthausen (1984), 72–89.

25. The continuity requirement described here helps to explain the puzzling drawing for the painting that the artist dated "1913." Two elements distinguished in this discussion clearly relate the drawing to the Bauhaus: the snub-nosed, pinkish seahorse-like figure that is so clearly defined in the drawing, and the "upside-down mountain range," likewise clearly defined there. Both motifs are inventions of the Bauhaus period. The snub-nosed horse figure first appeared in *On White II*, 1923, while the same

rider-cum-mountain-range figure, flipped over, mediates between saint and dragon in *Black Accompaniment* (lower left), 1924, directly following *Retrospect*, according to the artist's house catalogue. It was undoubtedly for the sake of continuity that Kandinsky dated the drawing, "in retrospect," 1913. Cf. Lindsay (1953), 50, and Rudenstine (1976), 270–271.

26. "The circle, that I use so much in recent times, can only be described as . . . romantic." In this discussion he imparted to the term *romantic* a transcendent meaning far beyond its normal use to signify a particular stylistic period. Kandinsky to Grohmann, 21 Nov. 1925, Gutbrod (1968), 49–50. And: "[The circle] is a link with the cosmic . . . a synthesis of the greatest oppositions. It links the concentric with the eccentric in a form in equilibrium. Of the three primary forms it is the clearest turning toward the fourth dimension." Kandinsky to Grohmann, 12 Oct. 1930, listing five specific characteristics of the circle: the most modest form, but relentlessly self-important; precise but inexhaustibly variable; stable and unstable; soft and loud; *one tension that carries in it countless tensions* (Gutbrod [1968], 55–56). The artist specifically requested that Grohmann include this text in his biography.

27. Kandinsky explained to Plaut that his inspiration might be stimulated by all the senses—visual, aural, tactile, olfactory, gustatory—that were for him synaesthetic, stimulating colors and forms, particularly singling out sounds both "organized" as in music and "disorganized," adding that although his ideas were in the first instance "purely painterly," they were at the same time deeply meaningful to him: *"one could also use the currently forbidden word 'symbolic' with full justification."* See Plaut (1929), 306–308. Emphasis added.

28. Thus, by 1924 when he was asked to create a painting on the theme of a phonograph playing music, Kandinsky already had the motif at hand. His watercolor demonstrates his metamorphosing "abstraction" of objectively inspired motifs, with its combination of circle and tri-

angle, and circle with three radiating forms, associated (as in *On White II*) with the music of the shaman's drum. In this case, the triangle is merely a reduction of the bell of the gramophone; straight lines suggest the blare of the music. At the same time, the whirling record itself and its sounds are signified by a circular disk from which radiate three triangles with curved sides. This "sounding circle" had appeared not only in *On White* but also in *Composition VIII* the previous year. See Bayer, W. Gropius, I. Gropius (1938 [1959]), 196–197.

29. On shaman drum pictographs as "star charts" and cosmogonic maps, see Jankovics (1984), 149–163, and Sommarström (1985), 139–156.

30. See Mikhailovskii (1895), 146–147, citing Klemm, who had also reproduced this drum in his 1844 work, which Kandinsky might also have known (Klemm [1844]; see Manker [1938–1950], no. 63). See Jacobi (1925), the Dresden museum's 50th anniversary catalogue. In any case, this was neither his first nor last visit to Dresden, since he had visited the city more than once during the Munich period (twice in 1905) and, during the Bauhaus period, attended Easter services every year at the Russian church; on at least one occasion he lectured there. The artist also frequently visited Grohmann, who resided in Dresden. According to Grohmann, Kandinsky gave paid lectures in Vienna, Wiesbaden, Braunschweig, Erfurt, Dresden, and Leipzig in 1924 (see Grohmann [1958], 13, 177). A trip to Dresden in February 1925 is recorded in Poling (1983), 352. See Manker (1938–1950), cataloguing 29 examples of Lapp drums then at Stockholm's State Historical Museum and others at the Nordic Museum (which today has most of the drums). The State Ethnographic Museum held at least one example of an Altaiac (probably Teleut) drum with bird helping spirits, the shaman on horseback, shaman's path, and other characteristic motifs (see Manker [1938], I, fig. 182). A 1911 guide to the collections of the Nordic Museum indicates that at least three of the drums and a mallet were on display at that time. See Hammarstedt (1911), 10. An archival photograph at the Nordic Museum, taken before 1925, shows four drums and two hammers in the Lapp display. (Among those known to have been shown were those corresponding to Manker nos. 14, 59, and 72.) Berlin's Museum für Völkerkunde had its shamanist treasures as well: not only a Lapp drum but Siberian shamanist materials, including amulettes, idols, shaman costumes, and at least one Siberian shaman drum (described as Dolgan), as well as numerous Northwest American Indian artifacts (the Franz Boas collection). See *Königliche Museen zu Berlin* (1908).

31. Jochelson (1908), 54. Jochelson had also observed that the drumstick was considered as "the tongue of the drum" among the Yukaghir and that, among the Koryak, the "Master-on-High" himself required a drum. (Jochelson's book had been reviewed by Maksimov in *E.O.* 79, no. 4 [1908]: 140.) The animation of objects had long since fired Kandinsky's imagination. In "Retrospects" he had recalled the moment of his realization of the difference between the goals of nature and of art: "Everything 'dead' trembled . . . not only the stars, moon, woods, flowers of the poets, but also a cigarette butt lying in the ashtray . . . every resting and moving point (=line) [came] equally alive and revealed to me its soul." Kandinsky (1913), VI. The passage eerily recalls a Chukchee shaman observation quoted by Bogoras: "All that exists lives. . . . The small gray bird with the blue breast sings shaman-songs in the hollow of the bough. . . . The woodpecker strikes his drum in the tree. . . . The lamp walks around. The walls of the house have voices of their own." Bogoras (1904–1909), 281 (anecdote first published, 1900). Cf. Kandinsky's house-catalogue sketch, 1925, no. 310, MNAM, Paris. The oval format of this and the related house-catalogue sketches clearly demonstrates that Kandinsky conceived of his "drum" paintings in this shape.

32. Just such figures, representing deities, had been recorded in the drum schemata published by Potanin, described variously as deity of the heavens, "the god playing with planets," "shaman ancestor," or as "master of the drum." Potanin (1881–1883), IV, pl. X (no. 65), pl. VI (nos. 55, 56). Cf. Jankovics (1984), 151, and Potapov (1968), 214, 224.

33. Evidence again of the side-by-side existence of pagan and Christian belief systems. Manker (1938–1950), II, esp. 51–53.

34. The famous "Linné" drum, once owned by the 18th-century Swedish scientist Carolus Linnaeus (Carl von Linné), also exhibited this feature. Displayed in Paris until 1912, where Kandinsky could have seen it at the Trocadéro, it was returned to the State Historical Museum, Stockholm (where it remained until 1933). See Manker (1938–1950), I, 698, no. 45. It had been frequently published, e.g., Weinitz (1910), 12.

35. Two such floating "worlds" were depicted on the drum illustrated here, which Kandinsky could have seen at the State Historical Museum, Stockholm (Manker's no. 1, in Friis [1869], Düben [1873], and others). Kandinsky had already often made use of similar free-floating, horizon-like devices in *In the Black Square*, *Circles on Black*, 1921, and *In the Blue*, 1925, among many others. See Manker (1938–1950), I, 447–452, and II, 217–223; 108ff., on the ancient meanings attached to this motif.

36. Widespread among many Siberian peoples was the belief that the soul, before birth or upon leaving the body during illness or at death, takes the form of a bird residing in the world, or "heavenly," tree. The conjunction of symbols for the world-tree and bird-soul is found on both Lapp and Siberian drums. See Basilov (1984), 54, and Ksenofontov (1928). See also Smoljak (1978), 439, citing Shimkevich (1896–1897); also Chernetsov (1963), 3–45; and Karjalainen (1922), II, 177. World-tree and bird-soul motifs are found, e.g., on a Lapp drum first published by Scheffer (1673) and on drums published by Potanin (1883), pl. VII, no. 57; and pl. VIII [fig. III-6]). Scheffer's drum F (Manker [1938–1950], no. 44) was in Leipzig. See Delaby (1970), 195–221.

37. Similar to those on drums in Dresden and Berlin that Kandinsky seems to have known.

38. According to Kandinsky's house catalogue this painting was made in June 1925, the month following *Oval No. 2*. The Thor's hammer motif appeared in several Kandinsky paintings, e.g., in *Kreuzform*, 1926, where it brands the chest of a ghostly figure carrying a "shaman's drum" and "drumstick." A similar Thor-like figure, as in *Oval No. 2*, also with the arms-outflung posture of World-Watching-Man, is found at lower right in *Development*, 1926. Cf. Friis (1871), pls. 7, 9, and 10.

39. Eliade (1972), 169 (original italics).

40. See Fitzhugh and Crowell (1988), e.g., figs. 65, 66, 245 (Tlingit Beaver Box, MAE, St. Petersburg), 368, 372, 382, and passim.

41. Tlingit/Chilkat designs had been analyzed and described by Boas and Niblack before the turn of the century, and by Emmons in 1904 (Boas's early work was cited, e.g., by Mikhailovskii [1892, I]). See Emmons (1904–1907), 329–350, and Boas (1904–1907), 351ff.; also Boas (1951 [1927]). Kandinsky might well have come across the article by Krickeberg (1925) on the disassociated representational elements of such designs and their symbolism (with illustrated materials from Berlin's ethnographic museum, where the artist could have seen them). Many Tlingit objects, including masks, were catalogued in the Dashkov collections, but since many are unspecified, it is impossible to determine if this same mask was actually there (see Golitsyn [1916], 22–26).

42. Among the Voguls the second soul, or *urt*, was often thought of as a species of sandpiper, perhaps a woodcock, distinguished by its long beak and prominent round eye. The thunderbird myths of many peoples were associated with folk beliefs in the ability of the woodpecker to summon or predict rain, and analogies have even been drawn between the drumming of the woodpecker and the drumming of the shaman in ceremonies to invoke rain. See Chernetsov (1963), esp. 16 and 17. See Armstrong (1970), 95–

112. (I am grateful to Michael Thomas for calling my attention to the latter reference.)

43. N. Kandinsky (1976), 216. In fact, all four of the first "drum" paintings made in 1925–1926 remained with them until their deaths. See Holmberg [Harva] (1938), 84, 166–167, citing earlier reports by Lopatin (1922), Rychkov (1917 and 1922), Vasiliev (1909), and Priklonskii (1891), and reporting that similar beliefs were held by the Dolgans, Tungus, and Yakuts. See Holmberg [Harva] (1938), 84 and 166–167, and Priklonskii (1886), 21–22.

44. On the world-tree motif, see, e.g., Potopov (1968), 226. As Thor's bow, it was sometimes represented on Lapp drums by the figure of an archer (see Manker [1938–1950], II, 73).

45. Potanin (1881–83), IV, pls. V, no. 54; VI, no. 56; VIII, no. 60; IX, no. 62; XIII, no. 69. A drum of the type represented by Potanin's pl. VI, no. 56, identified as Altaic, perhaps originally in the Dashkov collections, was located by the author in the MAE, St. Petersburg (no. 653–1, accessioned 1911). See Prokofieva (1961), figs. 4, 5, 10, 11, and 23, and pl. IV; and Ivanov (1954), figs. 60, 74 (Selkup drum), 165 (Evenki drum, fig. 60, no. 1), and passim. Cf. Lot-Falck (1961), 23–50. See Kandinsky (1926) [Bill, 1964], 164, on the transcendent power of the oval ground plane.

46. On the significance of the Easter egg in Russian lore, see chap. 4 above. Among many other examples, a drum reproduced by Friis included a boat with a flag on its mast (Friis [1871], pl. 8). Interestingly, Nina Kandinsky associated this painting with another, however in rectangular format, that Kandinsky presented to her at Easter twelve years later, *Entassement réglé*, which, with its musical ramifications, will be discussed in the next chapter. On the drum as the shaman's boat, see Lot-Falck (1961), 46; Prokofieva (1961); Hultkranz (1978), 36; and Bogoras (1904–1909), 438 (in which a word for "drum" also means "canoe"). Another painting that may reflect the death of the elder Kandinsky is *Riss*, 1926, also known as *Separation*, which includes many drum motifs. The smoke rising from the top

of a triangular "tent" or "yurt" form may have been intended to represent the "breath soul" of Zyrian and Finno-Ugric belief. Among Finns and Russian Karelians it was customary to open the smoke outlets of the home of a deceased person in order to allow the breath soul to escape (see Holmberg [1927], 17).

47. See Holmberg [Harva] (1938), 72, quoting Schiefner (1859); and Holmberg (1927), 349–360.

48. Precedents such as the Altaic and Tatar drums reproduced by Potanin clearly suggest the shamanist derivation and meaning of *Several Circles*. See, e.g., Potanin (1881–83), IV, pls. X, no. 65; V, no., 54; and VIII, no. 60.

49. The first drum ("Drum E") had been reproduced by Scheffer (1673), Rudbeck (1701), Peringskiöld (1710), and Düben (1873). At the time of Kandinsky's visit to Stockholm, it was apparently at the State Historical Museum (now in the Nordic Museum). See Manker (1938–1950), I (no. 43), 31, 32, 39, 65, 684–691; II, 350–360. See also Byhan (1909). The second drum ("Drum F"), also in Scheffer; by 1870 was in the museum in Leipzig. See Manker (1938–1950), I (no. 44), 691–697; II, 356–360.

50. Kandinsky's work on *Pictures at an Exhibition* deserves its own treatment and cannot be analyzed at length here. A memorial exhibition of renderings by the Slavic Revivalist architect Victor Alexandrovich Hartmann had inspired Mussorgsky's work. See Hamilton (1983), 446, n. 15, and Frankenstein (1930), 268–291. (I am grateful to John Bowlt for calling my attention to the latter.)

51. Kandinsky's German title *Launisch* has been translated by the English "Moody," but, given the source, "Peevish" is clearly a more suitable translation (cf. R/B [1984], 890). Quotations from Castrén (1853), 256–261.

52. On Gallen-Kallela, see chap. 2 above. For Kandinsky's Bauhaus teaching notes, see Sers (1975), 199. According to the notes by Jean and Suzanne Leppien (in Sers as "Cours du Bauhaus"), these remarks seem to have been made

during the summer semester of 1925, after completion of this painting. See also D/B (1984), 278.

53. On Kandinsky's early version of the scene, see chap. 2 above.

54. See Plaut [1929], 307–308, and Kandinsky (1926) [Bill, 1964], 137–138. Movement toward the lower right is literally toward "home," thus his rationale for placing St. George (or the shaman) at the upper right complies with the shaman-saint's divinity while at the same time confirming his role as intercessor between heaven and earth. Cf. Weiss (1985), 142.

55. Cf. Lönnrot (1969), 23, 121, 300–301. As noted, the Sampo, forged by the smithy Ilmarinen, has been variously identified as a miraculous mill, the North Star, an idol, a "world pillar," a shaman's drum, etc. On the identification of the Sampo as magic drum of the Lapp shamans, see Friis (1869), 263–265.

56. The Irtysch Ostiaks sometimes described Numi-Tōrem as "Golden Light" (sornisanka); see Patkanov (1897), I, 99. One Ostiak hero was described as so beautiful as to "illuminate the house like dawn" (Patkanov [1891], quoted by Jochelson [1908], I, 363). Cf. Weiss (1982), 30.

57. Kharuzin (1889), 40–41, and (1890), 212.

58. Cf. Oinas (1985), 41–45, 154–159. A second "peastalk" horse appears to the far left with flying mane and forelock (though it may also be read as part of yet another "hidden" profile). In the saga, the peastalk horse is sometimes associated with the pike (or other fish). See Lönnrot (1969), 4–5, 127–128, 189. As observed, Kandinsky more than once used themes related to the Kalevala (e.g., Tension in Red, 1926), and in a long series of works on the theme of the rowboat, e.g., Improvisation 209, 1917, in which the central motif is the rowboat with sail, also depicting the giant pike on which the Kalevala boat foundered (preparatory drawing, D/B [1984], no. 220). The relationship between the rowers motif and themes of the Kalevala was revealed, e.g., in the "bagatelle" Birds, 1916, in which two rowers man a craft with a distinctly "Viking" prow (Barnett [1989], no. 25).

59. Cf. Friis (1871), nos. 10 and 11. Also reproduced in K. Krohn (1906), 177. See Manker (1938–1950), 37, nos. 15 and 16. In the preparatory drawing for the painting are boat-like motifs also reminiscent of those on the drum.

60. Kandinsky to Grohmann, 12 Dec. 1931, Gutbrod (1968), 58. The exhibition, at the Akademie der Künste, included examples of Aztec, Mexican, and Peruvian pottery, weaving, goldsmithing, and stone carving. It was arranged by Walter Lehmann of the Museum für Völkerkunde, which loaned most of the objects. The battle between "art" and "ethnograpic object" was joined in a review by the art critic Scheffler ([1932], 26–30), who concluded somewhat ambiguously that the exhibition of these admittedly "splendid works" had successfully illuminated the much debated question "Ethnology or Art?" The same year Kandinsky designed ceramic murals for a music room for the Deutsche Bauausstellung in Berlin, which included motifs of Indian teepees, a tomahawk, and cacti (see Poling [1983], 334–335, nos. 300b and 302).

61. See Bogoras (1904–1909), 332. The symbolic significance of the color brown with respect to the Nazis, known as "brown-shirts," is obvious. On the Nazi attack on modern art, see Barron (1991).

Chapter 6

Epigraph: Lönnrot (Branch [1985]), Runo L, 645. Translated by W.F. Kirby (1907). The last two lines quoted here, from another version of the same concluding Runo in Lönnrot (1969), Poem 16, 261. Translated by Francis Peabody Magoun, Jr. Reprinted by permission Harvard University Press.

1. The degree to which each move had disrupted his work may be judged in Kandinsky to Galka Scheyer, 13 Aug. 1938: "Do you know what hinders me besides money from [making] this America trip? You say perhaps I could also work in Hollywood. Perhaps. But only 'perhaps.' Every time I move to another country (and how different America is!!!), I cannot work at first.

It is truly enough to drive one to despair. When we moved to Paris I could not work for three months. It was terrible. I thought I am no more a painter. No, it was extremely unpleasant" (Blue Four–Galka Scheyer Archive, Norton Simon Museum of Art). The Kandinskys arrived in Paris on 21 Dec. 1933 and presumably, by this testimony, he was unable to work until almost the end of March 1934. For more on the artist's Paris years, see Grohmann (1958), 221–248; Barnett (1985); Derouet (1985); and D/B (1984), 353–400.

2. See R/B (1984), 933, indicating that this painting was not included in Kandinsky's house catalogue, but dating it as "1933?" and including it between Development in Brown (August 1933) and Graceful Ascent (March 1934); and D/B (1984), 446, where this work is relegated to the end of the Paris period. Cf., however, e.g., the watercolor Sur Vert, with similar motifs, dated by the artist April 1934 (D/B [1984], no. 562).

3. The images of World-Watching-Man as a golden gander or riding a goose, and of the shaman magically transported on the back of a goose were widespread among the Ob-Ugrian and Siberian peoples (see chap. 3 above). See Ivanitskii (1890), 182–184.

4. For the untitled watercolor (with "Janusheads" motif), D/B (1984), no. 558.

5. See Weiss (1979), 132; (1982), 82; and (1985), 141.

6. Kandinsky was represented not only on the cover but with two illustrations inside (The White Line and Thirty) and a group of six prose-poems with three woodcuts. This issue included an essay entitled "Prehistoric Stones," with photographs of ancient menhirs and dolmens by Giedion-Welcker (who would later write on Kandinsky); an American Indian Musquakie "love song"; a photograph of an Australian aboriginal bark drawing; and an essay by Michel Leiris, then associated with the Laboratoire d'Ethnologie of the Musée National d'Histoire in Paris, on the "secret language" of the African Dogons of Sanga, with his translation of a funeral oration for a hunter. Besides fragments of a musical score, there were illustrations of works by

Bosch, Ernst, Klee, Siqueiros, Arp, Taeuber-Arp, Vantongerloo, Eggeling, and Le Corbusier, among others. Literary contributors included, besides fragments of James Joyce's "Work in Progress," Beckett, Breton, Kafka (the conclusion to "Metamorphosis"), Nin, Sweeney, and Herbert Read. See *transition* 27 (April–May 1938). The previous issue (26 [1937]) had also included a reproduction of a Kandinsky painting, *Dominant Curve*. Kandinsky's half-nephew Alexandre Kojève (Kozhevnikov, 1902–1968), a professor of philosophy at the Ecole Pratique des Hautes-Etudes in Paris, with whom the artist was in close touch, was for a time associated with Leiris and others (including Georges Bataille and Walter Benjamin) in an informal group called the Collège de Sociologie, whose focus was a kind of "surrealist ethnology." See Clifford (1981), 560–562, and Derouet (1985), 15, n. 11.

7. On the term *abstract* as misleading, Kandinsky (1931), as in L/V (1982), 756; on the function of line, Kandinsky (1935a), as in L/V (1982), 779; on free forms that function as objects, Kandinsky (1935b), 53–56, in L/V (1982), 766–767; on "abstract" forms as forms in nature, Kandinsky (July 1937), as in L/V (1982), 803. See also Kandinsky (1937), in L/V (1982), 807, where the artist vehemently denied the common assumption that abstract art has nothing to do with nature. He defended this view in several letters to Galka Scheyer, e.g.: "I love all of LIFE, thus also Nature, and my experiences here are the sources of my creativity" (Kandinsky to Scheyer, 19 May 1935); or again, 13 Aug. 1938: "I know . . . that in my pictures there is a calm affirmation of LIFE" (Blue Four–Galka Scheyer Archive, Norton Simon Museum of Art [emphasis in originals]).

8. Kandinsky (1935b), as in L/V (1982), 767–768, emphasis added.

9. In *Pointes*, May 1939, also on black paper, Kandinsky returned to the theme of the metamorphosed St. George on horseback. There the rider, wearing his shaman's coat of many patches and his headdress, his head turned back over his shoulder, again rides his steed, leaping from lower left toward upper right. From the horse's neck flies the "banner" of *The White Line*. Below right are the spiky "jaws" of the dragon stretching around the mountains, as he had appeared in earlier works.

10. The discovery that Kandinsky's St. George paintings occurred with great regularity to mark the spring or autumn St. George's Day led to the realization of the extent to which events in Kandinsky's personal life so often affected his paintings. Later St. George's Day paintings include *No. 629 (untitled)* (March 1936), *Dominant Curve* (April 1936), *Red Knot* (April 1936), *Entassement réglé* (February–April 1938), *Around the Circle* (May through August 1940), *L'Elan brun* (April 1943), and *L'Elan tempéré* (March 1944). While further investigation is required, it may even be possible to assign tentative April or November dates to such hitherto undated works as the St. George watercolor *No. 23*, 1922.

11. A vivid description of it had been published at the time of its acquisition in 1887 from the Joseph Martin Siberian expedition. See Landrin (1887), 503–506, also describing the Tungus drum that accompanied the costume, and Lapp drum pictograms.

12. The preparatory drawings for *Ambiguity (Complexity Simple)*, in D/B (1984), 414. See Stella (1984), 84–90, not, however, specifically identifying the image as a self-portrait. On the repeated fetal images in Kandinsky's Paris paintings, see Barnett (1985), 61–87.

13. On the effect of violet (Chinese color of mourning, sound of the shawm or bassoon, "like a slag heap"), see Kandinsky (1912) [Bill, 1965], 102–03. These bulbous, sometimes aquiline-nosed profiles were repeated endlessly in subtle variations throughout the Paris period. Because of their persistence and the frequent appearance of the shaman's "feathered headdress," or sometimes the knight's helmet, in conjunction with them, they may be taken as autobiographical signifiers. See also *Accompanied Milieu (Milieu accompagné)*, 1937, and *The Red Square*, 1939 (painted the same month as *Ambiguity*), which share a similar organization and thematic content, the artist "helmeted" and "feathered" before

his "easel." The latter work displays a more tentative approach to the theme, with "easel," disembodied helmeted head, serpent and land- and seascape elements attending. The vastly more complex *Accompanied Milieu* presents the helmeted artist-in-studio before an "easel," clothed in checkered coat draped with feather-like ribbons of the St. George/shaman figure of earlier works. Other remnants of the autobiographical "text" include the hieroglyphic hooked curve for horse and rider (far right) and the "world-tree" motif (with its bird on a top branch) standing between artist and work; beyond, a canvas on the easel spouts a rainbow of color over a "self-portrait" within the self-portrait. The helmeted and feathered headdress attached to the biomorphic self-portrait profile extended beyond the "studio" series to many other depictions of the St. George/shaman/artist (e.g., *Striped*, 1934, *Red Knot*, 1936, *Around the Circle*, 1940, and *Circle and Square*, *Brown Elan*, 1943). The full-figure self-portrait appears in *The Yellow Canvas*, 1938 (where the Orochon costume donated by the Kandinsky family to the Dashkov Museum is recalled; see chaps. 1 and 4 above), and *The Red Circle*, April 1939. See Weiss (1994) and "Kandinsky's Self-Portraits as 'Other'" (in progress). The world-tree was the main subject for one of Kandinsky's first Paris paintings, *Graceful Ascent*, March 1934, with its Lapp drum motifs; see also *Thème joyeux*, 1942.

14. Cf. Derouet (1990), 134, 136, 139, 140. Derouet suggested that Kandinsky repeatedly ignored the political chaos around him, withdrew into a "veneer" of stoicism, and that his late works have only "prettiness" and a "marvelous artificiality." As previously observed, this notion contradicts not only the clear evidence in the artist's works from early to late, but also his repeated engagement in political matters, both those that touched him personally and those of international significance from his student days onward. Contrary to Derouet's assertions, Kandinsky's correspondence, e.g., with Galka Scheyer, reveals in no uncertain terms his condemnation of Nazism and demagoguery of any kind.

15. Kandinsky (1931), as in L/V (1982), 759.

16. See Mikhailovskii (1895), 149, on snakes as "symbols of the power and art" of the noids, sometimes serving as transport for their celestial journeys. Kandinsky had already experimented with the concept of the shaman's coat as a substitute for the shaman himself in *Rigid and Curved*, 1935, where the circle at the "head" of the robe with its horned feathers, like those of the owl headdress, implies the identity of the shawl-like form that is also hung with snakes and other amulets (a one-eyed figure with a spiky headdress signifies the shaman's steed).

17. See preparatory ink drawing (Rudenstine [1976], 364), in which the costume's pendants are even more explicit and more snakes, as well as a St. George horse and circle motif, are included. Further autobiographical references include a floating skyline at lower left with a Russian church tower juxtaposed to a "yurt" with smoke rising from it, and a palette and St. George hieroglyph (just below) that are also clearly self-referential. The stark disks ranged along the upper right of *Dominant Curve* may have been intended to suggest the sun disks or "ice-hole" disks of shaman costumes (the latter representing the hole in the ice through which the Yakut shaman might descend to the lower world). See Jochelson (1926), 177–178 (citing Vasiliev and Pekarski and Vasiliev [both 1910]), and 454. The Tungus shaman costume at the Trocadéro also displayed such disks. The shamanic robe motif also appeared in *Formes en tension*, 1936, and *Tensions claires*, 1937.

18. Kandinsky (1935c), 117 (as in L/V, 780–83), emphasis in original.

19. Author's translation from Radloff (1893 [1968, original 1884], 21–23). The refrain "here am I" is a translation of Radloff's "da bin ich." Radloff's work was well known in Kandinsky's circle and often cited in the pages of *E.O.*, but Kandinsky's colleague Mikhailovskii had also quoted this passage in a long extract from Radloff published in his 1892 treatise on shamanism (see Mikhailovskii [1895], 74–76). The chant had actually been written down and published by

Verbitskii as early as 1864. See Weiss (1986) and (1987). Lindsay linked Kandinsky's "here am I" phrase to the Biblical tale of Moses and the burning bush (Lindsay, [1984, unpub., n. 40]; see also L/V [1982], 780).

20. See N. Kandinsky (1985), 214, associating this painting with *Easter Egg*, 1926, implying their common ground as "Easter gifts." I am indebted to Yve Alain Bois for an exploration of the implied meanings of this combination of terms in French.

21. Drawing, D/B (1984), 406, nos. 630 f 17 (the body floats upside down), and 647. The ladder is a constant motif from the earliest sketches in which it is more easily recognizable as a ladder.

22. Lönnrot (Magoun) (1849 [1969]), poem 29, ll. 153–216, pp. 170–171. On the magical powers of the cuckoo, see Armstrong (1958), esp. 197–210, recording that the cuckoo was used on the headdress of Numinchen shamans in Manchuria and in Giliak cremation ceremonies (206); further noting that in Baltic areas the cuckoo is associated in many tales with the "life-giving powers of spring" (210).

23. The genuine Finno-Ugric instrument, called "Crane" by the Ostiaks, while resembling the sacred migrating bird with its long neck, also invoked the shaman's horse with its "ears." Kandinsky has obviously romanticized his version but just as certainly knew the precedent. See Ahlquist (1885), 302–303.

24. See Friis (1869), 263–265. In some versions "its pictured cover" is referenced, lending weight to the drum theory (see, e.g., Lönnrot [Kirby/Branch (1849 [1985])], Runo XLIII, 554). In German translations, the "motley lid" becomes "der bunte Deckel."

25. Kandinsky (1935c [L/V 1982]), 782.

26. As, e.g., *Two Surroundings*, 1934, *Loose Tension*, 1935, *Succession*, 1935, *Thirty*, 1937 (and numerous other "number" paintings), *Sweet Bagatelles*, 1937, *Ascending and Descending*, 1938, *A Conglomerate*, 1943, and many others (including many watercolors and graphics).

27. On this bipartite organization, see Groh-

mann (1958), 230, emphasizing the Paris period and mentioning, e.g., among others, *Two, Etc.*, 1937, *Penetrating Green*, 1938, and *Composition X*, 1939. See also Lindsay (1966), 51. Other such paintings include *Two Green Points*, 1935, and *Contrast with Accompaniment*, 1935.

28. As in his drawing to Remizov's tale "The Flower" or the sketch for *Yellow-Red-Blue*.

29. Known as Kandinsky's "next to last" watercolor (D/B [1984], 445, no. 755). *Two Circles* of 1935, *Little Accents* of 1940, and *Balancing* of 1942, are others. Kandinsky would have seen illustrations of such sacrificial sites in the shamanist literature, e.g., Potanin (1881–83), IV, pl. 18, depicting an Altaic shaman's sacrificial rope with skins and *ongons* stretched between two sacred birch trees. See also drawings published by Bogoras of Chukchee ceremonials involving the suspension of nets to which magical amulets were tied (Bogoras [1904–1909], 394, fig. 272). See Kenin-Lopsan (1978), 295; 1916 photograph of shaman burial site at which posts were tied together and hung with the dead shaman's costume and instruments (fig. 3).

30. See Shargorodskii (1895), 135–148, illustrating these unique pictographic communications, in the journal of the geographic section of the Society to which Kandinsky belonged. Soon they were published by others both in Russia and abroad and thus the "love letters" of young Yukaghir girls, which had actually originated as a form of play, came to be well known among both Russian and Western ethnographers in the early years of the century. See, e.g., von Krahmer (1896), 208–211, illustrated (translation of Shargorodskii). See also Jochelson (1898), 255–290 (illustrated), (1900a and b), and (1926), 434–454 (in English, illustrated). See also De-Francis (1989), who found that a copy of one of Shargorodskii's letters (by the artist Paul Lindner) was reproduced in a pamphlet created by Karl Weule for a 1914 exhibition on the history of writing at the Leipzig ethnographic museum (according to DeFrancis, the pamphlet, *Vom Kerbstock zum Alphabet* [Stuttgart, 1915], went through twenty editions).

31. So developed was this pictographic language that quite sophisticated tales could be told by its means (e.g., a crisscrossed or zigzag pattern within a rectangular pattern indicated a "love embrace"). According to Boris Firsov, Miklukho-Maklai Institute of Ethnography, St. Petersburg, an expedition as recently as 1987 discovered Yukaghir people who remembered the old writing and even one man who was still able to practice it (Firsov to Paula Dowling, 15 June 1989, American Museum of Natural History). See Ivanov (1954), 524ff. For a recent report on these Yukaghir artifacts, see Preston (1985), 86–89.

32. The oddly shaped creature with a purple "hat" that floats in the upper center portion of the painting is reminiscent of an ideogram published by Hoffman (1891), 219, suggesting that Kandinsky, like his colleague Mikhailovskii, may have known publications of the American Bureau of Ethnology on Native American sign writing. In the sign as recorded by Hoffman, two figures, one of which is very similar in configuration to the Kandinsky figure, are linked by two wavy lines. The meaning given is: "We spirits are talking together." The suggestion is within the realm of possibility because of the active exchange program between the Library of Congress and the Rumiantsev Library. See Weiss (1994).

33. Cf. D/B (1984), 436, no. 724 f 6, again recalling the Yukaghir precedents, especially by virtue of the curving lines that connect the two entities. *Transparent* (1942) also presents two stick-umbrella forms united by lines, along with "letters" and a "shaman's coat." In *Balancement*, actually painted just prior to *Reciprocal Accord*, one stick-umbrella is presented tip-up, the other tip-down (a formulation common to the Yukaghir precedents); here united by "ropes" of amulets or "sacrifices." See also Messer (1976–1977), untitled watercolors: nos. 194, 195, 196, 200–201.

34. The painting is an eerie twin to Klee's *Death and Fire*, also of 1940, one of that artist's last works. Remizov's tale "Dread Skeleton" depicts the figure of death as "fearsome" and at the same time as a "carnivalesque figure with chattering teeth and a grimacing face" (Rosenthal

[1986], 108). The Yukaghir, like the Chukchee, excelled at making pictographic hunting maps which also seem to have inspired Kandinsky, as, e.g., in the lyrical fairy-tale "map" of an untitled gouache on black paper, 1940, that recalls such early works as *Song of the Volga* and *Golden Sail*, evoking the artist's trip along the Sukhona River. (See Barnett [1980], no. 48.) Jochelson's Yukaghir maps are in the American Museum of Natural History, New York (see Jochelson [1926], 439–442).

35. In a preparatory drawing (as in the preliminary oil sketch), this figure wore a pointed sorcerer's cap; there, too, we see that the dominant flying figure was originally conceived in the prone position of the trance (fig. 185). The antler headdress is common, e.g., among the Yenissei Ostiaks, Evenki (see Ivanov [1954], no. 169), Udegeis, Selkups, and Tungus.

36. Since these figures are traditional, they occurred repeatedly and Kandinsky could easily have known precedents from many different sources. On the Udegei apron illustrated here (now GME, St. Petersburg, acquired 1910; perhaps originally in the Dashkov collections of the Rumiantsev Museum), see Ivanov (1954), 340–341, no. 197, and 338–339, figs. 195 and 196.

37. Kandinsky had experimented with the combination of "doorway" and "bird" motif in *Allégresse* the preceding year. On the "magic gate," see Kagaroff (1928), 217–224. The theme of the flying shaman was repeated in a gouache created in the last year of the artist's life, in which his shamanic alter ego takes the same helmeted form as the flying shaman of *Around the Circle* (see D/B [1984], no. 759 ["Pochoir"].)

38. See Bourke (1892), 451–603 (fig. 444, 588). Many Bureau of Ethnology reports on Native Americans had been cited by Mikhailovskii (e.g., Boas, Cushing, Powell, Schoolcraft), who also cited reports in *American Anthropologist* (e.g., Dorsey, Hoffman [on pictography] and others), and who had himself lectured on American Indian pictography (see chaps. 1 and 3 above). The Smithsonian Institution Bureau of Ethnology reports were regularly received by

the Rumiantsev Library and reviewed in Russian journals. A study of Kandinsky's knowledge of Native American sand painting, pictography, and shamanism has yet to be undertaken. Just prior to *Around the Circle*, in *Figure Blanche*, Kandinsky had depicted another dancing shaman in full regalia, with mask, ribbed breastplate, feathered costume, and oval drum. His horse's arching neck is ribbed and feathered, but his profile suggests that of the shaman of *White Line*. The form of this shaman, like smoke billowing from a volcano or a "genie" from a magic lamp, had been enunciated in *Fixed*, 1935, and was reprised a year later in the somber *Five Parts* (one of a series of "iconic" and burial paintings), with ribbed breastplate, outflung arms, and all-seeing eye recalling the function of World-Watching-Man. The image of himself as a dancing shaman had appeared the previous year in *A Floating Figure*, its title suggesting the image of the shaman in flight.

39. On the shaman's fire persona, see, e.g., Qvigstad and Sandberg (1888), 84–87, and Holmberg (1927), 286–287, on the shaman's spirit flying in the form of fire taken from the aurora borealis. Kharuzin had also reported on the use of a magic shawl or kerchief by Lapp noids (which, together with silver coins, could ward off the "arrows" of disease). The stand-off depicted here also recalls vivid tales recounted by Kharuzin and others concerning the "battles of wills" for which Lapp noids were renowned.

40. The color combination itself suggests both persistence and vulnerability, the brown figures moving upon an unstable yellowish-brown ground through which the unlikely saturated pink of the skeletal outlines gleam with surprising vigor, like a virginal tone of "youthful pure joy" (Kandinsky [1912 (Bill, 1965)], 101–102). For an earlier interpretation, see Weiss [1979], 148. The artist had passed his 76th birthday, marking the occasion with *An Intimate Celebration*, characterized by significant "number" motifs and signs that clearly suggested the idea of passage from birth to death. Kandinsky's "number paintings" offer interesting material for a special

study. His library included a book on number games and puzzles (see Weidemann [1922]). Pictures like *Sept* (perhaps referring to the seven heavens of many Siberian peoples); *Fifteen*, April 1938; *4 × 5 = 20*, 1943, and *Thirty* challenge the observer to translate their grids into decades and years. See also Priklonskii (1890–1891 [Wise, 1953], 32:42), on Yakut calendars.

41. See Weiss (1985), 137, for an analysis of this work. Other Paris-period paintings with obviously humanoid figures arrayed in a row across the plane of the picture include *Reduced Contrasts*, 1941; *Three Variegated Figures*, 1942; and *4 Figures on 3 Rectangles*, 1943 (the latter was one of a series of burial themes).

42. Kandinsky (1912 [Bill, 1965]), 98 (on black). See drawing, D/B (1984), no. 733. See Jochelson (1926), 205.

43. Kandinsky (1912 [Bill, 1965]), 101 (on vermilion; emphasis added). Reprised as: "RED (vermilion) can give the impression of loud beats on the drum" in Kandinsky (1938), 9–15 (as in L/V [1982], 815); emphasis in original. Kandinsky had been "deeply affected" by the death of Sophie Taeuber-Arp in January 1943, and his unpublished essay in her memory was written in June, the same month of this painting, adding weight to this interpretation of the picture as a meditation on death (see L/V [1982], 845). *Dusk*, also June 1943, must be counted among these meditations on death, with its eerie back-lit painted mask and glowing head with crested helmet, its arrow-like "gan flies" and black surround. The image of an object bouncing off the drum's surface recalls the Lapp noid's use of a metal ring bouncing on the drum's surface to divine the future or determine destiny (see Kharuzin [1889], 51–52). In Finno-Ugric lore the soul might migrate in the form of a beetle, another possible interpretation of the scarab-shaped form (see, e.g., Chernetsov [1963], 13). See Rudenstine (1976), 388, concerning a possible alternative title found on the back of the painting: *Composition marron*. One meaning of "marron" is "runaway," "wild" (of animals that have been

tame). Here, St. George's horse is the fugitive, having bucked his rider.

44. See Weiss (1987), 208–209. On the imagery of eagle and snake, Holmberg (1927), 357, 505, citing Agapitov and Khangalov; on the origin of the first shaman, Mikhailovskii (1895), 64. See also Lehtisalo (1936–1937), 28. On the "fire wheel," see Vernadsky (1959), 112–113. Also in Finno-Ugric areas, ladder-shaped bread was often placed among the icons in the holy corner, where it was thought to take on magical properties, e.g., the capacity to heal (see Ränk [1949], 73).

45. See Weiss (1985), (1986), 59–61, and (1987) 209–213, for the first analyses of this work.

46. For details of the shaman's costume and its skeletal parts that guarantee his "resurrection," see chap. 3 above; Weiss (1986), 60–61; and (1987), 209–213. In particular, the drum depicted here closely resembles the side view of the Munich Lapp drum, especially when the progression of its development is traced from drawings to painting. See Kandinsky's contemporary sources on costume details: e.g., Priklonskii (1888), 172; Mikhailovskii (1895), 81; Pekarskii and Vasiliev (1910), 93–115; Vasiliev (1910b), 1–47, and (1910a), 73–76; Jochelson (1926), 169–191 (articulated leggings, 189, fig. 20).

47. Kandinsky (1889b), 107. Kandinsky would also have known Spencer's report on this burial custom "among the Tupis . . . 'that the dead man might not be able to get up and infest his friends with his visits,' " since he had reviewed the book for *E.O.*, even citing a passage from this section (see Spencer [1882], 168). Other ethnographers also reported the tying up of the dead shaman among the Zyrians. See Ivanitskii (1890), 192, on the dire consequences that could result in keeping the death watch over the corpse of an unbound sorcerer; Patkanov (1897), 144, on the Irtysch-Ostiak custom of tying the corpse with red woolen thread which thereby assumed magical power; Wichmann (1916), 132–134, reporting a Zyrian folktale in

which a woman was attacked by her unbound deceased husband, a powerful soothsayer in life; Fuchs (1924), 269; Chernetsov (1963), 11, 29, describing Ostiak and Vogul customs of tying the deceased, and use of a special "knot of the dead." See also Honko (1971), 179, undated photograph of a bound corpse laid out before the "red corner" of a Zyrian cottage (see also 181–182). See Balzer (1980), 80, on Ostiak ritual tying with a special "knot of the dead" still practiced in 1976. On the point-headed spirit-figures of the Ostiaks, see Castrén (1853), 288–290. See Ahlquist (1885), 294; Krohn (1894), 47, fig. 13; 65, fig. 22; 67, figs. 23, 24; and Woldt (1888), 92–107 (pl. VI), with photographs of objects in Berlin's Museum für Völkerkunde that include "point-headed idols." See also Holmberg (1927), 114, pl. X; Ivanov (1970); and Schellbach and Lehtinen (1983), for illustrations. Kandinsky had introduced a similarly "bound" figure on its side in *Two Lines*, 1940. Diamond-shaped motifs, perhaps disembodied "heads," had appeared in many Kandinsky paintings, sometimes suspended like amulets from a world-tree, as in *Levels*, *Graceful Ascent*, or *Joyous Theme*, 1942; sometimes attached to a body or skeletal form as in *Three Motley Figures*, 1942. See R/B (1984), 1065, where *Le Lien vert* is mistranslated as *The Green Band*. See Weiss (1986) and (1987).

48. Burial customs of the Finno-Ugric and Ob-Ugrian peoples required that implements used by the deceased in life be buried with him; in the case of a shaman, including his sacred instrument, idols, and amulets. See Belitser (1958), 361, on the use of panpipes among the Zyrians. On the requirement to break the implements buried with the dead, see Finsch (1879), 545; Holmberg (1927), 20; Chernetsov (1963), 29; and Balzer (1980), 82.

49. See Vasiliev (1910), 12, fig. 11 (six-fingered pendant to costume); Nioradze (1925), fig. 15 (six-fingered glove amulet), also pls. 15, 16 (illustrations of ribbed breastplates); Eliade (1972), 278, on the Yurak-Samoyed shaman's seven-fingered glove; and 274ff., on the signifi-

cance of the number seven. A six-fingered hand also appears in Kandinsky's *A Conglomerate*, 1943. On the function of the "smoke hole," see Holmberg (1927), 17, among the Finns; 6–11, on the Zyrian *lul* (actually *lol*) and the bird-soul; and 317–325, on the diver bird and creation myths. See also Holmberg (1938), 26, 52–57, Ostiak and Altaic "smoke-hole" beliefs. On the soul bird of the Ob-Ugrians, see Chernetsov (1963), 3–45; on rebirth as infant, Siberian and Buriat, 25–27. See also Anokhin (1929), 268; and Hoppál (1976), 232. Cast-bronze bird forms were among the most common burial-mound artifacts of the Ural area (see following discussion); one common shape was a long-necked goose or diver bird cast so that a coil of clay or a snake appears to glide from its beak (for illustration, bird casting discovered in the Vychegda valley, see Burov [1967], 9; see Jettmar [1964], 200, similar artifact). On the Chukchee amulet string ending in a bird from Gondatti's collection, see Bogoras (1900–1901), 1–65, pls. xviii and xxiv. Also illustrated in Bogoras's catalogue of the Gondatti collection was a small toy seal on wheels that may have inspired the "wheels" on Kandinsky's bird.

50. Mikhailovskii (1895), 77–78. See Radloff (1884), 49. The three ladders of the shaman's chant referred to the three tree trunks traditionally used to symbolize the world-tree in the Altaic shamanic rite.

51. See chaps. 1 and 3 above. The use of fly agaric (*Amanita muscaria* or *Agaricus muscarius*) for shamanic trance induction had been reported by many early Siberian explorers, including Pallas, Strahlenberg, Georgi, von Langsdorf, and Erman. See Patkanov (1897), I, 121; Munkácsi (1907), 343–344 (also citing a source on World-Watching-Man's use of fly agaric). On Kandinsky's understanding of the morphological association between *poganyi* (pagan) and *poganka* (a poisonous mushroom), and with *pagalny* (the Zyrian term for a drunken state) and *pankh* (the Finno-Ugric [Vogul] designation for fly agaric), see Weiss (1987), 213; Kandinsky

(1889b), 103; De Lossa (1988). For an etymological discussion of the problem, see Balázs (1968), 53–75. For a general summary, see, e.g., Wasson (1960), 164–168, 233–338.

52. Kandinsky (1918 [L/V 1982]), 892, n. 57.

53. See Laufer (1902), on the scallop pattern common to costumes of the Amur region (far-eastern Siberia). For Amur region costumes in the Rumiantsev Museum, see Golitsyn (1916), 86, and Ianchuk (1910), 45. The scallop motif also appears in *The Red Point*, 1943.

54. See also, e.g., the crest on the helmeted-horseman hieroglyph in *Division-Unity*, 1943, or on the masked head of the shaman in *Dusk*, 1943.

55. See Vainshtein (1968), 336, on the shaman's costume and horse as "pied."

56. See Grohmann (1958), 240–241, on this figure as an "angel." (But Grohmann had also interpreted "the figure" in *Brown Elan* as a "spiritual bird, a symbol of the Holy Ghost," clearly not the case.) See also Lindsay (1966), 46–52, on this image as "angel of death." Similar figures had already appeared in earlier works, and its double may be observed in nearly the same form and in the same location in an unfinished painting of the same year, where the "shamanic" figure of *Tempered Elan* lies on its back, as in death, on the right, or "earthly," side of the picture.

57. See Holmberg (1927), 439, and Holmberg [Harva] (1938), 53, 205–206, on the "thunderbird," emphasizing the role of the thunderbird among the Tungus, Yurak Samoyeds, and Trans-baikal Orochons as protector and guardian of the shaman's soul in flight to the heavens (citing, e.g., Potanin). See chap. 1 above on the gift of a Transbaikal Orochon costume to the Dashkov collections, Rumiantsev Museum, by a Kandinsky. See Native Southwest American "Thunderbird," illustrated in Anuchin (1899), 135 (on Anuchin's study, see below).

58. See, e.g., Vasiliev (1909), 314–317, with photograph of such a grave. The entire burial had been taken from its original site to St. Petersburg (MAE). See also Golitsyn (1916), 66, and Ian-

chuk (1910), 37 (similar sacred birds, Rumiantsev Museum). See Anuchin (1899), 143. Such a protective "bird pole" appears in Kandinsky's gouache *On the Green Line*, 1938.

59. As reported by Khangalov (1890), II, no. I, 95. See Holmberg (1927), 506, 508, n. 31, on the term *khubilgan* as derived from *khubilkhu*, "to change oneself," "to take on another form."

60. On the reindeer as the shaman's soul, see Holmberg (1938), 478. Often the same costume represented both bird and reindeer: the caftan decorated with feathers and the headdress, an iron crown of antlers.

61. See *Fragments*, 1943, where the stony ground in which the biomorphic animalesque form (carrying new life within it) and accompanying messages are laid, suggests archeological "fragments" from an ancient burial mound.

62. In this way each infant was thought to represent the reincarnation of a relative or clan member. See Chernetsov (1963), 24–25, 27.

63. A tradition doubtless related to the Zyrian custom reported by Kandinsky of placing a towel at the window so that the dead person's ort might wash itself. See Ivanitskii (1890), 114. See Paasonen (1909), 25, on the Zyrian concept of a soul bird that foretells death, linking this belief to the Zyrian concept of the ort. See also Nalimov (1907a), 14, and Chernetsov (1963), 13, 16–19, 21. See also Bäckman (1978), 74.

64. See Anuchin (1899), 87–160 and following plates (illustrations of bird artifacts found in the Ural region). On Anuchin's intimate relation to the Imperial Society of Friends of the Natural Sciences, Anthropology, and Ethnography and its journal during Kandinsky's years at the university, see chap. 1 above and Weiss (1994). See also Spitsyn (1899), 167–176, and Spitsyn (1906), 29–145 (profusely illustrated, including some same as Anuchin, e.g., Spitsyn, no. 423, and Anuchin, no. 5). Anuchin had proposed the magico-religious origins of these artifacts and illustrated their relationship to shamanism, e.g., with a photograph of a Manchurian shaman wearing an elaborate bird headdress. Moreover,

he had elaborated in his text on the symbolism of such birds and generally on the symbolic use of birds throughout history and around the world.

65. See Tolstoi and Kondakov (1889–1899), III, 43 (Uralic bird artifacts). The author located vols. 1–4 in the Kandinsky archive, MNAM.

66. Tentatively accepting Kondakov's association of the image with the Chudic figures, however, Anuchin admitted the possibility that in ancient times the Hindu image might somehow have been transmitted to the Chuds, for whom it naturally corresponded to their existing conceptions of the divinity of birds, through intermediary Arabic traders. At the same time, he argued that the Palatine Chapel image might have been intended by an inept artist to represent Alexander the Great himself as Naga, since the Macedonian king had in any case been perceived by the Hindus as an enemy and representative of destruction and evil. See Anuchin (1899), 154–155 (Palatine Chapel illustration, p. 152), and Tolstoi and Kondakov (1897), V, 17–18 (illustration of Palatine Chapel panel with repetition of Uralic artifact illustration from vol. 3). It is not known at this time if the artist ever owned vols. 5 and 6 of the set.

67. N. Kandinsky (1976), 213.

68. Significantly, the artist's own body was laid out before *Reciprocal Accord*. See photograph of the artist on his deathbed by Rogi-André (in Derouet [1982?], 89). I am grateful to Alyce Jordan for providing detailed notes on the coloring of this watercolor.

69. Donner (1926 [1915]), 200. The translation is the author's, from the 1926 German edition. Following in Castrén's footsteps, the linguist Kai Donner had, in the years just prior to the First World War, between 1911 and 1913—coincidental with Kandinsky's aesthetic revolution—lived among the Samoyeds. His account of his experiences was published first in 1915.

Postscript

From a Samoyed shaman song recorded by Castrén in the 1840s, as quoted by Gáldi (1968), 131 (translated by the author from Lehtisalo's German version).

bibliography

Works in Kandinsky's personal library (Musée National d'Art Moderne, Paris) are marked with asterisks. Book reviews by Kandinsky in *E.O.*, are numbered 1–7 (in brackets).

Adam, Leonard. 1923. *Nordwestamerikanische Indianerkunst. Orbis Pictus*, vol. 17. Ed. Paul Westheim. Berlin: Ernst Wasmuth.

Agapitov, N., and M. Khangalov. 1883. *Materialy dlia izuchennia shamanstva v Sibiri. Shamanstvo u buriat Irkutskoi gubernii*. Irkutsk.

——. 1887. Das Schamanentum unter den Burjäten. Trans. L. Stieda. *Globus* 52: 250–253; 268–270; 286–288; 290–301; 316–317.

Ahlquist, August. 1885. Unter Wogulen und Ostjaken Reisebriefe und Ethnographische Mittheilungen. *Acta Societatis Scientiarum Fennicae*. Vol. 14. Helsinki.

Andreyev, Nikolay. 1964. Pagan and Christian Elements in Old Russia. In Treadgold (1964), 140–147.

Anderson, Troels. 1966. Some Unpublished Letters by Kandinsky. *Artes: Periodical of the Fine Arts* 2 (October): 90–110.

Anokhin, A. V. 1929. Dusha i ee svoistva po predstavlenniu Teleutov [Conceptions of the Soul and Their Characteristics among the Teleut Shamanists of the Altai]. *Sbornik Muzei Antropologii i Etnografii* 8.

Anon. 1889. Izvestiia i Zametki [News and Notes]. *E.O.* 1: 177.

——. 1889. Izvestiia i Zametki [News and Notes]. *E.O.* 3: 212.

——. 1894. [Review of *Etnograficheskoe Obozrenie*.] In *Mittheilungen der Anthropologischen Gesellschaft in Wien* 24 (n.s. 14): 93–94.

Anuchin, Dmitri N. 1889. O zadachakh russkoi etnografii [Problems of Russian Ethnography]. In *E.O.* 1: 1–35.

——. 1899. K istorii iskusstva i verovanii u Priuralskoi Chudi [Contributions to the History of Art and Beliefs among the Ural Chuds]. In *Materialy po arkheologii Vostochnykh gubernii* (Moscow) 3: 87–160.

———. 1984. The Study of Shamanism in Soviet Ethnography. In Hoppál (1984), pt. 1: 46–63.

Armstrong, Edward A. 1970. *The Folklore of Birds: An Enquiry into the Origin and Distribution of Some Magico-Religious Traditions.* New York: Dover.

Armstrong, Terrence. 1965. *Russian Settlement in the North.* Cambridge: Cambridge University Press.

Arsenev, F. A. 1873. *Zyriane i ikh Okhotnichi promysly* [The Zyrians and Their Hunting (Craft)]. M[oscow?].

Ashmore, Jerome. 1977. Sound in Kandinsky's Painting. *Journal of Aesthetics and Art Criticism* 35, no. 3 (Spring): 329–336.

Bäckman, Louise. 1978. Types of Shaman: Comparative Perspectives. In Bäckman and Hultkrantz (1978), 62–89.

Bäckman, Louise, and Åke Hultkrantz, eds. 1978. *Studies in Lapp Shamanism.* Stockholm: Almqvist & Wiksell International.

Baedeker, Karl. [1914] 1970. *Handbook for Travellers: Russia.* Repr. New York: Arno Press and The New York Times.

Balázs, J. 1968. The Hungarian Shaman's Technique of Trance Induction. In Diószegi (1968), 53–75.

Balzer, Marjorie. 1980. The Route to Eternity: Cultural Persistence and Change in Siberian Khanty Burial Ritual. *Arctic Anthropology* 27, no. 1: 77–90.

Banzarov, Dorzhi. [1846] 1891. *Chernaiia vera ili shamanstvo u mongolov* [Black Faith or Shamanism among the Mongols]. Ed. G. N. Potanin. St. Petersburg.

Baraev, Vladimir V. 1991. *Drevo Dekabristy i Semeistvo Kandinskikh* [The Tree: The Decembrists and the Kandinsky Family]. Moscow: Izdatelstvo Politicheskoi Literatury.

Baran, Henryk. 1987. Towards a Typology of Russian Modernism: Ivanov, Remizov, Khlebnikov. In Slobin (1987), 174–194.

Barnett, Vivian. 1980. *Kandinsky Watercolors.* New York: The Solomon R. Guggenheim Foundation and The Hilla von Rebay Foundation.

———. 1985. Kandinsky and Science: The Introduction of Biological Images in the Paris Period. In *Kandinsky in Paris, 1934–1944,* 61–87. New York: The Solomon R. Guggenheim Foundation.

———. 1989. *Kandinsky and Sweden* [exhibition catalogue]. Stockholm and Malmö: Moderna Museet (1990) and Malmö Konsthall.

———. 1992–1994. *Kandinsky Watercolours: Catalogue Raisonné.* 2 vols. *1900–1921; 1922–1944.* Ithaca: Cornell University Press.

Barron, Stephanie, and Maurice Tuchman, eds. 1980. *The Avant-Garde in Russia, 1910–1930.* Cambridge: MIT Press.

Barron, Stephanie, et al., eds. 1991. *Degenerate Art: The Fate of the Avant-Garde in Nazi Germany.* Los Angeles: The Los Angeles County Museum of Art and New York: Abrams.

Basilov, V. 1976. Shamanism in Central Asia. In Bharati (1976), 149–157.

———. 1984. The Study of Shamanism in Soviet Ethnography. In Hoppál (1984), pt. 1: 46–63.

Bayer, Herbert, Walter Gropius, and Ise Gropius, eds. [1938] 1959. *Bauhaus, 1919–1928.* Repr. Boston: Charles T. Branford. [Orig. pub. New York: Museum of Modern Art.]

Belitser, V. N. 1958. Ocherki po Etnografii Narodov Komi [Essays on the Ethnography of the Komi People]. *Trudy Instituta Etnografii im. N. N. Miklukho-Maklaia* n.s. 45. Moscow: Akademii Nauk SSSR.

———. [1970] 1973. Komi. *Bolshaia Sovetskaia Entsiklopediia,* vol. 12, 598–99. Moscow: Sovetskaia Entsiklopediia Publishing House.

Belova, V. I., et al., eds. 1987. *Mastera Russkogo Severa Vologodskaia Zemlia* [Masters of the Russian North Vologdan Country]. Moscow: Isdatelstvo Planeta.

[Berlin] 1908. *Königliche Museen zu Berlin: Führer durch das Museum für Völkerkunde.* Berlin: Georg Reimer.

Bharati, Agehnanda, ed. 1976. *The Realm of the Extra-Human: Agents and Audiences.* The Hague: Mouton.

Bill, Max, ed. 1951. *Wassily Kandinsky.* Paris: Maeght.

———. [1955] 1963. *Kandinsky: Essays über Kunst und Künstler.* Bern: Benteli.

———. 1964. *Kandinsky: Punkt und Linie zu Fläche: Beitrag zur Analyse der malerischen Elemente.* 5th ed. with introduction by Max Bill. Bern-Bümpliz: Benteli.

———. 1965. *Kandinsky: Über das Geistige in der Kunst.* 8th ed. with introduction by Max Bill. Bern: Benteli.

Billington, James H. 1964. Images of Muscovy. In Treadgold (1964), 148–172.

———. 1966. *The Icon and the Axe: An Interpretive History of Russian Culture.* New York: Random House.

Boas, Franz. 1904–1907. Notes on the Blanket Designs. *Memoirs of the American Museum of Natural History* (New York). Vol. 3, pt. 4.

———. [1927] 1951. *Primitive Art.* Irvington-on-Hudson: Capitol. [Orig. pub. Oslo: Institutet for Sammenlignende Kulturforskning.]

Bogaevskii, Petr M. 1889a. Zametka o Narodnoi Meditsine [Notes on Folk Medicine]. *E.O.* 1: 101–105.

———. 1889b. Zametki o IUridicheskom byt krestian Sarapulskago uezda, Viatskoi Gubernii [Notes on Common-law Customs among the Peasants of the Sarapul District of Viatka Province]. *Izvestiia Imperatorskago Obshchestva Liubitelei Estestvoznaniia, Antropologii i Etnografii.* Vol. 61. *Trudy Etnograficheskago Otdela Imperatorskago Obshchestva Liubitelei Estestvoznaniia, Antropologii i Etnografii. Sbornik sviedienii izucheniia byta krestianskago naseleniia Rossii* (Moscow). Ed. Nikolai Kharuzin. Vol. 9, pt. 1: 1–12.

———. 1890. Ocherki Religioznykh Predstavlenii Votiakov [Studies on the Religious Beliefs of the Votiaks]. *E.O.* 4, no. 1 (pts. 1, 2, 3): 116–163; 5, no. 2, (pts. 4, 5): 77–109; 7, no. 4 (pt. 6): 42–70.

———. 1904. Zhenevskaia Konventsiia v istoricheskom Razvitii [Geneva Conventions in Historical Development]. *Zhurnal Min. IUst.* [offprint; full title not given] May: 34–49.*

Bogoras, Waldemar (V. G. Bogoraz). 1900. *Materialy po izucheniiu Chukotskago Iazyka i Folklora, sobrannye v Kolymskom Okrug* [Materials for the Study of Chukchee Language and Folklore, of Kolymskoe District]. Pt. 1. *Trudy Yakutskoi Ekspeditsii.* Sec. 2, vol. 11, pt. 3. St. Petersburg: Izdanie Imperatorskoi Akademii Nauk.

————. 1900–1901. Aperçu sur l'ethnographie des Tchouktches d'après les Collections de N. L. Gondatti. *Sbornik Muzeia po Antropologii i Etnografii pri Imperatorskoi Akademii Nauk* 1, no. 2: 1–66 (25 pls.). St. Petersburg.

————. 1904. Idées religieuses des Tchouktchis. *Bulletins et mémoires de la Société d'Anthropologie de Paris,* ser. 5, no. 5: 341–355.

————. 1907. *The Chukchee—Religion.* Jesup North Pacific Expedition. Vol. 7, pt 2. *Memoirs of the American Museum of Natural History.* Vol. 11. Leiden: Brill and New York: Stechert.

————. [1904–1909] ca. 1966. *The Chukchee.* Jesup North Pacific Expedition. Vol. 7, pt. 1–3. *Memoirs of the American Museum of Natural History.* Vol. 11. Ed. Franz Boas. Leiden: Brill and New York: Stechert. Repr. New York: Johnson, n.d.

————. 1910. K Psikhologii shamanstva u narodov Severo-Vostochnoi Azii [On the Psychology of Shamanism among the Peoples of North-eastern Asia]. *E.O.* 84–85, nos. 1–2: 1–36.

————. 1913. Chukotskie risunki [Chukchee Drawings]. In *Festschrift für Professor Dmitrij Nikolajewitsch Anutschin zu seinem 70-ten Geburtstage,* 397–420. Moscow: Izdanie Imperatorskago Obshchestva Liubitelej Estestvoznaniia, Antropologii i Etnografii, Sostoiashchago iri Moskovskom Universitet.

Bogoras, W., and W. Jochelson. 1901–1902. Shamans' Songs. Recordings on wax cylinders. American Museum of Natural History, on deposit at the Archives of Traditional Music, Indiana University, Bloomington.

Böhling, Georg. 1890. *Aus Nordrussischen Dörfern (Studiertes und Erlebtes).* Minden i. W.: Köhler.

Boissel, Jessica. 1986–1987. "Solche Dinge haben eigene Geschicke": Kandinsky und das Experiment "Theater." In Andreas Meier et al., eds. *Der Blaue Reiter: Kunstmuseum Bern* [exhibition catalogue], 240–251. Bern: Kunstmuseum.

Bosley, Keith. 1989. Introduction. In *The Kalevala: An Epic Poem after Oral Tradition by Elias Lönnrot,* xiii–liv. Translated and edited by Keith Bosley; foreword by Albert B. Lord. Oxford and New York: Oxford University Press.

Bourke, John G. 1892. The Medicine-Men of the Apache. *Ninth Annual Report of the U.S. Bureau of Ethnology, 1887–88.* Washington, D.C.: Government Printing Office.

Bowlt, John, ed. 1976. *Russian Art of the Avant-Garde: Theory and Criticism, 1902–1934.* New York: Viking.

Bowlt, John, and Rose-Carol Washton Long, eds. 1980. *The Life of Vasilii Kandinsky in Russian Art: A Study of "On the Spiritual in Art."* Newtonville, Mass.: Oriental Research Partners.

Branch, Michael. 1973. *A. J. Sjögren: Studies of the North. Mémoires de la Société Finno-Ougrienne,* no. 152. Helsinki: Suomalis-Ugrilainen Seura.

————. 1985. Introduction. *Kalevala: The Land of Heroes,* xi–xxxiv. W. F. Kirby translation (orig. pub. 1907) of Elias Lönnrot's 1849 *Kalevala.* London and Dover, N.H.: Athlone.

Brenson, Michael. 1988. Isamu Noguchi, the Sculptor, Dies at 84. *New York Times,* 31 Dec. 1988: 9.

Brinkmann, Heribert. 1980. Wassily Kandinsky als Dichter. Ph.D. diss., University of Cologne.

Brisch, Klaus. 1955. *Wassily Kandinsky: Untersuchungen zur Entstehung der gegenstandslosen Malerei an seinem Werk von 1900–1921.* Ph.D. diss., Rheinische Friedrich-Wilhelm-Universität, Bonn.

Brücher, Ernst, and Karl Gutbrod, eds. 1964. *August Macke–Franz Marc Briefwechsel.* Introduction by Wolfgang Macke. Cologne: M. DuMont Schauberg.

Buergel-Goodwin, Ulrike, and Wolfram Göbel. 1979. *Reinhard Piper: Briefwechsel mit Autoren und Künstlern, 1903–1953.* Munich: Piper.

Bulgakov, Sergei Nikolaevich. [1906] 1979. *Karl Marx as a Religious Type.* Edited by Virgil R. Lang, with introduction by Donald W. Treadgold. Belmont, Mass.: Nordland.

————. 1908. L'Intelligentsia et la religion. Abstract from *Pensée russe.* Moscow.*

Burke, Sarah. 1987. A Bearer of Tradition: Remizov and His Milieu. In Slobin (1987), 167–174.

Burov, G. M. 1967. *Arkheologicheskie pamiatniki Vychegodskoi doliny* [Archeological Monuments of the Vychegda Valley]. Syktyvkar: Komi kn. izd.

Byhan, A. 1909. *Die Polarvölker.* Leipzig: Quelle & Meyer.

Casanowicz, I. M. 1924. Shamanism of the Natives of Siberia. In *Smithsonian Institution Annual Report,* 415–434. Washington, D.C.: Government Printing Office.

Castrén, M[athias] Alexander. 1853. *Nordische Reisen und Forschungen.* Vol. 1. *Reiserinnerungen aus den Jahren 1838–1844.* Ed. Anton Schiefner. St. Petersburg: Buchdruckerei der Kaiserlichen Akademie der Wissenschaften.

————. 1856. *Nordische Reisen und Forschungen.* Vol. 2. *Reiseberichte und Briefe aus den Jahren 1845–1849.* Ed. Anton Schiefner. St. Petersburg: Kaiserliche Akademie der Wissenschaften.

Cheboksarov, N. N. 1962. Questions Concerning the Origins of the Finno-Ugrian Language Group. In Michael (1962), 207–219.

Chernetsov, V. N. 1963. Concepts of the Soul among the Ob Ugrians. In Michael (1963), 3–45.

Clifford, James. 1981. On Ethnographic Surrealism. *Comparative Studies in Society and History* 23, no. 4: 539–564.

257

————. 1985. Histories of the Tribal and the Modern. *Art in America* 4 (April): 164–215.

Clifford, James, ed. 1988. *The Predicament of Culture: Twentieth-Century Ethnography, Literature, and Art.* Cambridge: Harvard University Press.

Czaplicka, M. A. 1914. *Aboriginal Siberia: A Study in Social Anthropology.* Oxford: Oxford University Press.

DeFrancis, John. 1989. *Visible Speech: The Diverse Oneness of Writing Systems.* Honolulu: University of Hawaii Press.

Delaby, Laurence. 1969. A Propos des cannes chevalines du Musée de l'Homme. *Objets et mondes* 9, no. 3 (Autumn): 279–296.

————. 1970. Figurations sibériennes d'oiseaux à usage religieux. *Objets et mondes* 10, no. 3 (Autumn): 195–221.

————. 1977. Chamanes Toungouses. *Etudes mongoles . . . et sibériennes.* Cahier 7. Paris.

Derouet, Christian. [1982.] Notes et documents sur les dernières années du peintre Vassily Kandinsky. *Cahiers du Musée National d'Art Moderne* 9: 84–107.

————. 1985. Kandinsky in Paris: 1934–1944. Trans. Eleanor Levieux. In *Kandinsky in Paris, 1934–1944,* 12–60. New York: The Solomon R. Guggenheim Foundation.

————. 1990. On War in General and Vasily Kandinsky in Particular. In Springfeldt (1990), 133–144.

Derouet, Christian, and Jessica Boissel, eds. 1984. *Kandinsky: Oeuvres de Vassily Kandinsky (1866–1944).* Paris: Musée National d'Art Moderne.

Devel, F. [1896] 1901. *Razskazy o Vostochnoi Sibiri to-est o guberniiakh Eniseiskoi i Irkutskoi i ob oblastiakh IAkutskoi, Zabaikalskoi i Primorskoi* [Tales of Eastern Siberia, i.e., from the Districts of Yanesei, Irkutsk, and the Oblasts of Yakutia, Transbaikal, and the Maritime]. Moscow: I. N. Kushnerev.*

Diószegi, Vilmos. 1947. Šamán (The Etymology of the Word Šamán). *Magyar Nyelv* 43: 211–212.

———— [ed]. 1968. *Popular Beliefs and Folklore Tradition in Siberia.* The Hague: Mouton.

————. 1968a. The Problem of the Ethnic Homogeneity of Tofa (Karagas) Shamanism. In Diószegi (1968), 239–329.

————. 1968b. The Three-Grade Amulets among the Nanai (Golds). In Diószegi (1968), 387–406.

————. 1968c. *Tracing Shamans in Siberia: The Story of an Ethnographical Research Expedition.* Oosterhout: Anthropological Publications.

————. 1978. Pre-Islamic Shamanism of the Baraba Turks and Some Ethnogenetic Conclusions. In Diószegi and Hoppál (1978), 83–167.

Diószegi, Vilmos, and M. Hoppál, eds. 1978. *Shamanism in Siberia.* Budapest: Akademiai Kiadó.

Djakonova, V. 1978. The Vestments and Paraphernalia of a Tuva Shamaness. In Diószegi and Hoppál (1978), 325–339.

Donner, Kai. [1915] 1926. *Bei den Samojeden in Sibirien.* Stuttgart: Strecker & Schröder.

Düben, Gustav von. [1873]. *Om Lappland och Lapparne företrädesvis de Svenske. Ethnografiska Studier.* [Stockholm]: A. Norstedt & Söners.

Dyrenkova, N. 1949. Materialy po Shamanstvu u Teleutov [Materials on Shamanism among the Teleuts]. *Sbornik Muzeia Antropologii i Etnografii* 10: 107–190.

Ebert-Schifferer, S., ed. 1989. *Wassily Kandinsky: Die erste Sowjetische Retrospektive* (exhibition catalogue). Frankfurt: Schirn Kunsthalle.

Edsman, Carl-Martin, ed. 1967. *Studies in Shamanism.* Stockholm: Almqvist & Wiksell.

Efron, I. A. 1894. Zyriane. In *Entsiklopedicheskii Slovar.* Vol. 12. St. Petersburg: F. A. Brockhaus.

Eichner, Johannes. [1957]. *Kandinsky und Gabriele Münter: Von Ursprüngen modernen Kunst.* Munich: F. Bruckmann.

Eleonskaia, E. N. 1931. V. N. Kharuzina (1866–1931). *Sovetskaiia Etnografiia* 1–2: 153–155.

Eliade, Mircea. [1951] 1972. *Shamanism: Archaic Techniques of Ecstasy.* Princeton, N.J.: Princeton University Press.

Eliasberg, Alexander. 1915. *Russische Kunst: Ein Beitrag zur Charakteristik des Russentums.* Munich: Piper.

Emmons, George T. 1904–1907. The Chilkat Blanket. *Memoirs of the American Museum of Natural History* (New York). Vol. 3, pt. 4: 329–350.

Etnograficheskoe Obozrenie. (E.O.) Periodicheskoe izdanie. Etnograficheskago Otdela Imperatorskago Obshchestva Liubitelei Estestvoznaniia, Antropologii i Etnografii. Sostoiashchago iri Moscovskom Universitete. 1889–1916 [1918]. Vols. 1 through 111–112, nos. 3–4. Moscow.

Ettlinger, L. D. 1964. Kandinsky. *L'Oeil* (June): 10–17, 50.

Fedotov, G. [1946] 1960 and 1966. *The Russian Religious Mind.* Vol. 1. New York: Harper & Row (orig. Cambridge: Harvard University Press, 1946). Vol. 2. Cambridge: Harvard University Press.

Fet, A. A. [1883] 1982. Na Knizhke stikhotvorenii Tiutcheva [On the Poems of Tiutchev]. In *Sochineniia Tom Pervyi Stikhotvoreniia, Poemy, Perevody.* Moscow: Khudozhestvennaia Literatura.

Findeisen, Hans. 1956. W. G. Bogoras' Schilderung zweier schamanischen Séancen der Küsten-Tschuktschen (Nordostsibirien). *Abhandlungen und Aufsätze Institut für Menschen- und Menschheitskunde* 38: 1–33.

Fineburg, Jonathan. 1975. Kandinsky in Paris, 1906–1907. Ph.D. diss., Harvard University.

Finsch, Otto. 1879. *Reise nach West-Sibirien im Jahre 1876.* Berlin: Erich Wallroth.

Fitzhugh, William, and Aaron Crowell. 1988. *Crossroads of Continents: Cultures of Siberia and Alaska.* Washington, D.C.: Smithsonian Institution Press.

Flier, Michael S. 1964. Sunday in Medieval Russian Culture: *Nedelja* versus *Voskresenie.* In Henrik Birnbaum and Michael Flier, eds. *Medieval Russian Culture,* 105–149. Los Angeles: University of California Press.

Florovsky, Georges. 1964. The Problem of Old Russian Culture. In Treadgold (1964), 125–139.

Fokos-Fuchs, D[avid]. R. 1959. *Syrjänisches Wörterbuch*. 2 vols. Budapest: Akadémiai Kiadó.

Frankenstein, Alfred. 1930. Victor Hartmann and Modeste Musorgsky. *Musical Quarterly* 25, no. 3 (July): 268–291.

Freed, Stanley A., Ruth S. Freed, and Laila Williamson. 1988. The American Museum's Jesup North Pacific Expedition. In Fitzhugh and Crowell (1988), 97–103.

Friedrich, Adolf, and Georg Buddruss, eds. 1955. *Schamanengeschichten aus Sibirien*. Includes *Legenden und Erzählungen von Schamanen bei Jakuten, Burjaten und Tungusen gesammelt von G. K. Ksenofontov*. Munich-Planegg: Otto Wilhelm Barth. [Orig. pub. Irkutsk, 1928.] See Ksenofontov [1928] 1955.

Friis, J. A. 1869. Der Sampo Finnlands und des Lappen Zaubertrommel. *Magazin für Literatur des Auslandes: Monatschrift für Literatur, Kunst & Kultur* 57: 263–265.

——. 1871. *Lappisk Mythologi, Eventyr og Folkesagn*. Christiania: Cammermeyer.

Fuchs, D. R. [Fokos-]. 1911. Eine Studienreise zu den Syrjänen. *Keleti Szemle* 12, no. 3: 229–260.

——. 1923–24. Beiträge zur Kenntnis des Volksglaubens der Syrjänen. *Finnisch-Ugrischen Forschungen* 16: 237–274.

——. 1959. *Syrjänisches Wörterbuch*. Budapest: Akadémiai Kiadó.

Fuhr, James Robert. 1983. Klänge: The Poems of Wassily Kandinsky. Ph.D. diss., Indiana University.

Gáldi, L. 1968. On Some Problems of Versification in Samoyed Shamanistic Songs. In Diósegi (1968), 125–136.

Garte, Edna J. 1987. Kandinsky's Ideas on Changes in Modern Physics and Their Implications for His Development. *Gazette des Beaux-Arts* (October): 137–144.

Geelhaar, Christian, ed. 1976. *Paul Klee: Schriften, Rezensionen und Aufsätze*. Cologne: DuMont.

Goldwater, Robert. [1938] 1986. *Primitivism and Modern Art*. Cambridge: Harvard University Press. [Orig. pub. New York: Random House.]

Golitsyn, V., ed. 1916. *Illiustrirovannyi Putevoditel po Etnograficheskomu Muzeiu* [Illustrated Guide to the Ethnographic Museum]. Moscow: Imperatorskii Moscovskii i Rumiantskovskii Muzei.

Gollek, Rosel, ed. 1977. *Gabriele Münter, 1877–1962*. Munich: Städtische Galerie im Lenbachhaus.

——. 1982. *Der Blaue Reiter*. Munich: Prestel.

Gondatti, N. L. 1888a. *Sledy iazycheskikh verovanii u Manzov* [Traces of Paganism among the Mansi]. *Izvestiia Imperatorskago Obshchestva Liubitelei Estestvoznaniia, Antropologii i Etnografii* 48, no. 2. *Trudy Etnograficheskago Otdela* 8: 49–73. Moscow.

——. 1888b. *Kult medvedia u inorodtsev severo-zapadnoi Sibiri* [The Bear Cult among the Natives of Northwestern Siberia]. *Izvestiia Imperatorskago Obshchestva Liubitelei Estestvoznaniia, Antropologii i Etnografii* 48, no. 2. *Trudy Etnograficheskago Otdela* 8: 74–87. Moscow.

Gordon, Donald E. 1984. German Expressionism. In Rubin (1984), vol. 2, 369–404.

Gracheva, G. N. 1978. A Nganasan Shaman Costume. In Diószegi and Hoppál (1978), 315–324.

Gregg, Sara. 1981. Gabriele Münter in Sweden: Interlude and Separation. *Arts Magazine* 55, no. 9 (May): 116–119.

Gribova, L. S. 1980. *Dekorativno-Prikladnoe Iskusstvo Narodov Komi* [Decorative Applied Art of the Komi People]. Moscow: Nauka.

Grohmann, Will. 1958. *Wassily Kandinsky: Life and Work*. New York: Abrams.

Grünwedel, Albert. 1893. Sinhalesische Masken. *Internationales Archiv für Ethnographie* 6: 82–88.

Gutbrod, Karl, ed. 1968. *"Lieber Freund . . ." Künstler schreiben an Will Grohmann*. Cologne: M. DuMont Schauberg.

Hämäläinen, Albert. 1937. Das kultische Wachsfeuer der Mordvinen und Tscheremissen. *Suomalais-ugrilaisen Seuran Aikakauskirja* (Helsinki) 48: 5–158.

Hahl-Koch, Jelena, ed. *Arnold Schönberg–Wassily Kandinsky Briefe, Bilder und Dokumente: Einer aussergewöhnlichen Begegnung*. Salzburg and Vienna: Residenz.

——. 1980b. Kandinsky's Role in the Russian Avant-Garde. In Barron and Tuchman (1980), 84–90.

——. 1985. Kandinsky und der "Blaue Reiter." In von Maur (1985), 354–359.

Hahn, Peter, ed. 1984. *Kandinsky: Russische Zeit und Bauhausjahre, 1915–1933*. Exhibition catalogue with essays by Clark Poling, Peter Hahn, Magdalena Droste, and Charles W. Haxthausen. Berlin: Bauhaus-Archiv.

Hajdu, Peter. 1968. The Classification of Samoyed Shamans. In Diószegi (1968), 147–173.

—— [ed]. 1976. *Ancient Cultures of the Uralian Peoples*. Budapest: Corvina.

——. 1978. The Nenets Shaman Song and Its Text. In Diószegi and Hoppál (1978), 370–371.

Hamilton, George Heard. 1983. *The Art and Architecture of Russia*. New York: Penguin.

Hammarstedt, N. E. 1911. *Nordiska Museet Lappska Afdelningen*. Stockholm: A. Norstedt & Söner.

Hanfstaengl, Erika. 1974. *Wassily Kandinsky: Zeichnungen und Aquarelle im Lenbachhaus München*. Munich: Prestel.

Harva. See Holmberg.

Hausenstein, Wilhelm. 1913. Die Zukunft der Münchener Sammlungen. *Kunstchronik* n.s. 25, no. 11 (5 Dec.): 161–168.

——. 1920. *Exoten. Skulpturen und Märchen. Dreiundfünfzig Abbildungen nach Bildwerken des Museums für Völkerkunde in München*. Erlenbuch-Zürich and Munich: Eugen Rentsch.

Haxthausen, August Freiherr von. 1847. *Studien über die innern Zustände, das Volksleben und insbesondere die ländlicher Einrichtungen Russlands*. Secs. 8–9: Abreise nach Wologda, 223–282. Hannover.

Haxthausen, Charles W. 1984. "Der Künstler ohne Gemeinschaft": Kandinsky und die deutsche Kunstkritik. In Hahn (1984), 72–89.

Heger, Franz. 1890. Der achte russische

Archäologen-Congress in Moskau, 1890. *Mittheilungen der Anthropologischen Gesellschaft in Wien* 20: 161–162.

Heikel, Axel. 1888. Die Gebäude der Cheremissen, Mordwinen, Esten und Finnen. *Journal de la Société Finno-Ougrienne* 4. pt. 1.

Heller, Reinhold. 1992. Innenräume: Erlebnis, Erinnerung und Synthese in der Kunst Gabriele Münters. In Annegret Hoberg and Helmut Friedel, eds. *Gabriele Münter, 1877–1962: Retrospektive*, 47–66. Munich: Prestel.

Herberstein, Sigmund Freiherr von. [1549] 1556. *Rerum Moscoviticarum commentarij Sigismundi liberi baronis in Herberstain, Neyperg, & Guettenhag: Rvssiae, & quae nunc eius metropolis est, Moscouiae, breuissima descriptio.* Basel: Ionnem Oporinum.

——— . [1851–1852] N.d., ca. 1963. *Notes upon Russia: Being a Translation of the Earliest Account of That Country Entitled Rerum Moscoviticarum Commentarii by the Baron Sigismund von Herberstein.* Trans. and ed. R. H. Major. Repr. New York: Burt Franklin. [Orig. pub. London: British Hakluyt Society.]

——— . 1908. *Zapiski o Moskovitskikh Dielakh* [Notes on Muscovite Affairs]. Trans. and ed. A. I. Malein. St. Petersburg: Izdanie A. S. Suvorina.

Herzen, Alexander I. [1847] 1984. *Who Is to Blame? A Novel in Two Parts.* Trans. and ed. Michael R. Katz. Ithaca: Cornell University Press. (* 1891 ed. [Iscander, pseud., A.I. Herzen]).

Heymel, Alfred Walter, ed. 1911. *Im Kampf um die Kunst. Die Antwort auf den Protest deutscher Künstler. Mit Beiträgen deutscher Künstler, Galerieleiter, Sammler und Schriftsteller.* Munich: Piper.

Hilton, Alison. 1991. Piety and Pragmatism: Orthodox Saints and Slavic Nature Gods in Russian Folk Art. In William C. Brumfield and Milos M. Velimirovic, eds., *Christianity and the Arts in Russia*, 55–72. Cambridge: Cambridge University Press.

Hoffman, W. J. 1888. Pictography and Shamanistic Rites of the Ojibwa. *American Anthropologist* 1 (July): 209–229.

——— . 1891. The Mide'Wiwin or "Grand Medicine Society" of the Ojibway. *Seventh Annual Report of the U.S. Bureau of Ethnology, 1885–1886*, 146–300. Washington, D.C.: Government Printing Office.

Holmberg, Uno [Harva]. 1913. Die Wassergottheiten der finnisch-ugrischen Völker. *Mémoires de la Société Finno-Ougrienne* 32. Helsinki: Druckerei der finnischen Literatur-Gesellschaft.

——— . 1926. *Die Religion der Tscheremissen.* Folklore Fellows Communications 61.

——— . 1927. *Finno-Ugric, Siberian.* Vol. 4 of *The Mythology of All Races.* Boston: Archaeological Institute of America and Marshall Jones Co.

——— . 1938. *Die religiösen Vorstellungen der altäischer Völker.* Folklore Fellows Communications 125. Helsinki: Suomalainen Tiedeakatemia.

Honko, Lauri. 1971. Religion der finnisch-ugrischen Völker. In Jes Peter Asmussen and Jørgen Laessøe, eds., *Handbuch der Religionsgeschichte*, 1:173–224. Göttingen: Vandenhoeck and Ruprecht.

Hoppál, M. 1976. Folk Beliefs and Shamanism among the Uralic Peoples. In Hajdu (1976), 215–242.

Hoppál, Mihály, ed. 1984. *Shamanism in Eurasia.* Pts. 1 and 2. Göttingen: Herodot.

Hoppál, M. *See also* Diószegi and Hoppál (1978).

Hottenroth, Friedrich. [1884] 1891. *Trachten, Haus-, Feld- und Kriegsgeräthschaften der Völker alter und neuer Zeit.* Vols. 1 and 2. Stuttgart: Gustav Weise.*

Hultkranz, Åke. 1978. Ecological and Phenomenological Aspects of Shamanism. In Diószegi and Hoppál (1978), 27–58.

Ianchuk, N., ed. 1910. *Musée Ethnographique Dachkov au Musée Public et Musée Roumianzov à Moscou: Catalogue illustré à l'usage des étrangers.* Moscow: G. Lissera & D. Sovko.

Ilina, I. V. "Tödys" in Traditional Beliefs of the Komi People [paper presented at the Regional Conference on Circumpolar and Northern Religion. Helsinki, 1990]. Translated by Lilia Grubisic from the Russian typescript.

Iovleva, Lydia, et al., eds. 1986. *The Tretyakov Gallery, Moscow: Russian and Soviet Painting.* Leningrad: Aurora Art Publishers.

Istomin, F. 1892. Zyriane. In *Entsiklopedicheskii Slovar*, 24:724–727. St. Petersburg: F. A. Brockhaus and I. A. Efron.

Itkonen, T. I. 1946. Heidnische Religion und späterer Aberglaube bei den finnischen Lappen. *Mémoires de la Société Finno-Ougrienne* 87.

Ivanits, Linda J. 1989. *Russian Folk Bélief.* Foreword by Felix J. Oinas. Armonk, N.Y., and London: M. E. Sharp.

Ivanitskii [Ivanitzky], N. A. 1882. Über die Flora des Gouvernements Wologda. In A. Engler, ed., *Botanische Jahrbücher für Systematik, Pflanzengeschichte und Pflanzengeographie* (1882–1883), 3:448–482. Leipzig: Wilhelm Engelmann.

——— . 1890. *Materialy po Etnografii Vologodskoii Gub[erni]* [Materials on the Ethnography of Vologda Province]. Pt. 2 of Nikolai Kharuzin, ed., *Sbornik svedenii izucheniia byta Krestianskago naseleniia Rossii* [A Collection of Data for the Study of Everyday Life among the Peasant Population of Russia]. *Izvestiia Imperatorskago Obshchestva Liubitelei Estestvoznaniia, Antropologii i Etnografii* 69. *Trudy Etnograficheskago Otdela* (Moscow) 11, no. 1.

——— . 1891. Zametki o narodnykh verovaniiakh v Vologodskoi gub . . . [Notes on Folk Beliefs in Vologda Province (Worship of Fire and Trees; Beliefs in Metamorphosis; History of Burial Customs)]. E.O. 10, no. 3: 226–228.

——— . 1892. K narodnoi meditsine. Vologodskoi gub. [On Folk Medicine: Vologda Province]. E.O. 12, no. 1: 182–185.

Ivanov, S. V. 1954. *Materialy po Izobrazitelnomu Iskusstvu Narodov Sibiri XIX-Nachal XX v.* [Materials on the Pictorial Art of the Siberian Peoples]. Moscow: Akademii Nauk.

———. 1959. Religiöse Vorwürfe in der Kunst der Völker Nordasiens vor der Revolution. In T. Bodrogi and L. Boglár, eds., *Opuscula Ethnologica Memoriae Ludovici Bíró Sacra*, 113–136. Budapest: Akadémiai Kiadó.

———. 1970. *Skulptura narodov Severa Sibiri XIX-pervoi poloviny XX v.* [Sculpture of Northern Siberia]. Leningrad: Akademii Nauk.

———. 1978. Some Aspects of the Study of Siberian Shamanism. In Diószegi and Hoppál (1978), 19–26.

———. 1979. *Skulptura Altaitsev, Khakhasov i Sibirskikh Tatar XVIII-pervaia chetvert XX v.* [Sculpture of the Altais, Khakhasi, and Siberian Tatars]. Leningrad: Akademii Nauk.

Ivanov, Viacheslav Vsevolodovich. 1985. *Einführung in allgemeine Probleme der Semiotik.* Trans. Brigitte Eidemüller and Wolfgang Eismann. Tübingen: Gunter Narr.

Izhuroff, Basil A. 1913. Peculiar Life of Zyrians. *Overland Monthly* 62 (July–December): 278–286.

Jacobi, A. 1925. *1875–1925: Fünfzig Jahre Museum für Völkerkunde zu Dresden.* Berlin: Julius Bard Verlag für Literatur und Kunst.

Jankovics, M. 1984. Cosmic Models and Siberian Shaman Drums. In Hoppál (1984), pt. 1: 149–173.

Jettmar, Karl. 1964. *Art of the Steppes: The Eurasian Animal Style.* London: Methuen.

Jochelson, Waldemar. 1898. Po rekam Iasachnoi i Korkodonu: drevnii i sovremennyi iukagirskii byt i pismena [Along the Iasachnaia and Korkodon Rivers: Ancient and Contemporary Yukaghir Everyday Life and Letters]. *Izvestiia Imperatorskago Russkago Geograficheskago Obshchestva* 34, no. 3: 255–290.

———. 1900a. Materialy po Izucheniiu Iukagirskago Iazyka i Folklora [Materials for the Study of Yukaghir Language and Folklore]. *Trudy Iakutskoi Ekspeditsii* 9, no. 3. St. Petersburg.

———. 1900b. Über die Sprache und Schrift der Jukagiren. Bern: Haller'sche Buchdruckerei, 1900. Repr. from *Jahresbericht der geografische Gesellschaft von Bern* 17.

———. 1905–1908. The Koryak. In Franz Boas, ed. *The Jesup North Pacific Expedition.* Vol. 6. *Memoir of the American Museum of Natural History* (New York). Vol. 10, pts. 1 and 2. Leiden: Brill and New York: Stechert.

———. [1926] 1975. The Yukaghir and the Yukaghirized Tungus. In Franz Boas, ed., *The Jesup North Pacific Expedition.* Vol. 9, pts. 1–3. *Memoir of the American Museum of Natural History* (New York). Vol. 13, pts. 1–3. Leiden and New York: Brill & Stechert. Repr. New York: AMS Press.

———. 1933. The Yakut. *Anthropological Papers of the American Museum of Natural History* 33, no. 2. New York: American Museum of Natural History.

———. *See also* Bogoras and Jochelson (1901–1902).

Jusupov, G. V. Survivals of Totemism in the Ancestor Cult of the Kazan Tatars. In Diószegi (1968), 193–204.

Kagaroff, E. G. 1928. La Porte magique, comme instrument expiatoire dans le chamanisme. *Revue d'ethnographie et des traditions populaires* 9, nos. 34–36: 217–224.

Kandinsky, Nina. 1976. *Kandinsky und ich.* Munich: Kindler.

Kandinskii, Vasili [Kandinsky, Wassily]. 1889a. [Vologda Diary.] Typescript translation by Tamara Alexandrova and Alexei Dmitriev for P. Weiss. Original in the Fonds Kandinsky, Centre Georges Pompidou, Musée National d'Art Moderne, Paris.

———. 1889b. Iz materialov po ethnografii Sysolskikh i Vychegodskikh Zyrian—natsionalnyia bozhestva (po sovremennym verovaniiam) [Materials on the Ethnography of the Sysol- and Vychegda-Zyrians—The National Deities (According to Contemporary Beliefs)]. E.O. 3: 102–110.

———. 1889c. O nakazaniiakh po resheniiam volostnykh sudov Moskovskoi gub. [On the Punishments (Meted Out) in Accordance with the Decisions of the District Courts of the Province of Moscow]. *Izvestiia Imperator-skago Obshchestva Liubitelei Estestvoznaniia, Antropologii i Etnografii.* Vol. 61. In Nikolai Kharuzin, ed., *Trudy Etnograficheskago Otdela Imperatorskago Obshchestva Liubitelei Estestvoznaniia, Antropologii i Etnografii. Sbornik sviedienii izucheniia byta krestianskago naseleniia Rossii* (Moscow) 9, pt. 1: 13–19.

V. K—ii. 1889 [1]. IA. Novitskii. *Pesni Kazatskago Veka* [Songs of the Cossack Age]. *Ekaterinoslavskiia G. V. E.O.* 1: 154.

V. K—ii. 1889 [2]. Zyrianskii krai pri episkopakh Permskikh i Zyrianskii Iazyk. Posobie pri izychenii zyrianami Russkago Iazyka [The Zyrian Territory at the Time of the Episcopate of Perm and the Zyrian Language: Aids in the Learning of Russian by Zyrians]. Compiled by G. [Georgi] S. Lytkin, teacher of the Sixth St. Petersburg Gymnasium. St. Petersburg, 1889. E.O. 3: 166–168.

V. K—ii. 1890 [3]. Oskar Peschel. *Narodovedenie.* Perovod pod red. prof. E. IU. Petri s 6-go izdaniia, dopolnennago Kirkhgoffom. Vyp. I i II. E.O. 4, no. 1: 229–231.

V. K—ii. 1890 [4]. Maxime Kovalevsky. *Tableau des origines et de l'evolution de la famille et de la propriété.* Skrifter utgifna af Lorénska stiftelsen 1890, no. 2. Stockholm. E.O. 7, no. 4: 176–177.

V. K—ii. 1890 [5]. *Sbornik Svedenii dlia izucheniia byta krestianskago naseleniia Rossii* Moscow 1890 . . . N. A. Ivanitskii. E.O. 7, no. 4: 183–185.

V. K—ii. 1890 [6]. Georg Böhling. *Aus Nordrussischen Dörfern (Studiertes und Erlebtes).* [Minden i. W.: Köhler, 1890]. E.O. 7, no. 4: 200–201.

V. K—ii. 1890 [7]. V. K. Magnitskii. *Nravy i obychai v Cheboksarskom uezde* [The Manners and Customs of the Cheboksary District]. *Etnograficheskii Sbornik* (Kazan). E.O. 7, no. 4: 208–209.

———. 1901. Kritika Kritikov [Critique of Critics]. *Novosti dnia* (Moscow), nos. 6403, 6409 (17, 19 April). Trans. in Lindsay and Vergo (1982), 35–44.

———. 1902. Letters to Gabriele Münter, 19 and 27 Oct. 1902. Gabriele Münter- und Johannes Eichner-Stiftung, Städtische Galerie im Lenbachhaus, Munich.

———. 1910. Zu unbestimmter Stunde In *Neue Künstlervereinigung München*. 2d ed. Munich: Bruckmann.

———. 1911. Letter to Lucian Schermann, 13 Dec. 1911. Staatliches Museum für Völkerkunde, Munich.

———. 1912a [December 1911]. *Über das Geistige in der Kunst*. Munich: Piper.

———. 1912b. Über Bühnenkomposition. In Kandinsky and Marc (1912), 101–113.

———. 1912c. [Introduction.] *Kandinsky Kollektiv-Ausstellung, 1902–1912*. Munich: Neue Kunst Hans Goltz.

———. 1913. *Klänge*. Munich: Piper.

———. [1913] 1981. *Sounds*. Trans. and ed. Elizabeth Napier. New Haven and London: Yale University Press.

———. 1913. Rückblicke [Retrospects]. In *Kandinsky, 1901–1913*. Berlin: Der Sturm.

———. [1913] 1982. Reminiscences. Trans. in Lindsay and Vergo (1982), 357–382; 886–898.

———. [1918] 1982. Stupeni. In *Tekst Khudozhnika*. Moscow: IZO NKP. Variorum translations in Lindsay and Vergo (1982), 886–898.

———. 1919. O Stsenicheskoi Kompozitsii. *Izobrazitelnoe Iskusstvo* 1: 39–49. [Russian translation of his essay on stage composition; orig. pub. *Der Blaue Reiter* 1912.]

———. [1920] 1933. Programma Instituta Khudozhestvennoi Kultury [Program for the Institute of Artistic Culture], Moscow. In I. Matsa et al., eds. *Sovetskoe iskusstvo za 15 let* (Moscow and Leningrad), 136–137. Trans. in Lindsay and Vergo (1982), 469–470.

———. [June 1921] 1923. Untitled. [Plan for the Physicopsychological Department of the Russian Academy of Artistic Sciences (RAKhN)]. *Iskusstvo. Zhurnal Rossiiskoi Akademii khudozhestvennykh nauk* 1 (Summer): 415–416. Trans. in Bowlt (1976), 196–197.

———. 1926. *Punkt und Linie zu Fläche. Beitrag zur Analyse der malerischen Elemente*. Munich: Albert Langen.

———. 1930. Der Blaue Reiter (Rückblick) [letter to Paul Westheim]. *Das Kunstblatt* 4, no. 2 (February): 57–60. In Bill (1963), 133–138.

———. 1931. Réfléxions sur l'art abstrait. *Cahiers d'art* 1, nos. 7–8: 351–353. Trans. in Lindsay and Vergo (1982), 756–760.

———. 1935a. to retninger [Two Directions]. *Konkretion* (Copenhagen) (15 Sept.): 7–10. Trans. in Lindsay and Vergo (1982), 777–779.

———. 1935b. L'Art aujourd'hui est plus vivant que jamais. *Cahiers d'art* 10, nos. 1–4: 53–56. Trans. in Lindsay and Vergo (1982), 765–771.

———. 1935c. Toile vide, etc. [Empty Canvas, etc.] *Cahiers d'art* 10, nos. 5–6, 117. Trans. in Lindsay and Vergo (1982), 780–783; German trans. as *Leere Leinwand* in Bill (1963), 177–181.

———. 1937. Letter to André Dézarrois, 31 July 1937. Quoted in Derouet and Boissel (1984), 13.

———. July 1937. Tilegnelse af Kunst [Assimilation of Art]. *Linien* (Copenhagen) (July): 2–4. Trans. in Lindsay and Vergo (1982), 799–804.

———. 1937. [Interview Nierendorf-Kandinsky.] Trans. in Lindsay and Vergo (1982), 806–808; German trans. in Bill (1963), 212–215.

———. 1938. L'Art concret. *XXe siècle* 1, no. 1 (March): 9–15. Trans. in Lindsay and Vergo (1982), 814–817.

———. 1938. Mes gravures sur bois. *XXe siècle* 1, no. 3 (July): 31. Trans. in Lindsay and Vergo (1982), 817–818.

———. 1939. La Valeur d'un oeuvre concret. *XXe siècle* nos. 5–6 (Winter–Spring): 48–50. Also in English as: The Value of a Concrete Work. *XXe siècle* [English ed.], second year, no. 1, unpaginated.

Kandinsky, Wassily, and Franz Marc, eds. [1912] 1979. *Der Blaue Reiter*. Munich: Piper. Facsimile repr. after no. 30 of the 1912 edition's Luxus-Ausgabe.

[Kandinsky.] 1982. *Kandinsky in Munich, 1896–1914*. Exhibition catalogue, ed. P. Weiss, with foreword by Carl E. Schorske, essays by Peter Jelavich and Peg Weiss. New York: The Solomon R. Guggenheim Foundation.

[Kandinsky.] 1982. *Kandinsky und München: Begegnungen und Wandlungen, 1896–1914*. Exhibition catalogue, ed. Armin Zweite, with essays by Peter Jelavich, Johannes Langner, Sixten Ringbom, Carl E. Schorske, Peg Weiss and Armin Zweite. Munich: Prestel.

[Kandinsky.] 1983. *Kandinsky: Russian and Bauhaus Years, 1915–1933*. Exhibition catalogue with essay by Clark Poling. New York: The Solomon R. Guggenheim Foundation.

[Kandinsky.] 1985. *Kandinsky in Paris, 1934–1944*. Exhibition catalogue with essays by Vivian E. Barnett and Christian Derouet. New York: The Solomon R. Guggenheim Foundation.

[Kandinsky.] 1989. *Kandinskii, 1866–1944: Katalog Vystavki*. Ed. A. Gusarova and N. Avtonomova. Leningrad: Aurora.

[Kandinsky.] 1989. *Wassily Kandinsky: Die erste sowjetische Retrospektive*. Ed. S. Ebert-Schifferer. Frankfurt: Schirn Kunsthalle.

Kannisto, Artturi. 1906. Über die wogulischer schauspielkunst [sic]. *Zeitschrift für finnisch-ugrische Forschungen* 6: 213–237.

Karásek. 1894. [Review of] Etnograficheskoe Obozrenie. 1889. I–III. *Mittheilungen der Antropologischen Gesellschaft in Wien* 24, no. 14: 93–94.

Karjalainen, K. F. 1914. Alte Bilder zur ob-ugrischen mythologie. *Mémoires de la Société Finno-Ougrienne* 35, no. 5: 1–26.

———. 1921–1927. *Die Religion der Jugra-Völker*. Folklore Fellows Communications 7, no. 41 (pt. 1); 11, no. 44 (pt. 2); 20, no. 63 (pt. 3).

Katz, Michael R. See Herzen [1847] 1984.

Kemenov, V. 1979. *Vasily Surikov*. Leningrad: Aurora Art Publishers.

Kenin-Lopsan, M. B. 1978. The Funeral Rites of Tuva Shamans. In Diószegi and Hoppál (1978), 291–298.

Khangalov, M. N. 1890. Novye Materialy o Shamanstve u Buriat [New Materials on Buriat

Shamanism]. *Zapiski vostochno-sibirskago otdela imperatorskago Russkago Geograficheskago Obshchestva po Etnografii* (Irkutsk) 2, no. 1.

————. 1891–1896. Neskolko dannykh dlia kharakteristiki byta Severnykh Buriat [Some Data on the Characteristic Everyday Life of the Northern Buriats]. *E.O.* 10, no. 3 (1891): 144–165. Iuridicheskie obychai u Buriat [Legal Training among the Buriats]. *E.O.* 21, no. 2 (1894): 100–142. Dukhi-liudoedy u buriat [Folk Spirits of the Buriats]. *E.O.* 28, no. 1 (1896): 129–137.

Khangalov, M. N. *See also* Agapitov and Khangalov (1883); Klements and Khangalov (1910).

Khangalov, M. N., and N. Satoplaeff, eds. 1889. Buriat skazi i poveria [Buriat Tales and Popular Beliefs]. *Zapiski vostochno-sibirskago otdela imperatorskago Russkago Geograficheskago Obshchestva* (Irkutsk) 1, no. 1.

Kharuzin, Nikolai N. 1889. O Noidakh u drevnikh i sovremennykh Loparei [On the Noids (Shamans) among Ancient and Contemporary Lapps]. *E.O.* 1: 36–76. Trans. Robert De Lossa.

————. 1890a. Russkie Lopari [The Russian Lapps]. *Izvestiia Imperatorskago Obshchestva Liubitelei Estestvoznaniia, Antropologii i Etnografii.* Vol. 66. *Trudy Etnograficheskago Otdela* (Moscow) 10.

Kharuzin, Nikolai, ed. 1889–1890b. Sbornik sviedienii izucheniia byta krestianskago naseleniia Rossii [A Collection of Data for the Study of Everyday Life among the Peasant Population of Russia]. *Izvestiia Imperatorskago Obshchestva Liubitelei Estestvoznaniia, Antropologii i Etnografii.* Vols. 61, 69. *Trudy Etnograficheskago Otdela* (Moscow) 9, 11.

————. [N. Kharousine]. [1892] 1893. Etudes sur les anciennes églises russes aux toits en forme de tentes. *Mémoires de la Société Nationale des Antiquaires de France* 53: 84–96 [offprint*].

————. [Obituary]. *See* Miller (1900).

Kharuzina, Vera. [Obituary]. *See* Eleonskaia (1931).

Kharuzina, Vera, and Aleksei Kharuzin, eds. 1901, 1903. *Nikolai Kharuzin, Ethnografiia. Lektsii, Chitannyia v Imperatorskom Moskovskom Universitet.* Vols. 1, 2, 3. St. Petersburg.

Kimball, Edward J., and Peg Weiss. 1983. A Pictorial Analysis of "In the Black Square." *Art Journal* 43 (Spring): 36–40.

Kinzhalov, R. V. 1983. History of the American Collections in the Museum of Anthropology and Ethnography, Leningrad. In Henry Michael and James van Stone, eds., *Cultures of the Bering Sea Region: Papers from an International Symposium,* 311–324. Princeton: International Research and Exchanges Board.

Kirby, W. H. *See* Branch (1985).

Klements, Dmitri. 1890. Neskolko obraztsov bubnov Minusinskikh Inorodtsev [Some Drum Images of the Minusinsk Natives]. *Zapiski Vostochno-Severnoe otdelenie Rossiiskogo geologicheskogo obshchestva po otd. etnografii* (Irkutsk) 2, no. 2: 25–35.

Klements, Dmitri, and M. Khangalov. 1910. Obshchestmennyia okhoty u severnykh Buriat [The Community Hunt among the Northern Buriats]. *Materialy po Etnografii Rossii* 1: 117–154.

Klemm, Gustav. 1844. *Allgemeine Cultur-Geschichte der Menschheit.* Vol. 3. Leipzig.

Klimova, G. N. 1972. Ornamentatsiia Tekstilnykh Izdelii vychegodskikh Komi [Ornamental Textile Handcrafts of the Vychegda Komi]. *Etnografiia i Folklor Komi. Sbornik Statei. Trudy Instituta Iazyka, Literatury i Istorii Komi Filiala* 13: 77–85.

Kodolányi, J. Jr. 1968. Khanty (Ostyak) Sheds for Sacrificial Objects. In Diószegi (1968), 103–106.

Kodrianskaia, Natalia. 1959. *Aleksei Remizov.* Paris.

Kolarz, Walter. 1952. *Russia and Her Colonies.* New York: Praeger.

Kondakov, N. P. *See* Tolstoi and Kondakov (1889–1899).

Kovalevsky, Maxime. 1890. *Tableau des origines et de l'évolution de la famille et de la propriété.* Skrifter no. 2, utgifna af Lorénska Stiftelsen. Publications de l'Institution Lorén. Stockholm: Samson and Wallin.

Kovtun, E. F. 1981. Pisma V. V. Kandinskogo k N. I. Kulbinu [Letters of V. V. Kandinsky to N. I. Kulbin]. In *Pamiatniki Kultury 1980* (Leningrad), 399–410.

Krader, Lawrence. 1978. Shamanism: Theory and History in Buryat Society. In Diószegi and Hoppál (1978), 181–236.

Krahmer, von. 1896. Über jukagirische Briefe. Trans. of Shargorodsky (1896). *Globus* 69: 208–211.

Krickeberg, W. 1925. Malereien auf Ledernen Zeremonial-kleidern der Nordwest Amerikaner. In *Jahrbuch für Prähistorische und Ethnographische Kunst* (Leipzig), 140–150.

Krohn, Julius. 1894. *Suomen Suvun Pakanallinen Jumalanpalvelus* [The Pagan Ritual of the Finnish Tribes]. *Suomalaisen Kirjallisuuden Seuran Toimituksia.* Vol. 1. Helsinki: Suomalaisen Kirjallisuuden Seuran Kirjapainossa.

Krohn, Kaarle. 1906. Lappische beiträge zur germanischen mythologie. *Finnisch-Ugrische Forschungen* 6: 155–180.

Kruglova, O. 1974. *Traditional Russian Carved and Painted Woodwork from the Collection of the State Museum of History and Art in the Zagorsk Reservation.* Moscow: Izobrazitelnoye Iskusstvo Publishers.

Ksenofontov, G. V. [1928] 1955. Legenden und Erzählungen von Schamanen bei Jakuten, Burjaten und Tungusen. In Friedrich and Buddruss (1955), 93–214. [Orig. pub. as *Legendy i rasskazy o shamanakh u iakutov, buriat i tungusov* (Irkutsk, 1928).]

Kuusi, Matti, Keith Bosley, and Michael Branch, eds. and trans. 1977. *Finnish Folk Poetry: Epic.* Helsinki: Finnish Literature Society.

Kuznetzov, S. K. 1893–1897. Über den Glauben vom Jenseits und den Todten-Cultus der Tscheremissen. *Internationales Archiv für Ethnographie* 6: 89–95; 8: 17–23; 9: 153–61; 10: 41–52.

————. 1904. Kult umershikh i zagrobnyia vero-

263

vaniia lugovykh Cheremis [The Cult of the Dead and Beliefs about the Afterlife of the Meadow Cheremis]. *E.O.* 60, no. 1: 67–90; 61, no. 2: 56–109.

———. 1908. Cheremisskaia sekta kugu-sorta [The Cheremis Sect of the Big Candle]. *E.O.* 79, no. 4: 1–59.

Lampl, Horst. 1986. A. M. Remizov: A Short Biographical Essay (1877–1923). *Russian Literature Triquarterly* 19: 7–60.

Landrin, F. 1887. Exposition de M. Joseph Martin, au Musée du Trocadéro. *Revue d'ethnographie* 6: 503–506.

Langner, Johannes. 1977. "Improvisation 13": Zur Funktion des Gegenstandes in Kandinskys Abstraktion. *Jahrbuch der Staatlichen Kunstsammlungen in Baden-Württemberg* 14: 115–146.

———. 1979. "Impression V": Observations sur un thème chez Kandinsky. *Revue de l'art* 45: 53–65.

———. 1982. Gegensätze und Widersprüche— das ist unsere Harmonie—Zu Kandinskys expressionistischer Abstraktion. In Armin Zweite, ed. *Kandinsky und München: Begegnungen und Wandlungen, 1896–1914,* 106–132. Munich: Prestel.

Lankenau, H. v. 1872. Die Schamanen und das Schamanenwesen. *Globus* 22: 278–283.

Lankheit, Klaus, ed. 1965. *Der Blaue Reiter, herausgegeben von Wassily Kandinsky und Franz Marc. Dokumentarische Neuausgabe.* Munich: Piper.

———. 1974. *The Blaue Reiter Almanac,* edited by Wassily Kandinsky and Franz Marc: Documentary Edition. Trans. Henning Falkenstein from 1965 German ed. New York: Viking.

———. 1983. *Wassily Kandinsky–Franz Marc: Briefwechsel.* Munich: Piper.

Lashuk, L. P. 1959. Archeologicheskie Drevnosti Naroda Komi [Archeological Monuments of the Komi People]. In V. K. Kolegov, L. P. Lashuk, and G. A. Chernov, eds. *Pamiatniki Kultury Komi ASSR,* 49–62. Syktyvkar: Komi Knizhnoe Izdatelstvo.

Laufer, Bernard. [1902] 1975. The Decorative Art of the Amur Tribes. In Franz Boas, ed. *The Jesup North Pacific Expedition.* Vol. 4 of *Memoir of the American Museum of Natural History* (New York). Repr. New York: AMS Press.

Lee, Natalie. 1982. Some Russian Sources of Kandinsky's Imagery. *Transactions of the Association of Russian-American Scholars in U.S.A.* 15: 208–212.

Lehmann, W. 1905. Über eine lappländische Zaubertrommel. *Zeitschrift für Ethnologie* 37: 620.

Lehtinen, I. *See* Schellbach and Lehtinen (1983).

Lehtinen, Ildiko, and Jukka Kukkonen, eds. 1980. *Iso Karhu. The Great Bear. Old Photographs of the Volga-Finnic, Permian Finnic and Ob-Ugrian Peoples.* Helsinki: Suomalaisen Kirjallisuuden Seura, Museovirasto.

Lehtisalo, Toivo. 1936–1937. Tod und Wiedergeburt des künftigen Schamanen. *Journal de la Société Finno-Ougrienne* 48: 3–34.

Levin, M. G. [1958] 1963. Physical Anthropology and Ethnogenetic Problems of the Peoples of the Far East. *Trudy Instituta etnografii im. N. N. Miklukho-Maklaya* (Moscow: Publications of The Academy of Sciences of the USSR), n.s. 36. Transactions of the Northeastern Expedition, 2. Trans. Henry N. Michael as *Ethnic Origins of the Peoples of Northeastern Asia.* Arctic Institute of North America Anthropology of the North. Translations from Russian Sources 3. Toronto: University of Toronto Press.

Levin, M. G., and L. Potapov. 1961. *Istorikoetnograficheskii Atlas Sibiri.* Leningrad.

Levin, M. G., and L. Potapov, eds. 1964. *The Peoples of Siberia.* Chicago: University of Chicago Press.

Lindsay, Kenneth C. 1959. [Review of Will Grohmann, *Kandinsky* (New York: Abrams, 1958)]. *Art Bulletin* 61, no. 4: 348–350.

———. 1966. Les Thèmes de l'inconscient. *XXe siècle* 27 (December): 46–52.

———. 1981. Gabriele Münter and Wassily Kandinsky: What They Meant to Each Other. *Arts*

Magazine 54 (December): 56–62.

———. 1985. Kandinsky's Transfigural Impulse. Unpublished essay.

———. 1988. Kandinsky and the Blue Rider: Beyond the Masking of Things. Public lecture (3 Nov.), State University of New York at Cortland.

———. 1989. The Pitfalls of Simultaneity: Kandinsky's All Saints Reconsidered. Lecture, Metropolitan Museum of Art, New York, 17 Oct.

Lindsay, Kenneth C., and Peter Vergo, eds. 1982. *Kandinsky: Complete Writings on Art.* Boston: G. K. Hall.

Lodder, Christina. 1983. *Russian Constructivism.* New Haven and London: Yale University Press.

Lommel, Andreas. 1985. Schamanistische Kunst. *Die Kunst* 10 (October): 802–807.

———. 1967. *The World of the Early Hunters.* London: Evelyn, Adams & Mackay.

[Long], Rose-Carol Washton. 1968. Vasily Kandinsky, 1909–1913: Painting and Theory. Ph.D. diss., Yale University.

———. 1980. *Kandinsky: The Development of an Abstract Style.* Oxford: Oxford University Press.

———. *See also* Bowlt and Long (1982).

Lönnrot, Elias. 1969. *The Old Kalevala and Certain Antecedents, Compiled by Elias Lönnrot.* Prose translations with foreword and appendices by Francis Peabody Magoun, Jr. Cambridge: Harvard University Press.

———. 1989. *The Kalevala: An Epic Poem after Oral Tradition by Elias Lönnrot.* Translated by Keith Bosley, foreword by Albert B. Lord. Oxford: Oxford University Press.

———. 1907 (Kirby trans.) *See also* Branch (1985).

Loorits, Oskar. 1955. Der heilige Georg in der russischen Volksüberlieferung Estlands. *Slavistische Veröffentlichungen* 7. Freie Universität Osteuropa-Institut. Berlin and Wiesbaden: Otto Harrassowitz.

Lot-Falck, Eveline. 1961. A Propos d'un tambour de chaman toungouse. *L'Homme: Revue française d'anthropologie* 1, no. 2: 23–50.

Lytkin, Georgi S. 1889. *Zyrianskii Krai pri epi-skopakh permskikh i zyrianskii iazuk* [Zyrian Territory at the Time of the Episcopate of Perm and the Zyrian Language]. St. Petersburg.

Macke, Wolfgang. 1964. Foreword. In Ernst Brücher and Karl Gutbrod, eds., *August Macke–Franz Marc: Briefwechsel*. Cologne: DuMont Schauberg.

Maksimov, A. N. 1909. Waldemar Bogoras. The Chukchee [The Jesup North Pacific Expedition. *Memoir of the American Museum of Natural History* (New York). Vol. 7.] Leiden-New York 1904–1909. In *E.O.* 81–82, nos. 1–2: 186–189. [Moscow, 1910.]

Manker, Ernst. 1938–1950. *Die lappische Zauber-trommel: Eine ethnologische Monographie.* 2 vols. Stockholm: Acta Lapponica, H. Geber.

———. 1968. Seite Cult and Drum Magic of the Lapps. In Diószegi (1968), 27–40.

Markov, Vladimir I. [pseud. for V. I. Matvei]. [1912] 1976. The Principles of the New Art [Printsipy novogoiskusstva]. *Soyuz molodezhi* [Union of Youth] (St. Petersburg) 1 (April): 5–14; 2 (June): 5–18. Trans. in Bowlt (1976), 23–38.

———. 1914. *Iskusstvo Ostrova Paschi* [The Art of Easter Island]. St. Petersburg: Izdanie o-va Khudozh Soiuz Molodezhi.*

Maslenikov, Oleg A. 1968. *The Frenzied Poets: Andrey Biely and the Russian Symbolists.* New York: Greenwood.

Matthews, Washington. 1888. The Prayer of a Navajo Shaman. *American Anthropologist* 1 (April): 151–163.

Maur, Karin von, ed. 1985. *Vom Klang der Far-ben: Die Musik in der Kunst des 20. Jahrhun-derts.* Munich: Prestel.

McGrady, Patrick John. 1989. An Interpretation of Wassily Kandinsky's *Klänge.* Ph.D. diss. State University of New York at Binghamton.

Messer, Thomas, ed. 1976–1977. *Wassily Kandin-sky: 1866–1944.* Munich: Haus der Kunst.

Michael, Henry N., ed. 1962. *Studies in Siberian Ethnogenesis.* Arctic Institute of North America Anthropology of the North. Translations from Russian Sources 2. Toronto: University of Toronto Press.

———. ed. 1963. *Studies in Siberian Shaman-ism.* Arctic Institute of North America Anthropology of the North: Translations from Russian Sources 4. Toronto: University of Toronto Press.

Mikhailov, M. I. 1850. Ust-Vym, *Vologd.[a] G.[ubernskie] V.[edomosti]*, no. 2.

Mikhailovskii, V. M. 1890. Pervobytnoe iskusstvo i obraznoe pismo (piktografiia) po etnogra-ficheskim dannym [Primitive Art and Graphic Writing (Pictography) as Ethnographic Data]. Lecture at the Eighth Russian Archeologists Congress, Moscow, 1890. Reported in *E.O.* 6, no. 3: 238. *See also* Heger (1890).

———. 1892. Shamanstvo. Sravnitelno-Etnograficheskie Ocherki [Shamanism: Comparative-ethnographic Studies]. *Izvestiia Imperatorskago Obshchestva Liubitelei Estes-tvoznaniia, Antropologii i Etnografii.* Vol. 75. *Trudy Etnograficheskago Otdela* 12, pts. 1 and 2.

———. 1895. Shamanism in Siberia and Euro-pean Russia. *Journal of the Anthropological Institute of Great Britain and Ireland* 24: 62–100; 126–158. [Trans. of Mikhailovskii (1892), pt. 2, by Oliver Wardrop.]

Miller, Vsevolod F. 1887. *Sistematicheskoe Opisanie Kollektsii Dashkovskago Etnogra-ficheskago Muzeia* [Systematic Catalogue of the Dashkov Collections of the Ethnographic Museum]. Vol. 1. Moscow.

———. 1900. Nikolai Nikolaevich Kharuzin [obituary]. *E.O.* 45, no. 2: 1–14.

Mirsky, D. S. 1958. *A History of Russian Litera-ture from Its Beginnings to 1900.* New York: Vintage.

Molotova, L. N. 1981. *Narodnoe iskusstvo Rossii-skoi Federatsii iz sobrannia Gosudarstvennogo muzeia etnografii narodov SSSR* [Folk Art of the Russian Federation from the Ethno-graphical Museum of the Peoples of the USSR]. Leningrad: Khudozhnik RSFSR.

Monod, E. 1890. *L'Exposition Universelle de Paris, 1889.* Vols. 1–4. Paris: E. Dentu, Librairie de la Société des Gens de Lettres.

[Moscow.] 1889–1907. Dashkovskii Etnografi-cheskii Muzei [The Dashkov Ethnographic Museum]. *Otchet Moskovskago Publichnago i Rumiantsovskago Museev za 1886 [-1906] god.* Moscow.

———. 1892. *Congrès International d'Archéol-ogie Préhistorique et d'Anthropologie.* 11th sess. (August). 2 vols. Moscow: Imprimerie de l'Université Impériale. [Vol. 2, 1893.]

———. 1892. *Société Impériale des Amis des Sciences Naturelles, d'Anthropologie et d'Ethnographie Moscou. Congrès Internatio-naux à Moscou* (August). [Pamphlet by the organizing committee, December 1891.] Mos-cow.

———. 1914. *Imperatorskii Rossiiskii Istoriche-skii Muzei imeni Imperatora Aleksandra III v Moskve. Kratkii Putevoditel po Muzeiu.* Moscow.

———. 1916. [Guide to the Ethnographic Mu-seum.] *See* Golitsyn (1916).

Moyle, Natalie K. 1987. Mermaids (Rusalki) and Russian Beliefs about Women. In Anna Lisa Crone and Catherine V. Chvany, eds., *New Studies in Russian Language and Literature,* 221–238. Columbus, Ohio: Slavica.

Müller, Claudius. 1981. *400 Jahre Sammeln und Reisen der Wittelsbacher—Aussereuropäische Kulturen.* Munich: Hirmer.

Munkácsi, Bernhard. 1902, 1903, 1904. Ältere Berichte über das Heidenthum der Wogulen und Ostiaken. *Keleti Szemle* 3 (1902): 273–302; 4 (1903): 85–110, 172–194; 5 (1904): 56–88, 204–227.

———. 1905. Seelenglaube und totenkult der Wogulen. *Keleti Szemle* 6: 65–130.

———. 1906. Götzenbilder und Götzengeister in Volksglauben der Wogulen. *Keleti Szemle* 7: 89–115, 177–226.

———. 1907. "Pilz" und "Rauch." *Keleti Szemle* 8: 343–344.

———. 1907, 1908, 1909. Weltgottheiten der wogulischen Mythologie. *Keleti Szemle* 8

(1907): 94–129; 9 (1908): 206–277; 10 (1909): 61–83.

———. 1921. Sechzigerrechnung und Siebenzahl in den östlichen Zweigen der finnisch-magyarischen Sprachfamilie. *Keleti Szemle* 19, no. 1: 1–24.

Murr, Christoph Gottlieb von. 1801. *Beschreibung der vornehmsten Merkwürdigkeiten in der Reichstadt Nürnberg, in deren Bezirke, und auf der Universität Altdorf. Nebst einem Anhange.* 2d ed. Nürnberg.

Nalimov, Vasilli. 1903a. Nekotoryia cherty iz IAzycheskago Mirosozertsaniia Zyrian [Some Traits of the Pagan Worldview of the Zyrians]. *E.O.* 57, no. 2: 76–86.

———. 1903b. Zyrianskaia Legenda o Pame Shipiche [A Zyrian Legend of Pam Shipicha]. *E.O.* 57, no. 2: 120–124.

———. 1903c. "Mor" i "Ikota" y Zyrian ["Mor" and "Ikota" of the Zyrians]. *E.O.* 58, no. 3: 157–158.

———. 1907a. Zagrobnyi mir po verovaniiam zyrian [The Afterlife World in the Beliefs of the Zyrians]. *E.O.* 72–73: 1–23.

———. 1907b. Georgii Lytkin, 1835–1906. *Finnisch-ugrische Forschungen* 7 (Anzeiger): 77–81.

———. 1908. Zur Frage nach den ursprünglichen Beziehungen der Geschlechter bei den Syrjänen. *Journal de la Société Finno-Ougrienne* 25, no. 4: 1–31.

Nerdinger, Winfried, ed. 1982. *Richard Riemerschmid: Vom Jugendstil zum Werkbund: Werke und Dokumente.* Munich: Prestel.

Newall, Venetia. 1971. *An Egg at Easter: A Folklore Study.* Bloomington: Indiana University Press.

Nioradze, Georg. 1925. *Der Schamanismus bei den sibirischen Völkern.* Stuttgart: Strecker & Schröder.

Nordland, Odd. 1967. Shamanism as an Experiencing of the "Unreal." In Edsman (1967), 167–185.

Nosilov, Konstantin D. 1904. *U Vogulov Ocherki i Nabroski* [Among the Voguls: Essays and Sketches]. St. Petersburg: A. S. Suvorin.

Novik, Elena. [1984] 1990. Ritual and Folklore in Siberian Shamanism: Experiment in a Comparison of Structures: The Archaic Epic and Its Relationship to Ritual. In Marjorie M. Balzer, ed., *Shamanism: Soviet Studies of Traditional Religion in Siberia and Central Asia*, 121–185. Armonk, N.Y.: M. E. Sharpe.

Nyirady, Kenneth. 1989/1990. The Evolution of Komi Grammar Writing in the Nineteenth Century. *Etudes Finno-Ougriennes* 22: 65–82.

Obolensky, Chloe. 1979. *The Russian Empire: A Portrait in Photographs.* New York: Random House.

Oinas, Felix. 1978. The Balto-Finnic Epics. In F. Oinas, ed., *Heroic Epic and Saga*, 293–294. Bloomington: Indiana University Press.

———. 1985. Russian *Poludnica* "Midday spirit." In F. Oinas, *Essays on Russian Folklore and Mythology*, 103–110. Columbus, Ohio: Slavica.

———. 1985. *Studies in Finnic Folklore: Hommage to the Kalevala.* Indiana University Uralic and Altaic Series, vol. 147. Mänttä: Finnish Literature Society.

———. 1987. Shamanistic Components in the *Kalevala*. In Jocelyne Fernandez-Vest, ed., *Kalevale et traditions orales du monde*, 39–52. Paris: Colloques Internationaux du CNRS.

Okladnikov, Alexei. 1981. *Ancient Art of the Amur Region: Rock Drawings, Sculpture, Pottery.* Leningrad: Aurora Art Publishers.

Oplesnin, I., ed. 1959. *Pamiatniki Kultury Komi ASSR* [Monuments of the Culture of the Komi ASSR]. Editorial committee: V. K. Kolegov, L. P. Lashuk, G. A. Chernov. Syktyvkar: Ministerstvo Kultury Komi ASSR.

Paasonen, H. 1909. Über die ursprünglichen Seelenvorstellungen bei den finnisch-ugrischen Völkern und die Benennungen der Seele in ihren Sprachen. *Journal de la Société Finno-Ougrienne* 26, no. 4: 1–26.

Pain, James, and Nicolas Zernov, eds. 1976. *Sergius Bulgakov: A Bulgakov Anthology.* Philadelphia: Westminster Press.

Pallas, Peter Simon. [1771–1776] 1967. *Reise durch verschiedene Provinzen des Russischen Reichs vom Jahr 1772 und 1773.* 3 vols. St. Petersburg: Kaiserliche Akademie der Wissenschaften. Repr. Graz: Akademischen Druck- und-Verlagsanstalt.

Paproth, Hans-Joachim. 1988. Eine lappische Schamanentrommel. *Münchner Beiträge zur Völkerkunde* 1: 269–318.

[Paris.] 1889. *Congrès International d'Anthropologie et d'Archéologie Préhistorique.* 10th sess. (18–27 Aug.). Paris: Imprimerie Nationale.

———. 1890. *Congrès International des Sciences Ethnographiques* (30 Sept.–7 Oct. 1889). Procès-verbaux sommaires. Paris: Imprimerie Nationale.

Parton, Anthony. 1986. Larionov and the Buryat Shaman. Lecture, University of Essex, November, typescript.

Pashkova, A. I., and N. A. Tsagolova, eds. 1959. *Istoria Russkoi Ekonomicheskoi Mysli* [A History of Russian Economic Thought]. Moscow: Izdatelstvo Sotsialno-ekonomicheskoi Literatury.

Patkanov, S. 1897–1900. *Die Irtysch-Ostjaken und ihre Volkspoesie.* Pts. 1 and 2. St. Petersburg.

Paudrat, Jean-Louis. 1984. From Africa. In Rubin (1984), 1:129–164.

Paulson, Ivar. 1959. [Review of *Schamanentum, dargestellt am Beispiel der Besessenheitspriester nordeurasiatischer Völker*, by Hans Findeisen.] *Ethnos* 24, no. 3–4: 223–225.

———. 1961. *Schutzgeister und Gottheiten des Wildes (der Jagdtiere und Fische) in Nordeurasien.* Stockholm Studies in Comparative Religion 2. Stockholm: Almqvist & Wiksell.

———. 1964a. Seelenvorstellungen und Totenglaube der permischen und Wolga-finnischen Völker. *Numen: International Review for the History of Religion* 11, no. 3 (Sept.): 212–242.

———. 1964b. Jenseitsglaube der finnischen Völker. Pt. 1: In der Wolga-finnischen und permischen Volksreligion. *ARV* 20: 125–164.

———. 1964c. Outline of Permian Folk Religion. *Journal of the Folklore Institute* 2: 148–179. Also published as Grundzüge der Wolga-finnischen Volksreligion in *Ural-Altaische Jahrbücher* 36, nos. 1–2: (1965), 104–135.

Pekarskii, E., and V. Vasilev. 1910. Plashch i buben IAkutskago Shamana [Costume and Drum of a Yakut Shamaness]. *Materialy po Etnografii Rossii* 1: 93–116.

Pentikäinen, Juha. 1987. The Shamanic Drum as Cognitive Map—The Historical and Semiotic Study of the Saami Drum in Rome. In René Gothoni and J. Pentikäinen, eds., *Mythology and Cosmic Order*, 17–36. Studia Fennica 32. Helsinki.

Peschel, Oscar. [1874] 1876. *The Races of Man and Their Geographical Distribution*. New York: Appleton. [Orig. German, 1874.]

———. 1885. *Völkerkunde*. 6th ed. by Alfred Kirchhoff. Leipzig: Von Duncker and Humblot.

Piper, Reinhard. 1947. *Vormittag Erinnerungen eines Verlegers*. Munich: Piper.

———. *See also* Heymel (1911) and Buergel-Goodwin and Göbel (1979).

Plaut, Paul. 1929. *Die Psychologie der produktiven Persönlichkeit*. Stuttgart: Verlag von Ferdinand Enke.

Plesovskii, F. V., et al. 1972. *Ethnografiia i Folklor Komi* no. 13. Syktyvkar: Akademiia Nauk SSSR Komi Filial.

Poling, Clark. 1982. *Kandinsky—Unterricht am Bauhaus*. Weingarten: Kunstverlag Weingarten.

———. 1983. Kandinsky: Russian and Bauhaus Years. In [Kandinsky] (1983), 12–83.

Popov, A. A. 1932. *Materialy dlia bibliografiia russkoi Literatury po Izuchenniu shamanstva severo-asiatskikh narodov* [Materials for a Bibliography of the Russian Literature Concerning the Study of Shamanism among the Peoples of Northern Asia]. Leningrad: Izdanie Instituta Narodov Severa TSIK SSSR.

Popov, Klaudius. 1874. *Zyriane i Zyrianskii Krai* [Zyrians and Zyrian Territory]. *Trudy Etnograficheskogo Otdela* 3, no. 2. *Izvestiia Imperatorskogo Obshchestva Liubetelei Estestvoznaniia, Antropologii i Etnografii* 13, no. 2. Moscow.

Potanin, G. N. 1881–1883. *Ocherki Severo-Zapadnoi Mongolii* [Studies of Northwestern Mongolia]. 4 vols. Rezultaty Puteshestviia, ispolnennago v 1876–1877 godakh po poruche-niiu Imperatorskago Russkago Geograficheskago Obshchestva. St. Petersburg.

Potapov, L. P. 1968. Shamans' Drums of Altaic Ethnic Groups. In Diószegi (1968), 205–234.

———. 1976. Certain Aspects of the Study of Siberian Shamanism. In Bharati (1976), 335–344.

———. 1978. The Shaman Drum as a Source of Ethnographical History. In Diószegi and Hoppál (1978), 169–179.

Preston, Douglas J. 1985. From Siberia with Love. *Natural History* 94, no. 6 (June): 86–89.

Priklonskii, V. L. [1886] 1953. Yakut Ethnographic Sketches. Trans. Sheldon Wise. From *Tri goda v IAkutskoi oblasti (Etnograficheskie ocherki). O shamanstve u IAkutov*. In *Zhivaia Starina* 1890–1891 (1, no. 1, pt. 1: 63–77; no. 2, pt. 1: 24–54; no. 3, pt. 1: 48–84; no. 4, pt. 1: 43–66). Human Relations Area Files, pt. 1. New Haven. Orig. pub. in *Izvestiia vostochno-sibirskago otdela imperatorskago russkago geograficheskogo obshchestva* (Irkutsk) 17, no. 1–2.

———. 1888. Das Schamentum der Jakuten. Trans. F. S. Krauss. *Mittheilungen der Anthropologische Gesellschaft in Wien* 18: 165–182.

Prokofiev, G. N. 1940. Tseremonia Ozhivleniia bubna u Ostiako-Samoedov [The Ceremony of Animating the Drum among the Ostiak-Samoyeds]. *Izvestiia Leningradskogo gos. Universiteta Leningrad* 11: 365–374.

Prokofieva, E. D. 1949. Kostium Selkupskogo (Ostiako-samoedskogo) Shamana [Costume of a Selkup (Ostiak-Samoyed) Shamaness]. *Sbornik Muzeia Antropologii i Etnografii* 11: 335–375.

———. 1961. Shamanskie bubny [Shaman Drums]. Translation typescript provided by Henry N. Michael. Orig. pub. in Levin and Potapov (1961), 435–497.

———. 1963. The Costume of an Enets Shaman. In Michael (1963), 124–156.

———. 1971. Shamanskie Kostiumy narodov Sibiri [Shaman Costumes of the Siberian Peoples]. *Sbornik Muzeia Antropologi i Etnografii* 27: 6–100.

Propp, Vladimir I. 1974. The Historical Roots of Some Russian Religious Festivals. In Stephen and Ethel Dunn, eds., *Introduction to Soviet Ethnography*, 2: 367–410. Berkeley, Calif.: Highgate Road Social Science Research Station.

———. 1975. *Down along the Mother Volga: An Anthology of Russian Folk Lyrics*. Ed. and trans. Roberta Reeder. Philadelphia: University of Pennsylvania Press.

Pushkarev, Sergei, et al. 1970. *Dictionary of Russian Historical Terms from the Eleventh Century to 1917*. New Haven and London: Yale University Press.

Qvigstad, J., and G. Sandberg. 1888. Lappische Sprachproben. *Journal de la Société Finno-Ougrienne* 3: 1–110.

Radloff, Wilhelm. [1884] 1968. *Aus Sibirien: Lose Blätter aus meinem Tagebuche*. Leipzig. Rep. from 2d ed. [1893]. Oosterhout: Anthropological Publications.

Radó, Alexander, ed. N.d. [1926?] *Guide-Book to the Soviet Union*. New York: International.

Ränk, Gustav. 1949. *Die heilige Hinterecke im Hauskult der Völker Nordosteuropas und Nordasiens*. Folklore Fellows Communications 137. Helsinki: Academy of Sciences of Finland.

Rannit, Aleksis. 1979. Ten Drawings: Aleksei Remizov. *New Directions in Prose and Poetry* 38: 47–61.

Rédei, Károly. 1970. *Die Syrjänischen Lehnwörter im Wogulischen*. The Hague: Mouton.

Remizov, Aleksei. 1907. *Posolon* [Sunward]. Moscow: Zolotoe Runo (La Toison d'Or).*

———. 1910. *Razskazy* [Tales]. (With ex libris Alexander and Zinaida Eliasberg.) St. Petersburg: Progrès.*

———. 1910. Neuemnyi buben [The Indefatigable Drum]. In *Sochineniia*. Vol. 1. St. Petersburg: Izd. Shipovnik.

———. [1910–1912] 1971. *Posolon* [Sunward]. Munich: Wilhelm Fink [Repr. of vol. 6 of the Collected Works, orig. pub. St. Petersburg.]

——— [Aleksej Remisow]. 1917. *Prinzessin Mymra. Novellen und Träume*. Trans. Alexander Eliasberg. Weimar: Gustav Kiepenheuer.

————. 1924. *Zvenigorod Oklikannyi. Nikoliny pritchi* [Echoes of Zvenigorod: St. Nicholas's Parables]. Paris: Alatas.

————. 1937. Letter to Vasilii Kandinsky. 3 Feb. 1937. In Derouet and Boissel (1984), 362.

Ringbom, Sixten. 1966. Art in "the Epoch of the Great Spiritual": Occult Elements in the Early Theory of Abstract Painting. *Journal of the Warburg and Courtauld Institutes* 29: 386–418.

————. 1970. *The Sounding Cosmos: A Study in the Spiritualism of Kandinsky and the Genesis of Abstract Painting*. Helsinki: Abo Akademi.

————. 1986. Transcending the Visible: The Generation of the Abstract Pioneers. In *The Spiritual in Art: Abstract Painting, 1890–1985* (exhibition catalogue), 131–153. Los Angeles: The Los Angeles County Museum of Art. New York: Abbeville.

Roethel, Hans K. 1970. *Kandinsky: Das graphische Werk*. Cologne: DuMont.

————. 1976. Kandinsky: Improvisation "Klamm": Etudes préliminaires d'une interprétation. In *Wassily Kandinsky à Munich: Collection Städtische Galerie im Lenbachhaus* (exhibition catalogue), 49–52. Bordeaux: Galerie des Beaux-Arts.

Roethel, Hans K., and Jelena Hahl-Koch, eds. 1980. *Kandinsky: Die gesammelten Schriften*. Vol. 1. Bern: Benteli.

Roethel, Hans K., and Jean Benjamin, eds. 1982. *Kandinsky: Catalogue Raisonné of the Oil-Paintings*. 2 vols. Ithaca: Cornell University Press.

Roheim, Géza. 1954. *Hungarian and Vogul Mythology*. Monographs of the American Ethnological Society. Locust Valley: J. J. Augustin.

Rosenblum, Robert. 1975. *Modern Painting and the Northern Romantic Tradition: Friedrich to Rothko*. New York: Harper & Row.

Rosenthal, Charlotte. 1980. *Aleksej Remizov and the Literary Uses of Folklore*. Ph.D. diss., Stanford University.

————. 1986. Remizov's Sunwise and *Leimonarium*: Folklore in Modernist Prose. *Russian Literature Triquarterly* 19: 95–111.

————. 1987. Primitivism in Remizov's Early Short Works (1900–1903). In Slobin (1987), 195–205.

Rubin, William, ed. 1984. *"Primitivism" in Twentieth-century Art: Affinity of the Tribal and the Modern*. 2 vols. New York: The Museum of Modern Art.

Rudenko, S. 1927. Graficheskoe iskusstvo Ostiakov i Vogulov [Graphic Art of the Ostiaks and Voguls]. *Materialy po Etnografii* 4: 13–40.

Rudenstine, Angelica. 1976. *The Guggenheim Museum Collection: Paintings, 1880–1945*. 2 vols. New York: The Solomon R. Guggenheim Museum.

Rudenstine, Angelica, ed. 1981. *The George Costakis Collection: Russian Avant-Garde Art*. New York: Abrams.

[St. Petersburg.] 1904. *Putevoditel po muszeiu Antropologii i Etnografii imeni Imperatora Petra Velikago* [Guide to the Museum of Anthropology and Ethnography of Peter the Great]. Imperatorskaia Akademiia Nauk. Otdel Etnograficheskii.

Savvaitov, Pavel I. 1850. *Zyriansko-Russkii i Russko-Zyrianskii Slovar*. St. Petersburg: Akademiia Nauk.

Schefferus [Scheffer], Johannes. 1673. *Lapponia*. Frankfurt. Eng. trans. as *The History of Lapland*. Oxford: George West and Amos Curtein (1674).

Scheffler, Karl. 1932. Altamerikanische Kunst. *Kunst und Künstler* (January): 26–30.

Schellbach, Ingrid, and Ildikó Lehtinen, eds. 1983. *U. T. Sirelius: Reise zu den Ostjaken*. Travaux ethnographiques de la Société Finno-Ougrienne 11. Helsinki.

Schermann, Lucian. Letter to W. Kandinsky, 2 Nov. 1912. Staatliches Museum für Völkerkunde, Munich.

Schermann, Lucian, ed. 1908. Berichte des Kgl. Ethnographischen Museums in München 1 (1908). Repr. from *Münchner Jahrbuch der bildenden Kunst* (1909), 1. Halbband, 79–86. Munich: Georg D. W. Callwey.

————. 1909. Berichte des Kgl. Ethnogra-

phischen Museums in München 2 (1909). Repr. from *Münchner Jahrbuch der bildenden Kunst* (1910), 1. Halbband, 115–125. Munich: Georg D. W. Callwey.

————. 1910. Berichte des Kgl. Ethnographischen Museums in München 3 (1910). Sonderabdruck aus dem *Münchner Jahrbuch der bildenden Kunst* (1911), 1. Halbband, 143–161. Munich: Georg D. W. Callwey.

————. 1911. Berichte des K. Ethnographischen Museums in München 4 (1911). Repr. from *Münchner Jahrbuch der bildenden Kunst* (1912), 1. Halbband, 83–103 (with Walter Lehmann). Munich: Georg D. W. Callwey.

Schilling, Susan. 1982. On Stylization and the Use of Folktale Material in A. M. Remizov's *Posolon*. Ph.D. diss., Brown University.

Sebeok, Thomas, and Frances J. Ingemann. 1956. *Studies in Cheremis: The Supernatural*. Viking Fund Publications in Anthropology 22. New York: Gren Foundation for Anthropological Research.

Seidlitz, N. v. 1890. Ethnographische Rundschau [review of the third number of *Etnograficheskoe Obozrenie*]. *Internationales Archiv für Ethnographie* 3: 247.

Sers, Philippe, ed. 1975. *Wassily Kandinsky: Ecrits complets*. Paris: Denoël.

Setälä, E. N. 1910. Die Übersetzungen und Übersetzer des Kalevalas. *Finnisch-Ugrische Forschungen* 10, nos. 1–3 (Anzeiger): 1–39.

Shabad, Theodor. 1951. *Geography of the USSR: A Regional Survey*. New York: Columbia University Press.

Shane, Alex M. 1972. A Prisoner of Fate: Remizov's Short Fiction. *Russian Literature Triquarterly* 4: 303–318.

————. 1973. An Introduction to Alexei Remizov. *TriQuarterly* 28: 10–22.

Shargorodskii, S. M. 1895. Ob IUkagirskikh Pismenakh [On Yukaghir Letters]. *Zemlevedenie. Periodicheskoe izdanie Geograficheskago Otdelenia Imperatorskago Obshchestva Liubitelei Estestvoznaniia, Antropologii i Etnografii*, 2–3: 135–148 (pls. 1–6). Moscow: A. I. Mamentova.

———. 1896. Über jukagirische Briefe. Trans. von Krahmer. *Globus* 69: 208–211.

Shatz, Marshall S., and Judith E. Zimmerman, trans. and eds. 1986. *Signposts: A Collection of Articles on the Russian Intelligentsia.* Irvine: Charles Schlacks, Jr.

Shein, V. 1887. *Materialy dlia izucheniia byta i iazyka russkogo naseleniia severo-zapadnogo kraia* [Materials for the Study of the Daily Life and Language of the Russian Population of the Northwestern District]. St. Petersburg.

Sheppard, Richard. 1990. Kandinsky's Oeuvre, 1900–14: The Avant-garde as Rear-guard. *Word & Image* 6, no. 1 (Jan.–March): 41–67.

Shimkevich, P. P. 1897. Nekotorye momenty iz zhizni goldov i sviazannyia s zhizniu sueveriia. Obychai, poveria i predaniia goldov [Customs, Beliefs, and Some Moments in the Life of the Goldis and the Superstitions among Them: Customs, Beliefs, and Traditions of the Goldis]. *E.O.* 34, no. 3: 1–20; 135–147.

Shirokogoroff, S. M. 1935. *Psychomental Complex of the Tungus.* London: Kegan Paul, Trench, Trubner.

Shumikhin, S. V. 1983. Pisma V. V. Kandinskogo k A. I. Chuprovu [Letters of V. V. Kandinsky to A. I. Chuprov]. In *Pamiatniki Kultury Novye Otkrytiia Pismennost Iskusstvo Archeologiia Ezhegodnik 1981*, 337–344. Leningrad: Izdatelstvo Nauka.

Siebert, Erna, and Werner Forman. 1967. *North American Indian Art Masks, Amulets, Wood Carvings and Ceremonial Dress from the North-West Coast.* London: Paul Hamlyn.

Sieroschevski, W. 1901. The Yakuts. Translated and abridged from Russian (1896) by W. G. Sumner. *Journal of the Anthropological Institute of Great Britain and Ireland* 31: 65–110.

Siikala, Anna Leena. 1978. *The Rite Technique of the Siberian Shaman.* Helsinki: Finnish Academy of Science and Letters.

Silverman, Debora L. 1977. The 1889 Exhibition: The Crisis of Bourgeois Individualism. In *Oppositions; A Journal for Ideas and Criticism in Architecture* 8 (Spring): 71–91.

Simirenko, Alex, ed. 1966. *Soviet Sociology: Historical Antecedents and Current Appraisals.* Chicago: Quadrangle.

Simoncsics, P. 1978. The Structure of a Nenets Magic Chant. In Diószegi and Hoppál (1978), 387–402.

Sinany, Héléne, ed. 1978. *Bibliographie des oeuvres d'Alexis Remizov.* Paris: Institut d'Etudes Slaves.

Sirelius, U. T. 1904. *Ornamente auf Birkenrinde und Fell bei den Ostjaken und Wogulen.* Helsinki: Suomalis-Ugrilainen Seura.

———. 1906–1910. Über die primitiven Wohnungen der finnischen und Ob-ugrischen Völker. *Finnisch-ugrische Forschungen* 6: 74–104; 121–154; 7: 55–128; 8: 8–59; 9: 17–113; 11: 23–122.

———. 1928. Die syrjänische Wohnung in ihren verschiedenen entwicklungsstadien. *Journal de la Société Finno-ougrienne* 58: 331–365.

———. *See also Schellbach and Lehtinen (1983).*

Sivkova, K. V., A. A. Zimina, and L. I. Surinoi, eds. 1955. *Ocherki po Istorii Komi.* Vol. 1. Syktyvkar: Komi Knizhnoe Izdatelstvo.

Sjögren, Joh. Andreas. 1861. *Gesammelte Schriften.* Vol. 1. *Historisch-ethnographische Abhandlungen über den finnisch-russischen Norden.* St. Petersburg: Eggers.

Slobin, Greta, ed. 1987. *Aleksej Remizov: Approaches to a Protean Writer.* Columbus, Ohio: Slavica.

Smoljak, A. V. 1978. Some Notions of the Human Soul among the Nanais. In Diószegi and Hoppál (1978), 439–448.

Sokolova, Z. P. 1978. The Representation of a Female Spirit from the Kazym River. In Diószegi and Hoppál (1978), 491–501.

Sommarström, Bo. 1985. Pointers and Clues to Some Saami Drum Problems. In Bäckman and Hultkranz (1985), 139–156.

Sommier, Stephen. 1885. *Un "Estate" in Siberia fra Ostiacchi, Samoiedi, Siriéni, Tartári, Kirkhisi e Baskiri.* Florence: Ermanno Loescher.

———. 1887. *Sirieni Ostiacchi e Samoiedi dell' Ob.* Estratto dall' Archivo per l'Antropologia e la Etnologia 17, nos. 1 and 2. Florence.

Sorokin, Pitirim Alexandrovich. 1963. *A Long Journey: The Autobiography of Pitirim A. Sorokin.* New Haven: College and University Press.

———. 1910. Perezhitki animizma u zyrian [Vestiges of Animism among the Zyrians]. Trans. Rob De Lossa (typescript). *Izvestiia Arkhangelskogo obshchestva izucheniia Russkago Severa* 20: 49–62; 22: 39–47.

———. 1911. Sovremennye Zyriane [Contemporary Zyrians]. Trans. summary by Rob De Lossa (typescript). *Izvestiia Arkhangelskogo obshchestva izucheniia Russkago Severa* 18: 525–536; 22: 811–820; 23: 876–885; 24: 941–949.

Spencer, Herbert. [1876] 1882. *The Principles of Sociology.* Vol. 1. (Vol. 2, 1893; Vol. 3, 1896.) New York: Appleton.

Spitsyn, A. A. 1899. Shamanisme v otnoshenii k russkoi arkheologii [Shamanism in Relation to Russian Archeology]. *Zapiski imperatorskago Russkago Arkheologicheskago Obshchestva* n.s. 11, nos. 1–2: 167–176.

———. 1906. Shamanskie izobrazheniia [Shamanist Images]. *Zapiski Otdeleniia Russkoi i Slavianskoi Arkheologii imperatorskago Russkago Arkheologicheskago Obshchestva* 8: 29–145 (illus.). St. Petersburg.

Springfeldt, Björn, ed. 1990. *New Perspectives on Kandinsky.* With essays by Bengt Lärkner, Peter Vergo, Natasja Avtonomova, Vivian Endicott Barnett, Christian Derouet, Pontus Hulten and Thomas M. Messer. Malmö: Malmö Konsthall Sydsvenska Dagbladet.

Staniukovich, T. V. 1978. *Ethnograficheskaia Nauka i Muzei* [Ethnographic Science and Museums]. Leningrad: Nauk.

Stein, Susan. 1980. The Ultimate Synthesis: An Interpretation of the Meaning and Significance of Wassily Kandinsky's *The Yellow Sound.* Master's thesis, State University of New York at Binghamton.

———. 1983. Kandinsky and the Abstract Stage Composition: Practice and Theory, 1909–12. *Art Journal* 43, no. 1: 61–66.

Stella, Frank. 1984. Commentaire du tableau Complexité simple-Ambiguité [sic]. In *Kandinsky: Album de l'exposition* (exhibition catalogue), 84–90. Paris: Musée National d'Art Moderne, Centre Georges Pompidou.

Strmecki, Joseph. 1955. *The Zyrians (Komi)*. New Haven: Human Relations Area Files.

Stuckenschmidt, Hans Heinz. 1985. Musik am Bauhaus. In von Maur (1985), 408–413.

Succession de Madame Nina Kandinsky (auction catalogue). 1983. Hotel de Ville de Puteaux, 16 June 1983, no. 122. Paris.

Sumtsov, N. F. 1889. Simbolika krasnago tsveta [Symbolism of the Color Red]. *E.O.* 3: 128–131.

Teriukov, Alexander I. 1977. Pogrebalnyi Obriad Pechorskikh Komi [Funerary Customs of the Pechora Komi]. In *Polevye Issledovaniia Instituta Etnografii* (1979), 80–86. Moscow: Nauka.

———. 1983. K Istorii Izucheniia Pogrebalnogo Obriada Komi-Zyrian [A History of Research on the Funerary Rites of the Komi-Zyrians]. In R. V. Kinzhalov et al., eds., *Kratkoe Soderzhanie Dokladov Nauchnoi Sessii, Posviashchennoi Osnovnym Itogam Raboty v Desiatoi Piatiletke*, 79–80. Leningrad: Nauka.

Thürlemann, Felix. 1986. *Kandinsky Über Kandinsky*. Schriftenreihe der Stiftung von Schnyder von Wartensee 54. Bern: Benteli.

Tolstoi, Ivan, and Nikodim Pavlovich Kondakov. 1889–1899. *Russkiia Drevnosti v Pamiatnikakh Iskusstva* [Russian Antiquities and Monuments of Art]. Vols. 1–6. St. Petersburg: A. Benke. (* Vols. 1–4.)

Tolstoi, Jean, N. Kondakof, and S. Reinach. 1891. *Antiquités de la Russie Méridionale*. Paris: Ernest Leroux.

Treadgold, Donald W. 1964. *The Development of the USSR: An Exchange of Views*. Seattle: University of Washington Press.

———. 1979. Introduction. In Bulgakov ([1906] 1979), 11–33.

Umanskii, Konstantin. 1920a. *Neue Kunst in Russland, 1914–1919*. Potsdam and Munich: Kiepenheuer and Goltz.

———. 1920b. Kandinskijs Rolle im russischen Kunstleben. *Der Ararat* April–May: 28–30.

Unbegaun, Boris O. 1972. *Russian Surnames*. Oxford: Oxford University Press.

Uvachan, V. N. 1975. *The Peoples of the North and Their Road to Socialism*. Trans. Sergei Shcherbovich. Moscow: Progress.

Vajnshtejn, S. I. 1968. The Tuvan (Soyot) Shaman's Drum, and the Ceremony of Its Enlivening. In Diószegi (1968), 331–38.

Vasilevich, G. M. 1968. The Acquisition of Shamanistic Ability among the Evenki (Tungus). In Diószegi (1968), 339–349.

Vasiliev, Victor. 1909. Ein tungusisches Schamanengrab. *Globus* 96: 314–317 (illus.).

———. 1910a. Kratkii ocherk byta Karagasov [A Brief Sketch of the Daily Life of Karagas Women]. *E.O.* 84–85, nos. 1–2: 46–76 (illus.).

———. 1910b. Shamanskii Kostium i buben u IAkutov [A Shaman Costume and Drum of the Yakuts]. With French summary. *Sbornik Muzeia po Antropologi i Etnografii* 8: 1–47 (illus.). [Lecture first presented to Ethnographic Society, 31 Oct. 1907.]

———. *See also* Pekarskii and Vasiliev (1910).

Verbov, G. D. 1968. Funeral Rites among the Enets [Yenisei Samoyeds]. In Diószegi (1968), 123–124.

Vernadsky, George. 1959. *The Origins of Russia*. Oxford: Oxford University Press.

———. 1964. *A History of Russia*. Vol. 1. Ancient Russia. New Haven and London: Yale University Press.

———. 1969. *A History of Russia*. Rev. ed. New Haven and London: Yale University Press.

Vinnen, Carl. 1911. *Protest deutscher Künstler*. Jena: Eugen Diederichs.

Voigt, V. 1978. Shamanism in North Eurasia as a Scope of Ethnology. In Diószegi and Hoppál (1978), 59–80.

Volboudt, Pierre. 1974. *Die Zeichnungen Wassily Kandinskys*. Cologne: M. DuMont Schauberg.

Vucinich, Alexander. 1976. *Social Thought in Tsarist Russia: The Quest for a General Science of Society, 1861–1917*. Chicago and London: University of Chicago Press.

Vuorela, Toivo. 1964. *The Finno-Ugric Peoples*. Trans. John Atkinson. Vol. 39 of Indiana University Uralic and Altaic Series, project 75. Bloomington and The Hague: Indiana University and Mouton.

Vzdornov, G. 1978. *Vologda: Art of Ancient Vologda*. Leningrad: Aurora Art Publishers.

Warner, Elizabeth A. 1977. *The Russian Folk Theatre*. The Hague and Paris: Mouton.

———. 1985. *Heroes, Monsters and Other Worlds from Russian Mythology*. New York: Schocken.

Washton, Rose-Carol. *See under* Rose-Carol Washton Long.

Wasson, R. Gordon. 1960. *Soma Divine Mushroom of Immortality*. New York: Harcourt, Brace, Jovanovich.

Weidemann, Hermann. 1922. *Zauberquadrate und andere magische Zahlenfiguren der Ebene und des Raumes*. Leipzig: Oskar Leiner.*

Weinitz, Franz. 1910. Die lappische Zaubertrommel in Meiningen. *Zeitschrift für Ethnologie* 42, no. 1: 1–14.

Weiss, Peg. 1979. *Kandinsky in Munich: The Formative Jugendstil Years*. Princeton: Princeton University Press.

———. 1982a. Kandinsky in Munich: Encounters and Transformations, ed., P. Weiss. In *Kandinsky in Munich, 1896–1914* (New York: The Solomon R. Guggenheim Foundation, 1982), 28–82.

———. 1982b. Kandinsky in München: Begegnungen und Wandlungen. In *Kandinsky und München, 1896–1914* (Munich: Prestel, 1982), 29–83.

———. 1983. *See* Kimball and Weiss (1983).

———. 1984. Books in Review. *Art Journal* 44, no. 1 (Spring): 91–99.

———. 1985. Kandinsky and the Symbolist Heritage. *Art Journal* 45, no. 2 (Summer): 137–45.

———. October and December 1985. Kandinsky and "Old Russia"—An Ethnographic Exploration. Lecture, Syracuse University and State University of New York, Binghamton.

———. 1986. Kandinsky and "Old Russia"—An Ethnographic Exploration. *Syracuse Scholar* 7, no. 1 (Spring): 43–62.

———. 1986. Kandinsky and "Old Russia"—An Ethnographic Exploration. Lecture, University of Essex, 20 Nov.; St. Andrews University, Scotland, November.

———. 1987. Kandinsky and "Old Russia"—An Ethnographic Exploration. In Gabriel Weisberg and Laurinda Dixon, eds., *The Documented Image—Visions in Art History* [Festschrift for Elizabeth Gilmore Holt], 187–222. Syracuse: Syracuse University Press.

———. October 1988. Kandinsky and Modernism in Munich. Lecture, Philadelphia Museum of Art.

———. 1990a. Kandinsky's *Lady in Moscow*: Occult Patchwork or Chekhov's Dog? In Susan A. Stein and George D. McKee, eds., *Album Amicorum Kenneth C. Lindsay*, 313–325. Binghamton: MRTS State University of New York at Binghamton.

———. 1990b. Kandinsky: The Artist as Ethnographer. *Münchner Beiträge zur Völkerkunde* 3: 285–329. Munich: Hirmer.

———. 1990c. Kandinsky's Ethnographic *Klänge*. Lecture, Arnold Schoenberg Institute, University of Southern California, 13 March.

———. 1990d. Kandinsky and Shamanism. Lecture, American Association for the Advancement of Slavic Studies, Washington, D.C., October.

———. 1991. Evolving Perceptions of Kandinsky and Schoenberg in the Twentieth Century: Toward the Ethnic Roots of the "Outsider" [paper presented at the Arnold Schoenberg Institute, University of Southern California, November]. In Julie Brand, Christopher Hailey, and Leonard Stein, eds., *Constructive Dissonance: Arnold Schoenberg and Transformations of Twentieth Century Culture: Vienna, Berlin, Los Angeles*. Los Angeles: University of California Press [forthcoming].

———. July 1992. Kandinsky's Shamanic Emigrations. In *Acts of the Twenty-eighth International Congress of the History of Art* 1: 187–202.

———. 1994. Interpreting Kandinsky's Iconography: Sources in Ethnography and Shamanism. *Papers in Art History from The Pennsylvania State University* 9.

Werenskiold, Marit. 1989. Kandinsky's Moscow. *Art in America* March: 96–111.

Weule, Karl. 1915. *Vom Kerbstock zum Alphabet.* Stuttgart: Kosmos.

Wichmann, Yrjö. 1902. Kurzer Bericht über eine Studienreise zu den Syrjänen 1901–1902. *Journal de la Société Finno-Ougrienne* 21: 3–47.

———. 1916. *Syrjänische Volksdichtung.* Helsinki: Société Finno-Ougrienne.

Wiedemann, F. J. [1880] 1964. *Syrjänisch-Deutsches Wörterbuch nebst einem Wotjakisch-Deutschen im Anhange und einem deutschen Register.* St. Petersburg. Repr. Indiana University Uralic and Altaic Series 40. Bloomington: Indiana University Press and The Hague: Mouton.

Wildenstein, Daniel. 1979. *Claude Monet: Biographie et catalogue raisonné.* Vol. 3. *1887–1898: Peintures.* Paris: Bibliothèque des Arts.

Wilson, William A. 1978. The *Kalevala* and Finnish Politics. In F. Oinas, ed., *Folklore, Nationalism, and Politics*, 51–75. Columbus, Ohio: Slavica.

Woldt, A. 1888. Die Kultusgegenstände der Golden und Giljaken. *Internationales Archiv für Etnographie* 1: 92–107 (illus.).

Wolfram, Richard. 1968. *Die gekreuzten Pferdeköpfe als Giebelzeichen.* Veröffentlichungen des Instituts für Volkskunde an der Universität Wien 3. Vienna: A. Schendl.

Zelenin, Dmitrij. 1927. *Russische (Ostslavische) Volkskunde.* Berlin und Leipzig: Walter de Gruyter.

Zenkovsky, Serge A. 1974. *Medieval Russia's Epics, Chronicles and Tales.* New York: Dutton.

index

index

Page numbers for illustrations are in *italic*.

Abrikosov family triptych, 120
Abstraction, issues related to: "concrete" vs. "abstract," as terms, *xv*, 249n7; contradictions in concept of, *xiv–xv;* as formalist myth, *xiv–xv;* Kandinsky on, *xiv–xv,* 177, 249n7; Kandinsky as "first" abstract painter, *xv;* Kandinsky's invented pictographs and, 87–90; *Klänge* and, 110; Lapp shaman drums and, 81–85; "readings" of Kandinsky's work and, *xv,* 212n9; shamanic drums and, 153–73, 233n37; on Siberian shaman drums, 80–81; in Tlingit design, 160; as Western concept, *xiv. See also* Pictography and hieroglyphic figures
Activism. *See* Avant-garde movement, Russian;

New Artists' Society; Phalanx society; Political and social issues
Ahlquist, August, 11, 18, 49, 109, 225n48
Akkas (Lapp childbirth goddesses), 103
Aleutian culture, artifacts of, 133
Altaic culture: belief in World Tree, 159, 200, 202–03; checkerboard motif and, 243n2; deity motif and, 156. *See also* Shaman(ess); Shaman drums
Alter ego motif. *See* Egori the Brave; Kandinsky, Vasilii (artistic works): *St. George* paintings
American Indian culture: artifacts of, 133, 160, *197;* Kandinsky's knowledge of, 251n32; motifs of, in *The Arrow,* 195–97; picture writing of, 87
Amulet motif: in *Around the Circle,* 193–94,

207; in *The Arrow,* 197; diamond form of, 252n47; in *Dominant Curve,* 184; in *Dominant Violet,* 181; in *The Ensemble,* 189; in *The Green Bond,* 202; in *Untitled* (1944; "next to last watercolor"), 189–91; in *Untitled* (1944; unfinished watercolor), 208; in *The White Line,* 183
Amulets, 85, *197, 203*
Ancestor worship, 23–25, 27, 111. See also *Ort; Zyrian* culture
Andreevskaia, Nina. *See* Kandinsky, Nina
Angel motif, 103, 206, 253n56
Anti-Semitism, 148
Anuchin, Dmitri N., 207–08
Apache artifacts, 197
Archeology: Anuchin, Kondakov, and Spitsyn as

sources for, 206–08, 253–54nn64, 65; Chudic burial mounds, Kandinsky's interest in, 12, 18–19, 22; Chudic cast-bronze birds, 206–08; in *Fragments*, 253n61; in *Motley Life*, 49, 52. *See also* Ethnography: Kandinsky's writings on

Architectural motif, Old Russian, and *Hut of Baba Yaga*, 167. *See also* Crossed-horseheads motif

Arrow motif: in *Around the Circle*, 193; in *The Arrow*, 195, 197, 251n39; in *Dusk*, 250n43; in *Floating*, 183; in *Hut of Baba Yaga*, 167; in *Tempered Elan*, 206. *See also* Gan flies motif

Arrows of destruction and disease (Lapp). *See* Gan flies motif

Artifact, primitive, and contemporary art, *xiv–xv*, 92–93

Artist as shaman, 27, 71–112; "artist-in-his-studio" paintings and, 180–85; artist's canvas as analogue for drum and, 87, 156; ecstasy and, 108; Kandinsky's identification with St. George and, 72, 87; Kandinsky's self-concept as shaman and, *xvii*, 74, 79, 100, 106, 111–12, 121, 185–88; in Kandinsky's shaman drum paintings, 163–73; Kandinsky's shamanic illness and, 74–76; *khubilgan* imagery in *Tempered Elan* and, 208; mediation and, 72, 79; shamanic drum as vehicle and, 79

Artistic activism. *See* Avant-garde movement, Russian; New Artists' Society; Phalanx society; Political and social issues

Assemblage. *See* Fragmentation and assemblage

Avant-garde movement, Russian, 52, 56, 97, 108, 128

Azbé, Anton, 34, 35

Baba Yaga, tale of, 167
Bachofen, J. J., 29
Bagatelle paintings, series of, 114–20
Bai-Ülgön (Altaic god), 185, 203
Balloon motif, 199
Bauhaus, *xiv*, 66, 120, 138, 142, 174
Bavarian "miracle" paintings, in *The Blue Rider*, 94, 99
Bavarian mirror painting of St. Martin, 97

Bavarian reverse paintings on glass. *See* Reverse paintings on glass

"Beautiful corner." *See* Icon corner

Bells, on shaman costume, 85

Biomorphism, *xiv*; in *Ambiguity (Complexity Simple)*, 180; development of, in Kandinsky's work, 150; in *Diverse Parts*, 182; in *Hard but Soft*, 150; in *Ruled Accumulation*, 186; in St. George/shaman/artist cluster, 249n13; in *Sky Blue*, 188; in *Tempered Elan*, 205; in *Three*, 206; in *Untitled* (ca. 1934; mixed media), 176; in *Watercolor No. 23*, 142; in *The White Line*, 178

Birch tree: in horse-stick carving, 75, 77; in *Lyrical Oval*, 164; as motif, 111, 186; as sacred among Finno-Ugric peoples, 26, 111, 218n59, 220n78; symbolism of, 36, 40, 164, 220n78, 223nn25, 30. *See also* Tree

Bird: Anuchin on, 207–08; artifacts in museum collections, 133, 160; associated with *khubil-gan* figure, 206; burial customs and, 206, 253n49; images of, as sacred amulets, *207;* in *Kalevala*, 186; Kondakov on, 207, 208; mosaic panel at Palatine Chapel in Palermo, *208;* as portent of death, 207; as sacred among Finno-Ugric peoples, 160, 207; shaman costumes and, 85, 87. *See also* Bird-man

—as motif: in *Around the Circle*, 193, 195; in *Brown Elan*, 197; in *Composition X*, 189; in *Development in Brown*, 174; development of, 150; in *Dominant Curve*, 184; and doorway motif, 251n37; in *Firebird*, 117; in *The Green Bond*, 202; in *On White II*, 146; in *Oval No. 2*, 159, 160; in *Red Oval*, 138; in *Ruled Accumulation*, 186; in *Tempered Elan*, 206; in *Untitled* (ca. 1934; mixed media), 176

Bird-as-soul-form motif: in *Diverse Parts*, 182; Finno-Ugric belief systems and, 138, 159, 207, 242n54, 246n36; in *Le Filet*, 193; in *The Green Bond*, 202; in *In the Gray*, 132; in *Oval No. 2*, 160; in *Red Accent*, 198; in *Tempered Elan*, 206; in *Whispered*, 162

Bird-man, 80, 207–08

Black, significance of, 148, 197

Blaue Reiter, Der almanac. See *Blue Rider, The* almanac

Blue, significance of, 94, 160

Blue arc motif, 128, 151

Blue cornflower *(Poludnitsa-Sin)*, 26, 219n63

Blue Rider, The almanac (*Der Blaue Reiter;* Kandinsky), 35, 70, 72; and *Composition V,* 105; concept and purpose of, 92–99; correspondence with Franz Marc on, 97; cultural healing and, *xiv,* 94, 99, 104–06, 110; dissolving of, 113; ethnic artifacts illustrated in, 92–93; ethnography and, 234n45; Macke essay on masks and, 94, 106; "On Stage Composition" essay, 99, 106; Schoenberg and, 108–09; as shamanic metaphor, 72, 92–99; social and political message of, 97–99; *The Yellow Sound* in, 106, 108–10

—illustrations in: almanac cover, 1914 ed., *76;* Bavarian "miracle" paintings, 94, 99; Cameroons house post, 94, *96;* Ceylonese dance mask, 94, 106, *107,* 110; choice of ethnic artifacts in, *xvi, xvii,* 67, 69–70, 92–93; *Composition V,* 99, 103, *104,* 105–06; Easter Island ancestor figure, 94, *96;* Egyptian shadow play figures, 103, 110; frontispiece, 65; *Lyrical,* 87–*88;* placement of, in relation to text, 97, 234n52; Russian *lubki,* 110; St. George's Day *lubok,* 97, *98;* St. Luke, reverse painting on glass, 94, *103;* St. Martin, 97; Schoenberg self-portrait, 108; Tlingit dancer's cape, 69, *95;* van Gogh's *Portrait of Dr. Gachet,* 99, 105; Zipe Totec (Aztec god), 106

Boat motif: in *Black Accompaniment*, 148; in *The Blue Arc*, 128; in *Boatsman*, 117–20; burial customs and, 136, 242n50; and burial theme in *Red Oval*, 136; in *Compositions II and VI*, 100, 236n64; in concentric compositions, 133–34; in *Easter Egg*, 162; in *Glass Painting with Boat*, 122; in *Gray Oval*, 121; in *Harbor*, 114–15; in *In the Gray*, 130; and *Kalevala* saga, 117, 236n65, 248n58; in Kandinsky's Bauhaus mural project, 142; in *Levels*, 166, 167; in *Lyrical Oval*, 164; in *Oval No. 2*, 157; in *Peevish*, 169–70; pictographic form of, 87; in *Retrospect*, 151; shamanic drums and, 80, 84; in *Song of the Volga*, 42–43; in *Untitled (with Viking Ship)*, 121

Correspondence paintings. *See* Communication paintings

Cosmas and Damian. *See* Sts. Cosmas and Damian

Cosmic pillar motif. *See* World Pillar motif

Cosmic tree, in shamanic imagery, 80, 232n26. *See also* World Tree

Cosmogonic map motif, 79, 87–92, 127, 133–38; in *The Blue Arc*, 128; in *In the Black Circle*, 155; in *Little Worlds*, 92; in *Lyrical Oval*, 164; in *Retrospect*, 151; in *Several Circles*, 166; in *Small Pleasures*, 128; in *Whispered*, 162. *See also* Shaman drums; Universe

Costume: of eastern Slavs, 223n17; as motif, 85–87, 183–84, 189, 208; Orochon, donated by Kandinsky family to Dashkov Collection, 31–32, 133; Russian motifs in paintings and, 36–38, *37, 38*, 42; studies of, in Munich sketchbooks, 37; Zyrian people and, *4, 5, 6,* 16–17, 133, 223n29, 228n83. *See also* Shaman costume

Couple motif, 40–42, 125, 127, 138, 197

Cow motif, 244–45n15

"Cranes" (Finno-Ugric harps), 186, *188*

Creation motif, 136, 182, 185, 202

Creative process, Kandinsky on, 79–80

Cross motif, 15, 156, 157, 170, 191, 197

Crossed-horseheads motif, 35, 64, 167, 229nn100, 101, 185

Crowd scenes, and Russian motifs, 42–43, 47, 225n44. *See also Motley Life*

Cubist painting, 242n44

Cuckoo, 186, 250n22

Curves, hooked, as hieroglyphs for horses, 87

Dance Mask of the Demon of Disease (Ceylonese artifact), *xiv, 107; The Blue Rider* and, 94, 106, 110

Dashkov Ethnographic Collection (Moscow): description of, 94, 133, 233n34, 241n43; Eskimo artifacts in, 133; ethnic cultures and, 11; Kandinsky's contributions to, 31–32, 133; shaman costumes in, 85, 133; shaman drums in, 77, 80; Tlingit artifacts in, 133, 160; Vogul dance masks in, 109

Death: of Kandinsky's father, 164, 247n46; of Kandinsky's son, *xv,* 136, 160–62; Russian customs concerning, 136; of Sophie Taeuber-Arp, 252n43; Zyrian beliefs about (*see* Burial customs; *Domovoi; Ort*). *See also* Death motif

Death motif: in *Brown Elan*, 197; in *Diverse Parts*, 182; in *Dusk*, 252n43; in *Easter Egg*, 247n46; in *Le Filet*, 193; in *The Green Bond*, 200; in *Red Accent*, 197–99, 252n43; in *Red Oval*, 136; in *Untitled* (1944; unfinished watercolor), 208

Decembrists, 214n13

Department of Visual Arts (IZO) of Narkompros, 128

Destruction, use of Lapp shaman drum in, 84–85

Devel, Frederick, 111; *Tales of Eastern Siberia,* Kandinsky's copy of, 109

Dismemberment motif, 102. *See also* Shaman(ess): rituals of

Diver bird, 176, 202, 206, 252n49

Divination, use of shaman drum in, 85

Dog motif, 117–22, 172

Domovoi (Zyrian house spirit), 24–25, 28, 46, 218n58

Donner, Kai, 210

Dragon motif: in *Brown Elan*, 197; on cover of *Blue Rider* almanac, 72; in *Five Parts*, 206; in *Gray Oval*, 121, 134; in *The Green Edge*, 134; in *Harbor*, 115; in *Moscow II*, 125; in *Picnic*, 114; in *St. George* works, 73, *74, 75, 76*, 120; in *White Oval*, 134; in *Yellow-Red-Blue*, 170. *See also* Kandinsky, Vasilii (artistic works): *St. George* paintings. *See also* Serpent motif

Dresden, Germany, 246n30

Drums. *See* Shaman drums

Duality theme, 52, 61. See also *Dvoeverie;* Religious syncretism

Dukh, meanings of, 218n55

Dvoeverie ("double faith"), 99; childbirth goddess and, 22–23, 51; in Lapp belief, 85; legend of Pam and St. Stephen and, 22; *ort* and, 23–26; persistence of pagan beliefs and, 21–22; in Remizov's works, 143; Rusalka Week and, 229n97; as term, 21, 224n42; *vörsa* and, 227n72; Zyrian beliefs and customs and, 16,

19–20, 22–26, 51, 227n72. *See also* Duality theme; Religious syncretism

—in Kandinsky's works, 143; *All Saints' Day* paintings and, 56–63; in "Bell" (poem), 111; in *Composition II*, 54–55; development of, 150; final paintings and, 199; *Motley Life* and, 47–52; "Sunday (Old Russia)" paintings and, 38–40; in *Tempered Elan*, 208; in *Twilight*, 35

Easel motif, 249n13

Easter eggs, 242n52, 247n46. *See also* Egg motif

Easter Island ancestor figure, *xiv,* 94, *96*

Easter motif, 136–38

Ecstasy, shamanic, 76, 108, 124, 130

Egg motif, 136–38; in creation myth, *Kalevala,* 136. *See also* Burial customs; Easter eggs; Finno-Ugric peoples: beliefs and customs of

Egori the Brave, 34, 35, 55, 95

Egyptian shadow play puppets, 103–04, 110

Elijah/Thor/Perun motif. *See* St. Elijah; Thor motif

Elniki (Zyrian ancestors), 25

Embracing-figures motif, 51–52, 56, 58, 225n48; multiple meanings of, 59. *See also* Sts. Cosmas and Damian

Ensor, James, *xv*

Epiphanius the Wise, 22, 217n45

Eskimo artifacts, 133

Ethnographic Museum, Berlin, 160

Ethnographic Museum, Dresden, 155

Ethnographic Museum, Munich. *See* Munich Ethnographic Museum

Ethnographic Review (journal), 2; Kandinsky's book reviews for, 26–32, 121, 142–43, 219n64, 220nn72, 77. *See also* Ethnography: Kandinsky's writings on; Political and social issues

Ethnographic Society. *See* Russian Imperial Society of Friends of Natural History, Anthropology, and Ethnography

Ethnography: and art, *xiii,* 248n60; continuity of Kandinsky's artistic development and, *xiv,* 52, 56, 58, 63–64, 128, 130; Goncharova and, 132; as guiding principle for Kandinsky, 142, 193, 199; as inspiration for *The Blue Rider*, 234n45; Kandinsky's interest in, *xiii,* 1–2, 4, 6, 8–10,

285

Second Duma, mentioned, 98

Self-portraiture. *See* Kandinsky: self-portraiture

Serpent motif: in *Around the Circle*, 194, 195; in *The Arrow*, 195, 197; in *Diverse Parts*, 182; in *Dominant Violet*, 181; in 1924 drawing, 148–50; in drawing for *Dominant Curve*, 250n17; in *Drawing No. 4*, 150; in *In the Black Circle*, 155; in *In the Gray*, 132; Kandinsky's final paintings and, 199; in *Open Green*, 146; in *Red Accent*, 198, 199; in *Retrospect*, 151; significance of, 250n16; snake images in shaman costume and, 85; as symbol of regeneration (*Red Oval*), 138; in *Through-Going Line*, 146; in *Untitled* (1944; unfinished watercolor), 208; in *The White Line*, 178; in *Yellow-Red-Blue*, 170, 173. *See also* Dragon motif

Shadow-soul. *See* Ort

Shaman(ess) (*koldun*), 16; Altaic, 111, 185–86, 209; appearance in *Klänge*, 110; as artist, 72, 79, 185, 231n2; bird symbolism and, 206–07; birth of, in World Tree, 157–59; burial customs and, 28, 54, 220n78, 252n48; Buriat, 50–51, 75–76, *78*, 111, 130–32, 197; capacities of, 172; in Castrén's *Travel Memoirs*, 169; communication (mediation) with divine powers, 72, 77; derivation of term, 211n17, 231n4; drum as vehicle for, 85; ecstasy of, 76, 108, 124, 130; ethnographic interest in, 26–28; flight of, *xvii*, 75, 85, 112, 178, 193, 195, 197, 205–06; in *Glass Painting with Boat*, 122; and hallucination, 74, 79, 203 (*see also* Mushroom motif); healing role of, 72, 109, 110, 226n86; illness of, 72, 74–76, 231n5; image of, on shamanic drum, 80-*81*; infant in *Whispered* (Goldi), 160–62; Kandinsky's documentation of, among Zyrians, 23–24; Karagas (Tofa), *86*; language of (Chukchee), in *Yellow Sound*, 108; Lapp, 103, 197; legendary powers of, 84–85, 229n94; masked, *78*; Minusinsk Tatar, *82*; myth of First Shaman, 130–32; personal qualities of, 74; as rider, 77–79; prophetic powers of, 56, 84; rituals of, 72, 74–76, 102, 106, 108, 109, 111, 185, 229n94, 231nn5, 6, 250n29; role of, 72–74, 231n4; Samoyed, 111; supernatural journey of, 79, 130; symbols of immortality

and, 85; Teleut, *81;* Tungus, *86;* tying up of (burial custom), 23–24, 200, 252n47; ventriloquism of, 72–74, 106–08, 110–11, 231n7, 238n92; Votiak, 27; zigzag path of, 80, 92, 105; Zyrian terms for, 226n54. *See also* Artist as shaman; Kandinsky, Vasilii: self-portraiture, as shaman; *specific shaman entries below*

—as motif: in *All Saints' Day* paintings, 60; in *Around the Circle*, 193; in *The Arrow*, 197; in *Composition II*, 54; in *Dominant Curve*, 185; in *The Green Bond*, 200; in "Hill," 110–11; in *In the Gray*, 130–32; in *Intimate Communication (Oval No. 1)*, 156; Kandinsky's later paintings and, 193; in *Klänge*, 111; in *Levels*, 166–67; "old man" imagery in *Motley Life* and, 50–51; in *Peevish, 168-*70; in "Seeing" (poem), 110–11; in *Sky Blue*, 188; in *Untitled* (ca. 1934; mixed media), 176

Shaman artifacts, *xvi*. *See also* Shaman costume; Shaman drums

Shaman costume (caftan, robe), 69, 85–87, *86, 250n16*; amulets on, 85, *203;* bells on, 85; bird images on, 85–86, 87; in Dashkov Collection, 85, 133; inner eye relationship to, 85, 111; Karagas (Tofa) and, 86; Minusinsk Tatar, *82;* Potanin on, 233n34; Siberian, 85; Tungus (in Dashkov Collection), 133; Tungus (in Musée d'Ethnographie, Paris), 180-*81*, 184; Tungus (St. Petersburg), *86*; Udegei apron, *195*

—as motif: in *Around the Circle*, 193, 194; in *Composition V*, 127; in *Composition X*, 189; in *Development in Brown*, 174; *Dominant Curve* and, 184; in *The Ensemble*, 206; in *Floating*, 183; in *The Green Bond*, 200; in Kandinsky's final paintings, 199; in *Moscow II*, 127; in *Tempered Elan*, 205; in *The White Line*, 183

—breastplate motif, 86–87, 192–94, 252n46; in *Around the Circle*, 194; in *The Arrow*, 195–97; in *Brown Elan*, 197; in *The Green Bond*, 200–201; Karagas (Tofa), *86;* in *Light Construction*, 191–93; on shaman costumes, 86, 194, 197, 200, 252n46; in *Sky Blue*, 188; in *Tempered Elan*, 206

—glove motif, 85, 202, 252n49

—headdress motif, 85–87; in *Ambiguity (Com-*

plexity Simple), 180; in *Around the Circle*, 193; in *The Arrow*, 197; in *Black Accompaniment*, 148; in *Diverse Parts*, 181; in *Dominant Curve*, 185; in *Dominant Violet*, 180–81; in drawing for *Around the Circle*, 251n35; in *Drawing No. 4*, 150; in *The Green Bond*, 200; Kandinsky and "Indian" headdress, 100; profile motif and, 249n13 (*see also* Kandinsky: self-portraiture); in *Reciprocal Accord*, 191; in *Sky Blue*, 188; Tungus, 86, 193, 206; in *Watercolor No. 23*, 142

Shaman dance, 130, 195, 206, 251n38

Shaman drum sound motif, 134

Shaman drums, 246n30; artist's canvas as analogous to, 76–77, 148; as boat, 164, 236n65; cardinal directions, 85; color of, 105, 148, 155; as cosmogonic map, 106, 230n26; division of, 155; as horse, 72, 80, 87, 89; magical uses of, 85, 232n17; Minusinsk Tatar, 80; as musical instrument, 106; Ostiak, 87; as pictorial source, 79–81; sacred nature of, 85; as Sampo, 85; shape of, 110, 130; Siberians and, 80–81; size and frame of, 155; as star chart, 80, 232n26; Teleut, *80, 81;* Tlingit, 69; used to communicate with gods, 77, 80; as vehicle, 79, 106, 232n26; Yakut, 186. *See also* Pictography and hieroglyphic figures

—Altaic, *82*, 87, 89, *155;* animation ritual of, 185–86; deity motif and, 156; drum animation ritual and, 185–87, 202–03, 209–10; *In the Circle* and, 89; pictograms on, 87; and *Picture with the White Edge*, 87; and *Several Circles*, 247n48

—Lapp, *77, 81–85, 83, 84*, 102, *102*, 103, 155, *156*, 162, *167;* horizon line motif, 156, 157, 162, 171–73, 246n35; schema for, *167, 172;* Thor figure from, *159;*

—as motif: in *Around the Circle*, 193; in *The Arrow*, 195; in *Brown Elan*, 197; in *Composition V* and Munich Lapp shaman drum, 99; in *Easter Egg*, 164; "Empty Canvas, etc." essay and, 185–86, 202–03, 209–10; in *The Green Bond*, 200; in *Hut of Baba Yaga, 65*, 167; in *In the Circle*, 89; in *Intimate Communication (Oval No. 1)*, 155; in Kandinsky's drawing for

shamanic depiction of, 84, 85; in "Un-
changed" (poem), 111; in *Untitled* (ca. 1917;
watercolor), 134; in *Whispered*, 162. *See also*
St. Elijah; Hora-Galles

Thread, and shroud in *The Green Bond*, 252n47.
See also Knot of the dead

Thunderbird, 206, 253n57

Tikheeva, Lydia (Kandinsky's aunt), in *Glass
Painting with Boat*, 124

Tlingit culture: dancer's cape, 69, 94, *95;*
dancer's headdress, *161;* Dashkov collection
of, 69, 133; designs of, in *The Blue Rider* and
Oval No. 2, 160

Tokmakova, Elena Ivanovna (Kandinsky's
cousin), married to Sergei Bulgakov, 99

Tombstone motif: in communication paintings,
189; in *Improvisation (Ravine),* 125; in
Moscow I, 125

Tower imagery, 52, 54, 60. *See also* Cosmic pillar
motif; World Tree motif; World Pillar motif

Transcendence in art, 164

transition magazine: contents of and Kandin-
sky's contributions to 1938 issue, 248n6; cover
design for, 176–77, *178;* hieroglyphs and,
87–92

Translation, in shamanic ritual, 108

Tree: Lapp drums and, 84; as motif, 51, 89, 157;
pictographic form of, 87; as sacred, in pagan
belief systems, 218n59, 220n78. *See also* Birch
tree; World Tree motif; Willow tree

Triangle, 87, 214n11; in *Black Triangle,* 159; in
Composition V, 102–03, 236n68; in *Intimate
Communication (Oval No. 1),* 155–56; in *Oval
No. 2,* 156–57. *See also* Fir tree; Geometric
form; Mountain motif

Troika motif: in *The Blue Arc,* 128; in drawing
for *Picture with the White Edge,* 89; hiero-
glyph of, 87; in *In the Gray,* 132; in *On White
II,* 146; in *Watercolor No. 2 (St. Elijah),* 89. *See
also* St. Elijah

Trumpet-blowing-horseman motif, 45–46

Tungus culture (and Evenki): bird in burial cus-
toms of, 206; Kandinsky's genealogy and,
214n13, 222n97; shaman of, *86. See also*
Shaman costume

Tunisia, trip to, 46, 224n40

Udegei culture, shamanic costume of, in *Around
the Circle,* 194–95

Universe: animation of, with sound, 148;
Chukchee depiction of, 89–90; *In the Circle*
and, 89–90; shaman drums and, 87, 134, 159

University of Dorpat, 30, 34, 221n85

Ust Kulom, Vologda province, *19,* 20

Ust Sysolsk, Vologda province, 10, 15, *16,*
223n31, 225n49; folksongs and, 18, 19; *Motley
Life* and, 49. *See also* Vologda Diary; Zyrian
culture

Väinämöinen (*Kalevala* hero), 71, 113, 139, 175;
in *Boatsman,* 117; and creation myth, 136;
lyre of, and *Ruled Accumulation,* 186

Van Gogh, Vincent, *Portrait of Dr. Gachet,* 99,
105, *105,* 106

Vasa (Zyrian water spirit), 13, 25, 54, 63, 89-*90;*
sketch of carved figure of, 12, *13;* syncretism
and, *xvii*

—as motif: in *The Blue Arc,* 128; *Composition II*
and, 54; in *Composition V,* 100; in *Watercolor
No. 2,* 89

Vasilii III, czar of Russia, 95–97, *97*

Vekhi (signposts), 98

Ventriloquism. *See* Shaman(ess): ventriloquism
of

Verbnoe voskresenie (Palm Sunday, Willow Sun-
day), 39, 40

Vermilion, significance of, 198–99, 252n43. *See
also* Red

Viewer, participation of, in art, 166

Viking ship motif, 117, 120–21, 222n11, 248n58

Vinnen, Carl, 56, 59, 227n80

Vinogradov, Pavel, 29, 30

Virgin Mary/Golden Woman motif. *See* Mother
and child imagery; Zlata Baba

Visions. *See* Shaman(ess): and hallucination;
Shaman(ess): illness of

Vogul culture: artifacts of, in Dashkov Collec-
tion, 133; bear festival of, 109, 238n86; beliefs
of, 54–55, 178, 185–86, 227nn73, 74, 228n86,
247n42; burial customs of, 252n47; depictions
of World-Watching-Man by, *54–55;* and *The
Green Bond,* 202; spirit-figures of, 202; and

The Yellow Sound, 109. *See also* Ob-Ugrian
peoples

Voipel, in Zyrian belief system, 218n62

Vologda culture. *See* Zyrian culture

Vologda Diary (Kandinsky), 214n20; experiences
on expedition and, 11–20; observations on
"double faith" and shamanism, 15, 16

—sketches and drawings from, *13, 15,* 16–17, *17,
18, 19, 50;* bath house, *18;* carved *vasa, 13;*
chapel roof, *18;* clothing (*malitsa*), *17;* farm
implements, *18;* furniture decoration, *17;*
grain-storage shed, *50;* landscape at Ust
Kulom, *19;* log shed, 225n50; porch entrance,
18; St. Theodosia icon, *19;* wooden cross, *15*

Vologda expedition, *xiii;* area visited by Kandin-
sky on, 10; artifacts gathered on, 31; in *The
Blessing of the Bread,* 9; Church of St. John
Zlatousta and, *3;* discussed in Kandinsky's
memoir, 130; distance traveled on, 214n21;
ethnic groups and, 214n10; *The Green Bond*
and, 208; *The Horseman* and, 117; influence
on Kandinsky, *xiii,* 10–11, 20, 31, *46,* 67, 120,
142, 208–10; Kandinsky's bird artifact from,
160; Kandinsky's connection with Remizov
and, 243n6; Kandinsky's ethnic heritage and,
6, 8–10; Kandinsky's experiences on, 4, 6,
11–20, 46; landscape of, 11–20, *19,* 42, 49,
168–70; map of, *10,* 11; in *Motley Life,* 47–52;
in "Russian" paintings, 20; *Tempered Elan*
and, 208; Ust Sysolsk and, *16. See also*
Ethnography; Kandinsky, Vasilii (writings);
Vologda Diary

Vologda Province Gazette, 12

Von Zumbusch, Ludwig, 225nn44, 48

Vörsa (Zyrian water and forest spirit), 16, 25,
218n60, 227n72; in *Composition II,* 54. See
also *Leshie;* Vologda Diary

Votiak culture, 27, 227n73

Votive pictures, Bavarian, in *The Blue Rider,* 99

Vuolle (Lapp musical motif), 130

Wagner, Richard, 130

Walden, Herwarth, 114

Wasp motif, in *In the Gray,* 130

Water spirit. See *Rusalka; Vasa; Vörsa*

Werefkin, Marianne von, in *Picnic,* 114

Westheim, Paul, *xvii*

White, significance of, 242n54; in *Red Accent,* 198

White-horse motif, and World-Watching-Man, 55, 60

Wiedemann, F. J., 12, 25

Willow Sunday, 39. *See also* Palm Sunday

Willow tree, 38–39, 54, 223nn21, 23, 227n71

Window casing, carved (Gorky region), *6*

Wolf, Eugen (collection, Munich), 67

Wolfskehl, Hanna, 9–10

Women: in *Amazon* paintings, 121; in *Glass Painting with Boat,* 122–23; Kandinsky's bewilderment toward, 120; in *Lady in Moscow,* 240n18; in *St. George IV,* 120; as theme in *Bagatelles,* 114–20

"Wonder-houses" *(Wunderhäusern),* 4, 6, 20. *See also* Vologda Diary; Vologda expedition; Zyrian culture

Woodcock: in Kandinsky's collection, 64, *66, 162;* in *Oval No. 2,* 160; in Vogul belief, 247n42.

Woodcuts: Kandinsky's change to oil painting and, 76; *Klänge* and, 106–08, 110–12; Russian motifs and, 20. *See also specific woodcuts under* Kandinsky, Vasilii (artistic works)

Woodland spirits. *See Leshie*

Woodpecker, in folk belief, 160, 247n42

World Mountain motif, 111, 128, 151, 162, 200

World Pillar motif: in *All Saints II (Composition with Saints),* 60; in *Composition II,* 54, 227n79; in *Open Green,* 146. *See also* Tower imagery; World Tree motif

World Serpent motif, in *Around the Circle,* 195

World-Surveying-Man/World-Traveling-Man. *See* World-Watching-Man

World Tree motif, 61; in "Bell" (poem), 111; in *Between Two,* 180; in *The Green Bond,* 200, 202; in *Levels,* 166; in *Lyrical Oval,* 164; myth among Minusinsk Tatars and, 164; in *Oval No. 2,* 157–60; and Thor's bow, 247n44; in *Whispered,* 162

World War I, and *Improvisation (Ravine),* 125

World-Watching-Man (Golden Prince, Mirsusne-khum), *54, 55,* 72, 209, 227nn75, 79; as-

sociation with Christian figures, *xvii,* 51, 54, 55, 60, 100, 172, 227nn76; boat imagery and, 54, 100, 136; Golden Woman and, 55; and goose (gander), 54, 176, 178, 197, 248n3; horse-and-rider imagery and, 54; identified with Kandinsky, 100; in *Retrospect,* 151; St. George and, 76–77, 127, 156, 175–76; transformation into gander, 176, 178; Vogul representations of, *54–55;* and *Yellow Sound* (color composition), 110

—as motif: *All Saints' Day* paintings and, 60, 61; in *Black Accompaniment,* 148; in *The Blue Arc,* 128; in *Brown Elan,* 197; in *Composition I,* 55; in *Composition II,* 54–55; and *Composition V,* 100; in *Composition VI,* 100, 236n64; in *Composition X,* 189; in 1924 drawing, 148–50; in *Five Parts,* 206; in *Improvisation 13,* 76–77; in *In the Gray,* 132; in *Intimate Communication (Oval No. 1),* 156; in *Moscow I,* 127; in *Motley Life,* 51; outstretched arms and, 54, 55, 60, 61, 100, 236n66; in *Picture with Points,* 136; in *Red Oval,* 136; in *Retrospect,* 151; in sketch for *Composition I, 55;* in sketch for *Composition VI,* 100; in *Untitled* (ca. 1934; mixed media), 176; in *Untitled Study for Composition II, 57;* in *Vignette to "Leaves,"* 110; in *Yellow-Red-Blue,* 172; in *Yellow Sound,* 110

XXe Siècle, 213n18

Yakut culture: artifacts of, in Dashkov Collection, 85, 133; boats in death belief of, 136; icehole as shamanic gate and, 250n17; shamanic treatment of infertility among, 160

Yanukh-Tōrem. *See* World-Watching-Man

Yarensk, Vologda province, 15, 16

Yellow, significance of: in *Composition II,* 54; in *Red Oval,* 136; as symbol of divinity, 100, 136; in *Yellow Sound,* 110

Yenessei River cliffs, petroglyphs of, 87

Yukaghir culture, 198; love letters of, 191–93, *192, 193,* 250n30, 251n34; shamans of, 198

Yurt motif: in *Around the Circle,* 195; in drawing for *Dominant Curve,* 250n17; in *The Green Bond,* 202; in *Moscow I,* 127

Zemstvo movement, 221n84

Zigzag motif: in *Composition V,* 105; in *Composition VII,* 92; in *Diverse Parts,* 182; in *In the Circle,* 89; shaman and, 80, 92, 105, 234n43

Zipe Totec (ceramic Aztec figure), 106

Zlata Baba ("Golden Woman," childbirth goddess), *23,* 226n57; identification of, with Virgin Mary, 23, 51, 55, 61; Kandinsky on, 22–23; *Motley Life* and, 51; and World-Watching-Man, 50; wrapped effigies of, 226n58

Zyrian culture: "Bell" poem and, 111; Castrén's *Travel Memoirs* and, 11, 168–70; characteristics of, 215n34; costumes of, *4, 5, 6,* 16–17, *17,* 36, 133, 223n29, 228n83; Dashkov Collection artifacts and, 133; decorative motifs of, *6, 8, 17,* 117, 120; geographical branches of, 216n41; the hearth and, *25;* hunter's accoutrements collected by Kandinsky, 18; Kandinsky's essay on, 20–26, 205; Kandinsky's observations on, 4–6, 11–26; language of, 18, 27, 28, 225n50, 226n54; peasant house interiors of, 4, 6, *6, 8, 9,* 16, 66; remoteness of, 214n17; Sjögren on, 8, 11, 12, 22, 49; storage sheds of, *50,* 225n50; Wiedemann's dictionary of Zyrian language, 12; "Wonder-houses" *(Wunderhäusern)* of, *4, 6,* 20. *See also* Ethnography: Kandinsky's writings on; Vologda Diary

—beliefs of: citations of Kandinsky's work on, 81, 219n63; death and, 21, 23–24, 200, 247n46; *domovoi* and, 25; Kandinsky's final work and, 209; *ort* or shadow-soul and, 23–24, 143, 200; source for Remizov, 143

—customs of: ancestor cult among, 23–25; burial customs of, 22, 136, 200–201, 207; funerary customs, 23–26, *24,* 28; and *The Green Bond,* 200–201; and Poludnitsa, 26; and *rusalka,* 25; rye, sheaf of, in icon corner, 15–16; traditional wedding lament of, 142; and *vörsa,* 25; Zlata Baba and, 22–23

Zyrian territory. See Vologda expedition

Zyrianskaia Old Testament Trinity icon, in Vologda (city), 12–13